D0984942

WITHDRAWN

In the **Shadow** *of the* **Sun**

Perspectives on Contemporary Native Art

Edited by
The Canadian Museum of Civilization

Canadian Ethnology Service
Mercury Series Paper 124

Canadian Museum of Civilization

Canadian Cataloguing in Publication Data

Main entry under title:

In the shadow of the sun: perspectives on contemporary native art

(Mercury series, ISSN 0316-1854)
(Paper/Canadian Ethnology Service; no. 124)
Includes an abstract in French.
Translation of most of the essays included in the original German publication, *Im Schatten der Sonne: Zeitgenossische Kunst der Indianer und Eskimos in Kanada* (edited by Gerhard Hoffmann, and published by Cantz and the Canadian Museum of Civilization, 1988). cf Abstract.

ISBN 0-660-14012-8

1. Indians of North America – Canada – Art – Exhibitions. 2. Inuit – Canada – Art – Exhibitions. 3. Native peoples – Canada – Art – Exhibitions. 4. Art, Modern – 20th century – Exhibitions. I. Canadian Museum of Civilization. II. Canadian Ethnology Service. III. Title: Perspectives on contemporary native art. IV. Series. V. Series: Paper (Canadian Ethnology Service); no. 124.

E78.C215 1993 704'.039771'074
C93-099501-5

PRINTED IN CANADA

Published by
Canadian Museum of Civilization
100 Laurier Street
P.O. Box 3100, Station B
Hull, Quebec
J8X 4H2

Front cover:

Ceremonial Dance Puppet by Art Thompson (1986-87). Canadian Museum of Civilization

Standing Woman with Ulu and Bag by Joe Talirunili (1960-76). Canadian Museum of Civilization

Paper coordinator: Pam Coulas

Production coordinator: Lise Rochefort

Cover design: Francine Boucher

Canada

OBJECT OF THE MERCURY SERIES

The Mercury Series is designed to permit the rapid dissemination of information pertaining to the disciplines in which the Canadian Museum of Civilization is active. Considered an important reference by the scientific community, the Mercury Series comprises over three hundred specialized publications on Canada's history and prehistory.

Because of its specialized audience, the series consists largely of monographs published in the language of the author.

In the interest of making information available quickly, normal production procedures have been abbreviated. As a result, grammatical and typographical errors may occur. Your indulgence is requested.

Titles in the Mercury Series can be obtained by writing to:

Mail Order Services
Publishing Division
Canadian Museum of Civilization
100 Laurier Street
P.O. Box 3100, Station B
Hull, Quebec
J8X 4H2

BUT DE LA COLLECTION MERCURE

La collection Mercure vise à diffuser rapidement le résultat de travaux dans les disciplines qui relèvent des sphères d'activités du Musée canadien des civilisations. Considérée comme un apport important dans la communauté scientifique, la collection Mercure présente plus de trois cents publications spécialisées portant sur l'héritage canadien préhistorique et historique.

Comme la collection s'adresse à un public spécialisé celle-ci est constituée essentiellement de monographies publiées dans la langue des auteurs.

Pour assurer la prompte distribution des exemplaires imprimés, les étapes de l'édition ont été abrégées. En conséquence, certaines coquilles ou fautes de grammaire peuvent subsister : c'est pourquoi nous réclamons votre indulgence.

Vous pouvez vous procurer la liste des titres parus dans la collection Mercure en écrivant au :

Service des commandes postales
Division de l'édition
Musée canadien des civilisations
100, rue Laurier
C.P. 3100, succursale B
Hull (Québec)
J8X 4H2

ABSTRACT

This volume makes available in English most of the essays written to accompany the Canadian Museum of Civilization's exhibition **In the Shadow of the Sun**. Not included from the original German publication, *Im Schatten der Sonne: Zeitgenossische Kunst der Indianer und Eskimos in Kanada* (edited by Gerhard Hoffmann, and published by Cantz and the Canadian Museum of Civilization, 1988), are the exhibition catalogue section and the essays by Gisela Hoffmann, Bernadette Driscoll and Elizabeth McLuhan. However, Viviane Gray's article appears here for the first time. Complemented by images of contemporary Indian and Inuit art, the book provides an overview of the evolution of contemporary Canadian Native art. Regional styles as well as the styles of individual artists are discussed, and the various subjects, themes and techniques reflected in the works of art are examined. This publication testifies to the remarkable diversity of expression and creative vitality of Canadian Native art.

RÉSUMÉ

Cet ouvrage rend disponible en anglais la plupart des communications originalement écrites pour accompagner l'exposition du Musée canadien des civilisations, **À l'ombre du soleil**. Il ne comporte pas cependant certains éléments, qui apparaissent dans l'édition originale allemande *Im Schatten der Sonne: Zeitgenossische Kunst der Indianer und Eskimos in Kanada*, rédigé par Gerhard Hoffmann (publié conjointement par Cantz et le Musée canadien des civilisations, 1988), soit les quatre essais écrits par Gisela Hoffmann, Bernadette Driscoll et Elizabeth McLuhan ainsi que la section portant sur les objets exposés. En revanche, un article écrit par Viviane Gray apparaît ici pour la première fois. Agrémenté de reproductions d'œuvres d'art amérindien et inuit contemporain, ce livre offre un aperçu de l'évolution de l'art autochtone canadien contemporain. Il illustre l'évolution des styles personnels et régionaux, la diversité des sujets, des thèmes et des techniques. Cette publication témoigne d'une remarquable diversité dans l'expression de même que du dynamisme créateur de l'art autochtone canadien.

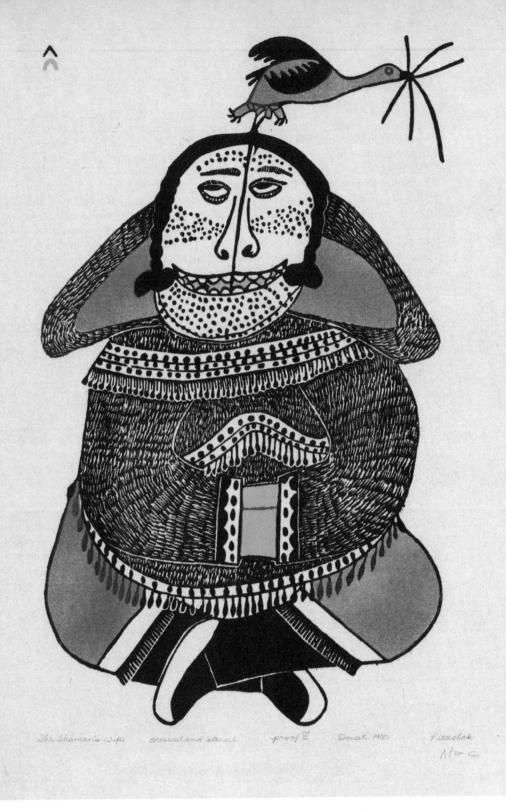

The Shaman's Wife Stonecut and stencil proof III Dorset 1980 Pitseolak

<u>The Shaman's Wife</u> by Pitseolak Ashoona (1980). Canadian Museum of Civilization CD 1980-42.

CONTENTS

INTRODUCTION

by

Gerald McMaster

In preparation for the opening exhibition for the new Canadian Museum of Civilization (CMC), we were approached by Dr. Gerhard Hoffmann of the University of Würzburg, West Germany, in early 1987, with a proposal to organize a joint project. The University of Würzburg would coordinate the production of an important and timely publication on the subject of contemporary Native Canadian art, and we would produce the accompanying exhibition. The result was an exhibition that toured to several museums in Europe and Canada.

From Dr. Hoffmann's point of view, an exhibition of contemporary Native Canadian art would enlarge the German perspective of the Native North American scene, which began with the successful touring exhibition 20th Century American Indian Art. The people of Europe, he and others reminded us, have an ardent interest in the Native North American, and an exhibition of their artistic heritage would no doubt advance an existing interest.

At that time, our perspective for organizing such an exhibition was that it would complement (and continue) the highly acclaimed and criticized exhibition The Spirit Sings: Artistic Traditions of Canada's First Peoples, whose emphasis was on pre-twentieth century Native Canadian art. Both exhibitions were being proposed as inaugural exhibitions for the new CMC in 1988. As it was, the opening was delayed an additional year, but The Spirit Sings did open in 1988 in the recently vacated National Gallery building.

From the start, the framework for such an exhibition was a survey of developments in both Indian and Inuit art focusing on masterworks drawn from public and private collections and highlighting the CMC collections, among the finest collections of contemporary Canadian Native art in the world.

Therefore, we needed to give our potential audiences an appreciation of the hidden treasures of the museum. These hidden treasures would soon be displayed: planning included an Indian and Inuit Art Gallery within the new museum. Since our collections began as contemporary developments in Native cultures, it was the contemporary Native artist who looked to the past for inspiration through whom the museum felt it had to maintain a continuity in its exhibition mandate. The mandate to collect and exhibit Native art at once received welcomed support by contemporary Native artist Edward Poitras. Indicating the honour he felt when the museum collected his works, he said it made him feel "at home with his ancestors." This is not to

suggest that all the museum's projects are made up of only Native inspired themes, styles, and media; some exhibitions had to prepare new ground. The new ground, as parts of this exhibition indicate, includes Western thought and ideas. It was, however, the placement of these works of art within the context of Native thought, history, and ideas that made the exhibition distinctive. It would show how the traditions of the past shed light on today's artists, and so we chose to call the exhibition In the Shadow of the Sun. The sun, in this instance, represents light, illumination, and knowledge in the modern world as well as in Native traditions.

In the Shadow of the Sun was the first major retrospective exhibition of contemporary Canadian Indian and Inuit art to be shown in both Canada and in Europe, outlining historical developments, stylistic variations, idiosyncracies, and current trends. An exhibition as ambitious as In the Shadow of the Sun in size and complexity called for a dedicated team along with inspired artists, past and present.

From the beginning, we knew a survey meant one thing: it was critical to be as inclusive as possible. To do this, we gathered a team of curators in the field of contemporary Indian and Inuit art. The Department of Indian and Northern Affairs (DINA) joined the project early on, their team led by Maria Muehlen of the Inuit Art Section. Once the basic infrastructure was established, we gathered the curators together in Ottawa for several meetings. Two teams were created. The Indian Art team consisted of Gerald McMaster, Tom Hill, Elizabeth McLuhan, Ruth Phillips, Alan Hoover, Carol Podedworney, and Karen Duffek. The Inuit Art team consisted of Odette Leroux, Maria Muehlen, Marie Routledge, and Ingo Hessel. Several meetings took place (with sub-teams meeting independently),and decisions were made about the exhibition's scope and content.

The essential criteria were that the artworks had to be extant and their "quality" had to be mutually agreed upon by the curators. The exhibition's framework of contemporaneity-works had to have been made after the Second World War-was established, with occasional exceptions. Then the thematic framework was established with the following categories: Northwest Coast; the Image Makers; Modernists/PostModernists; and Inuit sculpture, graphics, and textiles.

Two other decisions were made: who the artists were to be (some artists participated by default because they were deceased), and who the authors were to be.

As the finalizing of artists, artworks, and authors neared completion (spring 1987), research began in several key areas: a complete analysis of each work of art, the collating of artists' biographies and the authors' essays. Completion date was set for late winter 1988. Shipping of the artworks from public and private collections for photography and cataloguing took place

during this time. The direction the authors were given was that
their essays had to "problematize" and give context for each
theme. Other essays would deal with issues beyond the scope of
the works, but giving valuable arguments for the exhibition's
contemporaneity. Some essays thus begin at about the time of the
formation of "reserves" and the promulgation of the Indian Act in
the 1880s; but in most instances they do not refer to actual
works in the exhibition.

The decision early in 1988 to postpone opening of the museum
until 1989, because of construction delays, altered the timing of
the two shows. The Spirit Sings, amid an increasing controversy,
was scheduled to open in Ottawa that spring. In the Shadow of
the Sun, by contrast, needed a new venue. Negotiations then began
to send it to West Germany. The Ubersee Museum in Bremen was
targeted as the first venue in August.

With all 275 objects packed and ready for transport, with
the catalogue busily being translated into German at the
University of Würzburg, the exhibition was ready. In early July,
however, we discovered the Ubersee had backed out. But the
second German venue, Dortmund, was on schedule for an early
December 1988 opening. The delay gave Würzburg more time to
produce the catalogue.

Planning the exhibition's placement took account of two
factors: its relatively large size, and the two distinct
statements the exhibition would make (Indian and Inuit).
Consequently, arranging more than one exhibition facility was
tricky but gave receiving museums a higher profile. By the time
the show opened in Dortmund, two further venues had been
arranged: the Museum Am Ostwall exhibited the Indian art
portion, while the Museum Fur Kunst Und Kulturegeschichte
exhibited the Inuit art portion. The exhibitions, much to our
delight, were a critical success. Paying attendance was roughly
30,000, with considerable media coverage; and extremely vigorous
public programming ensured the exhibition's popular success.

The exhibition was brought back to Hull for the CMC's gala
opening on June 29, 1989. In the Shadow of the Sun inaugurated
the new Indian and Inuit Art Gallery, with about 50 per cent of
the exhibition on display in approximately 706 square m.

The premiere of the museum and the exhibition signalled a
new era for a redefinition of museums and their relation to art,
in particular non-Western or Native art. As these following
essays indicate, the study and elucidation of art (non-Western)
in non-traditional media, by (Native) art historians,
anthropologists, (Native) artists, and literary scholars, gives
critical awarness of the growing popularity of contemporary
Indian and Inuit art. The traditional notions of authority and
representation have been seriously criticized and eroded both
inside and outside the discipline of anthropology in the past
decade. No longer is Native art and/or culture its stronghold.

Anthropologist like James Clifford announce that "Anthropology no
longer speaks with automatic authority for others defined as
unable to speak for themselves ("primitive," "pre-literate,"
"without history")." (Clifford and George E. Marcus, Writing
Culture. University of California Press: Berkeley, 1986. p.10).
We hope this volume is exemplary in this respect.

The Indian and Inuit Art Gallery itself was created not as
an affirmation that such art belongs in anthropological museums,
nor as a critique of continuing neglect of it by art museums, but
simply as a reflection of the changing face of museums in
general. Within our institution, various exhibitions of
contemporary and traditional works would be in close proximity to
one another.[1] Thus we enhance the integrity of artists like
Poitras who see the importance of their antecedents.

The inaugural exhibition was seen by over half a million
people. It gave audiences a chance to discover the variety and
scope of contemporary Native art.[2] Indeed, the Gallery will be
able to offer works by contemporary Indian and Inuit artists on a
continuous basis. The museum's Grand Hall, devoted to the
cultures of the Northwest Coast, also provides an excellent
opportunity for visitors to explore the cultures from a
contemporary perspective. Works by contemporary West Coast
artists can be seen on many of the Grand Hall's facades and totem
poles.[3] Haida artists Bill Reid and Robert Davidson are
prominent throughout the museum, as is Chipewyan artist Alex
Janvier, whose paintings The Seasons can be seen at the entrance
to the museum. All the these works were reproduced in the
original German edition of the catalogue. These works remain on
long-term display.

The excitement of exhibition exchange remains at the top of
the list. As our exhibitions go on the road, we in turn receive
an endless supply of new shows. The museum's high profile makes
it more urgent for us to develop and bring in shows. In the
Shadow of the Sun was only the beginning of this process.

Following the Hull showing, the exhibition travelled to
Halifax's Art Gallery of Nova Scotia, in spring 1990. Again,
only about half the original exhibit could be shown. This did
not seem to discourage the audience. On the contrary, the
gallery and its audiences, although unaccustomed to seeing such
large displays of Native art, reached out to local Maritime
Native artists. They invited them to attend the opening and
asked them to exhibit their work in one part of the gallery. And
they committed themselves to an exhibition of Maritime Native
artists for 1993, thus committing themselves to the development
of greater awareness of this fledgeling area of artistic
creativity.

In the Shadow of the Sun completed its tour by travelling
back to Europe for presentation at two Dutch museums in September
1990: the Rijksmusem Voor Volkenkunde in Leiden and the Museon

in The Hague, where the Indian and Inuit sections were exhibited respectively. The Leiden venue was an ethnographic museum, while the Hague museum was a conglomerate of types. Interestingly, however, beside the Museon is a contemporary arts museum, the Gemeentemuseum, that did not wish to be involved in the project; their attitude to non-Western arts remains typical of mainstream art museums. In any case, two large Dutch cities did see the exhibitions, prompting some Dutch curators to explore possibilities for future exhibitions featuring contemporary Native artists.

In the Shadow of the Sun completed its circle and followed the sun home in late 1990. In retrospect it had many successes and some failures. Its successes seem more long-term: the opportunity to present Native Canadian art to European audiences, for example, occurs very rarely. Its scope may be a gauge for younger artists as they continue to develop. It provided the first-ever comprehensive view of both contemporary Indian and Inuit art history. It created new opportunities for future exhibitions of Native art. It inaugurated a new-style museum for contemporary Native expressions without any apologetics. And lastly, it brought togther many individuals completely committed to the success and articulation of contemporary Indian and Inuit art.

The exhibition's greatest failure, perhaps, was in not having included everyone. But that is the nature of any exhibition, however large. To anyone we may have offended we deeply apologize. We hope only that you will recognize and respect the fact that our views and visions were well-intentioned.

The future and success of Native Canadian art depends on honest, vigorous, and timely scholarship. We must never compromise. The 1990s hold exciting possibilities-something I never dreamed of when I entered art school. During the past number of years, I questioned the success of Native art in its marginality to the mainstream Western art world, and its stodgy defensive posture; but now we know that that hegemony is crumbling beneath its own ignorance and hypocrisy. Therefore, in many ways we are pleased this volume In the Shadow of the Sun is being made available, to confront those outdated notions. We hope this volume of essays will send signals out to students, teachers, and artists, everywhere about a renewed vision for the future.

Finally, it should be noted there are some differences between this volume and the original German edition. An original essay by Micmac writer Viviane Grey on artists' statements over time has been added. The essays from the catalogue portion of the German edition have also been added, for the further context they provide. The full-colour catalogue section and artist's biographies have been deleted.

As in any project, there are many people we must acknowledge for their commitment and support. They include all the artists past and present; Odette Leroux, the Associate Curator for the Inuit Art Section; Diane Bridges, exhibition coordinator; and Richard Garner, photographer. A very special thank-you to Maria Muehlen of the Inuit Art Section, and the Indian Art Centre, Department of Indian and Northern Affairs, for their financial commitment to the German publication. I would like to express my sincere gratitude to Dr. Gerhard Hoffmann, for the ideas, wisdom, and untiring energy he showed in seeing this project to completion; Dee (Tedds) Simmons, curatorial consultant; Angela Skinner, curatorial consultant; Allan Hoover, Royal British Columbia Museum; Carol Podedworney, Thunder Bay Art Gallery; Karen Duffek, UBC Museum of Anthropology; Diana Nemiroff, National Gallery of Canada; Ruth Phillips, Carleton University; Elizabeth McLuhan, York University Art Gallery; Tom Hill, Woodlands Indian Museum; Bill McLennan, UBC Museum of Anthropology; Stephen Rothwell, Indian Art Centre, DINA; Marie Routledge, National Gallery of Canada; Dorothy Speak, consultant, Inuit Art, Ottawa; Ingo Hessel, Inuit Art Section, DINA; Catherine Priest, Inuit Art Section, DINA; Tutavik, Toronto; Dalma French and Yves Paquin, designers, Canadian Museum of Civilization; and Nancy Gautsche-Emke. We benefited greatly from the assistance of all the institutions and private collectors from Canada, the United States, and Germany who generously parted with their works, and, of course, the authors whose catalogue essays we publish in this volume.

NOTES

1. Long before the opening, the CMC's historical and
contemporary collections were already nationally and
internationally known for both their quality and quantity. The
collections of contemporary Indian and Inuit art number 2,500 and
8,300 objects, respectively. There were many other public and
private collections containing masterpieces worthy of wider
national and international exposure. In the Shadow of the Sun
sought to provide that opportunity.

2. Dec. 9, 1988-Feb. 27, 1989, Museum Am Ostwall and Museum Fur
Kunst Und Kulturgeschichte, Dortmund, Germany; June 29, 1989-Jan.
2, 1990, Canadian Museum of Civilization, Hull, Quebec; April 20,
1990-June 24, 1990, Art Gallery of Nova Scotia, Halifax, Nova
Scotia; Aug. 30, 1991-Oct. 28, 1991, Rijksmusuem Voor
Volkenkunde, in Leiden, Netherlands; Aug. 31, 1991-Oct. 28, 1991,
Museon, The Hague, Netherlands.

3. Tsimshian house: Several Tsimshian artists from the Northern
coast, including Terry Starr, worked on the house front painting.
 Haida house: A team of Haida carvers led by Jim Hart.
 Nuxalk house: Glenn Tallio.
 Central Coast house: Douglas Cranmer restored the pole that
stands in front of the house; it had previously stood in Stanley
Park, Vancouver.
 Nuu-chah-nulth house: Ron Hamilton created the house front
painting. Tim Paul carved the totem pole.
 Coast Salish House: The painting was made by Shane Point.

THE FOURTH WORLD AND FOURTH WORLD ART*

by

Nelson H.H. Graburn

INTRODUCTION

This volume concerns the art of Native Canadians, focusing on
Indian and Inuit artists of the twentieth century. It is,
therefore, not primarily a book about "primitive art" in the old
sense of the word. Until recently, "primitive art" referred to
objects that were collected from exotic peoples and termed "art"
when they crossed the cultural boundary and were placed in the
museums and depositories of Western society. Such artifacts were
thus "art by metamorphosis" (Maquet 1971): they were considered
neither "primitive" nor "art" by the peoples who made them. Until
1976, these objects were generally deemed to be the internally-
consumed or locally-traded cultural expressions of traditional
non-literate societies. But, by the early twentieth century, the
Indians and Inuit of Canada were no longer "isolated primitives":
with rare exceptions, they were subjugated minority peoples
within the Dominion of Canada.[1] For the most part, their
spiritual and especially their material cultures had already been
drastically altered by contact with Euro-Canadians. Furthermore,
their arts have increasingly become "art by intention" (Maquet
1971), created by artists well aware of the art market and
external patronage (see Cole 1985).

These minority ethnic groups are the subject of internal
colonialism; they are collectively called peoples of the Fourth
World. The arts of peoples of the Fourth World show evidence of
this new political relationship, often through the incorporation
of newly traded materials and newly encountered cosmologies, and
through new functions such as trading with the world system and
acting as ethnic markers in the Canadian ethnic mosaic.

CONCEPT OF THE FOURTH WORLD[2]

The concept of the Fourth World, Quart Monde (Muller-Wille and
Pelto 1979), is an eminently political designation that, along
with other concepts like the Third World and ethnicity, is a
product of our increasingly selfconscious, postcolonial age. It
has to do with power, nationalism, and cultural integrity.

After the Second World War, the old world order of the
colonial and colonized nations fragmented along a number of
lines. The industrialized nations broke into two camps, those
siding with the United States and capitalism, and those dominated
by the Soviet Union and socialism. The smaller nations of the
world, both those that had been recently freed from colonialism
and those that were marginal to the military networks of the main

1

protagonists, fought these twin hegemonies. In 1955, the leaders of these less powerful nations attended the First World Conference of Non-Aligned Nations in Bandung, Indonesia, chaired by Marshall Tito of Yugoslavia and President Sukarno of Indonesia. They attempted to form a third power bloc, one that would enable them to resist the political and economic forces of the capitalist and socialist worlds. Although membership in this group has varied, its alliances have never been potent, and it has come to be known as the Third World, or Tiers Monde.

The division between the Third and Fourth Worlds separates the former, often ex-colonial peoples, from the latter still-colonized minorities of complex modern nations. "The Fourth World comprises those indigenous peoples whose lands and culture have been overrun by the modern techno-bureaucratic nations of the First, Second and Third Worlds" (Graburn 1976:frontispiece). The Fourth World thus consists of encapsulated non-nations, relatively powerless minorities within larger nation states. For example, within the First World they are represented by Eskimos and Indians in North America, Aborigines in Australia, Maori in New Zealand, and perhaps even the Basques in Spain and France. In the Second World, Fourth World peoples include the minority nationalities of the USSR and, perhaps, the small nations within China.[3] Within the Third World, the concept includes the Indian minorities of Central and South America, the "tribals" of India, the Kurds of Turkey, Iraq, and Iran, and some of the minority peoples of relatively heterogeneous nations in Africa, such as the Pygmies of Zaire.[4]

This scheme is a heuristic classification that refers mainly to power relationships in many areas, including the production of art. Simply put, even though Fourth World peoples may call themselves nations (such as the "Dene Nation," the "Navajo Nation," the "Miskito Nation" of Nicaragua, and the Eritreans of Ethiopia), they have neither the autonomy nor the institutionalized power to define their own national symbols, arts, and culture. Neitschmann (1987) has attempted to summarize the status of the struggles of all these indigenous peoples in their relationships to cultural and political hegemony.

The concept of the Fourth World as used here was first advanced by Whitaker (1972) to refer to exploited, internally colonialized peoples and, soon after, by the Canadian authors Manuel and Posluns in their book The Fourth World: An Indian Reality (1974). In his introduction to this book, Vine Deloria, an American Indian author, traces the breakdown of solidarity between what are now called the Third and Fourth worlds.

In summary, the Fourth World is a political classification, dependent upon the variables of political alliance and relative autonomy. It is not static and, even during the short period in which the new classifications have been in vogue, particular nations have "changed sides" (e.g., Somalia) or have moved from Fourth to Third World status (e.g., Greenland to some extent).

Others, which have been conquered by their more powerful neighbours, are in danger of losing their Third World status and becoming colonies (e.g., Afghanistan); they could thus become part of the Fourth World.

THE EVOLUTION OF FOURTH WORLD SOCIETIES

The creation of Fourth World societies by conquest and incorporation occurs in a relatively simple progression. Initially, the powerful expanding civilization (usually Western) acquires the territory of a small-scale, nonindustrial, indigenous society. The following diagram (fig. 1) outlines the main stages.[5] The production of art is often a point of articulation between the dominant and minority societies.

1. Initial contacts may be warlike or friendly; but if the dominant society wishes to acquire the territory, the scheme proceeds. Military contacts may cause some social regrouping of the smaller society and result in its extinction or withdrawal from the territory; but in all cases, the situation proceeds to stage 2.

2. Sooner or later, the dominant society takes over the land for economic or political purposes and "administers" the people of the small-scale society. One or more of the following three kinds of relationships may exist initially between the two groups:

a) If the larger society merely wishes to exploit the resources of the region, with little regard for tribal peoples, the latter may be pushed off the land or succumb to new diseases and become extinct. This was perhaps the fate of the Beothuk of Newfoundland (Marshall 1981). Alternatively, victims may move directly to stage 5: benign neglect on reservations.

b) The conquering society may wish to exploit the resources of the area by using the labour of the tribal peoples and may use coercion if the labour is unfamiliar or harsh. This process results in a drastic social reorganization of the minority peoples and a loss of some traditional skills. Indigenous peoples could be forced into slavery, indentured labour, or military service, and could even be used as beasts of burden. For example, during the Klondike Gold Rush of the 1890s, the Indians of the Canadian Cordillera were sometimes made to carry mining equipment and supplies from the coast of southeast Alaska over the Chilcoot Pass into the interior. This economic relationship may persist or may evolve to stage 5.

c) In many cases, the larger society wishes to make use of traditional Native skills or products. Such an employment or trading situation may seem mutually beneficial to both groups for a time. The tribal peoples enter this relationship in order to pursue their traditional activities more efficiently (e.g.,

4

Fig. I. The Evolution of Fourth World Societies

Process or Stage	Relationship Between Groups	Consequences for Minority Society
1. Early contacts	Warlike or Peaceful	Military grouping, withdrawal, extinction. To stage 2.
2. Initial economic relationships	A. Resource exploitation B. Labour exploitation or C. Use of Native products	Extinction, withdrawal or stage 4. Loss of skills; social reorganization for labour (possible mutual gain); to stage 3. Mutual gain, loss of some skills; to stage 3 social organization for trading, etc.
3. Structural incorporation	Division of labour by "race"	Loss of economic amd political independence to lower stratum of complex society; further social reorientation and some cultural assimilation. Relative stability; to stage 4 or 7.
4. Loss of initial economic relationship	2B and 2C cease; no longer useful or competitive	Move to stage 5 or extinction (further withdrawal rare).
5. Benign neglect	Relief, subsidy, reservations	Complete dependence; frustration due to uselessness and segregation; conspicuous deviance; apathy, aggression, and social movements, to stage 6 or 7.
6. Second special economic relationship	Division of labour by "race"	Back to stage 3. New skills and loss of some old ones.
7A. Assimilation	General education, non-racial division of labour	As a group–very rare; loss of ethnicity; as individuals–by mobility and "passing".
B. Self-determination	Pluralism; perception of separateness	Parallel education and occupational structures; bilingualism or language shift.

trapping in order to buy guns to hunt). As early as the eighteenth century in Canada, many Indian groups complemented the fur-trade by selling their own products as souvenirs and curios to the outside world (Clark 1974). Thus, the trade in material culture, classified in the metropolis as arts and crafts, may constitute part of the initial relationship between the two societies. The production of surplus materials or products of Native skills inevitably causes a social and economic reorganization of the Native society.

3. The institutionalization of these economic relationships (2b and 2c) leads to a division of labour by "race." The indigenous society becomes structurally incorporated into the national and world system; it is changed internally, becomes dependent upon the trading or employment relationship, and neither can nor wants to return to the autonomous, precontact way of life. There is an irrevocable loss of traditional skills, and of economic and political independence; and the indigenous peoples become members of the lower stratum of a complex society. They have become members of the Fourth World, and the next stage in their evolution is either benign neglect (stage 5) or assimilation and/or self-determination (stage 7).

4. Sooner or later (sometimes after many generations), the initial economic relationship ceases; fashion may deflate the prices of pelts, or animal populations may dwindle (Martin 1978). New technologies may lower demand, as was the case when whaling ceased in the first decade of this century; or Native labour may no longer be required, as occurred at the end of the Gold Rush. If the dominant society had no regard for the welfare of its newly dependent population, the latter, having lost many skills and traditional resources, may die off. Such was almost the case with some Canadian Inuit groups after the withdrawal of the Hudson's Bay Company during the Depression, and during and after the Second World War.

5. Many Fourth World peoples slip into benign neglect-also known as Welfare Colonialism (Castile 1983)-when they are no longer "useful" to the world society. No longer capable of an independent existence, they are maintained by the larger society through various kinds of welfare subsidies; they may even be confined to remnants of their traditional lands, called reserves or reservations. The Fourth World peoples experience self-devaluation and are often subject to social pathologies like alcoholism and family breakdown. The effects of this devastating social predicament have been reported for both the Canadian Inuit (e.g., Clairmont 1963) and Indians (e.g., Brody 1970; Shkilnyk 1985).

6. The pathology of neglect may cease with the introduction of another special role for the encapsulated Fourth World society, a role that elicits their pride in being appreciated by the larger world. In Canada, this new role has often included the production of arts and crafts. For instance, the Canadian Inuit

were encouraged to produce commercial arts during the forties and fifties, a time when more than half their monetary income derived from "relief" because of poor prices for fox pelts. In the sixties, the chronically unemployed Cree Indians of Quebec were similarly encouraged to produce an "ethnic art," named Cree Craft (Graburn 1978a). To a lesser degree, the same might be said about the rise of arts and crafts production among the Northwest Coast Indians, the Eastern Woodland Algonkians, and even the Iroquois. In such cases, unless other events spurred development on to stage 7, there was always the danger of a cessation of demand and a return to the horrors of stage 5.

7. Most of the Native groups in Canada have moved at least partially out of stage 5 toward assimilation, self-determination, or both. We may follow Bartels and Bartels (1987) in differentiating between structural assimilation-the ability to participate in the whole array of roles and institutions of the majority society-and cultural assimilation-the loss of culturally distinctive ethnic markers, such as language, dress, belief systems, and arts and crafts. Structural assimilation may be positive because it signifies the ability to assume positions of power and influence, without which Fourth World peoples are condemned to the margins of the society. Cultural assimilation, however, is negative because it leads to the disappearance of the ethnic group as a significant cultural entity.

Like most other Fourth World peoples, Canada's Native peoples have achieved a considerable degree of political awareness; although they have undergone partial assimilation and lost aspects of their indigenous culture, they are aware of their predicament, of their continuing uniqueness, and of the way to struggle for some form of self-determination (see Brosted 1985; Dyck 1985). Through new political leadership, they are staking claims to their lands and rights, often in the face of considerable provincial and federal resistance.

One major mechanism used by Fourth World peoples to assert their rights and channel their efforts toward self-determination is cross-cultural and cross-national alliances. They can learn from each other's experiences in fighting neglect, assimilation, and ethnocidal forces. Some of these alliances are intracultural, such as the Inuit Circumpolar Conference and the Saami Scandinavian Conference; some are national, such as the Alaska Federation of Natives and the Indian Brotherhood of Canada; and some are both cross-cultural and cross-national, such as the Assembly of First Nations and the recently formed Indigenous Survival International (Brody 1987). The widest level, represented at the United Nations, is the umbrella organization, the World Council of Indigenous Peoples.

The cultural and political struggles often involve a reification or reinvention of ethnic markers, differing from group to group but usually related to visual symbols and the arts, as well as ceremonies and other forms of cultural

expression. As we shall see below, the dilemma becomes largely
the burden of the artists, who may be only distantly aware of
traditional art forms (many of which are housed in the museums
and collections of the dominant society); who may have been
encouraged to produce new commercial forms of arts and crafts of
doubtful authenticity and symbolic significance; and, above all,
who may have been educated and seduced by the "world art system,"
with all its individualism, freedom, and competitiveness
(Graburn, in press).

CHARACTERISTICS OF FOURTH WORLD ARTS AND IDEOLOGIES OF FOURTH WORLD ARTISTS

Few of the traditional cultures of the ancestors of Fourth World
peoples included any concept of what we call "art."

Late in the colonial relationship, the forces of power and
dependency are even more striking: often members of the minority
societies become so assimilated that they internalize the
cultural and artistic system of the metropolis. The dominant
society thus has the power not only to extract and classify
objects made by members of the Fourth World societies, but also
to impose its own world view on the makers. In extreme cases,
the situation is like that described by Edmund Carpenter (1972):
"We tell them what to do and then we reward them for doing it."
The arts of Fourth World peoples differ from those of their
forbears, which were formerly called "primitive arts," in at
least two respects: (1) The arts of the internally colonized
Fourth World peoples have been influenced by the dominant society
and consequently changed in material, form, content, and
destination. (2) Many of the Fourth World arts are made not for
consumption by the producing society, but for export to the
dominant, colonizing society. Arts and crafts production very
often becomes a "cash crop" for minority groups that have little
else to sell, and the forces of tourism and commercialism may
determine what is produced by encouraging semitraditional
productions or introducing new, novel, and saleable types of
objects.

The relationship between the intended destination of the art
forms and the sources of their form and content is expressed in
Figure 2 (after Graburn, 1976:8 and 1984:396). While this
classification embraces all the different types of Fourth World
arts that may exist at any one time, the dynamic relationship
between these forms, showing possible directions and cultural
embeddedness, is better expressed in Figure 3 (after Graburn
1984:399).

We should remember that the situations modelled in the
following diagrams are in constant flux. For instance,
"traditional arts" usually refers to those being produced at the
time of the first European contact and documentation. From
archaeology, we know that traditions may have been changing up to

Fig. 2. Destination of Art Form

Intended Audience

Sources of the Art Form		Local/Ethnic Society	Visiting/Tourist Society
	Local/Ethnic Society	Functional Traditional e.g. religious figures, Dogan Granary doors, ritual masks	Commercial Traditional Upper Sepilk shields, Asmat bisj poles, Karen textiles
	Novel or Synthetic	Reintegrated Cuna molas, older kachina figures, Andean clothing	Souvenir Novelty Seri, Makonde carvings, Mexican amate paintings, Inuit sculptures
	National/International genres	Popular Arts Zaire painting, older Navajo jewelry, Ghanaian asato arts	Assimilated Fine Arts Namatjira watercolours, Sante Fe painitngs, Eskimo prints

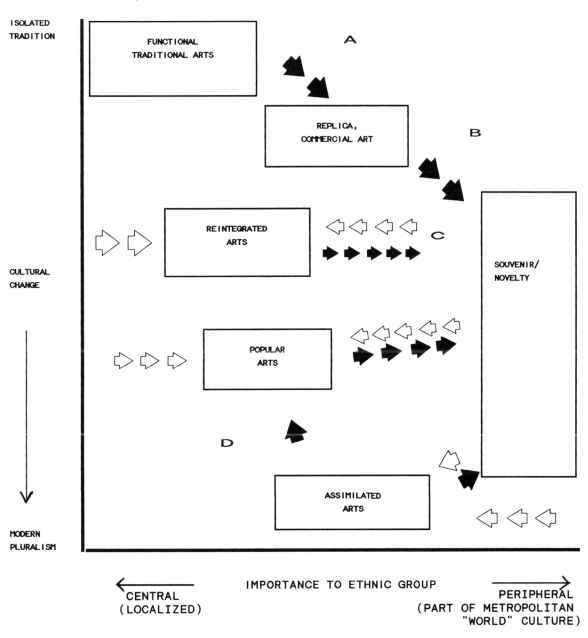

Fig. 3. Processes of Change in Tourist Arts

ISOLATED
TRADITION

FUNCTIONAL
TRADITIONAL ARTS

A

REPLICA,
COMMERCIAL ART

B

REINTEGRATED
ARTS

C

CULTURAL
CHANGE

SOUVENIR/
NOVELTY

POPULAR
ARTS

D

ASSIMILATED
ARTS

MODERN
PLURALISM

IMPORTANCE TO ETHNIC GROUP

CENTRAL
(LOCALIZED)

PERIPHERAL
(PART OF METROPOLITAN
"WORLD" CULTURE)

Forces of commercialism, for tourists, collectors, export

Cultural forces of ethnic reformulation and identity enhancement

the time of contact; and from ethnohistory and a close study of
museum collections, we know that the productions at the time of
first contact may not resemble what has been considered
"traditional" by the indigenous people themselves in more recent
times. For instance, Aleut bentwood hunting hats, collected and
illustrated before the turn of the nineteenth century, differ in
design motif from those collected in the latter half of the
nineteenth century, even though their Native makers considered
them "traditional" and did not recognize the incorporated
European motifs as innovations. Similarly, none of the
traditional Native peoples of the Northwest Coast made tall,
free-standing "totem poles" until the introduction of metal
tools; yet, "totem poles" are regarded as "traditional" by most
of the contemporary Native people who use them as well as by the
general public.

Some genres that are commonly labelled traditional were
invented during or after the period of early contact. For
instance, Navajo rugs came into being only as a result of the
Navajo contacts with nearby Pueblo peoples and the introduction
of sheep-herding and the loom by the conquering Spanish;
similarly, floral embroidery was taught to Eastern Woodland
Indians by French nuns in the eighteenth century. Such art forms
became functional traditions for the Native peoples and only
later evolved into commercial trade items. All these arts with
formal and technical origins outside the Fourth World society,
which were later modified and became part of the ongoing
traditions, I have called Reintegrated arts.

Later in the relationship between the Fourth World society
and the dominant society, objects and genres of the metropolitan
society may become incorporated in a relatively unmodified form
into the material and aesthetic world of the minority people.
The above two diagrams differentiate between objects that became
items of consumption by the minority people ("popular arts") and
objects produced by minority artists and craftspeople emulating
their counterparts in the majority society for export back to the
society of origin ("assimilated arts").

The phrase "arts of the Fourth World" describes a set of
material objects and aesthetic products according to the
sociopolitical context of their production. Given the enormous
range of the producers-the "ex-primitive" peoples-and the
contexts of production even in Canada-from near isolation to
almost total assimilation in the modern world-these arts possess
no immediately obvious set of distinguishing characteristics.
However, a large proportion of them are made for sale to
outsiders, members of the metropolitan societies; as direct and
indirect tourist arts, these objects share market-determined
characteristics (Aspelin, 1977). These characteristics often
include portability, exoticism (e.g., obvious differences from
the arts of metropolitan societies), and a simplified code for
cross-cultural apprehension (Ben-Amos 1977; Graburn 1983:72-75).

The latter two characteristics also describe another category of Fourth World arts-ethnic markers on tourist circuits. As the middle classes scour the world in search of new experiences (McCannell 1976:6-7), the exotic peoples whom they visit have developed (or had imposed upon them) obvious markers of ethnic identity, by which they are known around the increasingly interconnected world. Examples include the totem poles of the Northwest Coast, the feather bonnets of Plains and other Indians, the *inuksuks* of the Canadian Inuit, and the distinctive clothing, hats, and boots of the Saami (Lapps) in Scandanavia.

In many cases, these ethnic and portable markers had been appropriated from the Fourth World peoples by the larger nations in which they live and had become national markers on the world scene.[6] In a sense, these descendants of exotic, conquered minorities have been "made safe," even cuddly, for harmless consumption by the world system-again emphasizing the relative powerlessness of Fourth World peoples. The anthropologist Victor Turner has pointed out the symbolic power of the weak and anomalous (1969:108-111).

All the above examples of Fourth World art concern objects made for sale or at least display to outsiders-hence their relative exoticism and simplicity of code. The other half (see fig. 2) are made for or consumed by the Fourth World minority society. Apart from the first category (the traditional functional and possibly precontact arts), the productions of structurally incorporated Fourth World societies bear some, often a close, relationship to the productions of the conquering powers. This evidence of acculturation is frequently taken by more fastidious connoisseurs as a marker of non-authenticity, whereas the general, curio-buying public may not know the difference-ironically equating commonly accepted symbols of exotica with authenticity, as demonstrated above. Once in the contact situation, the Native peoples modify their traditions according to the opportunities provided by new tools, materials, models, and functions, and continually evolve new but equally embedded, traditions.

The following section illustrates the great range of Fourth World arts and the divergent attitudes of their creators, as found in Canada today.

FOURTH WORLD ARTS IN CANADA

In late August 1983, 110 Canadian Indian artists and a smattering of White people converged on the small town of Hazelton, British Columbia, a few hundred miles north of Vancouver. At the 'Ksan Indian Cultural Centre, on the banks of the Skeena River, they participated in the Third National Native Indian Artists' Symposium.[7] This gathering was conceived by the Indian Arts and Crafts Society of B.C. and supported by many local and national

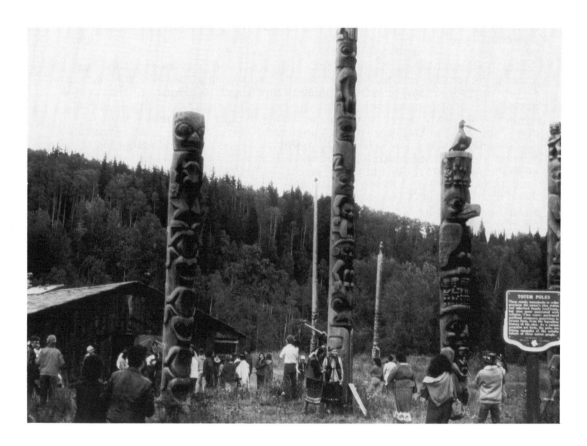

Plate 1. Members of the Native Artists Symposium visit the
village of Kitwancool, BC to view the outstanding collection of
traditional Gitksan totem poles. Photo by Nelson Graburn.

organizations with the goal of bringing together artist representatives from all the major Indian communities in Canada.

During the four-day Symposium, the participants met in the local high school to discuss the problems of Native Canadian artists, held "show and tell" sessions with the portfolios, slide sets, and maquettes they had brought, and attended the opening of an Indian art exhibition at the Nothwestern National Exhibition Centre in 'Ksan. The symposium also hosted barbecues and potlatchlike feasts at 'Ksan and in local villages, including Kitwankool and Hagwilget; informal discussions took place, and the artists had the chance to sell some of their pieces.

Although eighty-six of the Indian artists came from British Columbia, there were representatives from the Great Plains, the Eastern Woodlands, and the Iroquois.[8] The artists ranged from avant-garde painters at home in Taos or Paris to Native, unilingual, traditional craftspeople flown out of their small northeastern bush settlements. The majority, however, fell between these two extremes; they were typically Indian artists concerned with both the continuity of embedded tradition and the commercial necessities of making a living. Discussion between people of such different backgrounds was often difficult, and mediation was frequently offered by White specialists in Indian arts, such as anthropologists, art historians, and a few dealers and collectors.[9]

This pioneer effort, generously subsidized by public and private institutions at the national and local levels, embraced much of what typifies Fourth World art in Canada. As a vast nation containing many indigenous minority peoples, Canada may serve as a microcosm for examining both the theory and practice of the arts of the Fourth World.

Canadian Indian and Inuit artists exemplify the broad spectrum of Fourth World arts and artistic ideologies.

At the least acculturated end of the spectrum are the relatively unselfconscious artists and artisans who continue to produce artifacts characteristic of the traditional Native culture, unburdened by much knowledge of the art market or depth of meanings attached to the concept of "art." These include some Cree and Naskapi makers of snowshoes, mocassins and traditional clothing (e.g., Johnny and Emma Shecapio of Mistassini and Jean-Claude Paule of Huron), and many Canadian Inuit groups (Myers 1980).

A larger group in the spectrum consists of those still unburdened by a knowledge of Western art and art history but very aware of the market for their creations; they are attentive to market needs but often confused about the demand for their manufactures. This group includes the majority of Inuit sculptors and printmakers (Graburn 1987), and many makers of Indian souvenirs and portable arts (e.g., the Cree of Great Whale

Plate 4. <u>Winter Sealhunt</u> (1967), stonecut by Timothy Kuananapik, Povungnituk, Quebec. Courtesy of La Fédération des Coopératives du Nouveau-Québec. Photo by Eugene Prince, courtesy of the Lowie Museum, University of California, Berkeley.

Plate 5. <u>Almost Home</u> (1981), acrylic on canvas by Allan Sapp. Collection: Indian Art Centre, Ottawa. IANA #84-0059, ID #152920. Courtesy of the Indian Art Centre, Indian and Northern Affairs, Ottawa.

and Wemindji, who made Cree Craft; see Graburn 1978a).

Still others are aware of many of the genres of White art, which they try to imitate while adding suitable ethnic content; however, they have little formal training in art and art history. A few artists of Eastern Woodland origin (e.g., the Cree painter Alan Sapp; see Warner 1976) and some of the younger Inuit graphic artists (e.g., Audla Pudlat of Cape Dorset) exemplify this somewhat "naïve" form of assimilation.

A large group of more politically astute artists are aware of the connection between their tribal art forms and the integrity of their threatened cultures. Many of the Northwestern Coast Indian artists at 'Ksan claim that, if they do not produce arts embedded in the formal and spiritual tradition of their ancestors, they are "selling out." They resist the relative "freedom" of the art world, and place their arts within the context of ceremonials, dances, and traditional cultural expressions. Although very aware of art as a means of making money, they constantly fear the seduction of the outside art world and the necessity of producing stereotypical creations that White patrons expect of them. Some of these artists use their art to help them resist the temptations of the outside world and find a personal bridge of continuity to their roots. A few, such as Clyde Prosper and Curtis Mason, have made a livelihood as artists and found their Indian roots while in prison (Tawow, 1980:21-25).

Many Northwestern Coast artists have participated in a revival of two- and three-dimensional arts, an effort spearheaded by both Indians and Whites at institutional centres such as 'Ksan, Alert Bay, and the Museum of Anthropology at the University of British Columbia (Ames 1981; Holm 1965). Some of these artists continue to work in traditional media, mainly wood sculpture; others have branched out into new media, such as silver and gold work, and silkscreen (e.g., Bill Reid, Tony Hunt, Joe David and Vernon Stephens; see Blackman and Hall 1981).

Another group of contemporary artists aware of tradition is the "Plains School" of Canadian Indian painting (Warner 1985), which includes Alfred Youngman, Alex Janvier, Alvin Redman, and others. Their work is informed by modern mainstream fine and commercial arts, and they are careful to include symbolic references, e.g., hard-edge designs, sacred motifs, and colour combinations reminiscent of their traditional backgrounds. One American Sioux member of the group, Arthur Amiotte, has long taught art in a formal setting, and his work exemplifies these characteristics (Loeb 1985).

Perhaps the most notable of the new Indian art movements is Eastern Woodland "Legend Painting," which originated with Norval Morrisseau in the 1960s (Warner 1978). Well-known artists like David General, Jackson Beardy, and Daphne Odjig signal their adherence to "tradition" more in the content of their work, with

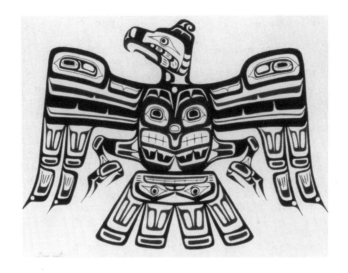

Plate 6. <u>Thunderbird</u> (1969), silkscreen print by Tony Hunt (Kwakiutl). Collection: Indian Art Centre, Ottawa. IANA #84-0127, ID #151764. Courtesy of the Indian Art Centre, Indian and Northern Affairs, Ottawa.

Plate 7. <u>Perseverence</u> (1980), acrylic on paper by Del Ashkewe (Ojibway). Collection: Indian Art Centre, Ottawa. IANA #85-0029, ID #152334. Courtesy of the Indian Art Centre, Indian and Northern Affairs, Ottawa.

Plate 2. <u>Mother and Child</u>
(1968) by Jimmy Innarulik
Kadyulik, Salluit, Quebec.
Photo by Nelson Graburn.
Courtesy of La Fédération des
Coopératives du Nouveau-
Québec.

Plate 3. Traditional Cree
snowshoes by Johnny and Emma
Shecapio, Mistassini, Quebec.
Collection: Indian Art
Centre, Ottawa. IANA #85-
0422B, ID #152766. Courtesy
of the Indian Art Centre,
Indian and Northern Affairs,
Ottawa.

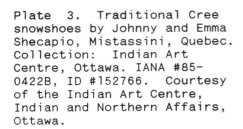

Plate 8. Two Songs (1977), serigraph by Jackson Beardy
(Ojibway). Collection: Indian Art Centre, Ottawa, IANA #84-
0569, ID #153256. Courtesy of the Indian Art Centre, Indian and
Northern Affairs, Ottawa.

Plate 9. Untitled #25 (no date), acrylic on paper by Benjamin
Chee Chee (Ojibway). Collection: Indian Art Centre, Ottawa.
IANA #85-0032, ID #151925. Courtesy of the Indian Art Centre,
Indian and Northern Affairs, Ottawa.

Plate 10. <u>Spirit of the Eagle</u> (1980), serigraph by Carl Beam.
Collection: Indian Art Centre, Ottawa. IANA #84-0405, ID #
152320. Courtesy of the Indian Art Centre, Indian and Northern
Affairs, Ottawa.

its references to mythology, nature, and spiritual beings, than in their highly distinctive use of fluid forms and original colour choices. This is because there was little continuity between the contemporary works and the rarely pictorial traditional arts of this area. Though a "young" tradition, this style has had tremendous impact on Canadian Indian artists in adjacent regions and on White awareness of Indian arts (Townsend-Gault 1983). This successful school of Indian art has had a very positive impact on the ethnic pride of Indian peoples. However, as Canadian Indian artists, like all Fourth World artists, need a regular income, popular and derivative versions of legend painting are found on calendars, greeting cards, and other forms of mass communication.

The ultimate philosophical predicament of Fourth World artists is found among those Native artists like Carl Beam and Pierre Sioui, whose professional assimilation into the mainstream art world is such that they define themselves as artists first, independently of their identity as members of Native Canadian groups. For instance, Benjamin Chee Chee (Ojibwa), a legend painter, "rejects the label 'Indian artist' just as he rejected the traditional form and materials of 'Indian' art" (Tawow, 1974, 4:1-4). One of the artists at 'Ksan warned: "We cannot live forever off the tradition of our forefathers."

These artists, the most acculturated, have usually attended formal art schools and defined themselves in the context of world art history. Many artists have achieved success in the art world-with its attendant travel and lionization-and feel less constrained by the formal requirements of the traditional styles of their ancestors. Their art is more likely to resemble that of other modern artists than that of their cotribals. They do not yearn for traditional spirituality but create as the mood moves them. At 'Ksan, a well-known eastern Indian artist asserted: "Let nothing and nobody interfere with the creative process."

*This essay was originally completed in 1987. Geopolitical changes in the intervening years have made some statements appear anachronistic but no attempt has been made to update the text.

NOTES

1. The dates of the first significant Euro-Canadian contacts and the degree of acculturation vary widely between different Canadian Native groups, from the initial contacts in the east in the sixteenth and seventeenth centuries to the first significant contacts of some groups of central Inuit with the outside world early in the twentieth century. However, by the Second World War all groups were involved in constant, even dependent, relationships with institutions of Canadian society.

2. For a more extensive discussion of these concepts, see Graburn 1976 and 1981.

3. Ideally, many of the minority peoples of the USSR inhabit their own autonomous republics or regions; but in fact, their political position, as defined by Joseph Stalin, then Commissioner for Minorities, is "nationalist in form; Socialist in content" (see Bartels and Bartels 1987).

4. Not all peoples in the world fit neatly into this classification. For instance, in many Third World African nations, there is no dominant majority. Therefore, all ethnic groups are minorities; similarly, peoples like the Scots, the Welsh, and the Franco-Swiss are minorities within large modern nations but are considerably autonomous or substantially powerful at the national level, or both.

5. After Graburn 1967 and 1978.

6. For instance, a study of dolls for sale in the United Nations store in Los Angeles revealed that almost all the dolls from a particular country were dressed in the clothing of the minority peoples of that country (e.g., Indians in Mexico, Inuit in Canada, and Siberians in the USSR).

7. 'Ksan is an Indian art centre at the boundary of the Gitksan and Carrier tribal lands. It is the result of initiatives by Indians and non-Indians to found a museum to preserve the threatened traditional artifacts in the Seekan treasure house. In the 1970s, the Kitanmax (later shortened to 'Ksan) School of Indian Art was founded. Since 1973, traditional Northwest Coast artists have taught there, and since 1978, it has also become a centre for Indian activism.

8. No Inuit artists were invited because the organizers thought it was complicated enough to bring representative Indian peoples together without compounding their problems with the very different linguistic and artistic situation of the Canadian Inuit. However, the organizers expressed great interest in Inuit artists and hoped to invite them to any subsequent symposium. Regular symposia have been held since then under the auspices of SCANA (the Society for Canadian Artists of Native Ancestry) but have not been attended by Inuit artists.

9. Non-Native participants included Carole Farber, University of Western Ontario; Marjorie Halpin, University of British Columbia; Alan Hoover, BC Provincial Museum; Carmen Lambert, McGill University; George MacDonald, National Museum of Man; Polly Sargent, Indian Art patron, Hazelton, BC.

BIBLIOGRAPHY

Ames, Michael M.
1981 "Museum anthropologists and the arts acculturation on the
Northwest Coast," B.C. Studies, 49:3 - 14.

Aspelin, Paul
1977 "The Anthropological Analysis of Tourism: Indirect
Tourism and Political Economy in the Case of the Mamainde of Mato
Grosse, Brazil." Annals of Tourism Research 4:3:135 - 60.

Bartels, Dennis and Alice Bartels
1987 "Soviet Policy Towards Siberian Native Peoples:
Integration, Assimilation or Russification?" Culture 6:2:15 -
32.

Ben-Amos, Paula
1977 "Pidjin Languages and Tourist Arts." Studies in the
Anthropology of Visual Communication 4:128 - 139.

Blackman, Margeret B. and Edwin S. Hall
1981 "Contemporary Northwest Coast Art: Tradition and
Innovation in Serigraphy." American Indian Art 6 (3):54 - 61.

Brody, Hugh
1970 Indians on Skid Row. Ottawa: NSRG 70 - 2.

1987 Living Artic: Hunters of the Canadian North. London:
Faber and Faber.

Brosted, Jens et al., eds.
1985 Native Power: The Quest for Autonomy and Nationhood of
Indigenous Peoples. Bergen: Universitetsforlaget.

Carpenter, Edmund
1972 Eskimo Realities. New York: Holt, Rhinehart & Winston.

Castile, George C.
1983 "Neo-Colonialist Models: Rotten Man Theory and the Native
Americans." Paper presented at Symposium E-335 on "The Fourth
World: Relations between Minority Indigenous Peoples and Nation
States" (Noel Dyck, Organizer) at the International Congress on
Anthropological and Ethnological Sciences, Vancouver, BC, August
20.

Clairmont, D. H. J.
1963 Deviance among the Eskimos and Indians of Aklavik, N.W.T.
Ottawa: N.C.R.C. 63-9.

Clark, Annette MacFadyen, ed.
1974 Athapaskans, Strangers of the North. Ottawa: National
Museum of Man/Royal Scottish Museum.

Cole, Douglas
1985 Captured Heritage: The Scramble for Norwest Coast
Artifacts. Seattle: University of Washington Press.

Dyck, Noel, ed.
1985 Indigenous Peoples and the Nation States: Fourth World
Politics in Canada, Australia, and Norway. St. Johns,
Nfld.: Institute of Social and Economic Research.

Graburn, Nelson H.H.
1967 "Economic Acculturation and Caste Formation." Paper
presented at the Annual Meetings of the Southwestern
Anthropological Association, San Francisco.

1976 "Introduction" to N.H.H. Graburn, ed., Ethnic and Tourist
Arts:Cultural Expressions from the Fourth World. Berkeley:
University of California Press, 1 - 32.

1978 "Inuit pivalliajut: The cultural and identity
consequences of the commercialization of Inuit art." In L.
Muller-Wille et al. eds., Consequences of Change in Circumpolar
Regions. Edmonton: Boral Institute.

1978a "'I like things to look more different than that stuff
did': An Experiment in Cross-cultural Art Appreciation." In M.
Greenhalgh and J.V.S. Megaw, eds., Art in Society. London:
Duckworth, 51 - 70.

1981 "1, 2, 3, 4... Anthropology and the Fourth World."
Culture 1:1:66 - 70.

1983 "Art, Ethnoaesthetics and the Contemporary Scene." In
Mead, Sid M. and B. Kernot, eds., Art and Artists of Oceania.
Palmerston, N.Z.: Dunmore Press; Mill Valley, Cal.: Ethnographic
Arts Publications, 70 - 79.

1984 "The Evolution of Tourist Arts." Annals of Tourism
Research 11:393 - 419.

1986 "Cultural Preservation: An Anthropological View." In
Pamela Foote et al. eds., Problems and Issues in Heritage
Conservation (Proceedings of the First HAPI Colloquium).
Honolulu: Hawaii Heritage Center, 36 - 46.

1987 "Inuit Art and the Expression of Eskimo Identity."
American Review of Canadian Studies 17:47 - 66.

 "Ethnic Arts of the Fourth World: The View from Canada."
In N. and S. Whitten, eds., Imagery and Creativity: Art and
Ethnoaesthetics of the Americas. Tucson: University of Arizona
Press.

Holm, Bill
1965 Northwest Coast Indian Art: An Analysis of Form.
Seattle: University of Washington Press.

Loeb, Barbara
1985 "Arthur Amiotte's Banners." American Indian Art 10(2):54 -
62.

MacCannell, Dean
1976 The Tourist: A New Theory of the Leisure Class. New
York: Schocken.

Manuel, George and Michael Posluns
1974 The Fourth World: An Indian Reality. New York: Free Press

Maquet, Jacques
1971 Introduction to Aesthetic Anthropology. Reading, Mass.:
Addison-Wesley.

1986 The Aesthetic Experience. New Haven, Conn.: Yale
University Press.

Marshall, Ingeborg
1981 "Disease a factor in the Demise of the Beothuck Indians."
Culture 1(1):71 - 81.

Martin, Calvin
1978 Keepers of the Game: Indian-Animal Relationships and the
Fur Trade. Berkeley: University of California Press.

Muller-Wille, Ludger and Pertti Pelto, eds.
1979 Quart Monde Nordique-Northern Fourth World (special
Issue). Études Inuit Studies 3:2.

Myers, Marybelle
1980 Things Made by Inuit. Montreal: Fédération des
Coopératives du Nouveau-Québec.

Neitschmann, Bernard
1987 "The Third World War." Cultural Survival Quarterly 1:3:1
- 16

Shkilnyk, Anastasia M.
1985 A Poison Stronger than Love: The Destruction of an Ojibwa
Community. New Haven: Yale University Press.

Tawow
1974 "[Benjamin Chee Chee] Indian Artist," Tawow 4(1):1 - 4.

1980 "[Indian] Art [in Prison]," Tawow 8(1):21 - 25

Townsend-Gault, Charlotte
1983 "Defining the Role." In Robert Bringhurst et al., Visions: Contemporary Art in Canada. Toronto: Douglas & McIntyre, 123 - 156.

Warner, John A.
1976 "Allen Sapp, Cree Painter." American Indian Art 2(1):40 - 45.

1978 "Contemporary Algonkian Legend Painting." American Indian Art 10(2):46 - 53.

Whitaker, Ben, ed.
1972 The Fourth World: Eight Reports from the Fieldwork of the Minority Rights Group. London: Sedwick and Jackson.

"The Whites Are Thick As Flies In Summertime"
INDIAN/WHITE RELATIONS IN THE NINETEENTH CENTURY

by

Joanne MacDonald

INTRODUCTION

This paper describes the invasion of the lands and lives of
Canada's First Nationas in the nineteenth century. It examines
the nineteenth century stereotypes and speculates on why some
Northwest Coast ceremonial objects are in museums. The data also
documents some of the social impact of the Whites[1] as they sought
to conquer the land and "civilize" the Indians through the
authority of religious and government institutions. The
conclusion provides an update with an optimistic tone which
offsets the bleak events of the nineteenth century.

In the nineteenth century, the concept of the Noble Savage
was still a viable image in Europe. At home on their own lands,
however, the Indians were progressively being treated as plain
savages, an uncivilized people whose adherence to their
traditional culture was hampering their assimilation into the
mainstream of Canadian society. Government attempts at
assimilation policies and the attendant erosion of traditional
Indian culture, accelerated throughout the nineteenth century.
The weakening of contact with traditional Indian spiritual forces
was effected in part by the missionaries who undermined the
traditional power figures in Native culture, both the hereditary
chiefs and the shaman. They encouraged the removal of the
traditional objects to museums and supported the government's
initiatives to civilize as well as Christianize the Indians. The
realization of the overwhelming odds against them was captured by
Chief Crowfoot's statement in 1880 after visiting Ottawa, "the
whites are as thick as flies in summertime" (MacEwan
1971:89)(fig. 1).

From the time of continuous European contact in the
sixteenth century, the Indians in the eastern part of Canada
provided services to the newcomers. The explorers and fur-
traders recognized and exploited the Natives' knowledge of their
land and its resources. The newcomers benefited from the
subsistence/survival techniques that had been developed over a
period of at least 15,000 years.

The explorers made maps and named significant "discoveries"
after their patrons in Europe, unaware or disinterested in the
fact that the Natives had already named the places. The Native
names identified food sources and the numerous spiritual places
in their landscape marking the epics of their culture heroes or
places where particular spirits lived. Rivers and waterways were
rich in such power spots where spirits manifested their presence

27

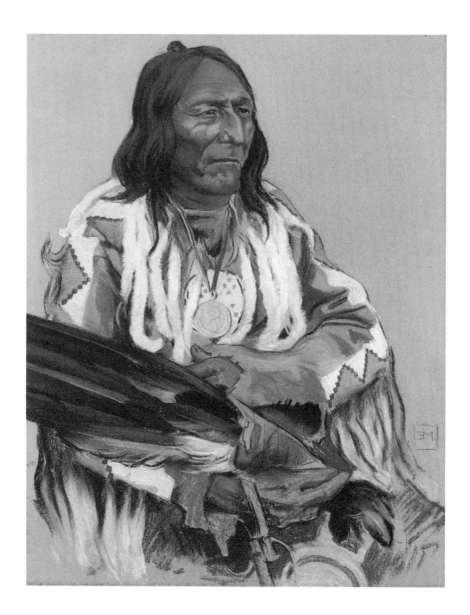

Fig. 1. Chief Crowfoot of the Blackfoot was signatory to <u>Treaty Seven</u> in 1877. Painting by Edmund Morris. Photo Credit: Royal Ontario Museum.

in whirlpools or bubbles in the water. The destruction of these
power spots started as early as 1786 when White traders removed
the painted rock on the Echmanish River in Manitoba. The rock
with Indian painting marked the spot where the river reverses
direction. It appears that the delay to make a tobacco offering
by the Indian paddlers was considered too time-consuming by the
White traders (Newbury 1974:19). Other sacred places are now lost
forever as landscapes are flooded by twentieth century
hydroelectric dam projects and the logging or "clear cutting" of
forests.

Beliefs were set out in myths describing the time when
animals and humans could communicate; the possibility of
transformation from animal to human form was accepted. Hunters
communicated with the animals and other supernatural beings
through dreams. Their garments, such as the Naskapi[2] painted
coat, worn with decorated hat, leggings, and mittens, reflected a
hunter's dream that was interpreted by his wife, who made and
decorated the clothing of unsmoked caribou skin (fig. 2).

Brasser's statement for the Plains Indians (1987:122) puts
the Native belief system in context: "Unlike the future orienta-
tion of the 'Great Religions' tribal ideology emphasized that
everything was good in its natural form—and should stay that way.
For untold centuries the present was experienced as continuation
of the past, a perpetuation of the sacredness of life in all its
manifestations."

While the philosophical debate raged on the concept of the
Noble Savage, economic factors were guiding colonial strategies.
France's interest in exploring North America was motivated by the
expectation of wealth like that the Spaniards had found. The
first recorded "treasure" from Canada was shipped by the explorer
Jacques Cartier to France in 1536-large quantities of potential
gold (iron pyrites) and some Indian hostages, including the
Iroquois Chief Donnaconna (Trigger 1985:302). Early in the
contact period, the middle of the seventeenth century, the Jesuit
missionaries arrived among the Huron and became the first
Europeans to live among the Indians. Their records, the Jesuit
Relations reveal the divisions created within the Indian
communities between those who wished to adhere to the old ways
and those willing to accept the missionaries.

NOBLE SAVAGE

As relations between Natives and non-Natives developed,
increasing numbers of Indian captives were taken to Europe. Some
were taken in retaliation for aggressive acts and presented as
curiosities in Europe (Taylor:1983,1984). Some were taken to be
trained as translators, though the colonial powers were not aware
of the diversity of cultures and indigenous languages in Canada,
which comprised twelve major groups and hundreds of dialects.
Some, such as the Mohawk "Kings," were invited to London in 1710

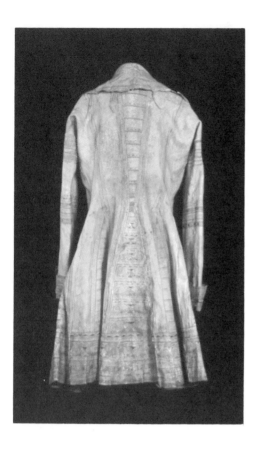

Fig. 2. Naskapi winter coat,
mittens, and moccasins. The
coat was collected by an
eighteenth century British
general. Mittens were in the
collection of Princess Therese
of Bavaria and the moccasins
were in the collection of the
Grand Duke of Baden. They are
now in the Ethnology
collections of the Canadian
Museum of Civilization. Photo
Credit: Canadian Museum of
Civilization.

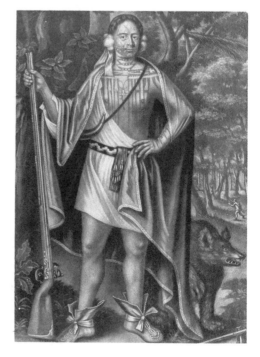

Fig. 3. Sa Ga Yeath Qua Pieth
Tow one of the "Mohawk Kings"
presented to Queen Anne with a
small bear representing his
clan emblem. Painted by John
Verelst in 1710, this portrait
illustrates one of the
earliest representations of
Indian contact period tatooing
(Phillips 1987:82). Queen
Anne's statue outside St.
Pauls Cathedral, London,
features a South American
Indian, representing New World
inhabitants. Photo Credit:
National Archives of Canada
#15102.

for political purposes. The British wished to impress their
guests with the greatness of Empire and to ensure their loyalty
in war (fig. 3). This need ended with the conclusion of the War
of 1812 - 14, and through government policies and legislation the
Iroquois were transformed from "warriors to wards" (Allen 1991).

By the 1830s the category of Noble Savage included Indian
missionaries trained to act as translators and teachers. Their
writings attempted to raise the awareness of the Whites on both
sides of the ocean to the realities of Indian life. George
Copway, an Ojibwa Methodist missionary, was the first Canadian
Indian to publish a book in English. It went into six printings
and was republished as Recollections of a Forest Life in 1851.
Copway travelled extensively in Europe and the United States
recounting his early life as a "child of nature" (Petrone
1983:106). Rev. Peter Jones, a Mississauga Ojibwa also trained
as Methodist minister, lectured extensively in New England and
Britain. When he was presented to King William at the British
court in 1832, the conversation focused on his Ojibwa costume
rather than on his writings, which expressed sentiments such as:
"Oh, what an awful account at the day of judgement must the
unprincipled white man give, who has been an agent of Satan in
the extermination of the original proprietors of the American
soil!" (Ibid:77 quoting History of the Ojibway Indians 1861:29).

While the nineteenth century published material reached the
educated reading public, the performing troupes of Indians in
Europe confirmed the stereotype of the wild and noble savage
often represented by the image of the Plains Indian (King:1991).
In Germany, performances featured indigenous peoples from around
the world-Lapps, Patagonians, and Labrador Inuit. Some
performances held in the zoological gardens owned by a private
entrepreneur underscored the nineteenth century view of Native
peoples as part of nature. The performance of nine Bella Coola[3]
Indians from southern British Columbia included traditional
winter ceremonial dances, featuring the "voluntary incineration
of a shaman (wizard)" which was very popular with German
audiences (Haberland 1987:347)(fig. 4). The nineteenth century
German author, Karl May capitalized on the German fascination
with Indians. His books still sell second only to the Bible in
Germany (Scanlon 1990:91). The annual gathering of Germans
playacting and dressing like Plains Indians in central Germany in
1990 was attended by a Sarcee Indian couple from Alberta
(Ibid.:57-67). They were uspet to see sacred dances trivialized,
even though the performers were wearing fastidiously accurate
nineteenth century Plains Indian costumes. "If they knew the
pain and hurt that Indian people feel to-day, they wouldn't do
this" said Sarcee guest Vanora Big Plume (Ibid.:65).

In Europe there was a general cultural arrogance in regard
to the material culture of other peoples. The earliest
collections of objects were described as "artificial curiosities"
(as opposed to natural-history pieces) and were displayed in
special "curiosity cabinets." The Crystal Palace Exhibition in

32

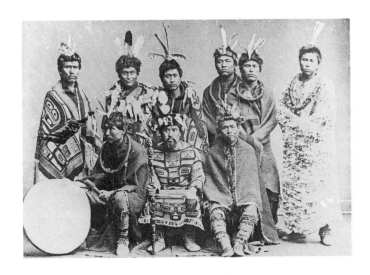

Fig. 4. The Bella Coola Indians in Berlin are wearing ceremonial clothing of the Tsimshian and Tlingit peoples of the North Coast of British Columbia. Collected by Phillip Jacobson for the Berlin Museum. The performers also carved and created Native art works during their one year visit to Germany in 1885 - 1886. Photo Credit: Wolfgang Haberland, Hamburg Museum.

Fig. 5. Design of a seventeenth century, two-masted shallop with figures wearing high boots and big hats incised on a rock at Kejimkujik National Park in Nova Scotia (Robertson 1973: fig. 203). Rock art occurs across the country and many sites with paintings-in red ochre etched in the rock-are protected in national and provincial parks. They are a source of inspiration to artists, as in the case of Norval Morrisseau and other artists who use the red ochre colour to suggest the sacred quality of an image. Photo Credit: Nova Scotia Museum.

London in 1851 confirmed that the Victorians were "fascinated by
their own progress in industry and technology," and that the
exhibits from other cultures present "accurate indices of the
limit of which civilization had attained in them respectively"
(Usher 1971:38, quoting the Intelligencer 1852:5). Civilization
of Victorian definition continued to be tied intimately to
Christianity, as one could not exist without the other.

INDIAN RESPONSE

The first foreigners seen on the coasts of Canada were not
missionaries but explorers and traders. The Indian rock
pictographs record the appearance of the sailing ships while the
oral traditions provide the context for Native thought (fig. 5).
The oral tradition of the Micmac[4] describes the sixteenth century
French ships as floating islands, while the sailors in the
rigging were glossed as bears in trees.

The oral traditions from the West Coast of Canada are quite
detailed as the first European ships did not appear until the
1770s. These ships of the Spanish and English were perceived as
giant birds, carrying a cargo of ghosts. Captain Cook's
expedition to Vancouver Island in 1778 received ritual gifts of
carved wooden trophy heads, which likely indicates the Indians
viewed the sailors as supernatural beings worthy of their esteem.
The Cook collection became the earliest documented collection of
artifacts from the Northwest Coast.

The superior technology of the newcomers was immediately
obvious, and Indian pilfering of iron nails and other metal items
was frequently recorded in the ship's logs. The Indians in
particular appreciated metal, as their own sources of Native
copper were quite scarce. In Newfoundland, the Beothuk were
driven to the interior of the island as a result of their habit
of stealing from the shore camps of the Europeans, and starvation
ensued. In the eastern portion of the country, where the fur-
trade in beaver pelts first became active, Hamel (quoted in
Trigger 1985:162) has speculated that the high status given metal
by the Indians may have led them to believe that the Europeans
were deities who controlled access to copper and iron from below
the earth. In exchange, these deities sought the skins of water-
dwelling creatures of which they were also keepers.

It is not surprising that the power of association carried
over to White objects as symbolizing the new order. The
following examples are taken from the Northwest Coast where the
lateness of the contact has resulted in extensive archival
material. Missionary writings in church journals and memoirs are
a particularly rich source for the northern portion of the
Northwest Coast. In the 1850's William Duncan of the Church
Missionary Society, newly arrived on the north coast, expressed
concern that he feared he might be murdered for his clothing.
The information for the Northwest Coast indicated that not only

clothing but White food-potatoes, rice, bread, butter, coffee, and tea served on china dishes with appropriate cutlery-replaced the traditional carved wooden crest dishes at a Port Simpson wedding in 1875 (James G. Swan, letter, 11 October 1875, quoted in MacDonald 1985:135). In the past, the foods from the territories and their presentation at feasts had recognized "the supernatural powers who have been responsible ultimately for providing the food one eats" (Adams 1973:43). It should be noted that traditional foods continued to be collected in the House territories, but they were replaced in certain situations where status of the event or individuals was enhanced with the presentation of White foods with appropriate dishes and table settings.

The replacement of the ceremonial objects representing the family crests opened the way for the massive collecting of these objects for museums in North America and Europe (Cole 1985). The first major collectors after the explorers and traders were the missionaries. It may be that the Indians were willing to relinquish their ceremonial-crest objects to the missionaries as part of a power exchange. The Indian power objects were the appropriate gift to present to the representative of the new power order. By this strategy of giving or selling their objects (there is no information on this point) to the missionaries they may have hoped to assure access to the new power order (MacDonald 1985).

The records of the missionaries in British Columbia indicate a feeling of particular triumph when they converted a shaman or medicine man. For example, William Duncan at Metlakatla wrote in the church journal, "The instruments of the medicine men which have spell-bound their nation for ages have found their way into my house and are most willingly and cheerfully given up" (The Gleaner, October 1881:112, quoted in MacDonald 1985:132)(fig. 6).

Objects of ceremonial value from across the country were collected and eventually found their way to museums, though often the ceremonial significance of the piece was lost. Possible reasons for this will be discussed later. In the case of the Northwest Coast, the underlying myth that accompanied and validated particular crest objects remained intact. The anthropologist Franz Boas attended a feast on Vancouver Island in 1930 where the host chief described the serving bowls appropriate for his guests as follows: "This bowl in the shape of a bear is for you, and you and so on; for each group a bowl." Boas captures the pathos in the chief's speech when he wrote, "But the bowls are no longer there. They are in the museums of New York and Berlin" (Rohner 1976:297).

LEGAL PROCESS

The missionaries did not work alone in their efforts to "civilize" the Indians. On the Northwest Coast, the legal system was supported by "Gunboat Diplomacy" (Gough 1984). It served to

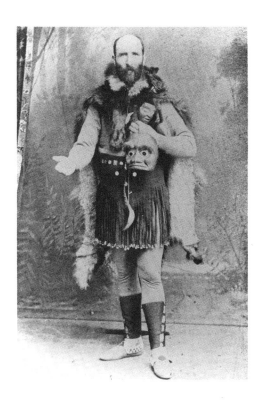

Fig. 6. Rev. McCullagh posed as a shaman in regalia presumably obtained while serving as a missionary to the Nisga'a Indians of the Nass River in northern British Columbia at the turn of the century. The image appeared in the 1923 book <u>McCullagh of Aiyansh</u> by J.W. Moeran.

Fig. 7. The man with the top hat represents Judge Pemberton of the Victoria Police Court and the man wearing a cap was the town clerk in Victoria. Villagers would make derogatory remarks about the "ridicule" figures and thus assuaged the chief's shame. The figures were eventually removed and cut up for firewood (MacDonald 1983:45). Photo Credit: Chicago Field Museum #93087.

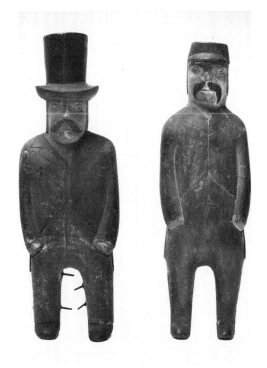

suppress any sign of resistance among the Indians to the spread
of "civilization" or objections to the small land alottements of
ten acres per family. Judge Begbie stated clearly the provincial
position: " In one year the white men could destroy all the
Indians on the Coast without losing a man. One of our cannon
could swallow up all the muskets of your tribe" (Stock 1899, vol.
11:618).

While the Indians were inhibited from violent protest, an
indignant Haida chief managed a public statement with his view of
colonial justice. He was embarrassed because of the arrest and
imprisonment of a family member. He opted for a traditional
solution when he commissioned the carving of two unique corner
posts or ridicule figures for his house (fig. 7).

In British Columbia treaties were never drawn up with the
Indians. There was strong Indian opposition to the surveying of
their lands, and ring-leaders were repeatedly jailed (Fisher
1977:205). A Nisga'a chief of northern British Columbia was
aghast to hear that the Queen was presenting him with a piece of
land which he considered his own (Ibid). The Nisga'a Indians took
their case for aboriginal title to the Supreme Court in 1971.
The split decision from the Supreme Court prompted the federal
government to establish a process for negotiating Indian land
claims through the Department of Indian and Northern Affairs. In
March 1991 the Gitskan-Wet'suwet'en, neighbours to the Nisga'a,
lost a court challenge in the Supreme Court of British Columbia
for ownership and jurisdiction of 57,000 square kilometers in
northwestern British Columbia.

The majority of Canada's treaties were concluded in the
nineteenth century. The Indian chiefs signed with an "X,"
underscoring their illiteracy and limited comprehension of the
English language. In exchange for "surrender, ceding, granting,
and conveying" aboriginal title to their land and its resources
the Indians received reserve lands on a family-quota basis. The
sovereign agreed to annuities on a per-capita basis, schooling,
and in many cases to the prohibition of liquor on reserve. At
the time of signing, the chief received a silver medal with the
queen's head on the obverse and a flag (figs. 8a, 8b).

The prairie Indians were starving when the numbered
treaties (one to seven) were signed. The buffalo herds were
depleted, and the government pushed to promote settlement and
railway development. The result was tense encounters between the
Indians, the Métis and the North-West Mounted Police. The
frustration culminated in the Riel Rebellion of 1885, in which
some of the Prairie tribes and the Métis fought to preserve their
lands and culture. The government put down the rebellion and
responded with more stringent measures to control the Native
populations. Fifteen years earlier, the Red River insurrection
of 1869 - 70 had helped the Métis gain recognition in the
Manitoba Act of 1870. The Métis have maintained a distinct
identity to the present time and are officially recognized as

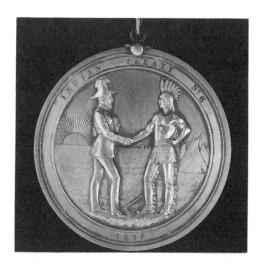

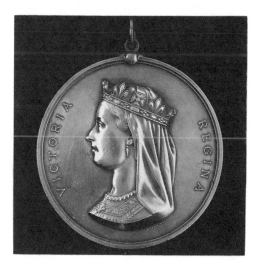

Fig. 8a, 8b. Medal given to the chiefs who signed treaties
between 1871 and 1922. The front depicts a handshake between a
chief and the commissioner acting on the Queen's behalf. The
setting sun in the background is reminiscent of the standard
treaty words, "As long as the sun shines, the grass grows, and
the rivers flow." Queen Victoria's head is on the obverse. In
the treaty-making process the sovereign was usually referred to
as the "Great White Mother." Treaty medals exist in a number of
museum collections. Photo Credit: Royal Ontario Museum,
Toronto.

aboriginal people, along with the Indians and Inuit in the
Constitution Act (1982).

The government assumed that the Indians once educated would
want to join the mainstream of society and abandon their Indian
reserves. After a brief experiment in Ontario in the 1840s of
developing Indian reserves as model communities contiguous to
White settlement, the decision was made to isolate the Indians in
remote locations where the "doomed race" could quietly fade away.
The government passed legislation protecting Indian land and
property from seizure and expropriation. In 1857 An Act for the
Gradual Civilization of the Indian Tribes in the Canada was
passed, formalizing the process of assimilation by which Indians
could become "enfranchised." Research in government documents in
the 1970s suggests that between 1859 and 1920 only 250 Indians
chose to be enfranchised (Richardson 1987:32).

The Indian Act of 1876 consolidated previous legislation in
regards to Indians and carried the earlier theme of assimilation
and civilization. It also provided for overriding approval from
the minister of the government department responsible for Indian
affairs for nearly all the decisions a band could make. While
the act was oriented to administering reserve lands, it has been
used to prohibit distinctive Indian ceremonies. The traditional
Indian governments in which hereditary chiefs had exercised power
within the confines of customary law were replaced by a system
based on that of British municipalities. Chiefs and councils are
elected by a majority rather than the decision-making by
consensus of the past.

The definition of an Indian included the system of marriage
recognition. Indian men could marry non-Indian women and their
wives and children were automatically added to the band rolls.
Indian women, by contrast, lost their Indian status when they
married a non-Indian. This provision of the act clearly con-
flicted with the terms of the Canadian Charter of Rights and
Freedoms, and the Indian Act was amended in 1984. The act also
described the lines of inheritance for property so that goods
passed from father to son, rather than the traditional uncle to
nephew inheritance found in many of the Indian groups. The
conflict created by this provision exists to this day when
precious old objects are inherited by a party not recognized as
the rightful heir under the traditional system. In other cases,
the stories that accompanied sacred objects were not passed on to
these inappropriate owners, who then sold these pieces to reduce
the stigma and tension in the community. While the objects are
usually only a part of a ritual that involves songs and dancing,
the loss of the objects to the community can be interpreted as
the loss of valuable memory-aids linking with the traditional
culture. Since the 1960s Indian artists, such as Bill Reid,
Robert Davidson, and Robert Houle report that they have been
drawn to museums to contemplate and study objects from their
cultural heritage.

One of the earliest revisions to the <u>Indian Act</u> in 1884 followed pressure from missionaries in British Columbia for provisions to ban the West Coast Indian potlatch and performance of the Kwakiutl[5] *tamanawas* dance. The dance was considered offensive and the potlatch was viewed as a wasteful exercise where hosts impoverished themselves in a lavish gift-giving process. Often Indians who supported the missionaries also supported the suppression of the old ways. Some chiefs supported a 1914 notice posted in a north coast village prohibiting feasts in memory of the dead as well as "dressing up in old fashioned costume or the painting of tattooing of the body or face" (Pritchard 1977:200). In order to escape detection, the north coast potlatches were conducted in silent form—which enabled some of the traditions to continue. However, the modified potlatch resulted in the invaluable loss of songs and dirges (Beynon:CCFCS).

The repercussions of the enforcing of the anti-potlatch law in 1921 (Sewid-Smith 1979, Cole and Chaikin 1990) were magnified when the potlatch ban was quietly dropped from the <u>Indian Act</u> in 1951. After a long agitation by the descendants of those embarrassed by the 1921 arrests, the confiscated objects were returned from museums in Eastern Canada in the late 1970s to specially built community museums in the villages of Alert Bay and Cape Mudge. The return of the confiscated potlatch goods signalled a new relationship between Indian communities and Canadian museums. For example, the Six Nations Iroquois at Brantford, Ontario, have successfully approached the Canadian Museum of Civilization with the request that their false-face masks, which have been used in ceremonies, not be placed on exhibition. The museum exhibits relicas instead. A dialogue has opened formally between First Nations people and Canadian museums to address the issues regarding curatorship and repatriation requests.

An 1895 amendment to the <u>Indian Act</u> included provisions to prohibit the Sun Dance on the prairies. The Department of Indian Affairs officials felt valuable time was wasted at these dances and noted that farming and dancing were incompatible. Rev. John MacDougall, a Methodist minister in Alberta whose wife was of Ojibwa/Cree parentage, wrote in defence of the Indian ceremony stating that they ought to be tolerated in the spirit of religious liberty.

Religion and education became directly associated when the government incorporated the missionaries into the education system, paying them a student per capita fee for their services. The link to the knowledge that was traditionally passed from grandparents to grandchildren was broken. The skills of living on the land and the accompanying spiritual knowledge as well as Native language skills were lost in many cases. Today, band-operated schools are increasingly offering Native language-instruction, as well as other programming directly relevant to the Indian culture.

Living in small European-style houses on reserves and the close confinement of students in the residential schools facilitated the spread of White diseases. Of all the students who attended the Sarcee Boarding School between 1894 and 1908, 28 per cent died, mostly from tuberculosis (Titley 1986:84). The Shingwauk Home, a long-established school in Ontario, had similar tubercolosis statistics. The level of health care on isolated reserves is still very poor.

CONCLUSION

The Canadian map is once again starting to reflect its native roots, as Native communities revive their original names. For example, Frobisher Bay in the Northwest Territories, named after the British explorer Martin Frobisher, ceased to exist in 1987, and Iqaluit took its place. The land-claims process has expanded the reclamation beyond renaming alone, in the cases of the James Bay Cree and the Inuvaluit of the Western Arctic who have concluded comprehensive land-claim agreements with the federal government.

In spite of the best efforts of the nineteenth century missionaries and government policies to recast Indian people into the White mold, the Indian culture has maintained its own distinct identity. This identity is being reinforced by the name changes by the Native peoples who are now correcting earlier mistakes in nomenclature (see notes). The Noble Savage stereotype may still live in the minds of some German Indian enthusiasts, or be manipulated by "Green" parties for some environmental issues. In Canada, the most refreshing recent image was Elijah Harper raising an Eagle feather to vote as a member of the Manitoba legislature.

Church leaders in British Columbia now talk of returning ceremonial objects collected in the last century from the first converts. Ceremonial objects in museums can be seen as markers of the past relationships, where the motives of the person collecting the object and those of the original owner deserve careful examination. The community tensions associated with the introduction of Christianity continue to this day with traditional people taking on political identity as well.

The federal government is proceeding to amend the Indian Act to accomodate Indian desires for more control over their lands and monies. Recent Federal and Provincial initiatives in the area of self-government are recognition of the fact that the needs of the Indian population were not being met. The Canadian courts have begun to interpret the treaties in favour of the Indians by acknowledging that oral promises made in the treaty-making process should be honoured.

The Indian people or First Nations across Canada (about 3 per cent of the population), whether status, non-status, or

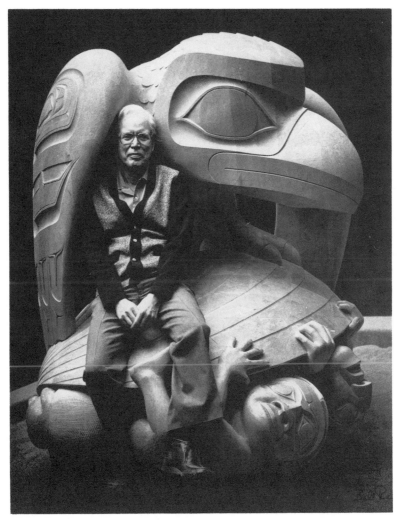

Fig. 9. Bill Reid with <u>The Raven and First Men</u>-yellow cedar sculpture on permanent exhibit at the University of British Columbia Museum of Anthropology since its unveiling by Prince Charles in 1983. Reid made contact with the Indian roots of his mother as an adult and has spent the last thirty years exploring and expanding Haida artistic expression. Photo Credit: Bill McLennan, University of British Columbia Museum of Anthropology, Vancouver, BC.

Métis, are waiting for the return of their culture heros. There is a belief that the Trickster figure, whether the Raven on the Northwest Coast or Nanabush in the east, left earth voluntarily or was killed when the Whites arrived. The Northwest Coast Raven was recently revived in a new form by the Haida sculptor, Bill Reid (fig. 9). He depicted one of the Raven's major exploits-the discovery of mankind in a clamshell.

Many of the nineteenth century encounters and experiences briefly described in this essay have formed the basis of contemporary First Nations's artistic and political expression. Thompson Highway, Cree playwright, stated in a 1987 radio interview, "the Trickster is still among us, on this continent, albeit in different guises, albeit a little the worse for wear. I believe the Trickster is passed out under a table at a bar on Hastings Street [Vancouver] for the past 200 years, and it's our responsibility as Native artists to sober him up... wake him up, so he can stand on his own two feet once more and make us laugh again." As the traditional Indian shaman sought to prevent soul loss, it can be said that the shaman is not dead, the shamanic spirit finds its expression among the artists.

NOTES

1. The term "Whites" in the nineteenth century was commonly used by both Indians and non-Indians to identify the dominant society. I have used it in this paper in a manner consistent with the nineteenth century.

2. The review of the ethnonym "Naskapi" by José Mailhot in "Beyond Everyone's Horizon Stand the Naskapi" (_Ethnohistory_ 33:4 [1986] 384 - 418) indicates the term referred to different groups at different times in Quebec\Labrador. The term was used to identify groups whose contact with Europeans was limited and whose traditional "material culture was practically intact." The term today is used by the Indians of Davis Inlet and Fort Chimo (Schefferville).

3. The Indian people who live in Bella Coola, BC are now known as the Nuxalkmc and form the Nuxalt Nation (Grand Hall Exhibit, 1991, Canadian Museum of Civilization).

4. The term Micmac is apparently in the process of changing spelling to "Migmag" to encourage the correct pronunciation (Viviane Gray, personal communication).

5. The ethnonym Kwakiutl in its many spelling versions is a proper name for the Fort Rupert tribe. According to Peter Macnair in "From Kwakiutl to Kwa Kwa Ka'wakw'" (_Native Peoples: The Canadian Experience_, R. Bruce Morrison and C. Roderick Wilson, eds. [Toronto: Morrison/McClelland and Stewart, 1986], 501 - 519) the new term was devised by the Indians of the twenty linguistically related communities who all speak Kwak'wala. The ethnonym translates as "those who speak Kwak'wala."

BIBLIOGRAPHY

Adams, John
1973 The Gitksan Potlatch: Population Flux, Resource
Ownership and Reciprocity. Toronto: Holt, Rhinehart and Winston.

Allen, Robert
1991 "His Majesty's Indian Allies: British Indian Policy in
the Defence of Canada, 1774-1815." PhD dissertation. University
of Wales.

Brasser, Ted J.
1987 "By the Power of their Dreams: Artistic Traditions of
the Northern Plains." In The Spirit Sings. Toronto: Glenbow
Museum/McClelland and Stewart, 93 - 131.

Beynon, William
n.d. Barbeau/Beynon Archives. Canadian Centre for Folk
Culture Studies. Canadian Museum of Civilization.

Cole, Douglas
1985 Captured Heritage: The Scramble for Northwest Coast
Artifacts. Vancouver\Toronto: Douglas & McIntyre.

Cole, Douglas and Ira Chaikin
1990 An Iron Hand Upon The People. The Law Against the
Potlatch on the Northwest Coast. Vancouver\Toronto\Seattle:
Douglas & McIntyre, University of Washington Press.

Fisher, Robin
1977 Contact and Conflict: Indian European Relations in
British Columbia 1774 - 1890. Vancouver: University of British
Columbia Press.

Gough, Barry M.
1984 Gunboat Frontier: British Maritime Authority and
Northwest Coast Indians, 1846 - 90. Vancouver: University of
British Columbia Press.

Haberland, Wolfgang
1987 "Nine Bella Coolas in Germany." In Indians and Europe.
Aachen: Christian F. Feest (Forum 11) Edition Herodot, Rader
Verlag.

Highway, Thompson
1987 Interview on CBC-AM radio, Vicky Gaberau Show, December
10, 1987.

King, J.C.H.
1991 "A century of Indian Shows: Canadian and United States
Exhibition in London 1825 - 1925." Native American Studies 5(1).

MacDonald, George F.
1983 Haida Monumental Art: Villages of the Queen Charlotte
Islands. Vancouver: University of British Columbia Press.

MacDonald, Joanne
1985 "From Ceremonial Objects to Curios: Power Exchange at
Port Simpson and Metlakatla." MA Thesis, Department of
Sociology and Anthropology, Carleton University, Ottawa.

MacEwan, J.W. Grant
1971 Portraits from the Plains. Toronto: McGraw-Hill.

Newbury, Robert W.
1974 "The Painted Stone: Where Two Rivers Touch." Nature
Canada January\March: 8 - 19.

Petrone, Penny, ed.
1983 First People, First Voices. Toronto: University of
Toronto Press.

Phillips, Ruth B.
1987 "Like A Star I Shine: Northern Woodlands Artistic
Traditions." In The Spirit Sings. Toronto: Glenbow
Museum/McClelland & Stewart, 51 - 92.

Pritchard, John Charles
1977 "Economic Development and the Disintegration of
Traditional Culture Among the Haisla." PHD Dissertation,
University of British Columbia, Vancouver.

Richardson, Boyce
1987 "Kind Hearts or Forked Tongues?" Beaver February/March:
16 - 41.

Robertson, Marion
1973 Rock Drawings of the Micmac Indians. Halifax: Nova
Scotia Museum.

Rohner, Ronald
1967 The Ethnography of Franz Boas: Letters and Diaries of
Franz Boas Written on the Northwest Coast from 1886 - 1931.
Chicago: University of Chicago Press.

Sewid-Smith, Daisy
1979 Prosecution or Persecution. Nu-Yum-Bayleess Society.

Scanlon, Kevin
1990 "Der Wilde Westen." In Equinox 53, September/October
1990.

Stock, Eugene
1899 The History of the Church Missionary Society. 2 volumes
London: Church Missionary Society.

Swan, James G.
1875 Letter, Smithsonian Institution archives, Washington.

Taylor, J. Garth
1983 "Mikak: An Inuit Woman in Labrador, 1769." Beaver
winter 1983:4 - 13.

1984 "The Two Worlds of Mikak. Beaver spring 1984:18 - 25.

Titley, Brian E.
1986 A Narrow Vision: Duncan Campbell Scott and the
Administration of Indian Affairs in Canada. Vancouver:
University of British Columbia Press.

Trigger, Bruce
1985 Natives and Newcomers: Canada's "Heroic Age"
Reconsidered. Kingston/Montreal: Queen's/McGill University
Press.

Usher, Jean
1971 "Apostles and Aborigines: The Social Theory of the
Church Missionary Society." Social History 1:21 - 51.

TRENDS IN NORTHWEST COAST INDIAN ART 1880 - 1950:
DECLINE AND EXPANSION

by

PETER L. MACNAIR

Northwest Coast Indian art is widely celebrated today for its aesthetic, intellectual, and ceremonial qualities. This art has had international appeal since the late eighteenth century, when early explorers and traders returned to Europe and the eastern American seaboard with artifacts acquired in trade. Within their cultural context these goods were not entirely dismissed as primitive exotica; surviving seamen's journals and records indicate that some early visitors appreciated, even if they did not entirely understand, the artistic achievements of Northwest Coast Indians. However, once removed from their cultural environment, such works often were treated more as curios than as art. A scholarly interest in the aesthetic values and the meaning of the art developed with the advent of serious anthropological collecting, about 1880.

Significant new directions in the art form began late in the nineteenth century, some representing decline, others celebrating a new vigour. These trends, such as changes in style, are reflected in both traditional ceremonial art and art produced for sale.

Documentation from artifacts collected in the late eighteenth and early nineteenth centuries demonstrate the folowing: the existence of clearly defined tribal styles, generally confined to specific linguistic groups; the institutionalization of classic tribal styles in both sculptural and two-dimensional art; and, recognizable regional sub-styles even personal styles, in this early period.

The fact that individual styles can be recognized suggests a flexibility in the art form, despite the rigorous rules that govern it. Within the prescribed boundaries, stylistic experimentation and innovation appear to have been acceptable. Evidence for this exists among some of the earliest anonymous practitioners (Wright 1979, 1982); after 1880, the work of known individual artists can be pointed out to support this claim.

Notable among the Haida is Charles Edenshaw (ca. 1839 - 1920). Traditional artifacts created by him reflect an artistic understanding firmly based in the ethnographic past, when Haida culture was at its zenith. His carvings in silver, argillite, wood, horn, and bone, and his paintings on spruce-root basketry, produced primarily after 1870, herald a triumphant personal style that pushed the intellectual and aesthetic limits of Haida two-dimensional art to a new height. Whether this accomplishment celebrated his mastery of a challenging art form or was a

Fig. 1. Haida artist Charles Edenshaw's technical skills and his expansion of form line design principles are evident in this argillite chest, collected ca. 1880. The fact that collectors of his work rarely recorded the meanings of his complex carvings in slate and other materials reveals an indifference to his genius. Fortunately, anthropologist John Swanton commissioned and documented an important body of Edenshaw's work (Swanton 1905). Featured on the lid of this chest is Raven presiding at the birth of humankind. Courtesy of the Royal British Columbia Museum, Victoria, BC, 10622.

Fig. 2. Like Edenshaw, Kwakwaka'wakw master Willie Seaweed introduced innovative sculptural and design elements to his work. His flamboyant eyebrow and the optically dazzling designs behind the nostril and above the upper beak of this cannibal-bird mask indicate he experimented as much as did his Haida counterpart. But Seaweed had the satisfaction of producing art for traditional ceremonial use. Photo courtesy of the Campbell River Museum and Archives.

desperate, final flowering of a tradition for which Edenshaw saw no future, is difficult to say. One suspects the latter, however, because most of his technically accomplished work was produced for sale to collectors who were often unable to appreciate his great artistic genius (fig. 1).

In interesting contrast is the work of Kwakwaka'wakw (formerly called Kwakiutl) artist Willie Seaweed (ca. 1873 – 1967) (fig. 2). His productive artistic life spanned nearly seventy years. In his seventh decade he was still in the forefront, continuing to experiment with the flamboyant style that came to characterize Kwakwaka'wakw art in the early twentieth century. Unlike Edenshaw, he displays no hesitancy, no underlying desperation. If anything, Seaweed remained defiant in the face of a changing world. Creating a cannibal bird mask remained as important to him in 1954 (Holm 1983:fig. XI) as it obviously was about 1910 (fig. 3), when his first documented work was produced. Seaweed's solace comes from the fact that he never had to compromise. With minor exceptions, he was able to create living artifacts for use by an Indian clientele who refused to forget or deny their mythic past.

The careers of Seaweed and Edenshaw demonstrate a different response to the pressures placed upon Indian cultures following 1871 when British Columbia joined the Canadian confederation. Their responses were complex and varied, but in important ways they both anticipated and influenced the revival the art form is experiencing today.

Trends in Northwest Coast Indian art between 1880 and 1950 can be better understood after a brief examination of the preceding period. Of special interest are population dynamics, which had an undeniable effect on the fate of the art and culture of Northwest Coast peoples. While we lament the destructive influence of White society and the irretrievable loss of cultural information through disease, warfare, and indifference, we cannot dismiss the fact that the White man's presence on the Northwest Coast stimulated an unprecedented movement of ideas and people throughout a territory where change and exchange had previously occurred at a slower rate. (This is not to suggest that no significant shifts in population and ideas occurred before the arrival of the White man. Haida incursions into Prince of Wales Island around 1700 have been confirmed by archaeological, ethnographic, and historical evidence.)

The presence of the White man, therefore, intensified economic reorganization, population movement, intertribal warfare, and intertribal marriages on the Northwest Coast, both at the local level and on a much grander geographical scale. Intertribal exchange, with economic and social purposes, was practised even before the arrival of the White man; however, the exchange of prerogatives through marriage intensified during the nineteenth century, increasing the movement of privileges and ceremonial gear from one linguistic group to another.

Fig. 3. In this, Seaweed's earliest documented carving, we see
the beginnings of an elaborate painted style which Kwakwa̱ka'wakw
artists began to apply to cannibal-bird masks in the last decade
of the nineteenth century. The cheek, temple, and nostril
designs are less developed in older prototypes. Courtesy of the
Royal British Columbia Museum, Victoria, BC, 1917.

Fig. 4. Serving bowl in the form of a frog, by Haida artist
Charles Edenshaw. While it demonstrates a masterful combination
of sculpture and flat design, the carving also reveals hidden
meaning and visual punning. The overall grace of the bowl is
apparent to most viewers, but few recognize its other levels of
accomplishment until they are pointed out. Even Franz Boas was
reluctant to accept Edenshaw's opinion on the complexity and
subtlety of northern two-dimensional design (Boas 1955:275).
Courtesy of the University of British Columbia Museum of
Anthropology, Vancouver, BC, A7054.

The acceleration of exchange is nowhere better seen than among the Kwakwaka'wakw in the latter half of the nineteenth century. This era saw the firm entrenchment in Kwakwaka'wakw ceremony of the cannibal dance of the Heiltsuk; the dancing headdresses, raven rattle, and Chilkat blankets of the three northernmost tribes; certain Nuxalk privileges; parts of the Nuu-chah-nulth wolf ritual; and the Coast Salish *sxwaixwe*. A wealth of artifacts, clearly manufactured by these outside groups, accompanied these exchanges. As newly acquired privileges were passed on to successive generations, new objects were created to replace their original prototypes. Among no other Northwest Coast tribe was there such an admixture of artifact and tradition.

Documenting trends in Northwest Coast art forms between 1880 and 1950 is a complex matter. In this brief space, we will only examine some coastal tribal traditions to see whether they went into decline or experienced uninhibited growth, and follow the course of both traditional ceremonial art and art for sale.

DECLINE

The fact that there are still practitioners of Northwest Coast Indian art demonstrates that its decline in the nineteenth century did not lead to the end of the art form. However, early in the twentieth century it appeared to many observers that there was no future for the art. This seemed especially true for the Coast Salish, Tsimshian, and Haida traditions, among which the classic forms either disappeared altogether or were replaced by substitute styles. The new forms sometimes achieved such public prominence and acceptance that they continued to be considered "art." Such was the fate of the Haida tradition.

No linguistic group suffered an artistic decline more profound than did the Haida. Justifiably or not, their art has always been considered the epitome of the Northwest Coast tradition. There is little doubt that the demise of the Haida was the result of a dramatic population decline, and the domination of the small remnant by civil and religious authorities. One authority estimates a reduction in the Haida population from about 6,000 in 1835 to 800 in 1885, to a low of 588 in 1915 (Duff 1965:39). By 1890 some twenty independent villages of the Haida were reduced to two closely administered communities. The only artistic expression encouraged, indeed allowed, by Indian agents and missionaries after 1890 was the production of curio items in precious metal, argillite, wood, and basketry. This repression must have been frustrating for the surviving artists, who had received a classical training in the ethnographic past, as they were compelled to turn away from the production of traditional ceremonial paraphernalia. However, when they reluctantly accepted their new role, their great tradition seemed about to disappear. Only in the late-flowering genius of Charles Edenshaw, described briefly above, do we

glimpse the agony that must have consumed them.

Edenshaw would have appreciated the challenge overcome by the anonymous Haida artist who combined classic sculptural form with two-dimensional surface decoration to create a grease bowl collected during Captain George Dixon's trading voyage to the coast in 1785 - 1788 and now in the British Museum (BM NWC 25; King 1981:fig. 49). Edenshaw's solution to the same challenge is found in his frog bowl (fig. 4), which, even more subtly than its precursor, combines sculptural form and flat design. However, Edenshaw's artistic statement goes beyond this interpretation because the receptacle of this container mimics yet another, more archaic-type bowl. The inspiration for it is found in the classic pure-form bowl (Sturtevant 1974:fig. 41) and is defined in the Edenshaw example by the sweeping four-sided rim: a bowl within a bowl. In all, it is a masterful statement of artistic and intellectual accomplishment. Yet the example shows no evidence of use, and this is the Haida master's tragedy. Edenshaw did produce art for traditional use; a good example is a settee, now in the collection of the Royal British Columbia Museum (RCBM 1296, ill. in Macnair et al. 1984:67). Yet his best known and most easily identified work was produced after 1870, mainly for the collector's market. The bowl must have been produced only for sale. Did the buyer have any understanding of the intellectual merit of the item?

There appear to have been fewer than a dozen active Haida artists of significance after 1880 (fig. 5). They barely survived as artists into the twentieth century. The work of six of the most prominent, including Edenshaw, are competently analyzed in an article by eminent Northwest Coast art scholar Bill Holm (Abbott 1981). By agreeing to create only marketable art, they unwittingly denied their successors an understanding of the traditional context of the art as well as careful instruction in its proper form. It cannot be too strongly emphasized that this commercialism was not entirely their fault; circumstances conspired to force it.

The minor practitioners who dominated the years 1900 to 1950 worked awkwardly and often without training, and almost exclusively in argillite. Regrettably, promoters of this commercial form continued to equate "argillite" with "art." In this unctuous shale lay the unhappy fate of Haida art; it remained popular with collectors but when compared with nineteenth century examples, it was artistically and intellectually moribund.

In interesting contrast is the Coast Salish tradition. The Coast Salish appear to have forgotten the classic forms of their art as completely as did the Haida. But conditions among this group were different, primarily because of population.

Occupying the Strait of Georgia, the Coast Salish were always susceptible to administrative authority in the urban

53

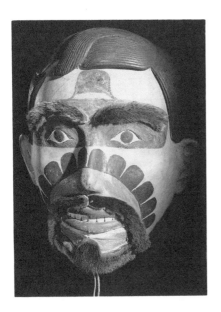

Fig. 5. Sensitive portrait masks
carved by Haida artist Charles
Gwaytil around 1880 appear never to
have been used in traditional
ceremonies. No work by this artist
has been discovered indicating use or
prefiguring his art for sale.
Courtesy of the Royal British
Columbia Museum, Victoria, BC, 10667.

Fig. 6. The human face on this
spindle whorl exhibits the flat,
frontal alignment expressed in
archaic Coast Salish carving. Its
near affinity to early Nuu-chah-nulth
structure should not pass unremarked
(compare with King 1981:colour pl.
6). A prototype form line structure
is evident in the split dragonlike
creatures that surround the central
human figure. The conceptual and
stylistic similarity between these
creatures and one decorating a comb
excavated from the Ozette
archaeologic site in Washington State
is striking (Carlson 1983:fig.
10:10). Courtesy of the Royal
British Columbia Museum, Victoria,
BC, 2454.

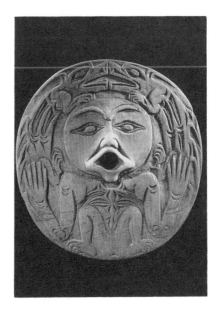

centres of Victoria, Nanaimo, and Vancouver. According to Duff's
population figures, the Coast Salish survival rate was much
higher than that of the Haida. Duff calculates Coast Salish
population figures of 12,000 for 1835, 5,525 for 1885, and 4,120
for the low year of 1915. Survival in the face of smallpox,
which was introduced in Coast Salish territory in 1862, is
intriguing but can be explained in part by the colonial policy of
inoculating or otherwise isolating Indians living near the
Hudson's Bay Company administrative centre. Their services were
desperately needed by the company and every effort was made to
protect them.

 Whatever Coast Salish traditions survived the nineteenth
century did not depart substantially in form or concept from the
designs executed on a horn rattle collected in the eighteenth
century (King 1981:pl. 52). Classic Coast Salish art was not as
intellectually challenging or flamboyantly dramatic as that of
other Northwest Coast groups. While its two-dimensional form
remains seminal to an understanding of the highly developed
northern flat design, only a limited number of Coast Salish
objects were decorated in this fashion (fig. 6). These did not
extend much beyond combs, clubs, sheephorn rattles, spindle
whorls and an occasional burial box. It can be asserted that
between 1900 and 1950 few, if any, Coast Salish carvers
successfully created, let alone replicated, any of the
challenging complex flat designs mastered by nineteenth century
practitioners.

 An intriguing exception is that of the *sxwaixwe* mask (fig.
7). As the only mask used by the Coast Salish, and with limited
distribution among high-ranking families, its use has continued
unabated to the present day. Significantly, many new examples
were carved and used between 1880 and 1950, most of them
incorporating subtle, but limited, two-dimensional design
elements (Macnair et al. 1984:54). The successful passing on of
these design elements virtually intact is more likely a result of
the slavish copying of older examples than the creative
continuation of a classic tradition (Hawthorn 1967:figs. 424,
425, 426). On the other hand, a remnant school may have
survived, retaining a reasonable understanding of classic rules.
Only in the *sxwaixwe* mask did this tradition continue; in
general, the need for the decorated accouterments of the weaver's
toolkit and the ritualist's fishing gear passed from use.

 The decline of the Coast Salish tradition was therefore of a
different order from that of the Haida. The fact that the Coast
Salish lost a little less than half of their estimated 1835
population and, more importantly, that they maintained at least
forty discreet settlements into the mid-twentieth century meant
that a policy of universal assimilation was much more difficult
to achieve. Traditional ceremony was much less ostentatious and
public than that of the Kwakwaka'wakw, for example, so the Coast
Salish were able to continue these traditions without the zealous
interference other linguistic groups suffered.

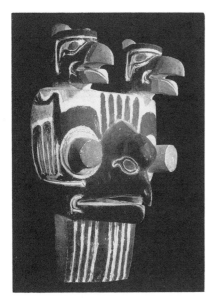

Fig. 7. The way in which two-dimensional and sculptural design elements are combined on this Coast Salish *sxwaixwe* mask confirms that this artistic device was universal among Northwest Coast carvers. Although less subtle than the Edenshaw example (fig. 4), it remains an artistic triumph. The "nose" of the main creature of course doubles as the head of a bird. The body of this bird creates a typical Northwest Coast eyebrow, while the feathered wings mimic temple designs found in other tribal traditions (see figs. 3, 13). Courtesy of the Royal British Columbia Museum, Victoria, BC, 2364.

Fig. 8. Classic Tsimshian frontlet collected at Kincolith village on the Nass River. The serene and sensitive human faces produced by Tsimshian carvers, on no matter what scale, always fascinate the viewer. While Tsimshian artists continued to produce in the early-twentieth century, they were unable to equal the accomplishments of their mentors. Courtesy of the Royal British Columbia Museum, Victoria, BC, 14310.

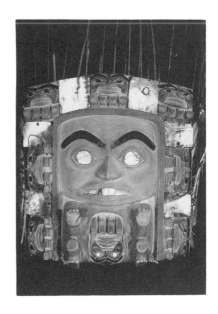

It must be admitted that Coast Salish people were aware of the curio market and, in certain of the scattered villages, individuals emerged as producers for this market. By and large, however, they produced few items for sale other than totem poles, and even these were acknowledged as imitations of Haida and Kwakwaka'wakw examples.

Such tourist art appears to have been produced mainly by individuals who had little or no connection with the production of traditional ceremonial art. Because the continuing use of ritual objects among the Coast Salish remained so private and so sacred, anyone with a significant knowledge of the art form would have been reluctant to produce commercialized images from this tradition. An easy solution would have been to imitate other tribal styles and to limit subject matter to publicly accepted forms, such as totem poles.

No regional sub-styles have yet been distinguished in Tsimshian art (figs. 8, 9). Interestingly enough, the production of art for sale supports the contention that there existed a separate Coast/Lower Skeena style. A number of bowls are known which, in my opinion, are stylistically akin to that shown in figure 10. I suspect that this bowl and its mates were produced on the northern mainland coast, within Tsimshian-speaking territory. Absolute confirmation of this provenance awaits further research. These bowls were probably produced in the period 1865 - 1885 and they can be considered a counterpart to Edenshaw's work for sale (fig. 4).

This Tsimshian sub-tradition seems to have disappeared by 1880; but by 1900 another identifiable coastal school had emerged, based in Port Simpson. Its leading proponents displayed a limited repertoire, producing spoons, ladles, walking canes, bowls, napkins rings, model canoes, and the occasional model totem pole. These artifacts are consistently well-finished, charming souvenirs (fig. 11), but they lack the vitality of the older school. They remain among the best early-twentieth century examples of Tsimshian tourist art.

While most traditional ceremonial artifacts produced among the Tsimshian in the first half of the twentieth century were unremarkable, raven rattles, frontlets, feast ladles, and totem poles were nonetheless created and used, especially among the Gitksan, or Upper Skeena River Tsimshian. Classic standards may not have been always met in these pieces but they and their older counterparts remained in relative abundance in the villages until the 1950s.

It is important to realize that while few skilled artisans were active at this late date, a knowledge of how prerogatives functioned was retained within the wider society, especially among the Gitksan. This knowledge is evident in land and resource ownership records set down in writing during the past two decades by Gitksan elders. While an informed understanding

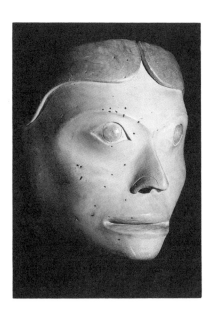

Fig. 9. Nineteenth century Tsimshian
mask used in a dramatic tableau to
represent a conceited woman. The
Tsimshian were particularly adept at
portraying personality traits in
their portrait masks. Idiosyncracies
of character effectively expressed in
the carving, were further enhanced
through the movements and actions of
the performer wearing the mask.
Courtesy of the Royal British
Columbia Museum, Victoria, BC, 9913.

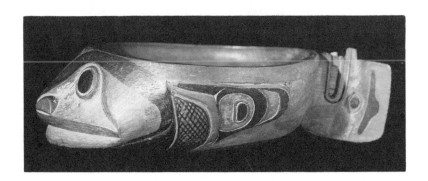

Fig. 10. Tsimshian (attributed) serving bowl. A number of
animal-form bowls were collected on the northern coast of British
Columbia between 1865 and 1885, after which date they seem not to
have been produced. Their place of origin remains uncertain, but
I am attributing them as Coast Tsimshian. Like the Edenshaw bowl
(fig. 4), they show little evidence of use, so were probably
produced for sale. A fish, possibly a sculpin, is represented in
this carving. Courtesy of the Royal British Columbia Museum,
Victoria, BC, 17020.

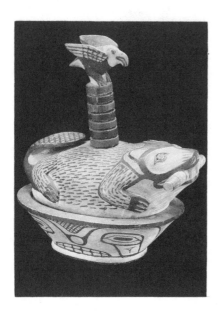

Fig. 11. Perhaps the successor to the commercial carving illustrated by figure 10 is this Tsimshian compote, produced c. 1900 at Port Simpson. A charming piece, it is, however, much removed from traditional form and exhibits only a minimal understanding of flat design. Literally dozens of examples from the hand of this single carver are found in museum and private collections. As yet unidentified by name, this craftsman was succeeded by a group of carvers whose work was much less satisfying. Courtesy of the Royal British Columbia Museum, Victoria, BC, 11432.

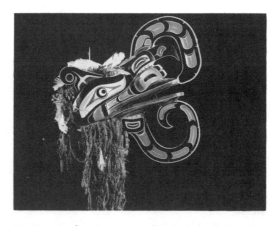

Fig. 12. This Kwakwaka'wakw cannibal-bird mask representing the mythical monster Crooked Beak of Heaven demonstrates why commentators on Northwest Coast Indian art use the term "baroque" when referring to Willie Seaweed's later work. Produced about 1940, it represents the same creature seen in figure 2 and 3 but is unquestionably more elaborate. The squared ovoid form of the nostril is repeated elsewhere on the mask where it functions to define the heads of two understated birds, a crooked beak of heaven (lower jaw) and perhaps a raven (above the nostril). Courtesy of the Royal British Columbia Museum, Victoria, BC, 17377.

of the classic Tsimshian art form might have been lost, the context in which the art was used was not. Again, survival statistics and the relative remoteness of Nishga and Gitksan villages through 1950 contributed significantly to this survival. The total figures for the three Tsimshian groups are estimated at 8,500 for 1835, 4,550 for 1885 and 3,550 for the low year of 1895.

We see in the Haida, Coast Salish, and Tsimshian traditions what on the surface appears to be an absolute decline in art production between 1880 and 1950. Among the Coast Salish and Tsimshian, however, the maintenance of language and a knowledge of tradition by a comparatively intact and widespread population kept the loss to a scale less than that suffered by the Haida.

EXPANSION

The artistic traditions of the Kwakwaka'wakw are recognized as having evolved during the decades between 1880 and 1950 and flourished. The ultimate statement on Kwakwaka'wakw art is made by Willie Seaweed during the last two decades of his career. While his singular personal sculptural and graphic style at this time (1940 - 1960) might be called baroque (fig. 12), the work of his contemporaries, such as Mungo Martin, also became nearly as flamboyant (fig. 13). The characteristic that defines the evolution of Kwakwaka'wakw art in this period is that of applied design. While sculptural planes became more clearly defined by the carver's adze and knife, it was the extensive use of painted design fields, incorporating many colours, that served to redefine the art. Scholars suggest that an increasing awareness of northern flat design was responsible for this change.

The precursor of this late-nineteenth century development is an archaic sculptural form called the Old Wakashan style that seems to have been universal among the linguistically related Nuu-chah-nulth and Kwakwaka'wakw peoples. In this style, humanoid faces reflect the understated conservatism of the earlier era and are best characterized by examples collected from the west coast of Vancouver Island by Captain James Cook (King 1981:pls. 60, 61, 62). Animal-form carvings were equally subtle, as evidenced by the Old Wakashan wolf headdress recovered archaeologically from Quatsino Sound (fig. 14). When it is compared to the twentieth century Willie Seaweed wolf headdress (fig. 15), the dramatic change in style becomes obvious.

During this period of intense change, the Kwakwaka'wakw were acquiring new privileges from both their northern and southern neighbours. While they often kept original artifacts obtained from outside their boundaries, they also quickly produced new versions to suit their own stylistic tastes (fig. 16).

Not to be forgotten in this evolution of traditional forms are the Heiltsuk, the northern linguistic affiliates of the

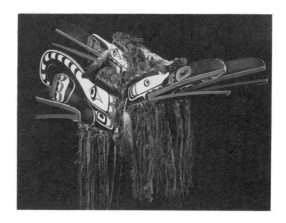

Fig. 13. The unrestrained twentieth century Kwakwaka'wakw
expression so manifest in Willie Seaweed's personal style is also
found in the work of his contemporaries. Mungo Martin's multiple
cannibal-bird mask featured here demonstrates that other
Kwakwaka'wakw artists contributed to the development of elaborate
applied design. Courtesy of the Royal British Columbia Museum,
Victoria, BC, 9201.

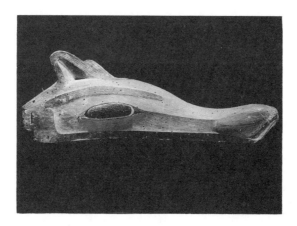

Fig. 14. The restrained accomplishment of the old Wakashan style
is epitomized by this wolf headdress. Elegant and simple, there
are nonetheless understated subtleties of line that contribute to
the aesthetic success of this gentle masterpiece. Note the
integrated sweep of the ears, the artful out-turn of the eye
socket line where it joins the eyebrow, and the lateral line that
continues from eyelid to nostril. This aerodynamic wolf seems
ready to leap forward of its own accord. Parallel knife marks
create an impression of fur over the entire carving. Courtesy of
the Royal British Columbia Museum, Victoria, BC, EdSv6:1.

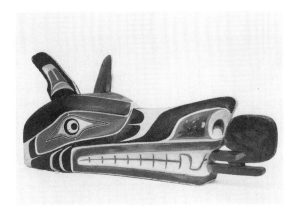

Fig. 15. Wolf headdress made by Willie Seaweed. Like its precursor (fig. 14), this wolf appears to be darting forward, but the effect is achieved through painted design more than by sculptured detail. When the two masks are compared, the way in which painted design elements served to define the emerging Kwakwaka'wakw style is obvious. Courtesy of the Royal British Columbia Museum, Victoria, BC, 16459.

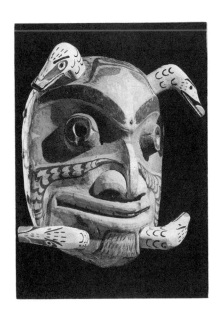

Fig. 16. The stalklike eyes and the protruding heads on this Kwakwaka'wakw mask reveal it was derived from the Coast Salish *sxwaixwe* (fig. 7). An account of how one Kwakwaka'wakw family acquired this mask in marriage from their southern neighbours is found in Boas (1921:891-937). Among the Coast Salish, the *Sxwaixwe* dance was an extremely serious production, used for life-crisis rites; the Kwakwaka'wakw inverted the intent so that the dancer's actions are exaggerated in a humorous fashion and function to provide comic relief. Courtesy of the Royal British Columbia Museum, Victoria, BC, 12685.

Kwakwaka'wakw. Their archaic humanoid representations have a serene quality, which almost overwhelms the viewer (fig. 18). About 1880 their very diminished population relocated from five major villages to a single centre, where some Heiltsuk artists began producing art for sale. Among their output were a number of masks which, much like those of Charles Gwaytil (fig. 5), seem never to have been used in ceremony. Figure 19 provides an example from a distinctive but anonymous carver who produced such masks, rattles, bowls, and model totem poles for sale. Like this example, most masks by this carver have a decidedly grotesque quality. At least one contemporary of this artist produced work for use (Boas 1909:pl. XXXIX, fig. 2). Another generation followed these late-nineteenth century practitioners; their work, while competent, is less frantic (RBCM 17941, not ill.).

While the Kwakwaka'wakw were reduced to about one fifth of their original number by 1929 (Duff 1965:39), their art and ceremony continued to flourish because they adamantly refused to accept the cultural restrictions imposed by government and religious authorities, at least until 1920. In addition, their dispersal in more than a dozen separate and isolated villages until the 1950s delayed integration.

The final group under consideration in this essay is the Nuu-chah-nulth, who remain very much overlooked in the popular literature and in discussions of Northwest Coast Indian art. Yet, in many ways, the blossoming of Kwakwaka'wakw sculpture and flat design after about 1870 was equalled among the Nuu-chah-nulth. Using the aforementioned human face masks collected by James Cook at Nootka Sound as the point of origin, we discover that a change on the basic structure of these masks had taken place by 1880.

In the archaic examples, the forehead, cheeks, and eyesockets are aligned on a slightly convex plane. This structure is somewhat akin to ancient Coast Salish sculpture (Macnair et al. 1984:52). In time, the forehead and cheek planes migrated toward the back of the mask, leaving a distinctive, sharp, vertical axis in the centre front (Macnair et al. 1984:52). How early this significant structural change took place is impossible to say, given the current state of research on the subject. However, practitioners of this variation dominated the 1880s.

Like the Kwakwaka'wakw artists, the Nuu-chah-nulth masters developed a fascination with northern painted design, seen in many dance screens painted after 1880 (Holm and Reid 1975:fig. 101). The Nuu-chah-nulth artist who produced the ceremonial screen illustrated in figure 20 reveals the diverging interest in formal structure and northern design elements like the salmon-trout head. Painted designs also decorate masks of this classic era, and while these may relate to traditional facial painting, a northern, or even Kwakwaka'wakw influence cannot be discounted.

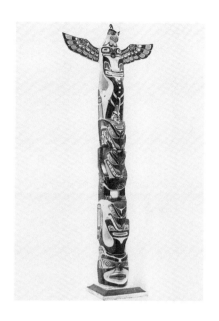

Fig. 17. Like all Northwest Coast tribes, the Kwakwaka'wakw produced an art for sale. The meticulous detail found in this model pole which stands about 60 centimetres high matches that found on full-scale examples. In terms of workmanship and design, this carving by Charles G. Walkus is equal to those produced for Swanton by Haida artist Charles Edenshaw. Courtesy of the Royal British Columbia Museum, Victoria, BC, 6794.

Fig. 18. Heiltsuk ceremonial objects were the main source of northern flat design for the Kwakwaka'wakw as the nineteenth century progressed. Design elements on such carvings were reinterpreted by the Kwakwaka'wakw, resulting in the distinctive twentieth century personal styles of Willie Seaweed, Mungo Martin and Charles G. Walkus. This genial Heiltsuk sun, dating from the mid-nineteenth century, serves to demonstrate the source of Kwakwaka'wakw inspiration. Note that the definitive rays and the recurved beak are missing from this example. Courtesy of the Royal British Columbia Museum, Victoria, BC, 55.

Fig. 19. This intriguing Heiltsuk mask, produced for sale around 1890, is in a stylistic category of its own. Its grotesque quality is matched in the work of only two or three other carvers from the Bella Bella region (see Boas 1909:pl. XXXIX, fig. 2 and Wardwell 1964:fig. 23). The device of nose turning into bird was a striking parallel in the Coast Salish *sxwaīxwe* (fig. 7) although it is difficult to argue that the two are directly connected. Courtesy of the Royal British Columbia Museum, Victoria, BC, 16344.

Fig. 20. The combination of alien styles and images on this Nuu-chah-nulth screen is indeed puzzling. The form line face in the upper right quarter and the salmon-trout head variations in the shoulder joints of the thunderbird are clearly derived from northern flat designs, as a comparison with figure 1 will reveal. The totem pole renderings are strangely reminiscent of Tlingit carvings, almost tempting one to speculate that some Nuu-chah-nulth fur seal hunter/artist spent time in southeastern Alaska. Comparing this screen with certain Yakutat Tlingit examples is indeed a provocative exercise (see de Laguna 1972:pls. 92, 93, 213). Courtesy of the Royal British Columbia Museum, Victoria, BC, 18772.

Nuu-chah-nulth human face masks appear to assume three
variant subforms in the late-nineteenth century. While these
schools had a number of practising adherents, each was dominated
by a master whose personal style becomes more evident as more
examples of Nuu-chah-nulth sculpture are discovered. The product
of the first sub-school is most closely aligned to the archaic
form. The sharp, horizontal brow remains but an increased three-
dimensionality is seen in the modelling (fig. 21). Applied
designs exhibit a curvilinear quality in these examples.

The sub-type most distant from this, yet entirely within the
new tradition, is illustrated by the example in figure 22. The
planes on either side of the central axis are much flatter and
recede at a more acute angle. Applied designs, not yet
successfully interpreted, are exclusively geometric.

Placed between these two extremes is the third sub-type
(fig. 23). Its sides fall back as rapidly as in the previous
example, but the additional modelling produces a softer, slightly
benign countenance. Broad geometric bands combined with
featherlike elements characterize the painting style of this
third sub-school.

Masks from the above three categories were in continual use
in villages until 1950, and were familiar to twentieth century
Nuu-chah-nulth carvers. Classic pieces were used with relative
frequency so that an impression of their form and meaning was
never eradicated from the consciousness of Nuu-chah-nulth
villages.

As with other culture groups, curio carvers emerged among
the Nuu-chah-nulth in the early twentieth century. Models of
totem poles and of figures in sealing canoes, as well as masks,
were produced at this time. While some Nuu-chah-nulth carvers in
this period functioned almost exclusively as producers of art for
sale, other leading proponents, well versed in traditional forms,
began to produce a curio art that denied the former artistic
integrity. Such a carver was Jimmy John (ca. 1876 - 1988). He is
known to have made many ethnographic pieces within the post-1870
tradition, perhaps including the *sxwaixwe* mask featured in figure
24. After his marriage he moved to his wife's home village in
Coast Salish territory, where, isolated from his own people, he
produced works of art almost exclusively for sale. Increasingly,
these commercial pieces incorporated shortcuts in the carving
process and reductions or minimalizations in the painted designs
so that the final product was far removed from the integrated
works of his early career. In the case of Jimmy John we find a
deliberate effort by an artist to reduce the complexity of
traditional forms.

Can we claim, as some have suggested, that Nuu-chah-nulth
art was lost because of this deliberate reduction of the form by
Jimmy John and some of his contemporaries? I hesitate to do so,
because even while Nuu-chah-nulth art was "rediscovered" in the

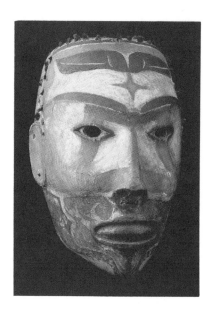

Fig. 21. The angular, nearly horizontal brow line, and lack of a defined eye socket clearly connect the form of this Nuu-chah-nulth mask from about 1870 with the human face masks collected on the Cook expedition (King 1981:pls. 60, 61,62). The split-U variants painted on the forehead suggest a connection to northern flat design but the geometric elements between cheek and brow and the curvilinear renderings from cheeks to chin are distinctly Nuu-chah-nulth in origin. Courtesy of the Royal British Columbia Museum, Victoria, BC, 16382.

Fig. 22. The wedge-shaped structure came to dominate Nuu-chah-nulth human face masks in the final three decades of the nineteenth century. Variations on this basic form, along with distinctive painting styles, show that many carvers were active in this period. While few examples can be traced to the unnamed artist of this work, his carvings are so unique that they cannot be mistaken. In the early-twentieth century minor carvers struggled to keep this characteristic style alive. Courtesy of the Royal British Columbia Museum, Victoria, BC, 10244.

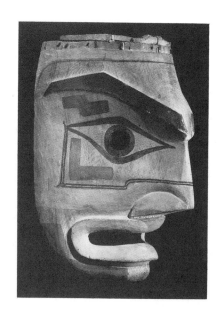

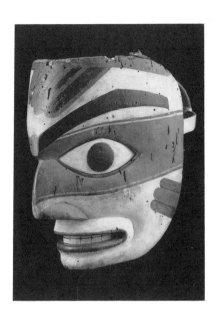

Fig. 23. A comparison between this Nuu-chah-nulth human face mask and figure 22 graphically demonstrates how two personal styles can exist within a single tradition. The rounded, softer planes in this example give it a less immediate quality than that of figure 22, but the result is entirely successful. The featherlike design elements running off the edge of this mask are devices preferred by the yet-to-be-identified creator of this fine sculpture. Courtesy of the Royal British Columbia Museum, Victoria. BC, 18273.

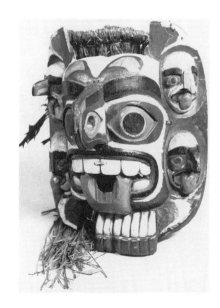

Fig. 24. This Nuu-chah-nulth *sxwaixwe* mask, created early in the twentieth century was once owned by a Moachat chief. The song that accompanies this mask is obviously Coast Salish in origin but the carving style is derived from a Kwakwaka'wakw variant. The source of inspiration may well have been an example now in the Museum of the American Indian, Heye Foundation (ill. in Lévi-Strauss 1982:11). This mask was reportedly carved by Yuquot village artist Jimmy John. Courtesy of the University of British Columbia Museum of Anthropology, Vancouver, BC, A8547.

1970s (Macnair et al. 1984:105 - 110), the budding proponents of rebirth were aware of, and respected, the decision of John and others to produce for a commercial market.

The coastal-dwelling Indians of British Columbia were subjected to considerable pressures once the province joined the Canadian confederation in 1871. Their traditional ways of life were denied by civil and religious authorities. Their right to produce a culturally meaningful art was similarly assailed; but, in spite of all the pressure against it, the art survived and in many instances flourished between 1880 and 1950. It is indeed a tribute to the tenacity of the human spirit that the art of the Northwest Coast Indians remained so creatively alive in an otherwise very dark period.

BIBLIOGRAPHY

Abbott, Donald N., ed.
1981 The World is as Sharp as a Knife, an Anthology in Honour of
Wilson Duff. BC Provincial Museum, Victoria.

Boas, Franz
1909 The Kwakiutl of Northern Vancouver Island. American Museum
of Natural History Memoir No. 8, New York.

1921 Ethnology of the Kwakiutl. 35th Annual Report of the Bureau
of American Ethnology, Washington, DC.

1927 Primitive Art. Oslo and London: Instituttet Sammenlignende
Kulturforskning, 8 (rpr. New York: Dover, 1955).

Carlson, Roy L., ed.
1983 Indian Art Traditions of the Northwest Coast. Burnaby, BC:
Simon Fraser University Archaeology Press.

de Laguna, Frederica
1972 Under Mount Saint Elias: The History and Culture of the
Yakutat Tlingit. Smithsonian Contributions to Anthropology, vol.
7, parts 1 - 3. Washington, 1972.

Duff, Wilson
1964 The Indian History of British Columbia: Volume 1, The Impact
of the White Man. Anthropology in British Columbia Memoirs.
Victoria, BC.: Provincial Museum.

Hawthorn, Audrey
1967 Art of the Kwakiutl Indians. Seattle: University of
Washington Press.

Holm, Bill
1965 Northwest Coast Indian Art; An Analysis of Form. Seattle:
University of Washington Press.

1983 Smokey-Top, The Art and Times of Willie Seaweed.
Seattle/London: University of Washington Press.

Holm, Bill and Bill Reid
1975 Indian Arts of the Northwest Coast: A Dialogue on
Craftsmanship and Aesthetics. Houston: Rice University,
Institute for the Arts.

King, J.C.H.
1981 Artificial Curiosities from the Northwest Coast of America.
London: British Museum Publications Ltd.

Lévi-Strauss, Claude
1982 The Way of the Masks. Seattle: University of Washington
Press.

Macnair, Peter, A.L. Hoover and K. Neary
1984 The Legacy: Continuing Traditions of Northwest Coast Indian
Art. Vancouver: Douglas and Stewart.

Sturtevvant, William C., ed.
1974 Boxes and Bowls: Decorated Containers by Nineteenth Century
Haida, Tlingit, Bella Bella, and Tsimshian Indian Artists.
Washington, DC.: Smithsonian Institution Press.

Swanton, John R.
1905 Contributions to the Ethnology of the Haida. Memoirs of the
American Museum of Natural of Natural History, vol. 5, part 1,
New York.

Wright, Robin K.
1979 "Haida Argillite Ship Pipes." American Indian Art Magazine
5(1) winter 1982:48 - 55.

IN SEARCH OF THINGS PAST, REMEMBERED, RETRACED, AND REINVENTED

by

Martine Reid

All things must die, and great art must be a
living thing, or it is not art at all.
(Bill Reid, 1971:100).

Following contact with the outside world's invading colonists and missionaries, Northwest Coast culture experienced severe strains with inevitable results. While some aspects of their traditional cultures were disrupted, altered, or even abandoned altogether, the cultures themselves were not rendered wholly impotent. Native societies created both conservative and innovative responses to their changing world, a dialogue witnessed in their art, which is at once tradtitional and innovative. In the twentieth century, it retains a traditional appearance, one that exhibits basic conceptual features characteristic of Northwest Coast art styles, but at the same time, it looks for a new purpose and new meanings.

THE RENAISSANCE METAPHOR/REQUIEM FOR A METAPHOR

Anthropologist Joan Vastokas was not the first to find a parallel between the resurgence of Northwest Coast art in this century and the European Renaissance. In an article "Bill Reid and the Native Renaissance" (1975) she wrote: "The decline of West Coast art and culture during the nineteenth century, for example, has already been compared with the cultural breakdown experienced in Europe during the Black Death of the fourteenth century, a period that marked the final destruction of Medieval world order. That period of cultural near-death, however, was almost immediately followed by what is often considered the peak of achievement of Western art, the Italian Renaissance of the fifteenth century. Themes of death, decay and destruction were replaced in literature and art by those of resurrection, growth and restoration" (Vastokas, 1975:20). But the analogy is misleading and the very term "renaissance" in this context is a misnomer.

Europe used the relics of classical Greece and Rome as a starting point for its Renaissance, and built on them a completely new structure embracing all aspects of art-painting, sculpture, music, drama, and literature. The Northwest Coast "Renaissance," on the other hand, was encouraged not by an indigeneous impulse or an inner innovation but by a few members of the White community, whose interest began to bloom thirty years ago. It involved only a few artisans, not a whole culture. And the rebirth it contemplated was not meant to serve some social or religious need, but to satisfy a commercial market ranging from "fine art," to "airport art."

71

GENESIS OF A METAPHOR

Each phase of human habitation on the Northwest Coast has had a unique and identifiable influence on Native art.

Three thousand years before contact, art and imagery along the Northwest Coast were already well established in heraldic, ceremonial, and symbolic forms. It was a grand art produced by a grand people.[1]

Beginning in the 1770s the fur-trade period brought with it increased wealth, and new chiefs emerged who required a host of ceremonial accouterments-crests, figures, masks, costumes, dishes, and other material goods. New technology, particularly the sudden abundance of metal tools, led to a flowering of architecture and the wood carver's art. It was the "golden age" of Northwest Coast Indian art. At the same time, Haida artists began to produce slate carvings, pipes, and other items specifically for the tourist market.

But the golden age was to be tragically shortlived, ending in a wave of epidemics in the early 1860s. Tribal institutions disintegrated, and colonial order reigned triumphant, further degrading traditional art forms. With the banning of the potlatch, totem poles and ritual objects were no longer made. "Arts and crafts" and "curios" for a growing tourist trade came to dominate the output of Native craftsmen.

By the early twentieth century, traditionally high standards of workmanship as well as traditional reasons for making art had almost disappeared. Only a handful of creative individuals were still working in 1950.

One of them was Willie Seaweed (1873 - 1967), a Kwakiutl chief and a master artist. Seaweed lived all his life among his people and his creations range from totem poles, painted house fronts, panels, and screens to coppers, drums, whistles, and horns, rattles, singers' batons, masks, and headdresses. Except for some miniature totem poles (see cat. no. 23 c.ii BCPM 15086) for sale to non-Natives, everything he made was created for use in the sociocultural context of Kwakiutl society.

Among the theatrical Kwakiutl, elaborate dramas were used to initiate the young. Individuals would be symbolically abducted by supernatural beings and return from the spirit world freshly endowed with spectacular ceremonial privileges.

Many Kwakiutl secret-society masks, take the form of mythic characters. One of which, called Hamatsa (Man-Eating), embodies Baxbakwalanuxsiwae, the Man-Eating Spirit.

An artist's style within an established genre is something like the fluency and expressiveness with which he uses his language. Seaweed's mastery of his media identifies him as a

great stylist; his art reached its zenith in masks and more specifically in those used in the Hamatsa ritual of the Kwakiutl.

The drama itself is one of universal scope, reaffirming and celebrating man's ascendancy over the forces of chaos. Seaweed went far beyond what had been produced before him, creating a unique kind of magic. In spite of the efforts by contemporary carvers to evolve new forms, no one has surpassed Seaweed's daring theatrical achievement. (Ref. Martine Reid 1987a:Bill Holm 1983).

By the late 1940s, the Pacific cultures and their art forms had disintegrated to the point that Wilson Duff was prompted to title a piece he wrote for Canadian Art Magazine "A Heritage in Decay: The Totem Art of the Haidas" (1955:56-59). Shortly afterward, Harry Hawthorn stated, "A later phase of changes in Northwest Coast carvings is its present decline; it can be labelled as nothing other than that" (Hawthorn, 1961:69-70). And five years later, Erna Gunther added, "when the society became disorganized through the impact of acculturation to White customs, the art lost all motivation. Moreover, the traditional forms could not easily be adapted to the use of outsiders, other than in the degenerate form of curios. Thus Northwest Coast Indian art must be regarded as a thing of the past, even though the peoples who created it still survive" (Gunther, 1966:2).

Some scholars have rejected this kind of art, solely because it was made for Whites. Wolfgang Paalen, for example, a surrealist artist and a West Coast Indian art scholar, considered argillite carvings and other creations made for the tourist trade, "at times beautiful and of great craftsmanly perfection [but an example of] the decadent stage at which a great art loses its *raison d'être* and degenerates into trifles" (Paalen, 1943:18).

For Paalen and others who shared his opinions, any Northwest Coast art that was not fully "traditional" was not "authentic" and not worthy of esteem. Art objects produced by tribal society in transformation were denatured, products of a decadent culture. Often, their very existence was seen as material evidence of this deterioration.

As Monique Ballini points out (1981), this view presupposes the existence of an ideal age, now lost, in which objects were somewhat "pure." But traditional objects are not invariable factual statements; they are permeable to external changes, and as a result, "pure" or uncontaminated objects do not exist.

New technology was not the culprit[2]-it was not because objects were manufactured with an alien technology that they were seen as degenerate. Rather, the objects seem to have lost their original ritual or contextual destination; they were conceived for sale and destined in many cases to be purely decorative. Thus the art of Native cultures had two strikes against it: not only was it the product of a decadent Native culture, it was

increasingly produced for an inauthentic use in a non-Native world.

The conventional attitude to Northwest Coast trade items, early or contemporary, is mistaken in two respects. Its condemnation of Northwest Coast art of the postcontact period as "non-authentic" relied upon a false understanding of precontact Northwest Coast art. It rests not on an aesthetic judgement but on a judgement external to the art pieces themselves. And its enthusiasm for a "renaissance" in art fails to see that the "newly-created" art is not a rebirth of an old but the emergence of a pseudo-traditional one.

Northwest Coast art has entered yet another phase in its continual process of transformation. It has not moved from authentic to non-authentic. Nor has it recovered its original character. Rather, after a period of dormancy, it has found a new cultural context in which to exist and perhaps to flourish.

THE FICTIVE RENAISSANCE

"Suddenly, overnight as it were, that seemingly overnight trend toward the death of West Coast art has been reversed and vital signs and symbols of cultural and artistic renewal have manifested themselves. In the summer of 1969, for example, Bob Davidson, a young Haida carver in his twenties, carved and raised a new pole in his Native village of Masset, the first pole to go up on the Queen Charlottes since that fateful year of 1884. The erection of this pole has been heralded as a miraculous sign of rebirth for Native culture as a whole. Now, instead of mourning the decline and death of West Coast traditions, writers have begun to proclaim a Native renaissance" (Vastokas, 1975:14). As Clive Cocking wrote in 1971, "The raising of that totem pole symbolized the current resurgence of pride among the Native Indians of B.C.. But more than that it presented tangible evidence of an Indian Renaissance-a Renaissance of the arts and crafts, and culture of the Northwest Indians. What was once virtually dead, has lately been reborn in the hands of young Indian artists" (Vastokas, 1975:14).

The myth of the Northwest Coast Renaissance was built on a European model. There were many motivations: genuine appreciation, a fascination for the exotic, boredom with the lack of richness in "Western" art, even feelings of guilt about the destruction of the once-flourishing cultures and the conditions of their survivors.

But despite a flood of more or less skillfully made objects for sale in the shops and galleries of the North Pacific region, and the attempt at a revival of nineteenth century Native ceremonial, there has been nothing that can justly be called a cultural renaissance among the Northwest Coast people. What we have seen instead is a growing interest in Native art among the

members of the immigrant community, and a resulting stimulus for a host of sometimes talented, sometimes not so talented, artisans.

From an iconographic point of view, because Northwest Coast artistic composition results in the organization of structural elements according to rules and conventions-a kind of visual grammar-it can be analyzed, decoded, broken into its constituent elements and then learned and taught. Anyone with a reasonable amount of manual dexterity can produce designs within this stylistic tradition. This perhaps accounts for the existence of a plethora of makers of art, Natives and non-Natives, in that particular style.

But someone who has learned to speak a second language is no more necessarily an orator than a draughtsman is necessarily a great painter. Imagination, intuition, a sense of design, and a cultural and symbolic context from which to draw are essential. The real artist not only works successfully within the rules, but varies them to go beyond a static system of icons.

Today, Northwest Coast Native artists are members of a larger society. They live a non- or pseudo-traditional existence, drawing upon the past, sometimes remembered, sometimes forgotten, retraced and reinvented, to produce contemporary Northwest Coast images in the style of traditional forms mostly (although not exclusively) for an outside world.

Reference to tradition becomes a cognitive way of assuming or reinforcing cultural identity. A traditional object becomes one that does not need an explanation but is sanctified by past usage. It is an object whose *raison d'être* is established by continuous use in some preexisting cultural context. Tradition does not refer simply to facts but to intents, to motivations predating these facts. Objects alone do not make tradition. Thinking makes tradition.[3]

For Dilthey "tradition is a process of scanning the past until we identify a perceived similarity with the present. It is a triumph of reexperiencing when we believe ourselves to be confronted by a continuity. Cultural transmission is not simply a replication of an old original, a mechanical transfer of the cultural heritage from generation to generation, as if we were passing along the class banner to each new cohort.... Culture is alive, context sensible, and emergent" (E.M. Bruner 1986:12).

Contemporary Northwest Coast arts rest upon a contradiction. Past objects belong to a long tradition that inspired their creation and gave them their form. Present objects belong to a somewhat different tradition but imitate the form without the creative content.

Bill Reid, considered one of the originators of the so-called renaissance movement, emphasizes this while paraphrasing

Wilson Duff: Is contemporary Northwest Coast art an art form in search of a reason for its own existence? A medium without a message? Is it all form and freedom and very little substance? (Reid, Bill, 1981:11).

Plainly the original semantic significance of much of Northwest Coast art is now lost. It has become a pseudo-language shared and produced by an elite because the created objects no longer signify potent cultural messages. They merely reproduce or imitate past objects and concepts that are not culturally relevant in the present society. Art has lost its sign-value. Content and form are no longer intimately bound-form now dictating and even replacing content. Creative gestures become stereotyped: the symbolic meanings of the colours are lost, and decoration acquires a new status.

These transformations have robbed Northwest Coast art of many of its original messages. As a new art, it seems a signifier in search of meaning. Clearly, though, it is an art in gestation, soon to emerge in a different context, with new cultural significance. The process is not a decline into non-authenticity or an ascent into rediscovery, but a transformation and another metamorphosis in a long history of change.

CONTEMPORARY NORTHWEST COAST ART

The only way tradition can be carried on is to keep inventing new things. (Robert Davidson, 1982)

Contemporary Northwest Coast art appears in several media and forms including wooden masks, rattles, screens, boxes, feast dishes, pieces of furniture, free standing sculptures in wood and bronze, monumental and miniature totem poles, argillite sculptures, silver and gold jewelry, serigraphs, paintings, pencil drawings, and stone lithographs (figs. 1, 2).

Contemporary Northwest Coast artists draw from a variety of sources appropriating and incorporating into their work technical and conceptual ideas from both Native American and non-Native sources. But, as we have seen, the process of adapting traditional imagery to a changing world is not new. Native people and artists have always taken advantage of new materials or tools and ideas when the opportunity arose.

There is a rich legacy of myths and rituals among the traditional cultures of the Northwest Coast. Sometime, though, artists break away from that tradition. Both traditional and non-traditional approaches are reflected in twentieth-century iconography.

The Raven and The First Man, a free standing sculpture on permanent exhibit in the Museum of Anthropology of UBC, by Haida artist Bill Reid, is a rendering of a classic legend addressing a

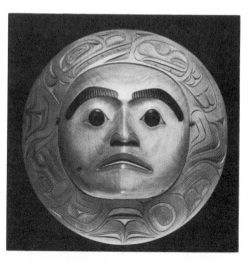

Fig. 1. "Moon Mask," Robert Jackson, Gitksan, 16 in. diameter, alder wood, stain, black and red paint, 1982. Private collection.

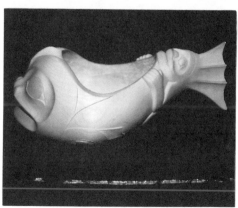

Fig. 2. "Sculpin Bowl," Dempsey Bob, Tahltan-Tlingit. 12 in. long x 7.5 in. wide x 5 in. deep, alder wood, 1982. Courtesy of the Potlatch Arts Gallery. Photo: Martine Reid

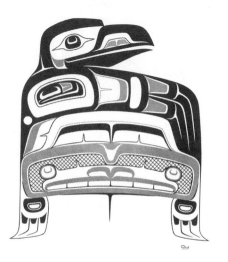

Fig. 3. "Raven in the 20th Century," Don Yeomans, Haida, 1979 serigraph, edition of 150, 48.5 cm x 38.5 cm, black and red and white, MOA 700/6. Photo: W. McLennan. Courtesy of the University of British Columbia Museum of Anthropology, Vancouver, BC.

universal theme. "Although the sculpture is immediately recognizable as Northwest Coast, it has no exact parallel with the traditional Coastal art" (Heath 1983:73). Its main characteristic is the dynamic effect of the European-inspired position of the Raven and the figures in the clamshell, all which have been captured in a moment of intense activity. This convention was seldom used by the Northwest Coast artists of the past. The work depicts Raven prying open a giant clam, from which the first people then emerge.

In myth time, human and animals were said to share the same faculties and, moreover, could exchange physical forms. Of all the artistic traditions of the world, those of the Northwest Coast of the Pacific are most graphically successful in giving convincing representations of the supernatural universe. It is the supreme instant of man's separation from the cosmos that is evoked in Bill Reid's monumental work. As soon as the winged spirit relaxes his grip, human beings tumble forth onto the world stage.

The myth and the real, the past and present, commingle. As Claude Lévi-Strauss put it, "faithful to the inspiration and the style of his ancestors, only the genius of Bill Reid could represent the debut of our species in the concise and vivid form of creatures totally unprovided for, confronted by the huge bird. Man thinks himself freed from the prison of nature, but with his powerful claws, his fabulous plumage, his ponderous, empty gaze, the Raven embodies the formidable riddles which, through the millennia, Nature will never cease to pose" (Claude Lévi-Strauss, 1980, personal communication, my translation).

The Raven's primary role as a culture hero is not so much to create things as to change them. He is a transformer, a trickster, and a catalyst; he carries with him the cleverness, curiosity, wit, humour, dignity, and despair of mankind. He makes people laugh at themselves and cry at the same time; he shows them greatness overlaid by vanity.

The silkscreen print Raven in the 20th century (fig. 3) by Haida artist Donald Yoemans is a marvellous example of humoristic poetry. It is an excellent example of how some Native artists use elements of techniques from the dominant industrial society without removing themselves from the basic mediating role of their traditional society.

Black primary form lines depict the devious Raven in profile, surmounting and embracing a red, secondary creature that can be identified as a car*; both share the same feet/wheels.

*At one time, the artist thought of titling this creation Raven and Thunderbird. Thunderbird in North America is also a brand name for a car.

Here, the artist caricatures the mischievous bird-hero, placid
and aloof, while capturing the spirit of the Raven in a post-
industrial style rich with irony and humour.

Even now, twentieth-century Northwest Coast art echoes the
past in terms of imagery and content. It still draws from myths
and legends that tell the adventures of ancestors of supernatural
beings who are often seen journeying across the several tiered
layers of the cosmos.

One such story is that of Nanatsimgit and his wife, depicted
here in this low-relief carving on a building door designed by
Bill Reid and carved by Haida artist Jim Hart (fig. 4). In their
story Nanatsimgit brings his wife a White sea-otter pelt that she
takes to the seashore to clean. While there, she is abducted by
killer whales and taken to their undersea village. Nanatsimgit
pursues them in his magic canoe and after many adventures, and
with the aid of supernatural beings, he rescues his wife and
returns to the world above the sea.

This door is executed within the Northwest Coast artistic
conventions. From top to bottom: Nanatsimgit, the hero is seen
in full face. Buttocks and legs are shown immediately above the
face, and his shoulders, arms, and hands fill the negative areas
within the flukes. The flukes themselves consist of the two
large ovoids below the human face and the U-forms extending
upward on either side.

The body of the whale is defined by two heavy, curving,
sinuous lines extending down the right side of the panel
enclosing the figure of the kidnapped wife. Extending
horizontally from the whale's body is a dorsal fin with another
human face enclosed in a U-form and connected by two curving
tapered lines to a small circle representing the spout hole of
the whale. (The spout hole is inserted into the thickest part of
the ovoid containing the eye of the whale.) In the upper part of
the whale's head, which lies horizontally facing left above the
complex pectoral fin, the round spout hole suggested the ideal
place to position the doorknob.

One of the Haida's most powerful images is that of the
elusive Dogfish Woman. Generally identified with the
characteristics of the dogfish crest itself, she has a high
forehead with deep wrinkles, gill silts on her cheeks, sharp
triangular teeth, and eyes with elliptical pupils. In addition,
her nose has become a beak that curves into her mouth and her
lower lip carries the labret worn by aristocratic Haida women.

The story of how she was a shaman of extraordinary
attainments is now lost. Her power came from the spirit of the
dogfish, who was her familiar.

The concept of transformation, integral to Northwest Coast
Indian aesthetics, is epitomized in the transformation masks of

Fig. 4. "Nanatsimgit Door," red cedar, 10 ft. high x 3.3 ft. wide, 1980. Design: Bill Reid, Haida. Carving: Jim Hart, Haida. Mr. and Mrs. Toni Cavelti. Photo: W. McLennan

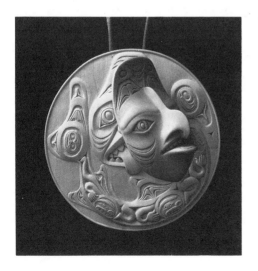

Fig. 5. "Dogfish Woman," boxwood transformation pendant, Bill Reid, Haida, 1982, 8 cm diameter. Photo: W. McLennan. Collection: Martine Reid.

the Kwakiutl and their Northern neighbours. In these masks two
creatures, sometimes more, occupy the same space at the same
time.

The boxwood transformation pendant Dogfish Woman (fig. 5),
by Bill Reid, reenacts such a miraculous sharing and releasing of
intimacy by the Dogfish Woman and her mythical alterego.

The contrast between the very austere look of the dogfish
(from the shark family) and the magical beauty of the Dogfish
Woman is tempered by the artist's sense of humour. Reid delights
in a series of little men for the dogfish's vertebrae. Content
and form are dissolved, tension is resolved, harmony is created.

Transposing his ideas into larger sculptures in bronze, Bill
Reid became the first Northwest Coast Indian artist to work in
that medium. His first bronze sculpture was a killer whale (5.5
m high), created for the Vancouver Public Aquarium. It was
preceded by a 1.2 m plaster maquette that was later cast in
bronze in a limited edition of nine (figs. 6, 7). This bronze
maquette (1984) depicts a leaping killer whale, chief of the
undersea world, emerging from cast-bronze waves at the base.

Mythic Messengers is a bronze-relief mural commissioned for
the entrance to Teleglobe Canada in Burnaby, BC (fig. 8). Its
composition recalls the involved and intricate argillite
carvings, and the panel pipes of the nineteenth century. Another
characteristic of traditional Northwest Coast Indian iconography
reemployed here is the tongue-exchange, where frog and human are
often seen joined by their common extended tongue, as if they
were exchanging supernatural powers. Reid emphasized this
tongue-exchange to symbolize the power of communication.

Other artists, such as Joe David, Robert Davidson, and Jim
Hart, are now turning to bronze. They tend to work on a smaller
scale, creating masks, miniature totem poles (some plated with 24
kt. gold), and free-standing sculptures in that medium.

The success of producing art for a non-Native market has led
some artists to explore dimly-remembered traditional functions.
The last decade has witnessed a revival of art production for the
Native context.

West Coast artist Joe David created his Thunderbird and
Whale Dance Screen (fig. 9) for the memorial potlatch in honour
of his father Hyacinth David Senior in 1977.

It depicts the Thunderbird and Whale, a powerful and classic
cosmic equation found in the iconography of all the Northwest
Coast groups. Lightning snakes outline the upper edges of the
bird's wings with a fluidity characteristic of David's work. The
thunderbird's stomach is at the same time the fin and the blow
hole of the killer whale. It also contains a circular face
representing the sun. The upper part of the scene is decorated

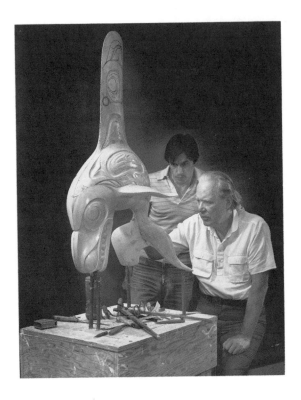

Fig. 6. "Killer Whale"
Bill Reid and Jim Hart,
plaster maquette, 4 ft.,
1982. Photo: Courtesy of
Equinox Gallery.
Collection: the artist.

Fig. 7. "Killer Whale,"
Bill Reid, Haida, 1982 -
84, bronze casting, edition
of 9, 52 in. high.
Collection: the artist

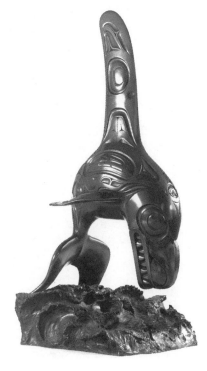

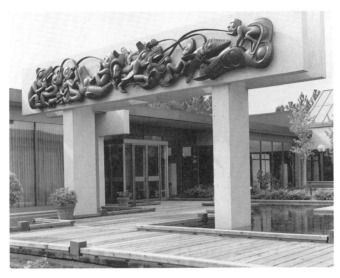

Fig. 8. "Mythic Messengers"
bronze relief mural-from the left: The Bear Mother, Bear and
Cubs; Nanatsimigit, his wife and her Killer Whale abductor; the
Sea Wolf; the Dogfish Woman; the Eagle Prince. 8.5 cm long x 1.2
cm high x 45.7 cm deep. Teleglobe Canada, Burnaby, BC, 1984 -
85. Photo: W. McLennan

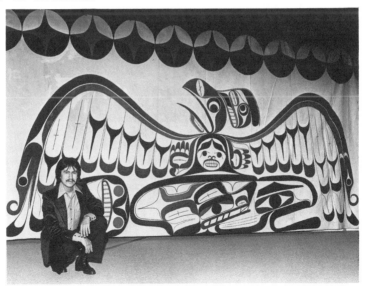

Fig. 9. "Thunderbird and Whale Dance Screen"
Joe Davis, West Coast, 10 ft. x 20 ft., black, blue, red on
canvas, 1977. Collection: the artist. Photo: Dan Scott 1975.
Courtesy of the Vancouver Sun.

with a border of stars.

Typical of West Coast stylistic traditions: "U-forms are rounded, ovoids are few and rounded without tautness. Open spaces are left undecorated, and four-way splits are prominent" (Hilary Stewart 1979:96).

Robert Davidson has also worked with a contemporary interpretation of the Dogfish Woman. In the late fall of 1986 Mrs. Florence Davidson hosted a two-day potlatch in Massett-Haida to commemorate the accidental deaths of her son Alfred and his wife, on one hand, and to bestow on her son Claude a chief's name, on the other. After the feast Robert Davidson's dance group performed a ritual dance in which the Dogfish Mother was the main character. The myth of the Dogfish Mother, as Davidson heard it from a Haida elder, tells of a man who encounters a huge supernatural dogfish stranded on the beach. He memorizes the creature's chant, returning home with the Dogfish Mother as his crest. Davidson was inspired to create a new Dogfish Mother mask (fig. 10) and to reinvent the performance. The impressive mask is carved from red cedar, and painted red, blue, and green (copper carbonate). The eyebrows are inlaid with copper, the eyelids are haliotis shell, and the mouth has opercula teeth. Hanging below the lower jaw is a fringe of hide to conceal the dancer. Horsehair surrounds the head.

Some works are visual paraphrases or transformations of earlier works, or variations on a particular theme.

In 1987 Robert Davidson, his brother Reggie, and Glen Rabina produced for Pepsicola Sculptural Garden in Purchase, New York, a set of three totem poles titled Three Variations on Killer Whale Myths (fig. 11). The poles depict: Wasgo (an aquatic sea monster) and Killer Whale (on the left), Thunderbird and Whale (center), and Nantsimgit (on the right).

These totem poles are superb examples of contemporary, classic Haida style. Davidson works within a strict convention, exploring and refining it with subtle variations, preserving a certain conservative austerity, and sacrificing movement and expression for unity and form. However, the artist's talent and his sense of design transcend the potential risk of rigidity as the poles radiate their eloquent with a remarkable, restrained strength.

Other artists explore themes extracted from a twentieth-century world view and religion.

Tsimshian artist Roy Vickers is a deeply religious Christian. At times his religious outlook and his art commingle. Several of his silkscreen prints are inspired by biblical themes and scenes, such as The Christ, The Creation of Eve (fig. 12) and Timothy 2:11.12 (fig. 13).

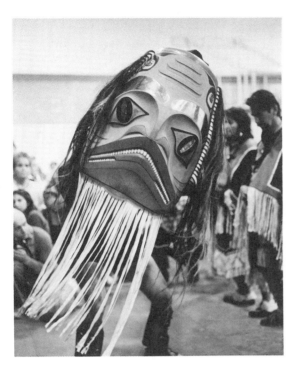

Fig. 10. "Dogfish Mother" mask, Robert Davidson, Haida, red cedar, opercula, copper, haliotis, hide, horse hair; red, blue green (copper carbonate) paint. Photo: Ulli Stelzer. Courtesy of the University of British Columbia Museum of Anthropology, Vancouver, BC. Collection: the artist.

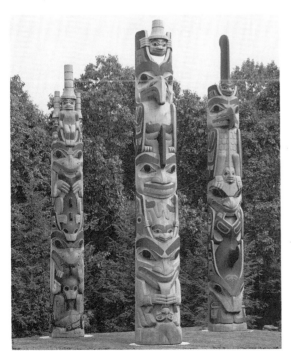

Fig. 11. "Three Variations on Killer Whale Myths," Robert Davidson, Haida, red cedar, paint: red, black. From the left: Wasgo and Killer Whale, 31' x 4'3"; Thunderbird and Killer Whale, 36' x 4'10"; Nanatsimgit, 32' x 5', Pepsicola Sculpture Garden, Purchase, New York. Photo: Illi Stelzer. Courtesy Pepsi Co. Inc.

Fig. 12. "The Creation of
Eve," Roy Henry Vickers,
Tsimshian, silkscreen print,
edition unknown, 1976, black
and red.

Fig. 13. "II Timothy 2:
11,12," Roy Henry Vickers,
Tsimshian, silkscreen print,
edition unknown, 1976, black
and red.

Fig. 14. "The Creator," Don
Yoemans, Haida, 34 ft. high x
21.5 ft. wide x 6 in. deep,
yellow cedar, stainless steel.
1985. Courtesy of the
Potlatch Art Gallery.
Photo: Martine Reid.

Prints that depart most dramatically from the traditional subject matter are the ones that have generated the most negative comment: "The artist has received criticism both from Christians who believe a 'heathen' art form inappropriate for representations of the Saviour and from fellow Native artists who view the work as a desecration of Northwest Coast art.... It would seem that Vickers has stepped beyond the bounds of what is acceptable to the community of Native Northwest Coast artists" (M.B.Blackman and E.S. Hall Jr. 1981:60).

Donald Yoemans, although not a reborn Christian, has worked on a similar theme, in a sculpture of a Raven as Creator, crucified (fig. 14).

Joe David has recently explored new media of expression, including stone lithography and pencil drawings. His portraits exist outside the convention style of the Northwest Coast and are included here (figs. 15, 16). The two portraits of a man and a woman are clearly identifiable as Native people. Their bodies are only silhouetted and their hands are conspicuous. The contrast between detailed faces and ageless bodies intensifies the sense of who these people might be, the artist trying to capture, or to restore, their intrinsic personality. David restores their cultural identity and their soul. The third drawing is a portrait of a young Haida woman (fig. 17) executed in the language of Matisse, to which David brings a remarkable immediacy.

David, a Clayoquot-West Coast artist spent most of his childhood in Seattle where he attended art school. But he kept ties with his people. Like Bill Reid's art, David's reflects a versatility-and a capacity for moving back and forth, in and out of the tradition-that only Native artists who have been trained as commercial artists seem to be able to have.

Although Reid remains devoted to the Northwest Coast forms, he sometimes feels the urge to do something radically different. Generally, he turns to his Western European background, as he did for two "modern" necklaces. But beneath the western format a Northwest Coast principle is still at work. Two distinct forms, the necklace's gold ground and its jewelled web, seem to occupy the same space at the same time.

In a sense, the same could be said of <u>Phyllidula-The Shape of Frogs to Come</u>, in which Reid "has freed this frog completely from its cultural as well as its formal container and given it his own meanings (Doris Shadbolt 1986:160).

Recent wire sculptures, executed with a pair of pliers, slip even further into Reid's European underpinnings. They represent <u>Pan and a Bachante</u> and will form part of a scene depicting a rite of spring from Neolithic Greece (fig. 18).

After thirty years of reawakening, the revival period is

Fig. 15. "Portrait of an Old Man," Joe David, West Coast, original pencil drawing, 1984. Collection: the artist. Photo: Martine Reid

Fig. 16. "Portrait of an Old Woman," Joe David, West Coast, original pencil drawing, 1987. Collection: the artist. Photo: Martine Reid.

Fig. 17. "Portrait of a Woman," Joe David, West Coast, original pencil drawing, 1987. Collection: the artist. Photo: Martine Reid.

Fig. 18. "Pan and a Bachante," Bill Reid, Haida, wire sculpture, 1987, approx. 15 cm high. Collection: the artist. Photo: Ulli Stelzer. Courtesy of the University of British Columbia Museum of Anthropology, Vancouver, BC.

definitively over. Northwest Coast artists have learned the
rules and conventions of their distinctive, traditional style and
use them in their own personal way, sometimes copying the
tradition, sometimes creating within it, sometimes breaking it.
Out of this process of evolution artists grew more numerous, more
confident in their own identity and in their own style. Signs of
incredible vitality are there, but has Northwest Coast art
reached its final maturity?

BIBLIOGRAPHY

Ballini, Monique
1981 "Tradition et innovation dans l'usage des objets de cultes mélanésiens: propositions pour une enquête." In RES I spring

1981 Peabody Museum of Archeology and Ethnology, Harvard University. In collaboration with the Laboratoire d'Ethnologie, University of Paris X, Nanterre.

Blackman, Margaret B. and Hall, Edwin S. Junior
1981 "Contemporary Northwest Coast Art. Tradition and Innovation in Serigraphy." American Indian Art Magazine 6(3) summer 1981: 54 - 61.

Bruner, Edward M.
1986 "Experience and Its Expressions." Anthropology of Experience, Victor Turner and Edward M. Bruner, eds. Urbana: University of Illinois Press, 3 - 32.

Davidson, Robert
1982 "Legacy Dialogue" with George MacDonald, Bill Reid, and Robert Davidson at UBC Museum of Anthropology, February 24.

Duff, Wilson
1955 "Heritage in Decay: The Totem Art of the Haidas." Canadian Art Magazine, 56 - 59.

1964 The Indian History of British Columbia. Volume 1. The Impact of the White Man. Anthropology in British Columbia. Memoir 5, Victoria.

Gunther, Erna
1961 Art in the Life of Northwest Coast Indians. Seattle: Superior Publishing.

Hawthorn, Harry
1961 "The Artist in Tribal Society: the Northwest Coast." The Artist in Tribal Society, Marion Smith, ed. New York: Free Press, 59 - 70.

Heath, Terrence
1983 "A Sense of Place." Visions, Contemporary Art In Canada. Vancouver/Toronto: Douglas and McIntyre.

Holm, Bill
1983 Smoky-Top: The Art and Times of Willie Seaweed. Seattle: University of Washington Press. Thomas Burke Memorial Washington State Museum, Monograph 3.

King, J.C.H.
1986 "Tradition in Native American Art." The Arts of the North
American Indian. Native Tradition in Evolution. Edwin L. Wade,
ed. New York: Hudson Hills Press, 65 - 92.

Lévi-Strauss, Claude
1980 Personal communication

Paalen, Wolfgang
1943 "Totem Art." DYN 4-5. Amerindian Number. Published and
edited by W. Paalen. New York.

Reid, Bill
1981 "A New Northwest Coast Art: A Dream of the Past or a New
Awakening?" Unpublished paper presented at Issues and Images,
New Dimensions in Native American Art History Conference.
Arizona State University, Phoenix, 22 - 24 April.

1971 Out of The Silence. New York: Outerbridge and Dienstfrey.
.
Reid, Martine J.
1987a Review of Smoky-Top: The Art and Times of Willie Seaweed
by Bill Holm. American Indian Culture and Research Journal 9(2).
Los Angeles: University of California, 90 - 93.

1987b "Silent Speakers. The Arts of the Northwest Coast." The
Spirit Sings. Artistic Traditions of Canada's First Peoples.
Toronto: Glenbow Museum/McClelland and Stewart, 201 - 236.

Shadbolt, Doris
1986 Bill Reid. Vancouver/Toronto: Douglas and McIntyre.

Stewart, Hilary
1979 Looking at Indian Art of the Northwest Coast. Vancouver:
Douglas and McIntyre.

Sturtevant, William C.
1986 "The Meanings of Native American Art." The Arts of the
North American Indian. Native Traditions in Evolution. Edwin L.
Wade, ed. New York: Hudson Hills Press, 23 - 44.

Vastokas, Joan M.
1975 "Bill Reid and the Native Renaissance." Arts Canada 32(2),
12 - 20.

Wade, Edwin L.
1986 "Introduction: What Is Native American Art?" The Arts of
the North American Indian. Native Traditions in Evolution.
Edwin L. Wade, ed. New York: Hudson Hills Press, 15 - 20.

TENUOUS LINES OF DESCENT:
Indian Art and Craft of the Reservation Period

by

Gerald McMaster

> *They were robbed by law or circumstance of most of the old, and they have been prevented by the same forces from acquiring the new.*[1]

This sentiment expressed in 1949 by the Federation of Canadian Artists in a brief submitted to the Royal Commission on Arts, Letters and Sciences, characterizes a time of transformation of the cultural life of Canadian Indians. During this period the material culture also changed: from a strict cultural context, to curio, ethnography, and art.

In the years from the 1870s to the 1950s there were rapid changes and developments in the relationship between the Euro-Canadian and the Native Canadian: social, political, economic, and cultural. In those eighty years the Indian people have had to survive overwhelming changes, moving for better of worse from a dependence on the land and sea, and their resources, to an economic base like the one established by the European, which brought with it commercial attitudes founded on possession, profit and achievement, and which ruthlessly undermined the Indian customs and values. Forced to abandon the old way of life after several unsuccessful attempts to retain it, the Indians became so increasingly isolated from the rest of Canada following the fur-trade, that they soon became heavily dependent on the trader and the government. Further isolation and dependence occurred when Indian people were placed on reserves as wards of the government, following the establishment of the <u>Indian Act</u> of 1874. This act was not revised until seventy-seven years later, in 1951. This period will now be referred to as the "Reservation Period," with implications of imprisonment and the extinguishing of religious and cultural freedom.

THE OBJECT TRANSFORMED

During the nineteenth century many European travellers and explorers had a penchant for collecting objects from foreign lands, especially souvenirs. Often objects created by the Indian for traditional purposes were highly valued, and found their way into many European public and private collections. Both nineteenth and twentieth centuries, the era that Bazin called "The Museum Age,"[2] saw the development of conservation and the growth of museums, for which voluminous quantities of material were collected and studied under the three rough divisions of "art", "history," and, "science." Art collections were usually confined to European cultures and their historical antecedents.

It was the museums of "natural history" that found room for the study of African, Oceanic, and North American Native collections. Rather than attempt to assess these objects primarily for their artistic merit, the Native arts were judged according to their ethnological value. But the arbitrary categorization of the "material" went even further than that.

During this time, some museums like London's Victoria and Albert acquired examples of Canadian Indian artifacts for collections of commercial materials made of animal products. These objects provided little interest to the ethnologist, however, because of their nontraditional nature. Their significance lay in the fact they were examples of objects made during the early period of assimilation into the dominant Euro-Canadian culture, and thus documented the process of cultural change.

Indian people quickly adapted foreign-made materials to their needs. When tourists demanded authentic artifacts, however, the Indians responded quickly to provide them. To the Indian, the importance of these artifacts lay not so much in the fact they were ethnographic or artistic, but rather in the fact that they were commodities, which is what they eventually became. Subsequently, the production of these commodities became an important business to many Indians across Canada-as early as the mid-nineteenth century in the Maritimes, and later in the rest of the country. Since they were usually small items, the returning traveller could easily pack them.

Traditional objects were unquestionably transformed. No longer did they symbolize the pride of generations of utility and significance but rather they became commercialized objects, evaluated within a wholly alien, western framework as artifacts that were "exotic," "primitive," "original," "decorative," etc. The very concept of tradition grew problematic as a result of such influences. From the Indian perspective artifacts of this kind-produced to be sold, often accomodated to the tastes of the foreign purchasers, and lacking any cultural context (masks without ceremonies or dances, for example)-appeared frequently "in-authentic." Ethnologists and western connoisseurs by contrast often preferred "artistically" formed works for reasons of personal taste; the authenticity of such artifacts could be substantiated, among other considerations, by the fact that in them Indian aesthetic attitudes, themes, and forms were developed to the maximum possible degree. Obviously, therefore, concepts like "tradition" and "authenticity" lost clear meaning.

Of prime interest in this connection is the *transformation of the traditional artifact into a souvenir*. This process is important for the issue of the reception of Indian art, since in Canada these are available on a mostly regional basis, without much distinction between (often clichéd) handicraft products and art proper. Art and handicraft alike have come under the influence of Western dealers, culture, and ways of thinking. The

two major influences, all pervasive and affecting changes at every level of Indian society, were the Government and the Church, with their programs of directed cultural change. Through the Indian Act of 1874 the government forbade the freedom of cultural expression and instead enacted a programme of assimilation.[3] The government gave the Church the responsibility of educating the Indian children. Most Indian children were removed from their families and sent to church-run boarding and industrial schools to become "civilized," which act deprived them of the chance to have a traditional education. Other issues that affected major changes in Indian art and craft at that time were: industrialization, as a result of which virtually everyone was influenced by the new technologies; mass production (Indian artists, like all artists, found it difficult to compromise to achieve low-cost mass production); westernization, the social development of which have carried the Indian artists into the general traditions of Western European art. Furthermore, global factors also proved to be major factors: the Depression and two world wars affected the society and artistic activities of Indians just as they did the whole of the Western world. Indian people, moreover, lacked experience and the money needed for the active organization or cultural development of market-oriented artifacts that took outside influences and Native traditions into account. Indeed, the the gradual proliferation of imitation, counterfeit, and "made in Japan" objects took business away from the Indian artist and craftsman.[4]

It is in this context that a brief history of the Indian art and craft movement of the twentieth century will be given. Three main institutions have played an essential role in this connection: the Department of Indian Affairs and two private lobby groups, the Canadian Handicraft Guild and BC Arts and Welfare Society,[5] were moving forces behind the rise of Canadian Indian art and craft during the first half of this century. Brief histories of the first two bodies follow to present Indian art and craft during the Reservation Period in its context. Then it will be examined from province to province.

THE DEPARTMENT OF INDIAN AFFAIRS

The government's involvement in the Indian art and craft industry, which began in the late nineteenth century, has continued until today. At first, during the late nineteenth and early twentieth centuries, the department's interest in Indian art and craft was minimal. Its policies stressed acculturation rather than the preservation of Indian cultures.

During the 1920s the department grew very active in organizing and supervising Indian exhibits at industrial and agricultural exhibitions, such as the ones in Brandon, Regina, Calgary, and Edmonton. This involved encouraging Indian students from industrial and residential schools to participate in the production of arts and crafts. One role of the Indian Affairs'

agent (to ensure that these Indians were being 'civilized', that is, becoming good farmers and tradesmen) was to exhibit their products to show their civilized qualities rather than their traditions, assuming that this would instil a Euro-Canadian spirit of competitiveness and motivation. Beneath the veneer, however, lay the chilling fact that the Indian was a showcase for the department's policy of assimilation.

The whole controversy about how Indian art was to be supported and promoted can be gauged from the diverse ideas put forward about how the Indians were to present themselves on such occasions. During this time, at many provincial industrial and/or agricultural exhibitions, it was common for many of the organizers and entrepreneurs to have local Indians appear in traditional costume (fig. 1). One Indian agent, J.A. Markle, for instance, said that their "participation was demoralizing and seriously interfered with the department's work among them." The promoters retorted that "they are not prisoners like other men... and they will come to the exhibition, pageant or no pageant." Another added, "They are free people and will take their holidays as anyone else will. The government cannot corral and imprison them."[6] In another incident, Duncan Campbell Scott, the superintendent of Indian education for the Dominion, said authoritatively, "They come to the fairs when they should be on their farms.... Our purpose in educating Indians is to make them forget their Native customs and become useful citizens of the Dominion... when it comes to encouraging them to act like uncivilized heathens I think it is time to draw the line."[7]

The department's interest in Indian crafts soon developed due to the active interest and participation of private associations and clubs. The first association to influence the department was the Canadian Handicraft Guild of Montreal. In the 1930s the department began receiving letters from private organizations, like the Guild, urging it to establish an organized system of collecting and marketing for Indian art and craft. In response, the Welfare and Training Division was created in 1936, headed by Dr. R.A. Hoey, who was responsible for "the creation and cultivation of subsistence gardens and the extension of agricultural operations; the purchase of livestock and equipment; [the] encouragement of arts and crafts and the sale of handicraft products."[8] This programme was intended to give Indian people an economic self-sufficiency.

Concentrating its efforts in the East (most notably with the Indians at St. Regis, Caughnawaga, and Pierreville, Quebec, and Muncy, Ontario[9]), the division organized the Indian people to make handicrafts according to a set list of items, with catalogues containing price lists. These mass-produced objects were then marketed in both East and West in such places as the Hudson's Bay Company, provincial exhibitions, and small tourist shops in national parks. In 1939 the division's first superintendent, Dr. Hoey, mentioned above, at a conference "The North American Indian Today," gave a number of reasons for the

Fig. 1. Plains Indians at the provincial exhibition, Brandon, Manitoba, early twentieth century. Glenbow Archives #NA-4630-15.

Fig. 2. Canadian Handicraft Guild exhibition, 1905. Photo courtesy of the Canadian Guild of Crafts, Montreal.

decline in handicrafts, and explained how his programme would improve the Indian's economic status. There was no mention of product authenticity. Instead, he said, "It is the intention and policy of the department to encourage high-quality production and by the establishment of a central warehouse at Ottawa to assure continuity of supply to the wholesale and retail trade."[10]

The nullifying result was the beginning in which productivity took precedence over quality. The Indian artist and craftsman were persuaded to produce only what was economically practical, overlooking authenticity. The result was a handicraft that began to take on a homogeneous appearance. Indian artifacts increasingly became indistinguishable. The context had changed its appearance and significance.

Finally, Tom Hill, director of the Woodlands Indian Museum, says that in the department, "Very few changes were made in program objectives over the years."[11]

THE CANADIAN HANDICRAFT GUILD

During the first half of the twentieth century the Canadian Handicraft Guild was opposed to the department's policies on assimilation and through their programmes attempted the reestablishment of the ancient arts and crafts.

The Guild was created in Montreal in 1902 as the Woman's Art Association, following the success of the Arts and Crafts Movement in Great Britain and Europe. They opened a shop that year with "a few webs of homespun, a few hangings, and a few Indian baskets."[12] Incorporated in 1906, the Guild was "organized to encourage, retain, revive and develop handicrafts and home art industries throughout the Dominion, and to prevent the loss and deterioration of these crafts."[13] It was primarily in Eastern Canada that their work began by selling artifacts in the shop, then preparing exhibitions at the Art Gallery in Montreal (fig. 2).[14] Early efforts by the Guild to establish a widespread market of Indian work were undermined by the curio hunter who limited the market with quick purchases.

The Guild sent Amelia M. Paget on a trip to Saskatchewan in 1912, to revive and conserve Indian crafts. She visited women in various reserves, Indian children in schools, and even talked to chiefs of four bands, reporting, "They all seemed to appreciate the efforts of the Guild in trying to perpetuate their handicrafts, and realize how much depends upon their own efforts to attain these ends."[15] Upon her return, through the Guild, she recommended to the department that someone teach handicrafts at the Lebret (Saskatchewan) Industrial School, which the department eventually agreed to do.

During their early years the Guild sponsored an annual exhibition and prize competition, urging its "workers throughout

the Dominion [to] send [in] articles of handicraft." In addition, in 1924 it pulled together a loan collection of Canadiana (fig. 3) from each of its members, to "enhance interest." The annual report for 1931 stated a special loan exhibition was organized of "Western Indian and Esquimaux" works, after realizing the paucity and availability of authentic objects. The reports said, "[With] the rapid decadence of Indian crafts, the Guild feels [it] to be a matter of grave concern to the whole of Canada, and every effort should be made now to arouse interest in preserving what can be saved of them. Herein lay the reason for gathering this special exhibit."[16]

In the following year, 1932, an educational and technical committee was formed to study why Indian craftwork was slowly diminishing. It discovered that the market for Indian artifacts in Canada functioned within the international context of commericial competitiveness and thus, ironically, could only be satisfied by means of import controls. As a result, the Guild proposed "to approach the Federal Government in an endeavor to obtain protection for the local work in the form of taxation on imported Indian work."[17] The reference here seems to be to the Japanese. The government never did respond, and any question of copyright protection was never addressed. That year the Guild formed an "Indian Committee" headed by Miss Alice Lighthall.

Politically, in the early 1930s, the Guild tried to counteract the Indian Act, which stated that Indians could not participate "in any show, exhibition, performance, stampede, or pageant in aboriginal costume without the consent of the Superintendent General or his authorized agent." There was, however, an exception: "any agricultural show or exhibition or the giving of prizes for exhibits thereat." Clearly the government wanted to abolish tribal costume and custom, preferring instead to show the products of an assimilated or "civilized" Indian. The Guild, on the other hand, was interested in the reestablishment of the ancient arts and crafts.[18] Nevertheless, in 1935 the department cooperated with the Guild by sending out a questionnaire to enquire about the state of Indian crafts in Western Canada. It yielded some facts: craftwork was becoming less available; designs were becoming non-traditional; younger people were no longer interested; and there was a lack of marketing facilities.

The Guild stepped up and expanded its activities, generally however against the tide of official government policies. In 1937 it suggested to the department that a central marketing system be established to gather and distribute crafts. The following year the Guild sensed a general shift in government thinking when quality of handicrafts became secondary to economic productivity. As the annual report reads, the Welfare and Training Division's work was only in its infancy, and "it must stress the economic side-sometimes above the artistic-in order to prove its value to our harrassed legislators. But it is work eminently along the right lines, and under the only authority by

Fig. 3. Canadian Handicraft Guild, Joint Loan Exhibition and
Prize Competition of Canadian made handicraft held in 1927. Note
the Indian woman, lower left, between the two others,
demonstrating basketry techniques. Photo courtesy of the
Canadian Guild of Crafts, Montreal.

which it can be adequately developed."[19]

It was 1940 and the Guild was becoming more involved in work with the Eskimo. The Guild also announced that the name of the "Indian Committee" would become the "Indian and Eskimo Committee." The war had interrupted many of the Guild's plans. As the 1942 annual report said, "Indians all over the country have found increased employment, many of the men being in the Army, while others, as well as women, are in war industries, or replacing others in civilian work."[20]

Following the war, in 1946, the Guild was busy organizing exhibitions and competitions, fearing that Indian arts would be "swept away in one great surge of commercialism," leaving nothing worthy to exhibit. After an unsuccessful exhibition in the spring of 1947, another show appeared that fall, this time successful. With the arrival of James and Alma Houston in 1948, the Guild shifted its emphasis nearly totally from the Indian to the Eskimo, much of its work having been taken over by the Quebec Indian Homemakers Clubs.[21]

OTHER INTEREST GROUPS

Following the Second World War there were other individuals and interest groups who were equally concerned about the rapid decline of Indian art and craft. Some, like Mildred Valley Thornton, saw how tenuous the traditions were becoming: "Our problem today with regard to Indian culture is not WHAT we shall salvage, but HOW best we may salvage it. How can we cut loose from the old traditions which are backward and retrogressive and at the same time conserve and promote the very things that lay at the very throbbing core of these practices? We must restore to the Indian that pride in his traditions and in his Native gifts which has been largely lost through the painful process of assimilation; in so doing we shall build up confidence, self respect and happiness which would surely attend recognition of his natural capacities."[22]

When a Royal Commission on the National Development in the Arts, Letters, and Sciences was appointed in 1949, it received sixteen briefs and presentations on Indian arts and crafts. One submission included the Sculptors Society of Canada. They indicated a projected activity of theirs was the "development of relations with Indian and Eskimo sculptors as colleagues, and the encouragement of their Native talents in ways not possible from the paternalistic handicraft or museum points of view."[23]

The Federation of Canadian Artists recommended "that the government make very special efforts to encourage the cultivation of the fine, and the practical, arts among the Canadian Indians."[24] The results of the briefs were published in the Royal Commission's Report 1949 - 1951, with thirteen recommendations. Douglas Leechman, of the National Museums of

Canada, submitted a report to the department on the state of Indian handicrafts in Canada in 1952. He stated: "there seems to be a very general feeling that Indian handicrafts should be encouraged and not allowed to die out. Many efforts have been made to attain these ends, with a degree of success achieved believed by some to be out of proportion to the effort expended. Perhaps the time is ripe for a reconsideration of the problems involved and an examination of the present situation."[25]

By now, all across Canada Indian and non-Indian organizations had pressured the government to change its policies. A year before, in 1951, the Indian Act had been revised, finally granting Indian people religious and cultural freedom. However, by that time many generations had passed. The government's cultural genocide had taken its toll. Thus ended the Reservation Period of Canada's Indians.

DEVELOPMENT IN THE CANADIAN PROVINCES

Within the larger Canadian context, provincial arts and crafts movements had had equally interesting histories during the first half of the twentieth century. With the exception of the Northwest Coast, highlights of each province will be discussed, beginning in the west and moving eastward.

Alberta

The following account provides an insight into Indian activities that were closely bound up with the annual flood of tourists visiting the national parks: "In mid-July each summer a colourful pageant which recalls vividly to all old-timers the days when Indians and buffalo roamed the plains of the Northwest, undisturbed by advancing civilization, is witnessed at Banff in the heart of the Canadian Rockies.... Little does the summer visitor... realize... that he is gazing upon the remnant of a once powerful tribe, long prominent in the history of the frontier."[26]

Banff was Canada's first national park, created in the wake of the railroad in 1885, and tourists, a Victorian phenomenon,[27] arrived on the first scheduled trains.

In the summer of 1889 the Banff Indian Days became an important festival for the Stoney (Assiniboine Indians) of Morley. They had already been on reserves for twelve years, and this now provided them with an opportunity to practise and enjoy their "Indianness" (fig. 4).

Indian Days provided the Stoney with an opportunity to reveal their proud past. It became an annual event for Indians and tourists, until the 1930s when the government began to order restrictions on the number visting Banff, to which "the Stoney replied they all came or no one came. They all came. The Stoney

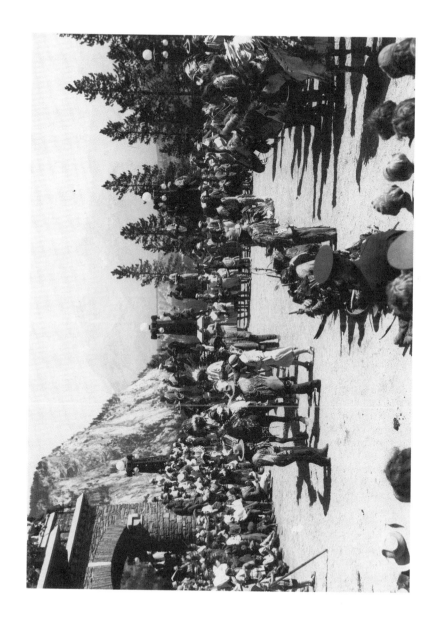

Fig. 4. Indian Days at Banff, Alberta, probably 1930's. Canadian Pacific Corporate Archives #19010.

held firm[ly] to their convictions, and little changed for three decades."[28] It is questionable whether the Stoney sold their crafts directly to the tourists, because in the town there were stores selling Indian arts and crafts as far back as the early 1900s-albeit in "Mackay and Dippie" (1900 to 1935) and "The Sign of the Goat" (1905 to 1960) mostly alongside stuffed animals.[29] Numerous pieces purchased and sold were post-traditional material, that is objects made during the early Reservation period (fig. 5).

Illustrations of authentic Plains Indian art began to appear in such magazines as the Ladies Home Journal. In it Frances Roberts discussed the revival of beadwork as a fashion and how it could be reproduced from old forms, suggesting that the modern craftsperson could update its function: drawings indicated that old needle-cases could become pencil holders or a knife-sheath became a scissors-case.[30]

With their traditional costumes and customs, such as dances, the Indians themselves became a kind of *objet d'art* attracting the interest of outsiders. By the 1920s the Indian people were considered "civilized" and, "no longer a threat to the security of the surrounding whites. Yet despite exposure to schools and missionary influence... a large number of traditional beliefs, practices and attitudes still persisted."[31]

Perhaps it was this fact of persistence that attracted many artists and writers west to paint and write about Indians.[32] Among the well-known artists who used Indians as subject matter was the German, Winold Reiss. His Art Deco painting style interpreted the characteristics and customs of the American Blackfeet, creating a new though somewhat romantic reality, around this "noble redman."[33] A young Canadian Blackfoot artist named Gerald Tailfeathers first came into contact with Reiss in 1935, working under his tutelage during the latter's summer art schools at Glacier National Park, Montana. Tailfeathers' early work showed the strong influence of Reiss.[34]

In the late 1950s, John Laurie, of the Canadian Handicraft Guild, Calgary Branch, reported great changes had taken place in the Indian craft market. Many of the fine old pieces were in museums. "Today Indians use commercial beads and threads and even this is becoming a lost art as hides are scarce and beads hard to obtain and expensive."[35] In the course of time such assessments grew more differentiated. Professor George Glyde, head of the Fine Arts Department, University of Alberta, lectured as follows to the Friends of the Indian Society in 1958: "The mission schools have not been a good influence on Indian art. They suppressed the creative instinct of the Indians and introduced a Europeanized art.... The modern Indians should use the same basic forms but the designs should change because their experiences are different... each artist is a product of his period... the twentieth century Indians cannot see their environment in the same way their grandfathers saw it."[36]

Fig. 5. Indian displays at the Hudson's Bay Company store, Edmonton, Alberta, 4 May 1920. Glenbow Archives #ND-3-445. Note that two products are for sale, Indian artifacts and taxidermy.

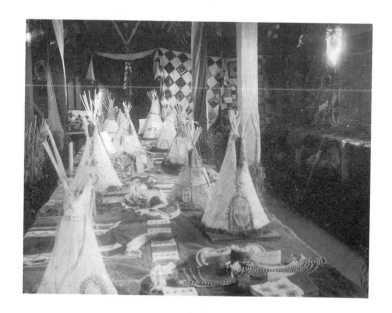

Fig. 6. Display of Indian handicrafts, File Hills, Saskatchewan, 1906 - 07. Glenbow Archives #NA-3454-21. Beadwork, miniature tepees, and Red River cart at an agricultural exhibition.

That same year Tom Hall, Indian Director, Calgary (Alberta) Stampede,[37] stated, "The decline in the famous crafts [is] one of the prices paid for [by the] integration of the Indians-the closer they come to the white man's way the farther they go from their own old way."[38]

Saskatchewan

With the exception of northern Saskatchewan, this province has not been a mecca for tourists. The relative isolation of the reserves and the changed lifestyles may explain the low production of Indian art and craft, although during the 1920's and 1930s, the Regina Agricultural and Industrial Association included exhibits from the various Indian schools. Three categories of Indian work were shown in the 1921 exhibition: (1) "beadwork" or traditional material: beaded suits, vests, shirts and leggings, porcupine quill, and silkwork moccasins, firebags, gauntlets, etc; (2) "School work," which reflected Europeanized activities like sewing, crochet, drawing, woodcarving, and weaving; and, (3) "farming" (fig. 6).[39]

In 1931 Mary L. Weeks, of the Guild's Regina Branch, reported the marked decline in the production of beadwork. The Indian woman's prestige, she says, "was no longer determined by elaborate beaded decoration of her deerskin dress. The styles of the white woman had aroused her interest and also her envy.... The styles for the men of the tribes had likewise changed.... Council meetings were discouraged, consequently there was no demand for ceremonial costumes. Happily of late, however, the demand for beadwork by collectors, who are unable to find the old pieces are turning their attention to reproductions, is causing the Indian women to take up this old-time handicraft with fresh interest.... Every year collectors from other lands visit the prairie provinces in search of Indian curios taking away some of the finest examples to enrich the museums of other nations.... In encouraging the reproduction of this old time-handicraft, the Women's Art Association is playing a valuable part. It is preserving one of Canada's most primitive and original forms of art-that of the aboriginal" (fig. 7).[40]

In 1932 the arts and letters committee of the Local Council of Women, Regina, was equally concerned about preservation. By 1938 - 1939 Mrs. Weeks had helped organize competitions in Regina to improve bead and quill work, in conjunction with the provincial government, as a new marketing plan.[41] No more was heard from this programme except that some of the pieces had been placed in the Regina Legislative buildings.

Plains style art and craft have survived. A big demand for traditional-style objects comes from the Indian people who regularly participate in the modern-day pow-wow circuit. Tourists, both Indian and non-Indian, are still the major buyers, proving that some traditions still survive.

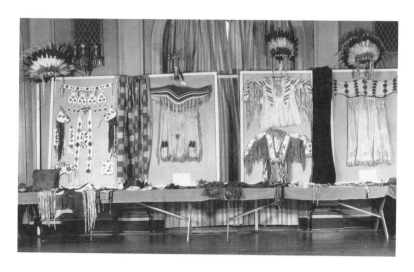

Fig. 7. Display of Plains Indian beadwork, probably at the Hotel Saskatchewan, Regina, Saskatchewan, 1927. Photo courtesy of the Canadian Guild of Crafts, Montreal.

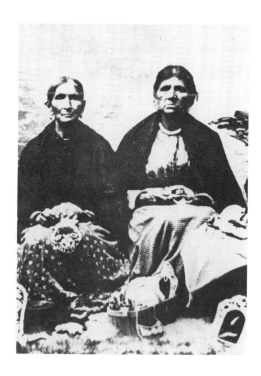

Fig. 8. Two Tuscarora women, Delia Patterson and her half-sister Elizabeth (Rihsakwad). The women are displaying the beadwork which they regularly sold to tourists in Niagara Falls. Photo courtesy of the Clinton Rickard family.

The Yukon and Northwest Territories

Douglas Leechman (1952) reported that handicrafts were not particularly important "in the economy of the Natives, though there has long been a steady demand for articles of Indian origin. During the big Gold Rush in 1898, miners found time to acquire Indian curios in addition to the Indian-made leather gloves, jackets, and moccasins, which many of them wore. There has been as well, a constant tourist traffic, particularly in Whitehorse and Dawson and, in the last few years, along the Alaska Highway and many of these visitors buy souvenirs of either Indian or white manufacture. The Natives of northern and central Yukon are noted for their exceptionally fine beadwork, but comparatively little of this reaches the 'outside' and, in recent years the difficulty of obtaining beads has been a serious handicap. In the southern part of the Yukon, the women make moccasins, gloves, and jackets, and the men derive some income from making toboggans and snowshoes for local use."[42]

Amelia M. Paget of Montreal's Guild, on her 1912 trip to Saskatchewan, reported meeting a Mr. D. Cadzow,[43] of Rampart, Yukon, "who trades with the Indians in that isolated part of Canada, and who was in on his annual purchasing tour. He promised to do all he could to interest the Indians in keeping up the standard of their work, which he assured me was of the best. He will endeavour to supply them with only such materials as will conform with the rules for good workmanship."[44]

Possibly Indian craftspeople sold their works to tourists who were on Canadian Pacific's "Alaska and the Yukon Princess Cruises." A 1939 CPR brochure announced a trip through the mountains by Yukon Railroad to Carcross, where they were met by "Bishop Bompas, pioneer missionary, and local Indian Patsy Henderson, Yukon lecturer."

Manitoba

The handicraft movement in Manitoba was largely a product of work by the Manitoba Women's Institutes that began in 1910 as home-economics societies. They were initially the responsibility of the Manitoba Agricultural College.[45]

The First World War brought money from the federal government into the provinces for an expanded rural education programme. The Women's Institutes provided an ideal vehicle for this programme in Manitoba and a rapid expansion occurred in the teaching of craft skills to rural women. By the 1920s the Canadian Pacific Railway and the Guild of Montreal had become involved in the Manitoba craft scene, after coproducing a successful exhibition in Quebec City. This resulted in the creation of the Manitoba branch of the Guild.

Although the Depression severely curtailed the government's financial support to all programmes, the Women's Institutes

carried on, with the support of public and private sponsorship.[46] During this period the Indians, relegated to the reserves, were largely forgotten.

In 1942 the Manitoba Pool Elevators developed a Rural Art and Handicraft Exhibit to encourage artistic ability in the agricultural communities of Manitoba. The exhibit, to emphasize its rural nature, was placed under the auspices of the Provincial Exhibition in Brandon. However, it was not until the 1950s that any Indian art or handicrafts were included in the Rural Art and Handicraft Exhibit.[47]

Leechman (1952) reported that handicrafts were being sold in the Fort Garry and Red River district, having long "been an important source of income to Indians living in the immediate vicinity. Moccasins and gloves were the principal products and they are still made in considerable numbers. There is also some work in porcupine quills being done on boxes and other objects of birch bark."[48]

Ontario

By 1900 the Indians of southern Ontario had developed a lively tourist trade, so much so that the Tuscarora began to act as middlemen for Indian crafts being sold in Niagara Falls (fig. 8).[49] "Iroquois souvenirs form[ed] the largest group of Native artifacts made for sale. Most of the Glengarries, pouches, and whimsies were made by the Tuscarora in New York and at Caughnawaga between the middle of the nineteenth century and the middle of this one. The Tuscarora still make Victorian style whimsies for sale at Niagara, which has a parallel in the production of factory moccasins at Lorette."[50]

The industrialization of southern Ontario attracted men from the reserves to work in cities like Toronto, Sarnia, and Detroit, leaving the handicraft industry largely to the women. Most Ontario Indians went home after the First World War to continue their previous occupations in farming or industry. The change from the traditional culture seems to have had more effect on the reservations in the southern part of the province, which were assimilating the culture of the nearby cities. The economic slump of the 1930s, but also the recovery of the following decade, likewise contributed for differing reasons to a further deterioration of the situation for handicrafts in many areas.

In 1942 N.E. Jamieson said handicrafts were still being practised in local reserves while in danger of being lost in others. She said, "In the past twenty-five years, Indian handicraft has widened considerably.... The Indian Fair (the Six Nations Agricultural Society)... which is celebrating its seventy-fifth birthday this year is unique in that it links the old with the new, the present with the past in the line of its exhibits depicting modern Indian handicraft and the relics of the remote past and planning for the revival of some of the lost

arts."[51]

The postwar period in Ontario brought a renewed interest in the arts and crafts. Florence Hill of the Six Nations Reserve was instrumental in organizing the Ohsweken Art Group in the 1950s, which later developed into the Six Nations Arts Council. Not only did it promote Indian arts and crafts, and introduce them to the world, but sponsored many exhibitions, including one at the Academy of Fine Arts in Philadelphia, and exchanging Native children's art with groups in Japan.[52]

Quebec

The ways of life of Quebec's Indians can be comprehended by the geographical location of the various tribes. The Montagnais-Naskapi and Mistassini of Northern Quebec, following a more traditional lifestyle, experienced very little European contact and influence until the early 1900s. This isolation created a favourable climate for anthropological and ethnographic studies.[53]

On the other hand, the Huron, Mohawks, and Algonquin of the South, in contact with Europeans for several centuries, had developed artistic styles, techniques, and products influenced by European tastes.[54] The Lorette Hurons (fig. 9) were known for their moosehair embroidered articles while the Kanawake Mohawks (fig. 10) and Algonquins of Maniwaki made beaded moccasins, pouches, and baskets.[55]

The Depression years were especially difficult for the Indians of Quebec. Except for the steelworkers, handicrafts and relief projects produced the only income for many families. In the northern regions very little cash was in circulation, but a living could at least be made by bartering furs for supplies, while fish and game provided food for nomadic families.[56]

In 1935 Mary A. Peck, one of the Guild's founders, observed at Kanawake that it was "much more paying to do poor, cheap work than the fine old-style embroideries in porcupine quills, beads or grasses, now so rare. Even the moccasins of the Iroquois have lost their distinct character and cannot be distinguished from those of several other tribes."[57]

As the general situation reverted to normal, interest in the plight of the Indians revived; certain individuals like James and Alma Houston, encouraged by the Guild, in turn tried to encourage, develop, and find markets for some of the northern Naskapi Indians.[58]

The Maritimes

The Maritimes, like the St. Lawrence Valley, were in a good geographical position for the marketing of arts and crafts. Often there were sales booths near the steamboat landing at

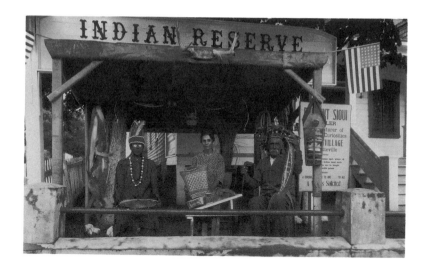

Fig. 9. Sioui family at Loretteville, Quebec (no date) selling handicrafts to tourists. Canadian Pacific Corporate Archives, Montreal, #22660.

Fig. 10. Indians, probably from Caughnawaga, ca. 1906, selling handicrafts. Photo courtesy of the Kanawake Cultural Centre, Kanawake, Quebec, #370.

Rivière-du-Loup,[59] although Halifax was probably the most common centre because of its link with Europe. Micmac birchbark boxes decorated with quills and split roots, model canoes, boxes, and a wide variety of other objects made for Native use, were sold there.[60]

Ruth Whitehead, in <u>Micmac Quillwork</u>, said that as early as the mid-nineteenth century Micmacs were entering their works in the Nova Scotia Industrial Exhibition.[61] Quillwork continued to be entered in exhibitions and became popular parlour furnishings. Its decline began at the turn of the century, because there were fewer craftswomen, and quality could not be maintained in economic terms.

During the Second World War the government reorganized the Micmac of Nova Scotia, closing the smaller reservations and relocating everyone to either Shubenacadie or Eskasoni.[62] The large influx of people overtaxed the employment situation and exacerbated the reserves' land problems.[63]

The economic forces at work in the Maritimes influenced the lifestyles and art forms of the Indians, since the agricultural land base and rapidly depleting natural resources of the Maritimes could not long offer employment for the Indians. When they turned to traditional lifestyles and handicrafts to earn a living, they rapidly depleted the reserves' raw materials.[64] The manufacture of baskets by the Micmac and Maliseet denuded large areas of forest, making the manufacture less economically feasible.[65] A birchbark blight, combined with a lack of interest, almost ended the manufacture of quillwork boxes, although there were still some practitioners of the art in the 1950s.[66]

CONCLUSION

In 1943 Teddy Yellow Fly of the Blackfoot tribe said,

> Many changes have taken place to suit modern tastes... caused by the white man's idea of Indian art and by the commercial demands for articles of Indian design and manufacture. Nevertheless, it remains true that the Indian has kept for centuries a heraldry of his own, a heraldry that records not only his achievements but his thoughts, so that a Blackfoot design is really a record of the Indian's soul.[67]

These "many changes" were what led to full-scale commercialization of the art and craft. "The commercial demands for articles of Indian design" by the tourist trade resulted in a standardization. Thus was born the homogeneous "Indian art and craft," similar to that sold at concession counters in the CPR

stations (fig. 11). Demand and mass-production also led to the development of the "miniature" as exemplified in totem poles, tepees, canoes, snowshoes, lacrosse sticks, and dolls.

Competition from Japan infuriated purists, because Japan was continually flooding the market with their own brand of "Indian art and craft," through a superior production and marketing programme.

Although Yellow Fly used his Blackfoot people as an example of a people who tried to protect many aspects of their culture, he gave a proud and eloquent invocation when he said, "the Indian has kept... a heraldry."

Today Canadian Indians recognize the importance of this emblematic heraldry to their traditions and cultures, no matter how tenuous have been the lines of descent; and modern Indian painting and sculpture are making use of it in their attempts to evolve an indigenous form of art that takes creative account of both Indian handicraft traditions and the artistic styles, as well as the art market, of the dominant civilization of the West.

Fig. 11. Canadian Pacific Railway news stand, Calgary, Alberta, 1921. It is questionable as to whether or not the curios were produced by Indians. If they were, they were mass-produced, because the same types of items were sold at all CPR news stands across Canada. Canadian Pacific Corporate Archives, Montreal, A13121.

NOTES

1. Federation of Canadian Artists, <u>Brief submitted to the Royal Commission on National Development in the Arts, Letters and Sciences</u>, October 1949, 30.

2. Germain Bazin, <u>The Museum Age</u>, (New York: Universe Books Inc., 1967), 193.

3. <u>An Act Further to Amend the Indian Act</u>, 1880. S.C. 1884, c.27. (47 Vict.), section 3, reads: "Every Indian or other person who engages in or assists in celebrating the Indian festival known as the "Potlach" [sic] or in the Indian dance known as the "Tamanawas" is guilty of a misdemeanor, and shall be liable to imprisonment for a term of not more than six nor less than two months in any gaol or other place of confinement; and any Indian or other person who encourages, either directly or indirectly, an Indian or Indians to get up such a festival or dance, or to celebrate the same, or who shall assist in the celebration of the same is guilty of a like offence, and shall be liable to the same punishment."

4. Rev. G.H.Raley, "Canadian Indian Art and Industries," <u>Journal of the Royal Society of Arts</u>, 83 (September 1935), 999. He said, "the Japanese in particualar are developing their trade with tourists in Canada in this way, at the expense of our Canadian wards. They have imitated Indian designs, developed them commercially, flooded Canadian stores with thousands of articles and used them to increase their trade results... it is easily understood that there are difficulties of legislation and international relations which might cause a government to proceed slowly in attempting higher tariffs to prevent the importation of such goods."

5. The British Columbia Indian Arts and Welfare Society's activites were confined to that province, beginning well before the Second World War.

6. "Says The Indians Are Benefitted By Fairs," Edmonton <u>Bulletin</u> (July 15, 1910).

7. "Indians Are Injured By The Exhibitions," Edmonton <u>Bulletin</u> (August 9, 1910).

8. <u>Annual Report for 1936-37</u> Department of Indian Affairs, (RG 10, Volume 6001, File 1-1-1, part 4) School Files.

9. See the Guild's Annual Reports for 1937 and 1938.

10. R.A. Hoey, "Economic Problems of the Canadian Indian," in The North American Indian Today, C.T. Loram and T.F. McIlwraith, eds. (Toronto: University of Toronto Press, 1943), 204 - 205.

11. Tom Hill, "Indian Art in Canada: An Historical Perspective," in Norval Morrisseau and the Emergence of the Image Makers (ex. cat.; Toronto: Art Gallery of Ontario/Methuen, 1984), 18.

12. "The Canadian Handicraft," Argus (October 22, 1904).

13. What It Has Done (Montreal: The Canadian Handicrafts Guild, 1917). A catalogue summing up facts and figures of what the guild had accomplished since its incorporation in 1906.

14. This was the Art Association of Montreal, which later became the Montreal Museum of Fine Arts.

15. Amelia M. Paget, "Report On Mrs. Paget's Trip To Indian Reserves In Saskatchewan," Annual Report of the Canadian Handicraft Guild (1912).

16. Alice M.S. Lighthall, "Report of the Exhibition Committee for 1931," Annual Report of the Canadian Handicraft Guild (1931).

17. A.T. Galt Durnford, "Work of the Educational and Technical Committe in 1932," Annual Report of the Canadian Handicraft Guild (1932).

18. A meeting of the Guild's Sub-Committee on Indian Arts was held on March 6, 1933. The discussion was in reference to the press article on "the Indian legislation at Quebec in regard to Indian customs and tribal costumes." A letter was drafted to the prime minister expressing the guild's views. The government did not respond but it later assisted the guild in their questionnaire on the state of Canadian Indian art and craft.

19. Alice M. Lighthall, "Report of the Indian Committee," Annual Report of the Canadian Handicraft Guild (1938).

20. "Indian and Eskimo Committee," Annual Report of the Canadian Handicraft Guild (1942).

21. Gordon H. Green, A Heritage of Canadian Handicrafts (Toronto: McClelland and Stewart, 1967), 110.

22. Mildred Valley Thornton, "Indian Native Art," Museum and Art Notes (September 1949), 23. The object of her discussion was the art of the West Coast, but her sentiments reached across the country.

23. The Sculptors Society of Canada, Brief to the Royal Commission on National Development in the Arts, Letters and Sciences (November 15, 1949), 2.

24. Federation of Canadian Artists, Brief submitted to the Royal Commission on National Development in the Arts, Letters and Sciences (October 1949), 29.

25. Douglas Leechman, Canadian Indian Handicraft, report submitted to the Panel on Indian Research, Indian Affairs Branch, Department of Citizenship and Immigration, Ottawa, May 19, 1952, file no. 1/25-1-1-4(E3). C.A.F. Clark, secretary to the panel said, "in the interval since this project was offered to the Panel there has come to hand a publication of the International Labour Office." The ILO Committee of Experts on Indigenous Labour said, "that, pending the development of industrialization, handicrafts are of importance to many indigenous peoples in independent countries and that there is a real need to improve the social and economic status of indigenous handicraft workers."

26. Philip H. Godsell, "The Vanishing Stoney Indians," Canadian Geographical Journal (October 1934), 179.

27. Jon Whyte, Indians in the Rockies (Banff: Altitude Publishing, 1985), 62.

28. Ibid. 77.

29. Personal communication with Mr. Whyte, Curator of the Heritage Collection of the Whyte Museum of the Canadian Rockies, Banff, Alberta, July 1986.

30. Frances Roberts, "Beadwork, Designs Which May Easily Be Produced," Ladies Home Journal (August 1903), 24.

31. Roma Standefer, "A Program of Directed Economic Change for the Northern Blackfoot Reservation." Thesis, University of Toronto, 1964), 18.

32. See George H. Gooderham, "I Remember - Artists, Writers, and Others," autobiographical ms., Glenbow Museum Archives, M3850(D819.G649), for all the artists and writers who came to visit or stay with him.

33. Rudolf G. Wunderlich, <u>Winold Reiss: Plains Portraits</u> (ex. cat.; New York: Kennedy Galleries Inc., 1972), 3.

34. In 1941 at the home of John Laurie, Tailfeathers saw the works of Charles M. Russel, Frederick Remington and other western artists, and "the exposure to these and other artists gave him ideas to experiment with and develop his own technique.... Between 1957 and 1959 he became concerned with the historical significance of his work, using his knowledge of his tribe to show events of the past. In 1958 he produced his first paintings on the style of Indian artists of the American Southwest, and he turned to cartooning to depict the Indians dissatisfaction with governmental involvement in their lives." Beth Duthie, "They Painted the Indians," <u>Glenbow</u> (July/August 1985), 6 - 7.

35. "Indian Crafts Becoming Lost Art, Says Speaker," Calgary <u>Albertan</u> (October 5, 1957). The guild was sponsoring an exhibition of handicrafts at the Hudson's Bay Company.

36. "Says Indian Art Reflected Life," Edmonton <u>Journal</u> (May 22, 1957).

37. The Calgary Stampede is one private institution that has had one of the longest working relationships with local Indian people. Witness for example the recent opening ceremonies at the XV Olympic Winter Games. The promoters reason that the Cowboy-and-Indian image is indivisable. The very least this does is help strengthen the tenuous lines with the past.

38. "Indian Crafts Disappearing," Calgary <u>Herald</u> (July 7,1958). The Stampede, long interested in Indians of southern Alberta, were concerned with the swift disappearance of the art and craft, created a prize competition. There were only two enteries: one was a headdress made of turkey feathers, the other was a pair of moccasins. This prompted an idea that the committee would commission large quantities, "while there are still people left who know how to do the work."

39. Letter from W.M. Graham, Indian Commissioner, Department of Indian Affairs, to the principal, R.C. Boarding School, Standoff, Alberta, May 27, 1921, with an attached official prize list of the Regina Provincial Exhibition, August 1 - 6, 1921.

40. Mary L. Weeks, "Beadwork of the Prairies," <u>Canadian National Railways Magazine</u> (September 1931), 26 - 27.

41. Alice M. Lighthall, "Indian and Eskimo Committee," <u>Annual Report of the Canadian Handicraft Guild</u> (1939).

42. Leechman, 4.

43. In her 1931 article, Mary L. Weeks makes reference to a Donald Cadzow as being from the Museum of the American Indian, Heye Foundation, New York. She said he "visited the reservations and collected several hundred dollars worth of beadwork, also a peace pipe-the last of its kind among the prairie Crees-for which he paid five hundred dollars."

44. Paget.

45. Gordon G. Green, <u>A Heritage of Canadian Handicrafts</u> (Toronto: McClelland and Stewart, 1967), 146.

46. Green, 148 - 149.

47. Green, 158.

48. Leechman, 6.

49. Ernest S. Dodge, "Some Thoughts on the Historic Art of the Indians of Northeastern North America," <u>Massachusetts Archeological Society; Bulletin</u> (1951), 1 - 5.

50. J.C.H. King, "Indian Souvenir Arts of Nineteenth Century Canada," in <u>Mohawk, Micmac, Maliseet, and other Indian Souvenir Art from Victorian Canada</u> (London: Canada House Culture Gallery, 1985), 15.

51. N.E. Jamieson, "Indian Arts and Crafts," in <u>Six Nations Indians: Yesterday and To-day 1867 - 1942</u>, 4 - 11.

52. "Native Arts a Testimony to Florence Hill," <u>Anglican Churchman</u> (January 1987), 5.

53. Frank G. Speck, "Montagnais Art in Birch-Bark; A Circumpolar Trait," <u>Museum of the American Indian, Heye Foundation</u> 11, 2 (1938) and <u>The Savage Hunters of the Labrador Peninsula</u> (Oklahoma: Oklahoma University Press, 1977).

54. Frank G. Speck, "Huron Moose Hair Embroidery," <u>American Anthropologist</u>, 13, 1 - 14 and "The Double-Curve Motif in Northeastern Algonkian Art," <u>Canada Department of Mines, Geological Survey Memoirs</u>, 42 (1914).

55. Ernest S. Dodge, "Some Thoughts on the Historic Art of the Indians of Northeastern North America," <u>Massachusetts Archeological Society; Bulletin</u> (1951), 4.

56. The Canadian Indian (Quebec and the Atlantic Provinces)
 (Ottawa: Indian and Northern Affairs, 1973), 31.

57. M.A. Peck, "Caughnawaga," Canadian Geographical Journal 10
 (February 1935), 99.

58. "Nascopies Turn to Art," The Indian Missionary Record
 (April-May 1953), 8. In a conversation with Miss Virginia
 Watt, director, Canadian Guild of Craft, February 1988, she
 said the guild had an exhibition in 1953 and again in 1976
 in an attempt to help the Naskapi regain their old art
 forms, but "with the rush of industrialization, especially
 at Scheffreville," the art was hopelessly lost.

59. Dodge, 4.

60. King, 15.

61. Ruth H. Whitehead, Micmac Quillwork (Halifax: Nova Scotia
 Museum, 1982), 51.

62. Elice B. Gonzalez, Changing Economic Roles for Micmac Men
 and Women, Mercury Series No. 72 (Ottawa: National Museum of
 Man).

63. Gonzalez, 97 - 98. The industrial possibilities at both
 reservations were overtaxed by the influx of people. The
 Natives who had been moved lost their animals and tools.
 They were settled on small plots of rocky land unfit for
 agricultural use.

64. Gonzalez, 86.

65. "Indian Basket Makers Find Ready Market for Products," The
 Indian Missionary Record (October 1956), 3. Mr. and Mrs.
 Abraham Bartlett, a Micmac couple from Yarmouth, were making
 baskets of maple and travelling up to 100 miles to find a
 market for their wares.

66. W.D. Wallis and R.S. Wallis, The Micmac Indian of Eastern
 Canada (Minneapolis: University of Minnesota, 1955), 92.
 They reported one woman over sixty-five and one under fifty
 doing quillwork baskets at Shubenacadie in the 1950s.
 Perhaps one of the these women was Susan Sack, the sister-
 in-law of Bridget Sack mentioned by Whitehead on p. 208.

67. Mary Graham Bonner, "Revival of Indian Art," Made in Canada
 (New York: Alfred A. Knopf, 1943), 22 - 23.

THE POLITICAL, ECONOMIC, AND SOCIOCULTURAL CONDITIONS OF LIFE FOR THE INDIANS OF CANADA IN THE TWENTIETH CENTURY*

by

Peter R. Gerber

INTRODUCTION

Anyone interested in the artistic activities of the Indian natives of Canada will, after a first phase of aesthetic admiration, necessarily be confronted with the circumstances of the artists' lives. Ethnologically, the artworks can hardly be understood without knowledge of these circumstances. The following essay will consequently survey the conditions under which the Indians of Canada are trying to survive today. I will concentrate on the last twenty years, which have seen events of dramatic importance, but also sources of hope, for the aboriginal inhabitants of Canada.[1]

More than a hundred years ago, the Indians lost their original sovereignty and were degraded to the status of wards of the state. This subjection was effected by means of the constitution of the then Dominion of Canada, the British North America Act of 1867, and the Indian Act of 1876. Since the end of 1960s, however, a revision of this historical fact has come due, with Native Canadians seeking to win back a part of their independence. On the basis of autonomous territories within the Canadian federal union, they are demanding self-determination in political, economic, and sociocultural affairs. First successful steps in this direction have been made, but to achieve this aim, Indians still have many obstacles to overcome, obstacles that those with political and economic power in Canada do not tire of setting up.

THE LONG ROAD TO SELF-DETERMINATION

To the present day, self-determination has been denied the Indians in Canada. Symptomatic of this fact are the long years of struggle by Native Canadians for the recognition of their existence in the new Canadian constitution of 1982. What have been the developments leading up to and following the promulgation of the new constitution?

In early 1969 the Liberal government of Pierre Elliott Trudeau announced a "new Indian Policy." The principal aim of this policy was to be the full and coequal participation of aboriginal peoples in the cultural, social, economic, and

political life of Canada. Since they were to be granted the same
freedoms, rights, and opportunities as all other Canadians, all
special privileges for aboriginal peoples would have to be
eliminated. In its arguments the Trudeau government cited
Article 7 of the Universal Declaration of Human Rights, which
asserts that "all people are equal before the law." The
Government interpreted this to imply a contradiction between
human rights and the special rights of Native Canadians, for
which reason these special rights, like freedom from taxation on
the reserve, and extensive hunting and fishing rights, had to be
abolished, as well as the reserves themselves.[2] Harold Cardinal,
a Cree politician from Alberta, commented sarcastically on this
"termination" policy by varying a well-known white maxim
slightly: "The only good Indian is a non-Indian."[3]

This "new Indian Policy" was never carried through because
of the unexpectedly vehement opposition of the Indians and part
of the white population; but it has never been officially
revoked. Thus it was only logical and in accord with this policy
that the aboriginal peoples of Canada found no mention in the
initial draft of a new constitution. It rained protests again,
and Native peoples gained entry to the next draft, but the
government did not relent. The legal existence of the aboriginal
inhabitants was called into question again in the autumn of 1981
when the premiers of the provinces and the federal prime minister
again struck mention of Native Canadians from the constitutional
draft then under consideration. Finally they were included in
the new Constitution of 1982, in Article 35: (1) "The existing
aboriginal and treaty rights of the aboriginal peoples of Canada
are hereby recognized and affirmed." (2) "In this Act,
'aboriginal peoples of Canada' includes the Indian, Inuit and
Métis peoples of Canada."[4]

With Article 35, Native Canadians have thus far achieved
more than Native Americans, whose treaty rights were declared
invalid in 1871. This relative success can be attributed to a
number of factors, but three were of particular importance: a
legal case, the unity of Native Canadians, and the
internationalization of their struggle.

The decisive legal case came in January 1973, after an
almost ninety-year struggle for land rights on British Columbia
in the part of the Nisga-Tsimshian, with a decision by a federal
court that brought about a breakthrough in the government's
attitude. The decision, although negatively answering the
question of whether the Nisga had a right to their traditional
tribal territories, proved on closer inspection to be a turning
point in Canadian jurisdiction. The majority of the judges
affirmed the existence of aboriginal land rights, with three
judges of the opinion that the founding of the Canadian
confederation cancelled such rights. Since the presiding judge

decided against the Nisga on a technicality, the final vote was four to three against the demand that the aboriginal territories be returned.[5]

That a federal court had affirmed the existence of aboriginal land rights of Native Canadians for the first time in Canadian legal history caused an impressed federal Government to reconsider its position and move toward a final settlement. But this new attitude on the part of Ottawa was only one side of the Government's political position; at the same time it continued to declare the aboriginal peoples to be legally non-existent.

Native Canadians welcomed this support from the legal establishment, but an even more important factor in their success in the constitutional controversy was their unity on a national level. The aboriginal inhabitants of Canada are today represented by four umbrella organizations: "status" Indians (those belonging to a band with a treaty with the government), by the National Indian Brotherhood (NIB), since 1970; "non-status" Indians (those to whom the government has no treaty obligations), by the Native Council of Canada (NCC); the Métis of Manitoba, Saskatchewan, and Alberta, by the Métis National Council (MNC); and the Inuit, by the Inuit Committee on National Issues (ICNI). These four organizations stuck together on important questions during the constitutional controversy. Other regional and provincial organizations struggled for the same goal, the greatest possible sovereignty.

The internationalization of the Indian struggle began with two trips to Europe by Native Canadians in 1979 and 1981 to draw the attention of world public opinion to their problems, especially of their legal existence in the new constitution. The degree to which decision-makers in Canada were influenced by this is difficult to determine. In any case, official Canada was concerned enough with maintaining a good international reputation to stand up for the observance of human rights around the globe.

In the years between 1982 and 1987, in accordance with a special constitutional mandate, the attempt was made to circumscribe the exact legal status of aboriginal peoples. But in four meetings of the premiers of the provinces and the prime minister, attended by representatives of the four national aboriginal organizations, no agreement was reached. The majority of the provinces opposed the proposal of self-government for aboriginal peoples. Into the difficult federal balance-of-power between the provincial governments on the one side and the federal government on the other would enter, according to a parliamentary commission, a third, coequal government for aboriginal inhabitants, with the same rights to land and resources as the provinces-which the resource-richest among them could in no way accept.[6]

No wonder that the Native Canadians took their domestic-policy grievance back to the international stage by descending upon Geneva in large numbers in August 1987. At UN Headquarters in Geneva the special UN Working Group for Indigenous Populations has met almost yearly since 1982. Its primary task is to register violations of the human rights of aboriginal peoples and make a yearly report to the UN Subcommission for the Prevention of Discrimination and the Protection of Minorities.[7] In the longer term, the Working Group is to devote itself to the question of the development of "new international legal standards to protect indigenous peoples."

In 1987 the public session dealt with the presentation of suggestions for a new UN declaration recognizing a special status of indigenous peoples in international law. Not only Native Canadians, but also the Sami or Lapps in Scandinavia, the Maoris in New Zealand, the Aborigines in Australia, the Kanakas of New Caledonia, and many others hope that such a declaration will secure their existence in autonomous areas within the respective countries. In 1988 the Working Group for Indigenous Populations has presented a draft declaration that, if the principle set down there became political reality, would represent a fundamental improvement in the status of aboriginal peoples in international law.

But international law, not to mention the national legal systems in the various countries, has not progressed this far, yet. Still, there has been movement forward. Within the International Labour Organization (ILO) work is currently under way on a revision of the thirty year old Convention No. 107, which is one of the few acts in international law with reference to indigenous peoples. Some of the suggested improvements under consideration are encouraging.[8] ILO Convention No. 107 was never ratified by Canada, with the excuse that this convention, in declaring indigenous peoples subjects in international law, gave these minorities a special status in the international law. The recognition of this status would be the first step towards the recognition of a special place for indigenous peoples in national law. Canada, however, has always wanted to treat her indigenous inhabitants merely as ethnic minorities, like ethnic immigrants from Europe, Africa, or Asia.

The work of the UN Subcommission for the Prevention of Discrimination and the Protection of Minorities also justifies certain hopes. In its session in August 1987, the subcommission accepted various resolutions that can be interpreted as steps forward toward recognition of the rights of indigenous peoples. Two points deserve mention here.

First, the Subcommission authorized a special study of all treaties ever entered into by indigenous peoples with larger

nation-states with the aim of establishing their present significance for the parties involved. Indian and a few non-Indian experts in international law are of the opinion, for instance, that the treaties between Indians and the United States of America unilaterally terminated by Congress in 1871 are still legally binding. Naturally, the US Government does not share this view. Canada also, as indicated, finds it difficult to accept the consequences proceeding from the constitutional recognition of all past treaties, whether in the form of the return of illegally appropriated lands or the payment of fair compensation for the exploitation of resources on aboriginal lands. It is noteworthy that an international body has commissioned such a study, noteworthy also that the representatives of Canada and the United States abstained while those of other countries favoured the study fifteen to nothing.

Second, the Subcommission recommended that the UN General Assembly declare 1992 the "International Year of the Indigenous Populations of the World." 1992 is, of course, the 500th anniversary of the so-called discovery of America by Columbus. Whether the UN General Assembly approves this proposal and passes the intended declaration on the status of indigenous peoples in international law still remains to be seen.[9]

NATIVE LAND – NATIVE RESOURCES

The main prerequisite for a life of economic self-determination is the right to control one's own land and the resources it bears. In the past, when reserves were set up in Canada, reserve land was allotted according to the size of the Indian community. Since that time, populations have increased steadily, and the land can no longer support the reserve communities. As a result, a great many Indians today must subsist on social-welfare payments.

Native Canadians wish to extricate themselves from this dependence on the state and hence are demanding "Indian control of Indian economy." The prerequisite for this is sufficient economic resources like land and capital, and local control of economic processes at the communal level. But Native Canadians still lack the necessary know-how. Only most recently has the Department of Indian Affairs come to the realization that more capital must be made available for development projects and investments on the reserve. Lack of capital and lack of expertise are both the result of a vicious circle involving poor schools, poor job preparation, poor chances on the job market, unemployment (with the incumbent alcoholism and prostitution), and poor credit-worthiness. Many Indians who have sought their fortunes in the White working world have to struggle not only with these difficulties but also with the bitter experience of

discrimination and racism. In recent years more and more Indians have been returning to their reserve, where they are better able to survive economically, tax-free and in the framework of the extended family, albeit largely under the humiliating guardianship of welfare.

A further factor in the denial of self-determination is the exploitation of mineral resources found on the reserves by White mining companies. That these are White firms has to do with the fact that in Canada the individual Provinces control their natural resources and dispense mining rights. The Indians have nothing to say about it and must be satisfied when they are accorded royalties. They also have the possibility of earning wages as workers in these companies. Since the exploitation of these resources often takes place in remote areas, environmental-protection measures have rarely been taken. No wonder, then, that often serious pollution of the air and water has resulted. A number of instances of pollution with detrimental consequences for the health of local-that is, usually Indian-populations have been documented. One of the crassest cases was the mercury pollution of the English-Wabigoon River, not discovered until 1970, and the connected destruction of the Ojibwa community in Grassy Narrows in the northwest corner of Ontario.[10]

Indian politicians and economists see ways of escape from this situation in demands for the return of Native lands or in compensation payments for land expropriations in violation of treaties. A further way out would be opened by long-term low-interest credits such as are offered to developing nations. But apart from this, in the past number of years Indians have initiated various larger and smaller self-help enterprises to lead Indian reserve communities out of the economic crisis most find themselves in.

An example of these self-help projects is the Denim Centre on the Mistawasis reserve forty kilometers east of Prince Albert, Saskatchewan. About six hundred Plains Cree Indians live on the reserve. Some are farmers, others have jobs in Prince Albert, but many are unemployed. Of the women, only ten had a paying job in 1980. Around New Year's Day 1980, Leona Daniels started a small project with nine other women. With some money left over from Christmas, she bought a supply of denim and taught the women to sew denim dresses. Four sewing-machines were bought with a development credit of $9,000.00. In a disused room in the old kindergarten, the women set up their small factory. For most of these women, this was the first paying job they had ever had. The dresses were sold not only on the reserve, but all over Canada, at prices from 20 to 40 per cent below those for dresses of comparable quality in department stores. However, the Denim Centre continued to receive a subsidy from a government fund for the support of Indian enterprises. This dependence was to have

fatal consequences when the subsidy was eliminated in the course of across-the-board budget cuts by the Conservative government of Prime Minister Brian Mulroney. In 1987 the Denim Centre had to shut down.

A further example, likewise from Saskatchewan, shows how Indians can create an economic base using their own energies in order to move a step further towards self-determination: the Saskatchewan Indian Corporation (SINCO). This economic enterprise, in which over fifty of the sixty-nine reserve communities in Saskatchewan participated, together with the Federation of Saskatchewan Indian Nations (FSIN), was founded in 1978 and operated according to four principles: SINCO was to 1) belong to the Indians, 2) be controlled by Indians, 3) be managed by Indians, and 4) operate profitably.

As of 1984, SINCO had ten enterprises, including a trucking company, a consulting firm, and an exploration company. With all of these companies, SINCO increased its capital from year to year, repaid its bank loans, and operated profitably. Also, the number of SINCO employees rose steadily, making SINCO with its over one hundred employees the largest employer of Indians in Canada apart from Government agencies and the big Indian organizations.

From the beginning, the trucking company, with more than forty trucks of various sizes and types, was SINCO's flagship. Most of the Indian drivers were owner-operators who lease-purchased their trucks from SINCO. The company generally operated on the basis of long-term contracts. The consulting firm specialized in questions involving community administration, community budgets, and reserve development, also offering training courses for community employees. The business of the consulting firm increased in importance as reserve communities assumed more and more responsibilities for self-government. For this, schooled and experienced administrative personnel were needed. The exploration company was charged with an equally important task: it was a manifestation of the policy of Indian control of resources on Indian land. Resource deposits do not follow reserve boundaries, of course, and unscrupulous oil companies, for instance, have in the past drawn off oil under reserves by setting up their drilling rigs right on the reserve boundary. Reserve communities fought against this with the help of SINCO. First the exploration company determined whether and what resources were on Indian land; SINCO then conducted negotiations for fair exploration contracts, a task once carried out by Department of Indian Affairs in Ottawa, often to the detriment of the Indians.

SINCO also employed non-Indians, primarily in management and staff positions, where trained Indian personnel were lacking.

But over 85 per cent of the jobs were filled by Indians, of whom many were formerly unemployed. SINCO president Doug Cuthand said proudly: "We provide the best social welfare when we-as a Native enterprise-are able to pay checks to Native people."[11] In the meantime SINCO has gone the way of the Denim Centre. Since the holding company was too dependent on federal subsidies, and since not all of the ten companies operated profitably, SINCO became insolvent in 1987 when the subsidies were rescinded.

These examples of only partially successful self-help enterprises underline the fact that the majority of Canada's Indians continue to live under difficult economic circumstances much like those in developing countries. Statistics at the beginning of the eighties showed an infant mortality rate of 60 per cent higher than the national average. In 1977 only 40 per cent of Indian houses had running water, sewage systems, etc., as against 90 per cent on the national average. Unemployment runs between 35 per cent and 90 per cent, depending on region, while the national average hovers around 10 per cent. The suicide rate is three times as high as the national average, with most of the instances occurring in the 15-to-24 age group.[12] Improvement on the basis of self-determination is just beginning to take place.

BICULTURAL IDENTITY

Apart from the struggle for legal-political and economic self-determination, the Indians of Canada are beginning to grapple with the sociocultural question of what Indian identity is and what significance it has in a primarily "white" surroundings today. Heretofore they have been the victims of a government policy of cultural assimilation that was presented as an opportunity for better integration into White society; today this "civilizing process" is condemned as "cultural genocide" ("ethnocide") because it shows no respect for other cultures and ultimately denies their right to exist. The practice of cultural genocide found its most drastic form in the government's education policy toward Indian children. This proceeded from the assumption that the parents and grandparents could no longer be changed, but continued to transmit traditional culture to the children, and hence stood in the way of successful assimilation. Two methods were employed: the placing of children in White foster families and schooling in boarding schools.

With the justification that children from broken homes must be offered a new chance in life in intact families, in the past one hundred years almost every third Indian child has been taken from his family, often with the unsuspecting assent of the parents. In time, these children began to be ashamed of their origins and soon learned that White society seldom accepted them as equals. The result has been catastrophic: the children have

generally become cultural cripples-neither Whites nor Indians. Under the guise of humane help, the destruction of Indian identity has been carried forward without many foster families even becoming fully aware of it.

While life in a foster family uproots the individual child and deprives him of his Indian identity, boarding school attendance affected whole generations of children by alienating them from their culture and bringing them into conflict with the older generation. In the boarding schools, teachers were convinced that their pupils could be made into Whites only with the help of stern measures. The children had to have European-style haircuts and wear European-style clothes; they had to conform to White middle-class ideas of discipline and order and speak English exclusively. The use of their mother-tongue was forbidden, and violations of this prohibition were severely punished. In class only European knowledge was taught, and of course the children received intensive instruction in Christianity.

Resistance to this inhuman practice arose from the very beginning, but in the case of foster and adoption rights, the legal struggle in Canada has not progressed as far as in the United States, where Congress passed a new law favouring Indian children in 1978. In Canada the matter of foster and adoption rights has been governed by special agreements between Ottawa, the individual reserve communities, and the provincial governments since 1982. Since 1985 Indians who lost their legal status because they lived in foster families as children or were adopted have been able to regain it, which thousands have done.

For the schooling of Indian children, the new Indian policy announced by the Trudeau government in 1969 signaled a turning point. In 1972 the National Indian Brotherhood presented a political manifesto entitled "Indian Control of Indian Education." The first point made here was that the school education of Indian children under the auspices of the federal and provincial governments had been a fiasco. In Saskatchewan, for example, statistics for the year 1976 showed that, while 80 per cent of non-Indian children finished high school, only 7 per cent of Indian children did, the majority dropping out early. From the founding of the University of Saskatchewan in 1907 to 1976, only twenty Indians received bachelor's degrees on a total of 40,000 BA's awarded; of 3,000 master's degrees, only five went to Indians, and not one of the roughly one thousand doctoral degrees. These numbers also recall the situation in developing countries.

In terms of the Indian criterion for success-the degree to which Indian identity is maintained-the outcome is even more catastrophic. The NIB authors stress how important the

transmission of traditional values is for the survival of Indian communities as cultural units. The children must develop self-confidence and pride in being Indian. They should also internalize the following values: to seek to understand one's fellow man and be generous towards him; to respect the freedom of others; to honour the wisdom of the older generation; and to respect nature and live in harmony with nature.

In this context, the question must be asked whether an integration of indigenous peoples into White culture and society ought to take place today. In the NIB's education proposals, the authors have the following to say: "In the past, it has been the Indian student who was asked to integrate: to give up his identity, to adopt new values, and a new way of life. This restricted interpretation of integration must be radically altered if future education programs are to benefit Indian children." Hence the authors insist that integration must not be a one-way street, but a process in which the best from Indian cultures and the best from White cultures come together. They write: "The success of integration is not the responsibility of Indians alone. Non-Indians must be ready to recognize the value of another way of life; to learn about Indian history, customs and language; and to modify, if necessary, some of their own ideas and practices."[13]

Today these hopes remain political wishful thinking. The White majority in Canada is clearly not prepared to change its behaviour, much less learn Indian languages. The sole concessions are of financial and legal kind. Since 1973 the reserve communities have been able to assume authority over their own schools and decide themselves which teachers are to be hired and what is to be taught. But bilingual education, education in the Indian mother-tongue and in English, and bicultural instruction, are only beginning to develop; the necessary teaching materials are still lacking, and the number of bilingually and biculturally trained teachers is growing only slowly. As of 1989, only 285 reserve communities enjoy "Indian Control of Indian Education." In the remaining 292 reserve communities, school education continues to be conducted by the Department of Indian Affairs or by the provincial governments. During the 1986/87 school year, 49 per cent of all Indian school children attended provincial schools, where bicultural education is still practically unknown.[14]

RELIGION AND IDENTITY

The forced assimilation of whole generations has thoroughly shaken confidence in the central values of Indian cultures. Religious life is doubtless among these central values and-along with the native language-plays the most important role in the

struggle for survival of a cultural community. The realm of religious values provides the soil for the growth of the identity of any sociocultural entity. Where central cultural values have been forgotten or destroyed, the roots of identity find no nourishment and the culture dies, even if the bearers of the culture physically survive. And where there is no communication and mutual respect between the generations, the transmission of the culture from one generation to the next is no longer assured.

More and more Indians of all age groups are coming to this realization and are recalling to mind in particular the eminently important role that the older generation, especially the elders and medicine people, once played in the transmission of the culture from generation to generation. They are not only remembering. Today, the elders and medicine people play an important role again.

The International Indian Ecumenical Conference in Morley fulfills a special function in this respect, to mention only one example. In 1969 a number of Indian personalities met who were concerned that so many Native Indians felt insecure as to their own Indian identity. These concerned individuals saw a way out of the crisis in an ecumenical conference in which thousands of Indians from all over North America might be offered the opportunity to reflect on their traditional cultures. In this way cultural alienation was to be stopped, the traditional religions revived, and intercourse between young and old renewed.

Between 1971 and 1984 the Conference took place every summer on the Stoney Reserve west of Calgary. Under a large tabernacle the audience listened to various speakers on topics of their own choice. Some spoke on how they had stopped drinking, others presented their views on political questions in general and in particular, and still others related the difficulties they had to overcome when they tried to revive local traditions. Under the tabernacle burned a sacred fire that had been solemnly lighted using a fire-drill at the beginning of the conference and was equally ceremoniously extinguished at the end. Young men and women were charged with seeing to it that the fire never went out. Medicine people conducted ceremonials, pipe ceremonies, or sweat-lodge rituals. And in the evenings there were atmospheric pow-wow dances.

For many participants, Morley was a place of mental and spiritual renewal, of revival in the literal sense. A Micmac, for example, relates how "Morley" helped him to know himself better, a man who had not known previously why he was born and who he was. He had nine children but, a total alcoholic for twenty-five years, had missed the experience of watching his children grow up: "I've wasted half of my life, I was no longer a human being these years. When coming home my kids run away." Now he was

"dry" again and in the process of learning the Indian way of life and seeking the purpose the creator had for his life. In moving words he begged his listeners, the "communion of Morley": "Please don't walk in front of me, because I may not be able to follow you; and please don't walk behind me because I may not be able to lead you. Just walk beside me and be my friend."

A consolation, also for outside observers, was the humour without which the struggle for survival probably could not be seen through. A scene from Morley may serve to illustrate how this humour, on the one hand, recalls political humour in countries with authoritarian structures and, on the other, shows that "religion" and humour are not mutually exclusive in Indian cultures. The host at Morley, Chief John Snow, announced a speaker with these words: "I have the honour to introduce Moose David. Hope I'm correct with Moose"-he looked at his note-"or is it Moses? I checked this with Adam [a coorganizer] and we decided it's Moose." The spectators laughed, an old man mounted the podium and said smilingly, "Thank you, John. My name is Moses David from the Mohawk Nation. I don't care what you call me as long you don't call me 'white man'...." "Renewed mirth in the audience.[15]

Moses David personifies, like many elders, the self-confident, firmly rooted personality that formulated both opinions and demands with firmness and humour. He urged that no one speak of "tribes" but instead of "nations," since only nations could assert their rights to self-determination before the governments in Ottawa and Washington.

Medicine people and elders are playing an increasingly important role in the political disputes between the "First Nations" and the federal government. In the Assembly of First Nations, all decisions of this Indian parliament must be approved by an elders council. Only after this "senate" has given its approval can a decision be enacted. Such decisions must be in tune with time-honoured traditional value concepts.

CONCLUSION

The aboriginal inhabitants of Canada, the Indians, Métis, and Inuit, continue to face an exhausting struggle for the recognition of their right to self-determination. They are finding increasing support from the media, members of Parliament, and not least legal scholars. A growing number of publications, including whole series,[16] bear witness to this fact.

The enormous energies that the struggle for survival has mobilized in the last twenty years make clear that Native consciousness of Native identity perseveres. The artistic work

of aboriginal Canadians is visible proof of that and also
demonstrates that varied Indian cultural values provide a living,
adaptable existential base, but also one that can be lovingly
cultivated.

*Translated from the German by Thomas J. Minnes

NOTES

1. I owe Elisabeth Biasio, Zürich, and Heinz Lippuner, Grüt, thanks for critical suggestions on the final German version of this article; revised for English version in January, 1989.

2. White Paper 1969; see also Weaver 1981.

3. Cardinal 1969, 1.

4. Inuit is the official designation for Eskimos in Canada; people of mixed blood, originally mostly of French and Indian origin, are called Métis. "Indigenous people" and "indigenous minority" are terms in international law for aboriginal inhabitants.

5. Bruggmann/Gerber 1989, 182f.; Sanders 1973.

6. "Penner Report 1983," named for the commission chairman, the Liberal politician Keith Penner.

7. This subcommission is subordinate to the UN Commission on Human Rights, an organ of the UN Economic and Social Council (ECOSOC).

8. See Barsh 1987.

9. Commission of Human Rights, E/CN. 4/Sub. 2/1987/L. 20 + L. 54; on the subject of this section, see also Gerber 1984, 1985, 1986.

10. Shkilnyk 1985.

11. From a conversation with the author, November 15, 1983.

12. Penner Report 1983, 15.

13. Both quotes from NIB 1973, 25, 26.

14. INAC 1987, 25f.; INAC 1989, 17; cf. also Gerber 1979.

15. All quotes from Morley from tape-recordings from 1978; Gerber 33 - 36.

16. For example, the journal Aboriginal Peoples and Constitutional Reform, published by the Institute of Intergovernmental Relations, Queen's University, Kingston, Ontario, after 1984.

BIBLIOGRAPHY

Barsh, Russel L.
1987 Revision of ILO Convention No. 107 (draft paper).
Seattle: Four Directions Council.

Bruggman, Maximilien and Peter R. Gerber
1989 Indians of the Northwest Coast. New York: Facts on File.

Gerber, Peter R.
1979 "Indian Control of Indian Education. Ein Bericht über die Erziehungspolitik kanadischer Indianer." Indianer Heute.
Berne: Schweiz. Ethnologische Gesellschaft.

1980 "Die Bedeutung der 'Religion' im Überlebenskampf der Indianer." Bulletin de la Société suisse des Américanistes (Geneva), 44.

1984 "Das Recht, Indianer zu sein: Die kanadische Regierung versus die Ureinwohner." Bulletin de la Société suisse des Américanistes (Geneva), 48.

1985 "Canada's Indians: From 'Band' to 'First Nations'."
Pletsch (see below).

1986 "'Selbst-Regierung' der Ureinwohner in Kanada?" Vom Recht, Indianer zu sein. Menschenrechte und Landrechte der Indianer beider Amerika, Peter R. Gerber, ed., Ethnologische Schriften Zürich, ESZ 4, Zürich.

Indian and Northern Affairs Canada (INAC)
1987 1986/87 Annual Report, Ottawa.

1989 1988/89 Annual Report, Ottawa.

National Indian Brotherhood (NIB)
1973 Indian Control of Indian Education. Policy Paper, presented to the minister of Indian Affairs and Northern Development, Ottawa.

Penner Report
1983 Indian Self-Government in Canada. Report of the Special Committee, House of Commons, Ottawa.

Pletsch, Alfred, ed.
1985 Ethnicity in Canada-International Examples and Perspectives. Marburg: Marburger Geographische Schriften.

Sanders, Douglas
1973 "The Nishga Case." BC Studies 19.

Shkilnyk, Anastasia M.
1985 "A Poison Stronger than Love. The Destruction of an
Ojibwa Community." New Haven: Yale University Press.

Weaver, Sally M.
1981 Making Canadian Indian Policy. The Hidden Agenda
1968 - 70. Toronto: University of Toronto Press.

White Paper
1969 Statement of the Government of Canada on Indian Policy.
Department of Indian Affairs, Ottawa.

INDIAN ARTISTS' STATEMENTS THROUGH TIME[1]

by

Viviane Gray[2]

FORWARD

This essay deals only with the visual arts and not the performing and literary arts of the First Nations; but whenever appropriate, all of these art forms were mentioned. The words Native, Indian, and First Nations are used interchangeably.

It is difficult to categorize the native Indian artists by nationality (Canadian, American, etc.) as some cited in this essay belong to tribal groups that straddle the two countries and do not affiliate themselves with either of the Euro-defined countries.

Throughout the twentieth century, native Indian artists in Canada communicated strong messages through their art. Expressing their tribal aesthetics or social or political views, the message was always different from that of other Canadian artists. It was based on their common ancestry as people of the First Nations of the Americas.

The varied artistic expressions of the artisans, sculptors, painters, photographers, printmakers, and installation and performance artists were only some of the means that enabled Native artists to communicate points of view that spanned personal human experiences, tribal beliefs and traditions, and current global issues.

In some cases, Native artists' work revealed a traditional style and form, or a very modern non-Native approach and form of aesthetics. Whatever the case, native Indian artists always demonstrated a cohesiveness that will be characterized in this essay as the integral element of the Indian Art Movement-a movement that has sustained its distinctiveness through time.

A SENSE OF TIME AND PLACE

The question of "who we are and where we come from" has never troubled the people of the First Nations. Tribal knowledge is essential to the survival and growth of Native Americans. Our history is alive through our languages and in our oral tradition. Our social order, though changed by the everpresent Euro-society, maintains its essential systems, such as Native metaphysics and

aesthetics, most apparent in visual statements by the people of the First Nations.

Canadian history reveals that even though the First Nations were excluded from the Canadian power structure, they never abandoned their traditional diplomatic system of sharing their views with Canadians and the rest of the world. This sharing is particularly evident in the field of native Indian visual art.

Prior to the 1940s works of art by the First Nations were looked upon merely as curiosities but this attitude toward especially works from the Northwest Coast had begun to change with the anthropological studies by Franz Boas in the early 1900s. The notable scholar of Northwest Coast art and culture Bill Holm refers to the early interest in Northwest Coast art in the 1940s in his collaborative publication with Northwest Coast Haida artist Bill Reid, Form and Freedom: A Dialogue on Northwest Coast Indian Art.[3]

According to Holm, a group of Surrealists living in New York in the 1940s-Max Ernst, André Bréton and others-discovered the artistic merits of Northwest Coast art sold in a shop on Third Avenue. This interest prompted Ernst and Barnett Newman to develop the exhibition Northwest Coast Indian Painting, with a catalogue, for the Betty Parsons Gallery in New York.[4] This exhibition recognized Indian-made objects for their beauty and aesthetics-as works of art.

Any student of twentieth century Indian art recognizes that Indian art existed prior to European contact. The First Nations always had the elements of artistic expression and visual aesthetics in their cultures. What was new in the development of native Indian art in the twentieth century was the interest in and recognition of Native art by a non-Native public.

This interest enabled the native Indian artists to show and sell their works to a new public, one beyond their own people. Indian artists quickly recognized the benefits of this phenomenon and took advantage of this opportunity to communicate not only their tribal aesthetics but all aspects of Indian realities. This essay will show those various statements made by the artists of the First Nations in Canada.

With the interest in native Indian cultures in the early 1900s, especially in the Northwest Coast cultures, it was not difficult to find statements made by Indian artists. The postwar period, which included the phenomena of global expansion and technological advances in communications, had its impact on the native Indian community.

Many of the First Nations took part in the two World Wars, and many of these people had to "enfranchise" or forfeit their Indian status to be part of the Canadian military. This forfeiture produced a whole new social structure that would not only result in the fracture of the traditional groups but also enrich the people of the First Nations with a whole new system that would blend the traditions of the First Nations with those of the European world. Their families would become the "urban Indians" or those Native people who lived off-reserve, usually near towns and cities.

Today, Indian artists' views are apparent not only in their works which have been given exhibition opportunities, but also in newspaper and magazine reviews, and in feature interviews for television and film. There are also an increasing number of Canadian and American publications by and about Indian artists. As well, many Canadian and American colleges and universities now include Indian Art courses in their curricula.

The difficult task in this essay was to choose those statements that best represent the native Indian artists of the twentieth century. The choice was based on two criteria. First, only those artists that had made some impact on the development of contemporary art in Canada were chosen; and second, only statements relating to this impact were chosen.

The survey of the artists' statements revealed a number of points in the study of contemporary Canadian Indian art. The most obvious was the shared concern in Native consciousness that permeated their philosophies, their aesthetics, and their worldview.

The artists' statements also addressed the fundamental question of Indian art by defining it and analysing its development. It is apparent that the artists of the First Nations have always understood their place in the sphere of contemporary Indian art.

Some artists describe themselves as "traditionalists" while others feel comfortable in contemporary art. Through their statements, native Indian artists not only conceptualize and verbalize their visions but place these visions in a context that has directed them onto the path of an Indian artists' movement.

SILENT STATEMENTS

There were and still are many Indian people who have demonstrated throughout their daily lives a strong belief, courage, and ability to pursue actions that would transmit their statements through time. The actions of such people who have silently

demonstrated these strengths and abilities are seen in the lives of two artists, namely, the Huron painter Zacharie Vincent, and Kwakiutl artist Willie Seaweed.

Zacharie Vincent (1812 - 1886), a Huron from Lorette, Quebec, was a recognized nineteeth century Canadian painter. His genre style included the lifestyle of the Huron of Lorette (near Quebec City): but his legacy was the self-portrait showing a proud man in tribal costume and everyday clothing. He interpreted a man who was not afraid to show his identity-a poor man who had dignity as an Indian (fig. 1).

Vincent's influence has remained untapped except for historic contributions to Canadian art. He is mentioned in Canadian art-history textbooks, and students of Canadian art are aware of his short career as a painter. It is however, not until 1986 that we find his spirit reappearing through the serigraphs of Huron artist Pierre Sioui (fig. 2).

The turn of the century was not a favourable time for Native people in Canada. Their communities were being set up on "reserved lands" or reservations across Canada. The British Columbia Indians were the last group introduced to this new system. Missionaries were in charge of educating Indian people, and numerous reports indicate Indian people were made to feel ashamed of their language, beliefs, and customs-beginning a long period of imposed assimilation.

Willie Seaweed (1873 - 1967) was Kwakiutl from the northeastern part of Vancouver Island in British Columbia. His long life enabled him to see numerous changes in his tribal group. The most drastic change in his community was the passing of a law in the Canadian parliament in 1884 outlawing the potlatch-the traditional Kwakiutl ceremony that redistributed wealth and maintained social rank and order. Despite this ban, clandestine efforts by the Seaweed family continued the practice of traditional ceremonies. Because of his carving abilities and his social skills as storyteller and dancer, Willie Seaweed contributed immensely to the continuation of the potlatch.

He was known as an "active potlatcher" at a time when he could have been imprisoned for participating in an outlawed activity. The Kwakiutl credit Willie Seaweed for the survival of the potlatch, knowledge of the artistic forms and oral traditions associated with this traditional ceremony.

ART AND THE SOCIAL MESSAGE

All forms of material culture are made for a purpose, and their aesthetics convey a message to the user and to the viewer. From

Fig. 1. Zacharie Vincent
(1812 - 1886), anonymous
photograph. Collection
initiale des Archives
nationale du Québec à
Québec.

Fig. 2. Pierre Sioui,
Regard Interieur (1985),
no. 12, (72.5 cm x 57.5
cm), Department of Indian
and Northern Affairs
Collection, Ottawa.

the practical items to the more elaborate ceremonial pieces, form
and aesthetics contribute to the overall effect and purpose of
the piece. For instance, in the Northwest Coast Indian cultures
"Button blankets are a legitimate and unique form of narrative
text...."[5]

Tahltan/Tlingit artist Dempsey Bob explains the meaning of
the traditional button blanket:

> When we wear our blankets, we show our face.
> We know who we are and where we come from.
> When we dance, we share part of our history
> with our people. It's more than just what
> you see when you look at a blanket. To us,
> it has so much meaning. The blankets become
> very personal.[6]

Today, Indian artists make strong statements through their
visual expressions. One example of a young artist whose work
effects the public through his strong and concise imagery is
Lance Belanger, painter from the Maliseet tribal group in
Tobique, New Brunswick.

His realistic painting The Good Doctor's Bedside Manner
portrays a real-life incident of a young Indian woman from
western Canada who was sewn up after a stomach operation. The
"beaded stitches," according to Lucy Lippard of the Village
Voice, "stands as a not-so-subtle metaphor of the extraordinary
callousness and cruelty that mark the anglo North American
approach to Native American people and cultures"[7] (fig. 3).

INDIAN ART ACCORDING TO INDIAN ARTISTS

The survey of Indian artists' statements since 1945 has shown
that Native artists made every attempts to address Indian art in
their own words and on their own terms:

> I'd like to take the time to briefly examine
> some of the problems that I've encountered in
> attempting to produce my work.... Totems were
> our daily fare, they bought our clothing and
> furnished our food. There was no problem of
> sale, since his [Charlie James's] work was
> eagerly sought. Now the situation is
> different. Curio dealers have so cheapened
> the art in their efforts to satisfy their
> desire for profit, that I doubt if one could
> find a single household where the
> authenticity of the work is important to
> them. I have striven in all my work to

> retain the authentic, but I find it difficult
> to obtain even a portion of the price
> necessary to do a really fine piece of work.[8]

Ellen May Neel (1916 - 1966), a Kwakiutl artisan of Alert Bay, British Columbia, who produced silk-screened designs on cloth scarfs, spoke these words at a conference held at the University of British Columbia in 1948. Her grandfather was the well-known carver Charlie James. Her dramatic presentation and appeal convinced the city of Vancouver to allow Indian artists and artisans the opportunity to create and sell their works in Stanley Park, and to control the creation and the sale of the works.

In the 1940s a Nootka artist, George Clutesi, from the Alberni Valley in British Columbia, was among the first people in the post-Second World War period to gain recognition for cultural interpretations by Indians themselves. For a long period of his life, Clutesi worked as a fisherman and a piledriver until he broke his back. His long period of convalescence provided him the time to express himself as an artist and author (Son of Raven, Son of Deer: Fables of the Tse-shaht People [1967], and Potlatch [1969], and later as an award-winning actor.

Clutesi provided generations of Indian people with inspiring words relating to creativity:

> So often the white man won't even ask the
> advice of an Indian. White educators don't
> seem to take us seriously. But there is a
> solution. We must start hitting back, by
> trying a lot harder. We must say to the
> white man. I don't care what you think.
> This is what I can produce, write or paint.[9]

The Indian and non-Indian people of Canada will miss the warmth and humour of this man. Clutesi died during the late winter of 1988 at the age of 83 years.

WHAT IS INDIAN ART?

It is often said that there is no word for "art" in any Indian language. In any search for the ideal translation of the European concept "art," this proves true. One definition of "art" from a Native perspective was given by Métis author and actress, Maria Campbell. In her introduction to Achimoona, Campbell uses her knowledge of the Plains Cree language and provides us with just one version of what "art" is to the First Nations:

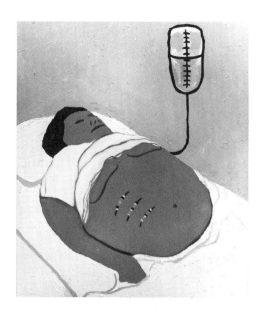

Fig. 3. Lance Belanger, The Good Doctor's Bedside Manners (1983), 91 cm x 76 cm. Department of Indian and Northern Affairs Collection, Ottawa.

Fig. 4. Sarain Stump, He Came Back (1969), 27 cm x 28.5 cm. Department of Indian and Northern Affairs Collection, Ottawa.

Fig. 5. Alex Janvier, Nobody Understands Me (1972), 92.5 cm x 122.3 cm. Department of Indian and Northern Affairs Collection, Ottawa.

the mind is called mon tune ay chi kun. Mom
tune ay chi kun is the sacred place inside
each one of us where no one else can go. It
is this place that each one of us can dream,
fantasize, create and, yes, even talk to the
grandfathers and grandmothers.

The thoughts and images that come from this
place are called mom tune ay chi kuna, which
mean wisdoms, and they can be given to others
in stories, songs, dances and art.

Stories are called achimoona, songs are
nugamoona, dances are neemeetoona and art is
tatsinaikewin. They sound almost the same,
don't they? That is because all these words,
describe gifts that come from the sacred
place inside.[10]

THE INNOVATORS

In the 1960s Canadians were introduced to the wondrous style of
Norval Morrisseau, Ojibway painter from the Lake Nipigon and
Thunder Bay district of northern Ontario. Morrisseau is
considered the founder of the Woodland School of Art, also known
as the School of Legend Painters-a popular style practised by the
Ojibway, Cree, and Algonquin of eastern Canada, notably in
northwestern Ontario/Manitoba regions. It was to become one of
the most popular styles in the Indian Art Movement.

In his book Legends of My People, The Great Ojibway (1965),
which contain his first illustrations, Morrisseau introduces
himself to the world:

I am Norval Morrisseau and my Indian name
is Copper Thunderbird. I am a born artist.
A few people are born artists and most
others are not, and it is the same with the
Indians.[11]

Morrisseau's candid assessment of himself as an artist and his
place in the world was made known to the public from the outset
of his career.

In 1979 Morrisseau again had the opportunity to address the
public in Jack Pollack's The Art of Norval Morrisseau; but this
time, his statement is backed by years of success and maturity:

I am a shaman-artist. Traditionally, a
shaman's role was to transmit power and

the vibrating forces of the spirit through
objects known as talismans. In this
particular case a talisman is something
that apparently produces effects that are
magical and miraculous. My paintings
are also icons; that is to say, they are
images which help focus on spiritual powers,
generated by traditional belief and wisdom.
I also regard myself as a kind of spiritual
psychologist. I bring together and promote
the ultimate harmony of the physical and
the spiritual world.

My art speaks and will continue to speak
transcending barriers of nationality, of
language and of other forces that may be
divisive, fortifying the greatness of the
spirit which has always been the foundation
of the Great Ojibway.[12]

The sixties and seventies were periods of considerable
change for Indian people in Canada. There was a growing
consciousness of Indian power. This was most apparent in the
political Indian organizations. In 1969 Harold Cardinal, Cree
spokesman for the Alberta Indian Association, published his first
book, The Unjust Society-The Tragedy of Canada's Indians, which
addressed the issue of self-determination of Canada's Indian
people. In 1974 George Manuel, past president of the National
Indian Brotherhood, now the Assembly of First Nations, coauthored
The Fourth World-An Indian Reality with Michael Posluns.

In the art world, Indian artists began publishing not only
their art but also their prose and their poetry. Sarain Stump
(1945 - 1974), a Cree-Shoshone who moved from Wyoming to Alberta
in the late sixties published his poetry and drawings in There is
My People Sleeping (1970; fig.4). His influences included the
European artist Pablo Picasso, and the Indian artist and writer
George Clutesi. In turn, Stump influenced many contemporary
Indian artists:

And there is my people sleeping
since a long time
But aren't just dreams
The old cars without engine
Parking in front of the House
or angry words ordering peace of mind
or who steals from you for your good
and doesn't wanna remember what he owes
you
sometimes I'd like to fall asleep too

 close my eyes on everything
 But I can't
 I can't.[13]

THE INDIAN GROUP OF 7

In 1972 a group of Indian artists formed a group who called
themselves the "Group of 7" after the famous Canadian "Group of
Seven." The Indian "Group of 7" included Alex Janvier, Daphne
Odjig, Norval Morrisseau, Jackson Beardy, Carl Ray, Eddy
Cobiness, and Joseph Sanchez. They usually met in Jackson
Beardy's studio or in Odjig's "little craft shop" that later
became the Warehouse Gallery in Winnipeg, Manitoba, to discuss
each other's works and upcoming exhibitions. The group quickly
dissolved; but alliances remained, especially between Beardy,
Janvier, and Odjig, who took part in an innovative exhibit Treaty
Numbers 23, 287, 1171-Three Indian Painters of the Prairies at
the Winnipeg Art Gallery in 1973.

 A notable artist of this period was Alex Janvier, a
Chipewyan of Cold Lake, Alberta. Through a career that began in
the early sixties, his artistic skills and hard work led him to
become one of Canada's most successful and recognized artists.
Janvier has exhibited internationally. His formalist style as a
painter is unique and his achievements immeasurable. His
explicit individuality, and his impressive career, have impressed
and influenced many young Indian artists.

 In September 1985 Janvier was one of three Canadian artists
chosen to tour China under an External Affairs Canada Council
programme.

 The following statement best represents Janvier's views on
being an artist. It was made in 1976 in an Artist Résumé that he
sent to the Department of Indian and Northern Affairs (fig. 5):

 Art, to me, cuts down barriers between the
 have and have not.... It is an ideology
 that lives on, and surpasses many civilizations.
 It is old, but new, born every time the
 artist brings it back to life. I wish
 well to all other fulltime artists for following
 a difficult trail and pity for those who deny the
 courage to paint today-fully. I hope this
 message will carry into the hearts of the
 next generation and the next who will enjoy
 doing their "thing" regardless who teaches
 otherwise, than "Be Yourself."[14]

Daphne Odjig is Potawatomi from Manitoulin Island, Ontario. In 1978 she was commissioned by the then National Museum of Man to paint a large mural. The result was a painting entitled The Indian in Transition, measuring 9 by 27 feet, documenting the ravages of social injustice, political oppression, and the cultural deprivation of Canada's Native people.

Jackson Beardy (1988 - 1984) was a Swampy Cree from Island Lake, Manitoba. His short career as a painter, lecturer, and art administrator left its mark on Canadian Indian art. He was one of the few artists to analyze Native art on its own terms and not according to the rules and structures of European art.

In a review of his Ottawa exhibition Chains of Being, in 1977, Jackson Beardy (fig. 6) said:

> I think there are two types of artists.
> The first are totally involved with their
> native culture and are personally responsible
> to that culture. They are merely tools of
> their tribes, responsible for producing work
> of the highest possible calibre.
>
> The second group are not responsible to their
> tribes. They sell their Indianness first. If
> you're an Indian and an artist, you're not
> necessarily an Indian artist.
>
> I belong to the first category. I can't
> paint anything if I don't have the back-
> ground and the cultural knowledge to make
> it right. It wouldn't be fair to my people
> and it wouldn't be fair to the rest of Canada.[15]

Arthur Shilling (1941 - 1986) was an Ojibway painter from the Rama Reserve in Ontario. Unlike any other contemporary Indian artist, he painted people. (See fig. 7.) His portraits have been compared in style and technique to Rembrandt and Van Gogh. In his last publication, The Ojibway Dream, published posthumously in 1986, he reveals why he liked to paint his favourite subject matter-the Indian people:

> Most people I paint don't like themselves.
> I try to reveal their spiritual soul,
> the quietness that makes us different,
> that no other nation or people have. The
> echoes of a great past may be a new beginning,
> a new peace. Our souls and hearts can heal,
> and a new togetherness make our people proud,
> and in harmony again with the land.[16]

149

Fig. 6. Jackson Beardy,
<u>Balance in Nature</u> (1981), 41.5
cm x 53.3 cm. Department of
Indian and Northern Affairs
Collection, Ottawa.

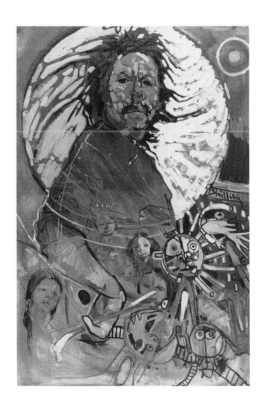

Fig. 7. Arthur Shilling,
<u>Self-Portrait</u>, taken from <u>The
Ojibway Dream</u> (c. 1986).
Estate of the late Arthur
Shilling, published by Tundra
Books, Montreal, Quebec, 1986.

Joe Jacobs is Iroquois of the Six Nations Reserve near Brantford in southern Ontario. Recognized as one of the most accomplished stonecarvers in eastern Canada, Jacobs was commissioned in 1985 by the federal government to produce a 15 by 15 feet relief in limestone for the Parliament Buildings in Ottawa. According to Jacobs, this was one of his greatest accomplishment since stone gave a form of permanency to the legends of his people (fig. 8).

THE 1980s-A NEW ERA

Canadian Indian art has taken on many new dimensions since its recognition by the non-Indian world in the 1940s. Artists like George Clutesi and Sarain Stump continue to have an influence on many artists today. Other living artists like Bill Reid, Alex Janvier, Daphne Odjig, Robert Davidson, and Norval Morrisseau, who began their careers in the fifties and sixties continue to gain world recognition.

It was not, however, until the 1980s that younger artists made a strong impact in Canadian art with their works of art, their words, and their actions. For this reason, they have not been included in the early part of this essay, since their strength and importance is more strongly felt today.

Blake Debassige is an Ojibway artist from West Bay in Manitoulin Island, Ontario. This young artist is an important leader in the contemporary "traditional" school of Indian art. His style has been largely influenced by the Ojibway "greats" Norval Morrisseau and Carl Ray. Debassige carries on the traditions of the Ojibway legend painters.

His enormous respect not only for the aesthetics of the Ojibway, but also for the spiritual and social rituals that are essential to the Anishnabe painters, have enabled him to gain the respect of his peers. In an age when being "modern" and "avant-garde" is synonymous with success, the actions of Blake Debassige are true statements of his beliefs.

The actions of one of Canada's most respected Indian artists, Bill Reid, a Haida carver, jeweller, and printmaker, have also emphasized the strength displayed by Canada's Indian artists.

In 1986 Reid, who for thirty years had worked as a successful artist, made an astounding political statement. He refused to have his commissioned work installed in the Canadian Embassy in Washington in a show of support for the Haida's move to save Lyell Island from the logging industry. In refusing to exhibit his work in the United States, he brought worldwide

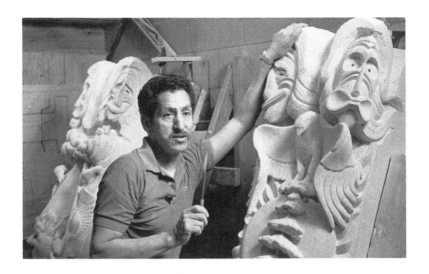

Fig. 8. Joe Jacobs at Curve Lake, Ontario. Photograph by Helena
Wilson, Toronto, c. 1985.

Fig. 9. "Quote the Raven-Carver, Never more!" cartoon by Roy
Peterson from the Vancouver <u>Sun</u>, April 1, 1987:B4.

recognition of the Lyell Island situation for his people. Roy Peterson of the Vancouver Sun quickly published a cartoon about Reid's actions. It is a spoof on the issue, juxtaposing Reid in place of Raven in one of his most recognized sculptures, the UBC-Museum of Anthropology's Raven Discovering Mankind in a Clamshell (fig. 9).

Since then, Reid completed the spectacular sculpture The Spirit of the Haida Gwai and it was installed at the new Canadian Embassy on Pennsylvania Avenue in Washington in late spring 1991.

THE MODERNISTS

A new group of artists making a tremendous impact on contemporary Canadian Indian art are those University of Ottawa art historian Jacqueline Fry calls the "modernists." They are a group of artists who have taken on distinctive directions in the Indian Art Movement.

These new group of artists are not afraid of breaking age-old tribal taboos. Being careful to respect sacred beliefs, the new artists are equipped to blend together the old traditions and their new knowledge of the modern world. They are usually educated in the areas of visual arts, art history, and art education and can compete with non-Indian artists in their respective fields: painting, sculpture, teaching, writing, and curating.

Artist-curator Robert Houle, former curator of contemporary Indian art at the Canadian Museum of Civilization, wrote about this new generation of Indian artists in The Emergence of a New Aesthetic Tradition in 1982:

> Today, there is an emergence of a new art by
> a new generation of young artists. These come
> from two different aesthetic traditions: North
> American and Western European. The former is
> deeply rooted in tribal ritual and symbolism;
> while the latter is an irreversible influence
> committed to change and personal development.
> This new art is traditional and contemporary in
> source. Also, it is innovative and sophisticated
> in style and technique.[17]

One of these artists is Bob Boyer, a Métis painter from Prince Albert, Saskatchewan. Boyer is assistant professor of art at the Saskatchewan Indian Federated College, University of Regina. In a recent publication that featured contemporary Canadian artists, Boyer was quoted about the global parallels he saw after his recent trip to Asia (fig. 10):

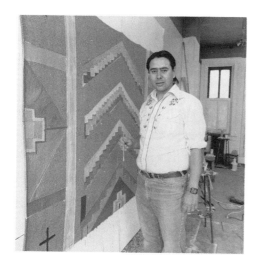

Fig. 10. Bob Boyer in his studio. Photograph by Don Hall. Courtesy of the Norman MacKenzie Art Gallery, Regina, Saskatchewan.

Fig. 11. Edward Poitras in his studio. Photograph by Don Hall. Courtesy of the Norman MacKenzie Art Gallery, Regina, Saskatchewan.

Fig. 12. Ron Noganosh.

> Throughout the world there are indigenous
> peoples who really do belong to the portion
> of the world they have occupied since time
> unremembered. For whatever reasons, we in
> this day and age do not have personal control
> over our persons, philosophies and lifestyles.
> This I believe permeates into the arts. Most
> indigenous artists are treated as anthropological
> playthings and are not thought of as valid
> artists.[18]

Edward Poitras is another modernist artist. He is a Métis
from Regina, Saskatchewan, and teaches at the Saskatchewan Indian
Federated College. He exhibits his installations and paintings
in Canada and throughout the world alongside other indigenous
contemporary artists and with non-Indian artists. His most
recent exhibition of works was at the prestigious Biennial at the
National Gallery of Canada in 1989 (fig. 11).

A new overview of Indian art is apparent in a statement made
by Poitras in New Work by a New Generation:

> I would like to suggest that a group of
> us malcontents get together and perform
> the sacred ritual of the Dadists for the
> origin of a new name. We will choose a
> new language that nobody can identify with
> and we will purchase a dictionary for it.
> We will shoot an arrow at this dictionary
> and the word upon which the tip of the
> arrow touches will be our new name. This
> will give us the freedom that we need,
> because nobody will know what to expect.[19]

Poitras credits Sarain Stump's art and poetry as his main
influence. Poitras' unusual approach to art has forced art
critics to view Indian art more seriously and more critically
than was done in the past. He is seen as a major impetus to the
contemporary Indian art movement.

Ron Noganosh, Ojibway artist from the Magnetawan Reserve in
northern Ontario, is another outstanding contemporary Indian
artist (fig. 12). He works primarily with discarded objects,
making us aware of our wasteful consumerist mentality. His works
focus on environmental issues that confront present and future
society. In It takes Time, now in the collection of the Canadian
Museum of Civilization, and which features an old dirty toilet
that catches water streaming from the planet earth, represented
by a globe, Noganosh says: "I think that it is every person's
responsibility to be ecologically responsible and I believe that
this piece conveys that thought.[20]

One of the most vocal of contemporary Indian artists is Lance Belanger, a young painter from the Maliseet tribe in Tobique, New Brunswick. His comments range from personal views on his own artistic development to tribal concerns. He makes reference to Indian women's issues, political issues like the Constitutional Talks during the early 1980s, and the redefinition of Native aesthetics in the modern period. This statement stands as the strongest of statements made by a contemporary Indian artist:

> I have a strong belief in a new Indian aesthetic.
> This aesthetic that narrates the past and more
> importantly the present socio-political
> sensibilities of Canada's Aboriginal people.
> While I am aware that mass media and
> government restraint can limit what we have
> to say about ourselves as the First People
> of Canada, I realize that our art can convey
> that which we are and what we have to say
> about ourselves and events around us.
> Through the work of contemporary Aboriginal
> artists, the unique positions of Canada's
> aboriginal peoples can be realized in a
> forceful and effective way. Through our
> art we will gain the recognition and
> respect from all other peoples of the
> world for the strength and beauty that we
> are.[21]

Carl Beam, Ojibway from West Bay, Manitoulin Island, Ontario, is the driving force among the Indian "modernist" artists. In 1985 his The North American Iceberg was the first work of art by a native Indian artist to be accepted by the National Gallery of Canada.

Carl Beam is known to his peers as an artist who is never at a loss for words, and it was difficult to choose the most appropriate statement by this illustrious artist. The following statement was made in 1981 during an interview with Trish Wilson for the Kitchener-Waterloo Record in which he reiterates Belanger's message about art's universality (fig. 13).

> I'm trying to deal with the native tradition
> in an ongoing way. I'm just trying to add
> to the iconography of art. I operate from an
> Indian background the same way that a Polish
> person operates from a Polish background. I
> would just like to see the same latitude of
> artistic expression extended to me.[22]

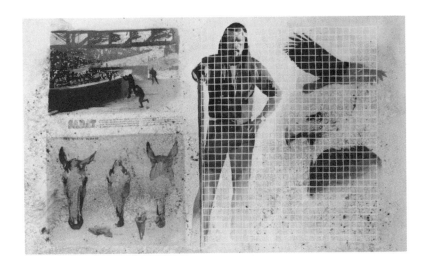

Fig. 13. Carl Beam, <u>The Artist And Some Of His Concerns</u> (1983), 101.6 cm x 150.7 cm. Department of Indian and Northern Affairs Collection, Ottawa.

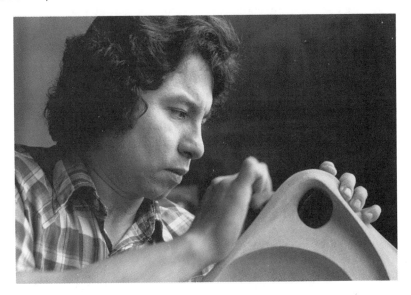

Fig. 14. David General in his studio in Oshwegan, Ontario. Photograph by Helena Wilson, Toronto, c. 1985.

IT'S ALL UP TO US

What is the future of Indian art? This will depend on future
generations of Indian artists. Will they be inspired by the past
artists and the developments they have made in the Indian art
movement? As is the case of all social phenomena, the future of
Indian art will depend on the communication that exists between
the artists and the rest of the world. Indian art will always
have the strength of the tribal ways to keep it in balance, but
there will also be the counter-balancing action of the strengths
of the other cultures.

The following statements were chosen to demonstrate the
continuing struggle faced by the artists of the First Nations to
define and maintain control of their place as artists in the
constantly changing world, especially as we enter the last decade
of the twentieth century.

Robert Davidson is a Haida carver and jewellery-maker who
apprenticed early in his career with renowned Haida artist
Bill Reid. He had been first taught by his father Claude Davidson
and his grandfather Robert Davidson. His views reflect an intense
concern for his tribal group and his own perceptions as an artist
and are reminiscent of those early words pronounced in 1966 by
another Northwest Coast artist, George Clutesi:

> I feel that we have been defined for
> generations by the white people,
> almost since day one, and now it's up
> to us to define who we are. When we are
> setting standards in art forms, it should
> come from us.[23]

David General is an Iroquoian sculptor from the Six Nations
Reserve in Ontario. He is very active in pursuing the
development of aesthetic standards in his own work as well as his
ongoing interest in generating national and international
communication for Canadian Indian artists as the past president
of the Society of Canadian Artists of Native Ancestry (SCANA).
He exhibits in Canada, the United States, and throughout the
world (fig. 14).

At the Fourth National Native Indian Artists' Symposium in
Lethbridge, Alberta in 1987, General delivered a paper entitled,
"Would It Carry More Weight If It Were Written In Stone?" This
is an excerpt from his presentation:

> The artist of native ancestry is no different
> than his counterparts throughout the world.
> We are always looking for "more." If we give
> "more," we expect "more." Sometimes, the means

of achieving this becomes a greater pre-
occupation than the necessity for our
creativity. We seek the opportunities to
define the realm of our interests, studies,
experience and work. We are individuals
pursuing recognition and distinction by
asserting our intellect, experience and
technical proficiency. When our efforts go
unnoticed, frustration and futility may set
in. It is difficult to know how to alter
attitudes and perceptions when the tools of
your profession are a paint brush, curve
knife or a chisel.[24]

Today, artists of the First Nations have access to a wide
variety of artistic media with all the advantages of advanced
technology. This will enhance not only their creativity but also
their chances of being heard. For example, in the 1990 - 91
National Art Acquisition Jury for the Indian Art Centre's
National Indian Art Collection of the Department of Indian and
Northern Affairs in Ottawa, many of the Native artists
complemented their entries with self-made videos about their
works of art.

The video productions became very personal studio-visits
with these artists. They were able to provide details about
their works, techniques, medium, and to speak on the content of
their works. These videos will be invaluable to the students of
Indian art and to interested art and museum curators.

In many cases, the "studio-visit" videos were "works of art"
and copies will be purchased to complement the Indian Art
Documentation Centre at the Department of Indian and Northern
Affairs-a centre that was started twenty-five years ago by well-
known Native artists, Alex Janvier and Tom Hill.

The artists of the First Nations are supported by a long
traditional history. The recognition of Indian art or the art of
the First Nations in the modern world of the twentieth century
has taken well over a hundred years. Indian artists are now
found in the National Gallery of Canada alongside their
contemporaries. More and more Native artists are collaborating
with non-Native artists in exciting and innovative art
exhibitions and performances in Canada and throughout the world.
Indian Art is finally being recognized as a valid part of
contemporary art in this changing world.

Tepiag.[25]

NOTES

1. This essay was originally written for the German published catalogue for the international exhibition In the Shadow of the Sun in 1989. However, due to an unfortunate series of events, it was not included in the German edition.

The summer of 1990 the political coup by Manitoba's Native member of the Legislative Assembly (MLA), Elijah Harper, and the Mohawk barricades in Kenasatake (Oka) and Kanawake showed the world that the spirit of Canada's First Nations is alive and well. Native people are finally speaking out in more forceful terms to defend their human and cultural rights.

Indian visual and performing artists and writers have also taken a stand against any form of appropriation of their Native culture, whether it be of the living arts or of aboriginal cultural ways.

This essay was written in close consultation with many of the Native artists cited in this essay. 1 wish to thank those artists and especially the members of the Society of Canadian Artists of Native Ancestry (SCANA) and the Society of Yukon Artists of Native Ancestry (SYANA) for their constant support in the publication of this essay in its original version.

2. Viviane Gray, a Migmag from the Listuguj (Restigouch) Band, Quebec, is an artist with experience as an art educator, curator, and writer and is presently manager of the Indian Art Centre and the National Indian Art Collection of the Department of Indian and Northern Affairs, Ottawa.

3. Bill Holm and William Reid, Form and Freedom-A Dialogue on Northwest Coast Indian Art (Houston, Tex.: Rice University, Institute for the Arts, 1975).

4. Ibid, 9 - 10.

5. Doreen Jensen and Polly Sargent, Robes of Power: Totem Poles on Cloth (Vancouver, BC: University of British Columbia Press, UBC Museum of Anthropology, 1986), 2.

6. Ibid, 6

7. Lucy R. Lippard, "Native Intelligence," Village Voice (December 27, 1983).

8. Hawthorne, H.B., ed., Report of Conference on Native Indian Affairs sponsored by the British Columbia Arts and Welfare Society at the Provincial Museum, Victoria, BC, April 1 - 3, 1948.

9. Ed Gould, "George Clutesi, Artist Gentleman," Victoria, BC Colonist (March 22, 1966).

10. Maria Campbell, Achimoona (Saskatoon, Sask.: Fifth House, 1985).

11. Norval Morrisseau, Legends of My People-The Great Ojibway, Selwyn Dewdney, ed. (Toronto: Ryerson Press, 1965), 1.

12. Jack Pollack and Lister Sinclair, The Art of Norval Morrisseau (Toronto: Methuen Press, 1979), 7.

13. Sarain Stump, There is My People Sleeping (Sidney, BC: Gray's Publishing Ltd., 1970).

14. Alex Janvier, "Be Yourself," artist résumé, Indian Art Centre, Department of Indian and Northern Affairs, Ottawa, 1976.

15. Kathleen Walker, "Artist Keeps Legends Alive," Ottawa Citizen (November 25, 1977).

16. Arthur Shilling, The Ojibway Dream (Montreal, Que.: Tundra Books, 1986), 22.

17. Robert Houle, "The Emergence of a New Aesthetic Tradition," in New Work by a New Generation (ex. cat.; Regina, Sask.: University of Regina, Norman Mackenzie Art Gallery, 1982), 2.

18. Norman Zepp and Michael Parke-Taylor, The Second Generation: Fourteen Saskatchewan Painters (ex. cat.; Regina, Sask.: University of Regina, Norman MacKenzie Art Gallery, 1985), 29.

19. New Work by a New Generation, 63.

20. Ron Noganosh, artist's statement, Indian Art Centre, Department of Indian and Northern Affairs, Ottawa, 1985.

21. Lance Belanger, artist's statement. Indian Art Centre, Department of Indian and Northern Affairs, Ottawa, 1983.

22. Trish Wilson, "Native Art Notions," Kitchener-Waterloo Record (May 13, 1981).

23. National Native Indian Artists' Symposium, August 1983, 'Ksan, BC.

24. David General, "Would It Carry More Weight If It Were Written In Stone?" Fourth National Native Indian Artists' Symposium, July 1987, Lethbridge, Alberta.

25. Tepiag in Migmag (Micmac) means "it is enough, sufficient" and is the traditional orator's way of ending a story or speech.

BIBLIOGRAPHY

Campbell, Maria
1985 "Introduction," <u>Achimoona</u>. Saskatoon, Sask.: Fifth House, 1.

Cardinal, Harold
1969 <u>The Unjust Society-The Tragedy of Canada's Indians</u>.
Edmonton, Alta.: M.G. Hurtig Ltd.

Clutesi, George
1967 <u>Son of Raven, Son of Deer: Fables of the Tse-shaht People.</u>
Sidney, BC: Gray's Publishing Ltd.

1969 <u>Potlatch</u>. Sidney, BC: Gray's Publishing Ltd.

Dinniwell, Norma and Tom Hill
1985 <u>From Masks to Maquettes</u> (featuring Vincent Bomberry,
Benjamin Thomas, David General, Jacob Thomas, Joseph Jacobs, and
Duffy Wilson). Ex. cat.; London, Ont.: University of Western
Ontario.

Fry, Jacqueline
1972 <u>Treaty Numbers 23, 287, 1171: Three Indian Painters of the
Praries</u>. Ex. cat.; Winnipeg, Man.: Winnipeg Art Gallery.

General, David
1987 "Would It Carry More Weight If It Were Written In Stone?"
Fourth National Native Indian Artists' Symposium, July 1987,
Lethbridge, Alberta. Unpublished paper.

Gould, Ed
1966 "George Clutesi, Artist Gentleman." Victoria, BC <u>Colonist</u>
March 22, 1966.

Hawthorne, H.B., ed.
1948 <u>Report of Conference on Native Indian Affairs</u> (sponsored by
the British Columbia Arts and Welfare Society). Victoria, BC:
Provincial Museum. April 1 - 3, 1948.

Holm, Bill and William Reid
1975 <u>Form and Freedom-A Dialogue on Northwest Coast Indian Art</u>.
Houston, Tex.: Rice University Press.

1983 <u>Smokey-Top: The Art and Times of Willie Seaweed.</u>
Vancouver/Toronto: Douglas and McIntyre.

Houle, Robert
1978 "Odjig: An Artist's Transition." <u>Native Perspective</u> 3
(2):42 - 46.

1982 New Work by a New Generation. Ex. cat.; Regina, Sask.:
University of Regina, Norman Mackenzie Art Gallery. July 9-
August 29, 1982.

Hughes, Kenneth James
1979 Jackson Beardy-Life and Art. Canadian Dimensions.

Janvier, Alex
1976 "Be Yourself." Artist Résumé, Indian Art Centre,
Department of Indian and Northern Affairs, Ottawa.

Jensen, Doreen and Polly Sargent
1986 Robes of Power: Totem Poles on Cloth. Vancouver, BC: UBC
Press/UBC Museum of Anthropology, 2.

Johnson, Eve
1982 "Masked Resurrection," Equinox July/August 1982:84 - 99.

Lippard, Lucy R.
1983 "Native Intelligence," Village Voice December 27, 1983.

Manuel, George and Michael Posluns
1974 The Fourth World-An Indian Reality. Toronto, Ont.:
Collier-Macmillian Canada Ltd.

McLuhan, Elizabeth
1984 Altered Egos-The Multimedia Work of Carl Beam. Ex. cat.;
Thunder Bay, Ont.: Thunder Bay National Exhibition Centre for
Indian Art.

Morrisseau, Norval
1965 Legends of My People-The Great Ojibway. Selwyn Dewdney,
ed. Toronto, Ont.: Ryerson Press, 1.

National Native Indian Artists' Symposium
1983 "August, 'Ksan BC" Unpublished transcript, Indian Art
Centre, Department of Indian and Northern Affairs, Ottawa.

Noganosh, Ron
1985 Artist's Statement. Indian Art Centre, Department of
Indian and Northern Affairs, Ottawa.

Pollack, Jack and Lister Sinclair
1979 The Art of Norval Morrisseau. Toronto, Ont.: Methuen
Press, 7.

Scott, Jay
1985 "I Lost It At The Trading Post." Canadian Art winter
1985:33 - 39.

Shilling, Arthur
1986 The Ojibway Dream. Montreal, Que.: Tundra Books, 22.

Sioui, Anne-Marie
1981 "Zacharie Vincent: Une Oeuvre Engagée?" Recherches
Amérindiennes au Québec XI(4):335 - 337.

Southcott, Mary E.
1984 The Sound of the Drum-The Sacred Art of the Anishnbabec.
Erin, Ont.: The Boston Mills Press.

Stump, Sarain
1970 There Is My People Sleeping. Sidney, BC: Gray's Publishing
Ltd.

Walker, Kathleen
1977 "Artist Keeps Legend Alive." Ottawa Citizen November 25,
1977.

Wilson, Trish
1981 "Native Art Notions." Kitchener-Waterloo Record, May 13,
1981.

Zepp, Norman and Michael Parke-Taylor
1985 The Second Generation: Fourteen Saskatchewan Painters. Ex.
cat.; Regina, Sask.: University of Regina, Norman Mackenzie Art
Gallery, 29.

THE ART OF CANADA'S INDIANS AND THE MODERN AESTHETIC

by

Gerhard Hoffmann

INTRODUCTION: Indian Artists and the International Art Scene

The art produced by twentieth century Canadian Indians is not isolated ethnic art but art that is created within the framework of the contemporary Canadian cultural, social, and economic milieu. The highly diversified milieu of the modern/postmodern world inevitably entertains not one, but a variety of analytical frameworks. In fact, no fewer than three such frameworks, each of which influences and interacts with the other two, must be taken into consideration: Indian traditions, the Canadian art scene, and Western mainstream culture.

Indian traditions, the old cosmologies, social structures, and cultural forms of expression are being threatened and altered by acculturation; since the sixties however, they have been variously renewed or reevaluated, in part in the form of a pan-Indian movement.

With its technological-bureaucratic administrative structures, its social, economic, and cultural organizational forms, and its network of stable and changing ideological positions, the dominant white world in Canada determines the modern civilizational milieu in which Indian artists, too, must assert themselves if they desire recognition beyond their own tribal and regional spheres.

Canada is part of the Western world and its cultural traditions and, as a result both of the mobility typical of today's world and of our global system of communications, is a direct participant in the international intellectual trends of our time, in the cultural developments and changing styles that are also reflected in the art market.

This essay deals with the international framework of which Indian art is a part and, specifically, with the influence of modernism and the incorporation of modern forms of aesthetic expression. The modern aesthetic (which must be differentiated from "modern" trends in government, society, technology, etc., which it often negates) is today being supplemented and in many cases superseded by a postmodern - in part, anti-modern - civilizational and aesthetic environment which, since the sixties at least, has increasingly shaped our perceptions. In other words, our present-day attitude towards modernism is always determined to some extent by the postmodern attitude. The modern aesthetic, which had wrought its essential changes by 1930 and then continued to produce variations on them in the late-modern period, is now a historical phenomenon. Its dogmatic claims to

being an exclusive imparter of meaning and definition have been relativized by change.

On the other hand, postmodernism is more than just a break with modernism and with that movement's new approach and thinking in terms of totalities. Postmodernism also incorporates elements of continuity, representing as it does the further development and radicalization of the positions and formal inventory of modern art. Postmodernism is therefore understandable only against the backdrop of modernism. It conceptualizes, so to speak, modernism as a uniform phenomenon, in order to contrast itself with modernism, take an ironic view of it, play with it, and also, abandoning the centred vehicles of aesthetic order, celebrate a liberation of consciousness and imagination. The postmodern aesthetic is pluralistic and eclectic. The transition from modernism to postmodernism is not irreversible, though. Postmodern artists, too, have at their disposal the strict aesthetic positions of unity and totality, aesthetic "purity," and the necessary concordant form - no longer as an indispensable "either/or" requirement, however, but as one (historically viewed) possibility among others.

Because of this interdependence of modernism and postmodernism, it appears advisable in the present essay to deal with modernism and its significance for Indian art without considering postmodern positions in detail, and to take the opposite approach in another essay, that is to deal with postmodernism as the successor to modernism. Only in this way can contemporary Indian art adequately be described. It did not blossom in Canada until the sixties, a time when late-modern and postmodern attitudes and forms of expression already overlapped and were simultaneously accessible to the artists of the day. Modernism's influence on Indian art is obvious; in dealing with the relationship between the modern aesthetic and Indian art, reference shall also be made to parallel developments in Indian art in the USA.

What is aimed at here is a discussion of the relationship between the art of the Native minority and the art of the majority. For this purpose, the Western world will be treated as a single intellectual unit - despite the relativization of the concept of wholeness, which, except for specific types of discourse, appears to be a mere thought-construct; despite all the differences in goals, traditions, and institutions that distinguish Canadian from American society, for example, or North American from European society (or the various European nations from one another); and also despite a clearly visible loss in terms of shared cultural integrative power. If we consider the intellectual history that has led to modernism and postmodernism, it still seems meaningful to use a comprehensive notion like "Western art"[1] - at least as a heuristic construct for analytical purposes - in part because this notion itself has evolved into a historical concept and has determined developments that have manifested themselves as assimilation pressures on minorities.

A concept like "Western art" does not say as much about geography, though, as it does about a cultural mentality, a concept of attitudes and convictions that change, of course, yet precisely in the process of artistic transformation - in the continual suppression of old by new - constitute a recognizable, albeit disputed, collective whole, one that has been variously interpreted and defined in the power struggle waged between the various trends and movements, a whole that simultaneously exhibits continuity and discontinuity, adaptation and conflict. The idea of the whole has shaped the aesthetic of modernism and as such has created realities, as, for instance, artistic programs and aesthetic works that in turn have been influential - and therefore consequential - for the development of artistic production in our time. In postmodernism, this notion of the (aesthetic) whole dissolves in a confrontation of Same and Other. The concepts (and realities) of Same and Other must needs form the decisive frame of reference for an examination of Indian art in the context of postmodernism. This will be discussed in greater detail later.

Indian art is directly affected by the aforementioned cultural trends of the twentieth century, however we may choose to label them. It was in fact modernism and postmodernism that created the prerequisites for understanding what was deprecatingly called "primitive" art to begin with, later primal art, and which is now also referred to as ethnic art. Thus it becomes important to discuss the problematic aspects of the concept of understanding. At the same time, any such discussion must also focus on the interrelation of the modern aesthetic and "primitive"/primal art.

CONCEPTS OF AFFINITY, UNIVERSALITY AND UNDERSTANDING

In broaching the subject of the relationship of modernism and postmodernism to "primitive" or primal art, a number of notions are touched upon that are explicitly or implicitly presupposed whenever the relationship between contemporary perspective and early stages of civilization, between the Eurocentric viewpoint and the cultures of the Third or Fourth World,[2] is at issue: (1) the belief in the *universality* of art; (2) the belief in the *affinity* of the modern for the primitive and *vice versa*; and, (3) the conviction that we as human beings are not only able, but are humanistically called upon to observe, to *understand* other cultures (past or present), to integrate them into our own understanding of history and thus to make them a factor in a comprehensive cultural consciousness, against a background of the origin or the general condition of humankind.[3]

A majority can take either of two contrasting approaches in an effort to understand something lying outside its own social, cultural, and aesthetic norms. Just as the members of a minority culture, a Fourth World culture, in their relationship to the dominant civilization, can accentuate either the aspects of

similarity and integration/acculturation, or the aspects of
difference and the distinctions between themselves and the
dominant civilization, so members of Western civilizations
likewise have the choice (subject of course to the restrictions
of historical circumstances and the spirit of the times) of
seeing "outsiders" from the point of view of continuity and
(universal) similarity or from the point of view of discontinuity
and racial and cultural differentness. The latter approach would
logically lead to an examination of minority art on a larger
scale, including the art of blacks, Latinos, Asian Canadians, and
Asian Americans, and Natives - that is Indians and Inuit.[4] This
essay concentrates on the specificity of Canadian Indian culture
as that of the first Americans, its Nativeness in Canada and the
United States, its orientation towards nature, and its own
endangered, but unbroken indigenous traditions.

The dialectic between Same and Other becomes important for
the acceptance of "primitive" art by the modern aesthetic. The
modern aesthetic introduced or prepared the way for a new,
positive view of folk art and the "naïve" art of primitive
peoples, and consequently of Indian art, too. In the wake of
Freud and Jung, myth was re-evaluated. Linking myth with the
human unconscious allowed those who followed Freud and Jung to
significantly relate primitive art, which often seemed to have
"mythic" characteristics, to the collective structures of the
human unconscious which in their turn have mythical traits. In
this way, the *diachronic* view, often proceeding on the assumption
that history is a continual "upward" development of the human
race, from a mythic and irrational level to a rational and
scientific one, was supplemented - and at times even supplanted
- by a *synchronic* view, a perception of various forms of thought
and feeling as simultaneous and mutually dependent or mutually
pervasive. The concrete-historical, contextual view and the
trans-historical, generalizing, panhuman view enter into a
conflict that becomes especially evident in the modern aesthetic.
Postmodernism, moreover, has introduced a third approach, a
radical deconstruction of Western concepts of thought and action
- notions like origin and progress, affinity and universality,
which appear as "allegories" of Western thinking.

As modern artists discovered artistic qualities in primitive
artifacts, especially masks and sculptures from Africa and
Oceania, and as they perceived the styles of these artifacts as
relevant to their own creative purposes, they viewed the pieces
as art, abstracting them from their tribal context (masks, for
instance, are part of dance and thus of ceremonial ritual) and
considered them not in the light of historical dissimilarity, but
solely in the light of *affinity* with the "primitive" in their own
unconscious - if they did not just take them as providers of an
arsenal of new forms. That is, modern artists took what was
essentially foreign to them and "understood" it as something akin
to their own experience and formal requirements, "translated" it
into their own categories of understanding and, using Western
concepts of humanity, domesticized it under the heading

universality. When John Sloan and Oliver La Farge organized the exhibition <u>Indian Tribal Arts</u> for the Museum of Modern Art in New York in 1931 - in their own words "the first exhibition of American Indian Art selected entirely with consideration of aesthetic value" - they presented the "tribal arts" as a naturally "modern" art form: "The Indian artist deserves to be classed as a Modernist, his art is old, yet alive and dynamic, but his modernism is expression of a continuing vigour seeking new outlets, and not like ours, a search for release from exhaustion."[5]

The cultural majority could also opt for the aforementioned second choice, of course; that is, it could regard primitive creations as the *other*, as something apart; it could view them in a *differentiating* light, motivated, for example, by a growing resistance to "understanding" when "understanding" functions as a leveller of differences. One can speak, in Todorov's words, of the "paradox of death bringing understanding,"[6] and understanding that, as he illustrated using the example of Mexico's Indians and the process by which they were "civilized," assimilates the "Other" (that is, foreign peoples and their cultures) into its own concepts and thereby destroys it. Against a background of civilizing progress and the superiority of Christian culture, this "understanding" leads ultimately beyond understanding to mere indifference. The postmodern attitude rejects such "deathbringing understanding." This rejection was clearly articulated, for instance, by the negative voices raised in the debate about concepts like affinity and universality following the 1984 exhibition mounted by the Museum of Modern Art in New York <u>Primitivism in 20th Century Art: Affinity of the Tribal and the Modern.</u>[7]

From an anthropological viewpoint, we can assume human consciousness is characterized by two tendencies. The one strives for unity, for intellectual *syntheses*, for connection of the individual with the whole and for the dominance of interpretation over the object of interpretation. The other is directed at *differentiation*; it preserves the variation and variety of life and perceives the indissoluble concreteness, partiality, and mystery of all experience. These two elemental impulses are dialectic, but without the possibility of a lasting syntheses. If this dialectic relationship is taken as a given, then there are also two types of understanding: understanding of the Same and understanding of the Other. The marked importance of the Other and of the concept of "difference" in contemporary thought has its roots in radical doubts about the human intellect's classificatory function, its rational and centred categories of analysis and comprehension with their one-sided predilection for causality and totality - in short, in doubts about our ability to "understand" and control our own civilization, let alone nature, in a meaningful way. In the words of a postmodern ethnographer, the encounter with the other culture "defamiliarizes common sense reality (erroneously viewed as secure, unambiguous and 'real') ... evokes a fantasy whole

abducted from fragments, and then returns participants to the world of common sense - transformed, renewed and sacralized."[8] From the point of view of the majority, too, this gives Indian and Inuit art a right to exist, a universal importance both as Indian or Inuit art and, *at the same time*, as art that is relevant to humanity in general - although one must allow for the historical cultural development that leads to the linking and overlapping of cultures and thus brings about *changes* in perception and forms of expression.

MODERNISM IN WESTERN ART

Modernism was originally a *European phenomenon* that drew its concepts, subjects, and forms from a "polylogue" between France, Germany, and Italy, with significant impulses from the Scandinavian countries and England. Modernism in art has introduced radical transformations in at least three spheres.[9]

Modernism in the first place altered the concept and the portrayal of *reality*. The belief in objectivity based on the unquestioned and unproblematic harmony between external and internal was lost, and this change created problems in respect of the relationship between the self and the world, which in turn forced an epistemological, ethical, and aesthetic reformation of art. More and more, the subject became the measure of true reality.

Modernism in the second place existentialized the perception of the role and life of the *artist*; the artist now stood at the crossroads of the mounting conflict between subject and object, individual and society, rational consciousness and the elemental impulses of the unconscious, and had to live out these conflicts in his or her own person. The artist was subjected to tensions that alienated him from a realistically conceived external world, from society, and even from himself, tensions that led to the experience and conception of the artist's life as a tragic existence (Gauguin, van Gogh, Munch, and Kirchner being only a few examples).

Finally, the change in modes of thought brought about a development of new *art forms*. They were founded in the need to adequately express the new, problematic view of our external and internal worlds, as well as the new intellectual and spiritual energies that were being released to overcome the tensions. It had become essential to depict the "real reality" that lay hidden behind surface phenomena that had become both irrelevant and impenetrable. In some cases (for example, Cézanne and the Cubists), this process of giving form to reality proceeded from superficial reality (for example nature), aesthetically distilling or reconstructing the spiritual (geometric) form that is contained in the material itself, as its inner form, so to speak; in other cases, the inner compulsions and hallucinatory images of the inner soul (van Gogh, Munch, Nolde) were embodied

in external images, whose subjects, as expressive correlates of compulsive and explosive psychological processes, often appear distorted.

By about 1930, the essential features of the high modernists' programme were fully developed. While the various modernist tendencies differed greatly among themselves, one feature that they shared (if we disregard certain contrary, deconstructive, avant-garde trends like Dadaism and its successors)[10] was the conviction that the artistic form must be congruous, that it must function autonomously as an "objective correlative" (T.S. Elliot) of modern experience as the artist perceived it and as it had been formulated and systematized in modern philosophy, psychology, sociology, and the natural sciences from the last two decades of the nineteenth century on. The no longer fully integratible experience of the discordant elements in our world, in society and also in oneself was translated into aesthetic form, giving this discord a (for the time being still) totalizing form.

The spiritual synthesis that the Middle Ages found in the cosmos of a metaphysical order, that from the Renaissance to the Enlightenment and the Age of Science was perceived as residing in human reason, and that the Romantic period placed even "deeper," in the realm of feeling and imagination, was in the modern aesthetic entrusted almost exclusively to the (constructive) results of creative imagination and expressed in the forms of corporeal (or visually constructive) consciousness. Autonomous art as an objective correlative of ambivalent and highly unsettling subjective experience was the last and ultimate synthesis of the modern intellect. This autonomous art existed in parallel and in addition to the empirical realities. It followed the concept of negative aesthetics (Adorno) resisting or reacting negatively against modern functionalizing and "anonymizing" society and the endangerment of the individual. In being symptom and rebellion at the same time, it formed ambiguous constructs of aesthetic unity containing both symbols of the unison of divergent elements and signals of an ironic dissolution of this unity. Modern art was a very serious and consequential art, both in terms of the individual works and in terms of the logical, seemingly irreversible development of its styles from Impressionism to Symbolism, from Fauvism, Expressionism, Cubism, and Futurism to Abstraction and Surrealism, to mention only those trends that have been most influential internationally. These styles were attempts at aesthetically synthesizing the divergent elements of the world. In these totalizing, at times violent and dissociated forms, postmodernism tends to see the signs of failure, of a magnificent - but in the end futile - experiment.

FOUR ASPECTS OF THE MODERN AESTHETIC AND INDIAN ART

It is evident that the modern aesthetic has had and continues to have an effect on Indian art. When it comes to determining

modernism's influence on Indian art, to analyzing the conditions
under which this art is perceived, it is not enough to point to
certain parallels: to the influence of Picasso on Daphne Odjig
for instance; of Kandinsky on Alex Janvier, Bob Boyer; of Duchamp
on Ron Noganosh; to the influence of the colour-field painters on
Norval Morrisseau, Boyer, or Beam; or to the influence of Pop Art
on Beam and Noganosh (together with Dadaism). Rather, those
aspects of modernism must be described that are particularly
fundamental to Indian art and reasons be considered for the
influence these art movements exert on the ethnic artists whose
work, paradoxically in a postmodern period, is significantly
influenced time and again by modern art styles (Odjig, Boyer,
Janvier, Ash Poitras, Joane Cardinal-Schubert, Gerald McMaster).
The range is considerable, though, sometimes even within a single
work, which, as in the case of Ash Poitras, Boyer, and sometimes
McMaster, may reflect modern and postmodern trends at the same
time. Indicative of the multiplicity of references is the fact
that Ash Poitras' work has been found to exhibit the influence of
"Hans Hofmann, Indian beadwork, Raphael, Kandinsky, Marcel
Duchamp, Helen Frankenthaler and Kurt Schwitters"[11]; or that
artists like Bob Boyer or Edward Poitras are seen to be
influenced by styles that are characteristic of (late-modern)
Abstract Expressionism as well as (postmodern) Conceptual and
Performance/Assemblage Art. This parallel incorporation of
disparate styles likewise merits consideration.

There are in fact four aspects of modern art that are
particularly accessible to Indian artists in Canada and the USA:
decoration, Cubism, Abstraction, and the magical dimension of the
thing.

Decoration

Gauguin, Denis, Bonnard, Matisse, and other artists gave
decoration a new, significant function within the autonomous
image, by using it to express spiritual contexts and
psychological states of consciousness. Decoration thus becomes a
medium of expressive art. The decorative and the expressive come
together in the autonomous picture space. Van Gogh's and Munch's
pictures are exemplary in this regard. In Gauguin's case,
decoration is a means of using pure line and colour to produce a
combinatorial, aesthetic formula and hence an artistic ordering,
integration, and synthesis of the material without the illusion
of an object. For Gauguin, "The crass mistake [is] Greekness,
beautiful as it is."[12] Decoration serves the de-rationalization
of contexts, the search for the absolute. Nature is not to be
copied; rather, it is to be "dreamt." These dreams are directed
at primordial states, at what is "old, sublime, religious," at a
mythic, primal link; they draw our gaze to the primitive, to the
exotic, to folk art. In contrast, Matisse's creative goal was
not "the veiled image of the unfathomable riddle"[13] that Gauguin,
van Gogh, and Munch painted, but rather the expression of a
specific (harmonious) spiritual state that is affected by its
surrounding but is nevertheless embodied in an autonomous

aesthetic realm, the "spiritual realm" of the image. Matisse's
formal tools are the blurring of differences between foreground
and background, surface and spatial depth, object and decoratable
line; the liberation of pure colour, with which the artist
produces the harmonious balance of the pictures, and of the line
or arabesque, which can define, arrange and express. Matisse
strove to do away with the tragic world view, producing spiritual
harmony by means of decorative figuration and rhythmic unity.
The Art Deco movement of the 1920s reinforced this tendency
toward de-rationalization, toward the dominance and playful
treatment of form. It became important for the Indian painters
in the USA, either as an influence or as a means of facilitating
the reception of their work (for the "Five Kiowa", Asah, Auchiah,
Hokeah, Mopope, Tsatoke, and in particular Woody Crumbo, all from
Oklahoma).

This decorative element has always been a pronounced
component of Indian art. It is evident in pre-Columbian kiva
murals painted by the ancestors of the Hopi; it is an integral
part of the embroidery and weaving done by Canadian and American
Indians and by the Inuit; and it is a determinative influence on
form in the traditional painting and carving of Canada's
Northwest Coast Indians.[14] It is also a structural basis for
modern Indian artists and as such can develop expressive quality
and take on great thematic importance, by signifying either
harmony or discrepancy. In the case of the painters of the
Artist Hopid in the USA and the so-called "image makers" of
Canada's Woodland School (Morrisseau, Blake Debassige, Joshim and
Roy Kakegamic, Saul Williams, Roy Thomas, Daphne Odjig), as well
as "abstractly" oriented painters like Bob Boyer and Alex Janvier
and, lastly, Inuit printmakers (Kenojuak Ashevak) and tapestry
artists (Jessie Oonark), decoration is used for the expressive
portrayal of an all-embracing spiritual context; conversely,
however, for modern Indian artists as diverse as Edward Poitras
or Lawrence Paul in Canada and T.C. Cannon, Grey Cohoe, Red Star,
Jemison, and Bradley in the USA, the decorative aspect also
expresses the divided nature of the existence and the
consciousness of the modern Indian who is placed, for example, in
decorative internal or external spaces that are foreign to him.[15]

Cubism

The second aspect of modern art that influenced ethnic art or
facilitated its acceptance is *Cubism* (especially its later form,
Synthetic Cubism); in work by Indian painters, Cubism often
combines with the decorative aspect of pure line and colour to
form a single unit of expression. Liberation from the
superficial aspect of the thing, and from linear spatial
perspective, enables artists to manipulate the world by reshaping
it aesthetically. The external world no longer matters; what
does matter is human reaction to that world, as conveyed through
constructive imagination. This imagination does not analyze the
object by describing its various facets; instead, it develops a
simultaneity of viewpoints in a kind of combinative play, a

simultaneity that transposes the imaging totality of the object
to the constructed set of fragmentary details on the visible
surface. Analysis of the thing goes hand in hand with creation
of a structural aesthetic formula for its "essence," which is
often found to be representable by the fundamental geometric
forms. Time is contained in space, together with a mathematical
order. It is the fourth dimension in space (and is then shaped
according to its own logical forms, in a hermetic and autonomous
space in which the natural object is transformed into an art
object, with overlapping surfaces that replace linear perspective
in representing the third dimension of space. The possibility of
changing from one to the other, of beginning with the idea of the
form and transforming it into the object, or of beginning with
the object and transposing it into form, makes Cubism highly
flexible and gives Cubist painting, as an "intellectual game"
(Picasso), not only an inexhaustible potential that makes itself
felt in almost any painting style, but also a constructive and at
the same time visible spiritual unity. In either instance,
moving from the object to the form or from the form to the
object, the paintings become symbols of equilibrium. From the
play with object and form results a spiritual formula in which a
precarious balance is established in the tension between man and
the world.

In the search for a spiritual formula, Indian painting
combines Cubist, decorative and Abstraction stylistic elements.
Because of its flexibility and its striving for spiritual unity,
Cubism - in combination with Abstraction - is one of the most
influential modern styles where Indian painting is concerned
(this is especially true in the USA as regards Oscar Howe, Mike
Kabotie, and Milland Lomakema, and in Canada as regards Daphne
Odjig and Jane Ash Poitras, for example). Here too, though, the
approach is eclectic. Elements of the de-ideologized Cubism are
isolated and adapted to the Indian's primal sensibility, which is
sympathetic to things, creatures, and nature; this is done by
combining such elements with a kind of Magic Realism, the
beginnings of which can be found in Picasso, and which will be
discussed separately below. What links decorative and Cubist
(and also Abstract) stylistic trends almost seamlessly in
modernism is that they function as guideposts, symbolically
pointing to a large spiritual context. *Symbolism* is one of the
central aspects - if not *the* central aspect - of modern art (it
will be systematically discussed elsewhere, in conjunction with
mythic and decorative elements, among others).[16] It is so
important because the most significant elements of modern art
symbolically allude to greater purposes, and because this
allusion takes place in a combination of decorative and
expressive tendencies. Much Indian art, actually its highest
achievements, can be analyzed in terms of a seamless fusion of
the decorative (universal) and symbolic (specific, general,
diffused) dimensions of art.

The Union of Decorative and Expressive Elements in Indian Art

Daphne Odjig and Norval Morrisseau, two of the most important Indian artists, who have been crucial to the development of Indian art in Canada, will be used in the following section as examples of how the many influences that affected modern Indian artists in the sixties and seventies can be viewed as a union between decorative and expressive elements. Specific examples will clarify the motives that prompted Indian painters to adopt modern styles, what the label "eclecticism" means in relation to modern Indian painting and the internal, spiritual motives that led the artists to combine styles, vary them, and adapt them for their own purposes (and cultural contexts). It is hoped that the notions of "understanding" and "affinity," which were spoken of at the outset, will also be more precisely delineated in the course of this discussion - from the point of view of Indian art, not of modern Western art - and that, in sketching out various possibilities, we may better understand artistic genius in connection with the emergence of modern Indian artists.

Daphne Odjig's "favourite painter" was Picasso: on the one hand because she admired "the way he was able to put down his own feelings"[17] and, on the other hand, because the Cubist technique of breaking up and then recombining views and surfaces offered stylistic and thematic possibilities of concentration; this technique enables Odjig to compose, to portray complex relationships, to depict the transformation and overlapping of existences. Like other Indian artists, she takes an eclectic approach. The drawings produced between 1969 and 1971 to illustrate the erotic stories in Tales from the Smokehouse, a volume published by Herbert T. Schwarz in 1974, are a combination of "realism" and cubism. After 1968 Odjig also began to use the technique of collage, but reconstructively, not deconstructively: "I've... become fascinated with collage from seeing works of other artists such as white artists, and I thought I'd like to do something along that line, but do my own thing. You know, being Indian, we're people of nature. I thought I'd use the normal things you find outside, the natural substances... moss, ground up peanut shells... pine cones."[18] One of her pictures is entitled From Mother Earth Flows the River of Life.

Her theoretical remarks and artistic practice point to a spiritual basis for the incorporation of Cubist techniques into Indian art (in the case of US Indian artists, too, especially Oscar Howe and the painters of the Artist Hopid).[19] Odjig comments: "I love to distort things... Picasso distorted.... Ever since I was a child, I elongated necks and always did faces over on top of others. But for me that had a meaning to it... one face emerging from another would be like the spirit of that person leaving that individual."[20] Echoes of shamanistic thinking (soul travel, for example) are clearly recognizable. Picasso has also influenced the "summational formulas" that Odjig uses in her painting; this influence is recognizable despite her personal modifications to the style. The epic painting that

Odjig did in 1978 for the Canadian Museum of Civilization in Hull, <u>The Indian in Transition</u>, represents a combination of Indian history and utopia in three parts: the early phase of contact between the Indian and the white man, cultural decline, and the vision of a cultural renewal. In its monumentality, its heroic character, its summational nature, and its combination of individually "readable" pictures, <u>The Indian in Transition</u> is reminiscent of Picasso's <u>Guernica</u>, but with the difference that, in Odjig, despite all the uncertainty and sense of danger, the heroic suffering of the distorted creature expresses more than just the principle of destruction and evil. The many segmented coloured areas that are rhythmically linked to one another by the interplay of line, coupled with a visionary, epic abundance of figures, give visible form to the integrative spiritual world view of Indian culture - a "melding together in spirit."[21]

Odjig's pictures show clearly how Cubist elements combine with the decorative element, how both contribute to the spiritualizing mastery of reality via line, form, and colour - but especially *line* - and thus have a liberating effect on the artist's style. In the beginning, Odjig (like Morrisseau) used the forms, lines, and design elements of Northwest Coast art (the "ovoid," the U-shapes, the eye motif)[22] and also made use of masks, although these, too, were always tied into the rhythm of the line drawing. Line developed as a stronger element in Odjig's work than in Morrisseau's and - unlike the static-heraldic line work of Northwest Coast painting - became increasingly *dynamic*, a *rhythmic*, sweeping "power line" that ultimately determines the picture, tracing oval shapes that could have been driven by the wind. (Odjig "loves the wind, does more of her painting during the winter, when there is more action in the air."[23]) She herself comments on the importance of line, which is a dynamic element connecting all the components of her pictures: "I do it. All Indian artists do it... we feel comfortable with this, working within the framework. You'll find it even in my soft pastels. If you took all the colour out of my painting you would see a line drawing. So you work within that line."[24] This dominance of line and the "framework" that is created by it, which is supplemented in Odjig's later work by the symbolic use of (primary) colours, also enables a smooth transition from pictorial depiction of motifs to stylization and abstraction and a constant (playful) to and fro between all three. This line forms a *rhythmic* contour; and rhythm, as virtually all modernist painters and authors have discovered (from Hofmannsthal, George, through Kandinsky, Klee, the American painters of the Taos Colony, etc.) is the *magical form* that Haftmann spoke of in connection with the central tendencies of modernism[25] and which is the link between Indian sensibility and modernism.

In the union of decoration and expression, the rhythmic flow of line can point in any one of several directions. As in Munch's famous picture <u>The Cry</u>, it can suggest the tragic aspects of human existence; it can also denote harmonizing synthesis, as

in Matisse; or, as was apparent above with the reference to T.C.
Cannon, it can (in the discrepancy between figure and background)
mark the contrast between harmony and disharmony. It is striking
that almost all significant Indian artists achieve their
individual style by balancing decorative and expressive elements,
and that it is in this balance of decorative expression - or
rather in the nature of the tension between the two - that the
artists' individual style develops and that the *special nature of
the artist's existence* is also expressed. Odjig and Morrisseau
embody two of the most important (and to some degree overlapping)
possibilities in modern Indian art in this regard. In Odjig's
work, the harmonizing element that integrates the cultural
influence is stronger; modern artistic means enable Odjig to
master the discrepant world through individual creativity.[26] The
fact that the creative synthesis succeeds, and also leads to
personal integration of the conflicting energies, makes her many
national and international activities possible; such success
fosters Odjig's curiosity vis-à-vis mainstream modern artists and
explains her ability to use the stimuli of the modern aesthetic
for her own purposes and to broaden her themes to include the
pan-Indian realm (as in her pictures of the Northwest Coast); or,
in a synthesizing vein, to include general cultural elements in
her work (as in Jerusalem Series). Inherent in this approach,
though, is the danger of broadening one's subject matter and
method of presentation to the extent that they ultimately
represent the general sphere of folklore and fairy tale. All of
this also fits into the *postmodern* scene, however, into an
abandonment of the modern ideology of alienation, into an
accentuation of artistic and playful elements and of the
combinatorial-decorative surface elements of the pictures.

In contrast, Norval Morrisseau of the Ojibwa tribe - the
founder of a movement whose representatives are known as "legend
painters" by virtue of their "image making" and as the "Woodland
School" by virtue of their origin - considers himself an
existential visionary[27] who is driven by a "spiritual force" to
"break down the barrier between the white world and my own."[28]
At the same time, of course, this intensifies the tensions
between the worlds, heightens the expressive element of line and
colour, and puts the artist at risk by increasing his isolation
and exposing him to inner conflict.

Morrisseau expresses the modernist spirit by selecting
certain spiritual elements of the shamanic role and transferring
these elements to the spiritual pretensions of the chosen role as
existential artist ("I am a shaman-artist"[29]). Modernism is
likewise evident in Morrisseau's work, though, by his attempt to
remove traditional motifs and stories from the realm of (for
White art observers) "mere" decoration or "exoticism" and to
transpose them into the realm of *expression* and symbolism. In so
doing, he has striven for a balance between the relevant *other*
and the relevant *universal,* a balance that is also characteristic
of modernism in many ways, proceeding, however, not (like
modernism) from the mainstream and its universal themes, but

instead from the Other, from what is strange and foreign to the White viewer.

It is clearer in Morrisseau's work than in Odjig's how the artist's own traditional cultural assets served as inspiration and formal stimulus as well as the starting point for the aesthetic argument. The existential basis of Morrisseau's unique artistry is discernible in his passionate attempt to "actualize" and functionalize his own cultural tradition as an expressive element - a tradition that, merely relegated to the past, would now be perceived and enjoyed only as a "decorative" element (in a negative sense). He is able to do this because he equates the artistic existence with the (shamanistic) ability to attain a higher level of consciousness (that of myth and sacredness) and to communicate that consciousness to the observer via the work of art. Morrisseau bases his approach on three Indian cultural traditions:

(1) the pictographic style; for example, the symbols carved into the holy birch-bark scrolls of the Midewiwin society - a brotherhood of Ojibwa medicine men - were used to hand down ceremonies and spiritual quests and they constituted an "environment" for Morrisseau, an inspirational "milieu" for someone seeking access to higher, spiritual levels of existence; Morrisseau himself created a scroll in the pictographic style in 1983, with the intention of including "any person that looks on this scroll... to feel that for a while there is a separate reality"[30]; (2) the old rock paintings and petroglyphs in the Canadian Shield, some dating back to pre-Columbian times, published by Morrisseau's former patron Selwyn Dewdney; to Morrisseau's mind they were "the Indians' cathedrals," and they helped him make the magico-symbolic dimension of art a fruitful element in his own works; (3) the magnificent floral patterns of Indian beadwork, which decorated clothing, bags, and other articles of daily use and fit in very well with Morrisseau's very rhythmic style and were "the main inspiration for the undulating line and richly contrasting coloration;"[31] in 1979 Morrisseau painted pictures in which he fused the lines of fantastic patterns into a dynamic network.[32]

The higher state of consciousness that Morrisseau, as an artist, is endeavouring to achieve and to communicate to others is a *dream state* - once again a recognizable parallel to modern art, if we recall both Jung's influential dream theory, with its notion of the archetype and primordial images, and the surrealists' concepts and artistic methods. This dream state is *evoked*; the image is the "objective correlative" to it (T. S. Elliot). The images are meant to be an "environment" for the viewer, giving the viewer access to different levels of consciousness.[33] In Morrisseau's best works, he evokes a meaningful "environment" for the viewer by successfully integrating decoration and expression - for example, by combining mythic figures, decorative textures, and hieroglyphic filler elements, which together create the suggestive dreamlike

character of his pictures. The *decorative element* is the unlimited "creative power of the surface"[34]; with its immediate appeal as an organizing pattern, as a balancing of surface and form and a dramatic interaction between sensuality and structure, it is the *universal* that acts as a formal bridge of understanding to the observer. In contrast, against this background of the decorative element and its universal appeal, the (distorted) *expressive* figural elements – for example the ancestor figures, self-portraits, or transformation motifs – are the *Other*, that which is strange or foreign. The enigma is established and maintained by the tension between the decorative effect of the pattern of lines, colours, signs, and signatures of the past and the stimulating, puzzling quality of the painting, its mysterious power to allude to the essentials of life, the elemental forces and gestalts of the universe. Thus, the Other opens itself up to *universal panhuman* considerations without cheap sentimental or merely programmatic synthesizing effects.[35] In this process, the serial, narrative aspect of the legends and myths is conveyed in the picture in the concentration of the "frozen moment."

In the best Indian pictures, this circular effect, the dynamic equilibrium of decoration and expression, of the universal and the Other, is translated into *symbolic* form. Morrisseau's art derives its expressive and symbolic power from its depiction of the interplay and "in-betweenness" of cultures, of forms and attitudes, of motifs and contents (a title like Portrait of the Artist as Jesus Christ and, finally, the sorrowful in-betweenness of a split existence.

Abstraction

Along with decoration and Cubism, the third aspect of modern art that follows from the primacy of form and becomes relevant for contemporary Indian artists is *Abstraction*, which is in any case a constitutive element of primal art and thus of Indian art. Abstraction avoids the tension and the confrontation of subject and object, or even negates them, by doing away with the external world of things. Abstract painting serves man's dialogue with the internal, not the external world. Again, what is sought is a form to express the cosmic *rhythm* of a spiritualized nature, the spiritual formula founded on the sympathetic oneness of subject and object. For art is - in Macke's words - an "expression of mysterious powers."[36] In his book Concerning the Spiritual in Art and Painting (written in 1910), Kandinsky states that the "artist must train not only his eye but also his soul, so that it can weight colors in its own scale and thus become a determinant in artistic creation" and the "color and graphic form which as such exist independently, are summed up by an inner necessity" and, in their thusly created shared life, form a whole that is called a picture.[37] According to Kandinsky, this inner necessity will in the future lead to two developments, for which Kandinsky himself in 1910 laid the foundation with his first Abstract watercolor. One is that of "Pure Abstraction."[38] Pure Abstraction was a way of making humanity's world of expression as

well as the mystic coherence of the universe directly manifest,
by means of pure colour and line, by translating matter into
energy and kinetic structures, by rhythmicizing and
"musicalizing" the forms of expression, and by doing this without
reverting to the objective world. The result was a dream world,
the beginnings of Abstract Expressionism. The other direction in
art that Kandinsky spoke of, and that he saw exemplified in Henri
Rousseau's "neo-primitivism," is that of "Pure Realism," whose
subject matter Kandinsky, however, looking at the essential,
calls "higher fantastic - the fantastic in hardest material."[39]
Klee, for his part, speaks of "the goal [of shifting] objects
into the beyond."[40] In order to give form to the "irrepressible
rhythm," which was also stressed by Delaunay, he developed the
fanciful line and picture figurations that Miró then playfully
developed further. These thoughts and artistic methods struck a
chord in Indian artists. Reference has already been made to the
element of *rhythm* in conjunction with Odjig and Morrisseau. It
allows the spiritualizing (and also the merely playful)
integration of decoration, Cubist distortion and Abstraction.
The influence of Abstract art is evident in Canadian Indian art,
not only in the work of the aforementioned artists, but also very
much so in Alex Janvier, Bob Boyer, Robert Houle, and Carl Beam,
and in the USA in artists such as George Longfish, Jaune Quick-
to-See Smith, and Emmi Whitehorse. In Canadian Indian art,
Abstraction follows both patterns: that of the very rhythmic,
lyric line (incorporating motifs of the past and of the
environment) as an expression of the internal world (as in
Janvier's work), and that of the reduction of objects, for
example the Indian shield, to geometric forms (as in Boyer's
work) to arrive, ultimately, at the direct depiction of geometric
motifs (as in Robert Houle's work).

The Magical Dimension of the Thing

Unveiling the *magical dimension of the thing,* and thus giving
shape to the "fantastic and hardest material" in Kandinsky's
sense, is the fourth method by which Indian painters heighten the
expressiveness of their work. As Haftmann wrote concerning the
development of the style in modernism, "it was discovered that
the silent life of things possessed a special aura of
strangeness, mystery, magic, which in the contemplating,
reflective mind evoked a response expressing fear or irony, or a
sense of deep kinship with things. The 'thing of hardest
material' became a component of human sensibility, and in it the
unity of the outer and the inner was once again achieved."[41]

The work of Iroquois sculptors like Duff Wilson and Joseph
Jacobs is, like Inuit sculpture, based fundamentally, although in
very different ways, on the magic of things. Modern/postmodern
Indian sculpture or assemblage - by Edward Poitras, Joane
Cardinal-Schubert, or Ron Noganosh is effective because although
the artists realize that the things - a buffalo skull, for
example - have lost the magic that was once activated in the sun
dance (in the case of the skull), they also realize that this

magic needs to be reactivated. One of the central elements
linking Morrisseau, Odjig, and Woodland School on the one hand
and artists like Carl Beam, Bob Boyer, Jane Ash Poitras, Joane
Cardinal-Schubert, and Edward Poitras on the other is the fact
that these artists conjure up the magical dimension of things or,
in the case of the Woodland painters, the mythic dimension of
legends and stories. Morrisseau, the other Woodland painters,
and Daphne Odjig evoke this magical dimension directly, by means
of their art evoke the very *loss* of this magical dimension (of
the buffalo skull, for instance), or, like Edward Poitras,
exploit the associative, magical potential of the things in their
arrangements, by transferring this dimension to other contexts
(airplanes for example), creating surprising and disquieting
contrast effects.

Modernism's fundamental position was determined by the two
poses of "the absolute (magical) thing and the (magical) absolute
form."[42] Whatever happened in modern art happened between these
two poles. The same belief in a higher oneness of the world
manifests itself at both poles: a oneness that is immanent,
aesthetic, beyond the metaphysical oneness of the old order, yet
also ethical and symbolic, a oneness that can and must contain
within itself the tension between humankind and the world, but at
the same time balance this tension in the aesthetic form. The
existentialization and spiritualization of the artist's role (as
in Morrisseau) and the spiritual or cosmic harmonizing formulas
of the modern aesthetic establish - despite all differences - a
"relationship" or rather an inner link between Indian (primal)
art and modern art and also explain the ease with which
traditional Indian myths and pictorial motifs can be combined
with modern imaging techniques.

MODERNISM IN AMERICA

Modern Indian art in Canada has really developed only since the
1960s and thus finds itself part of a historical era in which the
syntheses of modernism are already disintegrating. They were
impressively confirmed once again, though, in American Abstract
Expressionism (Pollock, Rothko, etc.). American Expressionism
was a new beginning for America after the Second World War and
offered a great opportunity to develop autonomously in a new
direction. This autonomy was connected with a conscious return
to myth and archetype, to the "other" tradition that had
continually occupied modernists, at least as an underlying
factor, since the days of Derain, Picasso, Matisse, etc. The
Indian's and the White man's search for the mythic past thus seem
to cross paths. New York became the new centre of international
art, influencing Canada and Europe and founding a series of new
international styles.

In the wake of Freud and Jung, and having witnessed the
failure of social and artistic utopias and ideologies, American
Abstract Expressionists set out on an inwardly-directed path.

They proceeded on the assumption that the residues of universal myths live on in our collective unconscious and that depicting these myths offered an alternative to Constructivist modern art. Gottlieb and Rothko, in their much-quoted letter of 1943 to the New York Times (in which Newman, too, had a hand) state that they are concerned with "primitive myths and symbols that continue to have meaning today... only that subject matter is valid which is tragic and timeless. That is why we profess kinship with primitive and archaic art."[43]

This connection with archaic art is apparent in the work of some of the most important artists, such as Pollock, Gottlieb, and Newman, in their interest - stemming in some cases from the 1930s - in the Indian cultures of the American Southwest, and of the Canadian Northwest Coast, with which they became acquainted through visits to museums, and studied, exhibited, and finally transposed into their own creations. A contemporary who knew these artists commented retrospectively: "Everyone was aware of Indian art at that time."[44] Barnett Newman shared the Surrealists' interest (Max Ernst's, for example) in Indian art, especially Northwest Coast Indian art. In 1944, with the assistance of the American Museum of National History, Newman organized the exhibition Pre-Columbian Stone Sculpture for the Wakefield Gallery in New York, and in 1946 the exhibition Northwest Coast Indian Painting for the Betty Parsons Gallery. In the catalogue for the first of these exhibitions, he wrote that this art should not be regarded primarily as ethnological or historical evidence, but rather as an expression of "the spiritual aspiration of human beings"[45]; that it has "reciprocal power," power "[that] illuminates the work of our time" and "gives meaning to the strivings of our artists."[46] In the works of the Northwest Coast Newman saw "an answer... to all those who assume that modern abstract art is the esoteric exercise of a snobbish elite."[47] Gottlieb's pictographs from the 1940s, which use mysterious images, schematic anatomical drawings of fish, reptiles, birds, and animals, or even abstract symbols, are deliberately reminiscent of rock paintings and of the paintings done by Northwest Coast Indians, and were intended to evoke humankind's prehistoric past. Pollock too was familiar with the art of Northwest Coast Indians and his Action Painting was influenced by the Navaho sand-paintings of the southwest: "My painting does not come from the easel.... On the floor I feel nearer, more a part of the painting.... This is akin to the method of the Indian sand painters of the West."[48] If, as it is said, Pollock released art in the United States from its long European bondage, then, as Alberto Busignani puts it, this was "by his acceptance of another kind of history, intimately linked to nature, magic, symbols, etc."[49] Pollock found this kind of history portrayed in the methods used by Canadian and American Indians.

As for myth, Rothko, Pollock, Clyfford Still, and Newman were concerned with "the Spirit of the Myth which underlies the myths of all times"[50]; with the help of a "ritualistic will,"

Newman aimed at "a metaphysical understanding."[51] To this end, the Americans, unlike the European Surrealists by whom they were strongly influenced, abandoned worn-out subject matter and tried new paths in the search for the infinite, for a new kind of myth. Rothko, Still, and Newman thus developed "Colour Field painting," which tried to avoid relating fine forms to each other in favour of more generous dimensions. Even before them, beginning in 1947, Pollock had tried to achieve the same effect of boundlessness by releasing a furious, inexhaustible energy in his drip paintings, in which the painting process became a quasi-ritual act. Significantly, he had previously painted "mythic" pictures closely related to Jung's writings and to the examples of animal sexuality and nightly rituals referred to by Jung. Schapiro wrote that Pollock, Still, Rothko, and Newman were searching for "an absolute in which the receptive viewer can lose himself in the compulsive (Pollock) or in an all pervading... sensation of dominant color."[52]

As de Kooning, Clement Greenberg, and others remarked, it was existentialism that determined the climate of the times for the "Action painters," even if this climate was more atmosphere than philosophy.[53] The representatives of "gesture painting" also number among the Action painters, Motherwell, for example, de Kooning, Hans Hofmann, Franz Kline, Sam Francis, etc. What was at stake was still the *true* image, and this true image was sought in the linkage of the unconscious and myth, through the painters' gesture of liberation from political, moral, and aesthetic compulsions, but with a sense of all moral and aesthetic responsibility.

To Indian painters, this approach offered a seductive potential for imparting universal-mythic meaning to their pictures. Their adoption of modern styles and techniques fits in well with the attempts of Indian painting in the 1960s to break out of conventional forms. Colour Field painting and its enormous power of evoking suggestions of universality and "myth" directly influenced modern Indian painters, taking them back, so to speak, to the Indian sources whence had come the stimulus in the first place; some of the painters affected were, in the USA, Ben Buffalo and, in Canada, Carl Beam right at the outset, then Morrisseau and the "image makers" of the Woodland School, as well as Robert Houle and Bob Boyer. The influence of "gesture painting" by artists such as Hans Hofmann can be seen in Ash Poitras' work. The eclecticism of the influences is apparent in the pictures Morrisseau has painted since the 1970s, which are remarkable for their luminous colours and large colour fields, but also for their "primitive" figural aspect and for their magic "surrealist" element. This eclecticism on a strictly individualistic basis, but with reference to one's own tribal culture, became the programme of the Institute of American Indian Arts, which was founded in Santa Fe in 1962, with the aim of bringing Indian artists from a wide variety of tribes and regions out of their isolation.[54] In 1967 Fritz Scholder began the series of pictures that, under the influence of Bacon, the Colour

Field painters, and Pop Art, took an ironic view of the White world's Indian clichés. The influence of the first twenty years of this institute - twenty very fruitful years - radiate out in all directions, encompassing Canada as well.

But the last Western art movement that was existentially rooted in modernism was already being called into question in its turn by the next generation, by artists like Robert Rauschenberg, Jasper Johns, and Allan Kaprow. Their mentor, John Cage, questioned the existential basis of artistic expression and, following Dadaism and Zen Buddhism, advocated a lighter, unsentimental, and *playful* approach to art, one embracing "unsureness, accident, confusion, and discontinuity."[55]

MODERN SCULPTURE AND INDIAN ART

Introduction: General aspects

Like the previous section on painting, the following section systematically presents some of modern sculpture's means of expression, in order to establish which of these have in fact been adopted by Indian sculptors. Since modern sculpture develops in the interplay of object and space, the following section will be organized on the basis of these two aspects. Indian sculpture seems to derive its perspectives from physical-abstract form and from the manipulation of space, while psychological dimension in the narrower sense is largely ignored. Sculpture, too, demonstrates the fruitfulness of the link with its "primitive" counterpart, with archaic and elemental components. The interplay between a modern artistic spirit and pre-civilizational, natural, and cosmic aspects must be mentioned here, as well as - conversely - Indian sculptors' tendency to take up the representational forms developed in modernism for the purpose of depicting the elemental aspect and to use these forms to present their own cultural and artistic standpoint. As in painting, the development of this art form is characterized by interaction, a productive cultural exchange.

Until 1945 modern sculpture was overshadowed by modern painting. Some of the most notable painters of our century were likewise some of the most innovative sculptors. This is true of Picasso, a Cubist, and of Matisse, a Fauve, as well as of the Surrealists Ernst and Miró. The painters' two-dimensional programme was often translated into three-dimensional form, although this transfer from one medium to another was not always in keeping with the internal logic of the concepts. The Cubists, after all, strove to emphasize in their paintings the two-dimensional quality of the surface and to eliminate the illusion of space, while the Surrealists propagated the spontaneous creative process of "automatic" painting and writing, which was scarcely translatable to the complex creative process associated with sculpting in stone, wood, or bronze. Painters and sculptors alike, however, took account of the special characteristics of

whatever medium was being used, in order to reestablish the essential nature, concreteness, and "purity" of that medium.

In painting, the *characteristics of the medium* are surface, line, and colour. Where sculpture is concerned, the medium's characteristics are determined by: (1) the *mass* of stone, wood, metal, etc., that is to be worked with; (2) the relationship of the sculpture or the object to the *surrounding (empty) space*, which can appear merely as negative space or can be activated as a positive means of expression; (3) the *nature of the artistic object*, which can also be an unworked, trivial "thing"; (4) the combination or *arrangement of the material* or materials - for example, according to a "spiritual principle" (Picasso) or by chance, with montage and collage becoming increasingly important in this last regard. In any case, the aim of the first modern sculptors was to liberate sculpture from purposes that are alien to it; from any representation of what is fleeting, illustrative, sentimental, anecdotal, or social. In place of these aspects was on the one hand the immediacy of the *material* and on the other hand *construction* - in the widest sense of the word - which also brought forth its negation, nonconstruction - that is (seemingly) chance arrangement. Herein lies the parallel to modern painting, which developed between the two poles of the "absolute thing" and the "absolute form." From the combination of material (absolute thing) and construction (absolute form) result the fundamental possibilities of modern sculpture, which sought to maintain the "purity" of its medium.[56] For our purposes, modern sculpture is of interest in virtue of two of its basic tendencies, the effect of which reverberated into the postmodern era.

Monolithic Body and Monolithic Material: Combining, Contrasting and Abstracting them

The first tendency began with the human body and tried to integrate it with the body of the material in order to create an expressive structure. The elemental quality of stone, wood, and metal seemed to be an obvious means of depicting what is elemental, fundamental, and archetypal in human beings, a means of connoting fundamental situations and basic feelings. The aim was to bring out what is *essential* in human beings, while respecting what is essential about the material and the form. Rodin was the first to experiment in this modern sense with the possibilities of sculpture, with its monolithic form, using an impressionist approach incorporating light, shadow, and surface effects (which break up form). In the experimentation that followed his work,[57] a number of expressive possibilities arose, depending on the relation of subject, form, and material.

(1) The first led to the attempt to *integrate* the essential elements of the material with the human body depicted in the sculpture, and to do so by harmonizing the form, the unbroken *rhythm* of form, line, light, and shadow. This rhythmic depiction is basically the method used by Rodin in his early work and in many cases also that used by Barlach, Kolbe, and Marcks, and in

part by Maillol – even given all the differences between these sculptors as regards subject matter, portrayal of the naked or clothed body and body attitude, and various degrees of stylization. The illusion of the human figure, of "realistic" or recognizable portrayal, of drama and sentiment, is still preserved here – even when the works rigorously concentrate on expressing a universal aspect of humanity, as in Rodin's <u>Thinker</u>, Barlach's <u>Singing Man</u>, Lehmbruck's <u>Large Sitting Figure</u>, etc.. This stylistic trend points back to the long tradition of monolithic expressive figures that has existed since the Renaissance. Indian sculptors, those from the USA in particular, emulating Allan Houser, used the simple forms of expressive figural sculpture and their archetypal significative elements to depict elemental situations (mother and child, conversation, storyteller, potter, buffalo dancers, etc.). Houser began as a painter in Dorothy Dunn's renowned studio in Santa Fe in the 1930s, then switched to sculpture and became one of the most influential teachers at the newly founded Institute of American Indian Arts. The danger in repeating quasi-elemental figures in the style of Western sculptural tradition is clearly evident in some of the sculptures produced by Houser's successors; their stylized poses, together with the strong grain of the stone (used to melodramatic effect), often take on merely cliché-like traits. No doubt one of the difficulties arises from the fact that facial (and body) depiction requires a certain psychological emphasis on the *individual* human being, an approach for which there is no tradition in the communally and cosmically oriented culture of the Indians.

(2) The interplay of human body as subject matter and material as monolith provides various *possibilities for reduction*, for contrast, for transformation, or simply for stylization. Rodin had contrasted the smooth surface of the modelled body or head with the mass of the crude stone and its surface (as did Michelangelo, in his unfinished slave sculptures); parts of the body grow out of the stone, as it were, or – from another viewpoint – are held captive in the stone. Modern Indian sculpture adopts this approach, but reverses it, working from a different, cosmically-oriented attitude. In *modern Iroquois sculpture*, by Joe Jacobs, for example, a number, indeed a riotous abundance, of figures emerge from the stone. Such sculpture reintroduces the narrative, which depicts the old legends and myths, at the same time points to the temporality of all life-forms (there being no difference between the animate and inanimate, between human beings and stone), thus manifesting the spiritual principle in nature; the disappearance of the figures into the stone or their emergence from it, together with the "extravagant" nature of all the forms and figures, makes the sculpture very dynamic and lively, but at the same time gives the precise, carved, realistic detail a surrealistic (and decorative) overall effect.

(3) In addition, the *form of the human body itself* can be *reduced*, or better, simplified, spotlighting only its fundamental

traits, its structure, and its sexual characteristics, for
example - an approach that heightens the expressiveness of the
sculptural work. Looking at it from the point of view of the
medium, one could also say that the form of the subject
approximates more closely the elemental quality of the material.
Matisse created series of bodies disappearing more and more into
the material in successive stages. Kirchner carves "primitive"
sculptures from crude blocks of wood and Germany's "Neue Wilden,"
or New Expressionists, have been doing something similar,
although more radical, in wood and bronze (Baselitz, Middendorf,
Lupertz, Penck). It is evident that such work was inspired by
the "primitive" sculpture of Africa, Oceania, and America. This
process removes the differences between subject matter and
material, but it also emphasizes the tension between them,
depending on one's viewpoint. In any case, an *expressive* tension
arises. Through the "contrasting" of the crude material and the
generalized subject matter (the human body), both retain their
"autonomy," and in the resulting tension they unite to depict
that which is essential and "natural," to which the elemental
realities of both material and form are bound. This redirection
method is one of the fundamental approaches taken in *Inuit
sculpture*. The works of John Tiktak, John Kavik, or John
Pangnark are reduced to what is rudimentary and essential in
human existence, and thus portray fundamental situations of
feelings. Herein lies a way for Inuit sculpture to introduce the
viewer to the notion of elemental being, to translate the
stereotype of traditional Inuit life, as close to and at the
mercy of nature, into a primordial image reflecting archetypal
energies in the Jungian sense.

(4) Conversely, the process of reducing the depiction of the
human body can also be carried out as formal *abstraction*. Here
reduction takes place through the artist's instinct for form;
material is subordinated to form for the sake of bringing out the
essential elements. In this case, the human body (or another
figuration) is transformed: planes may compactly intermesh to
make a three-dimensional sculptural figure, as with the Cubists
Archipenko, Laurens, Lipschitz, and Zadkine, or the body may take
on biomorphous or geometrically simplified, ovoid, tubular, or
cubical forms that point to the wholeness of nature. Arp and
Brancusi exemplify this last tendency. Through the abstraction
of form, through geometrical or biomorphous, organic
representation, the sculpture simultaneously depicts the
immediately universal, the "spiritual" in art in Kandinsky's or
Mondrian's sense. In contrast to figural sculpture in the
tradition of Rodin, the archetypal is no longer sought in the
human figure, but instead in impersonal, formal elements. This
search for the archetype also leads Brancusi back to the archaic
cultures, which for him however, are more a source of inspiration
than something to be imitated. This, logically, is another point
of departure for modern Indian sculpture. David General, an
Iroquois sculptor who has turned away from his colleagues'
narrative, rampant style, was impressed by Northwest Coast art,
by the work of artists like Bill Reid, Robert Davidson and

Charles Edenshaw, who - like their predecessors - achieve
simplicity and balance through form, not through the material;
and, influenced by Brancusi, Moore, and Arp, General has looked
for ways to stylize, reduce, and abstract in order to depict the
spiritual forces of the universe in the dynamics of a combinatory
and kinetic play of forms: "The personification of immaterial
concepts is no more interesting than the depiction of real
objects."[58]

(5) The *surrealists* - for example, Henry Moore or Giacometti in
their early works, or, in some cases, Max Ernst (who showed a
serious interest in sculpture from the mid-1930s on) - also
continued to make use of the monolithic figure. In their work,
though, the structural nature of the figure dissolves by virtue
of the merely associative, fantastic, or *dreamlike* links between
the parts. Also, the figure no longer seems to be placed in a
negative space; rather, the (surrounding, empty) space itself
becomes involved as a positive expressive fact as for instance in
Max Ernst or Henry Moore. The figure is diluted to the point of
constituting no more than a surface in the space, as in
Giacometti's work; the space breaks through a hollowed-out figure
(Henry Moore); or, in the extreme case, as in Giacometti's late
works, the figure is emaciated by the encroachment of space.
What is foremost is no longer the tactile element but rather the
visual factor (as a counterpart to the structural element) and
thus also the interplay between figure and space. It is not
surprising that the work of these sculptors, too, is marked by
archaic and archetypal elements. Max Ernst, for example,
discovered the *kachina* figures of the Hopi and himself collected
masks from the Northwest Coast; Giacometti was drawn to the newly
discovered Cycladic artifacts. Among the Native Canadian
sculptors Vincent Bomberry appears to experiment with surrealist
forms in some of his later sculptures, and "surrealist" traits
also appear in the extravagant narrative works created by
Iroquois sculptor Joe Jacobs, although they lack the spontaneous
expression of a conscious reflection of form.

Space

The second tendency in modern sculpture has already been touched
upon: the monolithic body and the human figure no longer
constitute the sculptor's starting point; instead, the starting
point is the *space* in which, and with which, the artist
constructs the sculpture. That is, the artist sees the sculpture
as a *structuring of space*, not as a whole that is congruent
within itself, whose formal principle guarantees aesthetic
totality; the individual work of art as something that is
structured and centred within itself is not what is important;
rather, what is important is the dynamic *relations* that are
established between the individual parts of the sculpture,
between the parts and the "whole" (which no longer needs to be a
whole), and between both these elements and the space that
surrounds them. Calder's mobiles and stabiles are exemplary of
this utilization of space as a setting in motion of *processes*,

both as regards the work of art, which in the case of the mobile actually becomes kinetic itself, and as regards the response of the viewer, who from the visual construct before him constructs relationships in a kind of *perceptual montage* of multifariousness, which, however, no longer merges into a geometric or even biomorphous creation. This principle of construction is still compatible with modernism, however, provided that - as in Calder - a totalizing, universal principle of wholeness can yet be perceived in the principle of *movement*,[59] and provided that the relation of the parts to the whole survives in the movement.

This relation of the parts to the whole is also preserved in the welded-stiff sculpture of Gonzales, Picasso, or David Smith. *Postmodern* sculpture, on the other hand, which in most cases is not really sculpture but rather assemblage, environment, takes space as its point of departure. It uses objects as "structural materials," makes the material itself the theme, so to speak (Imdahl), and thus abandons the certainty inherent in the things, just as it abandons the autonomy and auto-significance of the work of art. What is important, instead, are (energetic) *relational effects* between thing and thing, thing and space, space and exhibition (park, square, street), viewer and thing/space/exhibition. On the one hand, the exhibition too seems like an assemblage; on the other hand, the thing itself becomes a space, an environment. Just as painting bursts its pictorial boundaries (Stella), slits open or perforates the surface (Fontana), so the space is broken up (Serra) and is less and less predetermined by conventions of perspective, of fullness and emptiness; these conventions are reconstructed as fullness/emptiness relationships, as an open path (Long), as open volume (Judd), as an architectural remodelling of a given location (Serra), as a cultural "structuring" of the open landscape (Christo); and this is done in all cases in accordance with the principle of causal relationships, of the simultaneity of the Other, of confrontation with the conventional artistic notion of autonomy and of stretching tolerance to its very limits.

The result is a radical change in the concept of wholeness: it no longer proceeds from the sum of the parts, but from a "chaotic" interplay of forces that challenges our orderly cultural systems of knowledge. Finally, the paradigm of *chaos*, with elements of the arbitrary, the accidental, and the unforeseeable, has replaced that of objective and subjective order in the natural sciences, in sociology, and in philosophy. Thus, not the presence but the absence of order is the starting point for perceiving and reflecting upon the world. The observing individual now takes on responsibility for the relationships in a world that is shaped entirely by mental concepts, by "aesthetics" and art and is thus fictional. This world, as an "environment" encompassing the passage of time and reality, even the reality of lived time, envelops the individual, no longer giving him the famous Archimedian point outside time.

In art, familiar everyday objects, energy currents like "lances of light," and mathematically abstract structures of things (such as numerical combinations) combine and overlap to parallel aspects of reality (Merz). Arranged here in a "purified" structural framework of perception (along the lines of Minimal Art) are collective experiential spaces of physical and mental self-experience, including the emptied fullness in which the Other is just as present as the Absent, the Invisible and Infinite.

It hardly needs to be said that the Indian artist feels a bond with this type of art, whose themes are the existence of things next to and with one another, but also the existence of the Other, this art that operates with the principles of deconstruction and reconstruction. In environments that are concerned with relations, relationships can be depicted between past and present, minority and majority, secular time and sacred time, secular space and sacred space - in decentralized, "pluralistic" form. This art also offers the possibility of portraying and critiquing social conditions, of artistically projecting feelings of and reactions against imprisonment or entrapment, anonymity (and facelessness) and plundering of the land (Joane Cardinal-Schubert, Edward Poitras, Pierre Sioui). In this way Indian artists re-symbolize (and *remodernize*) the non-symbolic postmodern means of expression. These complex relationships are discussed in greater detail in the essay on postmodernism.

PROBLEMS IN CONNECTION WITH INDIAN ART IN THE CONTEXT OF MODERNISM

In Canada as in the USA, nontraditional Indian art adopted the expressionistic techniques of High Modernism and Late Modernism at a time when the fundamentals of this expressionism - an existentialist attitude that, in accordance with Sartre's doctrine, seeks to derive the essence of Being from existence - were already being questioned and modern and postmodern trends were struggling for supremacy. From this situation arose a number of basic problems that maintain a continued tension between modern/postmodern art and ethnic art. They can be summarized in three points:

(1) As a latecomer to the artistic scene, modern Indian painting in Canada and the USA was not caught up in the violent ideological struggles and conflicts that inevitably precede the acceptance of a new artistic direction, and had available to it the whole spectrum of modern and postmodern artistic styles at one and the same time. Thus, Indian artists were able to be, and had to be, more eclectic, more capricious, and more playful in their choice of styles. This is why Indian painting as a whole experiments with various modern art forms and why individual Indian artists like Carl Beam, Joane Cardinal-Schubert, or Gerald McMaster indulge in experimentation of this nature.

(2) Another problem that arises as Indian artists adopt modern artistic conceptions and forms is that modern art was originally the expression of an epistemology and aesthetic of the crisis of Western civilization, whereas in Indian art modern art forms are used not infrequently to express a truly "real" and existing alternative sense of the spirituality of a minority culture, thereby diluting - if not cancelling out - the genuine tensions of modern art. The spiritual element in modern art - so evident as an underlying trend in the later forms of Impressionism, in Symbolism, Cubism and Expressionism, in Abstract Art and Surrealism - was a search for fulfilment and enhancement of the self, a search that could no longer be realized in society or even in life in general; rather, it (and its inner anguish) could be expressed only in art. In Indian art, this kind of spirituality is communally oriented and is based on a mythical view of nature. It can thus easily become an expression of non-crisis, of flight from crisis - even and especially in abstract art forms. Indian art thus seems to negate or overcome the crisis of majority and minority culture through the modern symbolic expression of spiritual unity. On the other hand, the accessibility of modernism to Indian artists makes it clear that modern art was in the end more than an art of crisis, was in fact an art of overcoming crisis in a spiritual and aesthetic synthesis. It is precisely this integrative aspect that remains accessible in the late period of an artistic style, even when the existential circumstances have changed.

(3) We can perhaps even state that modern art forms first become accessible to Indian painters, as to the artists of any minority, any Fourth World, when these forms can be disengaged from their specifically ideological positions; conversely, the primal could be seen as a renewing force as it infuses the late forms of these styles with new expressive contents that are related at least in part to the old ones (mythical view of the world, oneness aspect of the world). Here, too, of course, the possibility of renewal is not far removed from the danger of routine dissipation. Both are founded in the accessibility of fully developed art forms that, "once their material essence is fully realized... turn into a spiritual substance, which exerts an attraction of its own."[60]

NOTES

1. One of the largest survey exhibitions of contemporary art was presented in 1981 by the museums of Cologne, under the title "Westkunst." Cf. the catalogue Westkunst: Zeitgenossische Kunst seit 1939, Laszlo Glozer, ed. (Cologne: Dumont, 1981).

2. See the essay by Nelson Graburn in this volume.

3. On the subject of "allegories," the reference framework that Western traditions provide for understanding so-called "primitive" culture, see James Clifford, "On Ethnographic Allegory," in Writing Culture: The Poetics and Politics of Ethnography, James Clifford and George E. Marcus, eds. (Berkeley, Cal.: University of California Press, 1986), 98 - 121.

4. This is the approach of Lucy R. Lippard, Mixed Blessings: New Art in a Multi-Cultural America (New York, NY: Pantheon Press, 1990).

5. John Sloan and Oliver La Farge, Introduction to American Indian Art (New York, 1931), 7.

6. Tzvetan Todorov, The Conquest of America, Richard Howard, trans. (New York, 1984), 167f.

7. Cf. for example William Rubin, "Modernist Primitivism: An Introduction," in Primitivism in 20th Century Art: Affinity of the Tribal and the Modern, two volumes (New York, 1984), 1 - 81. And as negative reaction, cf. Hal Foster, "The 'Primitive' Unconscious of Modern Art," October 34 (1985), 45 - 69; Arthur C. Danto, "Primitivism in 20th Century Art," in his collection of art criticism The State of the Art (New York, 1987), 23 - 27.

8. Stephen A. Tyler, "Post-Modern Ethnography: From Document of the Occult to Occult Document," in Writing culture, Clifford, Marcus, eds., 126.

9. In the presentation of modern-art trends, we are following in particular Werner Haftmann, Malerei im 20. Jahrhundert (Munich, 1962); rpr. as Painting in the Twentieth Century (New York and Washington: Praeger, 1965), vol. 1, passim. Haftmann clearly stresses the "logic" of the development of modern painting. There is no denying that he schematizes the picture somewhat in so doing. For our purposes, we will disregard the increasing complexity and discontinuity of this development in recent years. The detailed reasons for this approach are given in the text.

10. Peter Bürger, Theory of the Avant-Garde (Minneapolis, Minn.: University of Minnesota Press, 1982).

11. Cf. Stardusters: New Works by Jane Ash Poitras, Pierre Sioui, Joane Cardinal-Schubert, Edward Poitras, Garry Mainprize, ed. (ex. cat.; Thunder Bay, Ont.: Thunder Bay Art Gallery, 1986).

12. Quoted by Werner Haftmann, Painting in the Twentieth Century, I, 39.

13. Haftmann, Painting in the Twentieth Century, I, 36.

14. See Franz Boas, Primitive Art (New York: Dover, 1955) and Bill Holm, Northwest Coast Indian Art: An Analysis of Form (Seattle, Wash.: University of Washington Press, 1965).

15. Cf. the fundamental discussion of the connection between decoration and expression in the essay "Art and Culture in a Perceptual Interplay" in the present volume.

16. See the essay "Art and Culture in a Perceptual Interplay" in the present volume.

17. Elizabeth McLuhan and R.M. Vanderburgh, Daphne Odjig: A Retrospective 1946 - 1985 (Thunder Bay: Thunder Bay National Exhibition Centre and Centre for Indian Art, 1985), 13. For this same reason she also valued Van Gogh's "emotionalism" (Sandra Johnson, "Art and Artists," Winnipeg Free Press (30 October 1971) and Emily Carr's sympathetic understanding for the landscape of the West Coast and culture of the Indians.

18. "Daphne Odjig," transcripts from an interview by Tom Hill in preparation for the film Colours of Rude, quoted in McLuhan and Vanderburgh, Daphne Odjig, 27.

19. The fact that both the utilization and the transformation of Cubist stimuli was not an isolated instance is evident in Oscar Howe, an inspirational force for modern Indian art in the USA; for Howe, too, Cubism - strongly linked with Abstraction - was a way of using physical means to emphasize a spiritual phenomenon, the union of human beings with the cosmos. This principle of the unbroken continuity of life-forms and of spiritual oneness, a principle that is inherent in Indian cosmology, is also doubtless the reason why Howe (like Odjig) has resisted being labelled as just a Neocubist, and why he considered his pictures - which combine Cubism, Futurism, and magical view of things - to have originated primarily in a ("sympathetic") Indian sensibility.

20. McLuhan and Vanderburgh, Daphne Odjig, 13.

21. "Daphne Odjig," transcripts of interviews by Roz Vanderburgh, 1981, tape 1, side 2, quoted in Mcluhan and Vanderburgh, Daphne Odjig, 34.

22. Elizabeth McLuhan and Tom Hill, Norval Morrisseau and the Emergence of the Image Makers (Toronto: Art Gallery of Ontario/Methuen, 1984).

23. Sandra Johnson, "Arts and Artists," Winnipeg Free Press (30 October 1971).

24. "Daphne Odjig," transcripts of interviews by Dan Curtis in preparation for a film, 1982, quoted by Vanderburgh, "Daphne Odjig: Her Life" in McLuhan and Vanderburgh, Daphne Odjig: A Retrospective, 18.

25. See Haftmann, Painting in the Twentieth Century.

26. In 1970 Odjig wrote: "[in] recent years I feel I've found my place in life, I feel more content and most of the time I paint more for enjoyment and expression" (Daphne Odjig, in McLuhan and Vanderburgh, Daphne Odjig: A Retrospective, 29).

27. Lister Sinclair and Jackson Pollock, The Art of Norval Morrisseau (Toronto: Methuen, 1979) - Morrisseau's "Foreword," 7.

28. Quoted from an unfinished letter written by Morrisseau to Selwyn Dewdney, dated 12 January 1962.

29. Lister Sinclair and Jackson Pollock, The Art of Norval Morrisseau, 333.

30. Elizabeth McLuhan, ed., Norval Morrisseau: Recent Works (Thunder Bay National Exhibition Centre and Centre for Indian Art, 1983), 4. In a 1983 interview, Morrisseau linked the old picture scrolls/petroglyphs with the very personal, dreamlike visionary state that was so important for him as a way of reaching a higher level of spiritual reality: "When the Midewiwin drew simple bird symbols - all those symbols - then they had a reason for doing that. They were starting to conjure up the dream state from which they came." (Ibid.)

31. McLuhan, Hill Norval Morrisseau and the Emergence of the Image Makers, 53.

32. See the illustrations in McLuhan and Hill, Norval Morrisseau and the Emergence of the Image Makers, 74f.

33. McLuhan, ed., Norval Morrisseau: Recent Works, 3.

34. Robert Musil, Der Mann ohne Eigenschaften (Hamburg: Rowohlt, 1952), 408 (author's translation).

35. (In this connection, see the essay "Art and Culture in a Perceptual Interplay" in the present volume).

36. Haftmann, Painting in the Twentieth Century I, 180.

37. Wassily Kandinsky, Ueber das Geistige in der Kunst (Bern, 1963 Munich, 1912; trans. as Concerning the Spiritual in Art (New York: Wittenborn, Schulz, 1947), 109.

38. Kandinsky, Concerning the Spiritual in Art, 127.

39. Idem.

40. Haftmann, <u>Painting in the Twentieth Century</u> I, 190.

41. <u>Ibid</u>. I, 224.

42. <u>Ibid</u>. I, 282.

43. Adolf Gottlieb and Mark Rothko (in collaboration with Barnett Newman), "Letters to the Editor," New York <u>Times</u> (June 13, 1943), Section 2, p. 9; reprinted in <u>American Artists on Art – From 1940 to 1980</u>, E. Johnson, ed. (New York, 1982); on the subject of American Abstract Expressionism, cf. also the overview by Charles Harrison, "Abstract Expressionism," in <u>Concepts of Modern Art</u>, Nikos Stangos, ed. (New York, 1981), 169 – 212; and in particular the classic essay by Meyer Schapiro, <u>Modern Art: 19th and 20th Centuries</u> (New York, 1978), 185 – 232.

44. Fritz Bultmann, quoted by W. Jackson Rushing, "Ritual and Myth: Native American Culture and Abstract Expressionism," in <u>The Spiritual in Art: Abstract Painting 1890 – 1985</u>, (ex. cat.; Los Angeles: Los Angeles County Museum of Art/New York: Abbeville Press, 1985), 282.

45. Barnett Newman, "Introduction," <u>Pre-Columbian Stone Sculpture</u> (ex. cat.; New York: Wakefield Gallery, 1944).

46. Barnett Newman, "Introduction," <u>Northwest Coast Indian Painting</u> (ex. cat.; New York: Betty Parsons Gallery, 1946).

47. See W. Jackson Rushing, "Ritual and Myth: Native American Culture and Abstract Expressionism," in <u>The Spiritual in Art</u>, 273 – 296.

48. Quoted in Highwater, <u>The Primal Mind</u> (New York: Harper and Row, 1980), 120f.

49. Alberto Busignani, <u>Pollock</u> (Middlesex, 1971), 48.

50. Quoted by Sidney Janis, <u>Abstract and Surrealist Art in America</u> (New York, 1944), 118.

51. Barnett Newman, "The Ideographic Picture" (1947), in <u>American Artists on Art</u>.

52. Meyer Schapiro, "The Younger American Painters of Today," <u>Listener</u> 60 (26 January 1956), 140.

53. Clement Greenberg, for example, wrote as early as 1946: "What we are confronting here is a historical consciousness which has simply appropriated Existentialism in order to express and to justify itself, which was already credible before most of the people in question had ever read Heidegger or Kierkegaard.... Whatever the affectations of the philosophical imbalance of Existentialism might be, it is aesthetically adequate in our time. What we have here, to emphasize it once again, is not so

much a philosophy but a mood." From "Art," <u>The Nation</u> 163 (13 July 1946), 54.

54. See the essay by Lloyd K. New, the longtime director of the Institute, "Das 'Institute of American Indian Arts' und die indianische Malerei der Moderne," in <u>Indianische Kunst im 20. Jahrhundert</u>, Gerhard Hoffmann, ed. (Munich: Prestel, 1985), 81 - 88.

55. William C. Seitz, <u>The Art of Assemblage</u> (New York, 1961), 37.

56. Cf. Clement Greenberg, "The New Sculpture" and "Modernist Sculpture, Its Pictorial Past," in <u>Art and Culture: Critical Essays</u> (Boston: Beacon Press, 1965), 139 - 145, 158 - 163.

57. See also Bourdelle, Degas, Despiau, Maillol, and Matisse in France; Barlach, Kolbe, Lehmbruck, and Marcks, or Kirchner in Germany; and Modigliani in Italy - as well as Lachaise and Nadelman in the USA.

58. See the essay "Postmodern Culture and Indian Art," in particular section 3, in the present volume.

59. On the origin of this type of structuring of space in cubist collages, see Greenberg, <u>Art and Culture</u>, 142.

60. Cf. more detailed information in the essay "Postmodern Culture and Indian Art," in the present volume.

61. Haftmann, <u>Painting in the Twentieth Century</u>, I, 208.

OF PUBLIC CONCERN
THE PENSIONING OF THE VISUAL ARTS IN CANADA SINCE 1945

by

Michael Bell

The state... had little business there.[1]

*Petit peuple qui malgré tout se multiplie dans la
générosité de la chair sinon dans celle de l'esprit, au
nord de l'immense Amérique au corps sémillant de la
jeunesse au coeur d'or, mais à la morale simiesque,
envoûtée par le prestige annihilant du souvenir des
chefs-d'oeuvre d'Europe, dédaigneuse des authentiques
créations de ses classes opprimées.*[2]

*If we in Canada are to have a more plentiful and better
cultural fare, we must pay for it. Good will alone can
do little for a starving plant; if the cultural life of
Canada is anaemic, it must be nourished and this will
cost money.*[3]

*How to save artists from poverty without making them
the permanent pensioners of the state has been and
continues to be the most obstinate problem connected
with the public support of the arts....*[4]

*As Council policies in these matters showed signs of
becoming subsumed by and subordinate to a cultural
policy of the federal government itself, the process of
consultation and accommodation became an
intergovernmental affair, to be conducted within the
broader framework of federal-provincial negotiations.
This has the effect of further intensifying the
intrusion of governments, both federal and provincial,
in cultural matters, reinforcing the tendency toward
the politicizing of the arts and their public
patrons....*

*For in the dispute over which level of government
should determine the role of the arts in Canadian
society, what is lost is the question whether any
government should presume to do so-or whether the
function should be left to other, more diffuse, social
processes, in which artists, patrons, critics and the
interested public all play their parts. We may be
moving to a judgement of Solomon in a dispute in which
neither party has a valid claim to parentage. In such
a judgement, the welfare of the ward may count for
little.*[5]

*But the engagement of the private sector on a broader
scale than ever before is essential if the arts are to
flourish and grow in freedom and Canadian artists are
to cease to be, in general, the second most financially
deprived group in Canada.[6]*

*One condition shared by all governments–and it is
central to the whole cultural enterprise in Canada–is
that, whatever applied in the past, they are now all
completely committed to pursuing effective policies
with respect to the arts. If, indeed, one were to
identify a single pivotal principle of arts policies in
Canada, it would be that the arts are of public concern
and therefore within the jurisdiction of public
policy.[7]*

*The present... is a hopeful time. Some trends are not
easily reversed, however, and our public galleries have
not abandoned their attempts to become museums. They
have held themselves apart from the day-to-day
activities of the Canadian artistic life. The private
galleries have forged for themselves an imposing place
in the overall pattern, assuming some initiatives in
production as well as distribution, perhaps a mixed
blessing in the long run. Dealers, galleries, and
cooperatives have their place, but a balance is
necessary; in a healthy environment the artist must
have substantial control of the direction of his own
art for optimum growth and development. However, the
newly established art community in Canada-composed of
the artists themselves, their organizations, and the
galleries both public and private-is beginning to have
the potential, the "critical mass" as the nuclear
physicists say, to take its place on the world art
scene. Canadian art seems about to come of age.[8]*

January 1989 marked forty years since Vincent Massey, heir to a
fortune made in the manufacture of farm implements, patron of the
arts, and a diplomat who would later become the first Canadian-
born governor-general of Canada, was asked to chair the Royal
Commission on National Development in the Arts, Letters, and
Sciences.[9] Prime Minister Mackenzie King had shown no interest
when the commission had been proposed at the 1948 Liberal
Convention. But his successor, Louis St. Laurent, gave the go-
ahead for the commission despite his own doubts about its
national importance.[10] It did provide a means to diffuse the
pressure building for federal aid to universities and for an
examination of the Canadian Broadcasting Corporation.
Universities and the CBC were realities of Canadian life and
probably would not change a great deal in substance as a result

of the commission, but the arts were rather sad, weak, and shot through with amateurism and colonialism.

Massey and his family had been patrons of the arts. He himself had arranged to provide David Milne, an independent individual in both his aesthetic and his life, with an annual stipend in return for the paintings that the artist produced. As patron, Massey had arranged for the works to be sold in private galleries. He thus had some knowledge of the art world before he and his fellow commissioners investigated the state of the visual arts. Their investigation revealed that although Canada's steadily increasing population enjoyed a vigorous and growing economy stimulated by the war, and a fuller degree of political and constitutional independence than before, the arts had not kept up. A handful of artists had struck out in their own direction, abandoning the tired formulae of the Group of Seven and the succeeding Canadian Group of Painters, but they had little public support and were little known outside their immediate circle. Certainly the group of artists in Montreal who, with Paul-Émile Borduas, signed the Refus global (1948), were a powerful revolutionary presence, but were little known outside the immediate circle of artists in Quebec. There was no national gallery with its own building to present and promote painting, sculpture, printmaking, and design to their best advantage.[11] In the major centres of Toronto and Montréal, private citizens and artists gathered their resources to construct buildings, assemble collections, and establish art gallery programmes. Art writing existed as a parochial journalistic practice and rarely plumbed the issues shaping the postwar art world at an international level. Canadian Art, the heir of Maritime Art and forerunner of the now defunct artscanada, was the only art periodical of substance in the country.

The major recommendation of the commissioners, who ordered studies on the state of the arts, letters, and sciences,[12] and travelled across the country to gain a clear and broad perspective, was the formation of the Canada Council, to support the arts, letters, and sciences in Canada through grants to individuals and voluntary associations. The commissioners' concept of culture, conservative and characteristically Western, may be viewed as elitist. Their identification of "mass culture" (certainly undesirable) with the United States drew criticism; it should rather be seen as an adjunct to democracy.[13]

Just as the commission itself had lacked political appeal because it was limited to the arts, so the commission's recommendations on the arts and humanities met with little enthusiasm and lingered without action by the government for years after the commission's report was tabled in the House of Commons in 1950.

The Massey Report discussed the arts and crafts of the native populations, but the concerns did not register strongly enough for any major recommendations to be formulated. Action was referred to the appropriate government departments. Programmes eventually took shape to provide the foundation for the flowering of Inuit art in an artificially contrived "closed market," and several abortive attempts were made to achieve some similar success in an "open market" for Indian arts and crafts.[14] Both types of initiative, however, were founded upon economic rather than aesthetic justifications; and the results were quite at odds with the principles espoused by the Canada Council when it was formed to support the arts in Canada.[15]

A combination of events brought action on the commission's major recommendation. In 1956 Walter Gordon's preliminary report of the Commission on Canada's Economic Prospects suggested that Canada's dependence on capital from the United States was dangerous; this was an echo, in economic terms, of the message delivered by the Massey Commission. The threat of American imperialism was real: the nation had depended on the generosity of foundations in America and had no qualms about importing that country's entertainment, books, magazines, and films. The result was a steady erosion of what little Canadian culture existed, and meagre stimulation to create and nourish anything indigenous and new. Now, forty years later, with our new consciousness of our history and an established system of generous support for the arts, it may be difficult to imagine how fresh this observation was at the time. The second event to give substance to the commission's recommendation was a windfall of death duties that the government received from the estates of two of Canada's wealthiest industrialists, Sir James Dunn and Isaak Walton Killam.

The two estates yielded over $100 million in unexpected revenues for the government. John Deutsch, an economist and secretary of the Treasury Board, suggested that this money ought to be used for something other than the day-to-day operations of government. His suggestion was taken up, and $50 million was allocated to the new Canada Council, recommended by the Massey Commission and legislated into existence in 1957. The government of Canada was in the business of supporting the arts, letters, and social sciences, albeit at arm's length and with results that could not be envisioned at the time.[16]

As the Canada Council became operational, its clients (artists and scholars) were enlisted as advisers and evaluators in its earlier years and continued to be a dominant force, shaping policy and programmes in the years that followed. It has been observed that the arts prospered on the coattails of the social sciences and humanities, both of which were more appealing to politicians than were the arts. This seemed to be the case

until 1981, when the Canada Council's mandate was redefined to provide support for the arts only, and the Social Science and Humanities Research Council of Canada was created to fund the social sciences and humanities. One other significant change occurred in the late 1960s: in addition to receiving the endowment resulting from the windfall death duties, the Council was awarded an annual appropriation from Parliament and thus became more vulnerable to political pressures. This vulnerability manifested itself clearly in the early 1980s, when Parliament wanted to exert more control by making the Council (which, according to the Canada Council Act, was "not an Agent of Her Majesty") subject to government directive. This move raised the ugly spectre of "cultural dictatorship" by ministers of the Crown, and nightmares of arts grants awarded not on merit established by peer evaluation, but in response to policies formulated by elected politicians.[17] The arts community rallied to the defence of the Canada Council and the operational methods they had helped to shape from the Council's earliest days. However, 85 per cent of the council's budget still comes from the annual appropriations approved by Parliament.

Visual art is undoubtedly one of the sectors of the arts to benefit least from the Canada Council's budget.[18] Money is directed to grants for art-gallery exhibitions, operational and programme grants for the system of artist-run parallel galleries, and the purchase of contemporary art for the Canada Council Art Bank. However, visual artists and artist-run organizations are privileged in that they have managed to remain independent of traditional public organizations with powerful boards of trustees that, in disciplines like music, dance, and theatre, soak up huge amounts of money for the operations of symphonies, theatres, and opera and dance companies.

Yet, if the Canada Council has been the most important factor in the art world since 1945,[19] what precisely has it accomplished? How has its support made a difference? The most recent and thorough examination of these questions and a host of others occurred during the deliberations of the Federal Cultural Policy Review Committee, which reported in 1982.[20] According to the report, painting, the most familiar form of Canadian art both at home and abroad, has been displaced by sculpture, printmaking, and more recently developed media, such as video, conceptual, and performance art. Canadian artists have become known and highly regarded internationally for their innovations in the use of mass media, in performance, and in film. A great deal of this activity was nurtured in the system of parallel galleries. In the 1970s, the government ran programmes to absorb the energies of unemployed youth in local initiatives. These programmes-Opportunities for Youth (OFY) and Local Initiatives Programme (LIP)-attracted artists, who often formed art centres. When OFY and LIP ended, many of the centres approached the Canada Council

for modest funding in order to continue. Encouraged by the council, they eventually organized a network. The purpose of these parallel galleries was summed up clearly in Parallelogramme Retrospective 1976 - 1977, their own summary of activities published by ANNPAC (Association of National Non-Profit Art Centres, which, in 1977, had 18 members): "to respond to new art movements and to consider them as important to national culture as the preservation of historic treasures."[21] The presentation of contemporary art had been conducted mostly by the public art galleries and commercial galleries. But, as the editor of Parallelogramme noted, the "multidisciplinary aspects of new art, the inconsistencies, changes and risks of an evolving art do not fit easily into curatorial policies of traditional museums or exhibition centres."[22]

The rising level of visual-arts and related activity stimulated the publication of more magazines. In the 1950s, two periodicals, one in French and the other in English, served the community. By 1980, there were at least fifteen, many emanating from various regions and supporting local artists and their activities. Some, like Fuse, have served as effective vehicles of propaganda for artists and their organizations. There are now more visual arts departments in universities and community colleges. Public and commercial galleries are common in communities in every province. Many provinces have established funding programmes to complement the Canada Council's, and some municipalities have proven to be models of support for their public galleries and artists' organizations.[23]

The Canada Council has been so successful that in an artscanada issue entitled The Canadian Cultural Revolution: An Appraisal of the Politics & Economics of Art,[24] almost all the ninety or so pages of commentary focused on the Canada Council, especially the Art Bank. In the nine years following its foundation in 1972, the Art Bank spent $6.4 million on 10,000 works of art by about 1,000 artists.[25] The council again consulted artists in purchasing these works for its inventory of art to be rented to decorate government offices in Ottawa and across the country.[26]

The programme was the brainchild of artist Suzanne Rivard Le Moyne,[27] who found herself in a job in the Department of the Secretary of State in Ottawa working closely with André Fortier, then Assistant Under-Secretary of State. The department was led by Gérard Pelletier, one of the "three wise men" from Quebec and a close associate of Prime Minister Pierre Trudeau. In the federal system, culture was an area of unassigned responsibility under the British North America Act (although education was clearly a provincial concern). There is some reason to believe that the federal government used that area to intervene directly in the provinces. The Art Bank, along with a National Museums

policy,[28] fit the principles of democratization and decentralization that formed the keystones of the Liberal cultural policy.

Rivard Le Moyne took the idea with her to the Canada Council, where she was appointed the head of the Visual Arts Section. Fortier, who had been instrumental in securing the Council's parliamentary allocation, became the director of the Canada Council. Ironically, the Art Bank was the first programme of the Canada Council to be earmarked for a budget cut by John Roberts when he was Secretary of State. The spectre of political direction became tangible and was resisted by the council. It accentuated the risk to artists of government patronage–when "the government has effectively become the market" for contemporary art.[29]

Artists have a long history of organizing themselves into special-interest groups,[30] but since 1945 two organizations stand out: the Federation of Canadian Artists (which submitted the major artists' brief to the Massey Commission) and the Canadian Artists Representation (CAR), founded in 1968 in London, Ontario, by Jack Chambers and Greg Curnoe as a common front for the negotiation of artists' fees for the reproduction and exhibition of their works. Overtly nationalist in its ideology and dedicated to improving the legal and economic position of the artist, CAR established a fee schedule for exhibiting artists. Along with the Canada Council's insistence that its gallery clients pay exhibition fees, the fee schedule helped alleviate somewhat the marginal economic status of artists. But statistics have been less than encouraging, especially for women artists: In 1978 full-time, independent professional artists earned annual gross incomes of between $6,000 and $10,000; women artists earned less than $2,200.[31]

While the problems of artists in Canada may be legal and economic, they are probably rooted in the failure of Canadian society to demand that the visual arts be respected as an integral component of the education curriculum at all levels:

> The best test of an artist's work lies in its exposure to the critical gaze of discriminating audiences, with well-developed standards of aesthetic judgement, a desire to share artistic experiences with creative people, and an openness to new and innovative work. Audiences have to be discriminating in order to provide the artist with constructive responses. And audiences need to be open to new experiences in order that original work may emerge. It is these qualities of the audience, rather than sheer size alone, that must become the measure of successful artistic endeavour... one of the chief goals of cultural policy must be to

establish strong and stable lines of communication
between the artists of all kinds and those who will
see, hear or read their messages.[32]

There have been recent changes in Canada Council funding
programmes for parallel and public galleries, in response to
demands by the parallel network for a greater slice of the pie.
(In 1977, 18 artist-run spaces received $421,000 to support all
operations, while 18 public galleries received $1,069,000 for
programming alone.)[33], But the changes do not seem in keeping
with the position expressed in the <u>Report of the Federal Cultural
Policy Review Committee</u> (1982).[34] With the stability and
strength provided by the annual programme grants (now cancelled),
public galleries could take more risks-larger numbers of informed
and novice gallery visitors could experience contemporary visual
arts activity in an environment "firmly rooted in a respect for
our artistic and intellectual heritage."[35] In contrast, the
activities of the artist-run parallel galleries aim primarily "to
serve the contemporary arts community and the practising artist";
they attract small audiences, and generally isolate the
experience of contemporary art from a larger new audience.[36]

A small audience provided no protection in the ideological
climate of the 1980s. In Canada, the faltering economy, with the
steady reduction of purchasing power, required organizations to
account more closely for their spending, and government put even
more pressure on funded agencies by freezing budgets. The answer
to the pleas of the artists and the institutions that support
them was a call to the private sector. Business was invited and
encouraged to participate as a partner in support of the arts.[37]
The pressures of marketing methodologies started to shape the
programmes of the public galleries. Fund-raising specialists
were hired to work in the senior positions in the larger
galleries. A government-established task force headed by
businessman and arts volunteer, Edmund Bovey, examined ways of
funding the arts in the future. Businessmen play a major role in
the arts by shaping government policy, funding public
institutions, and serving as members of public boards and as
patrons.

The art world of the late 1980s was often as unsympathetic
to the participation of business as it was in 1976 when artists
protested the sponsorship by Reed Paper (widely known to have
polluted areas of northern Ontario) of an exhibition of landscape
painting at the Art Gallery of Ontario[38]:

> The public hearings [of the Federal Cultural Policy
> Review Committee] are merely part of a continuing
> struggle for the survival of a Canadian culture (or
> more correctly a set of distinct Canadian cultures).
> The federal government has shown much interest in

industrialising what there is and many enthusiastic
entrepreneurs are pressing for the entrée to be served
immediately on the finest of satellite dishes. The
non-isolationist policies of the government are in
themselves dangerous for the maintenance of indigenous
culture; industrialising what we have, in essence,
means letting the business sector run with what will
become a homogeneous ball.[39]

As far as I have been able to ascertain, the "new"
Power Plant gallery at Harbourfront is not for artists,
nor for a Toronto art community, nor for the people of
Toronto. It caters to an imaginary abstraction called
the "public." It employs advertising (about the
gallery and not the art inside) and spoonfeeding to
target this imaginary Gallup poll of the pluralistic
viewer. Its purpose, however, is not to inform this
"public" nor is it to legitimize art. Rather, its
agenda is to legitimate corporations as the benefactors
of culture and luxury development as public service
through a smoke-and-mirrors approach to history,
politics, art and ideology. What are we then as
artists and writers, as the producers of culture, to
make of this deliberate co-option of our work and
Harbourfront's wilful attempts to misconstrue its
intent through its "playful" disregard for history and
context?[40]

The above was written in reaction to the inaugural
exhibition (sponsored by Roots, a very successful consumer-goods
manufacturer) of the Powerplant, the major new gallery at
Toronto's Harbourfront, dedicated exclusively to the presentation
of contemporary art.

Visual artists in Canada are privileged in the late 1980s.
They control the production of their work; they control a network
of art centres for the presentation of that work; and in
magazines such as Parachute and C Magazine, they exercise a
strong influence on critical comment. Contemporary visual
artists in Canada help prepare recommendations for Canada Council
funding of their activities, including purchases of their works
by the Art Bank.[41] In addition, they have become their own
curators and critics.[42] Understandably, the prospect of
corporate funding to ensure an ever-increasing level of activity
is worrisome for artists, who struggle against such funding,
using the mass-communication and lobbying techniques they have so
effectively mastered in the last twenty years.[43] There have
undoubtedly been necessary changes, such as in the copyright law,
one of the most sophisticated in the world. But, as each of
these corrections is made, the government has one less reason to
continue making a special case for artists in Canada; the measure

of artistic quality will be determined by the demand from the consuming public.[44] Visual artists in Canada should seriously evaluate the continuation of privilege, which isolates them and makes them dangerously vulnerable in an environment where art has become the object of "public policy." All aspects of the Canadian art world have been increasingly subject to "public policy" at all levels of government since 1945. No policy is likely to be good for all aspects at the same time. Much energy has gone into assessing the costs, dangers, and rewards of the policies to the individual artist, perhaps at the expense of the art, and certainly at the expense of the formation of a broadly based, informed audience. The formation of this audience is the challenge for the future if the gains made to date are to be retained and the opportunities for intelligent choices are to be preserved.

NOTES

1. Robert Bothwell, Ian Drummond, and John English, <u>Canada Since 1945: Power, Politics, and Provincialism</u> (Toronto: University of Toronto Press, 1981), 165.

2. Paul-Émile Borduas, in <u>Paul-Émile Borduas: Écrits\writings</u>, F.-M. Gagnon and Dennis Young, eds. (Halifax: Nova Scotia School of Art and Design, 1978), 45.

3. <u>Report: Royal Commission on National Development in the Arts, Letters, and Sciences</u> (Ottawa: King's Printer, 1951), 272.

4. George Woodcock, <u>Strange Bedfellows: The State and the Arts in Canada</u> (Vancouver: Douglas and McIntyre, 1985), 177 - 78.

5. Frank Milligan, quoted in Woodcock, <u>Strange Bedfellows</u>, 188 - 89.

6. Woodcock, <u>Strange Bedfellows</u>, 194.

7. John Meisel and J. Van Loon, "Cultivating the Bushgarden: Cultural Policy in Canada," in Milton C. Cummings and Richard S. Katz, <u>The Patron State: Government and the Arts in Europe, North America, and Japan</u> (Oxford: Oxford University Press, 1987), 306.

8. Aba Bayefsky and H.M. Milne in <u>The Arts in Canada: The Last Fifty Years</u>, W.J. Keith and B.-Z. Shek, eds. (Toronto: University of Toronto Press, 1980), 144.

9. Bothwell <u>et al.</u>, <u>Canada Since 1945</u>, and Donald Creighton, <u>The Forked Road: Canada 1939 - 1957</u> (Toronto: McClelland and Stewart, 1976), provide accounts of the events and the results of the commission from different points of view.

10. According to a well-known anecdote, he was reluctant to be photographed with a ballet dancer.

11. The new National Gallery building, the first designed and built for the purpose, opened in May 1988.

12. Published in a separate volume as <u>Royal Commission Essays: A Selection of Essays Prepared for the Royal Commission on National Development in the Arts, Letters, and Sciences</u> (Ottawa: King's Printer, 1951). See in particular Gérald Morisset, "Les Arts Dans La Province de Québec," 393 - 406, and Charles Comfort, "Painting," 407 - 418.

13. See Bothwell <u>et al.</u>, <u>Canada Since 1945</u>, 167 for a discussion of the response to the Massey Commission report.

14. This is clearly set out in K. Friedl, "Politics and Patronage: Federal Sponsorship of Native Arts Development" (unpublished MA thesis, Institute of Canadian Studies, Carleton University, Ottawa, 1983).

15. As expressed by André Fortier: 1) pursuit of excellence; 2) broad and general policies that permit artists to choose several different creative paths; and, 3) peer assessment of the artists and their works. Quoted in "Patronage," in Art and Reality: A Casebook of Concern, R. Blaser and R. Dunham, eds. (Vancouver: Talonbooks, 1986), 136.

16. Bothwell et al., Canada Since 1945, 168: "Whether the Council has played a major role in the appearance of a sophisticated Canadian cultural life is debatable, as are all historic relationships between patrons and scholars and artists." For a stronger position see Creighton, The Forked Road, 249: "The fact was that the Canadians of the 1950s had not yet been taught to believe that the state was the great dispenser of social and cultural goodies and that unless the state designed and financed a literary or artistic project, its failure was virtually inevitable."

17. Very clearly articulated by then Secretary of State, John Roberts, in a speech to the Canadian Conference of the Arts, May 4, 1979.

18. See the table reproduced from a Canada Council press release in Meisel and Van Loon, "Cultivating the Bushgarden", in Cummings and Katz, The Patron State, 290. Of the allocation to disciplines in 1980 - 81 and 1984 - 85, 12 per cent and 14 per cent respectively were directed to visual arts and related activities, e.g. the Art Bank and media arts. Music and theatre each account for over 20 per cent of the total.

19. Other regional factors should be noted. For instance, the Saskatchewan Arts Board, formed in 1948 in the early days of the CCF government, has purchased works of art from Saskatchewan artists since its beginning.

20. Ottawa: Department of Communications, 1982.

21. Parallelogramme Retrospective 1976 - 1977 (Montreal: ANNPAC, 1977), 6.

22. Parallelogramme Retrospective, 6.

23. The Ontario Arts Council has a full range of visual arts support programmes, ranging from programme grants to public galleries to material assistance grants awarded to individual artists upon the recommendation of third parties (public

galleries and artist-run spaces). While this discussion focuses on the (federal level) Canada Council because it set the pattern for others to follow, it should be pointed out (as Meisel and Van Loon have done, in "Cultivating the Bushgarden," Cummings and Katz, The Patron State, 296 - 297) that provincial and municipal levels of support for the arts have been substantial since at least the early 1970s; in 1982 - 83 each level of government was contributing roughly one third of the total support.

24. Autumn 1975, issue 200 - 201.

25. By June 1987, 14,000 works by 1,800 artists had been selected by juries consisting of 300 individuals from the arts community-artists, curators, critics, and writers.

26. One of the purposes of the Art Bank-to make contemporary art more accessible-was described as "a travesty, with half the works buried in a warehouse and the other half mostly in the offices of government bureaucrats wherein the public seldom ventures (most government buildings do not have large foyers)." R. Endres, "Art and Accumulation: The Canadian State and the Business of Art," in The Canadian State: Political Economy and Political Power, L. Panitch, ed. (Toronto: University of Toronto Press, 1977), 429.

27. Artscanada (autumn 1975, issue 200 - 201), 4.

28. One of the programmes of the National Museums Corporation established National Exhibition Centres to act as nodes in a network of facilities to receive touring exhibitions. One of these, the Thunder Bay National Exhibition Centre, has since become a centre devoted to the collection and presentation of the Native arts. As its current director has remarked, it can now receive exhibitions of Native art organized by other galleries, rather than being the sole originator of this kind of show. The Thunder Bay Centre can take credit for its leadership in stimulating the present level of activity.

Another sign of the change in attitude toward Native arts is found in the Report of the Federal Cultural Policy Review Committee: "This Committee is convinced that Native artists must be recognized first and foremost as Canadian contemporary artists, whatever their field, and that federal policy should give special priority to promoting both traditional and contemporary creative work by artists of Indian and Inuit ancestry." (p. 11, committee's italics.)

29. Artscanada, (autumn 1975, issue 200 - 201), 43.

30. As opposed to the less formal groupings like Les Automatistes in Montréal, or Painters Eleven in Toronto, and the exhibiting societies.

31. Noted in Report of the Federal Cultural Policy Review Committee, 154.

32. Report of the Federal Cultural Policy Review Committee, 4. The report also notes (p. 145) that "the consequence of the present gulf in understanding [between the public and the contemporary artist] is a regrettable loss of public appreciation for the achievements of our artists."

33. Clive Robertson expresses a similar view: "And it is probably no exaggeration to suggest that all 18 of those public galleries combined did not provide the same amount of original programmeming as the most productive of the artist-run centres. The artists know this and so do the funding agencies and yet the disparity has remained the same over the last five years. The artist-space funding from The Canada Council had increased 53 per cent from $330,400 in 1975 to $506,000 in 1980, whereas the public galleries funding has increased 37.5 per cent from $1,126,400 in 1975 to $1,637,600 in 1980. They are indeed running parallel with a three-to-one ratio in favour of the unproductive public galleries... this abundance of programming and underfunding places the artists who work with and in these organizations in a continual position of labour exploitation, and potential collapse." "Don't Take Candy From Strangers! The Story Behind Organized Art," Fuse (November 1980), 321.

34. Confirmed by Michael Straight in 1983. See Straight's comment in "The Double Edged Sword: A Response," in Art and Reality, Blaser and Dunham, eds., 162. Working with organizations committed to public education has a greater potential to raise general awareness of the arts than providing grants directly to individuals and groups of individuals to serve their own autonomous artistic purposes.

35. Report of the Federal Cultural Policy Review Committee, 3.

36. Report of the Federal Cultural Policy Review Committee, 149 - 150. By ANNPAC's estimate, 280,000 in 1980. See p. 146 for the following observation about the estimated 140 public art galleries or museums that collect and display contemporary art. In 1981 - 82, the Council for Business and the Arts reported attendance at 32 major public galleries to be 4.6 million.

37. Endres notes that the trend started when the Canada Council provided seed money to found the Council for Business and the Arts in Canada in 1975. "Art and Accumulation," in The Canadian State, Panitch, ed., 415.

38. A comment by John Mays (art critic of the Globe and Mail) may offer some insights into this dilemma. "In this act, the definition of art and its institutions as acts of caring for

reality is affirmed. And we see this caring for art as a caring for humanity, and this in turn as a caring for the preservation of the world, a sequence of concerns, continually opening toward the more profound exercises in human courage on behalf of the world-or at least beginning to open upward awakening, and the dawning of compassion and critical consciousness." "Art and Reality?" Art and Reality, Blaser and Dunham, eds., 24.

39. Clive Roberston, "Business and Culture: A Shot in the Arm or a Shot in the Head?" Fuse (August/September 1981), 196.

40. Dot Tuer, quoted in E. Town, "The Other Side of the Tracks: Playing with Toronto History," Vanguard (September/October 1987), 28.

41. Has the Canada Council become "captive of the arts establishment" as André Fortier suggests? (See "On Patronage," Art and Reality, Blaser and Dunham, eds., 137.) Or from another point of view, that of the artist in Atlantic Canada, "the more one looks into the politics of art in Canada, the clearer it becomes that there is a network (an old boys' network) that the structure is based on and that it helps to perpetuate itself...." Summary of Briefs and Hearings: Federal Cultural Policy Review Committee (Ottawa: Department of Communications, 1982), 93.

42. Control of the means of production and control of the mode of communication are important powers in postmodern society. One can gain some important insights into their scope by examining the world of scholarly publishing. See I.L. Horowitz, Communicating Ideas: The Crisis of Publishing In a Post-Industrial Society (Oxford: Oxford University Press, 1986).

43. This observation is confirmed in an international sense by Cummings and Katz: "the arts groups have sometimes used techniques that could serve as lessons to some of the old-line lobbying groups. In short, there has been a rather remarkable increase in the political sophistication of the constituency for the arts." "Government and the Arts in the Modern World: Trends and Prospects," The Patron State, 366.

44. To counter any objection to the idea that the consumer is an element in the conceptualization of art and creativity by the powerful shapers of the funding environment of artists in Canada, I draw attention to the definition of creativity put forward by André Fortier, one-time Director of the Canada Council and Executive Director of the Bovey Task Force on Funding of the Arts in Canada: "the practice of creativity is extremely complex and involves four kinds of activity: creation, production, distribution, and consumption." "On Patronage," Art and Reality, Blaser and Dunham, eds., 130. Or, from another perspective, "the better product is still the ultimate critic of the good

expectation." Horowitz, <u>Communicating Ideas</u>, 6.

NORTHWEST COAST INDIAN ART FROM 1950 TO THE PRESENT

by

Karen Duffek

On the Northwest Coast and across Canada, issues of political and cultural self-determination for First Nations people are receiving increasing recognition. These issues are not lost on prominent artists working in Northwest Coast styles, who are engaged in a struggle to define their art as contemporary self-expression while working within centuries-old conventions of form and composition. If there is one overriding feature of the development of Northwest Coast art in the past four decades that sets this region apart from Native art communities in the rest of Canada, it is the art's connection to tradition and a cultural imperative that charges the artist with expressing not only a personal but also a collective identity.

Since the 1960s, a dramatic revival of Native art traditions has been taking place on the Northwest Coast, after a decline in art production that lasted several decades. This revival, termed by some a renaissance, has been most prominent in the urban marketplace where it has been encouraged by a growing tourist demand for souvenirs. In recent years, production has been accompanied more and more often by the renewed creation of works for personal, spiritual, community, and ceremonial potlatch uses. Leading artists working within each of these realms are creating new traditions. The term "revival"-suggesting a resurrection of old forms-no longer describes the best work, which, rooted in the recognized styles and imagery of Northwest Coast art, also bridges the gap between past traditions and the personal experiences of present-day artists.

From 1950 to the early 1960s, Northwest Coast art continued to decline. The Potlatch Law, an 1884 amendment to the Indian Act prohibiting the potlatch, was not repealed until 1951. This law had significantly aided the disintegration of the social, economic, and political structures that had supported the art and given it meaning. Moreover, a new audience and consumer, and a new economic and social support system, had not yet developed enough to replace those of the past and foster the same level of art production. Museums were providing some support by commissioning new work and attracting an appreciative audience. But most carvers were producing for an uninformed market, and were themselves untrained.

Of all the Northwest Coast tribal groups, the Southern Kwakwaka'wakw were the most successful in continuing their artistic traditions in the face of potlatch prohibition and

pressures to assimilate. Even among the Kwakwaka'wakw, however, art production decreased and was carried on by relatively few practitioners. Willie Seaweed (ca. 1873 - 1967) and Mungo Martin (ca. 1881 - 1962), among others, managed to maintain a viable and culturally significant art by producing ceremonial objects for potlatch use, as well as items for an outside market. Both artists were trained under the traditional apprenticeship system and contributed to the development of the Southern Kwakwaka'wakw style, now practised most notably by the Hunt family of carvers. As strong artists working within a tribal genre, they acquired reputations as great carvers among their own people and among museums and collectors in the larger society, and inspired new generations of Kwakwaka'wakw artists to carry on the tradition.

Willie Seaweed, like Mungo Martin, was a high-ranking chief whose commitment to the potlatch manifested itself in some of his finest works, created for the Winter Dances: the powerful monster bird Hamatsa masks. Carved in the years following the most serious suppression of the potlatch, these masks were political statements above and beyond their immediate expression of inherited status within Kwakwaka'wakw society. Both Seaweed and Martin also carved model totem poles for sale to a non-Indian public. The poles exhibit the same careful craftsmanship that was applied to more traditional pieces.

A series of watercolours painted by Mungo Martin in 1949 - 1950 anticipated the eventual importance of the silkscreen print to Northwest Coast artists two decades later. In his paintings, Martin presented mythological characters and masked dancers in a new way: as two-dimensional figures centred on a white page. The Kwakwaka'wakw artists to produce the first silkscreens for sale were Ellen Neel in 1949 and Chief Henry Speck in the early 1960s.

In 1949 - 1950, the University of British Columbia commissioned Mungo Martin and Ellen Neel to restore totem poles brought to the campus years earlier. This project heralded the beginning of active museum involvement in the promotion of Northwest Coast art by living artists. Martin spent two years at UBC as a carver and ethnology specialist for the Museum of Anthropology (under then-curator Audrey Hawthorn), and, when the project was extended into 1950 - 1951, carved two forty-foot poles exhibiting his family crests. Afterward, he spent ten years as carver-in-residence at the BC Provincial Museum in Victoria, where he constructed a new version of his traditional community house, and carved or replicated over twenty totem poles. He also established himself as a teacher of the old ways to several generations of Kwakwaka'wakw carvers, including his son-in-law Henry Hunt, grandson Tony Hunt, and step-grandson Doug Cranmer. Both the UBC and the BC Provincial Museum projects were successful in attracting public attention, and Martin can thus be

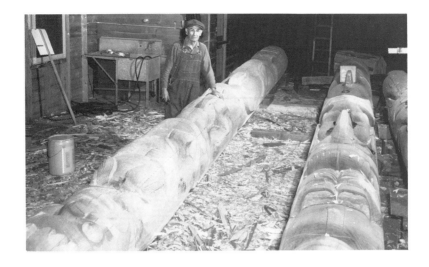

Fig. 1. Mungo Martin carving totem poles at the University of British Columbia, 1949. Photo by P. Holburn. Courtesy of the University of British Columbia Museum of Anthropology, Vancouver, BC.

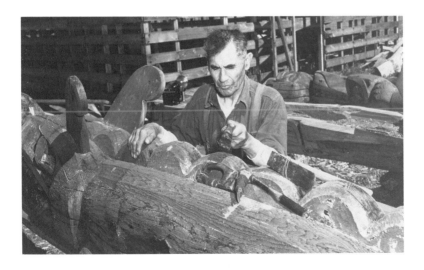

Fig. 2. Mungo Martin restoring totem poles at the University of British Columbia, 1949. Photo by P. Holburn. Courtesy of the University of British Columbia Museum of Anthropology, Vancouver, BC.

Fig. 3. Mungo Martin house, Thunderbird Park, Victoria, BC.
Courtesy of the University of British Columbia Museum of
Anthropology, Vancouver, BC.

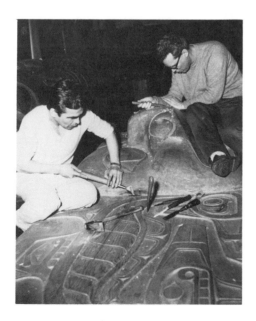

Fig. 4. Bill Reid (right) and
Doug Cranmer (left) carving
mortuary pole for University
of British Columbia Museum of
Anthropology. Photo by P.
Holburn. Courtesy of the
University of British Columbia
Museum of Anthropology,
Vancouver, BC.

credited with laying much of the groundwork for a renewed
interest in Northwest Coast art among both Native and non-Native
people.

Museum commissions continued in the following years. In
1954, the BC Provincial Museum hired Henry Hunt as carver-in-
residence, to continue the project that had begun with the hiring
of Martin and been carried on by Tony Hunt, Richard Hunt, and
Nuu-Chah-Nulth artists Ron Hamilton and Tim Paul. Henry Hunt
stayed with the museum until 1974; during that time and
subsequently, he produced works for sale to non-Indians and for
ceremonial use by his people. His Thunderdbird, Bear, and Sea
Urchin model totem pole demonstrates, even in miniature, his
mastery of Southern Kwakwaka'wakw monumental sculpture, which won
him high regard. In 1957, the UBC Museum of Anthropology
commissioned Haida artist Bill Reid and assistant Doug Cranmer to
carve six totem poles and a memorial figure, and to supervise the
building of a winter dwelling and mortuary house in the re-
creation of part of a Haida village. The three-and-a-half year
project allowed Reid to leave his broadcasting career, devote
himself full time to Haida art. Working closely with Reid,
Cranmer in turn developed an understanding of northern Northwest
Coast two-dimensional art, which he has integrated into his very
personal painting vocabulary.

From this period on, Vancouver, Victoria, and Seattle became
focal centres for the Northwest Coast art revival. Although
commercial art production was continuing in more remote Native
communities, many artists established themselves in the city,
where the main markets for Indian art were developing. The city
also provided artists with access to the museum collections,
photographs, and books that were now the major sources for
reconstructing and reinterpreting Northwest Coast art forms.

When Bill Reid embarked on a rediscovery of Haida artistic
traditions in the early 1950s, knowledge of the highly
conventionalized styles of northern Northwest Coast two-
dimensional art had been lost. By studying objects in museum
collections and ethnographies written by the early anthro-
pologists, he began to reconstruct the formal conventions of this
complex tradition and grasp the underlying artistic process. His
early attempts were conducted in a mechanical way by copying
older pieces. In essence, Reid became an "apprentice" to his
great-uncle, the late Charles Edenshaw (ca. 1839 - 1920), who
achieved renown as a master Haida artist and whose work was well
represented in museum collections and reproduced in books.
Reid's copying of the master's art was a traditional way of
learning Northwest Coast form and provided the foundation for the
original works he went on to create. It remains an important
technique for young artists today.

While Reid was making his discoveries, similar exploration was being conducted by Bill Holm, a young American art historian from Seattle, who later became the curator of Northwest Coast Indian art at the Thomas Burke Memorial Washington State Museum. Holm analyzed almost four hundred Haida, Tsimshian, Tlingit, Haisla, Heiltsuk and Nuxalk artifacts and created his own masks and ceremonial objects in Northwest Coast styles. By these methods he learned the design principles to which the art owes its structure. He created the vocabulary-"ovoids," "form-lines," and "U-forms"-that standardized and refined the criteria that artists and anthropologists alike could use to analyze designs and assess artistic quality. The results of Holm's studies were published in 1965 as Northwest Coast Indian Art: An Analysis of Form. The book has had an unforeseen, far-reaching, and sometimes moderating influence on the development of Northwest Coast art and connoisseurship by inhibiting further investigation of both the formalism and the flexibility of the art.

Haida artist Robert Davidson began learning directly from Bill Reid in the 1960s and, like other artists of his generation, used Reid's and Holm's work to build his understanding. By studying old pieces in museums and discussing them with knowledgeable curators, Davidson gained an awareness of the range of Haida artistic traditions, of which he knew little before moving to Vancouver from the Queen Charlotte Islands. Like Reid, he began by copying old pieces. But his art has progressed beyond mere copying, to a point where the standard formal analysis outlined in Holm's book has become inadequate to critically describe it. Davidson has in turn become a new source or channel through which younger artists can acquire knowledge about their evolving ancestral traditions.

Kwakwaka'wakw artist Tony Hunt is probably the only artist of his generation to have learned directly from a master-Mungo Martin-whose knowledge of art derived from direct experience of the traditional culture still practised in the early 1900s. Most artists today who wish to learn Northwest Coast art must settle for other methods: they can learn on their own from books, photographs, and museum collections; they can apprentice to other artists; or they can learn in a formal training setting such as 'Ksan, Tony Hunt's workshop in Victoria, or the U'Mista carvers' programme in Alert Bay.

The Kitanmax School of Northwest Coast Indian art at 'Ksan, located in the Hazelton area of British Columbia, was the product of local initiative and, eventually, federal government funding programmes. The artists' training programme at 'Ksan was created in 1967, both to revive an interest in the art and cultural traditions of the area and to provide graduates with a means of livelihood. Instructors representing various tribal groups were brought in to the school: Tony Hunt and Doug Cranmer,

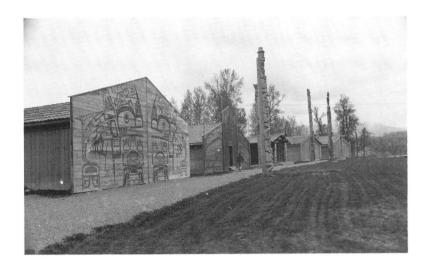

Fig. 5. 'Ksan village. Photo by M. M. Ames. Courtesy of the University of British Columbia Museum of Anthropology, Vancouver, BC.

Fig. 6. Masked and robed dancers at the opening celebration for the exhibition "The Copper that Came from Heaven," July 1983. Photo by W. McLennan. Courtesy of the University of British Columbia Museum of Anthropology, Vancouver, BC.

Fig. 7. Haida canoe "Lootaas," carved by Bill Reid and
assistants, being paddled at Skidegate in the Queen Charlotte
Islands, BC, 1986. Photo by J. L. Gijssen. Courtesy of the
University of British Columbia Museum of Anthropology, Vancouver,
BC.

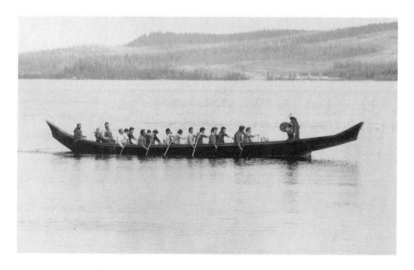

Fig. 8. Haida canoe "Lootaas," carved by Bill Reid and
assistants, being paddled at Skidegate in the Queen Charlotte
Islands, BC, 1986. Photo by J. L. Gijssen. Courtesy of the
University of British Columbia Museum of Anthropology, Vancouver,
BC.

Kwakwaka'wakw; Robert Davidson, Haida; and Duane Pasco, a non-Native artist from Seattle. Although all the instructors were accomplished artists, none was proficient in the traditional Gitksan, Tsimshian, or Nisga'a art forms. They introduced images and forms from their own art traditions, and the personal styles of Duane Pasco and Vernon Stephens, one of the school's first graduates, greatly influenced the distinctive 'Ksan style that emerged.

Walter Harris received his early training in Northwest Coast art at 'Ksan in 1969 under Duane Pasco and Doug Cranmer. Cranmer's influence is apparent in works such as the Sun Mask, which synthesizes Kwakwaka'wakw and Gitksan styles of sculpture and two-dimensional painted forms. Harris has produced works in wood, metal, and serigraphy, both for sale and for Gitksan ceremonial use; in 1971 he carved and raised a totem pole in his village of Kispiox. His involvement with the renewal of Gitksan ceremony shows that 'Ksan's positive impact on the community has surpassed the original goals set for the programme.

Canada's centennial year, 1967, marked not only the beginning of instruction at 'Ksan, but also the initiation of federal funding for artists to contribute to the formation of a national culture and image. At Expo '67 in Montreal, contemporary and traditional Northwest Coast art received some long overdue exposure outside British Columbia. The Vancouver Art Gallery also held a centennial exhibition, Arts of the Raven, regarded by some as a turning point in the appreciation of Northwest Coast art. Organized by Doris Shadbolt with the assistance of Bill Reid, Bill Holm, and anthropologist Wilson Duff, the exhibition was intended to present Northwest Coast art as fine art or high art, and not simply-as it was more commonly considered-curios or ethnographic objects. The exhibition included a gallery devoted to Haida artist Charles Edenshaw, and another gallery featuring contemporary works. Both sections represented new approaches to the appreciation of Northwest Coast art. The first focused on the Native artist as individual, and the second emphasized the continuation of traditional art styles in modern contexts.

By the late 1970s the revival of Northwest Coast art had grown to involve at least two hundred professional Native artists and many more craftspeople in an avid and specialized Indian art market, supported by a primarily non-Native public. But the fine-art status called for by Arts of the Raven and other museum exhibitions is often limited by ethnic classifications of the art. Indeed, the active support of the revival by the UBC Museum of Anthropology, the Royal British Columbia Museum (formerly the B.C. Provincial Museum), and the Vancouver Museum has probably contributed to the institutionalization of the art's anthropological status. The result has been a static view of an

organic and evolving indigenous art history, in which the art is seen as a mere repetition of forms and images.

Indeed, leading Northwest Coast artists emphasize the creation of art within centuries-old conventions of form and composition. Some artists go even further in their exploration of ancestral traditions. Robert Davidson, Tony Hunt, and Joe David, among the others discussed below, are striving either to maintain or to re-create a personally meaningful, Native context for their art through language study, spiritualism, and ceremony. At the same time, however, they are clearly twentieth-century artists, immersed in the dominant culture of North America. They respond to the challenge of innovation and creativity inherent in the structures of both Northwest Coast art and the Western avant-garde. Their work cannot simply be dismissed as tradition-bound. It has its roots in recognized forms and philosophies of Northwest Coast art, but is also part of new genres developing out of present-day experience.

For Nuu-Chah-Nulth artists Joe David and his cousin Ron Hamilton, art is rooted in the ancient cultural traditions of their people, and in their personal participation in ritual dancing and potlatching. Both men are responsible for reawakening and redefining Nuu-Chah-Nulth traditions in sculpture and painting, and have been joined in their goal by Art Thompson. Individually, each has undertaken an intense programme of learning about power and spirituality by acquiring traditional knowledge. Joe David, in particular, has chosen to pursue his learning through dreams, cleansing, prayers, and creating dances and songs. All three artists gained experience in Northwest Coast styles other than their own when they began their artistic careers, but are now developing personal interpretations of the Nuu-Chah-Nulth style in their work.

Serigraphy has become an important medium in contemporary Nuu-Chah-Nulth art. Ron Hamilton, who creates masks, dance screens, and drums exclusively for Native use, has become known to the larger public for his silkscreen prints. He often uses prints to express spiritual or narrative elements from oral tradition (as in The Whaler's Dream, while in Design for Woven Hat he isolates the geometric pattern as an image separate from the functional object. Joe David describes his own distinctive style as "the fluid line," evident in the painting on his dance masks as well as in his silkscreen prints. In a departure from legend images, David's Memorial Canoe and Memorial Rainbow Drum, as well as Art Thompson's Clo-oose Vision, draw on immediate personal experiences and altered states of consciousness as sources. Thompson has become recognized for his innovative work in serigraphy, as well as his accomplishments as a carver of masks and other objects for ritual use.

The work of Haida artist Bill Reid reveals the contradictions of his experience as a twentieth-century individual with ties to each culture. When he began his artistic career as an adult, he was not committed to the mythological or ceremonial aspects of the art but, rather, attracted to the aesthetics of the forms. He intended to apply the best of the old Haida compositions to jewellery, using the European jewellery techniques he had learned. But his role in reviving northern Northwest Coast art has extended far beyond the private world of his jeweller's bench. Reid gave back to the art a level of quality that informs the work of younger Haida artists. The jewellery techniques (particularly for engraving) that he brought to Northwest Coast art have since become the accepted methods on the coast. He was the first to focus broad public attention on Haida art through the silkscreen print and, more recently, has created works in the "new" media of pencil drawing and large-scale bronze casting.

Reid has spent most of his life on the periphery of Native society and, unlike some of his artist colleagues, has not actively participated in the revival of potlatching. Yet, in many ways he has become more deeply involved with the Haida people: in 1977 - 1978, he carved and raised a fifty-five foot totem pole in his mother's village of Skidegate, the first totem pole to be erected there in a hundred years; in 1985, he also initiated a canoe-carving project there, which culminated in the creation of an ocean-going canoe; and he actively supports Haida land claims. But such commitments are not integral to most of his artistic pursuits. Reid has often said that aesthetics are a valid enough reason for the existence of his art today.

Reid's use of Haida symbols does not hinge on one definition of their meaning, nor is it dependent on ceremony. Some of his works, particularly those that blend complementary elements of Northwest Coast iconography and Western naturalism (Haida Myth of Bear Mother, and Phyllidula, extend the definition of Haida art beyond its generally understood boundaries. In these works, Reid resolves the dilemma he has often expressed concerning the re-creation of nineteenth-century Haida themes and styles in the present day. By assimilating Haida imagery into his own artistic vocabulary and experience, he has imbued it with new significance as both a personal and cultural symbol.

In contrast to Bill Reid's formalist approach is the emphasis on meaning expressed in the work of Robert Davidson. Acknowledged as a contemporary Haida master artist, Davidson explores new principles of Haida form and composition while actively creating a context for his art through ceremony. "I can't create art or sing a song or dance a dance without

Fig. 9. Robert Davidson's totem-pole-raising at Masset, Queen Charlotte Islands, BC, 1969. Photo by Susan Davidson. Courtesy of the University of British Columbia Museum of Anthropology, Vancouver, BC.

meaning," he says. "You can only go so far with academic
knowledge. To go farther you need the experience."* Davidson's
imagery comes from the artistic tradition he has internalized,
and now flows outward to express his experience in contemporary
ceremony.

Davidson moved to Vancouver as a high-school student from
Masset, Queen Charlotte Islands, where he had already achieved
some success at argillite carving. In Vancouver, he met Reid,
who invited him to work in his studio, encouraged him to take
courses at the Vancouver School of Art, and taught him engraving
of flat designs in silver. By 1968 Davidson was teaching at
'Ksan and became interested in silkscreen printing. The solo
exhibition of Davidson's silkscreen prints held by the UBC Museum
of Anthropology in 1979 testifies to his artistic growth in the
previous ten years. Whether in serigraphy, painting, or silver,
Davidson's two-dimensional works demonstrate his aesthetic play
with the boundaries of Haida form and representation.

Davidson's effort to expand the formal language of Haida art
does not contradict his search for a deeper understanding of
Haida traditions in ceremony and mythology. When he returned to
Masset in 1969 to carve and raise a forty-foot totem pole-the
first to be raised in the Charlottes in almost ninety years-he
found that the art brought forth the dances and songs of a
sleeping culture. He has since organized his own potlatches,
including one in 1980 to celebrate the living Haida people, and
another in 1981 to adopt Joe David as a brother and give Haida
families a chance to pass on hereditary names publicly. As the
mythology used in his art acquires a meaning for today, Davidson
can set his own artistic boundaries.

In 1970 - 1971, Tony Hunt and his father Henry carved a
totem pole as a memorial to Tony's grandfather and teacher, Mungo
Martin. The pole was intended as a symbol of continuing
tradition, which Martin had always stressed as Tony Hunt's role.
The practice of honouring past chiefs had been somewhat neglected
during the preceding three decades, but by raising this pole-the
first to be raised in many years in the Alert Bay graveyard-the
Hunts stimulated a renewed interest in ceremony among younger
Kwakwaka'wakw.

The background that Tony Hunt brings to his art stands in
sharp contrast to that of Davidson and most other contemporary
Northwest Coast artists. He grew up in the dance-potlatch
tradition and now, having assumed his position as hereditary

* Personal interview with Robert Davidson, 3 January 1986.

chief, is carrying on the potlatch and teaching the next
generation their roles within that institution. Hunt has had a
direct influence on the careers of many younger artists who
trained under him in his Victoria gallery-workshop "Arts of the
Raven." Among these artists is his brother Richard Hunt, who now
works as chief carver for the Royal British Columbia Museum.

As early as 1960 Tony Hunt began producing silkscreen
prints. For Hunt, as for other artists, serigraphy allows
greater freedom for innovation than do traditional media more
directly connected to inherited crests and privileges. To date,
most Northwest Coast silkscreen-print images depict single,
representational animal forms and mythical beings. But in Hunt's
serigraphs and painting, he has introduced new subjects and new
ways of depicting ancient themes. The "Transformation" images,
in particular, explore the Northwest Coast belief in the interch-
angeability of two states of being: human-animal, natural-super-
natural. Hunt uses a sexual metaphor to show the creatures
interlocked as they penetrate each other during the instant of
transformation.

Less familiar to the public than Kwakwaka'wakw and northern
Northwest Coast Native art, Coast Salish art has only recently
been rediscovered by a new generation. Comparatively few
examples of the sculptures and engraved objects created and used
in the past have been collected by museums or illustrated in
books. Even fewer remain accessible to current generations of
Coast Salish people. Partly because of this, Salish craftspeople
who carve items for sale today work mostly in Northwest Coast
styles other than the traditional Salish. At the same time,
however, old and new masks, staffs, weavings, and objects of
personal religious significance are now used in a ceremonial
context by those committed to preserving their distinctive
cultural identity.

Susan (Sparrow) Point is one of a handful of contemporary
artists engaged in reviving the ancient principles of Coast
Salish two-dimensional design. As Salish art is based on a set
of stylized elements only distantly related to northern Northwest
Coast principles of form, Point could not rely on the same
sources that have informed the work of Northern artists. She is
self-taught, having acquired her knowledge of the art by
consulting experts and studying slides of artifacts in North
American and European museum collections. Many of her serigraphs
and paintings are based on the complex images of humans and
animals carved on spindle whorls, rattles, and other objects.
While some works are direct copies of museum pieces, others are
more experimental interpretations of the traditional designs.
Point's work is not based on ceremony and ritual. Rather, the
artist uses abstraction and printing techniques to open new
avenues for personal expression in Salish art.

Fig. 10. Susan A. Point paints the original design from which
she produced her serigraph <u>Vision of Power</u>, 1985. Photo by J. P.
Wvong Inc. Courtesy of the University of British Columbia Museum
of Anthropology, Vancouver, BC.

Such works reveal that the Western concept of art as individualist expression may also apply to art that is tied to tribal tradition. The conventions of northern Northwest Coast art, in particular, appear so strict as to stifle individual expression. But the constraints are characterized by great variability and compel, rather than restrict, personal creativity. To extend beyond the "rules" the artist must balance the constraints of this highly structured tradition with the courage to stretch them to new limits.

Tradition and innovation are often seen as mutually exclusive components in art, one belonging to the past and the other to the present or future. Yet both are part of a continuity, and artists build one upon the other as they develop their art through experimentation and learning. Today, Northwest Coast artists can experiment with aesthetic boundaries as well as participate in cultural tradition. Robert Davidson has found that ceremony must incorporate change if it is to continue to be meaningful to his art and to the Haida people. Tony Hunt, while striving to maintain the traditions he was taught, also seeks recognition on purely aesthetic grounds by the art gallery community. Each artist moves between the First Nations and non-Native societies, finding his or her own path toward a new definition of Northwest Coast art.

The artists' approaches to their art range from traditionalism to complete rejection of old conventions. In the series of paintings begun by Doug Cranmer around 1975, his experimentation with abstracting form-line elements has removed any iconographic references from some works. This direction, as yet followed by few others, has the potential to free the artist and the viewer from immediately associating the art with ethnographic meaning. Gitksan artist Phil Janzé is also creating works that defy ethnic categorization. He draws from various tribal traditions, combining them with Western techniques and perspective to create such works as <u>Through the Smokehole</u> and the gold and diamond <u>Crab Locket</u>. Joe David, on the other hand, carved a welcome figure in 1984 to protest logging on Meares Island, part of Nuu-Chah-Nulth ancestral lands. Similar in form to welcome figures carved centuries ago, the traditional image allowed David to make a contemporary statement of cultural and political sovereignty.

It is easy to label contemporary Northwest Coast art as simply derivative, as hiding behind the old mythology. It is more difficult to see the ironic truth that from within the "confines" of the formal tradition, works are emerging that offer glimpses of a possible future-one which recognizes both the art's independence from the Western version of modern art history, and its declaration of cultural sovereignty. Whether tradition-based or not, Northwest Coast art is concerned with the reality of

Fig. 11. Welcome figure by Joe David, 1984. Photo by M. Cotic.
Courtesy of the University of British Columbia Museum of
Anthropology, Vancouver, BC.

today, a reality that encompasses past and present, mythic art
and individual expression, and the Native and global communities
in which the artist is a participant.

BIBLIOGRAPHY

Vancouver Art Gallery
1967 <u>Arts of the Raven</u>. Vancouver: The Vancouver Art Gallery.

Duffek, Karen
1983 "The Contemporary Northwest Coast Indian Art Market."
Unpublished Master of Arts Thesis, University of British Columbia
Department of Anthropology and Sociology.

1986 <u>Bill Reid: Beyond the Essential Form</u>. UBC Museum of
Anthropology Museum Note No. 19. Vancouver: University of
British Columbia Press.

Halpin, Marjorie
1979 <u>Cycles-The Graphic Art of Robert Davidson, Haida</u>. UBC
Museum of Anthropology Note No. 7. Vancouver: University of
British Columbia Press.

Macnair, Peter, Alan Hoover, and Kevin Neary
1980 <u>The Legacy</u>. Victoria: British Columbia Provincial Museum.

"MESSAGES FROM THE PAST":
ORAL TRADITIONS AND CONTEMPORARY WOODLANDS ART

by

Ruth B. Phillips

"It is most important to me to carry on these
traditions in my work in steatite, as a way of
communicating the messages from the past."-Jacob
Thomas, Jr., in Dinniwell and Hill, 1985.

"See, there's lots of stories that are told in Ojibway.
But that wasn't enough for me. I wanted to draw them-
that's from my own self-what they would look like....
And I thought if they could be some place for a
hundred-two hundred-years-not for myself, but for my
people."-Norval Morrisseau, 1965.

The emergence of distinctive new kinds of art-making among
Woodlands Indians of Canada in the past three decades has been a
central part of a wider revitalization of Native life. Iroquois
sculptors and Cree and Ojibwa painters and printmakers have been
at the forefront of the new art. Their work is closely tied to
Native oral traditions, and is the result of a transmutation, new
in Woodlands Indian art, from verbal to visual artistic form.
The artists have been concerned not merely to act as scribes
providing a visual equivalent for an oral narrative. Rather,
they have sought an intellectual engagement with their traditions
in order to discover and express enduring underlying meanings.

The artists under discussion have chosen to use figurative,
representational modes, rather than the modernist nonreferential
styles that dominated mainstream art of the 1960s and 1970s. The
styles of the Iroquois carvers range from the simplified, almost
abstract shapes of Duffy Wilson and David General to the highly
naturalistic renderings of Joe Jacobs. For most Cree and Ojibwa
painters, the point of departure has been the flat, linear
stylizations of human and animal forms, loosely based on
traditional pictographs, that were first created by Norval
Morrisseau and further individualized by other Woodlands painters
like Carl Ray, Daphne Odjig, Jackson Beardy, and Blake Debassige.

The nature and variety of these individual styles have
sparked debate over whether the art fits into a conventional art-
historical progression and whether it can be categorized as a
series of "schools" or "movements." The lack of homogeneity has
also prevented contemporary Iroquois, Cree, and Ojibwa art from
being understood as part of a common enterprise. More
fundamentally, there is a persistent debate as to whether

contemporary Woodlands art should be seen as a continuation of "tribal" art or as a nontraditional and modern form. The ambiguous position of this art is also manifest in the contexts in which it has been collected and exhibited: although contemporary Woodlands art has usually been marketed through commercial art galleries, it has most often been collected by ethnographic museums, and its status as mainstream fine art has thus been effectively denied.

The persistent confusions in the literature and in museum practice result from two kinds of problems. The first is an inadequate understanding of the precise relationship of contemporary art to both oral and visual traditions. Statements that modern artists are depicting oral traditions have often caused an erroneous perception of the art as a literal and "naïve" illustration of legends and myths. The use of aboriginal graphic conventions by Cree and Ojibwa artists has led to a further labelling of the art as "primitive" or, alternately, "provincial" (Blundell and Phillips, 1983). It is thus important to define more precisely the stylistic relationship between the older and newer art forms, and also between the iconography of contemporary art and the oral traditions that have inspired it.

The second obstacle to the understanding of this contemporary art is the inadequacy of conventional art-historical frameworks of analysis. Stylistic and iconographic analyses by themselves will not tell us all we need to know. The works must be examined in the broader context of the artists' intentions and motivations, and the suitability of particular modes of representation to the achievement of their goals. The change from ritually embedded aesthetic forms of expression to autonomous "fine art" forms is a direct response to the process of forced acculturation and to the threat of assimilation. In this regard, the development of contemporary Woodlands art can be seen as parallel to that of many other hybrid art forms produced by Fourth World peoples during centuries of contact with Westerners-an important type of artistic expression for which conventional art history has no satisfactory categories.[1]

In this essay, the works of Iroquois, Cree, and Ojibwa artists are explored as parallel responses to a perceived threat of the "loss" of orally transmitted traditional culture. It will be suggested that the representational mode itself is more important than specific stylistic conventions, for figuration is both necessary and appropriate to the translation of "traditional" interconnected verbal and visual aesthetic expressions into independent visual forms.

The emergence of any new art movement involves one or more exceptionally innovative individuals whose seminal ideas are developed and carried forward by a talented group of artists.

The Ojibwa painter Norval Morrisseau is generally recognized as a key figure in the development of all subsequent Woodlands art. Several years later, John Dockstadter and Duffy Wilson had a parallel importance in modern Iroquois sculpture (Dinnewell and Hill, 1985:9). As George Kubler has written, however, the success of any innovator depends as much on the achievement of a "good entrance"-meeting with a propitious set of conditions and circumstances in the wider world-as on the inherent quality of the work itself (1962:41). We thus need to examine the status of Native art traditions in the mid-twentieth century, and also the pressures of social and political acculturation that shaped the artistic and social goals of Woodlands artists.

By about 1900 the making of many aboriginal forms of art, such as carved effigy pipes, clubs, porcupine quillwork on hide and other textile arts, had largely ceased. Even the tangible evidence of these artistic traditions had disappeared from Native communities, as objects became damaged and discarded or were spirited away to urban museums. Three kinds of visual artistic expression were, sporadically, distributed through the Woodlands region in the first half of this century: commercially-oriented tourist art, a small amount of Westernized graphic art, and hidden pockets of ritual art that had survived the repressive efforts of White authorities.

The pace of conversion, "progress," and modernization accelerated steadily during the nineteenth and twentieth centuries. These processes did not, of course, affect all parts of the vast Woodlands region at the same time. Iroquois people began to experience the effects of intensified White settlement of their lands soon after the American Revolution, while in remote parts of Ontario old ways of life were relatively undisturbed until well into the twentieth century. Among the Iroquois, a context for aboriginal religious art was located primarily within the Longhouse community, which observed annual ceremonial cycles according to the code established in the early nineteenth century by the prophet Handsome Lake (Wallace, 1972). Within Iroquois reservation society, too, other traditions were preserved that involved both oral and visual aesthetic expressions. Complex historical readings of wampum belts were memorized and passed on orally, and members of the Society of Faces continued to perform healing rituals in which they wore carved face masks representing forest spirits.

The carving of masks and other ceremonial objects has continued to the present, ensuring the survival, in many places, of a sculptural tradition that incorporates representational imagery. Iroquois people also produced quantities of goods for the tourist trade, particularly beadwork in styles heavily influenced by European needlework and floral decoration. Dolls were made in great numbers, most of them dressed in the

distinctive style of the Longhouse people. Other dolls were
adorned with headdresses, costumes, and masks worn in religious
ceremonies (fig. 1). Although categorized as souvenir products,
these dolls are also a form of three-dimensional sculpture
projecting visual messages about cultural and ethnic identity.
As such, they must be considered important precursors of modern
Iroquois sculpture. Still made today, dolls often display a very
high level of skill in carving and assemblage, and are frequently
exhibited and sold alongside stone sculptures.

By the twentieth century, many aesthetic forms, both verbal
and visual, had been deeply influenced by centuries of contact
with Europeans. Over the years, in areas where contact had been
relatively intense, Native people had sometimes been directly
instructed by missionaries and teachers in European-style
picture-making, usually as part of a didactic programme of
religious instruction. An early example is the sketchbook made
by Ottawa Indians around 1830 at the Catholic mission at Arbre
Croche, Michigan, and now in Vienna (Feest, 1984:61 - 83).

The sketchbook contains drawings of Christian religious
scenes copied from European pictures or book illustrations that
were used as aids in instructing Indians in Christian doctrine.
Feest has interpreted one group of scenes as depictions of Native
shamans (viewed as sorcerers) tormented in hell by snakes, water
monsters, and other dangerous animals (fig. 2). These scenes
offer a fascinating preview of the imagery that Morrisseau was to
use a century later to express the tormenting passions of the
flesh and the agony of the divided self. Morrisseau's work and
these nineteenth-century Ottawa drawings, though widely separated
in time, both reflect the changes wrought by Christianity in the
Great Lakes belief system, as expressed orally and visually. The
spirits of the upperworld and underworld-although capable of
bringing both the good and the bad in precontact cosmology-became
identified with the realms of good and evil; Thunderbirds of the
world "above" became heavenly beings, while the snakes and
mythological animals of "below" became hellish demons.

The cover of the sketchbook bears a finely embroidered
portrait of the Seminole chief Osceola that is based on George
Catlin's famous picture; the portrait thus represents a
replication by a Native woman artist of a European representation
of an Indian leader. Although objects like the Vienna sketchbook
are rare, similar self-images mediated by European attitudes and
representational conventions are characteristic of the quantities
of tourist curios produced by Indians during the nineteenth and
early twentieth centuries. Tourist art as a genre is usually
excluded from discussions of the origins of contemporary
Woodlands Indian art, despite the fact that these pieces often
display figural compositions that are a form of pictorial art.
Many of the souvenir birchbark boxes, trays, needle cases, and

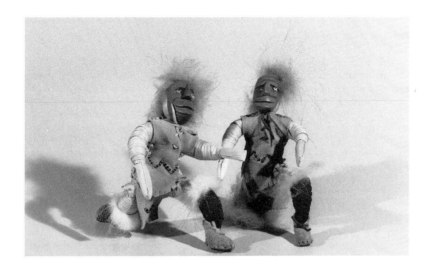

Fig. 1. Cornhusk dolls representing False Face Maskers. Made by Diana Sky, Cayuga, 1973. Average height 14.4 cm. Canadian Museum of Civilization III-I-1368 a, b, c.

Fig. 2. Shaman tormented in Hell by snakes. Page from the Arbre Croche Sketchbook, c. 1830. Museum fur Volkerkunde, Vienna. Photo: Museum fur Volkerkunde, Vienna.

cigar cases are embroidered with idealized figures of Indians
lounging in front of wigwams or among lush arrangements of
flowers and birds (fig. 3). These tourist-oriented pieces
reinforced rather than challenged the simplistic, stereotyped
images held by many late-nineteenth century Europeans and Ameri-
cans who thought of Indians as noble savages living in a timeless
natural world. On one level, contemporary Woodlands art is a
reaction against the denial of Native peoples' actual historical
experiences that is seen in tourist art.

The Arbre Croche sketchbook also contains several scenes
illustrating Midewiwin ceremonial dances (fig. 4). The style in
which the figures are drawn is more detailed and descriptive than
that found in aboriginal pictography. Elements of costume and
equipment are carefully depicted, and the poses and actions of
the figures show more naturalistic movement.[2] The depictions of
ceremonial dances in the sketchbook also display a radical break
with Native compositional and narrative structure. The figures
are drawn from a single perspective point and are arranged in
parallel rows against implied groundlines. The perspective
adopted is that of Western post-Renaissance art, in which scenes
are rendered as optical phenomena existing in the natural world.
By contrast, aboriginal compositional structure emphasizes the
metaphorical and magical dimensions of the ritual acts being
performed. In bark scrolls, figures are commonly arranged in
sequences around the edges of the panels, which act as a kind of
groundline, so that the sequential order of ritual acts is
clearly understood. Figures are shown either from an aerial
perspective, as they would be seen by spirits above or below the
earth's surface, or simultaneously from several perspective
points (Vastokas, 1987:6). The changes wrought by the Arbre
Croche artist make the scenes more comprehensible to the
outsider-the viewer on the ground, as it were. The work can thus
be understood independently, without oral instructions,
explanations, and interpretations. The new pictures are at once
more accessible and more limited. We can read the scenes but
would not know how to perform the activities depicted.

Feest rightly calls the Arbre Croche sketchbook a kind of
"missing link" between traditional pictography and the kind of
painting that emerged in the twentieth century. In the early
twentieth century, analogous, though more sophisticated,
illustrations of traditional life and ritual were produced by
several Iroquois artists, notably Jesse Cornplanter and Ernest
Smith. Cornplanter, a Seneca and a member of the Newtown
Longhouse, illustrated Arthur Parker's translation of the code of
Handsome Lake in 1913, and later illustrated and published his
own record of Iroquois oral traditions as <u>Legends of the
Longhouse</u>, in 1938. Ernest Smith is known for the archival and
exhibition paintings he created for the Rochester Museum of
Science (fig. 5). In both cases, the artist's aim was to provide

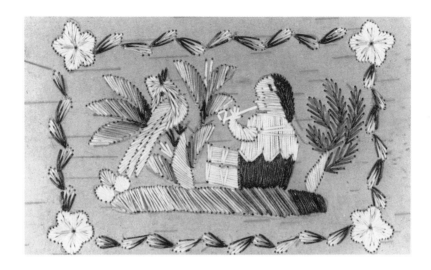

Fig. 3. Birchbark tray embroidered with moosehair (detail).
Huron type, c. 1850. Canadian Museum of Civilization III-H-423.

Fig. 4. Midewiwin dance. Page from the <u>Arbre Croche Sketchbook</u>,
c. 1830. Museum fur Volkerkunde, Vienna. Photo: Museum fur
Volkerkunde, Vienna.

Fig. 5. Midewiwin Scroll (detail). Ojibwa, from Mille Lacs Reserve, Minnesota. Canadian Museum of Civilization accession number 88/1/1.

Fig. 6. "The Evil-Minded Pours Ashes on the Corn to Spoil It." Illustration by Jesse Cornplanter in his Legends of the Longhouse 1937.

visual records of Iroquois life and belief for the uninitiated-
both non-Indians and future generations of Iroquois unfamiliar
with traditional belief. The meticulously descriptive style that
characterizes their work is sometimes rather contemptuously
categorized as illustration; but it was ideally suited to its
task: the unambiguous transmission of information.

One of the features uniting these diverse creations as a
category of visual expression is that they were all made for
White patrons. The tourist curios, the Arbre Croche sketchbook,
and the early twentieth century illustrations of traditional life
and mythology all relied on a style that was heavily influenced
by European art traditions in its descriptive detail and
narrative pictorial qualities. Such art also conveyed a European
vision of Indian culture as fixed in a timeless past, or an
"ethnographic present," while ignoring the realities of cultural
conflict and repression. These works earned their creators a
measure of approval but provided no entry into the higher ranks
of the fine-art hierarchy.

In northern Ontario and Manitoba, ritual art was centred on
the Midewiwin or Grand Medicine Society. However, as this
association of shamans was widely viewed with suspicion as a
pagan organization involved in illicit magical practices, its
members were forced to perform ceremonies under cover of a
secrecy that had been unnecessary in the past. The visual
traditions of the Midewiwin have been of major importance to
contemporary Woodlands artists. The incised panels and birchbark
scrolls used by Society members were the most elaborate
manifestation of the Great Lakes pictographic traditions (fig.
6). These scrolls and tablets recorded both individual visionary
experiences, and ritual procedures and songs. The images that
they depicted ranged in style from simple and functional signs to
more complex and aesthetically refined drawings.

For aboriginal Cree and Ojibwa art, this pictographic
imagery constitutes a particularly important "formal sequence,"
in Kubler's terminology. Other contexts in which pictographs had
been used previously had become "arrested" sequences because the
objects were no longer made. A good example of this phenomenon
is rock painting, an ancient ritual art that had largely ceased
to be practised in the twentieth century (fig. 7). However, as
many of the old paintings still existed and knowledge of them was
retained in oral traditions, the interrupted formal sequences
could be resumed in the new art of the 1960s.[3] But merely
listing the survival or disappearance of visual forms is not
enough, for none of these aboriginal aesthetic forms-sculpted,
embroidered, or incised-were self-contained symbolic expressions.
Their meanings depended on a shared knowledge of orally
transmitted belief and history, and on specific contexts of song,
dance, and ritual activity. In many places where the objects

Fig. 7. Rock painting of the Mishipeshu from the Agawa Site,
Lake Superior. (Photo: Ministry of Natural Resources,
Government of Ontario).

Fig. 8. "Rebirth" by Jackson Beardy, lithograph, 1976. With
permission from Indian and Northern Affairs Canada.

themselves were no longer in use, the knowledge of their symbolism, related belief, and ritual was remembered and passed on orally. Kenneth Hughes has written, for example, in his study of the Manitoba Cree artist Jackson Beardy, that the artist grew up in a virtual vacuum of traditional visual art. "Cree visual art was not possible in this world in the first two thirds of the twentieth century," writes Hughes, because the religious beliefs that had inspired earlier art forms had been so thoroughly repressed. He adds, however, that "oral traditions in the verbal arts were much stronger and more capable of survival than the visual arts. For what people think and say among themselves is by no means easily discovered, as more than one tyrant has learned in history" (1979:5).

Significantly, the pioneer figure of contemporary Woodlands art, Norval Morrisseau, not only inherited a knowledge of oral tradition but also was familiar with Midewiwin graphic conventions. Born in 1932 on Lake Nipigon in northern Ontario, Morrisseau received a rudimentary education in White residential schools in the region. He acquired his knowledge of traditional belief and practice from his grandfather, Moses Nanakonagos, who was largely responsible for his upbringing and familiarized him with Midewiwin scrolls (Sinclair and Pollock, 1979:45). Out of their intimacy "came a kind of teaching that is vouchsafed to few," Dewdney has written (1965:xvi). The letters and notes made by Morrisseau in the 1950s are evidence of the broad knowledge of myths and stories he had acquired and of his burning desire to continue, and contribute to, the tradition. Some of Morrisseau's earliest attempts to record oral traditions survive in the letters and papers he sent to Selwyn Dewdney around 1960. A very close relationship to traditional Ojibwa pictography is clear. The images are presented as signs requiring further interpretation through the written explanations provided on the same pages (fig. 8). They are visual correlates of oral narratives and ritual procedures similar to those recorded in the nineteenth century by Kohl and Hoffman.

In the first stages of his artistic development, Morrisseau retraced the stylistic steps of nineteenth-century Great Lakes artists who transformed the pictographic into the pictorial. Early drawings by Morrisseau in the late 1950s, loosely based on Midewiwin narratives, are also remarkably similar to the nineteenth century examples mentioned above (McLuhan and Hill, 1984:pl. 4). Only in its first stages, however, is Morrisseau's development analogous to that of his predecessors. In a few short years, Morrisseau had pushed his art into a completely different expressive mode. The first works that he exhibited in Toronto in 1962 were easel paintings showing not strings of sequential images, but pictorial scenes in which one scene or figure is isolated from the complete narrative and communicates its central thematic meaning. A selective clarity has been

imposed on the complex episodic structure of the original scroll-derived strings of motifs, and descriptive detail is added to make them readable by uninitiated viewers. The rock-art images that Morrisseau had come to know better through Dewdney during his formative period probably led to his use of single bold images or groupings. He was thus able to incorporate compositional and graphic devices that both belonged to the Ojibwa visual tradition and also were in harmony with Western artistic conventions (Phillips, 1987).

When Morrisseau came to prominence in the 1960s, the climate of receptivity in the wider art world was considerably different from that encountered by earlier generations. Though relatively isolated, northern Ontario was tied to a wider southern Canadian society, populated by non-Natives who now showed not disapproval and contempt but respect for and strong interest in Morrisseau's "pagan" past. This society was also excited by the idea of Native people as producers of fine art because of the dramatic success achieved by Inuit sculpture and printmaking in the previous decade. Through his three early patrons, Dr. Joseph Weinstein, Selwyn Dewdney, and the Toronto art dealer Jack Pollock, Morrisseau's desire to record Ojibwa traditions in distinctively "Ojibwa" style was strongly reinforced. The form Morrisseau's art took resulted not only from his deep sense of purpose, but also from the fact that through the influences of his early patrons he came to see himself as an independent artist in the Western sense. There was an audience prepared to read his paintings not as curios or illustrations, but as they would any other works of fine art, as unique creations expressing broader cultural values and beliefs.

In contrast to earlier generations of Western-influenced artists, Morrisseau did not attempt to illustrate the outer appearance of ritual activity. His goal and that of other contemporary Woodlands artists has been to penetrate the narratives in order to extract central philosophical principles and values that can be lived today. On careful examination, almost no contemporary Cree or Ojibwa works are full narrative illustrations of myths and stories. Four distinct uses of oral tradition can be identified in the work of post-1960 Woodlands artists. The first group includes works directly based on particular oral narratives. Although some of these illustrate a scene fully, most depict only the central character or characters together with abstract symbolic forms that express larger metaphysical meanings. This relationship between narrative and picture is typical of much post-medieval European art. The work of Joe Jacobs, whose sculptures often depict several successive events in a story, is an exception to this pattern.

More frequently, Woodlands artists have worked with oral traditions in a second way, which Hughes has termed the making of

"independent creations" (1979:25). In Jackson Beardy's <u>Rebirth</u>, for example, the artist does not refer to any particular myth but uses a single image of intertwined geese juxtaposed with abstract symbols to express the principles of cyclical rhythm and balance in nature that underlie Cree sacred traditions and world view (fig. 8). Similarly, Benjamin Thomas's <u>Golden Eagle</u> symbolizes the concept of rejuvenation rather than a specific myth (fig. 9).

A third type of content involves the recording of individual visionary experiences, often achieved through prescribed traditional ritual practice. This artistic direction was pioneered by Morrisseau, who has painted not only his own visions but also those described to him by people in his community.[4] Other artists, such as Michael Robinson, have also focused on ritual process and visionary experience. The highly personal and autobiographical nature of these works is at once typical of the modernist Euro-American mode and characteristic of an important category of aboriginal vision-related art, including drums, bark engravings, and rock painting. A fourth type of artwork addresses a historical aspect of orally received tradition. Daphne Odjig's large mural <u>The Indian in Transition</u> and Morrisseau's <u>The Gift</u> narrate postcontact historical experience from a Native point of view rather than illustrating sacred truths or ritual events.

These distinctions clearly show that the oral traditions on which Native artists have drawn are not a unitary body of knowledge but a multifaceted legacy, representing an accumulation of individual experiences, community history, legend, and mythic formulations. There has been too little emphasis on the fact that the development of a viable modern art, though important, was accompanied by a parallel effort to give permanent written form to oral traditions. For Cornplanter, Morrisseau, and other artists, making a book was, at least initially, as important as making pictures. The manuscript that Morrisseau painstakingly put together became <u>Legends of my People: the Great Ojibwa</u> edited by Selwyn Dewdney and published in 1965.[5] In this record of oral traditions a transformation of verbal narrative structure occurred that parallels the new visual pictorial structures. Just as the strings of pictographs were cut up and rearranged to be legible to a non-Native audience, so too was the rich growth of orally transmitted lore pruned and restructured. According to Dewdney,

> The contents of both [books] were poured out of
> Morrisseau's mind and memory as fast as they rose to
> the surface without regard for sequence, so that in
> their original form they comprised a fascinating but
> often confusing *pot-pourri* of legends, anecdotes,
> observations, reports and personal comments
> (Dewdney, Morrisseau, 1965:viii).

To the Western mind accustomed to a rigid separation of the sacred from the profane, fact from fiction, and the personal from the communal, Native oral traditions have often appeared "confusing." James Stevens has made similar observations on his collaborative effort with the Cree artist Carl Ray, Morrisseau's contemporary, to record the legends of the Sandy Lake Cree (Ray and Stevens, 1971).

A common motivation lay behind these contemporary records of oral tradition, both written and visual. What explains the intense production of books and pictures that began around 1960 after the long period of relative inactivity? The answer lies not only in the receptivity of the non-Native community, but also in the particular experience of the generation of Native people born in the 1930s and 1940s. In southern areas, mission schools were well established by 1900, but in more remote areas, formal education became widely available only in the mid-twentieth century. The institutions of formal education and the assumptions about Native culture on which they were founded were, however, remarkably similar despite the uneven spread of these institutions and the different Christian denominations that sponsored them. Native students across Canada have reported very similar experiences. The central assumption was that, in due course, Native people would be assimilated into White society and their distinctive cultures would become extinct. Policy and logistics dictated that children be removed from their families to residential schools, where discipline was strictly enforced. For their own "good," and to hasten the process of assimilation, the schools forbade the children to speak any language other than English; contact with other family members and, through them, with traditional practices and beliefs was minimized or eliminated for long periods of time.

The trauma of the residential-school experience for most children can hardly be exaggerated-and indeed, many instances of outright abuse have recently been revealed. Jackson Beardy, born in 1944, was removed from his family on a reserve in northern Manitoba and flown hundreds of miles south to a school with barred windows and a barbed-wire fence around it. When he arrived, he spoke only Cree; but during the eleven years he spent there, he was forbidden to speak Cree or discuss the heritage of Cree stories and lessons told to him by his grandmother during the brief summer holidays. As Hughes has eloquently written, learning to "speak white" also meant learning to "see white" (1979:6). The animist world view underlying Woodlands belief and practice is inherent in the lexical elements of the language itself (Hallowell, 1960). For Beardy, like other Indian artists, being deprived of a way of speaking meant also being deprived of a way of thinking, which, as an adult, he sought to relearn at great effort and personal cost.

In this context, it becomes possible to understand the urgency felt by Indian artists born in the middle decades of the twentieth century about their efforts to preserve traditional knowledge. Residential schools are particularly representative of the repressive side of "progress" in the recollections of the founding generation of Woodlands artists. The attack on Native languages was inevitably an attack on the oral traditions-the irreducible essence of Native culture. The artists and their contemporaries had grown up in two more radically contrasting cultures than had their parents and grandparents, most of whom still lived as hunters and spoke only Native languages. To many of these artists it seemed that they might be the last to speak both languages and the last to receive the gift of the collective wisdom transmitted through oral traditions.

This strong sense of the imminent loss of Native culture is expressed repeatedly by contemporary Woodlands artists. In the prefaces to their publications and in the solicited "artists' statements" that appear in exhibition catalogues, the phrases echo with inexorable consistency. "This book is dedicated to all my people.... Thanks to these people, their stories are recorded in this book before all is lost in the void of the white man's civilization," wrote Carl Ray (Ray and Stevens, 1971:vi). "We are strong in the ways of our grandfathers and my art is one way of keeping traditions alive," the Iroquois carver Jacob Thomas, Jr., has said (Dinniwell and Hill, 1985:28).

There is a further significance to these statements of purpose. As spokespeople for their communities, artists and authors wanted to set the record straight, to counter the accusations of inferiority, ignorance, paganism, and past savagery. "We, therefore, must write down and record legends, art, songs and beliefs, not for ourselves alone but for all future Ojibway," wrote Morrisseau. "One would not like to open a book to read that we were tough, ignorant savages or a bunch of drunkards, but rather a people who were proud of their great culture" (Morrisseau, 1965:3). Odjig has clearly described the direct link between her art and her experience in White schools:

> In my childhood we had no Indian heroes. If you read, if you go back to your history books, you learned about the Indian savages. So what was there to be proud of?... We must have had our heroes. We must have had our people that we could have looked up to but... we read in the history books that this wasn't so. We were heathens (Canadian Broadcasting Corporation, 1982:32 - 33).

The Midewiwin shaman James Redsky told his editor, James R. Stevens: "I want our children to know that they have a history in this country too" (Redsky, 1972:22). And the Iroquois sculptor

Fig. 9. "Golden Eagle" by Benjamin Thomas, Jr., steatite, 1984. 21 x 20.5 x 13 cm. Photo: Royal Ontario Museum, Toronto.

TALES from the SMOKEHOUSE
Herbert T. Schwarz
Illustrated by Daphne Odjig

Fig. 10. Cover of Tales from the Smokehouse by Herbert T. Schwarz, illustrated by Daphne Odjig, 1974.

Benjamin Thomas stated: "As I develop, I have come to the realization that the practice of making 'things,' sometimes called 'art,' has also provided an arena for expressing a unique way of looking at the world" (Dinniwell and Hill, 1985:28).

Another way in which contemporary artists have restored uniqueness and vitality to oral narratives has been through their frank acceptance of the erotic and the scatological. These are important elements in Woodlands Indian narratives, but until recently, virtually all written versions published by non-professionals and ethnographers alike were prudishly censored (Wolfart, 1986). Morrisseau was again the pioneer. From the beginning, his work had been characterized by a sexual energy that has its roots not in modernist European influences but in Ojibwa traditions, never before fully expressed in print or in paint. Daphne Odijig's illustrations for Tales from the Smokehouse also recognize the erotic elements that inform the oral tradition (Schwarz, 1974) (fig. 10).

Unlike Morrisseau or, in an earlier period, Cornplanter, many contemporary artists have not inherited these oral traditions directly from Midewiwin or Longhouse members. Younger Cree and Ojibwa artists like Blake Debassige and Michael Robinson have initially sought knowledge from books, from other artists, and from elders. Many modern Iroquois carvers are not Longhouse members but rely on the considerable number of published collections of Iroquois myths. Indeed both groups have found themselves at odds on occasion with traditional religious practitioners who objected to the representation of sacred images in the secular context of commercial contemporary fine art. The habit of secrecy necessitated over the past two hundred years by White repression of Native religious life has gradually become a system of "taboo" (a term frequently used in the literature on Cree and Ojibwa art).[6]

This situation, perhaps more than any other, reveals the role of contemporary artists as cultural mediators. Part of the definition of a Fourth World people is that it is one among many component groups forming a modern nation. The community of which it is part is heterogeneous, complex, and geographically extensive. Anyone who has visited an Indian reserve knows, too, that the omnipresence of television has brought Native people into Marshall McLuhan's global village. Within or outside the reserve, there no longer exists a unitary world view or a single code of visual signs recognized by everyone. Contemporary artists have not sought to replicate the visual forms of the past, which are comprehensible only to ritual practitioners, but have transformed them into new kinds of art in order to explore their meanings in the context of the modern world. This "appropriation" is legitimate for these artists because it is a means of preserving knowledge for future generations and of

uniting the self divided between two worlds.

The process of transformation from ritual to pictorial forms of aesthetic expression is not unique to Woodlands Indians. It is one of the earliest and most profound changes that resulted from cultural contact between Europeans and Amerindians. Missionaries had early found that pictures and book illustrations were powerful tools for religious conversion. In response, Native artists often turned to the style of picture-making they had learned from Europeans, as a powerful and evocative means of preserving the memory of cultural activities disrupted and transformed by contact. This process has repeated itself through the centuries of European contact in all parts of the Americas from colonial Peru to the Great Plains in the late nineteenth century.[1] A narrative pictorial scene could transmit its messages independently of a living ritual context, even when this context was threatened or destroyed; it could communicate meaning across generational or ethnic boundaries. Contemporary Woodlands artists have carried on this process. They have created new forms of representation that bridge past and present realities and provide permanent markers along the path to the future.

NOTES

1. The formulation proposed by Nelson Graburn (1976:1 - 37) is
widely referred to and has been very useful as a model in the
sociology of art. His categories, however, are intentionally
built on the past practices of art critics and historians that
have created the existing unsatisfactory situation. These
practices now need to be revised to reflect the new
understandings contributed by postmodernism and globalism in
mainstream contemporary art.

2. Such changes in the style of figure-drawing occurred very
early in the history of contact. For example, they are already
present in one of the earliest known pieces of Great Lakes
souvenir art, a canoe paddle engraved with genre scenes; the
paddle was collected by Colonel Jasper Grant about 1809
(Phillips, 1984:71).

3. The example of rock painting is an interesting test of
Kubler's valuable theories on change in visual forms. It
suggests that it is not enough to look, as he does, only at the
physical survival of objects themselves. In the case of
Woodlands art, it was apparently vital for both the orally
transmitted traditions and the actual paintings to survive and be
made available to a new generation of artists.

4. For example, a painting by Morrisseau of about 1965 entitled
Power Giver, in the Glenbow Museum, Calgary (M.66.26.5), has
these words inscribed on the back: "One Ojibwa Indian told me
upon his/fasting years in order to know the/shaking tent Rites in
his dream vision he was/told to disrobe naked and to bend down a
little/man with horns the power giver blowed into/his rectum
which came out of his mouth/his breath send vibrations all
through his/body given him power/and horns represent
power."

5. Examples of other published collections collaborated on and
illustrated by Ojibwa and Cree artists are Sacred Legends of the
Sandy Lake Cree by Carl Ray and James Stevens (1971), and Tales
from the Smokehouse by Daphne Odjig and Herbert Schwarz (1974).
Artists like Jackson Beardy and Del Ashkewe have also provided
illustrations and cover designs for books. The activity of
contemporary Woodlands artists as book illustrators is an
important area, that has yet to be fully documented.

6. The use of sacred imagery in contemporary paintings and
sculpture is part of the much broader problem of appropriation in
art, which has been of increasing concern in both Native and non-
Native communities (Doolittle, Elton, and Laviolette, 1987). The
issue is a particularly sensitive one for Native people as the
use of sacred images in the past was carefully controlled through

systems of apprenticeship to ritual specialists and, in some places, through inheritance.

7. My conclusions regarding the connections of contemporary Woodlands art to other forms of acculturated art were stimulated by the panel "Acculturation and Amerindian Art" held at the annual meeting of the College Art Association in Houston, Texas, in February 1988. Papers by Tom Cummins and Lee Anne Wilson illustrated processes in seventeenth-century Peru that directly parallel those discussed in this essay.

BIBLIOGRAPHY

Blundell, Valda and Ruth Phillips
1983 "If It's Not Shamanic, Is It Sham? An Examination of
Media Responses to Woodlands School Art." Anthropologica
25(1):117 - 132.

Canadian Broadcasting Corporation
1982 "Spirit Speaking Through." Transcript of television film
for "Spectrum" series.

Cornplanter, J.J. (Jesse)
1986 Legends of the Longhouse (1938), Repr. Oshweken, Ontario:
Iroqrafts Ltd., Indian Publications.

Cummins, Tom
1988 "Painting the Past: Conquest and Acculturation in
Colonial Native Peru," unpublished paper presented at the annual
meeting of the College Art Association, Houston, Texas. February
1988.

Dewdney, Selwyn
Correspondence with Norval Morrisseau. Unpublished. Indian Art
Section, Department of Indian and Northern Affairs, Ottawa.

Diniwell, Norma and Tom Hill
1985 From Masks to Maquettes. Brantford, Ontario: Woodlands
Indian Cultural Educational Centre.

Doolittle, Lisa, Heather Elton, and Mary-Beth Laviolette
1987 "Appropriation: When Does Borrowing Become Stealing?"
Last Issue (Calgary, Alberta) autumn:20 - 28, 30 - 34).

Feest, Christian
1984 "The Arbre Croche Sketchbook." In Beadwork and Textiles
of the Ottawa. Harbor Springs, Michigan: Harbor Springs
Historical Commission, 61 - 83.

Graburn, Nelson
1976 "Introduction: Arts of the Fourth World." In Ethnic and
Tourist Arts: Cultural Expressions from the Fourth World.
Nelson Graburn, ed. Berkeley, California: University of Califor-
nia Press, 1 - 37.

Hallowell, A. Irving
1960 "Ojibwa Ontology, Behaviour and World View." In A. Irving
Hallowell, Contributions to Anthropology, Stanley Diamond, ed.
Chicago: University of Chicago Press, 1976.

Hughes, Kenneth James
1979 "Jackson Beardy-Life and Art." In Canadian Dimension
(special issue) 14(2).

Kubler, George
1962 The Shape of Time. New Haven, Connecticut: Yale
University Press.

McLuhan, Elizabeth and Tom Hill
1984 Norval Morrisseau and the Emergence of the Image Makers.
Toronto: Art Gallery of Ontario.

Morrisseau, Norval
1965 Legends Of My People: The Great Ojibway, Selwin Dewdney,
ed. Toronto: The Ryerson Press.

Phillips, Ruth B.
1984 Patterns of Power: The Jasper Grant Collection and Great
Lakes Indian Art of the Early Nineteenth Century. Kleinburg,
Ontario: McMichael Canadian Collection.

1987 "From Mide Scroll to Easel Paintings: Norval Morrisseau's
Early Phase." Unpublished paper presented to the biennial
conference of the Native American Art Studies Association,
Denver, Colorado, September 1987.

Ray, Carl and James Stevens
1971 Legends of the Sandy Lake Cree. Toronto: McClelland and
Stewart.

Redsky, James
1972 Great Leader of the Ojibway: Mis-cuona-queb. Toronto:
McClelland and Stewart.

Schwarz, Herbert T.
1974 Tales from the Smokehouse, Daphne Odjig, ill. Edmonton:
Hurtig Publishers.

Sinclair, Lister and Jack Pollock
1979 The Art of Norval Morrisseau. Toronto: Methuen.

Vastokas, Joan
1987 "Pictorial Conventions of Algonkian Bark Records in the
Context of Native North American Art History." Paper presented
at the Native American Art Studies Association Meeting, Denver,
1987.

Wallace, Anthony F. C.
1972 The Death and Rebirth of the Seneca. New York: Vintage
Books.

Wilson, Lee Anne
1988 "Survival, Resistance and Acculturation: Guaman Poma's Use of Costume and Textile Imagery." Paper presented to the annual meeting of the College Art Association, Houston, Texas, February 1988.

Wolfart, H. Christoph
1986 "Taboo and Taste in Literary Translation." In <u>Actes du dix-septième congrès des Algonquinistes</u> Ottawa: Carleton University Press.

POSTMODERN CULTURE AND INDIAN ART

by

Gerhard Hoffmann

DESCRIPTION AND EVALUATION OF POSTMODERNISM

Modernism and postmodernism will be viewed here in terms of continuity and discontinuity.[1] The new experimental tendencies in contemporary posmodern art are interpreted against the backdrop of the overall cultural and social context that creates both the intellectual climate and the material conditions in which art is made. Postmodernism - however it may be defined - is not a fashionable cult, but rather a far-reaching reordering and revaluation not only of art, music, and literature, but of the very notions of what culture and civilization are, should be, and can be. This process of change is an international phenomenon, and its artistic and literary manifestations are also international in scope; they are seen in all Western countries, including, very clearly, Canada.[2] Through the international network of exhibitions, the workings of the art market, art books and magazines, and the media in general, the public and artists are informed quickly and extensively about everything new, making it much easier than ever before to keep abreast of new trends and developments. The market, for better or for worse, has become the arena of various contrasting tendencies, leading to a quick exhaustion of modish phenomena and at the same time to the coexistence of different aesthetic concepts and art forms and a tolerance of the "other", including past and revived modern art trends. The synchronicity of the asynchronous and the simultaneity of the nonsimultaneous may even be said to finally dissolve postmodernism as a readily distinguishable (anti-modern) movement.

There is also a postmodern movement in Indian art (and literature).[3] In view of the diversity of individual approaches, "Indian" art can be nothing more than a vague - albeit necessary - construct that serves to emphasize certain shared characteristics. The following discussion is intended to place Indian art within the postmodern context and to analyze the conditions that currently influence the reception of this art.[4] An attempt will also be made, however tentatively, to establish links between Indian artists, or discernible trends in Native art,[5] and the artistic options offered by postmodernism. Starting from a description and analysis of the postmodern cultural situation, the altered concepts of reality, identity, and art, this essay seeks to elaborate the new and fundamental concept of the "other" or "difference" that underlies both postmodernist theory and postmodern art. This concept is then used as a tool for understanding Indian art - which is, after all, in certain respects also the art of the other - within the framework of the postmodern art scene.

The developments of the sixties, seventies, and eighties have been described in such terms as "post-industrial society," "post-metaphysical," "post-histoire," "post-cultural," "post-existential," and "post-humanist," as well as "post-modern," "post-absurd," "post-avantgarde," or "post-contemporary."[6] The words themselves reveal a number of new qualities in contemporary society and culture that evidently can be described only in negative terms, that is, by contrasting them with the accepted definitions of art and culture from the modern period. In seeking a common denominator for uncertainty, discontinuity, and mere "immanence" in private and public life, in science and ethics, in the economic, social, and cultural spheres, one is struck by the situation-oriented, "local" quality that is shared by epistemological and ethical structures. They are marked and have meaning for individual sectors and functions, short periods of time, and particular values; and there are only futile attempts to arrive at a holistic view, a sustained and in-depth understanding of reality or a progressive vision of the future. The question of whether the movement referred to as postmodernism, which began in the sixties, is a continuation of modernism, a reaction to modernism ("anti-modernism"), or simply an intermezzo, an ultimately overrated, perhaps already outdated transitional period, is an important one for the cultural critic, who characterististically finds it is easier to describe the phenomena observed than to assess their significance.

In order to *describe* the international development of the cultural situation since the Second World War and particularly since the mid-sixties, three approaches offer themselves.

(1) Almost all theories speak of *change and transition*. In a cultural world dominated by the media, the only constant appears to be the ever-increasing pace of change - a phenomenon that can no longer be domesticated and humanized by the ideologies of progress. The acceleration of change weakens traditional logic and ethical and metaphysical concepts of order. In an increasingly uncentered world, the measurement of historical time appears to exist purely for its own sake. This leads to a first paradox, one which is of particular importance for Indian art and its references to its own cultural traditions.

On the one hand, the *historical perspective* of continuity and of discontinuity appears to become irrelevant, because references to origins or tradition, like visions of the future or promises of salvation, have lost their guiding and ordering function. The primary value that remains is the present; the past is treated as a museum of arbitrary or chance events. On the other hand, the process of change itself encourages a historical perspective, for without such perspective change, which after all consists in the constant succession of material conditions and intellectual positions, would not be recognizable as such.

2) The process of change just noted can be seen as the loss

of a central perspective and as a *multiplication of positions* in an acknowledgement of *possibility*. Fundamental to this view is a dual phenomenon, a second paradox, that again is extremely important for an understanding of Indian (and Inuit) art by virtue of the link it establishes between that which is "other" and that which is "same" or universal. Its very paradoxical nature has sparked a vigorous and by now highly ideologized debate among cultural critics. In the United States and Canada, as in Western civilization in general, the predominance of media-produced cultural trends has led to a widespread levelling and *uniformization* of mass culture as technology makes it possible to present the same forms of entertainment and diversion everywhere on the globe. At the same time, however, the cultural scene is increasingly marked by a highly differentiated *pluralism* of group interests, making the use of the word culture in the singular virtually obsolete and pointing toward a dismantling and fragmentation of traditional cultural norms and hierarchies (which were never particularly well established in Canada and the United States in any case). Paradoxically, both the "same" and the "other" have emerged stronger than ever before from the cultural crisis, thereby contributing to the increasing diffuseness (and thus the contradictory analyses and assessments) of the present cultural situation.

3) A description of the postmodern scene since the sixties can also begin with the increasingly radical challenging of the pillars of (aesthetic) modernism: (a) the notions of *reality* and *truth* that remained essentially intact (albeit subjectivized) throughout the modern period, but now seem to be hardly distinguishable from cliché and fiction; (b) the concept of *identity*, which guaranteed the dignity and uniqueness of the individual, but must now compete with ideas about the role – and situation-bound nature of man – a fact that hampers the hope for a new liberalism and humanism based on the responsibility of the individual and a consensus between groups arrived at through rationality and good will; and (c) the belief in *art* as a vehicle of truth and meaning that could not be communicated by other means – a view now threatened by the arbitrary and reversible nature of intellectual and artistic positions. The postmodern exhaustion of Western elitist culture is reflected in the gradual collapse of modern aesthetic positions, which had in common the concept of the autonomy of art and are now losing their superior meaning as the boundaries between practical life and art have become increasingly blurred. Thus we see contemporary Indian art in the sixties entering the context of White culture at a moment when the pillars of modernism are crumbling and the dominant culture itself is in a state of crisis.

This brief summary of the aspects from which a description of cultural change might be approached avoids attaching values to the social, cultural, and aesthetic phenomena described. The *valuation* of these phenomena is largely determined by the particular ideologies of various cultural theories and critics, ranging from neo-conservative through socially critical or neo-

marxist to pragmatic or "dynamistic" positions.

(1) The neo-conservative approach divides the phenomenon of modernism into various components. It sees a positive aspect in technological and social modernism, but views as destructive what it considers to be a sterile modern/postmodern aesthetic that posits individualism as an absolute value and, ultimately, hedonism as a last retreat, that promotes a kind of narcissistic attitude that endlessly contemplates and reflects itself and obstructs social progress. The term "adversary culture" has been used.[8] From the point of view of the neo-conservatives, the rational and progressive program of modernism has not yet been completed. They believe that a return to the old values of social responsibility and achievement and an elimination of the culturally promoted isolation of the individual would allow us to face the future with continued optimism. This position has been strengthened by the revolution of 1989 in eastern Europe, the victory of liberal democracy as the best form of government and of the free market as the best economic system. But it has been weakened by a *laisser-faire* attitude especially toward processing ecological problems and by the dominance of economic values of unceasing consumption of goods, services, and images.

(2) Those theorists who take a more socially critical or neo-Marxist view also believe that social progress is necessary and possible – although they naturally start from a different set of presuppositions, namely an often harsh critique of the liberal capitalist system[9] that to the neo-conservatives is sacrosanct. The analysis of cultural developments from this point of view, however, leads to contradictions in the evaluation of modern aesthetics. The traditional Marxist view[10] sees in "elitist" modern art a decadent and socially irresponsible autonomous aestheticism that has turned its back on the realities of life. Yet some critics believe, like Adorno, that anti-bourgeois and anti-capitalistic elitist art, through its "negative commitment," has a special mission to criticize ("indirectly," not by direct, satirical confrontation) and, ultimately, change social conditions. In a reapplication of the Marxist reflex theory (reflection of the social state of affairs in the state of the arts), critics like Fredric Jameson tend to see in the postmodern crisis of culture and art/literature a parallel to the crisis of a superficial capitalism of consumption. In this, they are in agreement with conservative or modernist cultural critics like Hilton Kramer and Clement Greenberg. At this point postmodern art becomes divided up into (a) a "good," "negative," emancipatory, anti-capitalistic, and anti-bourgeois variant, precisely the one that might be expected to offer a forum to ethnic minorities, including the Natives, and (b) a "bad," market- and consumer-oriented, "kitschy," mediocre, or reactionary type, which has lost its "subversive" quality and – so one might speculate - would be of little relevance to Indian art because it is no longer value-oriented. This broad group of critics has come to dominate the debate on postmodernism, at least in the United States. Their astute analysis of the

negative effects of postmodern social and cultural conditions contrasts with the less convincing utopian outlook. The utopian Marxist outlook has been discredited by the eastern European revolution, which has shown up the ineffectiveness, corruption, and terrorism of "real existing socialism." But this kind of criticism has been strengthened by the abandonment of rigid Marxist theory and an alliance with liberal humanism and a highly moral thrust, giving to (utopian) socialism or humanism the role of a theoretical and practical corrective to the aberrations and abuses of capitalism and the free market.

(3) The neo-conservative and the more or less radical neo-marxist and socially critical positions have one thing in common: a belief in reason and in man's ability to overcome aggression and concern with mere self-interest, and to arrive at (dialogic or institutional) consensus, to conquer social problems and create man's own future in a positive sense. The approach of the "pragmatic" or "dynamistic" cultural theorists, on the other hand, is based on radical epistemological and ontological *doubt* directed against the logocentric positions and systemic thinking of Western civilization. Metaphysical instances, human reason, authority, and truth in any guise are "deconstructed,"[11] as is any thinking based on historical continuity.[12]

The "grand narratives of legitimation," the "dialectic of the spirit, the hermeneutics of meaning, the emancipation of the rational or working subject" - in other words, the comprehensive universalist and utopian intellectual projects, the narratives of enlightenment or emancipation, and the teleological expectations of Western cultures - are "delegitimized" in favour of heterogeneous and circumscribed "little narratives [*petits récits*]."[13] The result, as already mentioned, is the concept of a *pluralistic* society and culture. One can argue that this pluralism leads to the radical hedonistic eclecticism of "anything goes"[14] and ultimately to an attitude of radical indifference. With faith in human reason, one can call instead for socially responsible consensus, equality and unity.[15] Or one can finally celebrate this pluralistic diversity as something "vital" and dynamic, seeing in it a sign of the breaking down of intellectual and cultural barriers and polarities, a promise of a future in which non-alienating forms of art, such as produced in the "counter-cultures" of the sixties and early seventies, can flourish.[16] Depending on the radicalness of the standpoint, what has been here propagated in growing radicalness are (a) a new art and theory in the tradition of the avant-garde; (b) a new way of interpreting the world at large, a new (aesthetic) attitude; and (c) a dissolution of the reality principle, which is questioned by a blurring of border lines between reality and fiction. Most of postmodern artists have been affected by this dynamistic, anti-realistic, and constructionalist position.

The dynamistic view of postmodernism holds both disappointment and hope for Native art in Canada and the United States: disappointment in so far as it calls into question the

binding nature of cultural traditions of any kind, and hope in the sense that, with the gradual breakdown, the deconstruction of the "grand narratives," the systematizing ways of thinking and consequently the West's claim to cultural dominance and leadership, tolerance can grow. Indeed, in a pluralistic, decentralized world it would no longer be possible to make categorical and arrogant judgments from a predisposed cultural centre (the West) and evaluate the one apart from the "other," An emergent multiculturalism relativizes the value statements of the mainstream culture. The mainstream quality concept has been determined by Western views of innovation and autonomy of art and is challenged by the art concepts of minorities (Natives, Blacks, Latinos, Asians), for instance the understanding of art as self-expression, the struggle against stereotypes, the fusion of the spiritual and physical, the dominance of hybrid contents and forms, a combination of ritual and art, empathy with materials, and an affirmative montage/collage style.[17] The eastern European revolution of 1989 has strengthened the trend toward multiculturalism and tolerance. It has brought a new infusion of compassion and enlightenment into culture, a new appreciation of freedom as the basis of Western civilization, a new, positive evaluation of the masses and their call for freedom and also of the media that played a decisive role in the liberation of eastern European peoples. Television is increasingly seen not only as producing sameness but also plurality.[18] This does not change the main tendencies of postmodernism – relativity, pluralism, and the dominance of the market – but relativizes the feeling of immobility, entropy, and apocalypse that has been a central factor in postmodern culture too. Hope lies in a new, productive symbiosis of political and economic internationalism and cultural regionalism the way Europe envisions it.

DECONSTRUCTION-RECONSTRUCTION, DIFFERENCE-OTHERNESS

The point of departure for an analysis of the postmodern cultural situation is, as already mentioned, the *absence* of a centre, a basis, an integrating point of reference, a sense of transcendence. Man can passively endure the cosmic chaos – an attitude that led to the ideology of the waste-land[19] and to the existential sense of alienation that could be answered only by subjectivity and the preservation or reconstitution of totality in aesthetic form. (This is the by-now traditional view of modern aesthetics.) Or man can see in the confrontation and, better yet, the dialogue with that which is unruly, undefined, and fluid in the everyday world, an opportunity to develop mankind's uninhibited creativity, for critical or playful purposes. This is an extension or transformation of modern aesthetics in the postmodern cultural climate. In the second case, the artist brings to the task a twofold perspective involving the active *deconstruction* of boundaries and privileges as well as the active *reconstruction* of man's relationship with the environment in which he lives through a dialogue with nature. In the field of art it seems that the reconstruction of a

holistic worldview can occur only through a dialogue and a coming
to terms between culture and nature. Indian culture, with its
emphasis on community, nature, and the universe, offers an
important point of reference for this dialogue, a dialogue that
can be given universal, historical, and at the same time
individual expression through art. However, since the
reconstruction of such an overall perspective demands that
ideological and formal dogmas be avoided, it must always retain
elements of the playful and the eclectic, but also of open-
endedness. It can do this in one of two ways.

(1) It can be *processually* oriented, filling the empty
continuum of time - in a kind of creative anarchy - with an
unending series of fragmented, persistently discontinuous, but at
the same time reflexive or imaginative constructs to produce a
projection of the possible. Repetition and variation,
dissolution of organic, ideological, and conventional
relationships, and the bringing together of discrepant elements
are the principles on which the flexible but arbitrary production
of context is based. The production and reception of these
constructed contexts occurs without a foreseeable element of
arrest or determinable rules of interpretation, and find their
justification in the capacity to transform passivity and
consumption into activity, static states into dynamic ones,
fixated and stereotypic attitudes into productive and creative
energy. Montage and collage place or assemble "fiction upon
fiction," *ad infinitum*. For Indian art and culture - value-
oriented and defining itself as it does largely as a function of
the dialogue between minority and majority - this would not
appear to represent an attractive option without further-reaching
intentions and meanings, at least not yet and not in the radical
form of mere aesthetic "happenings" without moral meaning (though
Carl Beam, for example, has produced such a happening to open an
exhibition of his works).

(2) The reconstructive process can also, to follow
Heidegger, begin with the realization that within the
aforementioned absence is concealed *Being* itself, which may be
glimpsed particularly in language, the "house of being,"[20] but
can never be rationally and systematically grasped. Herein lies
the postmodern relevance of Heidegger's philosophy[21] and herein
lies also its relevance to art - a "language" in which Being is
present in its very absence. As one might expect, Indian artists
who work in the postmodern idiom (Beam, Poitras, Cardinal-
Schubert) feel themselves particularly attracted to this
possibility. A link exists also to more modernist Indian
paintings, like those of Morrisseau, Odjig, and Janvier, which
seek to evoke with the image the essence of Being in the absence
of Being. On the socio-cultural level, reconstruction takes its
cue from a new, decentralized ("post-humanist") concept of
freedom and emancipation, which prefers *difference* to sameness
just as it prefers the many to the one.[22] In this respect many of
the neo-Marxist and "dynamistic" critics agree; they make
difference the basis for the claim of a new humanism and

liberalism. Whereas Hegel wrote, "What is true is the whole,"[23] Adorno countered with the opposite: "The Whole is what is untrue."[24] Jean-François Lyotard, author of one of the most influential books on postmodernism, rejects the ideology of consensus and standardization proposed by Jürgen Habermas and declares, "We have paid a high enough price for the nostalgia of the whole and the one, for the reconciliation of the concept and the sensible, of the transparent and the communicable experience.... The answer is: let us wage a war on totality; let us be witnesses to the unpresentable; let us activate the differences and save the honor of the name."[25] This discourse of difference has increasingly ethical goals. It focuses on the disruptive and subversive potential of the Other, on that which has been called "transgression," the "logic of the contradictory" or, in Foucault's words, a "form of thought in which the interrogation of the limit replaces the search for totality."[26] But even the concept of limits is no longer an entirely accurate indicator of the direction of postmodern thought. Through the thought-process, confining limits have been eliminated and oppositions deconstructed. Polarities once considered fundamental, such as natural-unnatural, conscious-unconscious, authentic-inauthentic, function-ornament, art-merchandise, and particularly same-other have been qualified or even dissolved. Western binary thought itself is being questioned, as the shifting and increasingly open relationship between Same and Other demonstrates. We have, in effect, come to "use culture as a series of unexpected alternatives."[27] As the Other is de-dialecticized and de-polarized, it is transformed into the "unclassified, unsought Other"[28] that has no meaning within a binary structure, but simply is; or, in Paul Ricoeur's words, "suddenly it becomes possible that there are just 'others,' that we are an 'other' among others."[29]

This way of thinking about difference is a prerequisite for the acceptance of Indian and Inuit art in mainstream Western culture and on the Western art market, for only in this way can it cease to seem "exotic," "quaint," or "interesting" in the sense of a temporary and superficial attraction that can be readily replaced by another. This change of climate also means that Native art can assert itself away from the universal, general, and actual and towards the individual, the other, and the possible - or rather, in the interstice between the universal and the other.

As the notions of culture and its value hierarchies become increasingly flexible, the *historical element* takes on special importance for native cultures, for it is only by viewing one's own culture from a historical perspective that the aspect of *transition* can be perceived, situating the culture in its relationship to past, present, and future and in a dialectic relationship with its present civilizational milieu. This destabilization of stereotypic thinking among the majorities, and the experiencing and recognition of the complex cultural situation within Western civilization on the part of the Native

artists, open the way for them to choose their subjects, forms, and intentions of artistic expression (subject of course to the restrictions imposed by external and internal circumstances).

In the postmodern intellectual climate, in which the "primitive" no longer exists as a phenomenon that can be isolated in time or space,[30] and in which a high value is attached to the other, Native art too has changed. Postmodernism has offered Native painters and sculptors not only the (modern) concepts and techniques of aesthetic symbolization of thematic content, but also the (postmodern) forms of expression characterized by radical irony and free play. Both facets, the modern and postmodern, coexist today in Native (as in Western) art and make for its tensions.

POSTMODERN ART

The development of postmodern art can be considered an ongoing discovery and integration of the other. This broadening of the horizon takes place both in the form of a subversive crossing of established boundaries, an experimentation leading into unknown territory, a challenging of bourgeois or modernist notions of art. It is a factual acknowledgment of the discovery that nothing is the same and everything is "different," that "otherness" is hence simply the other face of sameness. Art no longer possesses an unquestioned and unquestioning frame of *aesthetic* reference. On the one hand, the "aesthetic" inundates the "real" world by the sheer volume of the omnipresent, media-transmitted images that hamper our direct, sensory apprehension of "reality," whatever that may be. In this sense one can speak of an "aestheticization" of the world. On the other hand, this rampant aestheticization is, paradoxically, anti-aesthetic, if one considers it from the point of view of art, that sees art as separate from life, autonomous, and, in its strict formal structuring, bestower of meaning.[31] Here, too, one concept (the aesthetic) is permeated by the other (the non-aesthetic) and in the process its sharp modern contours are affected. Under today's changed conditions - the fictionalization and aestheticization of the world - the separation of art and life is no longer viable; as art crosses the boundaries separating it from life, its special (critical, "negative," essentializing) function is also called into question.

The crossing of boundaries, the integration of the Other and the awareness that art does not form a totality, but is always only partial art, opens up the concept of art. Everything becomes possible. Art no longer separates itself from life, nor from the machine, which is a part of life, nor from the other media of communication, which like art supply mankind with its fiction. It is completely consistent with this trend that pop artist Andy Warhol should have advocated a kind of artistic nihilism: "The reason I'm painting this way is that I want to be a machine, and I feel that whatever I do and do machine-like is

what I want to do."[32] Another pop artist, Roy Lichtenstein, summarizes this negative (anti-modern) attitude by defining the goal of Pop Art as "anti-contemplative, anti-nuance, anti-getting-away-from-the-tyranny-of-the-rectangle, anti-movement-and-light, anti-mystery, anti-paint-quality, anti-Zen, and anti all these brilliant ideas of preceding movements which everyone understands so thoroughly."[33] The Korean artist of flux, Nam June Paik, who works in America and Europe, has been putting this manifesto into practice since the early sixties in his video sculptures and video environments and has expanded the concept of art in the process. By actively including the viewer in the work, his montages and superimposed images combine the theme of communication with the passage of time in actions or happenings, and with the simultaneous existence of the other in environments, expressing "synchronicity as... the principle of accusal contexts."[34] Interestingly enough, in an interview with Allen Ginsberg, Paik referred to an ethnic aspect of his by now internationally renowned and much imitated video art: "Perhaps my 'minority complex' as an Asian or a Korean drives me to compose extremely complicated cybernetic works of art [in which analogies to music also play a role]."[35] Indian art has so far failed to play such an avant-garde role in mainstream art, probably because Indian artists do not identify with technology as Paik does (even though he treats it in an ironic and comic fashion), but rather retain as their point of reference their own traditions and Indian sensibility. The advantages and disadvantages of this approach will be discussed further on.

A look back at the beginnings of postmodernism in art, which coincide with the breakdown of modernist aesthetic dogmas, may help to clarify the current situation of Indian art. The development initially led, as one might expect, to aggressive provocation and then, little by little, to the merely "factual" acknowledgement of the "Synchronicity of the Other," as the title of a 1987 exhibition in Basel so suggestively noted. The breakdown of modernist aesthetic positions is reflected in the extension of the concept of the *artist* and of his position and role in society. John Cage reports a conversation with Willem de Kooning in which the latter said, "We are different... you don't want to be an artist, whereas I want to be a great artist." Cage adds, "Now it was this aspect of wanting to be an artist... who has something to say, who wanted through his work to appear really great... which I could not accept."[36] Cage could not accept the greatness of the work of art or the idea of art that one preserves, and instead called for "impermanent art."[37]

The notion of "impermanent art" finds an echo (and a typical transformation) in the continuing Indian conception of the cyclical and self-renewing force of nature. It is illustrated in Ron Noganosh's approach to art, for example: he let the sculpture It Takes Time lie outdoors for several years, exposing it to weathering and decay. Carl Beam emphasizes the underlying belief in the principle of cyclicity in a remark that is also significant in relation to his work or, specifically, to its

playful quality: "If we can see disintegration for what it is, it's not so terrible. It's evolution, natural things decay; this civilization is decaying. That's what I mean in Dying in Time. It's just a process. Your life is a process and once you view it as a process, nothing can hurt you."[38] The purpose of "impermanent art" in the context of Western postmodern art was obviously different and yet ultimately similar. It was to encourage the viewer, through disorientation and "de-familiarization," to see and hear what was in front of him – "just seeing what there was to see"[39] – with fresh senses and without attempting to place the details within a predetermined hierarchy. The process encompasses impermanence and renewal, absolute silence, and the presence of that which is absent, indefinable and infinite, the representation of which Lyotard considers to be the most important functions of art.

This de-dogmatization of ideas about art and artists naturally affected the *form* and *content* of art, which, although it moved increasingly into the statement of relations in time and space, also came to orient itself more and more in terms of the dynamistic principle of opposition (art/life, surface/space, sculpture/object, nature/culture, and so on) and its diffusion. The issue initially was one of *overcoming limits*, with the new movements taking on an increasingly subversive character. They could look for inspiration to the Dadaists with their blurring of the boundaries between art and life, as well as to the Surrealists with their breakdown of the differences between reality and dream, the truth and fiction. The deconstruction of form was reflected in the modification of the structure and format of the painted picture, which the artist now regarded as an autonomous "object" with which he could do as he wished. Jackson Pollock had already abandoned the concept of "centre," without which an autonomous construction cannot exist, in his action paintings or "over-all" pictures. They no longer admit of hierarchies and symmetries and thus offer the viewer no point of equilibrium, no place to rest. With his "shaped canvases," Frank Stella broke down the boundaries imposed by the frame, adapting the format to the abstract forms of his paintings by means of semicircular, angular, or undulating outer contours.

The *surface* of the work itself offered further possibilities. It could be penetrated, as did Arte Povera artist Mario Merz (using a neon tube as a "light Barrier" and "light flux"): "The neon tube that bored through and perforated [the canvases] created a duplication between the canvas and the light, i.e., a true destruction of the canvas as a space of canvas and of painting." The purpose, as Merz suggests with regard to a bottle perforated by a neon tube, is "to destroy the surface, to make something other [!] of the surface, which nevertheless remains surface and light."[40] Merz is not an isolated case. Lucio Fontana slit open the canvas surface of his pictures – as too did Indian artist Carl Beam in early works – and Otto Piene burned holes in them. In this way the surface opens itself to space, becomes "dramatized" in relation to other surfaces and

forms in an intermediate zone between painting and sculpture (Merz, Stella). The concept of *"betweenness"* itself becomes a useful tool for an understanding of the expanded possibilities of art; and it is here, as we will see, that Indian art finds its point of access to postmodernism. Finally, the "substrate" of the painting, traditionally paper or canvas, is replaced by aluminium, copper, or magnesium (Stella), or gives way from the outset to the *"object."* Found objects such as doors, moulding, rags (Rauschenberg), old TV sets (Paik) or earth, coal, wool, plants, and stones (Kounellis, Broothaers, Beuys) are turned into assemblages and environments. Here again we find examples among postmodern Native artists who, like Beam, paint old doors and window frames to produce objects or, like Noganosh, put together an old toilet bowl, a small globe, a metal rod, a lamp with a metal shade, and some strips of plastic to create an assemblage. The attractiveness of this kind of assemblage art for the Native artist lies in its tendency to break down traditional ideas about art and eliminate hierarchies, which of necessity was one of the central issues for Indian artists. The incorporation of "other," non-artistic objects in the wake of the de-hierarchicalization of art explains, moreover, why postmodern sculpture in general is flourishing. However, it is no longer sculpture in the traditional sense of a composition of parts forming a whole, but rather object art, which defines elements and creates spatial (and temporal) relationships.

Just as Abstract Expressionism pointed the way for art in the late forties and fifties, so Pop Art set the trend for the sixties. By following in its ceaseless experimentation a "sense of possibility" and not a "sense of reality" (Musil), Pop Art continuously created new contexts for art through its montage and collage techniques. Art now came to mean in effect the combination and superposition of various domains to serve as *"contexts"* for the work; in extreme cases the work itself might contain nothing *but* contexts, associational frameworks and concepts for the viewer, whose sense of art and reality was stretched to the limit. Assemblage and collage had of course been used at least since Picasso and the Dadaists as a means of de-familiarizing all too familiar objects. Now, however, they became the main formal means of a central direction in art, one that quite simply exploded the accepted boundaries of what constituted art and thus became the most important provocation of the sixties.

Robert Rauschenberg, for example, one of the forerunners of Pop Art, documents the other - the wealth of superficial stimuli that flood the senses of the city dweller and with which art must compete - as a context in his work; he experiments with the use of images and texts from the media. (He was one of the first to use comic strips, later used extensively by Roy Lichtenstein as a source of the iconography for his master paintings.) The reproduction of canonized works of art from the past formed yet another context, as did relics of nature, with the context often appearing as "material" in the picture (in the forms of a stuffed goat's head or eagle, for instance, as a "door" or a photograph

with traces of paint, as in his Combine Paintings), so that his
works became situated in the "interstice between art and life"
(Cage). From the "interstices" in these pictures, the space
between two poles - the gap, for that which was in fact *absent*,
namely the meaning-bestowing, totalizing *gestalt* in the modern
sense - the artist drew elements of paradox and contradiction
that were aimed at the viewer, shocking him and confronting him
with the reciprocal questions of nature and meaning of art and
"reality" (such an approach was perfectly suited to the concerns
of Indian artists, such as Carl Beam[41] in "Flags"; or by casting
two empty beer cans in bronze and placing them on a pedestal).
Central to Jasper Johns' experimentation, too, is the element of
the other: "I am concerned with a thing's not being what it was,
with its becoming other [!] than what it is, with any moment in
which one identifies a thing precisely and with the slipping away
of this moment...."[42] This approach is also of interest to
Indian artists: Edward Poitras, for example, operates with well-
known, connotation-laden objects like the buffalo skull - a relic
of the Indian ceremonial tradition (sun dance) as well as part of
the stereotypical picture of the Indian - but integrates it into
new contexts along with other (discarded) materials, so that the
objects themselves take on a variety of new meanings. Carl
Beam's use of familiar symbols of Indian identity, such as
buffalo and eagles, can be seen in a similar light.[43]

This style of de-familiarization, which expands the
repertoire of artistic media to include " non-artistic," everyday
objects, and even the discarded refuse of civilization, and
shatters stereotyped ideas, is also characteristic of the work of
Andy Warhol, whose photo series of famous people, such as movie
stars and rock stars (Marilyn Monroe, Elvis Presley), are
rendered strange and unfamiliar by the application of jarring
colours. Each photo evokes the other, yet at the same time calls
into question the other's (and its own) "documentary" nature - a
process of mutual relativization that in modified form is also
used by Indian artists. In order to destabilize perceptions of
reality, Christo, the originator of "packaging" art, alters the
"objective" qualities of his objects and at the same time gives
them a new identity by covering and wrapping them. The technique
of wrapping as a means of representing the invisible, the
unidentified, is used by Edward Poitras in his assemblages to
illustrate the problem of ethnicity - on the one hand the aspect
of being tied and dominated, on the other the self-absorption in
one's identity and traditions.

This intentional alienation is related to the attempt to
"cleanse" reality of any form of artistic "expression," thereby
preventing the facile projection of subjective reality onto the
external world. This is precisely the goal of so-called
minimalists (a very vague term but one which nevertheless
indicates one of the most important postmodern trends). Against
the background of the expansionist tendencies of art, its
increasing encroachment on life, these artists now sought to
focus attention on the object itself rather than its artistic

representation by the painter or sculptor, One of two very different approaches were used, making a clear definition of this movement impossible. Some artists reduced their paintings to monochrome canvases (a development which had in fact begun with the Abstract Expressionists, such as Newman and to some extent Rothko) in which artistic design played little or no role, as in the black-painted surfaces of Ad Reinhardt. Others used everyday, mass-produced and thus non-artistically formed objects in (seemingly) unartistic arrangements, the sole purpose of which was to clarify and organize sensory perception and thus mark the contrast between sensuality and (artistic) structure. The tendency toward monochrome canvases in many respects seems to run counter to Indian sensibilities, which are shaped by the experience of "between" rather than the experience of uniformity or the desire to minimalize human expression. The technique of isolating objects as a means of creating new experiential contexts that stimulate the viewer to think and reflect was better suited to the concerns of Native artists because it allowed the articulation of alternative works. However, because of cultural traditions, the postmodern idiom as used by Indian artists (e.g. Poitras, Cardinal-Schubert, Noganosh) is so permeated with "messages" and associations with that which is other and at the same time universal, that minimalization, which inevitably also means neutralization, hardly occurs in the way it does in Western art.

This search to portray the other through the minimalization of art was in fact based on the fallacy that the artist could reduce his activity to a minimum and still remain an artist. The result of this minimalist use of artistic means was rather that the artist's *concept* became apparent or even dominant in his work, infiltrating the object, as in so-called conceptual art, or that art, by giving up its artistic means, effectively proclaimed the *end of art* - a development that in many cases was either consciously intended or at least accepted by the artists. Lucio Fontana, who makes slits and holes in his monochrome canvases in order to "open them up," noted that, "Beyond the perforation a newly gained freedom of interpretation awaits us, but also, and just as inevitably, the end of art."[44] Reinhardt, who documented the decline of the Abstract Expressionists, once said that he was "just making the last painting that anyone can make."[45] Naturally, this was not an attitude that contemporary Indian art could share, since it was only just entering the art scene and proclaiming its own breakthrough from craft or ritual to art.

But art did not die, and paintings continued to be made, even after Ad Reinhardt. Through its aggressive challenging of what it called the (corrupt) bourgeois or (exhausted) modernist-aesthetic dogmas, postmodern art on the contrary had created for itself a new space, which it now set about exploiting. Mere rejection of societal values became meaningless as soon as the bourgeois art industry began to tolerate and even expect and enjoy the artists' harangues as an expression of the other. In this way provocation in turn became a cliché, a dogma that had

run its course; the end of the avant-garde was imminent.[46] At the same time, though, the newly created contexts did not lend themselves to the making of positive or meaningful statements, either. As art increasingly drew its reference from life, it had to face the fact that in the age of the nuclear arms race, environmental disaster, famine in the Third World, and other apocalyptic developments, humanity, despite all its technological advances, could point to little real progress, and that art - as the experience of the sixties had shown beyond a doubt - could do little to improve our lot.

What had been gained in the field of art in the revolutionary sixties and since can perhaps best be expressed by the notion of "between-ness" that has already been alluded to several times - an intermediate zone situated in the breach, the gap, in the silence, the absence of all "statements"; a *void* in which associations, allusions, connections, and impulses can accumulate and exert their effect on the viewer, who, whether he wants to or not, is forced to become an active participant in the creation of the work of art. Without the viewer's cooperation, his ability to make associations, to enter into a dynamic relationship with the observed object, the "work" or, as it now became fashionable to say, the "text," is not complete. Art has always taken its meaning from a dialogue *between* the image ("text") and the viewer, but this relationship now became increasingly evident. In this the postmodern aesthetic no longer followed the modernist aesthetic based on the autonomous qualities of the work, choosing instead to define itself as an aesthetic of *reception*. From the point of view of postmodern (and modernist) Indian art (or any minority art), however, with its need to produce a particular "effect," a "message," and to assert itself, this development was not entirely welcome. An aesthetic based entirely on the reception of the work, not on the work itself or its creator, was particularly problematic for the more traditionally oriented art of the Northwest Coast, because it meant that the uninitiated (Western) viewer had to be accorded a key role in the definition and interpretation of the art. Out of its context, he might reduce it to its decorative and exotic aspects, ignoring the Native traditions of the artist. Yet in the void of "betweenness," in the *absence* of a significant in postmodern art, paradoxically a new *"fullness"* could now gather, arising out of the dynamic contradictions and taking its meaning from the recognition, acceptance, and reflection of the other and, consequently, of the self as *Other*. Perhaps one could even say that free play of associations encouraged by the best works of the seventies and eighties lead us to contemplate our connection with the infinite and the cosmic - not, as in modernist art, through positive or symbolic references to meaning, but simply through the evocation of thoughts and fictions that remain within the realm of *possibility*. The result, too, is a revaluation of apparently outworn concepts like that of *myth*.

POSTMODERNISM AND MYTH

In postmodernism, art has largely lost its modern integrating power and its ability to represent spiritual meaning in symbolic form (Kandinsky, Klee). The paradigms of organic life and consciousness are replaced by those of *material* and *construction*. In a culture of exhaustion and deconstruction, myth has become the subject of play, as have all concepts and expressive forms of the past. Nature is deconstructed and arbitrarily reassembled in montages and collages. And this deconstruction does not stop at the concept of the "natural" unconscious. As Fredric Jameson noted, "late capitalism can... be described as the moment in which the last vestiges of Nature which survived on until classical capitalism are at length eliminated: namely the third world and the unconscious."[47] The artifice that has replaced nature, however - the restricted constructive moment raised to the level of absolute - is itself ambivalent, oriented as it is towards *possibilities* rather than realities. This in turns opens the way, paradoxically, for nature to take on a new importance as part of a constructive and ecological consciousness. In a now *decentralized* and *de-realized* world view, a new radical subjectivism that posits play and imagination as absolute values coincides with the notion that nature and its mysteries constitute a final, meaningful, and vitally important frame of reference whose inherent order should be unquestioningly accepted without becoming a screen for anthropomorphic projections of man's inner world, and without regard to utilitarian considerations.

This then is the point of departure for a new mode of thinking in primal categories, which includes a willingness to accept mythical interpretations or those based on the modern analogue of myth. The result is the *second revaluation of myth in the twentieth century*. After the modern consciousness-paradigm had exhausted itself, the direct experience of myth or spirituality through mythical communion in the moment of "Being" or "recognition" (Virginia Woolf, Joseph Conrad) was called into question. This led to the crisis of abstract art, its transformation from a sublime blueprint of the spiritual, in the presence of which the mystery of Being too is present in its infinity, to an "aesthetic" design on the surface that no longer points to any "meaning" and thus no longer has any "content." As the question of origin becomes a subject for critical investigation (a process that, as Nietzsche already pointed out,[48] strips it of its aura and reduces it to an empty shell in a *regressus ad infinitum*), time-primordial or mythical time loses its function as an expression of Being itself, as a medium of archaic religiosity. And the same is true for the moment of revelation and its immediate evidence. In its place, (nonideologized) *space* and the *things* inhabiting it as the "other" come to the fore as the basic category of mythical thought. In a world in which ideologized schemata are breaking down, in which wholeness is called into question and plurality becomes increasingly important, space becomes the medium for

various simultaneously existing and mutually complementary matrices.

Art thus articulates itself through the dynamic principle of opposition. Resistance *and* transference become key aesthetic concepts. The resistance of consciousness against habit, rationalization, one-sidedness, and one-dimensionality, against norms and utilitarianism, against the sterile beauty of a self-referential "formalism," is transferred onto the resistance of *matter* in space. The work of art that activates this resistance in the material sphere becomes inaccessible and thus retains the quality of the unknowable; it cannot be classified, psychologically interpreted, or functional. Even in pictures or assemblages it presents the resistance to synthesis that is inherent in art, according to the asemantic principle of dynamic contrasts which remain without dialectic, without resolution, creating only a reference of opposition without a context.

In a process that has been termed "Spurensicherung"[49] (preserving traces of the past), "earth artists" like Robert Smithson, Michael Heizer, Richard Long, Robert Morris, Michelle Stuart, and others create analogies to the mysterious prehistoric constructions of seemingly "primitive" cultures (whose knowledge is now being viewed in a new light by postmodern science), such as the monoliths of Stonehenge, the figures carved into the Nazca Plain in Peru, or the Indian mounds in Ohio. Others, like Nancy Graves, reproduce prehistoric skeletons, fossils, or ancient cave paintings as projections of the past. In both cases there is an awareness that the present is part of the past and the past may be longer than the future. Richard Long uses lines and circles as the basis for physical experiencing of space and delineates a specific site with stone markings, thereby producing a structural reference point for the environment. Christo's enormous curtain in the middle of the California landscape and Walter de Maria's Lightning Field in the New Mexico desert use "land art" sculpture to establish a dialogue between nature and culture. All of these works seek to establish links between present and past, art and anthropology, feeling and intellect, spontaneity and rigidity, communion with the mystery of a concrete (archaeological) site and the symbolic system of mythical thought; between transcendence and fixation, hubris and vanities, orientation and disorientation.

The possibilities available to the postmodern artist are endless and extended to all natural and man-made spaces, including squares, parks, museums, and exhibitions. They show that the mythical element has not disappeared from postmodernism, but has simply expanded its base to comprehend all primary phenomena, be it the primary aspect of granite or metal, the cube form, the colours black or white, or archaeologically significant monuments. The methods by which it may be evoked include all forms of reduction and montage. Richard Serra places his archaic steel barriers in space like foreign bodies and allows them to create their own hermetic territory. Cy Twombly removes the

thing-like quality from everyday, chance objects by painting them white, the colour of resistance and denial, thereby making them into something opaque, foreign, Other. Ulrich Rueckriem's blocks of hewn dolomite, set in the middle of the busy man-made landscape, are a monument of permanency to the history of the earth. Joseph Beuys moves his social sculpture into archaic, mythical realms, establishing links between historic and cosmic time and consciously taking on shamanistic traits in his performance.[50] Sol LeWitt sets the primary white form of the cube, with or without truncated edges, in the middle of a hall or a park.

What is created in all of these cases is a condition of "*betweenness*," a rupture, a gap, a vacuum, in which the absent is made present and absolute within the relative, not in the form of a symbol, however, but as (primary) *energy* that arises from the dynamic contradiction. Thus, Cage speaks of absolute silence, which is in itself a contradiction, and Mario Merz of absolute form, which he then negates in practice. The igloo that has become Merz's trademark is a prime example of how the postmodern artist "quotes" the old archaic forms with their wealth of associations; he reconstructs them and then deconstructs them, but this time as something unfinished and transformable, rather than as an organic unity. For Merz the igloo is the "primordial image of the mythical tent." But he, like the other postmodern artists cited, seems to find it impossible to concentrate on one of the available collectivities; thus he layers and combines various natural and cultural systems of coordinates, such as the form of hemisphere, the material of broken shards, light from neon tubes, written characters, and arrangements of numbers (the Fibonacci series) in his various igloo arrangements. In each arrangement, space, time, and number come together in new and seemingly chance ways to produce a construct-like "primordial phenomenon" that exists like a mythical object in tension between ordinariness and extraordinariness, absolute stillness and constant change. That the expressive intent of these works is to approximate myth or present it in a new form is seen not only in the fact that Merz, like his fellow postmodernists, uses the work "myth" frequently in his commentaries, but also in the fact that he uses the elementary forms of space, time, and number, which Cassirer termed the basic forms of myth, perhaps not to create an actual mythical space, but to evoke the potential for such a space through pictorial and spatial impulses.[51]

All of the assemblages and environments mentioned so far are spaces of *meditation*, representing the breakdown of predetermined structures, the elimination of barriers, the dramatization of relationships, the infiltration of primary forms, the overriding presence of matter and tension-filled contradictions. The predominance of objective consciousness undermines human self-consciousness. They are cryptic arrangements that depict the contradictions of life, not of the psyche. They are not centered in man, but in that which is raw, massive, powerful, and energetic - in short the external world in all its

inaccessibility - and in this way they serve as analogies to the inaccessibility of nature as well as to the uncontrollable nature of civilization. They cry out against the hubris of "making" and call for a new dialogue with the more comprehensive systems of nature, magic, ritual, and other forms of social organization. Myth as a modality of thought here is both a reference to and an analogy for the pluralistic paradigm. It is paradoxically also the postmodern form of resistance against the postmodern credo of "anything goes" (Feyerabend).

MYTH AND CONTEMPORARY INDIAN ART

The transition to the postmodern was made easier for the Native artist by their own hybrid position. At least since the Second World War, the existence of the Native artist has become increasingly "postmodern." The Indian has come to play a double role as an Indian and as a participant in the White labour and consumer world. The solution to the problem of identity could only be achieved in the consciousness that these roles cannot be integrated in the self, must be accepted as two identities. This awareness made the whole concept of identity itself problematic. The seemingly absent existential commitment to the expressive forms of modernism and the idiosyncratic, sometimes playful choice of forms were in a certain sense already a manifestation of the Native American artist's own postmodern situation. The Indian playfulness in the choice of subject and method was supported or, rather, made possible by an essential feature of postmodern art, its quotational character. Postmodern art notions no longer show a belief in progress and development, in the truth-stimulating function of an avant-garde, in the necessity or even possibility for (endless) innovation. From the viewpoint of the uprooted, art history presents itself as a storehouse of accidental and freely available art styles and philosophies. This holds equally for White and Indian artists, except that the consciousness of this state of affairs is continuously forced upon the latter through their own existence between many worlds of the past and the present. This gives eclecticism a new, almost existential relevance for the Indian artist. Comparing the mythical elements in Indian art of the last few decades with the myth-analogical forms of expression in postmodern Western art that have been briefly touched upon in the preceding section, one may observe three parallels between the two.

TRADITIONS OF MYTHICAL EXPERIENCE

Western and Native North American art both harken back to the traditions of mythical experience and to the symbols of the mythical world (e.g., in Western art the revival and reference to tribal traditions). Indian art in its reference to tribal culture and art, however, goes back to all stages and forms of myth. In the concern with the spiritual substance of the tribal

cult activities and traditions, including pan-Indian combinations of them, Indian art connects traditional, modern, and postmodern styles.

However, the tendency on the part of Indian artists to identify with their own tradition is now often an eclectic *quoting* from various sources, for instance old pictographs and prehistoric rock paintings, traditional ceremonies, and the protective magic of masks, items of clothing, and shields, or old jewellery designs. Not the organic matrix of the land, but the constructive energy of the artistic imagination is the leading force, though both do combine.[52] The double purpose of this quoting of motifs and gestures is the blending of viewpoints and the raising or keeping intact of respect for the role of the culturally other. For instance, in Joane Cardinal-Schubert's This is my History, an assemblage of canvas and wooden poles, pictographs collected from rock paintings from different parts of Alberta are scattered across the surface of the painting. For her warshirts with their magical protective function play a similar role. She associates them with the four cardinal directions, the mythical spirits of the west, east, north, and south, and decorates them with the animals connected with them: buffalo, bear, eagle, and mouse.[53] Other magical "icons" or motifs used in this way are the shield (Bob Boyer and Ron Noganosh in Canada, or Scott Momaday, Karita Coffey and Theodore B. Villa in the U.S.), the sun-dance ceremony (in Canada Bob Boyer, Gerald McMaster, Edward Poitras) or animal symbols, such as the eagle as the bringer of visions and a sign of (spiritual) power and strength in general (Edward Poitras, Carl Beam) and the elk as a symbol of love (Beam). All of these works in some way quote from a "ceremonial context" (McMaster), or one understood as such, and often vary the mode of referring to (symbolic) modern or (playful) postmodern associations in order to point up the defamiliarization of reality, the destruction of the environment, and, in spite of all this, the (consoling) transformation of all things by time.

THE AESTHETICS OF OPPOSITION

The quotation of mythical, ceremonial, and cultural contexts in Indian art form follows an aesthetic of opposition and confrontation. In pictures and assemblages by Native American artists there is a tension between Indianness and nature on one side and Western civilization and its corruptions of nature on the other. Within this pattern there are endless variations possible with accentuation of the elemental/aboriginal/mythical or the defunct/alienated/clichéd. It is important that both poles are associated. In the works of Native artists, totalizing and unifying frameworks are used as a kind of reference line from which to measure the shortcomings of the present and of Western civilization in general from a tribal as well as a universal perspective. The artwork acts as a depiction or, rather, reflection of a thought *process*. Beam's The North American

Iceberg filters and reshuffles the animal symbols of Indian
tradition (painting over, distorting, or dissecting them) as well
as symbols and events of human history, and creates a mental
space for contemplation. Disparate images, historical
photographs of Indians, self-portraits, a printed page, and rolls
of film are used as symbols of second-hand existence and as a
means for criticizing the technological imperative that drives
Western civilization on beyond control, destroying nature and
effacing cultural differences. All this is done in a rather
detached, even playful manner that intends to stimulate the
process of thinking, yet provides no ideological maxim and
leaves, as Beam himself has noted, conclusions to the viewer.
This is also true of the concept artist Edward Poitras, who with
a kind of Dada sensibility joins together disparate objects to
make surprising assemblages like the horned buffalo skull that
recalls the sacred sun dance but is combined with a transistor
radio and old photo of Indian schoolchildren (As Snow Before the
Summer Sun). In Mythical Balance Poitras plays with the concept
of twins, which in the mythology of the Plains Indians represent
the universal concept of duality (good/bad, light/dark, etc.),
and with the ideal of ritual (transference of energy). Myth and
ritual are embodied in two rubber dolls whose protective armour
of nails also suggests a nail fetish. The dolls face each other
at opposite ends of a see-saw and act as a counterweight to the
magnetic energy of the earth and gravity – all this in a
playful/serious spirit.[54] In the same vein Ron Noganosh uses
found objects in connection with an Indian canoe to condemn the
environmental pollution of the disposable society and montages
(just like Bob Boyer), traditional motifs like the shield, made
of hubcap and beercans to make clear that today alcohol and self-
delusion have taken over the function of rawhide and visions as
protection against external threats.

In the U.S., collage artists work in similar directions, but
perhaps less intensively. Leonard Harmon expresses with his wood
assemblages the spirituality and healing qualities of his art,
employing a simplicity of form and colour. The Native metalsmith
Cheyenne Harris combines in her collages metalwork with abstract
sculpture, and associations with Native images like the arrow.
Faye Heavy Shield uses minimalistic forms in the combination of
fibreglass, wood, and acrylic paint, for instance, to show the
reaction of the Indian to the infected gift blankets given to
the Indians by the White Man (Like Thanks for the Blanket).

The thought-stimulating appeal can also be achieved with
surrealistic methods, as Lawrence Paul from British Columbia
demonstrates. In quite a different setting, but again opposing
the poles of nature and civilization, Paul presents surrealistic
versions of the landscape of the Northwest, pictures of
destruction, pollution, and isolation that derive their power
from the associations with a mythical, prehistoric time – for
instance, an image of Mother Earth in the form of a face made
with her tongue hanging out in agony, mountains in the shape of
dinosaurs, and symbolic forms of Northwest Coast art, such as the

image of the killer whale, here placed on top of trees.

SPACES OF MEDITATION

Meditation on ancient traits of culture and their comparison are important elements in the production of contemporary Indian art. For all of the above-named artists and their works it is typical that the horizon has expanded. It often embraces, along with the pan-Indian tradition and Western civilization the remnants of older cultures, and indigenous cultures generally, with a sense of elective affinity and extension of the magical-mythical worldview. Joane Cardinal-Schubert finds inspiration not only in sweat-lodge and sun-dance ceremonies but also in Stonehenge. Edward Poitras, in his Iron Bow assemblage, combines private and mythical images, allusions to the ritual Deer Dance of the Mexican Yaqui Indians, and his own dream of a deer spirit. In Day Break Sentinel, he combines the motif of the nail fetish from African culture - something he saw in a New York museum - with the mystical theme of light and dark from Gnostic texts. Pierre Sioui travelled to Africa in 1986, and the impressions he gathered there have come to fruition in a collage of relics from various cultures and geographic locations, amulets, animal parts, and religious objects in a box arrangement.[55] Bob Boyer discovered parallels between Indian and Asian art in their Fourth World status. The waving banners that he saw in parades in China inspired his blanket paintings. In the United States, Armond Lara's works - as if spontaneously, via the object and its pictorial function as a "relic" - establish the connection to other traditional peoples. He painted and assembled some of his paintings/collages on a trip to Africa, one is called Nomads, the other Heathen Truth. At the same time, the object is a bridge to the present. Jim Schoppert (USA), who sculpted and painted polychrome carved-relief panels, non-functional masks, and acrylic paintings on rice paper, drew inspiration from the woodcarving traditions of his Tlingit ancestors, Mayan friezes, Eskimo masks, pictographs, Northwest Coast totem poles, and the Baha'i faith.[56] Karita Coffey (USA), who works in clay configurations and combines (in pieces like Horse Shield) clay work, feathers, and paint, remarks, "What makes my work unique is the influence of several cultures - African, Aborigine, and Native American."[57] And Sylvia Lark's paintings have been influenced by her travels in Asia and Middle East and by the deep impressions made on her by the spirituality and close ties to the land of the people in Tibet.[58]

This expansion of interest and feeling toward other primal cultures, a "pan-primal" horizon, is followed by the search for a primordial image to contain the elementary aspects of life and cosmic spirituality and act as a pan-primal and cross-cultural aesthetic summation formula. For a Native artist this is mostly a symbol of *transition*. Robert Houle stresses the spiritual associations of the sign in the circle, which is important in most primal cultures.[59] Gerald McMaster (just like Blake

Debassige) chooses the Tree of Life, which Jung analyzed as a
archetypal image, for its cross-cultural symbolism in order to
give shape to his installation of six hundred or so telephone
books, with a slide projector in the assemblage - a chaotic
composition that, in its dual frames of reference ("These
telephone books are dead trees") points to the waste of natural
materials. In his own words, "The great Tree of Peace is an idea
that seems to be an international one - in other cultures, it's
known as the 'Cosmic Tree,' or 'The Tree of Life.' There's the
notion of the tree acting as a conduit point between the
different worlds." According to McMaster it acts also between
the male spirits of the heavens, and the female, or animal,
spirits of the earth, and between Native shamanic cosmology and
the Christian tradition that points to the tree as sign of death
and life through Christ's crucifixion and resurrection.[60]

Just as the pan-primal world and its opposition to
contemporary civilization spur thought and meditation in the
artist, the interrelation in the artwork of the elemental and
alienated, the aboriginal and the clichéd, stimulate reflection
in the viewer. The interrelation of the disparate evokes
reflection. Joane Cardinal-Schubert comments on War Shirt - A
Declaration, a picture that came about, along with The Earth
Belongs to Everyone II, as a reaction to Chernobyl, as follows:
"I'm saying to the viewer, I know what this space feels like to
be in... it's not meant to be entered, but you can still
participate without being threatened or alienated.... [It]
creates a sense of wondering why, of what is this?"[61] Carl Beam
observes that his work "approaches the idea of stopping time to
reflect."[62] The way to do this, as Beam says in connection with
his Koan Series, is by setting riddle or puzzle for the viewer,
thereby creating the basis for that "betweenness," the presence
in absence discussed earlier in connection with postmodernism; it
opens the way for cosmic spirituality to enter the picture.
Beam's cosmic nature-consciousness and its combination with
ritual and ecological messages are not an isolated case. Jane
Ash Poitras took up contemporary themes like the Chernobyl
catastrophe and the disposable society after she experienced a
sweat-lodge ceremony in 1983: "Rapture, that's what I felt,
standing at the back door just outside the sweat-lodge.... I was
fascinated with the activity and ceremony going on inside, but
more importantly, with how nature is the obvious genesis of all
such ritual."[63] The influence of this experience was seminal:
"My viewpoints, ideas, and beliefs totally changed... things I
once considered acceptable in Edmonton became totally
unacceptable as a result."[64]

The contemplative dialogue that all of these Native works
draw the viewer into is aimed at bringing about a
decentralization of the self by opening up a new realm of
experience in which there is no absolute, no "center" or point of
reference for the movements of the self, where "mankind has no
superiority" (Noganosh), and where the "arrogance of the spirit
towards time" (Lyotard) is replaced by a new/old humility and a

reaching out horizontally and vertically in space. The artist
searches out the simultaneously existing realities or traces of
other indigenous peoples in order to broaden the base for
"alterity," to transcend sameness and guarantee what Bloch,
Kracauer and Koselleck have called in almost identical terms the
synchrony of the nonsynchronous or the simultaneity of the non-
simultaneous[65] - that is, the other in sameness. This new
humility is also present in cases where the painting offers a
synthesis, which then has a utopian character. In the pictures
from the series entitled <u>Sky Peoples' Village</u>, with their highly
significant titles, Jane Ash Poitras refers to a mythical origin
and a mythical utopia and depicts a return to the beginnings of
Indian culture and its magical, life-enhancing powers, but in a
utopian society of celestial beings in a sky village, as in
<u>Return to the Land of Ancient Moccasins from Deserted Garden
Houses</u>.

In the works of contemporary Canadian Indian artists a
triple intention is discernible: to extend the subject matter
not only towards pan-Indian, but even towards pan-primal and
cross-cultural contents; to use the montage/collage method for
generating the mythical view; and to employ the latter for the
promotion of ecological thinking and thus for the inclusion in
their works of the pressing global problem of preserving nature.
This is also true for Indian artist in the United States. But
some of the latter use a postmodern variant that radicalizes the
spirit of play. Here the influence of Pop Art and its spirit of
everything-can-be-combined, observable also in Beam's and Edward
Poitras' work, sets free an unbounded play of the imagination,
making the figures and the materials that bear the mythical view
tools for the breakup of everything that is one-dimensional,
merely functional and clichéd in its meaning. The works of Harry
Fonseca, Bob Haozous, and Richard Glazer-Danay are characteristic
examples.

OUTLOOK: THE NATIVE AND THE WESTERN VIEW

For Native painting there are two important interrelated
problems: one, the place and status of the Indian artist in
Western society; the other, the White viewer's ability (or
inability) to relate to Native American painting. Several
conclusions can be drawn from what we have discussed. The first
four have to do with the relevance of tradition/nature and social
reality to aesthetic beliefs and forms in Indian painting; the
other three concern the relationship of the Western viewer to
Native art in a postmodern world, and the "discourse of
difference" in Western thinking.

(1) Native artists, it seems, often feel they must find a
way to accept their own tradition and view it as something
normal, *not* as the manifestation of a peculiarity, in order to be
an artist in the Western sense of the word (e.g., Daphne Odjig,
Carl Beam, Robert Houle). They strive to develop individual

creativity that answers to their own tradition *and* does justice
to the demands of the artistic medium and the responsibility of
the artist as one who registers the contradictions and deficits
of the times. There are of course tensions, and the solutions to
the problems that arise from the status of betweenness are quite
varied. The artists themselves almost invariably stress the
importance of *individuality*, an indication that practically all
Native painters and sculptors make their own personal identity
the measure of their art and thus submit to Western judgemental
criteria. The maxim is, in Alex Janvier's words, "Be
Yourself."[66] Yet with the acceptance of the Western role-model
new problems arise for the Native artist from the crisis of
Western culture and art. In the sixties and seventies, the
political movements surrounding the Vietnam War, the ecology
movement, and cultural groups like the Hippies and the Woodstock
Generation, with their dedication to "peace" and "love" and their
rejection of the Western work ethic, signalled a crisis of
American civilization and its self-image. Leading sociologists,
psychologists, and philosophers spoke of the lack of immediacy,
the cliché quality of a media-dominated world, its lack of
"reality," its merely mediated character, as well as the
pronounced role-playing quality of human individuality which no
longer allows an integrated unity of personality and thus a
formation of identity in the old humanistic sense. This crisis
scenario of reality and identity also impaired the modernist
aesthetic philosophy of the New and the innovation principle of
the avant-garde, which with its approval by and reception into
middle-class society lost its opponent and with it the cutting
edge and function of providing shocking alternatives.

All this had positive and negative consequences for the
Native artist. In a condition in which reality and fiction,
identity and role seem to merge into one other, and in which the
common cultural tradition disintegrates into subcultures,
minorities regain an important position. Native culture with its
myths, its striving for harmony, its reverence for the Earth, and
its collective lifestyle appears as a viable alternative to the
mentalities and lifestyles of Western civilization. This gives a
new identity and added creative stimuli to the contemporary
Indian painter, whether or not he or she wants to be "Indian."
But if the Native artist takes this alternative Native identity
seriously, problems of identity again arise. The artist may
question his or her self-image as a professional artist and
personal (urban) lifestyle away from the tribe or pueblo.
Indeed, the question arises whether a successful and, following
the Western role-model, individualistic Native artist can still
be a good tribe member.[67] Yet even accepting the necessity of
this separation of Native beliefs and urban lifestyle for the
sake of being an artist, the Native artist is confronted with the
fact that, like it or not, Indianness still defines his or her
mentality and creativity and gives the artwork its specific
identity. The Indian artist may even find that the aesthetic use
of nature/myth as an alternative form of reference entails an
unforeseen existential reidentification with the Native tradition

and thus a necessary separation from modalities of perception and
thought that the mainstream artist embraces. Bob Haozous, the
son of Allan Houser and one of the most successful contemporary
Native artists, has phrased the paradox the Native American
artist faces: "I've lived in many different situations, with
Indian families, my own included; with white people; in the city
and in the country. I've related to all different kinds of
peoples in different settings. With this background have come a
lot of different feelings and experience. So I don't see why I
only have to do Indian art. Yet that's where the paradox comes
in: I'm still doing Indian art."[68] And Joane Cardinal-Schubert,
in a partial reversal of the concept of universality in art and
reaffirmation of the Native heritage as the decisive and limiting
factor for the Indian artist, stated in 1990, "I'm beginning to
think that Native art is something different. There is more of a
commitment, more of a connection to, I guess, a responsibility of
being part of this whole world. I think Native people know that
they are an important component of the whole world. It's a
different way of looking at things, and that's usually what gives
people a style."[69] The five hundredth anniversary of Columbus's
"discovery" of the "New World" in 1992 has sharpened the senses
that "the denial and erosion of indigenous history by the
newcomers has effected lasting damage, rendering indigenous
peoples all but invisible." In an art project, <u>INDIGENA:
Perspectives of Indigenous Peoples on Five Hundred Years</u>, eight
writers and nineteen artists offer a sharp counterstatement to
the "official" version of history.[69a]

The Indian artist for the first time is involved in
aesthetic polemics. A three-stage development of Native art is
observable from passively fulfilling the expected role of an
Indian artist to emancipation as an Indian *artist* to a new
identification with the Native roots and traditions and a
willingly accepted tension between being an *Indian* artist and
being a contemporary artist. Sometimes all three (mostly the
last two) stages of development merge in the same person and form
his or her aesthetic identity. Indian artists at all events
stand between the traditions, myths, attitudes, and mentalities
of their Indian heritage (which most say is still important for
them) and the demands of urban civilization, the art schools, and
the art market in which they have to succeed in order to secure
their livelihoods. "To be an Aboriginal [Native] person, to
identify with an indigenous heritage in these late colonial
times, requires a life of reflection, critique, persistence and
struggle."[69b]

(2) A rich inventory of connotative Native images enables
the artist to articulate the postmodern artistic credo of
potentiality, which is directed against the narrow-minded realism
and functionalism of the actual social scene. As early as 1931,
C.G. Jung, in <u>On the Archetypes of the Collective Unconscious</u>,
wrote of the "increasing impoverishment in symbols" that began
with the "iconoclasm of the Reformation," and advised that man
should "acknowledge boldly the *spiritual poverty of*

symbollessness." He then goes on the qualify this, however: "He who has lost the historic symbols and cannot be satisfied with 'ersatz' is in a difficult situation, to be sure: before him yawns the void from which we recoil in fear."[10] Often only "primitive" or primal symbols or highly evocative images can help alleviate this fear, for they create an awareness of the other that is inherent in all archetypes. A.R. Penck's stick man, inspired by prehistoric cave paintings, the Indian figures of Rainer Fetting (both of these artists are outstanding exponents of the neo-expressionist figurative movement in painting) and the transparent igloo sculpture of Mario Merz (intended to represent the nomadic element of our culture) demonstrate that these primary and elemental images and their connotations continue to be significant for the mainstream of Western art. The advantage of the Indian painter is that he has not yet exhausted his images, that they still exist and are rooted in an "authentic" tradition of history and myth, that they have meaning and, as archetypal symbols with a rich store of connotations, can be introduced into the mainstream of art where such images are in short supply and where, as symbols of "betweenness," they can establish a fruitful tension between Same and Other.[11] The method for arousing attention and stimulating the thought process is almost invariably defamiliarization of the commonplace (also the cliché of the Indian) and the setting of riddles or puzzles that keep open spaces for reflection.

(3) To the Indian artist, the frame of reference for balancing the various personal and social challenges is most often *nature* and the land, be it in a more cosmically religious (that is, mythical/quasi-mythical) sense, or in a more social, ecological one. Often artists use a combination of the two. Such a synthesis makes possible a consideration of global problems of the present under a unifying perspective that has its focus in concepts of *transition* and *transformation* and ultimately in the life cycle and the shamanic suspending of boundaries. While such a blend of perspectives contains individual and social responsibility, it also provides the possibility of gaining - in change and fluidity, struggle and conflict - a spiritual, but not man-centred, a religious, but not meta-physical, value point for judging the controversial and conflicting issues of the present. This is done with critical engagement (Cardinal-Schubert, McMaster, Edward Poitras, and others) and with philosophical detachment, seeing in the concept of transition an all-encompassing reason for consolation (Carl Beam, Edward Poitras). Often, both modalities of perception combine in varying relationships of domination.

A *remodernizing* of postmodern art can here take place, but now in a spirit of a positional inbetweenness, otherness. This leads to a paradoxical tension between (modern) spirit and (postmodern) form. The Native contemporary aesthetic arrangement has to do without the modern dogmatic ideology of totalizing form; but it still points to a notion of cosmic wholeness and is thus symbolic in intent and effect, whereas postmodern aesthetic

concepts and art forms mostly reject symbols as something that
transcends the art object; the latter is supposed to be
something that just "is," but does not "mean." For the Native
artist this difference between *is* and *mean* does not exist. His
or her artwork is *and* is meaningful in expressing cosmic nature-
consciousness in a space of meditation, not within the aesthetic
absoluteness of the artwork. In its montage/collage style, with
its clash of nature/culture, much of Indian painting is
postmodern in appearance. This is also at least partly true for
an apparently playful spirit. Yet play here derives not only
from a highly independent imagination, but above all from cosmic
spirituality and its underlying force of *universal
transformation*, which signifies to the Native artist not chaos
but order.

 (4) Indian art is part of the postmodern art scene, which
is often attacked for its noncommittal *eclecticism* verging on
triviality, its radical irony, its sense of free play, and use of
the juxtaposition and uniformization of contexts for the sole
purpose of producing a pleasing comical or interesting shock-
effect. The result is not only to expand the limits of art, but
through the breakdown of all limits to call into question the
function of art as a source of meaning. In this respect one can
speak of a *crisis of art*, at least of art as we traditionally
knew it. This means, however, that there is also a crisis in
Indian art, which cannot easily be overcome, for it runs parallel
to the crisis in postmodern art. It means, too, that the social
or cosmic responsibility postulated by the postmodern Indian
artist (and by the postmodern Western artist), and which he or
she seeks to realize through the associative potential of form,
material, and object, remains in the realm of *play*, a game of
possibilities. The postmodern spirit offers no firm foundation
for either unrelieved satire or for metaphysical despair or
consolation.[12] Cage therefore suggests that laughter should
replace the weeping and "self-pain"[13] of the Abstract
Expressionists. With the calling into question of the
traditional concept of art, however, art itself is not dead, It
has only undergone a transformation. As the lines of demarcation
become increasingly blurred, its potential lies in the realm of
possibility, which appears as the only true reality, while what
we know as reality is only actualization of one possibility among
many. The imagination is the creative source for the intuitive
and connotative images in both the production and reception
process.

 In these circumstances the difference between traditional
and modern or postmodern Indian painting – at least as regards
their status as representations of "truth" – become blurred for
the attentive contemporary viewer of art. This is true of the
repetitive though stylized compositions of contemporary
traditional Indian painting and carving of the Northwest Coast
style, of their translation into new media like printmaking
(e.g., Reid, Davidson, Thompson); it is true of the dreamlike
visions of Morrisseau and the pictorial legend paintings of the

Woodland School; and, finally, it is true of the work of modern and postmodern Indian painters in their use of innovation and irony. They all, at least as far as "truth" and aesthetic value are concerned, acquire in the context of the Western art market the same status of fictions that are binding and yet not binding. As such, given the simultaneity of all possibilities, they take on the value of aesthetic positions in an attractive artistic synchronicity of thematic and formal elements that are historically asynchronous. The difference between ethnic art and mainstream art, in their status as representation of "truth" and bestowers of meaning, disappears. This is true from the viewpoint of sameness. Yet, since there is a struggle between sameness and otherness, it is not necessarily true with regard to the otherness of Indian art.

(5) The *Western recipient* of Native painting is left with a space that invites reflection and *contemplation*, a space in which to meditate on alternative possibilities of being. The opening up to past spiritual forms offers, as Heidegger said, the possibility "of entrusting ourselves... to a liberating bond in tradition"[74] and of experiencing the emancipation that comes from remembering the (historically) other, from operating in the midst of difference. But the associations of the recipient play an important role. Much of Indian art reveals its full meaning only to the viewer who brings to it an understanding of myth and cosmic spirituality, of historical Indian mythology, and in some cases (McMaster's earlier drawings) even the history of Indian-White relations. This is particularly true of works from the Northwest Coast, but also of the painters of the Artist Hopid in the United States, for instance, Mike Kabotie and Milland Lomakema, and contemporary Canadian artists like Cardinal-Schubert, McMaster, and Poitras. To the recipient, these pictures and assemblages become variable contexts offering manifold possibilities for shifts in focus and meaning. The viewer can move at will between the elements of decoration, symbolism (specific, general, or diffuse), and myth. Proceeding from an analysis of form, Franz Boas formulated a central insight that combines the aspects of an aesthetic of production and an aesthetic of reception. The "permanence of pattern," he says, is due to the fact that "a useful form that has lost its function persists as a decorative element."[75] However, such a form can only be "decorative" in a positive sense "provided it is artistically suited,"[76] that is, if it manifests a visual order. Provided it is so suited, it can, as the object of the viewer's contemplative process, again become a symbol of a spiritual value. This cycle is unceasing and no doubt also unpredictable, and conditioned above all by the nature of the individual work that, although it cannot be independent of the other wider context within which it is created and received, must always, in the final analysis, stand alone before the viewer and be judged on its own associative potential, which lies in its surface-transcending aesthetic riddles.

(6) The reception of Native art by the white public makes

evident the *problems* innate in *difference* and *otherness* in the
struggle with sameness. For Native artists, communicating the
genuineness of their tradition and its otherness to the majority
is problematic. In the words of Paul Ricoeur: "There is the
paradox: how to become modern and to return to sources, how to
revive an old, dormant civilization and take part in universal
civilization."[77] For the dominant civilization, accepting the
other on its own terms is likewise difficult. Robert Houle has
sharply indicted the majority's confinement in clichéd thinking
and its lack of tolerance towards the other: "We are well-
trained, we can easily use the techniques of the most modern art,
[but] we are still treated as something different, enclosed in a
ghetto. Our reserve exists always, it is mental; we are
exhibited in the Musee de l'Homme, not in the National
Gallery.... That is really ridiculous, all artists refer to their
original sources: refusing the Amerindian artists the legitimacy
of their source of inspiration is as if one did not have the
infusion of the Graeco-Roman heritage into Renaissance."[78]

 The concept of the "mainstreamness" of art and its
universality, which as been discussed above, stands in the way of
the appreciation of art with an ethnic label, though postmodern
pluralism with its decentralizing tendencies and wider range of
tolerance may gradually change this. Yet its new universalizing
attitude and meaning-giving symbolism paradoxically confines
Indian art to the position of the Native Other even as prejudices
against the ethnic label are being weakened. Here the Native
artist often has the exasperating feeling that the dialectic
between sameness and otherness is without lasting synthesis,
frozen in conflict. The answer to the problem innate in the
relation between majority and minority, if there is one, can only
lie in the deideologization of both the universal and other.
Hope for the future lies in the fact that there has been a
paradoxical interchange between the other and the same. If the
other by adaptation to the mainstream culture has turned into the
universal, the standard features of the dominant civilization
have become different; and "others"[79] - and also the present -
have become only one other among many past and future others,
which are connected by the concept of transformation.

 (7) Yet there is also hope in Sameness, the "shamanistic"
aspect of both Western and Native art. Robert Houle has said,
"A very wise shaman once observed, that if man is unaware of his
sacred center, that being a part of a mystic circle together with
nature, then he is not really a man." This is relevant to Native
art in so far as, according to Houle, "whether or not [Native]
work is a non-objective painting existing purely as an aesthetic
object free of any ceremonial performance, there will be the
presence of ritualistic will. In creative activity this will is
beyond rationality or system but within metaphysical
understanding or spiritual and literal realities."[80] The
creative activity of the ritualistic will and the return to the
sacred openings of the past cannot and should not change
contemporary culture; but they can via the imagination point to

its spiritual deficits. Epes Brown speaks in this vein when he
says, "The great hope for this search on the part of Indians and
non-Indians consists in putting together a truthful and open
dialogue in which no one tries to imitate the other, but instead
everyone will rediscover and confirm the sacred dimensions of his
own traditions."[81] Yet the sacred dimensions of these traditions
can no longer be rendered as an aesthetic whole, and therefore
not represented unbrokenly in totalizing aesthetic symbols, even
though Native art is rooted in ancient symbolism and mostly
"conceptually oriented."[82] The sacred areas of thought have to
be relativized in a multidimensional context of opposition, or
made visible in terms of their absence, or be transferred to the
primal and resistant quality of material (stone, steel), or to
signatures of the past. That is the message postmodern Indian
and Western art impart in unison, though with attitudinal and
mythological differences, to the viewer - together with the human
need for the spiritual element even if it can only be manifested
in minimalistic material or collage of the oppositional.

NOTES

1. This is a revised and updated version (end of 1990) of the essay in <u>Zeitgenoessische Kunst der Indianer und Eskimos in Kanada</u>, Gerhard Hoffman, ed. (Stuttgart: Cantz/Canadian Museum of Civilization, 1988).

2. See Linda Hutcheon, <u>The Canadian Postmodern: A Study of Contemporary English-Canadian Fiction</u> (Toronto: Oxford University Press, 1988).

3. <u>Narrative Chance: Postmodern Discourse on Native American Indian Literature</u>, Gerald Vizenor, ed. (Albuquerque, NM: University of New Mexico Press, 1989).

4. Some of the general arguments in this first section are taken from the author's foreword to the first volume of <u>Der zeitgenossische amerikanische Roman,</u> 3 vols., Gerhard Hoffmann, ed. (Munich: Fink, 1988).

5. The terms "Native," "Native American," and "(American) Indian" are used in the following without difference. For a European public, Indian is still the widely used term, in the United States and especially Canada the term Native or Native American art (including Native art from Canada) is now often preferred.

6. Cf. the following works on various aspects and differing evaluation of postmodernism:

<u>Postmodernism: ICA Documents,</u> Lisa Appignanesi, ed. (London: Free Association Books, 1989);

Jonathan Arac, <u>Critical Genealogies: Historical Situations for Postmodern Literary Studies</u> (New York: Columbia University Press, 1978);

<u>After Foucault: Humanistic Knowledge, Postmodern Challenges,</u> Jonathan Arac, ed. (New Brunswick, NJ: Rutgers University Press, 1988);

Daniel Bell, <u>The Coming of Post-Industrial Society: A Venture in Social Forecasting</u> (New York: Basic Books, 1973);

Herbert Blau, <u>The Eye of Prey: Subversions of the Postmodern</u> (Bloomington, Ind.: Indiana University Press, 1978);

<u>The States of Theory: History, Art and Critical Discourse,</u> David Carroll, ed. (New York: Columbia University Press, 1990);

Steven Connor, Postmodernist Culture: An Introduction to Theories of the Contemporary (Oxford: Basil Blackwell, 1989).

G. Deleuze and F. Guattari, Anti-Oedipus: Capitalism and Schizophrenia (London, 1984);

Jacques Derrida, Of Grammatology (Baltimore, Mld.: Johns Hopkins University Press, 1976);

Thomas Docherty, After Theory: Postmodernism/Postmarxism (London: Routledge, 1990);

Colin Falck, Myth, Truth and Literature: Towards a True Post-Modernism (Cambridge: Cambridge University Press, 1989);

Paul Feyerabend, Against Method: Outline of an Anarchistic Theory of Knowledge (New York: Schocken, 1978);

Leslie Fiedler, "Cross the Border - Close the Gap," in his The Collected Essays II (New York: Stein and Day, 1971), 461 - 85;

Michel Foucault, The Archeology of Knowledge and the Discourse on Language (New York: Pantheon Books, 1972);

The Order of Things: An Archeology of Human Sciences (New York: Random House, 1970);

Gerald Graff, "The Myth of Postmodern Breakthrough," Tri-Quarterly 26 (1973), rpt. in Graff, Literature Against Itself: Literary Ideas in Modern Society (Chicago, Ill.: University of Chicago Press, 1979), 31 - 62;

David Harvey, The Condition of Postmodernity: An Enquiry into the Origins of Cultural Change (Oxford: Blackwell, 1989);

I. Hassan, Paracriticisms: Seven Speculations of the Times (Urbana, Ill.: University of Illinois Press, 1975);

The Right Promethean Fire (Urbana, Ill.: University of Illinois Press, 1980);

Innovation/Renovation: New Perspectives in the Humanities, Ihab Hassan and Sally Hassan, eds. (Madison, Wis.: University of Wisconsin Press, 1983);

Zeitgeist in Babel: The Postmodernist Controversy, Ingeborg Hoesterev, ed. (Bloomington, Ind.: Indiana University Press, 1991);

I. Howe "Mass Society and Postmodern Fiction," Partisan Review 26 (1959), 420 - 436, rpt. in The American Novel Since World War II, M. Klein, ed. (Greenwich, Conn., 1969), 124 - 141;

Andeas Huyssen, After the Great Divide: Modernism, Mass Culture, Postmodernism (Bloomington, Ind.: Indiana University Press, 1986);

Charles Jencks, The Language of Post-Modern Architecture (New York: Rizzoli, 1977);

Postmodernism and its Discontents: Theories, Practices, E. Ann Kaplan, ed. (London: Verso, 1988);

J. Klinkowitz, Literary Disruptions: The Making of a Post-Contemporary Fiction (Urbana, Ill.: University of Illinois Press, 1976);

Postmodernism and Its Critics, John McGowan, ed. (Ithaca, NY: Cornell University Press, 1991);

David Kolb, Postmodern Sophistications: Philosophy, Architecture, and Tradition (Chicago, Ill.: Chicago University Press, 1990);

Pluralism and Postmodernism, Helmut Kreuzer, ed. (Frankfurt: Lang, 1989);

Scott Lash, Sociology of Postmodernism (London: Routledge, 1990);

David Lewis, On the Plurality of Worlds (Oxford: Blackwell, 1986);

G.B. Madison, The Hermeneutics of Postmodernity: Figures and Themes (Bloomington, Ind.: Indiana University Press, 1988);

Christopher Norris, What's Wrong with Postmodernism? Critical Theory and the Ends of Philosophy (Baltimore, MD: Johns Hopkins University Press, 1990);

Richard Rorty, "Habermas and Lyotard on Postmodernity," in Habermas on Modernity, Richard Bernstein, ed. (Cambridge, Mass.: MIT Press, 1985), 161 - 76;

Margaret A. Rose, The Post-modern and the Post-industrial: A Critical Analysis (Cambridge, Mass.: Cambridge University Press, 1991);

Postmodernism: Philosophy and the Arts, Hugh J. Silverman, ed. (New York/London: Routledge, 1990);

George Steiner, In Bluebeard's Castle: Some Notes Toward the Redefinition of Culture (New Haven, Conn.: Yale University Press, 1971).

Patricia Waugh, Postmodernism: A Reader (London: Edward Arnold, 1992);

Edith Wyschogrod, Saints and Postmodernism: Borrowing Moral Philosophy (Chicago, Ill.: University of Chicago Press, 1990);

For an overview of the diverse positions on postmodernity see:

Gerhard Hoffman, Alfred Hornung, Rudiger Kunow, "'Modern,' 'Postmodern' and 'Contemporary' as Criteria for the Analysis of 20th Century Literature," Amerikastudien/American Studies 22 (1977), 19 - 46; and Gerhard Hoffmann, "The Aesthetic Attitude in the Postideological World: History, Art, Literature, and the Museum Mentality in the Cultural Environment," Amerikastuden/American Studies 34 (1989), 423 - 479.

7. See Bell, The Coming of Post-Industrial Society; Peter L. Berger and Thomas Luckmann, The Social Construction of Reality: A Treatise on the Sociology of Knowledge (Garden City, NY, 1966). A detailed outline of these positions is found in Jürgen Habermas, "Neoconservative Culture Criticism in the United States and West Germany" in Habermas and Modernity, Richard J. Bernstein, ed. (Cambridge, Mass.: MIT Press, 1985), 78 - 94.

8. Bell, The Coming of Post-Industrial Society, and The Cultural Contradictions of Capitalism (New York: Basic Books, 1973).

9. Jürgen Habermas, "Der Eintritt in die Postmoderne," Merkur 421 (1983), 752 - 761, and Der Philosophische Diskurs der Moderne: Zwolf Vorlesungen (Frankfurt, 1985); Albrecht Wellmer, Zur Dialektik von Moderne und Postmoderne. Vernunftkritik nach Adorno (Frankfurt, 1985); Fredric Jameson, "The Politics of Theory: Ideological Positions in the Postmodernism Debate," New German Critique 33 (1984), 53 - 65, "Postmodernism, or the Cultural Logic of Late Capitalism," New Left Review 146 (1984), 53 - 92, and Postmodernism or, The Cultural Logic of Late Capitalism (Durham, NC: Duke University Press, 1991).

10. Georg Lukács, "Die Weltanschaulichen Grundlagen des Avantagardismus," in Die Gegenwartsbedeutung des kritischen Realismus. Werke, Vol. 4 (Neuwied/Berlin,

1971); Christopher Cauldwell, Studies and Further Studies on a Dying Culture (New York, 1971).

11. Jaques Derrida, Writing and Difference (Chicago, Ill.: University of Chicago Press, 1978); see also Jacques Lacan, Ecrits (Paris: Seuil, 1966).

12. Michel Foucault, Order of Things: An Archaeology of the Human Sciences and The Archaeology of Knowledge.

13. Jean François Lyotard, The Postmodern Condition: A Report on Knowledge, Geoff Bennington and Brian Massumi, trans. (Minneapolis: University of Minnesota Press, 1977), 48ff; and "Answering the Question: What is Postmodernism?" in Innovation/Renovation, Ihab and Sally Hassan, eds., 329 - 341.

14. Paul Feyerabend, Against Method.

15. Jürgen Habermas speaks of the "unity of reason in its diversity." See also Habermas, "Questions and Counterquestions," in Habermas and Modernity, R. Bernstein, ed., 192 - 216.

16. Leslie Fiedler, "Cross the Border - Close that Gap"; Susan Sontag, Against Interpretation (New York, 1966) and Styles of Radical Will (New York, 1969).

17. See Lucy R. Lippard, Mixed Blessings: New Art in Multicultural America (New York: Pantheon Books, 1990).

18. See for instance, John Fiske, Television Culture (London: Methuen, 1987), especially chapter 5; for the counter position see Neil Postman, Amusing Ourselves to Death: Public Discourse in the Age of Show Business (New York: Penquin, 1985), or Jean Beaudrillard, Simulations (New York, 1983).

19. From the poem by T.S. Eliott. Cf. also M. Bradbury and J. McFarlane, "The Name and Nature of Modernism," in Modernism, Bradbury, McFarlane, eds. (Stanford: Harvester Press, 1978), 19 - 55.

20. Martin Heidegger, "Der Weg Zur Sprache" in Unterwegs zur Sprache (Pfullingen: Neske, 1959), 239 - 268; here, p. 267.

21. William Spanos, "Heidegger, Kierkegaard and the Hermeneutic Circle: Towards a Postmodern Theory of Interpretation as Disclosure," Boundary 2, 4 (1976), 455 - 488, Martin Heidegger and the Question of Literature: Toward a Postmodern Literary Hermeneutics, W. Spanos, ed. (Bloomington, 1979); Richard E. Palmer, "The

Postmodernity of Heidegger," Boundary 2, 4 (1976), 411 - 432.

22. Jean Baudrillard, In the Shadow of the Silent Minorities: Or the End of the Social and Other Essays, Paul Foss, Paul Patton and John Johnson, trans. (New York, 1983), as well as Power/Knowledge: Selected Interviews and other Writings, 1972 - 77, Collin Gordon, ed. (New York: Pantheon, 1980); Lyotard, The Postmodern Condition; Hassan, Paracriticisms.

23. George Wilhelm Hegel, The Phenomenology of Spirit, A.V. Miller and J.N. Findlay, trans. (Oxford University Press, 1977).

24. Theodor W. Adorno, Minima Moralia ([1951]; Frankfurt: Suhrkamp, 1969), 57.

25. Jean-François Lyotard, The Postmodern Condition, 81f.

26. Michel Foucault, "A Preface to Transgression" in Language, Counter-Memory, Practice, Donald F. Bouchard, ed. (Ithaca, NY: Cornell University Press, 1977), 50.

27. Charles Newman, The Post-Modern Aura (Evanston, Ill.: Northwestern University Press 1985), 161.

28. James Clifford, "On Ethnographic Allegory," in Writing Culture: The Poetics and Politics of Ethnography, James Cliffort and George E. Marcus, eds. (Berkely, Cal.: University of California Press, 1986), 110ff.

29. Paul Ricoeur, "Universal Civilization and National Cultures" in History and Truth, C.A. Kelbley, trans. (Evanston, Ill.: Northwestern University Press, 1965), 278. The so-called post-structuralists, who have made a major impact on the intellectual climate of Western culture in recent years - particularly Jean Baudrillard, Michel Foucault, Jacques Derrida, and Jean-François Lyotard - have developed a philosophy of difference. Their concepts and metaphors - "archeology of knowledge," "genealogy" (Foucault), "deconstruction," "différence" (Derrida), "delegitimation" (Lyotard), "agony of the real" (Baudrillard) - refer to the breakdown of concepts and ideas such as continuity, coherence, and reality, to the process of decomposition of Western logocentric thought and to a new valuation of the other, both within and without the individual, within and without Western civilization and its historical tradition. This revaluation of the other was prepared by Nietzsche's "perspectivism" (Friedrich Nietzsche, On the Genealogy of

Morals and "Ecce Homo" [New York: Vintage, 1969], 76) and
Mikhail Bakhtin's "dialogic attitude" (M.M. Bakhtin,
Problems of Dostoevsky's Poetry [1929], Caryl Emerson,
ed. and trans. [Minneapolis, Min.: University of
Minnesota Press, 1984]; The Dialogic Imagination: Four
Essays, Michael Holquist, ed., Caryl Emerson and Michael
Holquist, trans. [Austin, Texas: University of Texas
Press, 1981]), and it is reinforced - in a further
development of Heideggerian thought - by what Hans-Georg
Gadamer has called "methodical weakness." This way of
thinking emphasizes the audition of the other, respects
his vulnerability and does not insist on the self-
interest of the subject or the rationality of his own
thought (Hans-Georg Gadamer, Truth and Method [New York:
Continum, 1975]). Discernible in this approach is a new
philosophical and theoretical direction, a "weak" style
of argumentation that avoids confrontation and
polarization. Roland Barthes favoured political
positions "[that one could] advocate casually," (quoted
by Susan Sontag in the "Introduction" to A Barthes Reader
[New York: Hill and Wang, 1981], xxii) and the Italian
Gianni Vattimo proposes a philosophy of "weak thought" in
distinction to the "strong thought" of metaphysics and
ideology, of universalization and homogenization, and of
any self-centred and intolerant ways of thinking (Gianni
Vattimo, "Bottle, Net, Truth, Revolution, Terrorism,
Philosophy," Denver Quarterly 16:4 [winter 1982], 26ff.
See also by the same author: Al Di La del Sogetto:
Nietzsche, Heidegger, e l'ermeneutica [Milan: Fetrinelli,
1981] and The End of Modernity: Nihilism and
Hermeneutics in Postmodern Culture [Cambridge: Polity
Press, 1988]).

30. Cf. James Clifford, "On Ethnographic Authority,"
Representations, 2, 118 - 146; "On Ethnographic Allegory"
in Writing Culture, 98 - 121; and Stephen A. Tyler,
"Postmodern Ethnography: From Document of the Occult to
Occult Document" in Writing Culture, 122 -140.

31. This modernist point of view explains, for example,
the title of the collection of essays: The Anti-
Aesthetic: Essays on Postmodern Culture, Hal Foster, ed.
(Port Townsend, Wash.: Bay Press, 1983).

32. Andy Warhol in an interview with G.R. Swenson, Art
News (November 1963), rpt. in Pop Art Redefined, John
Russel and Suzi Gablik, eds. (London, 1969), 117.

33. Interview with Roy Lichtenstein, rpt. in Picasso to
Lichtenstein (ex. cat.; London: Tate Gallery, 1974).

34. Quoted by Wolf Herzogenrath, "Die antitechnologische
Technologie: Nam June Paiks Roboter," in Positionen
heutiger Kunst (ex. cat.; Berlin: Nationalgalerie, 1988),

59.

35. <u>Positionen heutiger Kunst</u>, 63.

36. Quoted by Irving Sandler, "1946 - 1960" in <u>The Hirshhorn Museum and Sculture Garden</u>, Abram Lerner, ed. (New York, 1974), 454.

37. In a lecture entitled "Sand Painting" held in 1949, in John Cage, <u>Silence: Lectures and Writings</u> (Cambridge, Mass., 1967), 10.

38. Quoted in Elizabeth McLuhan, <u>Altered Egos: The Multimedia Work of Carl Beam</u>, catalogue of the exhibition of the same name (Thunder Bay, Ont.: Thunder Bay National Exhibition Centre and Centre for Indian Arts, 1984), 7.

39. Cage, <u>Silence</u>, 12.

40. Conversation between Geronimo Celant and Mario Merz, reprinted in <u>Positionen heutiger Kunst</u>, 36.

41. Like Rauschenberg, Beam combines de-familiarization and re-combination with life-orientated artistic responsibility and carefully calculated aesthetic form. In a 1983 interview, Rauschenberg said: "I want to make [people] aware of individual responsibility, both for themselves and for the rest of the human race... you, yourself, are totally responsible. And your awareness is your best protection." (Mary Lynn Katz, "Robert Rauschenberg's State of the Universe Message," <u>Art News</u>, 82:2 [February 1983], 56). Beam, referring to the global transmission of the news in images by the media, says "if you have your own face next to a rocket, if you have your own face next to the Sadat assassination, this, to me, implies that one... has to have personal responsibility for world events" (<u>Altered Egos</u>, Elizabeth McLuhan, 5). Such similarity in thinking can also be seen in artistic method. The shocking montage of image-opposition by Indian artists like Beam, Pierre Sioui, and Edward Poitras *destabilizes* old *clichés*.

42. Quoted by G.R. Svenson, "What is Pop Art? Part II, Jasper Johns," <u>Art News</u> 62,10 (February, 1964), 43.

43. See also the remarks about Carl Beam in the following pages.

44. Quoted by Jan van der Marck in the introduction to the catalogue of the Fontana exhibition at the Walker Art Center (Minneapolis, 1966).

45. Ad Reinhardt, "Art-as-Art," <u>Environment I</u>, 1 (autumn 1962), 81.

46. See Peter Buerger, Theory of the Avant-Garde
(Minneapolis, Minn.: University of Minnesota Press,
1982).

47. Fredric Jameson, "Periodizing the Sixties," in The
Sixties Without Apology, S. Sayers, A. Stephanson, S.
Aronwitz, and F. Jameson, eds. (Minneapolis, Minn.:
University of Minnesota Press, 1984), 207.

48. "The meaninglessness of the origin increases with in
insight into the origin." (Morgenröte, Werke in 3 Bänden,
Karl Schlechta, ed. [München, 1956], I, 1044, aphorism
44).

49. Günter Metken, Spurensicherung: Archäologie und
Erinnerung, (ex. cat.; Kunstverein Hamburg, Städtische
Galerie im Lenbachhaus, München, 1974.

50. "So when I appear as a kind of shamanistic figure,
or allude to it, I do it to stress my belief in other
priorities and the need to come up with a completely
different play for working with substances. For
instance, in places like universities, where everybody
speaks so rationally, it is necessary for a kind of
enchanter to appear" (Caroline Tisdal, Joseph Beuys [New
York: Solomon R. Guggenheim Museum, 1979], 23).

51. According to Cassirer, the "process of mythical
apperception" takes place in "stages of objectivation."
Space is the "ground moment" of mythical thought because
mythical thought "has the tendency to transform all
differences it sets and grasps into spatial differences
and to visualize them in this form." Thus the first
intuitive experience of the numinous powers has its
origin in spatial-sensuous appearances in which the
creative forces of the universe are visualized as images
and gestalts. In the second phase "the divine explicates
its being and its nature in time, where the constitution
of mythical figures and gods is followed by narratives
about them. Numbers like two, three, four, seven then
organize and divide space and time into spheres, cardinal
points, cycles, etc. (Ernst Cassirer, The Philosophy of
Symbolic Forms, 3 vols. [New Haven, Conn.: Yale
University Press, 1955 - 57; German 1923 - 29] II, 103,
116, 129). While Cassirer analyzes the mythical
experience, Claude Lévi-Strauss sees in the mythical
perception a symbolic system that is different from but
no less logical than the intellectual models of the West.
"System" here refers to a model-like abstraction, a
construct that can be taken from stories, rituals,
practices, and taboos and constitutes a "homology between
two parallel series - that of natural species and that of
social groups." The world is seen as a natural unity and
duality; it is "represented as a continuum made up of

successive oppositions." This modality of thought
associates categorical opposition (up-down, high-low),
elemental opposition (heaven-earth) or specific
opposition (eagle-bear) in a unbroken continuum. (The
Savage Mind [Chicago, Ill.: Chicago University Press,
1966], 224, 139) - yet it has become increasingly
apparent that the Western taxonomic conventions and the
conceptualizations of myth are fictitious. The "mythical
apperception" (Cassirer) and the mythical order of the
"savage mind" (Lévi-Strauss) are seen by post-
structuralist and postmodern ethnography, in a third
phase of interpretation, as allegories of Western thought
(cf. James Clifford, "On Ethnographic Allegory," in
Writing Culture: The Poetics and Politics of
Ethnography, 98 - 121). Nevertheless, the concept of
myth is part of the inventory of Western thought. It has
contributed greatly to the West's understanding of the
development of its own cultures and indeed has made the
bipolar interpretation of these cultures in terms of
beginning/end, origin/now, periphery/center,
primitive/civilized, and unconscious/conscious possible
in the first place. It is no longer of any importance
whether the idea of myth corresponds to a reality, for it
has its own reality as a fertile idea. We can proceed on
the assumption that "it is not finally some mysterious
'primitive philosophy' that we are exploring" when we
seek to understand myth, "but the further potentiality of
our thought and language" (Talal Asad, "The Concept of
Cultural Translation in British Social Anthropology," in
Writing Culture, 141 - 64, here p. 159).

52. See, for instance, the non-functional masks by R.E.
Bartow, Lillian Pitt, Jim Schoppert (in the catalogues of
the Heard Museum Biannual Native American Fine Art
Invitational, 1983 - 89). George Longfish fashioned
nontraditional masks from canvas and "found" material.

53. Cardinal-Schubert shows in her comment on Four
Directions - War Shirts how the magical and the
ecological views are combined: "These warshirts
symbolize the defensive covering, the armour, the
heraldry; the concerns and challenges facing you, the
pedestrian warriors of this time. No concern is too
small! Each tree destroyed means less oxygen and
increased erosion, every watershed disturbed means less
fertile land, and each animal destroyed means an
interruption in the food chain, and pollution of the air
and ground threatens man's existence and the environment
as life sustaining entity" (Genesis of a Vision - The
Warshirt Series - A Declaration [Calgary, Alta.: Masters
Gallery]).

54. Postmodern play is also endless transformation, not without a humorous touch. Just as Edward Poitras places traditional objects, for example "archaeologically" seen bones, in a new context, he would translate the sense of sacred ritual into the "ritual" of the Dadaists: "I would like to suggest that a group of us malcontents get together and perform the sacred ritual of the Dadaists for the origin of a new name. We will choose a new language that nobody can identify with and we will purchase a dictionary for it. We will shoot an arrow at this dictionary and the word upon which the tip of the arrow touches will be our new name. This will give us the freedom that we need, because nobody will know what to expect" Edward Poitras, "Artist's Statement," in New Work By A New Generation, 63.

55. See illustration in Stardusters: New Work by Jane Ash Poitras, Pierre Sioui, Joane Cardinal-Schubert, Edward Poitras, G. Mainprize, ed. (ex. cat.; Thunder Bay, Ont.: Thunder Bay Art Gallery, 1986), 52.

56. See Portfolio, unpaged.

57. Contemporary Native American Art (San Francisco, Cal.: American Indian Contemporary Arts, 1986), unpaged.

58. Ibid.

59. See the quote above.

60. McMaster emphasizes the aspect of transition so important for primal cosmology and Native art. "There are some drawings I've seen where Christ was actually crucified on a tree, with branches, as opposed to the pole you often see. There was a transition between life on earth to the heavens, so he was in transition. In shamanic terms, the ability to transform, to travel this distance between the earth to upper and lower worlds was in the same way that Christ was seeing dying and resurrecting and so forth" (Mike Anderson, "Gerald McMaster/Joane Cardinal-Schubert," Metro).

61. Stardusters, 23.

62. Carl Beam, Altered Egos, Elizabeth McLuhan, ed., 24.

63. Interview with Garry Mainprize, Stardusters, 23f.

64. Stardusters, 10. As to the ecological argument, Pierre Sioui, for instance, asserts that "the process of understanding one's true existence can only begin at the moment when one stops polluting and interfering with nature's process... " (Stardusters, 19). Ron Noganosh is pursuing similar reasoning when he says, "I think that it

is every person's responsibility to be ecologically responsible... " (Ron Noganosh, "Artist's Statement" [Ottawa, Ontario:Indian Arts Center, Department of Indian and Northern Affairs, 1985]). However, Sioui adds a proviso: "But realistically this is not possible with today's way of living and it can only be achieved after death" (Stardusters, 16). Like Beam, Sioui, Cardinal-Schubert, and the others, Edward Poitras is convinced of the inevitability of cultural change: "acculturation is something one cannot avoid... an international process [wherein] nothing is lost no matter how much the culture changes" (Stardusters, 28). For him rituals are "a doorway into understanding the larger patterns of life... the most effective way of seeing the logic of chaos.... Without ritual there is no reason or control" (Ibid.). This is a ritual of introspection that respects the power of symbols, rituals, and magic (Ibid.). Like Poitras, Sioui has developed a repertoire of traditional and ritual images and objects, above all bones and skeletons, that recall the past, an "image bank" that "heralds rebirth, true birth and truer life" (Stardusters, 17). For Sioui, as for many of his colleagues, for Morrisseau, Odjig, Janvier, and Boyer as well as Noganosh, "Mankind has no superiority" (Stardusters, 18) - that is the common and symbolically expressed basis of their work.

65. Cf. Ernst Bloch, "Nonsynchronism and Dialectics," New German Critique 11 (1977), 22 - 38; Siegfried Kracauer, History: The Last Thing Before the Last (New York: Oxford University Press, 1969); Reinhard Koselleck, Vergangene Zukunft (Frankfurt: Suhrkamp, 1979).

66. Alex Janvier, "Be Yourself," Artist's Résumé, Indian Art Centre, Department of Indian Affairs, Ottawa, 1976.

67. Cf. Edwin L. Wade's comment: "Individual artistic success runs counter to Southwest attitudes concerning man's relationship to the supernatural (which is considered a collective responsibility) and to the egalitarian idea of what constitutes a 'good' man or woman... " ("Straddling the Cultural Fence: The Conflict for Ethnic Artists Within Pueblo Societies," in The Arts of the North American Indian: Native Traditions in Evolution, Edwin L. Wade, ed. [New York: Hudson Hills Press, 1986], 243 - 54, 171 - 202): See also John Anson Warner, "The Individual in Native American Art: A Sociological View" in the same volume.

68. Edwin L. Wade and Rennard Strickland, Magic Images: Contemporary Native American Art (Norman, OK: University of Oklahoma Press, 1981), 16.

69. Mike Anderson, "Gerald McMaster/Joane Cardinal-Schubert," Metro. See also McMaster's statement in a 1990 catalogue: The common "argument of homogeneity [of art] denies the possibility that an *Indian* artist can see the world differently.... Thus, the severity of maintaining a position as a Nehiyaw [a person from the Reserve, a member of "the exact people"] becomes ever more increasingly important in a world that attempts conversion, through acculturation or assimilation, for I will always see the world from the perspective of a Nehiyaw" (ex. cat., Why Do You Call Us Indians? 6).

69a. INDIGENA: Contemporary Native Perspectives, Gerald McMaster and Lee-Ann Martin, eds. (Vancouver/Hull: Douglas and McIntyre/Canadian Museum of Civilization, 1992), 12.

69b. INDIGENA, 11.

70. C.G. Jung, "Uber die Archetypen des Kollektiven Unbewussten" in Von den Wurzeln des Bewusstseins: Studien über den Archetypus (Zürich, 1954).

71. See in this context Robert F. Berkhofer, Jr., The White Man's Indian: Images of the American Indian from Columbus to the Present (New York, 1978).

72. For a more detailed discussion of this point, see my "Perspektiven der Sinnstiftung: das Satirische, das Groteske, das Absurde und ihre Reduktion zur 'freien Komik' durch Spiel und Ironie" in Der zeitgenössische amerikanishe Roman: Von der Moderne zur Postmoderne, Gerhard Hoffmann, ed., Vol. I: Elemente und Perspektiven, 225 - 308.

73. A term coined by Larry Rivers, quoted in Thomas B. Hess, "U.S. Painting: Some Recent Directions," Art News Annual 25 (1956), 196.

74. Heidegger, Der Satz vom Grund (Pfullingen, 1957), 187.

75. Boas, Primitive Art (New York: Dover Publications, 1955), 354.

76. Riegl, Stilfragen (Wien, 1893), 32.

77. Paul Ricoeur, "Universal Civilization and National Cultures," in History and Truth, 227.

78. Sylvie Halpern, "Le peintre sans réserve," L'Actualité 11 (July 1986), 56 - 61. My translation.

79. See Foster, "The 'Primitive' Unconscious in Modern Art," 64ff.

80. Robert Houle, "The Emergence of a New Aesthetic Tradition," in New Work by a New Generation, 3.

81. Joseph Epes Brown in Seeing With the Native Eye: Contributions to the Study of Native American Religion, Walter Holden Capps, ed. (New York: Harper & Row, 1976), 161.

82. Carol Podedworny, Portraits - Painting and Photographs by Rick Hill (Thunder Bay: Thunder Bay Art Gallery, 1986).

CANADIAN INUIT CULTURE 1800 - 1950

by

Ernest S. Burch, Jr.

Historic Canadian Inuit culture evolved primarily from the prehistoric Thule culture, which developed out of traditions from the Bering Strait area and was carried eastward beginning around AD 950. By AD 1500 Thule culture predominated throughout a huge area of the Canadian North, extending from the southern coast of Labrador on the southeast to the Alaskan border on the northwest, and including the Arctic coast and most of the major islands in the Canadian Archipelago.

Their common Thule culture origin gave the several Historic Canadian Inuit populations their common language and the many social and technological characteristics they shared. In fact, these features provide the basis for any meaningful writing about a general "Canadian Inuit culture."

THE THULE LEGACY

An appropriate introduction to Historic Inuit culture is an overview of the elements of the Thule culture that were passed on to the Canadian Inuit of historic times. These elements may be grouped into seven broad categories: (1) organizational framework, (2) economy, (3) shelter, (4) clothing, (5) oral traditions, (6) artistic expression and (7) religion.

Organizational Framework

The Canadian Inuit inherited from their Thule ancestors an organizational framework of societies, or tribes, of roughly two hundred to eight hundred people. There is no way of knowing how many of these societies rose and fell during the early Historic Inuit period, but I estimate that fifty-two of them were operating in Canada at the beginning of the nineteenth century.

Each society comprised a number of large extended families, which were highly self-sufficient both economically and politically. Each of these extended families consisted of smaller units-conjugal families (husband, wife, and children), sometimes with a grandparent or two-that could operate independently for several months at a time if necessary. The self-sufficiency of the different types of family unit made it possible for the population to spread out across the land in time of hunger so as to reduce the overall risk of starvation and increase the chances that at least some families would find enough food to survive.

The several families that made up the primary constituent parts of a society were related by blood and marital ties, and various kinds of voluntary association, usually described in English as "partnerships." These connections formed the social bonds that brought the different family groups together in larger aggregations for festival and recreational purposes whenever food resources permitted. There were no governments or other institutions encompassing the entire membership of an Inuit society.

Economy

The second important feature that the Canadian Inuit inherited from their Thule ancestors was an economy based on foraging. Their technology enabled them to harvest a wide variety of marine and terrestrial mammals, fish, and birds, as well as the relatively few plant resources that their environment provided. The most sophisticated aspect of this technology was the method of marine mammal hunting. Inuit could kill and retrieve anything from a 20-kg seal to a 900-kg walrus to a 50,000-kg bowhead whale. They also hunted belugas, narwhals, caribou, muskoxen, polar and grizzly bears, various fur-bearing animals such as wolves, wolverines, and foxes, and small game, such as muskrats and hares. Char, most importantly, but also salmon, whitefish, and cod, where available, were caught in the lakes, rivers, or sea. Migratory waterfowl (ducks and geese) and cliff-nesting birds (murres, guillemots, and dovekies), and their eggs were harvested during the spring and summer months; the grouse-like ptarmigan was an important winter resource. Altogether, animal resources provided the Inuit with meat and fat for a balanced diet; skins for clothing, bedding, storage bags, boat covers, tent covers, and rope; sinew for thread; bone and ivory from which to make tools, utensils, and weapons; and oil for heat and light.

The Inuit were probably less dependent on wood than were any other peoples in world history except, perhaps, some of their own ancestors. This was the key to their ability to live all year round far north of the tree line, as most of them did. Only the people in the extreme south had direct access to trees. Farther north, wood had to be acquired through trade, through the sporadic acquisition of driftwood, or through long and infrequent trips south to the tree line. Almost the only other plant resources available for human use were berries, which were harvested enthusiastically when in season, and dwarf shrubs, which were employed as fuel in some areas.

Mineral resources, though restricted, were put to important uses. Flint or other hard rocks provided the raw material for arrow, lance, and harpoon points, scrapers, adzes, and knives. Slate was also used for knives. The only other widely used

mineral in Canada was steatite (soapstone), a heavy, relatively soft rock, which was carved into oil lamps and cooking pots. A major medium of Inuit artistic expression in the middle and late twentieth century, soapstone virtually never served that purpose in traditional times.

Shelter

Shelter-in the form of tents in the summer and warm, semi-subterranean houses in the winter-was a third important legacy of Thule culture. Thule houses in Canada were rounded in shape. The floor and the rear sitting and sleeping platform were covered with gravel or stone slabs, and the walls were built of boulders, whale bones, and wood; and the whole was then covered with sod. These houses had long entrance tunnels, which doubled as storage areas; in some regions, they also contained anterooms, which served as cooking areas. The tunnels provided a means of entering and leaving the house without exposing the interior to the snow, wind, and cold from outside.

An important feature of Thule house construction was the cold-sink principle. The living area in the house was higher than the entrance level. As cold air sinks, any that did come in through the entrance tunnel did not reach the occupants inside the house.

Clothing

Clothing is a fourth legacy from their Thule forebears that served the Canadian Inuit well. Inuit clothing was designed on the heat-trap principle, whereby heat produced by the body was prevented from escaping. Clothes were made deliberately loose and bulky, and held only at the shoulders and waist so that an envelope of warm air surrounded the flesh. A hood attached to the jacket kept the warm air from escaping at the neck. The long parka hung over the pants to below the waist, and the pants overlapped the top of the boots. Mittens that fit inside the loose sleeves completed the outfit. As there were no openings to let air escape, all the heat generated anywhere within this protective cover was retained.

The preferred material for clothing in most regions was caribou hide, but seal skin and, occasionally, furs of various kinds were also used. In the winter, a person normally wore two layers-an inner hide or fur with the hair side in and an outer one with the hair side out. (In the summer, only the inner layer was worn.) This outfit was so effective that a person wearing less than 5 kg of clothing could remain comfortably warm in temperatures below -40 degrees Celsius.

Oral Traditions

The Thule culture also passed on a common language and a rich legacy of stories, myths, legends, and songs that were found everywhere in the Canadian Inuit world. The Thule people did not have a system of writing, but they did possess a well-developed body of oral traditions in which many of the original themes were preserved for nearly a millennium. Many of the motifs expressed in modern Inuit art originated in this ancient tradition.

Artistic Expression

The sixth feature inherited by the Canadian Inuit was a tradition of artistic expression focused on the materials of everyday life rather than on art for its own sake. The bearers of Thule culture did not produce works of art. Instead, they produced clothing that was elegant as well as functional, and weapons that were masterpieces of design and ornamentation as well as effective killing and retrieving devices. Nomadic peoples who could not afford the luxury of transporting works of art, the Thule people and their Inuit descendants instead infused their necessary possessions with a variety of artistic qualities.

Religion

Finally, the Thule people passed on to their descendants an animistic religion in which everything was considered to be imbued with a spirit and was therefore inherently capable of action of some kind. There were also spirits associated with whole classes of phenomena, such as caribou or seals, while others were associated with general conditions, such as the weather. There were still others that were not connected with any particular physical manifestation-they were simply spirits. Most of these spirits were capable of doing harm to people in one way or another, and Inuit life was severely hedged about with taboos, or restrictions on behaviour, designed to please or placate one or more spirits. Practically everything an Inuit person did was suffused with some kind of religious significance.

DISCUSSION

During the centuries from the initial spread of the Thule culture in Canada until AD 1800, certain changes in Thule-Inuit culture did, of course, occur. Some of them came about because of the geographic isolation of the various societies from one another in the vast northern landscape. This isolation led to the development of distinctive regional dialects, the growth of separate bodies of regional oral traditions in addition to the common one, and the increasing adaptation of societal economies to regional and local conditions.

Other important changes occurred because of the steadily deteriorating climate. The trend began about AD 1200 and reached its nadir during the "Little Ice Age," of about AD 1650 to 1850. The climatic changes were especially pronounced in the Canadian Archipelago and along the central Arctic coast. Much of the archipelago was progressively abandoned, apparently because local populations simply died from starvation. Farther south, along the central Arctic coast, famines led to population decline, and a small number of new societies were formed by the survivors of several previous societies. This process continued through much of the nineteenth century. The large boats (*umiaks*) formerly used for summer travel went out of use. As people were forced to abandon their relatively sedentary winter life, they built less permanent winter dwellings that were little more than tents surrounded by stone, snow, and sod windbreaks. Probably toward the end of this period, the dome-shaped snowhouse was perfected, and knowledge of its construction spread throughout much of the Inuit area. Technology generally became more rudimentary, and artistic expression decreased. These changes produced what Robert McGhee has described as a "general impression of a poorer and less secure way of life."

Another source of change was contact with Europeans. There probably had been some brief encounters between the early Thule migrants and the Norse in Ellesmere Island and possibly Baffin Island, although very little is known about them. Contact was likely reestablished by Basque fishermen off the coast of Labrador in the sixteenth century. The Basques were quickly followed by explorers, fishermen, and whalers of several European nations, and eventually by traders and missionaries. By the early 1800s, all Canadian Inuit groups except those in the most inaccessible parts of the Central Arctic coast and islands had had at least some contact with Europeans.

AGENTS OF CHANGE

The people who introduced changes to the Inuit way of life between 1800 and 1950 fall into a few basic categories. The groups involved almost everywhere in the Canadian North were explorers, traders, missionaries, and police. Less widespread groups were whalers and fishermen. The timing and sequence of arrival of different groups varied from one region to another, but the general pattern of contact was the same everywhere.

Explorers

Explorers led the way in most regions. The first of these explorers was the Portuguese Gaspar Cort-Réal, whose expedition visited the coast of Labrador in 1501 and returned home with about fifty captive Inuit. Exploration then remained south of

Inuit area until Martin Frobisher explored the east coast of Baffin Island in 1576. Many others followed and, by the beginning of the nineteenth century, most Inuit groups in Labrador and Quebec, and on Baffin Island and the west coast of Hudson Bay had experienced some contact with explorers.

During the nineteenth century, exploration focused on the Arctic coast between Hudson Bay and northern Alaska, and on the islands of the Canadian Archipelago. In the early decades, much of the effort was devoted simply to delineating and mapping the outline of the country. Around mid-century, however, there was a massive effort to locate the expedition of Sir John Franklin, which had set out in 1848 and was never seen again. By the time the last of the search expeditions was completed, in the early 1860s, virtually every Inuit group had at least encountered explorers, and some had been in contact with them for several months at a time.

During the sixteenth and seventeenth centuries, relations between the Inuit and the European explorers had been filled with mistrust. They were often hostile and occasionally resulted in bloodshed. In the nineteenth century, however, interethnic relations were almost always peaceful. Even brief encounters often involved enthusiastic trading, which led to the rapid spread of European goods across the Inuit realm. Expedition leaders who were wise enough to learn from the Inuit acquired considerable knowledge of the country and of survival techniques. Many hired Inuit hunters to provide them with fresh meat and fish, and Inuit women to make warm winter clothing. For their part, the Inuit enjoyed the novelty of strange people and acquired axes, knives, and many other useful items. Unfortunately, they often contracted venereal and other diseases from the explorers, and the essential seasonal migratory movements of some groups was disrupted.

Traders

Professional traders-as opposed to explorers who traded as a sideline-usually arrived in Inuit country after the explorers. In some cases, however, the larger trading companies sent out their own exploring expeditions. The Hudson's Bay Company, for example, actively explored the west coast of Hudson Bay, and an exploring party sent out by the North West Company was the first group of Europeans to encounter the Inuit of the Mackenzie Delta. But whether or not they reached an area first, the traders, unlike the explorers, usually came to stay.

The overwhelmingly dominant trading company in Canadian Inuit country was the Hudson's Bay Company (HBC). During the early years-in the eighteenth and nineteenth centuries-the greatest demand in Europe was for the furs of beavers, minks,

muskrats, and coloured foxes. These are generally forest creatures and live well south of Inuit country. The HBC's primary route to the Canadian interior was through Fort Prince of Wales (later Churchill) and York Factory, on the southwest side of Hudson Bay. The company attempted to maintain trading operations among the Quebec and Caribou Inuit (on the east and west sides of the bay respectively) more as a means of protecting their sea lanes from competition than as an economic enterprise. In these regions, the HBC traded for walrus ivory, blubber, seal and caribou skins, and whatever furs happened to come in. In the second half of the century, the company attempted to tap the large European market for buffalo robes by purchasing muskox robes. As a result, muskoxen in the country west of Hudson Bay were nearly exterminated.

The trade advantage during this period was largely in the hands of the Inuit. They could acquire all kinds of useful commodities from traders in exchange for surplus hides and furs of animals they hunted regularly. There was relatively little disruption of native life along the Hudson Bay coast, while most regions farther north and west were outside the orbit of trading operations altogether. Only in the Mackenzie Delta did the Inuit become heavily dependent on the fur trade as early as the 1860s. All of this changed in the early twentieth century, when there suddenly arose a great demand for white-fox pelts. White foxes are abundant north of the tree line; and within only two decades, traders had established permanent trading posts all across the Canadian North. By the time the price of furs crashed in the 1930s, most Inuit were dependent on trading posts for weapons and ammunition, boats, some forms of clothing, utensils, certain foodstuffs (especially sugar, tea, and flour), and tobacco.

Missionaries

Missionaries generally arrived after the traders during the nineteenth century and usually set up permanent establishments where trading posts were already located. This meant that, as a rule, they stayed out of Inuit country except for usually brief forays from their home bases south of the tree line. The one notable exception to this pattern was in Labrador, where Moravian missionaries had been established since 1771.

In the twentieth century, missions were established throughout Inuit country, either at the same time as HBC posts were set up or shortly afterward. They were almost always built in the same locations. Every settlement almost always had two different missions-one Roman Catholic and the other Church of England (Anglican). The competition between them was intense and often bitter. (Only in the 1950s did other denominations begin to spread, thus compounding the confusion in the small northern settlements.)

Missionaries were dealers in beliefs and ideas. They learned the native language, developed writing systems for it, and translated the Bible and other religious works into Inuktitut (the Inuit language). They often operated schools-which their migratory parishioners could usually attend for only a few weeks a year-and in a few places they built and operated hospitals or nursing stations. Some priests made extensive winter journeys to minister to their widely dispersed flocks.

Many missionaries spent years and even decades in the North and acquired an intimate knowledge of Inuit culture. They were dedicated, however, to undermining the basic philosophical tenets of that culture and replacing it with beliefs of their own. They were uniformly unsuccessful in their endeavours at first but, with persistence, managed to prevail. By 1950 Christianity in one form or another had been widely, if not universally, accepted by Canadian Inuit.

Police

Police began to operate in the North in 1903, when Royal Canadian Mounted Police (RCMP) posts were established on Herschel Island, west of the Mackenzie Delta, and at Cape Fullerton, on the west side of Hudson Bay. The primary purpose of these posts was to help establish Canadian sovereignty over the vast Canadian Arctic. During the early years, the police were less law-enforcement officers than general representatives of the Canadian government.

As missions and trading posts spread throughout the North in the early decades of this century, so also did RCMP detachments. Travelling widely in the country around their posts, the police checked on the general welfare of the natives and dealt with trouble as it occurred. In Labrador, then part of the separate colony of Newfoundland (until 1949), rural police, or "Rangers," were first posted in the mid-1930s. Like their Canadian counterparts, the Rangers had relatively little to do with law-enforcement during this period. Any enforcement work in which they did participate was often a source of confusion to the Inuit, as the law being enforced was utterly foreign to their way of thinking.

Fishermen and Whalers

Fishermen intruded into Inuit country primarily along the Labrador coast. Although Europeans had been fishing in Labrador and Newfoundland waters since the early 1500s, they had operated generally south of the Inuit area. In the mid-nineteenth century, however, the number of fishing vessels operating off Newfoundland and Labrador increased dramatically. The fishermen encountered the Inuit at their summer stations on the outer

islands and often traded with them. This exposed the Labrador
Inuit to some of the cruder bearers of Western culture, although
they were relatively well protected by the Moravians from
pernicious outside influences after 1771. These contacts
provided access to new kinds of European food and trade goods,
but unfortunately also to alcoholic beverages and new diseases of
various kinds.

Whalers operated in three parts of Canadian Inuit territory
at various times. They arrived first off the Baffin Island coast
in the mid-1700s. By the mid-nineteenth century they had so
reduced the number of whales in Davis Strait that they shifted
their operations to the west side of Hudson Bay. They had
largely cleaned out this area too by the end of the century. In
the late 1880s whalers moved to an area along the Western Arctic
coast near the Alaskan border, where they remained until about
1910. By that time, the price of whale products (baleen and oil)
had fallen so low that whaling became unprofitable. Whalers in
all areas traded extensively with the Inuit, particularly after
declining stocks of whales began to reduce their profits. Along
the western Arctic coast and on the west coast of Hudson Bay,
whalers spent the winter in the North and hired Inuit to supply
them with fresh meat and warm clothing. They often brought
alcohol with them and sold it to the natives, and sexual contacts
between whalers and Inuit women were frequent. Epidemics often
followed in the wake of the whalers.

THE POST-SECOND WORLD WAR PERIOD

The several agents of change among the Canadian Inuit profoundly
altered the native way of life between 1800 and 1950. At the
beginning of this period, the Inuit were a completely independent
people, living a way of life inherited from their ancestors. By
1950 they had become dependent on others for all manner of
weapons, implements, clothing, boats, and other goods, as well as
many kinds of food. They were also beginning to rely on the
government for welfare funds because trapping failed to provide
them with enough money to support their new way of life, and they
looked to the missionaries rather than their own traditions and
shamans for spiritual guidance. Their diet had deteriorated in
many regions, and their numbers had declined almost everywhere as
a result of famine and disease. They nevertheless continued to
live in their ancient homeland and to follow a modified version
of their traditional way of life.

In 1950 a typical Canadian Inuit winter settlement consisted
of an HBC post, an RCMP post, Anglican and Roman Catholic
churches, and a few households of Inuit employed in support of
these organizations. Spread out at favourable hunting, fishing,
or trapping sites over the surrounding countryside were several

dozen small satellite camps occupied by Inuit living a more traditional way of life. These camp-dwellers came into the main settlements when they had enough furs to sell or when they needed supplies. During the summer almost everyone converged on the main settlement for a period of several weeks for trading, socializing, and temporary employment unloading supply ships.

The late 1940s was a difficult time throughout much of the Canadian North because the old way of life was becoming almost impossible to follow successfully; but the means of following a new, more Westernized way of life were not yet available. The situation was particularly disastrous along the west coast of Hudson Bay, where a staggering array of dreaded diseases, including polio, caused the entire district to be placed under quarantine. During the same period, the caribou population west of Hudson Bay dwindled, depriving the people of their primary source of native food. The Canadian government was not prepared to deal with this disaster, which was publicized across the country. The ensuing furor led to a fundamental revision of the government's policy toward Inuit citizens, which set the stage for the many changes that took place in the North after 1950.

THE HISTORY OF INUIT CULTURE

by

Patricia Sutherland

The Inuit occupation of Arctic North America can be seen as one of the unexpected accomplishments of the human species. Choosing to live in the coldest and least hospitable region of the habitable world, the Inuit developed technology, skills, and knowledge that not only allowed survival but also served as the basis for a frugal but relatively secure way of life. Although few in number, they occupied millions of square kilometres of tundra and sea ice spanning over 120 degrees of longitude--one-third of the distance around the northern world--from northern Alaska to eastern Greenland.

The Inuit way of life, as it was described by the Europeans who penetrated most of Arctic North America during the nineteenth century, was not a recent development. In the absence of written records, Inuit history can only be known through archaeology; yet, the Inuit are relatively well served by archaeology. The cold temperatures of the Arctic and the small amount of disturbance have resulted in remarkable preservation of objects from the distant past. If the remains of a camp are buried in the permanently frozen earth, items as fragile as skin mittens may be preserved for over a thousand years, while wood or bone will last for several millennia. From the remains of dwellings found in ancient occupation sites, archaeologists can obtain hints of the social organization of the people who once lived there; from the lost or abandoned weapons and the scattered remains of animal bones we can learn how the people made a living. The carvings and other non-utilitarian objects left behind in such camps provide hints of the artistic and spiritual lives of the former occupants.

From such evidence we can trace in broad outline the history of Inuit culture (Dumond 1977, Maxwell 1985, McGhee 1978). It is a more complex history than we might expect, involving a distant origin, at least two major episodes of expansion across the New World Arctic, the amalgamation of technologies and ideas from several diverse sources, and adaptation to a variety of environments and to several periods of changing climate.

The Inuit of Arctic Canada are part of a group of related peoples who can most conveniently be called by the traditional term "Eskimo". The nucleus of Eskimo population is in Alaska, where Eskimos occupy most coastal and adjacent interior regions. In their physical characteristics, their language, and their way of life, the Eskimos are related to the Aleut peoples of the Aleutian Islands and, much more distantly, to groups like the Chukchi of eastern Siberia. In none of these ways are they very closely related to any American Indian populations. From this

Fig. 1. Early twentieth century photograph of Copper Inuit,
people who are at home in the inhospitable environment of the
central Canadian Arctic. (Canadian Museum of Civilization,
negative number 38971).

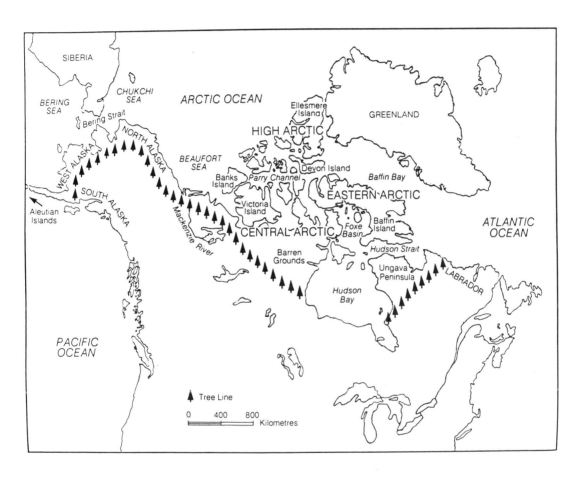

Fig. 2. Map of the North American Arctic.

evidence, it would seem most reasonable to seek Eskimo origins in the west, in the area around the Bering Strait, which separates the Asian and American continents.

The first archaeological evidence of people who may have been ancestral Eskimos does not appear until about four thousand years ago. Prior to that time, various Indian groups had ventured into the fringes of Arctic North America, but had not achieved extensive or permanent occupation of the areas north of the tree line. Then, apparently rather suddenly in the centuries around 2000 BC, people began to occupy the Arctic coast and tundra from southwestern Alaska to northeastern Greenland. Archaeologists refer to these first inhabitants of the Arctic as Palaeo-Eskimos ("Old Eskimos"), in order to distinguish them from more recent peoples whose technology and way of life were very different from that of their ancient predecessors.

The remains of early Palaeo-Eskimo camps show little resemblance to those of any American Indian groups of that period or earlier. Rather, both the forms of Palaeo-Eskimo dwellings and the tools and weapons scattered about them are similar to those left by eastern Siberian peoples of the time. This suggests that the Palaeo-Eskimos were recent immigrants to North America, having crossed the Bering Strait either by boat or on winter sea ice sometime after 3000 BC. Having acquired a knowledge of arctic environments on the shores of the Bering Sea, they appear to have spread extremely rapidly across the northern fringe of the New World.

At the time of the early Palaeo-Eskimo expansion, the Arctic climate was somewhat warmer than at present. The difference must have been slight, a matter of a few degrees above current average summer temperatures, but may have resulted in longer periods of open water and larger populations of some animals. Winters were as dark and probably as cold and long as they are today. Yet, the Palaeo-Eskimos managed to survive these extremely harsh conditions with a technology that, by traditional Inuit standards, appears to have been impossibly simple. There is little evidence that they used boats or the sophisticated harpoon equipment used by the later Inuit to hunt and retrieve sea mammals in open water. There is as little evidence that they possessed dogs, and the few dogs they may have had were probably used only in hunting and not for pulling sleds. Across Arctic Canada, there is no indication of early Palaeo-Eskimo dwellings more permanent or better insulated than skin-covered tents. Instead of the stone lamps used by the traditional Inuit to burn sea-mammal oil for heat and light, we find small central hearths containing the remnants of open fires in the remains of Palaeo-Eskimo dwellings. Such fires could not have been used in snow houses or other tightly closed dwellings, and the available fuel--scarce driftwood, arctic willow twigs, heather and the bones of animals--must have provided only small, smoky, and occasional fires.

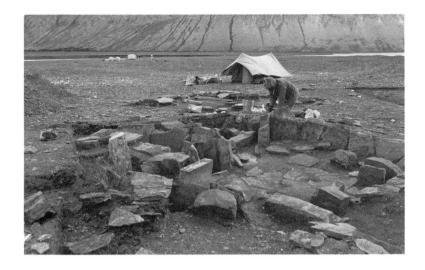

Fig. 3. An archaeologist excavating the remains of a prehistoric dwelling structure on Axel Heiberg Island in High Arctic Canada.

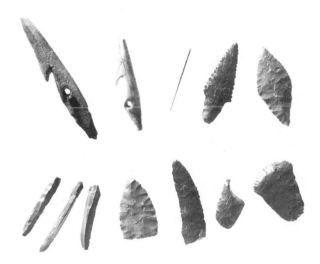

Fig. 4. Artifacts recovered from Independence I sites. The two harpoon heads at the upper left were carved from antler and ivory, the needle from bone. The remainder of the tools were chipped from flint. The harpoon head at the extreme upper left is 8.6 cm long.

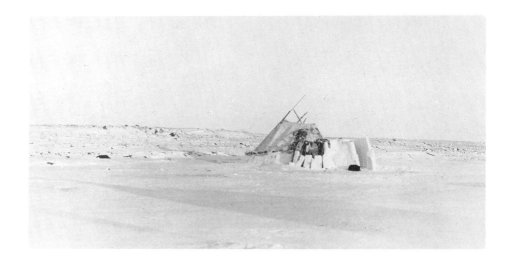

Fig. 5. The dwellings of the Independence I people probably resembled this central Arctic Inuit tent banked with snow. (Canadian Museum of Civilization, negative number 37055).

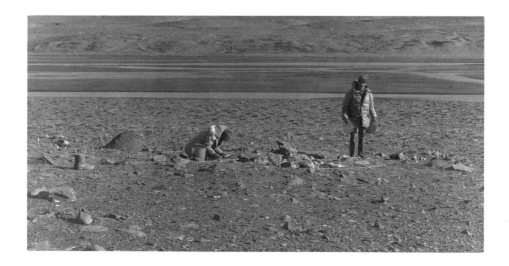

Fig. 6. The excavation of an Independence I dwelling at a site located in the interior of northern Ellesmere Island.

Fig. 7. One type of
Dorset dwelling had a
central hearth and
passage structure,
similar to those of
earlier Independence
dwellings.

Fig. 8. Small Dorset
carvings in ivory,
representing a falcon,
swimming bear, muskox,
and seal. Note the
skeletal motif on the
seal. This speciman is
4.2 cm long.

Most early Palaeo-Eskimo camp sites are small, and appear to have been occupied for only a few days or, at most, a few weeks. They suggest a picture of small groups of people, living as single families or in temporary groups of a few families, moving constantly in order to find enough food to survive. This picture is most evident on the islands of the High Arctic and in northern Greenland. Here, groups known to archaeologists as the Independence culture (named for Independence Fiord in northeastern Greenland, where remains of the culture were first discovered) lived primarily by hunting muskoxen with bows and lances. On the more southerly islands of the Arctic Archipelago, and on the northern mainland, lived related peoples who are assigned to the Pre-Dorset culture. Pre-Dorset groups in the Central Arctic concentrated on hunting muskoxen and caribou, and on river or lake fishing. In the Eastern Arctic, where land mammals were not as abundant, Pre-Dorset people lived mainly on the coast, where they hunted seals, and occasionally walrus and small whales, with hand-held harpoons that were probably thrown from shore or from the sea ice. Their success at such hunting is reflected in the size of their camps, which suggest larger groups of people living a somewhat more settled way of life. Yet even in the remains of such camps there is very little evidence of the artistic activities of the early Palaeo-Eskimos. Two small miniature masks carved from ivory (Rousselière 1964; Helmer, 1991), and a few artifacts decorated with incised lines, are the only art objects that have been recovered from Pre-Dorset sites to date. This may be partly due to the relatively poor preservation of organic materials on such ancient sites, but it may also reflect a relatively low level of carving activity among these first occupants of Arctic Canada.

The later stages of Palaeo-Eskimo development, between approximately 500 BC and AD 1500, are assigned by archaeologists to the Dorset culture, named after Cape Dorset where the remains of this cultural occupation of the Arctic was first recognized. Early Dorset sites in the Eastern Arctic are generally considerably larger, and were more permanently occupied, than were the camps of their Pre-Dorset ancestors. The large quantity of sea-mammal bones found around their sites suggests that they had become more efficient hunters, perhaps because a rapidly cooling climate provided improved conditions for people who hunted primarily from the sea ice. In some locations, the occupants began building semi-subterranean dwellings, walled with boulders and turf. Such houses could be heated with sea-mammal oil in small soapstone lamps, which appeared at this time; oil lamps could also have heated domed snowhouses, which may have been an invention of the Dorset people. The Dorset people of the Eastern Arctic appear to have lived in larger and less transient settlements than did their ancestors, and their way of life appears to have been somewhat less precarious.

The Dorset period is also marked by an apparent increase in artistic activity. Small carvings representing humans and animals are found in limited numbers in most early Dorset sites.

Fig. 9. Dorset "wand" of
antler covered with carvings
of approximately sixty faces.
This object may have been used
by a shaman in ritual or
healing performances. The
faces may be those of members
of a community, the recent
dead, or ancestoral spirits.
The speciman is 19.5 cm long.

The occurrence of human masks, the heavy emphasis on the representation of certain animals, such as bears and birds of prey, and the use of skeletal and other motifs in Dorset art have led scholars like Taylor and Swinton (1967) to interpret the carvings as amulets used in hunting magic, or equipment used by shamans in ritual and magical practices. The full meaning of such artworks eludes our understanding.

The Dorset way of life spread across Arctic Canada and as far south as Newfoundland. Over the centuries there were changes in the areas occupied, perhaps resulting from variations in the climate and local environments; and there were changes in the styles of tools, weapons, and dwellings used by the Dorset people. Rather surprisingly, such stylistic changes occurred not in isolated regions but over the entire range of Dorset occupation, suggesting communication networks that extended over thousands of kilometres. Stylistic similarities over great distances are most marked in the carvings and other equipment that may have been associated with religious practices. Despite such extensive communication, there is little evidence that the Dorset way of life was influenced by contacts with other peoples, either the Indians, the Norse whom they probably met in Labrador, or the Eskimos who occupied the western Arctic coast.

The greatest expansion of Dorset occupation occurred between approximately AD 500 and AD 1000 and encompassed an area from Victoria Island in the west to Greenland in the north and Labrador in the east. This "Late Dorset" period also saw a marked increase in the artistic activity of the Dorset people. The camps occupied at this time produced large numbers of figurative carvings, mostly executed in ivory and wood, as well as many objects that appear to have had a role in shamanistic religious practices (McGhee 1985). It has been speculated that the increased carving activity by the Dorset people may have resulted from socioeconomic stresses related to a warming climate, which decreased the productivity of ice-hunting, and to the appearance of invaders in their homelands. The situation may be analogous to that which Rasmussen (1931:268) described among the Netsilingmiut of the early twentieth century, who must have been undergoing similar stresses caused by the intrusion of European influences in their homeland. Everyone in this society possessed numerous amulets, each designed to confer a special ability or to ward off a specific evil. In earlier times one amulet had been considered sufficient for an individual. Both the Netsilingmiut and Late Dorset peoples may have viewed social and economic stresses as the result of a decline in the power of amulets and the spiritual forces on which they depended.

Dorset culture seems to have disappeared suddenly from most Arctic regions around AD 1000, surviving for a few more centuries only in northern Labrador and Ungava. Across the rest of Arctic Canada and Greenland, the Dorset people were replaced by a new population, the ancestors of the Inuit, who moved into the area from the west.

Fig. 10. The human face was portrayed in both realistic and
stylistic forms on a wide range of Dorset artifacts. The ivory
tube on the left is 4.5 cm long.

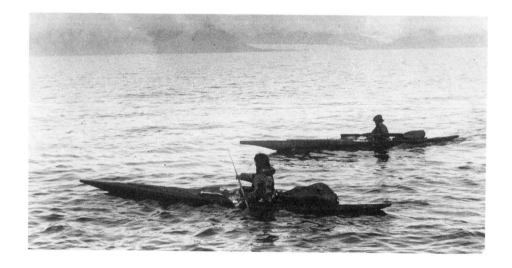

Fig. 11. Among the most important inventions brought to Arctic
Canada by the Thule people were skin boats and harpoons attached
to inflated skin floats such as those on the rear decks of the
hunting *kayaks*. This photograph was taken in the early twentieth
century in the eastern Arctic. (Canadian Museum of Civilization,
negative number 61068).

Fig. 12. The sinew-backed bow was an important weapon brought by the Thule people from Alaska. It was used for hunting land mammals and for warfare as shown in this detail of a fighting scene engraved on an ivory drill-bow or handle recovered from northern Baffin Island.

Fig. 13. The remains of a large Thule winter house on southern Devon Island. The gravel and turf walls of the house still stand, but the upper walls of boulders and the roof frame of whale bones have been disturbed.

During the three thousand years that the Dorset people and their ancestors occupied Arctic Canada, their relatives who had remained in Alaska gradually developed a much different way of life. Compared to marine conditions in the Central and Eastern Arctic, the Bering Sea is relatively free of ice for a long summer season and supports an abundance of fish and sea mammals. Along the adjacent rim of the North Pacific, from Japan to British Columbia, various coastal peoples were at this time developing boats, fishing gear, and hunting weapons that allowed them to exploit the rich marine resources of the region. The Eskimos of the Bering Sea coast appear to have adapted many of these inventions to local conditions and materials, and developed a marine-oriented economy and culture that archaeologists term Neo-Eskimo ("New Eskimo").

Probably the most important elements of Neo-Eskimo technology were skin-covered boats--the single-place *kayak* and the much larger *umiak*, or women's boat, capable of carrying twenty or more people. From these craft, they hunted sea mammals with a variety of spears, lances, and harpoons. By at least AD 500 they had learned to hunt large whales from *umiaks*, using harpoons attached to drags and floats, that impeded the animal's escape and tired it until it could be killed with lances. The abundant yield of meat and oil from such hunting permitted the occupation of large and permanent winter villages of log houses, insulated with turf and heated with oil lamps. It also allowed the growth of relatively complex social organizations and the development of an important complex of artistic, ritual, and religious activities (Fitzhugh and Kaplan 1982). Contacts with eastern Asiatic groups, which were probably fostered by trade, resulted in the introduction of pottery, small amounts of metal that were used as cutting tools, and items such as the recurved bow powered by a cable of twisted sinew, and slat armour cut from bone or ivory. By about AD 1000 the way of life of the Alaskan Eskimos was closer to that of the Northwest Coast Indians of southern Alaska and British Columbia than to that of the Palaeo-Eskimo Dorset peoples of Arctic Canada.

The climate of Arctic North America entered a warming phase in the centuries around AD 1000. Summers were probably consistently warmer than now, the amount of sea ice was reduced, and sea-mammal populations probably expanded both in size and range. Perhaps in response to these environmental conditions and because of population pressures, Alaskan Eskimos expanded eastward across Arctic Canada, reaching Greenland by at least the twelfth century AD. It has also been suggested that an interest in obtaining iron from the meteorites of northwestern Greenland or from the Norse Greenlandic colonies may have stimulated migration (McGhee 1984). Equipped with boats that allowed them to travel in relatively large groups, armed with sinew-backed bows, and probably with long experience of inter-village warfare in their Alaskan homeland, the newcomers soon displaced the Dorset people occupying the area. Inuit legends tell of their ancestors driving away or killing an earlier population named

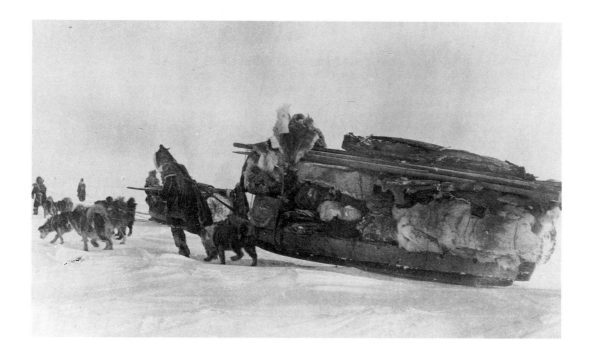

Fig. 14. Dog-hauled sleds provided the Thule people with an
efficient form of winter transportation and were used both for
moving camps and for travel over long distances. This photograph
was taken by a member of the Canadian Arctic Expedition studying
the Copper Inuit in the early twentieth century. (Canadian
Museum of Civilization, negative number 37028).

327

Fig. 15. Thule comb of ivory, decorated with incised lines, figures of birds, and a whale tail. This speciman is 12.3 cm long.

Fig. 16. Ivory carvings representing water birds, many of which have the torsos and heads of women, are a characteristic Thule form. The figure at the lower left is 3.7 cm long.

"Tuniit," a people who may be identified with the Dorset Palaeo-Eskimos.

These early Inuit immigrants from the west are called the Thule people by archaeologists, who first excavated their villages in the Thule district of northwestern Greenland. The open-water conditions and relatively easy hunting that characterized Arctic Canada during this period of warm summers allowed the Thule people to maintain much of the way of life of their Alaskan ancestors. During the summer they hunted whales and other sea mammals from boats and, in the winter, occupied permanent winter villages of houses built with boulders and whale bones rather than logs. Archaeological evidence suggests that the Thule people traded scarce commodities throughout the area they occupied: native copper from the Coppermine area, meteoric iron from northwestern Greenland, smelted metal obtained from the Greenlandic Norse, and soapstone from several localities. Such trade and communication, as well as movement into new areas, was facilitated by the use of dogsleds, which seem to have been developed early in the Thule occupation, and by the other means of transportation mentioned above.

The art of the Thule people is well represented in the material recovered from the frozen remains of their winter houses. In contrast with the art of their Dorset predecessors, Thule art is less obviously related to religious practices; although such a relationship may be present, it is difficult to interpret (Thomson 1979). Thule art is characterized by the decoration of functional artifacts with drilled dots and incised lines, forming geometric patterns or human and animal figures, which are occasionally portrayed in scenes of hunting or other activities. We may speculate that this type of decoration was encouraged by the availability of small quantities of metal, which were used for drill bits and the cutting edges of engraving tools. Figurative carvings are limited to a few forms: human figurines, usually of standing women; small carvings of waterfowl, sometimes with the heads and torsos of women; and occasional small figures of whales.

An interesting contrast between Palaeo-Eskimo and Neo-Eskimo art is found in the portrayal of bears. Dorset artists made numerous carvings of bears, ranging from realistic to highly stylized, which are usually interpreted to be amulets or representations of helping spirits. Thule representations of bears are limited to occasional attachments for harpoon lines, which are carved in the form of a bear's head. Most Thule sites, however, reveal numerous canine teeth of bears, extracted and drilled to be worn as pendants. The apparently common use of extracted bear teeth as either amulets or personal decoration suggests that the Thule people, in contrast with their Dorset predecessors, perhaps thought of the bear as more of a trophy than a threat. Thule art gives an impression of a people whose economic efficiency allowed them the time to decorate all manner of personal possessions.

Fig. 17. This small ivory disc from a Thule village is incised
with figures representing two humans and eight birds. The
opposite surface bears a series of radiating lines and small
drilled dots. The disc is 3.9 cm wide.

Fig. 18. Ivory drill-bow or handle from northern Baffin Island,
decorated with a series of incised scenes from Thule life. This
detail shows a tent camp and hunters in an *umiak*, while a line of
caribou swim in a river along the opposite margin. This section
of the artifact is approximately 14 cm long.

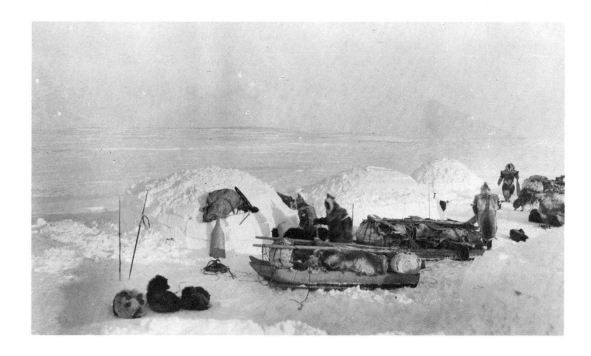

Fig. 19. By the time that Europeans began to explore the central
Arctic, the permanent winter houses of the Thule people had been
abandoned, and their descendants were passing the winter in
snow-house communities. This photograph was taken by a member of
the Canadian Arctic Expedition (Canadian Museum of Civilization).

The environment of Arctic Canada, however, was not as stable nor as predictable as that of the Alaskan coasts where the Thule economy and way of life had developed. After about AD 1200, the climate began to deteriorate slowly, and the deterioration accelerated until the Little Ice Age (approximately AD 1600 to AD 1850), when conditions were considerably colder than now. As cool summers became more frequent and the amount and extent of sea ice increased, the type of maritime hunting that formed the basis of the Thule economy must have become increasingly difficult. The Thule people abandoned High Arctic areas where their ancestors had flourished and, throughout most of Arctic Canada, whale hunting either decreased or ended. Only in the relatively warm areas of southwestern Greenland, southern Baffin Island, and Labrador, where conditions were better because of the open water of Baffin Bay and the Labrador Sea, did the Inuit continue to hunt whales and live in permanent winter villages until the nineteenth century.

Elsewhere, the Inuit adapted to the changed environmental conditions by rapidly evolving new hunting patterns. Through most of the Central Arctic people began to spend the summers in the interior, hunting caribou and fishing in rivers and lakes. Such hunting did not permit the acquisition of large food stores for winter use, and permanent winter villages were no longer established. Instead, the Inuit began occupying temporary villages of snowhouses, built on the sea ice where they had access to seals, their staple winter food.

By AD 1800, the Inuit way of life appears to have been more precarious than that of their Thule ancestors. The art of the early Historic Inuit shows certain continuities with that of the earlier Thule period, but carvings and decorated artifacts were much less common, less complex, and generally more crudely made and finished. Similarities between the art of the Historic Inuit and that of earlier Arctic peoples are very limited (Martijn 1964). They are the types of similarities that we might expect between the arts of unrelated peoples living in the same environment and sharing similar shamanistic beliefs and views of the northern world.

ACKNOWLEDGEMENTS

I wish to acknowledge the help of David Laverie, who drew the map that appears with this paper. I also wish to thank Jean Blodgett and Robert McGhee for their discussions on the subject of prehistoric Inuit art.

BIBLIOGRAPHY

Dumond, D.
1977 The Eskimos and Aleuts. London: Thames and Hudson.

Fitzhugh, Wm. and Susan Kaplan
1982 Inua, Spirit World of the Bering Sea Eskimo. Washington,
DC: Smithsonian Institution Press.

Helmer, James W.
1991 "The Palaeo-Eskimo Prehistory of the North Devon Lowlands."
Arctic, vol. 44(4):301 - 317.

Martijn, Charles A.
1964 "Canadian Eskimo Carving in Historical Perspective."
Anthropos 59:546 - 596.

Maxwell, M.
1985 Prehistory of the Eastern Arctic. Orlando, Fla.: Academic
Press.

McGhee, R.
1978 Canadian Arctic Prehistory. Toronto: Van Nostrand Reinhold
Ltd.

1984 "The Timing of the Thule Migration." Polarforschung 54
(1):1 - 7.

1985 "Ancient Animals, The Dorset Collection from Brooman Point."
In Uumajut, Animal Imagery In Inuit Art, Bernadette Driscoll,
ed., Winnipeg: Winnipeg Art Gallery.

Rousselière, G.-M., OMI
1964 Palaeo-Eskimo Remains in the Pelly Bay Region, N.W.T.
Contributions to Anthropology, 1961 - 62, Part 1, National Museum
of Canada, Bulletin 193, Anthropological Series No. 61, 161 -
183.

Rasmussen, K.
1931 The Netsilik Eskimos: Social Life and Spiritual Culture.
Report of the Fifth Thule Expedition 1921 - 24, vol. 3(1-2),
Copenhagen.

Taylor, Jr., W.E. and G. Swinton
1967 "Prehistoric Dorset Art." Beaver 298:32 - 47.

Thomson, Jane Sproull
1979 "Recent Studies in Thule Art: Metaphysical and Practical
Aspects." In Thule Eskimo Culture: An Anthropological
Retrospective, Allen P. McCartney, ed., National Museum of Man
Mercury Series, Archaeological Survey of Canada Paper 88.

SOCIAL, ECONOMIC, AND POLITICAL TRANSFORMATION
AMONG CANADIAN INUIT FROM 1950 to 1988*

by

Marybelle Mitchell

The period after 1950 marks the transformation of Canadian Inuit from a nomadic to a "settled" population, dispossessed of their land and entangled in economic relationships of dependency on the rest of Canada.

Canadian Inuit were completely isolated until the sixteenth century, when they began to be "discovered" by explorers looking for a northwest passage to the Orient. The explorers who had little impact on Inuit lifestyle, were followed by whalers who paved the way for a major transformation of Inuit relationships and practices. Not only did they stimulate new needs, which could be satisfied only by imported goods, but they also served as a catalyst to finally attract the attention of the Canadian state to the Arctic territories and its inhabitants.

It was only when Canada realized the extent of American whaling activity in her Arctic regions that the North West Mounted Police were sent to establish a Canadian presence by collecting customs duties on trade goods and informing the Inuit that they were Canadians. The first police-cum-administration posts were established at Fullerton Harbour in Hudson Bay and at Herschel Island in the Mackenzie Delta in 1903, two important whaling areas. Close on the heels of the police (or, in some cases, preceding them) came the missionaries, mainly Roman Catholic and Anglican, who invaded the North to counteract the "evil" influences of the whalers, who brought alcohol and disease along with trade goods.

The first half of the twentieth century was dominated by traders, missionaries, and police, who together were responsible for converting the Inuit from hunters to trappers, from their own unnamed religion to Christianity, and from self-regulating and self-sustaining family units (they weren't organized into bands) to marginalized Canadian citizens. Whereas previous contact had ranged from incidental to collaborative, the project of this notorious triad was characterized by its purposefulness. In the early stages, they encouraged Inuit to stay on the land to engage in an intensified exploitation of natural resources; but the headquarters they established around the trading posts became the nuclei of future villages in which Inuit who had been nomadic for centuries would, finally, "settle."

The movement away from camp sites (satellites of the posts to which people journeyed for trading purposes) began in the 1950s, spurred by increasing state activity in the North and the expansion of the trading posts into administrative centres

Fig. 1. By the 1950s, the Inuit had incorporated some manufactured items into their traditional lifestyle. A woman from Coppermine is shown here boiling water over the *kudlik*, a soapstone lamp. Photo courtesy of Richard Harrington, National Archives of Canada, PA-112075.

Fig. 2. Prior to moving into settlements, Inuit lived in small camps and made periodic trips to trade at the fur posts. This Padlei hunter is trading white fox, the exchange value of which is indicated by tokens laid out on the counter. Photo courtesy of Richard Harrington, National Archives of Canada, PA-129942.

Fig. 3. An Inuit camp near Pangnirtung, July 1951. In only a few years, Inuit would be encouraged and induced to settle in the administrative centres which grew up around the trading posts. Photo courtesy of Wilfred Doucette, National Archives of Canada/ National Film Board of Canada, PA-146647.

Fig. 4. Civil servant Alex Stevenson explains the workings of a helicopter from the northern supply ship, the C.D. Howe, to Eskimos at Pond Inlet, July 1951. Photo courtesy of Wilfred Doucette, National Archives of Canada, PA-111208.

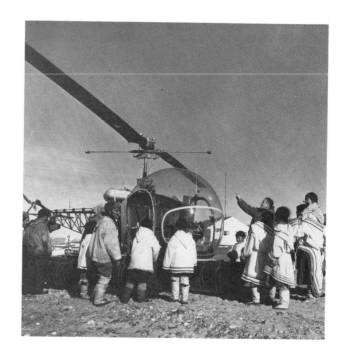

offering such inducements as medical services, schools, and welfare. The decade culminated with the founding of the cooperative movement, a state-sponsored economic-development strategy which was to have far-reaching consequences for Inuit. Taking a rather different turn in the seventies, state activity, focused on the formation of Inuit political organizations as institutionalized authorities with which Canada could, finally, negotiate treaties.

CENTRALIZATION. Social Disorganization and Economic Dependency

The mainly scientific interest in the North of the Canadian state prior to the Second World War was drastically changed and broadened after it. The three reasons usually given to explain this are: a perceived need to expand sovereignty over the northern territories, a growing awareness of the region's resource potential, and an emerging awareness of the plight of Natives who were now dependent upon trapping and experiencing cyclical periods of starvation (Rea, 1968:55).

The Department of Northern Affairs and National Resources was established in 1953. The department's responsibility to the people was fulfilled through the expansion of the social-benefits programmes in place in southern Canada to the Inuit. Its second responsibility was discharged through investment in social-capital-overhead facilities (transportation systems, electrical power, etc.) to provide private enterprise with access to resources.

Providing new services to the North entailed the building of schools, nursing stations, administration offices, and housing for new personnel, mainly transient. These were usually constructed at the site of the trading posts, inspite of the fact that these locations had been chosen to satisfy the demands of the fur trade (access to ports, for instance) and were not necessarily suited to supporting large colonies of people. There are now some twenty-eight thousand Inuit living in sixty-six communities, most of them consisting of no more than a few hundred people. The new communities were efficient administrative centres enabling the state to deliver services to the Inuit; but while they contained more people than the land could support, they were too small and scattered to permit the development of viable local economies or extensive internal exchange.

The process of centralization began in the mid-fifties. This was not an abrupt, singular event, but took place over a period of several years as movement between the camps and the posts was increasingly restricted. In some areas, it was not completed until the mid-sixties. Movement of Inuit from the camps into the new administrative centres was mainly voluntary but, in some cases, was necessitated by the evacuation of large numbers of tuberculosis patients to southern sanatoria. This

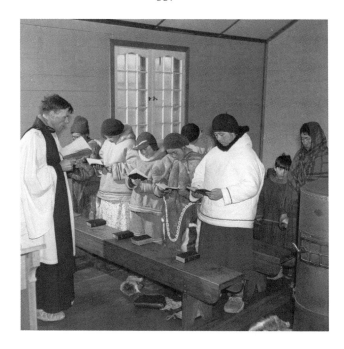

Fig. 5. The Anglican missionary, W. James, conducting a service
in Baker Lake, March 1946. Photo courtesy of George Hunter,
National Archives of Canada/National Film Board of Canada, PA–
141735.

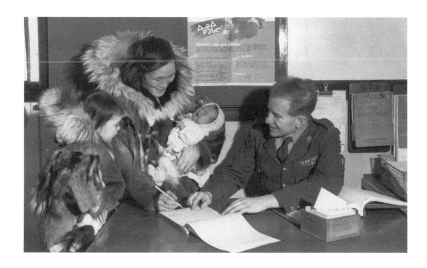

Fig. 6. An Eskimo mother signing for her family allowance
benefits in Coppermine, 1949 or 1950. Photo courtesy of Richard
Harrington, National Archives of Canada, PA–129879.

assault on the population, combined with the vagaries of hunting and trapping and fluctuating fur prices, rendered camp living untenable. The people from Cape Smith, for example, moved south to Povungnituk when over one third of their number was evacuated in a 1955 medical survey.

The acculturation process was, of course, greatly accelerated in towns. Earlier contact with traders, missionaries, and police had been at least partially controlled by the Inuit since it was they who decided when to go into the post to trade, and they usually did not stay very long. The missionaries and the police tended to visit the Inuit in their camps. Changes that had previously been gradual picked up momentum after Inuit settled in large communities; and the result, predictably, was considerable social disorganization.

Self-reliance quickly gave way to dependency, as town living relied heavily upon outside institutions. Although they were the numerical majority (in some cases there might only be half a dozen outsiders in a village), Inuit townsmen were in effect a minority. They had once patterned their lives according to a biologically determined rhythm-a time for catching caribou and a time for making clothes-but town life was decisively patterned by outsiders who had direct access to external support systems. Planes and ships began coming into the isolated Northern villages more or less regularly, though infrequently, but they contained nothing (mail, foodstuffs, equipment) that was addressed to the Inuit. Their cargo was the "property" of the non-Inuit residents who distributed it, at their discretion, to the "community." There was, however, very little feeling of community among the Inuit, who were family-oriented and lacked a strong ethnic identity. The new villages were artificial conglomerates of previously discrete camp groups. Vallee (1967a) and others observed that Inuit did not adjust easily to life in these erstwhile urban centres but tended to resist integration through adherence to their old camp identities.

Before Inuit had settled in villages, their children had been airlifted hundreds of miles to residential schools at Aklavik, Churchill, and Yellowknife where they received a non-Native education and were socialized into a foreign lifestyle unfitted to life on the land. The first village schools were run by missionaries who provided an inadequate education, modestly subsidized by the federal government. Responsibility for education was eventually taken over by the state, and by the late 1950s federal day-schools were built in virtually every community.

Attendance was coerced by being tied to family-allowance payments. Southern curricula were employed and the use of Inuktitut in schools was disallowed, in deference to the so-called "universalist" approach to education that stresses cultural replacement rather than continuity (Vallee, Smith and Cooper, 1984:672). Educational content and methods were designed

to emulate those current in the rest of Canada, so that Inuit could make their way in the broader society.

In addition to a school and a trading post, virtually every community had a Roman Catholic and an Anglican mission, although in some cases one of them might have had few or no converts. Missionaries had come north to combat the debauchery and vice brought by the whalers, and the unseemly competition for souls between the two main denominations led to superficial instruction and hasty baptisms. Nevertheless, most Inuit espoused one of the two faiths, creating a new line of that divided camps and even families.

The missionaries were relentless in their opposition to such Inuit practices as polygamy, infanticide, wife-exchange, the wearing of amulets, child betrothals, and hunting on Sundays; and the *angaqok* (shaman) was considered to be the perpetuator of evil. The Christians looked upon the shamans as their foes, often referring to them as "conjurors." The shamans proved unequal to the battle with the Christian emissaries who, Vallee says, "had spectacular success," in converting whole camps at one stroke (1967b:25). As townsmen, Inuit were more effectively under control of their new spiritual mentors, observing the Sabbath with attendance at Morning Prayer or Mass. With the assistance of Inuit catechists, the Anglicans transposed their southern programme to the North: Sunday School for old and young, Bible-study groups, and the women's auxiliary. The Catholic missionaries, mostly from Belgium, tended to live with the people, spending months with them away from the villages at fishing and sealing camps. Perhaps because of their involvement in subsistence living, the Roman Catholic missionaries were, often, more active in trying to find remedies for Inuit economic problems than in trying to exert ideological hegemony. Some were instrumental in the cooperative movement and some even set up trading posts on their own, as at Pelly Bay, where there was no Hudson's Bay Company store.

Social disorganization was not the only negative consequence of town living. The development of the people as consumers and their deterioration as producers was almost immediately evident. Firearms had by now virtually replaced harpoons and spears, and by the mid-sixties, snowmobiles were replacing dog-sleds as the principal means of land transportation. The most significant material changes that occurred were the move from skin tents and snowhouses into pre-fab houses, and the shift from country food to imported food. The trading posts expanded their stocks of imported goods to provide for new needs that were generated from necessity (as alternative food and clothing sources) and from emulation of the transient White population.

Increasing Inuit reliance upon imported consumer goods led inevitably to the loss of their formerly necessary hunting and handicraft skills, passed, in apprentice fashion, through generations. For the first time Inuit became large-scale

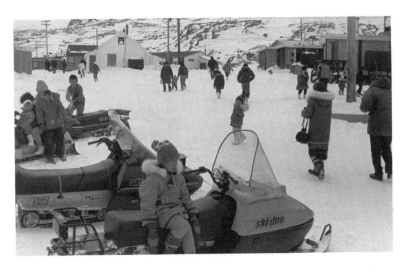

Fig. 7. Street scene in Lake Harbour, 1988. Snow machines are as ubiquitous in the North as are cars in southern Canada. Photo courtesy of John Paskievich, Indian and Northern Affairs Canada.

Fig. 8. Most Inuit now live in pre-fabricated bungalows with telephones and television. This photo was taken in Spence Bay in 1987. Photo courtesy of John Paskievich, Indian and Northern Affairs Canada.

consumers and occasional producers, providing for themselves through a combination of hunting and trapping (for use and exchange), some handicraft production, wage labour, and social assistance. The latter was the most common recourse when wildlife resources in the immediate area were exhausted, and town populations continued to swell through migration from camps and as a result of improved health care.

Although there are regional variations, the Inuit population has been increasing rapidly since 1951, but mortality rates remain high and life expectancy low. An enlarged population is a mixed blessing for, as Vallee, Smith, and Cooper point out, "The high ratio of children to adults means that a relatively small number of adults must support a relatively large number of dependents" (1984:663).

ATTEMPTS TO DEVELOP A REPLACEMENT ECONOMY

Given the declining ability of the Inuit to look after themselves, the state undertook in the late fifties to stimulate local economies by a more efficient exploitation of renewable resources and the creation of wage labour. Potentially profitable, non-renewable resource exploitation was left to private enterprise, while attempts were made to establish Native enterprise in the form of cooperatives based on commercial fishing, handicraft programmes and, in some cases, retail stores.

A great deal was expected of these cooperative ventures. As Arbess (1966:47) says, "The official policy was that the Eskimo people should, with all deliberate haste, have control over these organizations in all of their aspects, and should regain their self-sufficiency" (1966:47). Statements to this effect-and they abound in the literature-should not, however, be taken too literally. "Self-sufficiency" was a term used rather ambiguously by civil servants to mean the aboriginal people should exploit renewable resources more vigorously than before in order to generate a profit that would eliminate the need for state funding. They were, it might be added, expected to do this with little hope of generating internal exchange and in the face of a massive lack of social-capital-overhead facilities.

Canada's position on northern development has always been marked by considerable ambiguity; and it may be speculated that the cooperative form of business was selected as the ideal development vehicle because it would enable the Inuit (hence the state) to keep one foot in both worlds. Americans had forthrightly declared that the traditional culture must be suppressed in the interests of assimilating Alaskan Natives. The Danes took an opposite, but equally unequivocal stance: that Greenlanders, being inferior, could never be assimilated and that they should, therefore, be helped to become better Eskimos. Canadians, however, have vacillated in between, believing on the one hand that the culture was doomed and that the people must be

assimilated, and on the other that they should be helped to live off the land in ways that would not cause undue violence to the traditional culture and the romantic concept of the noble savage.

Cooperatives, capitalizing on traditional activities and values, were a felicitous form, accommodating Canadian ambivalence by both "modernizing" Inuit (involving them in a wage economy) and enabling them to retain roots in the past (espousing principles of egalitarianism and expanding traditional activities). As Louis Tapardjuk, a past president of Canadian Arctic Co-operatives Federation Limited, explained so succinctly: "We're all aware that the co-op is the best vehicle for joining the two activities of culture and money."

ORGANIZATION AND POLITICAL-ECONOMIC IMPACT OF COOPERATIVES

The first Arctic cooperative, based on commercial fishing, was established at George River in northern Quebec in 1959 on the initiative of federal civil servants. The forty-six Eskimo cooperatives now active have achieved economies of scale and a unified voice through two centralized administrative bodies. Arctic Quebec coops, including one Indian-Eskimo one, are members of the Montreal-based La Fédération des Coopératives du Nouveau-Québec, while the Northwest Territories cooperatives are members of Arctic Cooperatives Limited, now based in Winnipeg. Virtually all of the Inuit population is involved in one way or another with a local cooperative.

In many cases, due to the difficulty of explaining business concepts to non-English-speaking Inuit (whose vocabulary, in any case, would not lend itself to such talk), co-ops were implemented before the people really understood their operation and implications. Civil-service project officers believed that Inuit would "learn by doing." In the meantime, they were wooed by promises of lower prices than were available at the Hudson's Bay stores and cash dividends at the end of the year-promises the undercapitalized co-ops have been mostly unable to keep.

Although the co-ops are best known for their arts and crafts production, they are almost all multipurpose enterprises with two main types of activity. First, they provide goods and services locally-oil and gas sales, restaurant and hotel operations, general stores, recreation facilities (such as movies and poolrooms), the sale of country food, and construction services. Second, they produce goods and services for export, fish, eiderdown, tourists, and arts and crafts.

Expansion in the first area is limited because of the small and scattered market, which inhibits internal exchange, and the lack of linkage between production and consumption. Commercial production is for export, except in the case of country food, which accounts for only a small percentage of total local sales. As for expansion in the second area, most efforts to develop

exportable products have failed because of the high cost of production anywhere in the North. Many things have been suggested and tried (and are being suggested again): food processing, component assembly, saw mills, logging operations, and tanneries. Ruffing (1979) makes the salient point (with specific reference to the Navajo Nation) that North American Natives cannot compete with "Asian sweatshops" and "are one of the latest victims of the new international division of labour." Anything you can do in the Arctic, you can do cheaper somewhere else.

In spite of the cooperatives' efforts to diversify, most revenue continues to be derived from consumer rather than producer activities. The most successful area of production is handicrafts, which have replaced fur as the significant trading commodity and are universally identified with Inuit. The Hudson's Bay Company, the Quebec Handicrafts Guild, and the federal government laid the groundwork for the handicraft programmes, but the cooperatives developed them into a multi-million-dollar cottage industry.

The commercial success of Eskimo soapstone carving was, literally, a lifesaver to Inuit, who had no other alternatives to dependence upon a boom-and-bust fur cycle. As Johnny P.O.V., an Inuk from Povungnituk, said, "Carvings rescued all the people from the wretched situation they were in. If they had to rely only on the trading of fox skins, they would undoubtedly still be poor today" (in Myers, 1977).

It may have been a marketing success story, but handicraft production is far from being a profitable venture. People do not get rich on arts and crafts, and it is increasingly clear that, however important crafts may be, they will never be sufficient to bridge the gap between development and underdevelopment. Yet, more and different handicraft programmes are invariably touted as the cure for a failing Inuit economy. As the non-Native manager of the West Baffin Eskimo Cooperative said in 1978, "Due to government's failure to develop alternative industry in the north, there is an inordinate pressure on talent in the north to make up for the lack of development. Craft projects seem to be considered the magic solution to everything."

Certainly, the commercial success of soapstone carvings exceeded all expectations. Wholesale arts and crafts sales from all Inuit co-ops were less than $100,000 in 1965. In 1987 they were in excess of $5 million. (What is being sold outside the co-op system may amount to several more millions.) Until recently, carving, as a cottage industry, was the single largest source of earned income for the North, and it continues to provide a significant income for many. An estimated 30 per cent of all co-op payouts are for arts and crafts production.

The income derived from carving is important to Inuit, who do not invest art-making with mystical significance but look upon

Fig. 9. Soapstone carving provides a livelihood for a large percentage of Inuit. Because of the hazards of soapstone dust in cramped living quarters, carvers mostly work outside, a hardship in sub-zero temperatures. Joe Kiloonik, Spence Bay, 1988. Photo courtesy of John Paskievich, Indian and Northern Affairs Canada.

Fig. 10. Religious art adorns the walls of many Inuit homes. The Anglican and Roman Catholic missionaries competed for converts in the early days but there is now a strong fundamentalist movement in the Arctic. This photo was taken in Holman Island in 1987. Photo courtesy of John Paskievich, Indian and Northern Affairs Canada.

it as away to obtain what they need. There is, in fact, a direct relation between production and consumption, as Inuit make carvings not to get rich but to satisfy immediate needs. As Hugh Brody has remarked (Brody, 1975:173), when a carver needs $30, he makes a $30 carving. "Target marketing," as Graburn (1976:46) calls it, has been the pattern, with carvers sometimes making a very large sculpture for which they might receive several thousand dollars, enabling them to purchase expensive equipment like snowmobiles and boats. This practice has been modified somewhat by quotas imposed by the cooperatives on size and prices in an effort to alleviate overproduction problems; but peak purchasing times for carving still coincides with peak buying times in the local retail stores—just before Christmas and just before sea-lift in late summer. The frank motive for carving is to earn money; and although this leaves the door open for those wanting to earn quick dollars, it is not necessarily a deterrent to quality. As Pitseolak said, "I became an artist to earn money but I think I am a real artist" (quoted in Swinton, 1972:245).

The commercial success of Eskimo art resulted from a fortuitous convergence of skill, need, opportunity, and demand. The launching of Inuit art corresponded with an increasing world-wide interest in ethnic arts (Graburn, 1975:190),and a time when Canadians in particular were developing a concern for authenticity and in preserving the ways of the past. Inuit were enthusiastic about carving because it released them from dependence upon wildlife and because they could produce it without major social disruption. They could carve according to their own schedule, utilizing their own raw materials and a customary division of labour, and they did not need to learn a new skill or a new language in order to succeed. As the Inuk president of the Canadian Arctic Cooperative Federation Limited told the third Cooperative Conference: "Arts and crafts is our largest industry which does not require skill or knowledge that is developed by southern training or educational institutions" (Nortext, 1980:9).

It is difficult to assess the economic advantages of carving for the Inuit. Carvers might earn twenty to thirty dollars for a few hours work and, unlike their Southern counterparts, do not bear the risk or expense of selling their own productions. But they must provide their own tools and gather their own materials. Inuit consider this the most onerous part of the work of carving since it means, for instance, having to buy and maintain expensive equipment (snowmobiles, boats, and motors) and travelling many miles by land and water to hack soapstone out of the frozen ground. The most primitive, nontechnological mining methods are employed. Inuit crave assistance in mining stone, but it has not been forthcoming.

A high percentage of adult Inuit know how to carve, vestige of the recent past when each family unit was required to provide for itself. Historically, the cooperatives have bought virtually everything produced, but this egalitarian practice increasingly

clashes with the realities of the market, resulting in problems
of overproduction, quality, and pricing. Inventory buildups have
ranged from nagging to acute, while quality and pricing have been
erratic.

ARCTIC QUEBEC AND THE NORTHWEST TERRITORIES

Regional differences are of necessity glossed over in a general
discussion, but important differences between the co-op movements
in the Northwest Territories and in northern Quebec, reflect, to
a large extent, the French-English split in southern Canada and
should be noted. Since the co-op movement in Arctic Quebec is
more highly developed and firmly entrenched than that it is in
the Northwest Territories, it will be the reference point here.

There are two main operating principles in the Arctic Quebec
system. The first is that producer and consumer activities
should be closely linked. Simply put, the idea is to recycle
money by providing consumer outlets (the main one being general
stores) at which money earned for production can be spent. In
this way, the co-op attempts to become a self-contained and self-
sustaining system, an aspiration thwarted by the production-
consumption imbalance mentioned earlier.

The second principle is that Inuit should be self-
determining. To this end, an early goal was the elimination of
outside managers and outside funding (to which controlling
"strings" are usually attached). Inuit were installed in all
salaried positions in the local cooperatives, although management
and staff of the Southern-based federation remains non-Native. A
longer term objective was to provide a unified voice for Inuit.
Successful co-op movements have always managed to establish
political linkages-the grain growers' cooperative in the Canadian
West is a good example-and this has been, for some time, the
major objective of the federated northern Quebec co-ops, which
functioned, to borrow a term from Thomas Sulluk as "underground
governments" (Iqalaaq, September 1980).

The coop provided the only organization Inuit had as they
moved into the seventies, but it was treated as spokesperson only
reluctantly by the state, which began at that time to sponsor
local community councils to represent the people on "political,"
that is, non-economic issues. Guided by civil-service field
staff, residents were invited to comment on garbage disposal and
dog control, but not asked about the larger issues of game
management, education, land and resource use, or local
government.

It was the cooperatives that first advanced the issue of
self-determination in Quebec. At the co-ops' instigation, the
community councils joined with them in petitioning the Quebec
provincial government for regional government status in 1971.
They stimulated debate and attracted media and official attention

to the cause of Inuit self-determination, but although a bill was drafted, it was never presented to Quebec's National Assembly.

There were a number of factors contributing to the failure of the co-op to consummate its bid for power. The federal government was urging Inuit to join the provincial Indian Brotherhood, a move that would have been welcomed by Quebec Indians (then pressing their own territorial claims within Quebec) since inclusion of Inuit would have extended their claim to include most of the province. At the same time, the Quebec government was pressing its own territorial claims against the federal government. In 1962 Premier Jean Lesage had announced Quebec's intention of assuming what were then federal responsibilities in its northern regions and, by the late sixties, the province was actively negotiating a takeover from the federal government. The federal government promised that the transfer would take effect when the province could provide the services and the people were ready for them. This meant that, for several years, duplicate federal and provincial services and staff were in place in Arctic Quebec (a provincial and federal school, for instance), creating overlap and dissension. It was probably more than enough to make claims of yet _another_ minority group seeking status most unwelcome.

This was a decisive moment, for it signified the coops' failure to legitimate its power. Instead, new organizations were created to deal with the state in the settling of land claims.

THE BIRTH OF ESKIMO POLITICS

Eskimo politics were born in the 1970s, when land claims were assuming some urgency and the first generation of town-born and town-bred Inuit was approaching adulthood. Following the establishment of the Committee for Original Peoples' Entitlement (COPE) in the Western Arctic in 1969, Inuit political organizations proliferated. A national organization, Inuit Tapirisat of Canada, was established in 1971 to provide a voice for Inuit on such important issues as game laws and education. ITC now has six regional affiliates: COPE, the Baffin Region Inuit Association, the Kitikmeot Inuit Association (Central Arctic), the Keewatin Inuit Association, Makivik Corporation (Northern Quebec), and the Labrador Inuit Association.

Inuit had signed no treaties with the federal government until 1975, when the James Bay and Northern Quebec Agreement (JBNQ) was signed by the Inuit and Cree with the federal and provincial governments. Before that could happen, an organization with the authority to deal with the government on land rights had to be established. As Quebec Inuit had refused to join forces with Quebec Indians, the federal government set up the Northern Quebec Inuit Association (NQIA). Inuit were trying to make up their minds whether to continue lobbying for regional-government status or to accept the government's proposal to set

up their own Inuit association, but the decision was made for
them. They said they needed time to arrive at a consensus (the
traditional mode of decision-making), but land and energy
concerns forced the issue. Like the cooperatives, NQIA was put
into place presumably with the hope that, once again, Inuit would
learn by doing. The state funded a willing group of Inuit and
NQIA was a *fait accompli* with headquarters, operating funds, and
a mission: settlement of Quebec Inuit land claims. NQIA's
leaders represented that segment of the Arctic Quebec population
opposed to the co-ops' regional-government lobby because it
meshed with Quebec's desire to take over responsibility for the
North. As is the case with Indians, many Inuit prefer to remain
under federal rather than provincial jurisdiction.

Prompted by Quebec's incursion into its northern territories
to mount the James Bay Hydro-Electric Project, the JBNQ, is now
law, although it remains a source of controversy among Arctic
Quebec Inuit. The referendum to ratify the agreement in 1977 was
95 per cent in favour, but 34 per cent of the population
abstained from voting to demonstrate their opposition to it.
Three communities (Povungnituk, Ivugivik, and Sugluk), comprising
one third of the population, formed a dissident association, ITN
(Inuit Tungavinga Nunami meaning "Inuit who stand up on their
land"). Thirteen years later, ITN continues to oppose the
agreement, its members claiming that the powers of attorney that
enabled NQIA to negotiate on their behalf had been falsely
represented to them. They believed that they were merely
empowering NQIA to provide Inuit assistance to Quebec Cree in
their fight to halt construction of the James Bay Dam, when they
were in fact empowering NQIA to negotiate settlement of their
aboriginal title.

The agreement is complex but essentially Inuit (and Quebec
Cree) relinquished title to almost a million square kilometers of
land in return for $90 million in cash and royalties (but
diminished by inflation); exclusive hunting and fishing rights in
certain areas; outright ownership of 8,500 square kilometers of
land; and certain political rights, including regional
government, and control over education and language.

The immediate consequence of the JBNQ was the appearance of
a new Northern phenomenon: the development corporation, which
ironically is an institution incorporating political and economic
power. "Ironically," because the state, determined to separate
economic and political power, thwarted the cooperative's bid to
legitimate its power. A common refrain in the subsequent years
of competition and antagonism between the development
corporations and the cooperatives has been that the co-ops should
confine their activities to the economic domain and refrain from
even discussing political and cultural issues.

Makivik Development Corporation was set up in 1978 as a non-
profit channel to receive the compensation money flowing from the
JBNQ and to represent the Inuit of northern Quebec in discussions

of environmental, resource, and constitutional problems. All
Arctic Quebec Inuit are shareholders in Makivik, whose publicized
mandate is to develop profit-making enterprises for Inuit and to
protect their interests as an ethnic group. Like many Third
World countries, Makivik is attempting to secure development
without Westernization, in spite of the fact that "there is
virtually no aspect of the conceptual framework of a corporation
that has a counterpart in Native culture" (ITC, 1974:28-29).

Shortly after the JBNQ was signed, disenchantment set in
among its Inuit proponents. The president of Makivik publicly
announced his dissatisfaction with its terms and implementation.
As for ITN, the dissident Inuit Association, its position has
always been that Inuit, the rightful owners of the land, must
have a government "that can make laws, be self-supporting
financially, raise taxes and claim royalties from any activities
in its territory" (Sivouac in Nortext, 1980:21). For a while,
the dissident communities refused services set up with JBNQ
money, going so far as to boycott the schools. The duration of
the legal proceedings and the necessity of certain services
covered by the agreement, especially health services eventually
resulted in capitulation. But using services is not equated with
accepting them; indeed, there is movement in Povungnituk to
establish a separate school.

Although it has been the cause of some dissension within the
cooperative movement, ITN has been supported by management of the
Quebec co-op federation, which is sympathetic to the aims of the
dissidents. It is no coincidence that the dissident movement is
led by Povungnituk, the strongest co-op in Arctic Quebec. ITN
does not have a lot of money available to fight the agreement,
but it is attempting to raise funds to take its case to court.
For several years, the defiance of its Pov contingent was
signalled by a sign at the airstrip which read, in four
languages, "Welcome to the territory which has not been ceded, in
spite of the James Bay Agreement." Made of plywood, the sign
rotted away before the case could be argued in court.

Predictably, Makivik and the co-ops clashed as attempts have
been made to establish regional businesses (mostly unsuccessful,
such as a shrimp fishery, a construction company, and restaurants
and hotels). The only flourishing enterprise is Air Inuit, which
has exclusive rights to fly the Northern Quebec routes. The co-
op's response to competition has been ideological appeals to the
"old way," and, indeed, it is considered by many to be "the
guardian of the old way" while Makivik (the name means
"advancement") is considered the way of the future.

As for land claims in the rest of the Arctic, the Inuvialuit
in the western Arctic have signed an agreement with the state,
but several others are still being negotiated. Inuit have
learned a great deal in the last decade, and there is a growing
demand for what might be called "ethno-regional collective
rights." The Tungavik Federation of Nunavut, for instance, has

called for division of the Northwest Territories to create an Inuit homeland with an Inuit-dominated government and with Inuktitut as one of the official languages. The government of Canada is prepared to grant regional government rights, but there is evidence that Inuit want more than that. As one Inuit observer remarked, "Inuit are not trying to be part of the Quebec or federal government. We must control our own land because if we are controlled by white rules, things will only become worse."

WHERE ARE THEY NOW?

Inuit have also achieved considerable local control. The non-Native bureaucracy has been replaced with an Inuit bureaucracy, which runs many of the services administered by a transient non-Native population, including policing and the distribution of welfare. Most Inuit communities in the Northwest Territories are now incorporated hamlets governed by an elected council. In Quebec, Kativik regional government has incorporated municipalities in all but the three dissident communities. There are a number of elected Inuit officials in the twenty-four-member Northwest Territories Legislative Assembly and some of them hold ministerial posts. On the federal level, Inuit did not have the right to vote until 1962, and have had to scramble to catch up. The first Inuit member of Parliament was elected 1979, and there are now two Inuit senators.

The Northern education system has undergone considerable streamlining in the last decade. Elementary education is available in virtually every community, and Inuit are involved in decisions concerning curricula and school administration. They have been trained as teaching assistants and teachers, and in most areas Inuktitut is the exclusive language of instruction for at least the first few years. In Quebec, instruction in the early years is in Inuktitut and at the grade-three level, and parents decide whether they wish their child to have a French or English education. Inuktitut language-instruction continues in later years, and in many Arctic schools, Inuit lifestyles (preparation of skins, carving, etc.) are taught by elders. There are also many adult-education programmes available, and Arctic College, established in 1984, provides extension courses and occupational training throughout the territories.

Although the system has become more responsive to Inuit needs, it has a long way to go. In most cases students wishing to attend high school must leave their communities for the school year. Only in Labrador can Inuit complete high school in their home communities. Most of the twenty-to-thirty-year-olds have received some level of state education that, along with the ability to speak English (in Quebec, some speak French), provides an advantage in dealing with the non-Native world. The dropout rate is high, however, and very few Inuit have been exposed to post-secondary education, for which they would have to leave the North entirely. Formal education has not been available to Inuit

for very long, it is not culturally valued, and it is educating people for jobs that do not exist.

The economy of the eighties is a mixed bag of transfer payments (especially welfare), income from cottage-industry production, full-time and part-time wage employment, and subsistence activities. The state has long been the main employer; but in Quebec Makivik and its affiliates are a strong contender for this title, and in the Northwest Territories the co-ops are now the largest employer of Native people. The well-funded Native organizations tend to pay higher wages than the cooperatives, and a new phenomenon in the North is the emergence of inequalities of wealth and power in a previously homogenized society.

The high unemployment rate in the North is at least partly responsible for the severe social problems that have overtaken most Arctic communities. Drug- and alcohol-abuse are rampant, and vandalism and domestic violence, previously unknown among Inuit, have become commonplace. In recent years many communities have prohibited the distribution and use of alcohol.

Medical services are provided by local nurses; doctors are available only in the larger centres to which emergency cases are evacuated by air. The administration of health services has changed over the past two decades; but although TB has been virtually eradicated, Inuit still suffer a high rate of infectious disease attributable to inadequate sanitary facilities, malnutrition, alcohol-abuse, and overcrowded housing (Vallee, Smith, and Cooper, 1984:673). The housing problem has been considerably alleviated in recent years with the introduction of modern, subsidized housing, comparable to that long enjoyed by the transient non-Native population, although running water is not available to either because of the permafrost.

Extended family affiliations, the rule of generations, have been crisscrossed with allegiances to foreign institutions. One line of division is between Roman Catholic and Anglican converts, but the insurgence of Pentecostals in the late seventies has created another line of cleavage, between "born again" and conventional Christians. Some suggest that the success of the evangelical movement in the North is due to its links with shamanism (speaking in tongues, emotionalism, etc). In any case, it appears that in spite of its condemnation by foreign missionaries, shamanism merely went underground where it is coexisting with Christian practices.

Yet another line of division was created by the co-op, which made employees of some Inuit and bosses/managers/directors of others. Sorting Inuit into better and best carvers and businessmen, the new criteria of selection made it possible for younger men to attain authority over older men and, as Arbess (1966:47) points out, the nature of the authority also changed,

since that "expected by the co-operative... resided not in an individual but in his position."

The co-op is an inherently contradictory institution, undermining at the same time as it attempts to reinforce non-capitalist practices. Although it has endeavoured to uphold the old ways, it has been responsible for linking Inuit into a market economy. It did this job so well that the North is now fertile ground for entrepreneurs ("free traders") who are buying and selling handicraft, capitalizing on the development and training paid for by co-ops. This has become such a serious problem in recent years that the formerly intense competition between the Hudson's Bay Company and the co-ops has mellowed considerably.

The Hudson's Bay Company and the cooperative are still competing for the local retail business in most northern villages, and although the HBC has consistently refused to release data, it is generally assumed that Inuit split their business evenly between the two. Co-ops are locally owned, and it is in the interests of the local people to provide them with all-out support; but Inuit support of the HBC has proven intractable. People continue to patronize "the Company" in appreciation of its having been around to avert famine and death in the forties when Inuit were literally starving to death. Individual HBC managers are still remembered for having extended the credit that meant the difference between survival and death.

Competition between the HBC and the co-ops is not confined to the retail business; both are buying handicraft production. The HBC has a history of buying intermittently, but in latter years it had pursued a reinvigorated marketing policy.

A significant development in the mid-seventies was a "back-to-the-land movement" that saw new communities springing up at the old campsites. The segment of the Povungituk population that had originated in Cape Smith moved back in 1972, for instance, renaming their old site "Akulivik." Significantly, however, when people go back to the land they want a store, a school, three-bedroom bungalows, and medical services because they now *need* those things.

Cultural institutes are a phenomenon of the late seventies. The Inuit Cultural Institute based in Eskimo Point has undertaken to collect and publish legends and knowledge from elders in an effort to preserve Inuit culture. It is also exercising stewardship over Inuktitut. A language commission was established to standardize the two writing systems, Roman orthography and the syllabic system taught by the missionaries. The Labrador Cultural Institute and, in northern Quebec, the Avataq Cultural Institute, have similar objectives.

Inuit are setting up museums and relearning old skills, but still the prevailing pull is to Westernization. Language is the most significant indicator of ethnic survival, and everyday

affairs in the Arctic are increasingly conducted in English. Efforts to buck the trend pale beside such powerful weapons of acculturation as radio and television, a major innovation in the seventies made possible by the launching of satellite Anik A in 1972 (which also meant improved telephone service). In communities of five hundred or more, the Canadian Broadcasting Corporation has set up local radio stations to access regular programming. In smaller communities, the government of the Northwest Territories provides radio and television satellite equipment, and in northern Quebec, Taqramiut Nipingat Inc. (TNI) oversees locally owned and operated radio stations.

Although television has been available in the North for less than a decade, most houses have a set that remains on most of the day as a backdrop to everyday life. Soap operas have become an obsession with the adolescent and early-twenties age group, providing a distorted view of the Western lifestyle that has had a noticeable impact on the affective life of this segment of the Inuit population. There has been an attempt to counteract such effects through the development of Inuit-content programming. The Inuit Broadcasting Corporation (IBC), a non-profit network, was established in 1981 with representatives of Native associations across the North on its board. IBC, which produces shows in both English and Inuktitut, reaches approximately two thirds of all Inuit communities (approximately twenty-five thousand Inuit in Northern Quebec, Labrador, and the N.W.T.), but with only five hours of air-time per week, it is an ineffective antidote to the same American programming that is eroding Southern Canadian culture.

In spite of efforts expended to preserve the past, there is no doubt that most Inuit desire "progress." They would like to retain certain elements of their culture and are worried about "technological excesses" that disrupt environmental harmony (D'Anglure, 1984:662); but they are also clearly interested in pursuing a future based upon the Western model.

Always ethnically fragmented, and further fractured by allegiance to foreign institutions. Inuit have come to see that if they are to improve their lot, they must speak with a unified voice. They are attempting to achieve some leverage in the Canadian state through negotiations to have aboriginal rights enshrined in the Canadian constitution. In northern Quebec, a unity movement began in 1983, in response to a promise by the then-premier, René Lévesque, that if the warring groups, Makivik, ITN, and the co-ops, got together on a proposal, Quebec would grant self-government to the region. Nunasimajortigut (which means "responsible government through or by the citizens") is now preparing for an election in the fall of 1988. Elected representatives will work out the constitution and structure of regional government for Arctic Quebec. On an international level, Canadian Inuit have joined with their cousins in Alaska and Greenland in a Pan-Eskimo movement sponsored by the Inuit Circumpolar Conference established in 1977. The first President

of ICC has gone on record (<u>Tundra Times</u>, April 21, 1982) as saying that the ultimate Eskimo unity would be an Eskimo nation.

It seems inevitable that Inuit will become more nationalistic; perhaps eventually they will want outright separation from Canada, although they will certainly press their claims with considerably less clout than do the French in Quebec with similar aspirations. The critical factor is their economic dependence upon the state. Predictably, during the early unity meetings in Quebec, concerns were raised about how an Inuit government would provide old-age security and family allowances. No one had the answer.

*This essay, written in 1988, incorporates and updates **segments** of my 1982 and 1984 articles listed in the references.

REFERENCES

Arbess, Saul E.
1966 "Social Change and the Eskimo Co-operative at George River." Ottawa: Northern Co-ordination and Research Centre.

Brody, Hugh
1975 The People's Land: Eskimo and Whites in the Eastern Arctic. Middlesex: Penguin Books Ltd.

D'Anglure, Bernard Saladin
1984 "Contemporary Inuit of Quebec." In Handbook of North American Indians, Vol. 5, Arctic, D. Damas, ed., Washington: Smithsonian Institution.

Graburn, Nelson, ed.
1976 Ethnic and Tourist Arts. Cultural Expressions from the Fourth World. Berkeley: University of California Press.

Inuit Tapirisat of Canada
1974 "The Alaska Native Claims Settlement: A Report on a Trip to Alaska by Representatives of the ITC." Ottawa.

Myers (Mitchell), Marybelle
1982 "Beyond the Fur Trade: The Rise and Fall of the Eskimo Co-operative." Alternate Routes (1982).

1984 "Inuit Arts and Crafts Co-operatives in the Canadian Arctic." Canadian Ethnic Studies XVI(3).

1977 Davidialuk. Montreal: Fédération des Coopératives du Nouveau-Québec.

Nortext Information Design Ltd.
1980 Report on the Pan-Arctic Co-operative Conference, George River, Quebec. April 10 - 25. Ottawa.

Rea, K.T.
1968 The Political Economy of the Canadian North. Toronto: University of Toronto Press.

Ruffing, Lorraine Turner
1979 "The Navajo Nation: A History of Dependence and Underdevelopment." Review of Radical Political Economy 11 (2):25 - 43.

Swinton, George
1972 Sculpture of the Eskimo. Toronto: McLelland & Stewart.

Vallee, Frank G.
1967a Povungnituk and its Cooperative: A Case Study in Community Change. Ottawa: Northern Co-ordination and Research Centre.

1967b <u>Kabloona and Eskimo in the Central Keewatin.</u> Ottawa: Canadian Research Centre for Anthropology, Saint Paul University (out of print).

Vallee, Frank G., Derek G. Smith, and Joseph D. Cooper
1984 "Contemporary Canadian Inuit." In <u>Handbook of North American Indians, Vol. 5, Arctic.</u> D. Damas, ed., Washington: Smithsonian Institution.

INUIT ART: A HISTORY OF GOVERNMENT INVOLVEMENT

by

HELGA GOETZ

INTRODUCTION

Cape Dorset is a community of over nine hundred Inuit in Canada's
Northwest Territories. Virtually everyone has relatives who
carve, draw, or make prints. In less than forty years art-making
had become a realistic economic option for modern Inuit. The
idea of creating images of Inuit life for a foreign culture began
in the late 1940s. During the following years a complex mixture
of individuals, organizations, institutions, and governments
conspired to encourage, discourage, and alter the work of Inuit
artists. An astonishing percentage of these culture-change
agents were civil servants, formulating or carrying out
government policy, and almost all art programmes depended to some
extent on government funding. Therefore, understanding
government involvement in the history of Inuit art must be
divided into five time periods: (1) the pre-1950s produced
casual art; (2) the 1950s saw the introduction and initial
development of specific Inuit art programmes; (3) in the 1960s
more organization and programme consolidation took place; while
(4) the 1970s saw major attempts at legitimization of Inuit art
as a world-class phenomenon; (5) finally, the 1980s have seen the
maturation of both the Inuit art industry and the individual
artists.

PRE-1950 - CASUAL ART

Before 1950 Inuit art-making was individual and sporadic.
Carvings were made for amusement, as toys, as magico-religious
objects, or as objects for trade to the occasional explorer,
missionary, scientist, trader, or policeman who ventured into the
Arctic. These curios, usually carved in ivory, were normally
images of Arctic life, but included miniature saws, scissors,
guns, and other southern goods (fig. 1). From the beginning,
Inuit were well-accustomed to bartering. William Parry described
how his ships Fury and Hecla were greeted on their arrival off
the south coast of Baffin Island in 1821 by Inuit anxious to
trade: "They brought a little oil, some skin dresses and tusks of
walrus, which they were desirous of exchanging for any trifle we
chose to give them. They had, also, a number of toys of various
kinds, such as canoes with their paddles, spears and bows and
arrows, all on a very small scale."[1] The ships' crews must have
encouraged further trade in curios while wintering over north of
Somerset Island, for the Inuit camped nearby "now brought with

them a great many little canoes and paddles, sledges, figures of
men and women, and other toys, most of them already bespoke by
the officers and men, and the rest for sale."[2] The arrival of
ships in Arctic waters became an annual event. Many Inuit took
advantage of this opportunity to make and sell carved objects.

One hundred years later carving activity was encouraged and
organized by outsiders. For example in the 1930s carving or
other handicraft work was encouraged in "Industrial Homes" for
the care of the aged or infirm. These homes were managed by
Roman Catholic missionaries in Chesterfield Inlet and the
Anglican Church in Pangnirtung. The government provided some
funding for these programmes.

The official attitude toward handicraft development during
this period is expressed in the Annual Report of the Department
of the Interior in 1927 - 28: "Serious study is being given to
the problem of providing convenient opportunities for the natives
to develop themselves by practicing the handcrafts for which
nature has fitted them...."[3] On a more practical note, a small
government collection, started in the 1920s, was exhibited from
time to time. A special effort was made to include Inuit
carvings in the National Gallery exhibition organized for the New
York Worlds Fair in 1939.

One civil servant believed strongly that government should
take a more active role. Major David McKeand was officer in
charge of the annual Eastern Arctic Patrol. He vigorously
petitioned the Northwest Council to act on handicraft
development. McKeand believed that the reduction in trapping
income due to a poor fox cycle provided "an opportune time to
initiate the natives in making handicrafts which will be readily
marketable and profitable to him physically, mentally and
financially.[4] Among McKeand's ideas was a plan to teach the
Inuit to make wooden puzzles of Arctic scenes. The Northwest
Territories Council, however, was slow to respond to such ideas.
The beginning of the war served to further reduce possibilities.
In March 1940 a senior official wrote: "The development of
handicrafts among the Eskimos of the Eastern Arctic is still a
matter of concern to this administration. Owing to the present
unsettled conditions, efforts in this direction have been
temporarily suspended."[5]

The scarcity of indigenous materials and the difficulty of
finding stable markets were two major obstacles to northern
handicraft development during the prewar period. McKeand
believed that the Canadian Handicraft Guild in Montreal offered a
possible solution to these problems. He hoped that this group,
which had a proven interest in native Canadian crafts, could be
helpful in supplying Inuit with raw materials and finding a
market for the finished product. He urged officials of the

Northwest Territories Council to work with the Guild.

The Hudson's Bay Company solved these problems very successfully in Lake Harbour. In the 1940s the presence of US military personnel created a temporary and inflated market for souvenirs on Baffin Island. The Hudson's Bay Company organized a small carving industry that fed this market. R. B. Tinling, Hudson's Bay Company Post Manager at Lake Harbour in 1949, described the production and marketing practices: "Raw ivory was shipped into Lake Harbour from most of the other posts. Each year we would receive 500 - 1000 pounds of ivory. This was issued out on charge to the carvers on a poundage basis. The cost of ivory was deducted from the finished carving. At that time, 1949, the carvers had developed techniques which could not be improved upon without changing the style or motif. Carvings ranged from beautifully carved cribbage boards, to all forms of Arctic animals and birds. One carver as a specialty used the boiled method for softening ivory and carved fox traps in perfect detail. Each trap worked...."[6]

Most of the carvings produced were marketed by the Hudson's Bay Company through the American Forces Post Exchange at Frobisher Bay. Tinling recalls one shipment of fifteen cases valued at over $3,000 being sold in less than twenty-four hours. For the most part, however, individual Inuit continued to create souvenirs where there was an opportunity for trade. Only a minor interest existed in southern Canada. At this point in history, the needs of government, the interests of a private institution, and the enthusiasm of one individual coalesced to usher in the development of contemporary Inuit art.

1950s - INTRODUCTION AND DEVELOPMENT

Federal-government programmes in the Arctic of the 1950s were politically motivated and econocentric. How could a new economic base be created in a remote area populated by scattered groups of hunters and trappers? An organized craft industry offered one possibility. On the eve of the 1950s Deputy-Minister H. L. Keenleyside wrote to the president of the Canadian Handicrafts Guild, "The Eskimo economy has, in the past, been based largely upon the white fox trade. The white fox is subject to cyclic scarcity and wide fluctuations in price depending on world fur markets. We are anxious to introduce new industries at suitable points to improve the Eskimo economy and the proven ability of the natives in producing characteristic handicraft articles holds promise for developing a small industry in this field if the Eskimo production can be properly organized and outlets to suitable markets provided."[7]

The interest of the Canadian Handicrafts Guild was centred

on the encouragement of Native crafts. This interest had been
further stimulated by the young artist James Houston. Eager to
explore the north, Houston set out in 1948 on a sketching trip to
the eastern shore of Hudson Bay. There he was delighted by the
small carvings shown to him by their makers. He collected a
number of examples to take south with him to Montreal. There, an
enthusiastic audience was found in members of the Indian-Eskimo
Committee of the Guild. Houston was authorized to return north
in the summer of 1949 to buy carvings for the Guild shop.

Houston was the right man in the right place. His
activities meshed perfectly with Keenlyside's desire to introduce
new activities. Officials working with the Canadian Handicraft
Guild reached an agreement in which the government offered
funding. In return the Guild would: "1. ...employ a capable
handcraft instructor (preferably Mr. Houston) who is to proceed
to the Arctic to organize the instruction of Eskimos in native
handicrafts and wherever possible, train local people as
instructors to carry on after his departure. 2. ...publish a
simple book of instruction for Eskimos on handicrafts. This book
is to be in Eskimo syllabics as well as in English, and suitably
illustrated. 3. ...cooperate closely with the Northwest
Territories Administration in the selection of sites at which the
handicraft industry should be developed... 4. ...supervise the
production of handicraft products as far as possible and ... buy
and market these products in accordance with the Guild's normal
practice-the general aim of course being to establish the
handicrafts industry on a completely self-sustaining basis as
soon as possible."[8]

Houston returned to the east coast of Hudson Bay for four
months in 1950. His presence resulted in a flood of handicraft
production, 2,500 pieces, primarily carvings, were purchased for
resale through the Guild. In addition Houston travelled
northwest to Repulse Bay, where he spent three weeks, purchasing
handicrafts made there as well as items traded down from Spence
Bay and Pelly Bay. The purchase system was simple. Houston
encouraged production and allocated funds provided by the
Canadian Handicrafts Guild to the local Hudson's Bay Company post
manager. After Houston's departure, the post manager continued
to buy carvings. The purchases were shipped out on the annual
supply ships late in the summer. They arrived in Montreal on
time for a late fall sale at the Guild.

This sale became an exciting annual event as collectors vied
to purchase their favourite carvings. It is still echoed to a
degree in some annual print collections today, when collectors
camp out on the doorsteps of galleries to be first in line of
purchase an especially desirable print.

The success of the 1950 collection led to continued

361

Fig. 1. Standing Hunter with Rifle, ivory, Eastern Canadian Arctic, before 1900. Collection: Canadian Museum of Civilization, Hull.

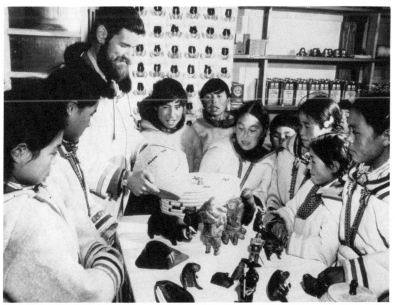

Fig. 2. James Houston with a group of Inuit children during his trip on Baffin Island in 1951. Photo: Wilf Doucette. Collection: Inuit Art Section, Indian and Northern Affairs

government funding. Houston and his new wife, Alma Bardon, travelled by dog-team from Frobisher Bay to Cape Dorset, visiting camps along the way to encourage the making of carvings and other crafts. Their results in Cape Dorset show the effects of an energetic catalyst. During their stay over 80 per cent of the adult population participated in craft production. Among those who began carving at that time was the fifteen-year-old Kiawak Ashoona, today a renowned sculptor (fig. 2).

A number of other persons, less well known, furthered Inuit art in the North. One of them was Margery Hinds. The government teacher/welfare administrator described the positive effects of this new income-producing activity on the Inuit living on camps around Port Harrison (now Inoucdjouac). In her reports she told of recently completed carvings proudly displayed on boxes in a tent; of young boys travelling seven hours by kayak to bring carvings to trade at the Hudson's Bay post. Hinds also pointed out problems of overproduction and lack of stone. In July 1950, soon after Houston's departure, she reported that the Canadian Handcraft Guild money had already been used up and, in early 1952, that both stone and ivory were in short supply. Furthermore, Hinds encouraged crafts development by working on methods for tanning skins and for using natural dyes to enhance woven-grass baskets. She is only one of the many outsiders who encouraged the Inuit to create carvings and other crafts but whose influence cannot be measured and is seldom acknowledged.

In Coppermine the teachers were energetically involved. Douglas Lord was the first government teacher there, and did his utmost to develop production and marketing of carvings and other crafts. As an instructional aid, Lord used Jenness Report on the Material Culture of the Copper Eskimo. The pictures in the report were shown to the people with the suggestion that they try and make models of the implements that were used in the past. Lord explained: "This was done with the idea that any talent present would be revealed. To a certain extent this proved to be the case, however, some who were good at reconstructing hunting and other material equipment were poor at other forms of handicraft as revealed by later developments. A great number of inferior articles flooded in as the idea of making some 'easy' money seemed to take hold...."[10] As the project began to flourish, Lord worried about its implications: "The program should be carefully controlled as it is often so hard to make the Eskimo understand our view of handicrafts.... The emphasis should be placed on the spare-time aspects of handicraft and the native urged to bring his handicrafts into the Post as he does with his fur."[11]

In most communities, the only regular feedback received by carvers was from the local trader, whose personal taste dictated the price received. Houston wrote the booklet Eskimo Handicrafts

on part of the initial grant from the Canadian Handicraft Guild. It was intended to provide further guidance to Inuit artists and any administrator, policeman, missionary, or trader who was in a position to influence production. The introduction stated: "This pamphlet... is the first of a series to be published in Eskimo for the people of the Canadian Arctic, to encourage them in their native arts. It is hoped that these illustrations will suggest to them some of their objects which are useful and acceptable to the white man. These suggestions should in no way limit the Eskimo. He should be encouraged to make variations and introduce new ideas into his handicrafts."[12]

The pamphlet was illustrated with examples of handicrafts already produced and included a number of pieces from the permanent collection of the Canadian Handicraft Guild. Examples included woven-grass baskets, sealskin slippers, model tools, cribbage boards and other games, cigarette boxes, and carvings. A caption in Inuktitut syllabics accompanied each illustration. These comments are quite explicit. For example, "The three bears show some of the ways they may be carved from ivory or stone. Often a bear and a small cub are worth more-or perhaps a man with spear hunting the bear"[13] (fig. 3).

Houston had a strong, positive effect on art activities wherever he travelled in the North. His skills were equally effective in the South, where he promoted the art with energy and enthusiasm. Largely through his efforts reports of Inuit art events appeared in newspapers and magazines. More and more collectors came to look but stayed to buy.

The huge interest generated in the North, coupled with indiscriminate purchasing policies, soon began to cause problems. By the fall of 1952 the Canadian Handicraft Guild was overstocked and overextended.

Production of carvings and other handicrafts on the east coast of Hudson Bay and Baffin Island had increased dramatically. The Guild alone received $8,000 worth of Inuit handicrafts in their 1951 shipment, and more than doubled that in 1952 when they found it necessary to call a temporary halt. Under these circumstances the Houstons were recalled from Cape Dorset to undertake market development, which they did with their usual energy. Among their important contacts was the American Eugene Power, who established Eskimo Art Incorporated and introduced Inuit art in the United States through a program of sales exhibitions.

Increasing Government Interest

Government officials did not make grants indefinitely to the Canadian Handicraft Guild. It would be more satisfactory to

Fig. 3. A page out of James Houston's booklet Eskimo Handicrafts. The text in syllabics reads as follows: "Man throwing harpoon, or spearing through ice, dog, walrus or seal. If they are carefully carved and polished the kaloona [white man] will buy them." Courtesy of the Canadian Guild of Crafts, Montreal.

ᐊᒍᐱᒋ ᕲᐅᕲᐊᒍᐊᑐ ᓂᐸᒍᐊᑐᒥᓗᓂ
ᕿᒍᐳᓂᑦ ᐃᕿᕗᓂ ᕿᐃᕗᓂ
ᓴᕲᕐᒪᕪᐊᐸᐸ ᕿᐳᕐᒪᕪᐊᐸᐸ
ᕿᓗᕲᕪᐅ ᓂᐅᐸᕗᒋᐊᕪᐃᐳ

Fig. 4. Father and Son by Akeeaktashuk, Inukjuak, 1954. Collection: Winnipeg Art Gallery, Winnipeg. Courtesy of La Fédération des Coopératives du Nouveau-Québec.

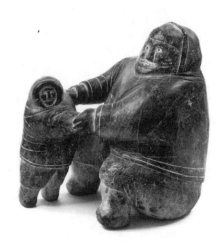

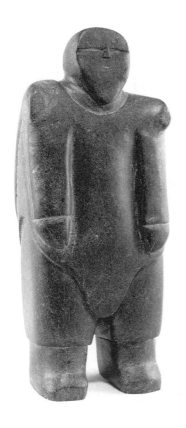

Fig. 5. <u>Women</u> by Francis Kaluraq,
Baker Lake, 1964. Photo: Paul von
Baich. Collection: Canadian
Museum of Civilization, Hull.
Courtesy of Francis Kaluraq.

Fig. 6. <u>Standing Man</u> by Davidialuk
Alasua Amittu, Povungnituk, 1955.
Collection: Toronto Dominion Bank,
Toronto. Courtesy of La Fédération
des Coopératives du Nouveau-Québec.

employ Houston directly, using his services and talents to promote handicraft manufacture and sale as well as to develop other local industries in the Arctic.

This government decision to become directly involved in handicraft development was part of a growing concern for more effective administration of the north. In December 1953, the Department of the Interior was renamed the Department of Northern Affairs and Natural Resources, reflecting the increasing emphasis being placed on northern concerns. Under the direction of newly appointed Deputy Minister R. Gordon Robertson, a vigorous support programme for Inuit art was established. A programme of Inuit art exhibitions was linked to cultural/informational activities of Canadian consulates aboard. The department owned only twelve contemporary carvings at that time. To support the exhibition programme, extensive purchases of Inuit carvings were made over the next few years, usually from the Canadian Handicraft Guild or the Hudson's Bay Company. These early purchases became the foundation of two important public collections: those of the National Museum of Canada and the present Department of Indian and Northern Affairs (figs. 4, 5). The initial purchases were exhibited in January 1955 at the National Gallery of Canada and then circulated to galleries and museums in the United States. A larger collection was circulated in Europe.

Marketing

Marketing of carvings remained a problem that government officials were anxious to solve without becoming directly involved. In 1955 agreement was reached on a new marketing strategy. The Hudson's Bay Company would purchase carvings at the posts and ship the carvings out to their Winnipeg warehouse. There the cases would be divided, half being sent to the Canadian Handicraft Guild in Montreal. The Guild would then act as middleman for all distribution in the West. In addition, both agencies would continue retail sales in their stores. The new alliance was an uneasy one. Department officers entered into seemingly endless negotiations to ensure the satisfaction of everyone concerned.

Influence of the Hudson's Bay Company

Hudson's Bay Company policy determined overall production and buying patterns. However, individual Hudson's Bay post managers had a tremendous influence on production, quality, and pricing. Managers' views sometimes differed considerably, and carvers must have been frustrated and confused when managers were transferred. In Povungnituk, especially, carvers were strongly influenced by a series of strongly opinionated catalysts. Houston, on his early visits, had delighted in imaginative, creative works of art (fig. 6). "Shorty" Tinling disapproved of the carvings he found upon

taking over as post manager in 1950. He wrote, "one of the first chores I performed was to dump several boxes of small poorly made carvings into the sea. Then I began buying carvings which I thought would appeal to the average public."[14]

Peter Murdoch who later took over as manager, who also outspoken in his opinion of what made a good carving. He insisted on carefully finished polished, detailed pieces and sent back carvings he disapproved of for "finishing"[15] (fig. 7).

Meanwhile, a new category of civil servant was established. Northern Service Officers were sent to Arctic communities as administrators of government policy. Among their duties was the encouragement of handicraft development. Houston was anxious to live in the North for an extended period. He proposed to the department that he be sent to Cape Dorset as Northern Service Officer, but with the special task of establishing an arts and crafts centre. This would be a centre for carving in the first place, but also a place to produce functional mosaic-topped tables and whaleskin lamps.[16] Of special importance for the future were his ideas on printing and printmaking. He hoped to obtain a small surplus printing press with fonts for use in Cape Dorset. The Inuit would be trained to turn out books, pamphlets, cards, and posters. Houston suggested: "In the beginning I would like to concentrate on the reproduction of their art, using soapstone blocks etched by hand, inked and the impressions taken on paper. I feel that these reproduced as Christmas cards, gift wrapping paper and in book form would be immediately saleable and would pay for the labour and materials. In the first year we would attempt a book of, perhaps, 60 pages with drawings and text, short stories and songs, recounting the life of the people and their history as told be themselves.[17]

Houston was especially hopeful that printmaking might become a successful enterprise. Experiments in producing stencil and stonecut Christmas cards led to limited-edition printmaking. Houston sent the first examples south at the end of April 1958 (fig. 8). Houston even travelled to Japan to expand his repertoire of woodblock printmaking techniques. After his return to Cape Dorset this knowledge was used for stoneblock printmaking. The oriental-style chop mark used to identify artist and printer is still employed in Cape Dorset. Houston left Cape Dorset and government service in 1962. His contributions are legendary and he is justly considered the founder of modern Inuit art (figs. 9, 10).

1960s - ORGANIZATION AND CONSOLIDATION

The federal government directed an astonishing amount of energy and money into northern development during the 1960s. Economic

Fig. 7. Peter Murdoch in conversation with Tamusi Tulugak of Povungnituk Cooperative in 1985. Courtesy of the Inuit Art Section, Indian and Northern Affairs, Ottawa.

Fig. 8. Walrus on Ice-floe by Kanaginak Pootoogook, Cape Dorset, 1958. Courtesy of the West Baffin Eskimo Cooperative.

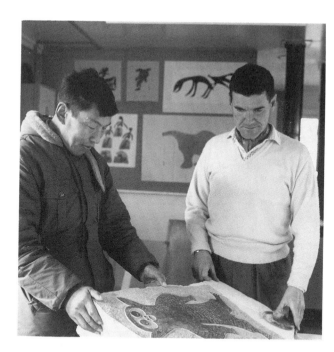

Fig. 9. James Houston and Pauta Saila in the Cape Dorset printshop in 1961. Courtesy of the Inuit Art Section, Indian and Northern Affairs Canada, Ottawa.

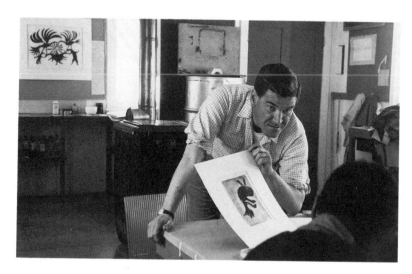

Fig. 10. James Houston in the Cape Dorset printshop in 1962. Courtesy of the Inuit Art Section, Indian and Northern Affairs Canada, Ottawa.

development projects of all sorts were attempted and Arts and Crafts Officers sent to areas identified as suitable for arts and crafts projects. These recruits usually had no northern experience and faced very difficult conditions. Promised buildings were not in place, supplies did not arrive, living conditions were primitive, and they did not speak the language of the people they were to inspire. Communications with the South were by radiotelephone when atmospheric conditions allowed. Travel was impossible during freeze-up and break-down. Added to these difficulties were Southern bureaucratic rules and regulations that caused constant confusion.

Special attention was given to economic development of the Keewatin district, west of Hudson Bay. The inland population had been decimated by the starvation of the mid-1950s. Many of the survivors had settled in Baker Lake, Eskimo Point, and Ranklin Inlet. Arts and Crafts Officers were sent to Baker Lake and Ranklin Inlet. Gabe Gely worked with the Baker Lake artists on a number of possible projects in the early 1960s. Artists such as Makpa and Akanashoonark were encouraged to make the bulky, powerful carvings that became the hallmark of Baker Lake style.

In Ranklin Inlet Claude Grenier introduced pottery-making. John Kavik and Tikeyayuk were among those carvers who turned to creating imaginative clay vessels that were more sculpture that pot (fig. 11). The Ranklin Inlet project provides an example of how even the best-funded of projects could fail. The potters were plagued by problems of poor clay coupled with constant kiln breakdowns. Southern experts differed widely in their opinions about the finished products, and despite a successful Toronto exhibition introducing the work, no market developed. Yet the artists, paid a salary by the project, continued to produce their clay sculpture until the premises filled with unfired work and creativity ran dry.

An example of a very successful project was stonecut printmaking. The first annual print collection from Cape Dorset was presented at a gala opening at the Montreal Museum of Fine Arts in January 1960. The manner of presentation was carefully orchestrated by a team of government officials and ad hoc advisers so that this new form of Inuit art would be controlled from the start. The limited-edition prints were accompanied by a fully-illustrated catalogue. The response was immediate and positive, as art museums and private collectors vied to purchase prints.

The success encouraged ongoing developments in Cape Dorset and formed the basis for the development of the West Baffin Eskimo Cooperative as the major source of Inuit art prints and sculpture in the North. Cape Dorset was a model for success-a group of talented, creative artists, first organized and

encouraged by the energetic James Houston and then led by the young artist, Terry Ryan, it became an independent group of printmakers and sculptors. The model, however, had its stability provided by a strong catalyst/adviser who was hired by the Cooperative and remained in the community. Ryan maintained his links with the Southern art world while settling in Cape Dorset. He became the bridge to the South for the artists (fig. 12).

It is an axiom of Inuit art that upwellings of creative activity occur when and wherever an effective catalyst is in place, and subside when that catalyst leaves. In general the catalysts have usually been especially creative outsiders funded by government.

In Povungnituk, the next community to try printmaking, the Sculpture Society, guided by the local missionary, Father Steinmann, hired an instructor from southern Canada and forged ahead. Gordon Yearsley arrived in the spring of 1961. In just three months, forty-eight images were produced in stonecut, stencil, and cast-resin plate methods. A collection of twenty-four prints was marketed in Toronto at the end of July. Those involved with Cape Dorset's successful beginnings were afraid that the haste with which Povungnituk prints were produced and marketed would have adverse effects on collector acceptance of Inuit prints in general. When forty more prints were presented to the newly-formed Canadian Eskimo Art Committee (later called the Canadian Eskimo Arts Council) in November, the Committee suggested that further development was needed. Povungnituk lost patience. Yearsley pointed out that production of arts and crafts in Povungnituk was a matter of grave economic need rather than a question of art, and that the Cooperative wanted a share of the print market.[18] They finally went ahead and marketed their collection.

This dilemma of economics *versus* aesthetics has been a continuing problem. Members of the Council were committed to maintaining an orderly flow of limited-edition, high-quality prints. They did this by acting as a jury for the annual collections, and marking the approved editions with an embossed seal. This mark of approval became a guarantee that these were quality-controlled original works of art created by Inuit. Recommendations of the Council influenced government funding of printmaking facilities, too.

As a result of Cape Dorset's success, an interest in the new art form was aroused in Holman as well. The local missionary and organizer of the Holman Cooperative, Father Henri Tardy, encouraged Helen Kalvak, Victor Eekotak, and others to draw. Father Tardy had little knowledge of printmaking techniques, but understood that some prints in Cape Dorset were made with sealskin stencils. About a dozen sealskin stencils were produced

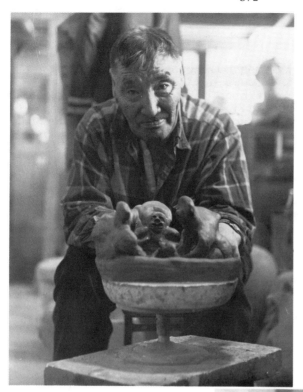

Fig. 11. John Kavik at
work on a ceramic piece
at Rankin Inlet in 1968.
Photo: Claude Grenier.
Courtesy of the Inuit Art
Section, Indian and
Northern Affairs Canada,
Hull.

Fig. 12. Terry Ryan with
Kenojuak Ashevak in 1964.
Courtesy of the Inuit Art
Section, Indian and
Northern Affairs Canada,
Ottawa.

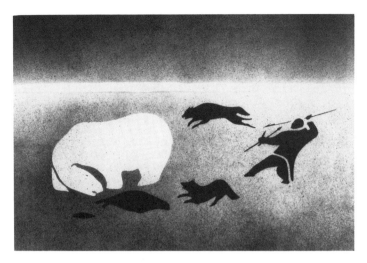

Fig. 13. An early print from Holman, which was rejected by the
Eskimo Arts Council and therefore never published. Photo: Inuit
Art Section, Indian and Northern Affairs Canada, Ottawa.
Courtesy of the Holman Eskimo Cooperative.

Fig. 14. Luke Anguhadluq from Baker Lake, an important camp
leader and, later in his life, a famous artist. Courtesy of the
Inuit Art Section, Indian and Northern Affairs Canada, Ottawa.

at the cost of Father Tardy's entire year's supply of razor
blades. Father Tardy was an adviser who had difficulty accepting
the advice of the Eskimo Art Committee. But with government
funding provided to hire an instructor, Holman artists presented
their first collection in 1965. They have continued to produce
their distinctive style of prints in small annual or semi-annual
collections (fig. 13).

 In Baker Lake printmaking experiments began at this time
also. Several drawings by Jessie Oonark (Una) were auditioned
with Cape Dorset collections of 1961 and 1962. Luke Angosaglo
(fig. 14) was encouraged to draw by the local administrator. But
printmaking attempts during the 1960s were generally
unsuccessful. Not until 1970 did Southern artist Jack Butler
inspire local artists into producing a brilliant collection of
prints. Again there was a need for a strong Southern catalyst.

1970s - LEGITIMIZATION

During the 1970s concerted efforts were made to ensure that Inuit
art was accepted as an important Canadian art form. Exhibitions
were shown in major public museums and sales galleries held solo
or group shows.

 Conferences of Inuit artists were organized and individuals
were brought South to attend the openings of their shows. The
work was presented as the creative effort of an individual rather
than the anonymous product of an amorphous group of northern
Natives.

 Following the successful 1967 Centennial Celebrations,
Canada experienced growing nationalism and national pride. Inuit
art became a perfect medium to show that Canada was not only
different from her southern neighbour but world-class in art
production. The trend was to show individual, signed artworks as
distinct from "souvenir" or "tourist" art.

Sculpture Inuit Exhibition

The decade began with the internationally circulated exhibition
Sculpture Inuit: Masterworks of the Canadian Arctic. The show
was organized by the Canadian Eskimo Arts Council, funded by the
Department of Indian and Northern Affairs, supported by the
National Museum of Man and the Department of External Affairs,
and curated by a superbly suited ambassador for Inuit art Sharon
Van Raalte. The exhibition travelled to Vancouver, Paris,
Copenhagen, Moscow, Leningrad, London, Philadelphia, and Ottawa.
Among the more than three hundred pieces included in the
exhibition were precious carved artifacts dating to prehistoric
Dorset and Thule cultures, examples of small ivory trade items of

the historic period, and a selection of masterpieces carved since 1950. The archaeological and historical pieces served to make the exhibition acceptable to institutions like the British Museum and the Musée de l'Homme. In addition, they provided a background to the contemporary work and appeared to legitimize it as a continuation of a long tradition.

The manner in which the exhibition was presented ensured that the work was taken seriously. The pieces were borrowed from important public and private collections. The exhibit design enhanced the work beautifully. Care was taken to identify the artists of the contemporary work and to have artists present at each gala opening of the exhibit. Media coverage was extensive. Sharon Van Raalte, coordinated all arrangements in person, travelling so extensively that a suspicious Royal Canadian Mounted Police was led to question her about her repeated trips to the USSR.

Conferences

The Ottawa showing, at the National Gallery, was accompanied by a conference of Inuit artists representing all areas of the Arctic. This "Week of the Inuit" was intended as a forum for artists to exchange views with each other and with those who promoted and sold their work. It was followed by other conferences and workshops with varying themes. All made the attempt to communicate across the cultural barrier. I was a participant or observer at many of these meetings. They appeared to do little to increase understanding on either side. Instead, they demonstrated the gulf that separated the artists from the promoters and collectors of their work.

Two examples come to mind. The Cooperatives on Baffin Island were asked to select their best carvings for an exhibition/sculpture conference sponsored by the Canadian Eskimo Council in Frobisher Bay. Delegates from the communities met with Council to discuss the work. The overall quality of the pieces submitted was disappointing. Council members were especially critical of one indifferent carving from Lake Harbour. The Lake Harbour delegates were dismayed, protesting that the artist was old and nearly blind and had done the best he could.

At a conference for Inuit craftswomen held in Toronto in 1973, the women were introduced to a tempting array of new craftmaking possibilities. They were obviously delighted to try spinning, weaving, pottery-making. They were enchanted by the crafts from around the world on display in the World Crafts Council exhibit In Praise of Hands. But their discussions centred on the need to have their sewing machines repaired without delays of many months, or the need for day-care, or for better insulation in their houses. The women could not turn

their attention to new craft possibilities when problems central
to their family lives were not resolved. The conference
organizers could not help with practical problems and had no
influence on political issues.

Marketing

Sculpture Inuit served to stimulate the market for Inuit art.
The work of those artists included in the show was especially in
demand. Canadian Arctic Producers responded by setting aside the
work of these and other talented artists for solo or group sales
exhibitions at galleries specializing in Inuit art. Southern
entrepreneurs, however, began to compete with the cooperatives
and established marketing agencies by buying work from the
artists. Government tried to stem this trend, and its employees
in the North were sternly admonished not to assist the
entrepreneurs by becoming their agents.

Other problems arose when the elitist approach of Canadian
Arctic Producers in identifying and separating out more talented
artists was shunned by the Fédération des Coopératives du Nouveau
Quebéc. Carving was treated as an income-producing occupation
like any other. While the Quebec position more closely matched
the surface realities of Inuit art production, there is no
question but that the creative spark had been damped down there
through the egalitarian process, and also by the insistence on
uniform "standards" of what made a carvings greeted the visitor
to the Lévis, Quebec, showroom and warehouse of the Federation.
Nevertheless, by the end of the decade, the gulf between the
talented artists and the second-rate carvers was well-established
and accepted by both marketing agencies.

Inuit Art Section

Inuit art lacked strong institutional support at this time. The
Winnipeg Art Gallery had a strong interest, and the beginnings of
a major collection, but limited funds. National Museum of Man
Director William E. Taylor would have liked his museum to become
a centre for Inuit art. Other pressures prevented such a
commitment. Only the Department of Indian and Northern Affairs
had the interest and resources to establish a support programme.

Department administrator Gunther Abrahamson was the main
facilitator behind the Sculpture Inuit exhibition. Following its
success he revamped the small exhibition/promotion programme of
the department's Inuit Art Section. Staffing changes brought in
people with museum and art-history backgrounds. I was brought in
as section head from the National Museum of Man, where I had
worked on the exhibition programme in general and the Sculpture
Inuit show in particular.

As in the 1950s, attention was given to collection and exhibition. Now, however, priority was given to identifying and collecting major works of art and exhibiting them in public museums and galleries, Wherever possible, the more important exhibitions were organized by the Inuit Art Section as joint projects with Canadian art museums. The People Within: Art from Baker Lake featured the work of six artists and was organized in cooperation with the Art Gallery of Ontario in Toronto. The retrospective show The Inuit Print was a joint project with the National Museum of Man. Inuit Art in the 1970s was circulated by the Agnes Etherington Arts Centre of Queen's University, Kingston.

These joint ventures were encouraged for two reasons. First, exhibition of the work of Inuit artists by these galleries placed it in the mainstream and provided a validation that could not be achieved by exhibits in other public spaces, not by exhibits seen as primarily government-sponsored. Second, curators of these institutions were often interested in Inuit art, but lacked sufficient knowledge to organize an exhibition. The department provided the expertise and an excellent collection, as well as funding. The hope was that these exhibitions would encourage collection and further exhibition of Inuit art by these museums and galleries.

The other main thrust of the Inuit Art Section was to establish a photo library/documentation centre for the use of researchers. This was a massive and expensive undertaking but again served to show that Inuit art was worthy of serious study.

Research

One person who encouraged Inuit art research was George Swinton. He had a passionate interest in Inuit art and communicated this to his students at the University of Manitoba in Winnipeg and at Carleton University in Ottawa. Several of these students continued their interest in Inuit art and later worked professionally in the field of Inuit art. In the early 1970s Swinton's Eskimo Sculpture (1965) and a few government booklets were the only readily available publications on Inuit art. By the end of the decade numerous well-researched exhibition catalogues and several monologues on individual artists had been published.

1980s - MATURATION

The 1980s were the decade of maturation of Inuit Art. Evidence of this maturation process was found in the increased interest taken by major Canadian public art galleries. Especially significant is the fact that the new National Gallery of Canada

includes Inuit art in its permanent exhibitions.

This new interest was due partially to major donations to these art museums by collectors of Inuit Art. The National Gallery of Canada, the Art Gallery of Ontario, and the Agne Etherington Art Centre, Kingston, all received substantial collections. Both the donation and the acceptance of such private collections showed the maturity of the art form. In accepting the gifts, the institutions committed themselves to caring for and exhibiting the works. More important, they publicly recognized Inuit Art as an art form worthy of art-historical attention. The donors had been passionate, even obsessive collectors for many years. Their collections had enough depth to record the changes in Inuit Art over time. Institutional acceptance of their collections gave the ultimate validation to their collecting habits.

Further evidence of maturation was found in the existence of a second and third generation of artists. In some communities it is not unusual to have two or three generations of artists in the same household. The hunters and seamstresses who began carving or drawing in the 1950s and 1960s were artists who remembered and recorded a traditional Inuit way of life. But there are younger artists who translated that image in new intellectual and emotional ways. The more successful artists maintain a strong link with their land and culture. Pangnirtung graphic artist Thomassie Alikatuktuk uses his art to express his feelings about his relationship with his land and his culture.

He finds that his art suffers if he spends too little time on the land (personal communications). Another young artist, David Ruben, is an exception in that he is well assimilated in southern Canada. His major work has been done in Vancouver and Toronto. Yet he appears to be using stone sculpture as a means to explore his cultural roots, to forge a link. His subjects are those of the culture in which he was raised but no longer lives.

Aliva (Ali) Tulugak of Povungnituk is a second-generation carver of considerable talent. He likes carving legends best and sees himself filling in the gap left by the death of Davidealuk. He returned to the land for a few years as a way of sorting out his life after returning from living and working in Montreal. From his experience in learning to carve and learning to survive on the land he found the importance of skills in working with one's hands. He suggests that young people should learn to carve, even if just as an activity to keep them out of trouble, because what they learn with their hands can be put to use in sled-making or harpooning, or any activity that is useful when they are away from the village. In the 1950s carvers used the skills learned in making hunting implements to carve images in stone. Ali's suggestion is a startling reversal of that process.

Inuit art seems to have come full circle.

CONCLUSION

This capsule history of government patronage of Inuit art illustrates a few of the many successful and unsuccessful ideas and projects tried over forty years. It especially reveals the depth of government involvement. The individuals responsible for formulating or carrying out policy were high-energy people who cared passionately about their tasks. Their critics were equally opinionated.

It was against this background that Inuit artists created the carvings, drawings, prints, and tapestries that record their culture for the pleasure of ours.

NOTES

1. William E. Parry, <u>Journal of a Second Voyage for the Discovery of a North-West Passage</u> (1824; rpr. New York: Greenwood Press, 1969), 24.

2. <u>Ibid.</u>, 173.

3. Department of the Interior, <u>1927-1928 Annual Report</u> (Ottawa, 1928).

4. <u>Public Archives of Canada Documents</u> (PAC) 108: 255-1. Memo from D. McKeand to R. Gibson dated 1/3/39. (All documents have RG85 as the call number.)

5. <u>PAC</u> 108: 255-1. Letter from R. Gibson to Howard Reddick dated 8/3/40.

6. <u>Northwest Territories Archives Documents (NTA)</u> GNFA 1/797: A255-4-5. Letter from R.B. Tinling to Nelson Graburn dated 2/1/69.

7. <u>PAC</u> 108: 255-1. Letter from H.L. Keenleyside to G.S. Currie dated 11/17/49.

8. <u>PAC</u> 108: 255-1. Letter from R. Gibson to G.S. Currie dated 1/19/50.

9. <u>PAC</u> 1040: 21755. Welfare Reports from Margery Hinds dated 7/52 and 8/52.

10. <u>PAC</u> 1279: 255-1. Report from D.B. Lord dated 5/7/52.

11. <u>Idem.</u>

12. James Houston, <u>Eskimo Handicrafts</u> (Montreal: Canadian Handicrafts Guild/Department of Resources and Development, 1951), ii.

13. <u>Ibid.</u>, 31.

14. <u>NTA</u> GNFA 1/797:A255-4-5. Letter from R.B. Tinling to Nelson Graburn dated 2/1/69.

15. <u>PAC</u> 486: 255-4-4. Memo from H.V. Piddington to F. Symington dated 23/7/57.

16. <u>PAC</u> 678: 225-5/166. Proposal from J. Houston dated 11/55.

17. <u>PAC</u> 318: 255-5/166. Memo from J, Houston to B. Sivertz dated 27/12/55.

18. <u>PAC</u> 521: 255-3-3. Letter from G. Yearsley to R. Phillips dated 14/2/62.

THE AESTHETICS OF INUIT ART:
Decoration, Symbolism and Myth in Inuit Graphics;
Material, Form, and Space in Inuit Sculpture;
The Context of Modernism and Postmodernism

by

Gerhard Hoffmann

In spite of all influences of Western technological civilization and the dominant role of Euro-Canadian-American culture, the subject matter of Inuit art is the primal experience of a nature-oriented people and the mythical world view.[1] After at least forty years of radical change in Inuit life, this clinging in art to the indigenous tradition is a remarkable fact that bears no simple explanations and therefore has been the object of much speculation.[2] The same is true for the sheer amount of artwork produced. As many critics have remarked, the economic incentive does not suffice to explain the mobilization of so much talent among the Inuit for artistic activity. Art has been produced of a quality far greater than that required for the White tourist. Any explanation of these phenomena must go beyond Inuit culture and take into account a general pattern of cultural interchange that many cultural critics have recognized; the interrelation and simultaneous assertion of sameness and difference in the interstices of cultures. The ethnologist James Clifford, in his recent The Predicament of Culture,[3] has argued that since the 1920s the hegemonic power of the dominant Western civilization has forced the peoples of the Third World to create their own identity and that, conversely, their resistance has forced Western civilization to revise its claim to universality. This circle of influence and counterinfluence is also recognizable in the Inuit art movement. Inuit artists – like North American Indian artists, though in different ways – are reasserting Inuit identity by fictionalizing or rather aestheticizing the Inuit past of primal experience. The acknowledgment by the White art market that the Inuit artist has indeed succeeded in producing important art propels the movement forward. This art is now developing according to its own aesthetic rules.

This essay has three parts. First, it analyzes Inuit graphics, their unique combination of decoration, symbolism, and myth and the reasons for the appeal of Inuit prints and drawings to the Western mind. Second, it attempts to interrelate the primal quality of Inuit sculpture[4] with aesthetics, more precisely, with the aesthetics of sculpture. It examines the possibilities sculpture has developed in the twentieth century, in modernism and postmodernism, and uses Western sculpture as a frame of reference for Inuit art. The central source of Inuit art is seen to be the primal mind and its expressionistic spirit. The third part of the essay shifts the focus from the artwork to its reception in the art market and, concentrating on Inuit sculpture, attempts to isolate the many facets of its success in

the dominant Canadian/Western culture against the background of
modern and postmodern art trends and the tastes of the public for
the sensuous, the "natural," and the primal.

DECORATION AND SYMBOLIC STRUCTURE IN INUIT GRAPHIC ART AND WESTERN AESTHETICS

Problems of Definition

In discussions of Inuit art, terms like decorative, symbolic, or
mythical are generally used indiscriminately, without much regard
to historical changes in their meaning and without much attention
to the relations that might exist between them. A clearer
definition of these terms would make for a clearer analysis of
the elements of meaning and their blending in the individual
Inuit artwork; for they often overlap. Indeed, the special
interrelation of the decorative, the symbolic, and the mythical
might be said to give Inuit graphics (and often Inuit sculptures)
their specific character.

Quite generally speaking, decoration, structure, symbol, and
myth may be understood as conceptual models, as frames of
reference or meaningful classifications. Such models express the
basic need of human beings to impose order on chaos and the void.
Being modes of perception, decoration can be characterized as the
"perception of order," symbolism as the "perception of meaning,"[5]
and myth as the experience of cosmic identification; they can
undergo manifold combinations and permutations. As Inuit art is
made for the commercial art market and depends for its evaluation
on the White collector and critic, the appreciation and
understanding of its decorative and symbolic traits depend on the
attitudes and the interpretative approach of the recipient and on
the underlying Western, especially modern and postmodern,
"allegories" of interpretation and signification, which again are
subject to change.[6]

Evaluation of Decoration

In the history of art and artistic taste, decoration has been the
subject of much controversy, at least since Winckelmann attacked
its irrationality and lack of meaning.[7] The different ways of
perceiving decoration in the nineteenth century - both negative
and positive - resurface in the current debate, or serve as a
background to it. On the one hand, decoration is universal:
"There is no tribe or culture which lacks a tradition of
ornamentation."[8] On the other hand, decoration is subject to
changing tastes. Thus, as art developed into a separate concept
in the more complex civilizations, tension arose between art as
structure/ expression and art as *decoration/formal play*.

Decoration is created by an interplay of points, lines,
planes, colours, and forms. The resultant relationships between
these reveal both continuity and discontinuity. Continuity and

discontinuity express themselves as consistency of form, and this consistency of form may be called *rhythm*. The rhythmic momentum may be created by repetition and variation, or it may result from more complex arrangements – forms like straight or curved lines, circles, spirals, or figures; and it creates patterns of reciprocal effects between figure and ground. The rhythm is temporal and spatial at the same time. It expresses the elementary fact that experience is an interaction of temporal and spatial configurations. Being, so to speak, the "inner form" of decoration, rhythm is the mediating link between surface order and depth structure. Thus decoration can become the basis of *expression*.

In the second half of the nineteenth century, William Morris noted a break between art and decoration, or art and craft, and felt that "the handcraftman, left behind by the artist when the arts sundered, must come up with him, must work side by side with him."[9] This led to a levelling of the distinctions between high art and craft in Art Nouveau (Jugendstil), where the decorative element blossomed. Modernism's faith in ornament is linked to a faith in pure form, in the objectification and autonomy of the medium that characterized all modern art in the wake of Impressionism. Oscar Wilde,[10] Maurice Denis,[11] and Paul Signac[12] associated decoration with the psychological plane, with synthesis and universal validity. These are the parameters that later, right up to the postmodern era, defined the positive value of decoration as such, or the positive contribution that decoration can make to art via its rhythmic patterns. Gauguin's reference to the "expressive powers of suggestive colour" and Signac's comment that "the painter becomes a poet, a creator by subordinating colour and line to the emotion that fills him"[13] show the beginnings of the *expressive element* that was to combine with the decorative element and finally dominate the aesthetic definition of modern art – to a point of an expressive deformation that made objects and motifs into mere expression marks. These in turn, in the eyes of postmodernists, often assume a decorative character – an object lesson in how conditions of perception change. A psychological explanation of the link between decoration and expression in terms of *simplicity* is provided by <u>gestalt</u> theory, which identifies a perceptional preference for simple combinations (of lines and planes).[14] These elementary forms may be standardized geometric shapes that in a very general way express human culture – for example, the dominion of the intellect rather than of nature – and form the basis for symbolic, magical, or mythical thinking.

When the decorative element turns into pure abstraction, it may, as suggested by Oscar Wilde and Maurice Denis, reflect a greater tendency to transpose reality onto the intellectual plane and thus make it obey the rules of structured design. Modern abstract art made use of the dynamics of decoration, but the last thing it wanted was to be merely decorative. However, to the extent that the decorative element obeys formal principles and creates rhythmic patterns in time and space, decoration can be

employed in modern abstract art to produce and express aesthetic meaning. The central position occupied in modern art by rhythm and its link with the spiritual (Gauguin, Matisse, Kandinsky) indeed marks decoration as a factor in the meaning-imparting aesthetic structure, the "mythical inner construction" (Marc)[15] of a work of art. So does the recognition of "good" decoration as the basis of symbolic structure by the Abstract Expressionists in the United States after the Second World War. Frank Stella said, "My main interest was in making what is generally called decorative paintng really viable in a clearly abstract idiom."[16] In a process of "memories, association, nostalgia, legend, myth," these artists now turned to "pure" formal means in order to evoke "absolute emotion."[17] This particular school of painting (for instance, Gottlieb, Pollock, Newman) chose to reuse - now on the basis of the elemental expressiveness of pure form - the concept of the mythical, at first influenced at least partly by their fascination with the art of the American Indian and the Jungian concept of the Collective Unconscious. The belief that the "configuration of the sensuous moment" (decoration) could be made transparent to the "spiritual facets"[18] or the archetypes of the unconscious by formal means, i.e., symbolism, remained viable, indeed was the basis of the painters' argument. For the evaluation of decoration, the interaction of the decorative and the expressive constitutes the central frame of reference. This is the *modern* context in which Inuit graphic artists started their career in the art market in the 1960s and in which they had a surprising success - surprising because they did not tend to abstraction, because they did not express absolute emotion, and because their relation to the mythical was full of "memories, associations, nostalgia, legend, myth", elements of their indigenous traditions that at least at that time were a part of their lived experience of immediate memories.

The Decorative Element in Inuit Graphic Art

Inuit graphic art is decorative in many of its aspects; the decorative traits, however, can take on highly suggestive connotations and become symbolic of the elementary dimensions of life and reach into the mythical realm of primal experience. It is hard to say which of these elements or combination of them is responsible for the success and aesthetic value of Inuit prints and drawings. Inuit graphic art is based on simple, recognizable motifs depicting everyday life: journeys over land, water, or ice; social occasions like feasting, games, and dancing; activities like hunting and fishing; animals, fish, and birds; myths and legends, shamanistic activity such as human-animal transformation; and many aspects of the spiritual world, with its wealth of connotations. The pictures combine mimetic and imaginative, narrative and decorative elements. The melding of these elements is grounded in a unique aesthetic with a specific formal repertoire.

The composition of Inuit graphic art emphasizes two-dimensionality in its use of line and contour, and shows a

preference for balance and symmetry.[19] The clear compositional
structure is characterized by sharply defined forms and figures
whose size often reflects their relative importance (Parr,
Davidialuk Amittu, Mark Emerak). The organization of the surface
elements may be serial, a collection of individual images (Joe
Talirunili), or it may emphasize central focus and symmetry
(Pitseolak Ashoona, Pudlo Pudlat, Myra Kukiiyaut). Almost
always, though, it is characterized by a rhythmic interplay of
line and form, figure and ground, positive and negative, shaded
and unshaded, patterned and unpatterned areas (Parr, Pitaloosie
Saila, Jessie Oonark, Lipa Pitsiulak) as well as by contrasts
between black and White (Juanisialu Irqumia), clear primary
colours (Luke Anguhadluq, Oonark) or, more recently, by nuances
of colour and shading that indicate contour more through subtle
gradations of colour than through the use of line (Myra
Kukiiyaut, Tommy Nuvaqirq, Elisapee Ishulutaq). As in Indian
art, though in a different way, contour lines are of utmost
importance to the design, even when used in combination with
bright colours (Pudlo Pudlat). They also convey a sense of
volume and three-dimensional form. Central perspective is rarely
used. Instead, perspective is marked by placing forms side by
side, or one behind the other, on the surface; the use of various
viewpoints, for example as a result of turning the paper while
drawing, and the juxtaposition of different perspectives, destroy
the illusion of realism. In the case of stonecuts, the texture
of the stone often lends a tactile quality to the print. The
outer edges of the stone are incorporated into the composition,
with interest occasionally added by syllabic inscriptions. The
edges and corners of the stone plates act as a frame for the
pictorial elements, which are generally sharply contoured and
often provide a ground line as well (Talirunili).

The compositional elements frequently consist of large,
simplified areas that provide room for a multiplicity of
straight, curved, and angular lines engraved into the surface to
suggest the natural markings of fur or feathers; they represent
invisible phenomena like wind, cold or sound (Josie Papialuk),
and depict land forms or bodies of water (Pudlo Pudlat), thereby
creating playful or eccentric decorative patterns on the surface
(Josie Papialuk, Pitseolak Ashoona, Parr, Pudlo Pudlat,
Talirunili). However, the composition may also consist of many
small figures scattered over the surface, which are subordinated
to the overall design (Talirunili). The fact that the figures
are almost always shown frontally or in profile makes them two-
dimensional and amenable to stylization and decoration.
Experiments with body forms (such as faces: Oonark, Simon
Tookoome) and items of clothing (such as the *amautik* of the Inuit
woman with its ample hood) offer possibilities for stylization
combined with realistic detail and abstract, geometrical
composition (Pitseolak Ashoona, Emerak, Oonark, Elisapee
Ishulutaq).

The effects of the formalization of the design are: (1) the
de-dramatization of the daily struggle for survival and

distancing the pictorial and narrative content from a purely realistic depiction; and (2) emphasis on the two-dimensionality of the image in the interplay of figure and ground (Kenojuak Ashevak). The term "decorative realism"[20] has been used, for instance, to describe the work of Josie Papialuk. The combination of stonecut (with its emphasis on line and its incorporation of the surface markings and natural contours of the stone at the edges of the picture) and stencil (which emphasizes areas and gradations of colour) offers endless design possibilities in addition to the wealth of variations inherent in the subjects themselves, and thus makes possible highly individualized styles combining elements of decoration with narration and symbolism. The interplay of line, form and colour, in conjunction with the content of the pictures (usually some sort of activity), expresses the vitality, *energy*, and strength, the spontaneity and directness of a past life that the Inuit people, in the face of profound cultural change, may look back upon as a simpler, less complicated existence. However, the representation of this past life can only be in aesthetic terms, and the *aesthetic* expression of this life-feeling results in highly decorative works. The seeming contrast between content and form - between the existential directness of the subject matter and its decorative, indirect aesthetic representation - is precisely what gives Inuit graphic art its aesthetic quality.

In order to elucidate the function and effect of the decorative surface treatment in much of Inuit graphic art, it is helpful to recall the formal aspects and criteria of decoration that determine the aesthetic and thus the expressive quality of this art. Essentially, decoration is formed by the organizing structure of points, lines, and forms. Colour complements point and line. It does not change the basic constituents of decoration, but furnishes another medium for the variability and intensity of the design by rivalling form, line, and contour for dominance. Patterns are created through repetition, variation, central focus, symmetry, and dynamization; they result in *tensions between the individual and the whole* in an interplay of continuity and discontinuity.

If consistency and symmetry are the dominant factors of the decorative pattern, the emphasis is on an integrating *whole*, forming the basis for a meaning-imparting symbolic structure that can point to a pervasive, underlying spiritual content. The decorative pattern may also, however, concentrate on the perception of order arising from the linking of continuity and discontinuity. Rather than creating an interpretive, intrinsic context of wholeness to which each individual element is directly related in a symbolic manner, the decorative pattern may establish associated narrative or design-dependent relationships between the individual elements and figures that "merely" form a collectivity or totality of the individual parts (with no underlying ideal whole) and, despite the stylization, linkage, and transformation of separate bodies, always preserve the concreteness and thus the *independence of the individual element*.

It is this second approach that applies to much Inuit graphic art and creates its style of non-hierarchical seriality also in cases where, as for instance in the work of Pudlo Pudlat, the subject is not the primal experience, but rather contemporary reality and changes in the Inuit way of life. This decorative surface treatment can also approach abstraction, for example, in Pudlo's animal studies or Kenojuak's bird prints. By removing the realistic aspects of the motif (a process which need not detract from its recognizability), the individual creature too is integrated into a design totality marked by the abstractness or stylization of the decorative pattern and thus "emptied" of its significance as a creature of nature. But though in some cases formal design wins out over nature, actually subdues it, this may correspond to a heightening of connotative potential and symbolic richness.

A number of questions present themselves. Is decoration in Inuit graphic art "merely" a perception of order, or is it transformed into a perception of meaning (into symbolism). If it is a perception of meaning, how can a serializing matrix achieve a totalizing aesthetic integrity, a structure in which every particular detail is related to the whole; and what would this whole (which would not be an essentializing whole in the Western modern sense) look like? The answer lies in the special sense of relationship that is created by the ornamental pattern.

As has been mentioned, there is a contrast between the subjects depicted: on the one hand, the extreme conditions in the Arctic environment (with its vast emptiness marked by the large negative surface in White) and the elemental and existential life situations of the Inuit; and on the other, the seemingly light-hearted, non-essential decorative treatment arising from the artist's selection, combination, and contextualization of his subject matter, reflecting a distancing, playful approach. To be sure, the memory of a harsh and difficult existence, which formerly had meaning in and of itself, might have been de-existentialized in hindsight and romanticized to appeal to the White public's nostalgic wish to return, at least in the imagination, to nature and its elemental living conditions. Yet such a "merely" outer-directed simplification of a complex matter could scarcely be the foundation for the aesthetic quality of the picture. There is more to the contrast between decorative form and existential content. This decorative, non-centralized, and non-existentialized order now indeed becomes symbolically expressive by representing an insight, a world view, and, paradoxically, an existential situation of a nomadic people facing life on a practical level without expectations of security or permanence.

The contrast between content and form, (extreme) situation and (decorative) interpretation - the discontinuity of the code of signification - reveals an attitude of *humorous detachment* that affirms the multiplicity and diversity of life in spite of, or perhaps because of, its elementary, irreconcilable, and

threatening contradictions. The relics of a certain fatalism
acknowledge the incomprehensible and uncontrollable nature of the
universe, the dangerousness of life, and death as a giver of
life, and merge with a resignatory or submissive casual seeking
to follow the rules of the spirit world but otherwise concerned
only with today and tomorrow. The transfer of these experiences
into aesthetics makes possible an attitude of detachment, humour,
and irony recognizing that life is too important, too short, and
too fragile to be jeopardized by unnecessary thoughts, abstract
concerns, and intellectual turmoil. It is a nature- or life-
oriented, not a man-oriented aesthetics. Form is not
anthropomorphic as it is in Western art, where it consumes
figuration and space in the infusion of the ideal and the real.
In Inuit art, space has its own formative role to play, opening
up possibilities of linkage and transformation. Life emanates
from both the figures' forms and the surrounding white space, the
two still unsystematized, unessentialized by man. It is a *mythic*
world view that here comes to the fore and establishes in the
aura of everyday subjects the primal context of an animate
universe, an unbroken continuity of space and time, a balance
between culture and nature.[21] Nature, of which man is an
integral part, is the ultimate authority. What is symbolized by
the decorative perception of order is the principle of permanent
transformation, the fact that everything is in transition, and
that the "essential" spirituality is *energy* that arises out of
contrast, contradiction, and *struggle*, the struggle between
consistency and inconsistency, symmetry and nonsymmetry,
similarity and dissimilarity. It is graspable in life and
expressible in art as *rhythm*, whose base is the decorative
pattern.

What was once the magical power of the shaman, activated and
controlled by his "technique of ecstasy,"[22] now, like other
objects, images, and figures of myth in art, becomes a symbol of
vital principle, the mutability and spirituality of the universe.
Or, to put it the other way around, that which is spontaneous,
vital, and dynamic in Inuit art can now be better understood, in
mythical terms, as arising from the primordial shamanistic
understanding of nature as energy, force, power, and mystery.
The apparent contradiction between the decorative style of these
pictures and the elemental situation of danger and bitter
struggle for survival frequently depicted in them (or at any rate
forming the backdrop to them) can be seen in relation to the
traditional Inuit spiritual understanding of the world. The
decorative element in Inuit art then would be an expression, on a
purely aesthetic level, of respect for all life and a way of
exercising magical or rather enchanting power that harkens back
to an earlier time of mythic-shamanistic thought when decoration
was fully integrated into the cultural context.[23]

The fact that shamanism is no longer a powerful force now
makes the decorative, vitalistic representation of shamanistic
motifs in Inuit art possible. Yet differentiations have to be
made. The Inuit artist thematizes the shaman and his

transformations as well as other magic shamanistic actions as motifs, because Christianity and the secularizing effects of civilization have freed the artist from the taboos of an older belief that caused fear of, not faith in, the supernatural powers. In spirit the artist harkens back not to the shamanistic, that is, the elitist and fearful, but rather the pre-shamanistic or all-shamanistic, ideal stage "at the very first times," when in the words of an Inuit woman, "both people and animals lived on the earth, but there was no difference between them."[24] At this early "equalizing" stage, every person could "shamanize" (Eliade) without effort, though art then did not exist outside the religious and cultural context. Such a naïve pre-shamanistic attitude also shows in the lack of the reflexiveness and distance that are eminently important for the modern Western aesthetic imagination. This attitude is also evidence in the symbolism of Inuit art, which, generally speaking, exhibits an operational fusion of the real and the artificial element in art, but readily establishes the emotional/cognitive identity between creator, created artwork and its viewer. This is an important difference from Western symbolism, which at least since Romanticism (in theory since Hegel) places discrepancy within the fusion of idea/ideal and concrete gestalt.

Inuit artists depict a situationally-oriented world with the days serially connected and a continuity that leads from one to the other, transcends boundaries, and makes for completeness; though even in cases where modern means of transport like helicopters and skidoos, or Christian motifs, are incorporated into the design (Pudlo Pudlat, Mark Emerak, Jessie Oonark) the figurations remain "singularities," parts of a totality that is not defined in ideological, technological, societal, or organizational terms. Accordingly, the concept that comes to mind to describe the aesthetic surface treatment is not structured wholeness but *completeness*, and its determining factor is meaningful decoration. In the words of Kenojuak Ashevak, "I lay down more parts, until all of a sudden I look at it and say, well, it is complete; that's it."[25] This completeness is a *"horizontal"* sympathetic relating of the human beings, creatures, or things depicted.

Changes of Meaning in the Process of Reception

For the modern viewer this completeness, which is openness, plurality, and interrelation, can attain a new and different *symbolic* quality. In the *modernist* understanding of art, there is, in spite of all interrelations, layerings and ambiguities, a *discrepancy* between surface and depth, decoration and expression, which is made to serve symbolic intentions; the symbolic message of art is brought out only indirectly, through form and its *tensions* or ambivalences. Thus a modern viewer may well discern in Inuit graphic art, with its tension between form and content, an additional symbolic reference, a sort of understatement (as in Hemingway's "iceberg technique," in which one eighth of the

expression is on the surface while the other seven eights are below it) or decorative overstatement (as in Faulkner's baroque style), depending on the method and viewpoint. Both understatement and overstatement are art codes that refer to something hidden and unexpressible. (The same holds for the aesthetic composition, elegant poses, and decorative surface treatment of many Inuit sculptures from Cape Dorset). What is perceived by the recipient in a modernist view is the representation of an attitude, and a deep intricise, the acknowledgement and the depiction of a network of *elemental* relationships.

For the *postmodern* viewer, there is a change in the conditions that influence the reception of decoration, and this change gives the Inuit graphic styles another basis of appreciation and support. The decorative treatment in Inuit graphics of subjects that in themselves are not at all decorative is supported by the domination in contemporary culture of the interpretational paradigm that holds there is no such thing as a reality, situation, or action *per se*, but rather that the world is determined by "perspectivism" (Nietzsche); that the difference between appearance and being, fiction and reality, is not clearcut; that it is only the interpretation of the situation that creates the situation and therefore no one interpretation can be more "real" or more valid than another. This gives decoration a new validity and diffuses symbolism. Furthermore, a new importance is gained by what has been called - either disparagingly or approvingly - the new ethic of pleasure (as opposed to a moral imperative). Deriving its authority from a growing awareness of plurality, the ethic of pleasure has led to a rediscovery of fun and enjoyment in art. Fun and enjoyment imply a certain mixture of familiarity and surprise. The arising tensions and the bridging of tensions in the depicted unfamiliar/familiar situations and their formal treatment provide both familiarity and surprise in Inuit art. The viewer's imagination is stimulated by the narrative depiction of contradictory elements and their decorative interpretation, and the transparency of the "rules" of this decoration, but above all by the fact that the best Inuit artists work on many levels of meaning, the primitive and elemental, the decorative and beautiful, the symbolic and mythical, in a continuity of perspectives none of which excludes the other - just as no state of existence excludes the other.

THE AESTHETICS OF SCULPTURE AND INUIT ART

Sculpture develops in the interplay of object and space.[26] In our context the possibilities of relating object and space are the more important since the specific way in which form and space relate defines Inuit art in its singularity. Yet aesthetic evaluation demands the transcendence of ethnic labels. The aesthetics of Inuit sculpture can only attain sharp contours in the context of other sculptural possibilities, especially those

of modernism and postmodernism. Comparisons have been made
between Keewatin art (John Pangnark, John Kavik, Lucy Tasseor
Tutsweetok) and Brancusi, Moore, Giacometti and other modern
artists, comparisons that demonstrate that Inuit art belongs in a
wider context, beyond what has been called "primitive," "naïve,"
and indigenous or "Native" art. It should be emphasized at the
outset that no Western influence on Inuit art is suggested.
There is no such influence in a more closely definable sense,
though, of course, White advisers and the art market have had a
certain impact that has tended to foster some approaches more
than others. Modern and postmodern art concepts and styles have
had no important direct influence on Inuit sculpture, yet
determine the climate in which the reception of Inuit art in the
art market takes place.

The affinity or nonaffinity of Inuit sculpture (and also
Inuit graphic art) with modern and postmodern cultural trends
will be discussed in the third section under the aspect of
reception aesthetics. A few remarks, however, may establish the
sculptural possibilities that the twentieth century developed as
a context for the placing of Inuit sculpture and its treatment of
material, form, and space. The aim of the first modern sculptors
was to liberate sculpture from purposes that were alien to it:
from any representation of what is fleeting, illustrative,
sentimental, anecdotal, or social. These aspects were replaced
on the one hand by the immediacy of the *material* and on the other
hand by creative *construction* - which also brought forth its
negation, nonconstruction, seemingly chance arrangement. The
guiding notions were *authenticity*, *genuineness,* and *elementarity*,
the elemental qualities of both material and subject. The aim
was to bring out what is essential in human beings, while
respecting what is essential in the material and the form. Rodin
was the first to experiment in this modern sense with the
possibilities of monolithic form, but a long tradition of
monolithic expressive figures goes back to the Renaissance.

The interplay in sculpture between the human body as subject
matter and the material as monolith provides various
possibilities for the *reduction* of "realistic" representation,
for instance by contrasting figure and material in the way Rodin
contrasted the smooth surface of the modelled body or head with
the mass of the crude stone and its surface (as did Michelangelo
in his unfinished slave sculptures). Or the form of the human
body itself can be reduced or, better, simplified in its
attributes, spotlighting only its fundamental traits, its
structure, so to speak. Thus the form of the figure approximates
more closely the elemental quality of the material. Matisse
created series of bodies that disappear more and more into the
material in successive stages. In addition, the process of
reducing the depiction of the human body can also be carried out
as a formal abstraction. Here reduction takes place through the
artist's instinct for form; material is subordinated to form for
the sake of bringing out the essential formal elements. Either
the human body is transformed into essentializing shapes and

constellations of forms, as with the Cubists Archipenko, Laurens, Lipschitz and Zadkine, or the sculpture may take on biomorphous or geometrically simplified, ovoid, tubular, or cubical forms that point to the wholeness of nature. Arp and Brancusi exemplify this.

In all of these instances, space surrounding the sculpture is negative space, it does not contribute creatively to the sculpture's form. This principle is changed with the sculpture of the Surrealists. With Henry Moore or Giacometti, in their early work, or, in some cases, Max Ernst, *positive space* became an important factor. In the Surrealists the structural nature of the monolithic figure dissolves by virtue of the merely associative, fantastic, or dreamlike links between the parts. The surrounding empty space itself becomes involved as a positive, expressive fact. The balance between form and space can, of course, tip toward *space*. Then the monolithic block and the human figure no longer constitute the sculpture's starting point; instead, the starting point is the space in which and with which the artist constructs the sculpture. The individual work of art as something that is structured and centered within itself is not what is important; rather, what is important are the dynamic *relations* that are established between the individual parts of the sculpture, between the parts and the "whole" (which no longer needs to be a whole), and between both these elements and the space that surrounds them. Calder's mobiles and stabiles are exemplary for the utilization of space as a setting in motion of processes in which a totalizing, universal principle of wholeness can still be perceived in the principle of movement.

Postmodern sculpture, on the other hand, which in most cases is not really sculpture but rather *assemblage*, *environment*, takes space as its point of departure. It often abandons the human theme and uses objects as structural materials in space to make the material itself and space the theme. It forgoes the (organic) autonomy and the auto-significance of the work of art, but rediscovers the associative potential of nature and the archaic traces of the past. The artwork can now only establish its traditional artistic claim to give meaning by articulating or, rather, revealing in the formal design spaces of displacement, of absence, the radical "other" and fields of possibility, making the sculpture into something "in between" positions and focusing on relational effects. This is the point where a new mythical view enters postmodern art - a view that is quite naturally present in Inuit art as the outflow of a primal mind. In Western postmodern art, however, it is constructed as an alternative to exhausted culture in order to fill the spiritual vacuum. One of the most interesting artists in our context is Mario Merz, because he uses as connotative medium the emblem of Inuit culture, the igloo. He produces igloo sculptures of glass and other materials for the representation of Western nomadic existence. For Merz the igloo is the "primordial image of the mythical tent." But he, like other postmodern artists, seems to find it impossible to concentrate on one of the available organic

unities or social collectivities; thus he "quotes" old archaic forms, layers and combines various natural and cultural systems of coordinates - such as the form of the hemisphere, the material of broken shards, light from neon tubes, written characters, and arrangements of numbers (the Fibonacci series) - in his various igloo arrangements.

Inuit sculpture also uses material, form, and space in an anti-traditional manner. It takes a different tack from modern and postmodern sculpture; it touches on modernist aesthetic principles of structural unity and also on postmodern aesthetics based on the de-construction and reconstruction of the reality principle, the decentralization of man and de-legitimization of functional reason.

Inuit Aesthetics: The Prevalence of the Situation

The aesthetic of Inuit art gives primacy to the subject matter, not the form: it bases itself on the primal experience and the mythical world view.[27] The "deep structure" of Inuit art, correlating with the basic elements of the primal experience and the mythical attitude, is the *unity in multiplicity* of all aspects of life, of the material and the spiritual, of transitoriness and permanence, fixity and fluidity, in short, the linkage of the one with the other and the *transformability* of one mode of existence into another. The concrete manifestations of such an attitude show man and all living creatures *within* nature; *life*, not man, is the most general horizon of meaning to which everything points. This has formal consequences for Inuit art. Its singular aesthetic form might be called a *situational* orientation, one that does not show the single figure in isolation but rather in its connection to the environment.

The comparison with classical sculpture clarifies the specificity of Inuit sculpture. Classical sculpture represents in the human body the Platonic unity of body, soul, and mind; the sculpture shows the oneness of beauty, goodness, and truth. In Keats's words from the <u>Ode on a Grecian Urn</u>: "'Beauty is truth, truth beauty,' - that is all Ye know on earth, and all ye need to know." The outer shape is structured according to the "inner form" (Goethe), and the inner form is symbolic of the "ideal" (Hegel), the "truth of the heart" (Hawthorne) and the truth of the mind.[28] The material of the sculpture, its surface, its texture and colour, and the mass and volume of the stone have no value of their own, do not extend into space; stone and space do not act as complementary creative forces that, as it were, "complete" the inner form. In such a form- and man-dominated art world, the animal has no independent place as subject matter. And inanimate material in itself, of course, has an even lower status, serving, at most, decorative purposes.

In Inuit sculpture, form is not "free" as in Western art, where it "consumes" material and space in favour of the man-defined idea or ideal that is incorporated in form. It is, so to

speak, not turned "outside in" but "inside out." The Inuit
sculptor does not work according to preliminary drawings that
give his ideas shape and direct the stone-work. George Swinton
has a point when he says that the Inuit artist's "responses are
physical, sensuous, tactile, and intuitive. The material
suggests the subject matter which in turns suggests the form."[29]
John Tiktak has remarked, "I do not think out what I will do. My
thought comes out, while I work. My work expresses my
thought."[30] Whatever is first, the idea or the stone, the
important thing is that a "dialogue" takes place between carver
and his material and that this dialogue is processional and
direct and stresses the mass and volume of the material, thus
also expressing the strong relationship of the Inuit to the land.
The land in its dominating immensity as the Infinite, but also as
a precarious source of nourishment, is included in the feeling of
togetherness that defines all of Inuit existence. It is the
basis of the subject matter and the artist's self-assertion in
art.

The finished artwork is then composed of material elements
that retain their material character and together with the
subject matter also express themselves, the independent, material
object. Though the form of this art object may be flat or round,
symmetrical or asymmetrical, mimetic or fantastic, "realistic" or
abstract, it accentuates undifferentiated masses, bulky rounded
planes (that, for instance, turn into the "rolling 'landscape' of
a mother's body"[31]), almost geometrically pure shapes, gentle
curves, soft contours, smooth surfaces, and the decorative effect
of incised lines. They all establish a kind of contrastive
harmony between material and form and contribute to a feeling of
spatial stasis and stability. Space (and the material things it
contains), as Cassirer remarked, is the most fundamental
dimension of the mythical world and life in general,[32] and it is
for Inuit art the most important element. The head is often
small compared to the body, and the body in its rich volumes and
broad planes is at rest; the plastic form adds weight to weight,
or sets weight against counterweight and often extends the
complex of merging forms in all directions, thereby creating a
visually balanced, but still vital composition. And as the
single-figure form is spatially situated, so is the multiple-
figure form; it is not hierarchically structured but additive,
that is, spatially oriented in its composition, which has its
overall theme in togetherness, mother and child, human and human,
human and animal/bird or animal/bird and animal/bird. The body
form is not independent, it is related to the other and to the
stone that is always physically and conspicuously there; the same
holds true for the surrounding space that is the foundation and
expression of life and the natural elements. Stone and space are
the two basics of Inuit art, "in between" is form. The art form
interprets nature; it changes nature into art, but it makes the
unformed material and the surrounding elements part of the form.

For example, the bodies of muskox, bear, seal, and owl in
Inuit art are both self-contained and "open" to environmental and

spiritual forces; they rest in themselves, start a temporal
sequence, and ultimately are bound into the cycle of time. Time
is cosmic and cyclical and part of space, and space participates
in time. Time and the natural elements are present in their
absence in the surrounding space. Without them the animal and
the human being are not "whole." In many Inuit sculptures, it is
as if "the Arctic wind blows over the tundra," signifying "a life
that comes and goes."[33] The wind indeed blows in the pelt hair
of the muskoxen by Nooveya Ipellie (Iqaluit); and Margaret
Uyauperq Aniksak's Woman with Fishing Pouch and Two Fish "braces
herself against the wind."[34] The extreme weather conditions
under which the Inuit and Arctic animals live are often present
as physical evidence, the heavy clothing, the tilted parka of a
woman, the postures of resistance and interplay with the
surrounding space, but also in the impassive, stoic facial
expression, all of which bear witness to the confrontation with
nature and the drama of survival. People actually appear "to
listen" for "messages in the air" "as the wind blows," for "it is
important to understand the elements."[35] The depiction of
everyday Inuit activities, the mother nursing her baby, carrying
it in her amautik, cleaning fish, stretching a skin over a frame,
all these motifs imply space, nature as environment, not shelter
and social surroundings that are different from nature.
Transformation marks and thematizes the fundamental
interconnections. The natural elements are spirits; humans,
animals, and spirits change into one another.[36]

Transformation is the opener of form, the transformation,
for instance, of the shaman into a bear or a seal, and vice
versa. It is the "in-between" status that often attracts the
Inuit sculptor, a situation where he can show both forms, the
human and the animal shapes combined, the bird on top of a man's
head or a woman's feet turning into a seal. Formally there is a
tendency to add to the main figure extensions or appendages that
turn into the form of the caribou carcass carried on the
shoulder, the mother's baby within the amautik or on the lap or
in the arms, the baby bear and baby owl or spirit helper;[37] these
extensions unclose the compact volumes and stone planes in order
to merge them anew, make the contours more intricate, and
complicate the continuous rhythm of the piece. Since rhythm is
the life-principle, the piece gains with the formal tensions and
the balancing of force and counterforce vibrancy, vitality, and,
most importantly, a radiating spirit beyond its formal limits so
that even resting animals/birds appear to rest only momentarily
before moving away and starting anew.[38] Finally, the combination
of different materials breaks up the unifying surface and instils
tensions of otherness that again are bridged by subject, form,
and rhythm. All the "openers" together lend ambivalence to the
form, and ambivalence opens the situation.

The openness of form also shows in the human figure,
especially in the faces and the eyes. Their expressions, of
course, vary. Human faces in Inuit art often appear like magic
phenomena out of space or the carved form,[39] as subjects with

shamanistic power, or frightened objects in the power of outside
forces, or both, as in the shamanistic transformation pieces from
Spence Bay and Gjoa Haven; or they radiate a quiet balance of
energies as in pieces by Karoo Ashevak (Spence Bay) and Davie
Atchealak (Cape Dorset).[40] With David Ruben (Paulatuk/Toronto)
this balance already has the serenity of a self-contained person
and approaches - not always for the better - the facial
expression of eighteenth and nineteenth century Neoclassical
sculpture.[41] Not reflecting an inner emotional or intellectual
life, the faces of many Inuit sculptures resemble masks directed
toward the outside, the eyes looking beyond the horizon, the
mouth often open, chanting. The faces (and the eyes) may be of a
material different from that of the bulk of the sculpture. They
are set into large stones in which they would be lost except for
the difference of material (Mattiusi Iyaituk, Ivugivik); here
they "belong" to the mass/volume/shape and yet form an "opening"
at the same time.[42] In a larger composition, faces with the eyes
wide open and a staring gaze may give focus to the organic shapes
of a piece of whalebone (Judas Ooloolah, Gjoa Haven)[43] or centre
more or less complex transformation arrangements with human and
animal figures (Abraham Anghik and David Ruben).[44]

Groups of faces or columns of heads may grow out of the
stone, as in works by Mary Akjar (Arviat), John Tiktak (Rankin
Inlet), Lucy Tasseor (Arviat), Luke Anowtalik (Arviat), or Simon
Tookoome (Baker Lake),[45] indicating the unity of the organic and
the inorganic, soul (face) and body (stone), man and environment,
and thus emphasize the basics of transformation, the material and
the spiritual and their interrelation. For the outcropping human
heads or incised faces, the stone acts as a natural base, just as
the surrounding space acts as a natural medium for the elements
and thus as a frame for the fully shaped figures of animals or
humans. The strong impression the group-head pieces make, their
stark expressionistic effects, result from the double framing of
the human signatures by the stone and the surrounding space, from
both of which they emerge. The tension between the
human/spiritual element, represented in the heads and faces, and
the material/spatial frames, diminishes the importance of the
individual, as do the serializing of faces and heads, the
vertical or diagonal "chain" effect, and the spread-out pattern
of incised faces and figures, in favour of the communal and the
material/spiritual basis, nature. This is quite different from
the figures in modern art like Rodin's that seem to be imprisoned
by the material and strive to escape. In the network of
relationships of opposition, correlation, and analogy, in a
"magical system of sympathetic correspondences,"[46] man claims for
himself "no paramount position in the hierarchy of all that
is."[47]

For "placing" and "extending" the sculpture, the eyes are of
central importance. The eyes of the owls by Osuitok Ipeelee give
the bird, in addition to its natural characteristics, a
mysterious dimension of its own that bears witness to the
mythical oneness of the material and spiritual.[48] The inlaid

eyes made from different material, set in the bone or stone compositions of spirits and shamans in sculptures by Karoo Ashevak, Judas Ooloolah, and Maudi Okittuq,[49] serve to disembody the figures and place them in an undefinable area "in between." In these pieces the face and the eyes are often oversized, the mouth open with teeth showing prominently, the voice chanting or screaming. The expressiveness of the facial features dominates the body and the whole composition, often in the process of transformation. The single human figure, or mother-and-child image, from Baffin Island and the Keewatin district mostly integrate the face; with eyes looking into space, it is a part of the body, and the latter is balanced in its form by the strong texture and colour of the stone. The strong material element gives the rhythm of line, colour, and shape quite an independent and dynamic play, not abstracting from the human figure, but bestowing on its realism an additional non-human note in the surface of the stone and its interface with surrounding space and the Arctic elements.

Inuit sculpture does not represent the inner in the outer in a kind of vertical reference from the surface to the essence of "depth," but refers the one to the other *horizontally* in nature. The "waiting" attitude of the human and animal figure strengthens the opening of the piece to the continuum of space and nature (Nooveya Ipellie from Iqualuit, Barnabas Arnasungaak, and Peter Sevoga, from Baker Lake and Joe Talirunili from Povungnituk). And so does the playful spirit of the dancing bears by Pauta Saila and Davie Atchealak, and the dancing walrusses by Aqjangajuk Shaa (Cape Dorset). The posture of the animal figures takes on a shamanistic-transformative, unveiling and veiling, quality. Pauta himself said, "I think and feel that the bear has a spirit to be put into the carving,"[50] and he explains that "his bears have shamanistic implications because of their powerful neck."[51]

The balance that Inuit sculpture represents is expressed in figurative form. Unlike modern and postmodern art, it is an unreflected situationally determined balance. The figure, human or animal, alone or in a constellation with others, always appears as both subject *and* object of the situation in a world defined by solidarity of experience. The open form also explains why the Inuit sculpture is *serially* oriented, why one single animal or human figure extends into the next one seamlessly – into a small child, animal, bird, or, bridging the surrounding space, in a group. Open space is no hindrance and does not existentially separate one sculpture from the next, again unlike Western sculpture, where every artwork has its individual and essential identity in itself. The Inuit sculpture "connects," as does the print. As Claude Lévi-Strauss has said, in expressions of the primal mind a system of correspondences enables every sphere to be linked horizontally with every other, no matter how distant, either diachronically, through time, or synchronically, through space.[52]

Narrative in Inuit Sculpture

The fact that the represented situation is open and relates to the other, that it implies transformation and joins nature and the universe, extends it also into narrative. Narrative is interpretation. Situationally oriented and ordering events, persons, constellations, thoughts within the indefinable flux of time, narrative marks the openness, multifariousness, infinity, and ambivalence of life, its contradictions, struggles, and conflicts.[53] In sculpture, the plastic form "situates" a story and the story-building process is a primary code for the interaction between sculpture and viewer. In viewing sculpture, for instance, Joe Talirunili's boat with people (<u>Migration</u>) or Kiawak Ashoona's <u>Howling Spirit</u> or Lucy Tasseor's <u>Group of People</u>,[54] one wonders how the situation continues and changes. The paradoxical fact that the timeless causes the time - bound to emerge is the central characteristic of narrative in sculpture. The "silent form" (Keats) and the absence of the cause-effect scheme stimulate the imagination, a thinking not in actualities but possibilities. These, however, in the representation of primal experience in Inuit art, are actual possibilities in nature. In Western sculpture the sculptural meaning is anthropocentric, in Inuit sculpture *physiocentric*.

This means that in Inuit sculpture narrative connects figure and space. The struggle goes on between man and nature, man and animal, man and man. Narration thus comes in everywhere, not only in story scenes of hunting or domestic activities. It can also create connections below the level of existential boundary situations without having to stress outer event or human action. In primal experience everything is *struggle*.[55] Struggle can be depicted *statically* in the "closed" or, rather, composed compact form before or after action by giving it the aura of "waiting," of openness for the next step;[56] or *dynamically* in motion (as in many recent pieces) but always in the relation between the sculpted form and the surrounding formative space, which acts both as the potentially other (in terms of time) and as the surrounding and inclusive whole. By dramatizing the figure/space continuum, the time element and the narrative dimension can be accentuated. The emphasis on time (and motion), since it is second to space, almost always indicates a later phase of development.

There are a number of recognizable steps in the development of styles in Inuit sculpture that follow, so it seems, the space-time logic. George Swinton's assessment is surely correct: "Essentially, the sequence begins with the crude stage (which often is mistakenly called 'primitive') followed by refinements that lead into two areas - naturalism and formalization."[57] Naturalism here indicates an increasing ability and inclination to represent humans and animals in "natural" proportions, outlines, and postures, and formalism marks the growing importance of form; but the two terms require more specific differentiations. A certain logic of development can be

described in terms of space, time, and attitude without claiming a definite and irreversible temporal sequence.

One important change in "spatial" style is the replacement of flattened figures typical of the earlier carvings "by bulky, fully rounded forms, whose surfaces are more smooth and highly polished."[58] The mother-and-child sculptures by Kaka Ashoona are an example.[59] Another possibility of "acquiring" space is the spreading out of the arms of the figure, as in Lucassie Ohaytook's <u>Hunter with Raised Arms</u>[60] or the legs, as in Willie's <u>Standing Man</u>. The spreading of the owl's wings or of the four legs and the head in Charlie Kittosuk's <u>Polar Bear</u> and the addition "serially" of other beings, as in Tudlik's <u>Kneeling Man and Dog</u>, achieve the same result.

In a second logical stage, the time element is activated in more dynamic form and the emphasis laid on movement. One step is here the twisting movement of extremities or the head out of a restful mass. The lengthening of the neck, as in Osuitok's <u>Kneeling Caribou</u> or John Kaunak's <u>Stalking Bear</u>, or of the whole figure, as in Solomonie Tegodlerrak's <u>Caribou</u>, heightens by distortion the expressive element and, through the expressionistic gesture, the dynamics of the piece. Then the movement passes through the whole body, as in Bernadette Iguptaq's <u>Drum/Dancer</u> or Kavik's <u>Somersaulting Man</u>. Sculptures like <u>Man with Child on the Shoulders</u> and <u>Dancing Caribou</u> by Aqjangajuk Shaa or pieces by Osuitook Ipeelee supply examples for how the massively carved forms are ingeniously arranged around a central axis and balanced by weight and counterweight to stand on a small base.[61] Here the dynamic image acts out into the surrounding space and starts a sequence in time.

Now, time and space can be distorted; and indeed, as Marybelle Myers has said, the "angry young men" placed between the old and the new way of life introduced in many communities at varies times in the sixties an "abstract phase," or rather an anti-realistic phase that produced mythological pieces: "Overwhelmed by the untenable present their art, naturally enough, tended to reflect an essential disharmony - weird conglomerates of tentacles, eyes and dislocated members called, variously, 'abstract,' or mythological."[62] Though these carvings were not very saleable at the beginning, the great success of the carvings from Spence Bay and Gjoa Haven has demonstrated that in accordance with a wider variety of interests in the contemporary art scene, a wide variety of subjects and art styles in Inuit carvings also became desirable. More will be said later about this broadening of interest.

The Storyteller

Time also constitutes the story; and the story creates mythical order, especially the creation or origin story. The story is the product of the mythical imagination roused by fear or, rather, "ancient awe" (Scott Momaday). Induced by the mythical experience

of the numinous powers, stories in fact are transformations of fear into a form of understanding; they transfer the direct experience of mythical spirituality into aesthetic form. They organize experience through time and keep its concrete situational shape. According to Cassirer, the "process of mythical apperception" takes place in "stages of objectivation," and he distinguishes three phases, which are marked by space, time, and number, in that order. Space is the "ground moment" of mythical thought in so far as mythical thought "has the tendency to transform all differences it sets and grasps into spatial differences and to visualize them in this form," and also because the orientation in time presupposes the orientation in space. This means that the first intuitive experience of the numinous powers has its origin in spatial-sensuous appearances in which the creative forces of the universe take their form in certain images and gestalts, while thereafter "the divine explicates its being and its nature in time, where the constitution of mythical figures and gods is followed by narratives about them."[63] Tales of myth thus constitute a later phase of the "mythical apperception" and assume an explanatory function. In art they are retransformed into a spatial state of aggregation.

Sculpture, by freezing a moment and the openness of the before and after, has a natural affinity to the moment of mythical experience and often concentrates it in the dance motif, which in the figure of the dancing, chanting, and drumming shaman (as in Kiawak or Kaka Ashoona) takes on symbolic function for the "mythical apperception" in general. Telling legends and stories in sculpture (and prints) to a White public is more difficult than in literature, since knowledge of the story is necessary to decipher the details in the image and their meaning. Yet there are ways to overcome this difficulty, by concentrating on a central figure and its double character, for instance, Sedna, the sea goddess, in the shape of a woman and fish. Its riddle status stimulates the mythological imagination even without knowledge of the details of the story. Or the sculptor can concentrate on a fertile moment in the legend, for instance, the story of the blind boy who lived with his mother, was mistreated by her, and, after his eyesight was magically restored by birds, took revenge on her by pushing her into the sea, where she became a narwhale (or, in another version, by having her drawn into the sea by a harpooned whale). Here the fertile moment is, for instance, the restoration of the eyesight by the birds, the mother's transformation into the narwhale, or the moment she is carried away into the sea.

It is interesting to note that even the most modern and acculturated Inuit artists, David Ruben and his brother Abraham Anghik, understand their role as that of storytellers. It is their conscious and "sophisticated" way of relating to their heritage and assuming the role of bridge-makers. The place they come from, Paulatuk in the western Arctic, "is a place of stories. Here a man becomes a bear, a woman is also an owl. Demonic spirits invade the bodies of twins. This is the place of

Sedna the sea goddess and of spirit helpers that accompany both animals and humans. Here a shaman voyages into the night sky and returns bearing White translucent stones to prove that he has been to the moon."[64] Ruben's and his brother Anghik's role is to be a mediator between the old and the new. In Ruben's words: "For at least 14 years I have been travelling back and forth to my home town of Paulatuk. A lot of my storytelling works originated from my trips to the Arctic - listening to the elders like Johnny Ruben and Nora and Evik Ruben and my parents. I have learned the importance of learning about my past and translating oral stories."[65] The result of this listening is the taking up of the *persona* of a shaman. Commenting on a major piece, <u>Spirit World of the Inuit</u>, Ruben says, "An old shaman is telling stories of how the Inuit people, animals and spirit world co-exist. Images of ceremonial masks, animals, and people appear and the powerful bear-spirit supports the whole sculpture."[66] The continuum between material, form, and space is the basis of transition and transformation and the foundation of Inuit aesthetics. It is now consciously thematized, for instance in Anghik's <u>Spirit by the Seashore</u>, which the artist describes as "a composition of birds, whales, seals, bears and spirit figures in a continuity of form and motion, the element of animal and spirits being inextricably tied one to the other in Inuit lore and mythology."[67]

Inuit art in its most convincing pieces produces a synthesis of the nature model and the principle of style, a synthesis that modern Western art also strove for, and which postmodern art has lost because the discrepancy between what one sees and what one knows of the seen has become unbridgeable. Here once again Goethe's (and the modernists') insight proves to be right: the proximity of the art work to nature is the more convincing the more it has "style."[68] Style is here, however, not the circumscribed "inner form," but the interconnection of material, form, and space. For the representation of the totality of life in Inuit art, a small inventory of figures, groups, and relations suffices. Often a single figure situated in creative space is enough. The simple or intricate, static or dynamic Inuit image finds its formal synthesis in *rhythm*, while *narrative* is the connecting principle between the sculpted form and space. If narrative alone is the forming principle of the piece itself, of the depiction of everyday life in a *scene* on a base, the scene paradoxically has a greater closure, opens less to the surrounding space, because it is self-centered and without concern for the surrounding environment. Both rhythm and narrative achieve the fusion of form and content that Hegel made the criterion of art.

There are, of course, ongoing new developments in the style of Inuit art. The stronger dynamic posture in many of the recent pieces has already been mentioned. While experiments with the fusion of space and time, stasis and dynamics, are producing ever bolder and more elegant solutions, further changes have become visible. A tendency towards "modernism" - with its principle of

aesthetic unity, the consciously striven-for interface of form and content - is documented in the work of the brothers Anghik and Ruben, whose Western education, professional training (Anghik), residence in the South, and liaison with art galleries have widened their horizon. Anghik and Ruben have become interested in other Native communities and their art, in Alaska, the Canadian Northwest Coast, and Africa. As a result, they have gained a conscious identification with their own heritage and the artist-as-shaman role, which made them storytellers, continuing to carve in a more conscious way and in larger compositions what the Inuit artists had been carving from the beginning: transformation motifs. The brothers have also turned to an eclectic use of non-Native materials and non-Inuit styles, for instance the contour-defining form line from Northwest Coast art.

Two further developments have taken place within the Inuit art community of a quasi-postmodern nature, one in Cape Dorset, the other in Gjoa Haven and Pelly Bay. Developing certain possibilities of "opening up" the stone that are already indicated in the work of Eli Sallualuk (Povungnituk) and Manno (Iqaluit),[69] Tukiki Manomie from Cape Dorset, with a playful spirit in his experimental pieces, breaks up the stone planes, eliminates the material, creating hollow spaces, letting stand stone ribs that may bear animal and human heads, creating a fantastic web of flowing forms with allusions to the Arctic world. Nick Sikkuark, formerly from Gjoa Haven, now living in Pelly Bay, manifests a playful and humorous touch in spirit figures made out of whalebone. He uses montage methods that emphasize discrepancies in material, style, and expression, showing the great potential that can be activated by a change in attitude, by emphasizing not unity but discrepancy. Emily Illuitok from Pelly Bay, in quite a different style, employs a similar playful spirit and montage method, though her pieces are smaller and more intricate. Employing an aesthetics of opposition, Inuit art leaves its secluded realm and enters the postmodern art scene.

THE RECEPTION OF INUIT SCULPTURE IN THE ART MARKET AND THE CONTEXT OF MODERNISM AND POSTMODERNISM

Tension in Inuit Art: Experience and Aesthetics

The complexity of the Inuit art phenomenon, its astonishing variety and vitality and immediate impact in the South, have been analyzed with various methods, generally examining the conditions of production and the "Inuitness" of contemporary Inuit art. Yet Norman Zepp's statement from 1986 still seems correct: "Although contemporary Inuit art is generally conceded to be somewhere between the arbitrary poles of traditional artistic expression and the art of Western civilization, exactly where cannot as yet be determined."[70] The question is whether this "whereness" is so important, and if it makes much sense to discuss the "genuineness" and "authenticity" of this art[71] at a time when in

the global postmodern, media-dominated cultural scene the
boundaries between reality and fiction, meaning and non-meaning,
high art and popular art, art and environment, structure and
decoration seem to disappear. Like "primitivism," "genuineness"
is a category of the White man; it belongs to his taxonomic
system and changes as the notion of tradition changes.[72] Such
terms define themselves in the ongoing dialogue between the
present and the past and, in the case of Inuit art, between the
mainstream art market and minority art production.[73]

Inuit art, like all art, is a reflection of the time in
which it is created, with a confusing array of influential
factors assuming ever new relations of domination according to
changes in the concepts of art, realism, and truth and the
prevailing interests and modes. At the beginning, the market
defined the artistic importance of Inuit art, gave it a public,
but also used "romantic" stereotyped ethnicity as a promotional
feature, suggesting, in James Houston's words, that the Inuit
artist was "a hunter first, a carver second."[74] Thus the market
emphasized the primal *experience* rather than the aesthetic
expression, though, conversely and illogically, the *economic*
potential was deemed to be there because of the *creative*
potential of the Inuit artists and the artistic substance of
their works. Now the substance of Inuit art is foregrounded.

The art scene and aesthetic notions in Western culture have
become less dogmatic and more varied and complex, bringing forth
a plurality of concepts and standards, thus also multiplying the
criteria that determine the appeal of Inuit art in the South.
Difference now is the paradigm. In order to clarify some of the
issues involved in the reception of Inuit art, a number of
differentiations have to be made to distinguish levels and
aspects of acceptance. In accordance with the singular character
of Inuit art as Native art and its diversity in material,
subject, form, and style, the reasons for its appeal in the
mainstream art market are different. Especially Inuit sculpture,
for reasons that will be analyzed, addresses various levels of
meaning, conscious and unconscious ones, and gives different
people quite different kinds of satisfaction. Some of these
levels of appreciation can be isolated, though in practice they
often fuse. This is one main reason why it is so difficult to
define the place of Inuit art. To quote Norman Zepp again, it is
"between the arbitrary poles of traditional artistic expression
and the art of Western civilization."[75]

The Sensuous Quality

There is one basic characteristic of Inuit stone sculpture that
no one who looks at it can resist: the sensuous attraction of
the stone, its shape, texture, and tactile quality, which invite
the viewer - like the artist - to feel it with his hands. In the
words of George Swinton, "I secretly have an irrepressible urge
to touch and fondle some of these sensuous objects as I used to,
carrying them around in my pockets as objects of tactile

pleasure."[76] What the piece represents, the primal quality of
life, is directly transferred to the recipient by touch (or the
imagination of touch), a primal form of sense stimulation, a
sensuous awareness that comes from the body and reaches the
unconscious. On this basic level, a much more elemental contact
with the sculpture is established than the usual, more "rational"
visual sense could provide. This can also be seen in the context
of C.G. Jung's complaint about the loss of elemental, spiritually
connotative images, which can be directly "felt" in Inuit
sculpture. Here the connotative elemental quality of the
sculpted image with its fusion of the material and the spiritual
is corroborated by the rich sensuousness of the object awakened
in the viewer by the tangibility of the piece. The attraction of
the brilliant, shining surface that has characterized the
sculptures especially from Cape Dorset and Lake Harbour in recent
years has an additional source in the postmodern rediscovery of
decorative elements and material charm. Whalebone and antler
sculptures have a similar elemental appeal, which, however, works
less through touch than through the "organic-ness" of the
material, and its association with nature and the transformative
processes of time. While the high polish and the elegant form of
the Cape Dorset pieces profit from the popularity of the
ornamental, the "rough" whalebone sculptures gratify the
contemporary urge to experience the archaic. In the light of
Minimal Art, one can read the history of art in the twentieth
century as a continuous process of reduction, the end point of
which seemed to have been reached in the sixties and seventies.
The anthropological one-sidedness of this view is now obvious.
It suppresses man's need for the physical and figural/pictorial
and leaves out of consideration the specific
spiritual/intellectual potential of the sculptural or painted
figure. This cannot be replaced by another artistic discourse.
The basic sensuous quality of the material, the tactile level of
contact, and the concrete images satisfy these elementary demands
for "bodiliness." They are the foundation on which the appeal of
Inuit sculpture is built.

"Naïve" and "Primitive" Art

Many Inuit artworks appear to fulfill the expectations directed
towards "primitive" and "naïve" art, though they may go far
beyond such labels in their artistic quality. To see in an Inuit
work of art the expression of a certain naïveté does not
necessarily diminish the artistic quality of the work; such an
approach, however, unduly limits the artistic radius of Inuit art
if naïveté is considered the only source of its aesthetic
quality, as in Sam Houston's estimation: "This naïveté is his
[the Eskimo artist's] true strength."[77] Nobody has pegged
exactly what "naïve" and "primitive" art mean, much less what
their differences are; but critics seem to agree that naïve art
covers work produced by "natural" artists with little or no
formal training who are not in touch with the mainstream art.
This is true of contemporary Inuit art. But at the same time
Inuit artists have a long tradition of carving to look back to

and a common source of primal and spiritual experience. The "inbetween" position of Inuit art is also evidenced by the fact that it does not fit into the category of "primitive" in the sense that the artworks are part of an intact system of indigenous social traditions and religious cult activities - notwithstanding the "myth of the 'great-universal-primitive-Eskimo-artist'"[78] against which George Swinton has rightfully argued.

Contemporary Inuit art is produced by economic incentive for an outside public that has quite different ideas and tastes and buys the artwork for its own, often non-transparent reasons, which include the naïve, primitive, and folk-art appeal.[79] Swinton has correctly described the basic qualities of Keewatin, and, one might add, of much of Inuit art as "simplicity and strength of expression."[80] These formal qualities of simplicity and expressiveness reduce complexity to a simple, resolved shape, often expressing acceptance of life, and they have a high communicative potential. But they are also found in naïve and folk art, which stands out for its spontaneity, freshness, directness, and force of visual revelation,[81] and the energizing quality of fundamental experience. Categories like simplicity and strength of expression are only a beginning for the analysis of the aesthetic structure of Keewatin art and Inuit sculpture in general. Like "naïve" art, Inuit art utilizes simplicity of subject, animals with a "soul" or spirit, and the charm or cuteness of the small form and the miniature figure and narrative scene. But it further transforms them according to the nature of primal experience.

For the White public the primitive, naïve, primordial, and fundamental appeal of Eskimo life comes across in the documentary aspect of Inuit art. But here reception is distracted and transformed by prefabricated romanticized notions of the nomadic life in the Arctic and its wildlife. Thus the reception of Inuit art even as documentation is often determined by non-aesthetic motives and ideologized viewpoints, which do not accept Inuit artwork on its own terms. A popular escape into the vitalism of a simple, "natural" life, coupled with ecological beliefs, finds in the combination of the primitive and naïve, the "romantic" and documentary aspects of Inuit art, a related subject in art. A taste for excitement and sensation "exoticizes" the seemingly naïve and primitive traits of Inuit art. To exoticize something means to banish it to the outer fringe, to push it into an alien and strange irrationality, an unlocalized otherness. Such extrusion intolerant of ethnic differences, indicates merciless exclusion, of which "orientalism" in Western culture over many centuries is a revealing example. It only serves the purpose of legitimizing the authenticity and domination of Western culture[82] in contrast to the (fictionally constructed) inauthentic rather undeveloped other. Change in the other is not accepted.

It is important to note that art pieces of quite different form and quality, also those that fully satisfy the formal

requirements of modern art, communicate on these two elemental
levels of sensuous material and "primitiveness" and "naturalness"
of subject and form, which together arouse a feeling of diffused
excitement and nostalgia for nature and the simplicity of
statement and form. This basic attraction is furthered by the
depiction of the heroic gestures of man under extremely
unfavourable living conditions and the animals' amazing talent to
express just being there, the absolute presence. Everything else
the Inuit sculptures accomplish as art, they do above and beyond
these basics. This does not interfere with their potential as
art. On the contrary, it shows that in Inuit art the elemental
images and sensuous qualities are still intact, while they are
lost in much of Western art. Av Isaacs asserts in his article
"Different Rubrics for Different Artists" that the
distinctiveness of Inuit art, by contrast with works of other
Canadian artists, is instantly recognized by the public and that
"we frequently sell works for $2000 or more to clients who have
never before heard of the artist and who are unconcerned with his
reputation."[83] These buyers may be looking for a satisfaction
that cannot be found in the difficult, radically "negative" works
of the modern Western avant-garde; they may be frustrated by the
directionlessness and disorientation of the contemporary art
market, which has lost its sureties and often seems to offer
arbitrary empty signs without any depth and symbolic relevance;
or they may be exercising a new freedom of choice that is no
longer restricted by elitist dogmas, especially the modern notion
that art must defamiliarize reality (Shklovsky),[84] and readmits
pleasure as a motif in the viewer of art. Pleasure requires a
mixture of familiarity and surprise. Modern industrial society
increasingly lacks the elements of surprise and exertion; the
life of comfort and security is paid for with boredom, boredom
also with art that has lost its excitement. Inuit art, through
its physicality, close relationship to nature, and pre-
civilizational heroism, counters this feeling of *ennui*.

Modern Art and Shamanism

But Inuit art is not cherished only by the unsophisticated or
resigned buyers. The top-quality pieces meet highly
sophisticated modern aesthetic standards, showing the
interpenetration of reality and style, an aesthetic
transformation of the subject expressing content in form. The
focus on the elementary aspects and archetypal energies of life,
as well as the primordial images of nature that provide the idea
of wholeness and thus meaning, correspond to the modernists'
concern with the mythical and the spiritual, the elemental in
nature, and the unconscious drives of man. The transformation
motif and the transformative element in general make the Inuit
artwork ambivalent, an aspect that is central to the modern art
concept.

Critics are aware of the presence of modern qualities in
Inuit art, as can be seen in the fact that Pangnark has been
called "the Brancusi of the North,"[85] that Tiktak has been

compared with Henry Moore,[86] Kavik with Giacometti,[87] and Eli Sallualuk's work with "daliesque surrealism."[88] Although the modern quality is usually attributed to the Minimalists, Reductionists and "Surrealists" in Inuit art, the best Inuit pieces from all regions fulfil the modern requirement of totalizing form and the functionality of all parts of the artwork in the creation of an aesthetic whole.

Yet there are differences. Inuit art does not mirror the human psyche, the modern attempt to gain knowledge, even certainty in an increasingly uncertain relationship to the world. Inuit art does not display the tension between the objective and subjective, ideal and gestalt, identification and reflection that modernism introduced into the symbol. This "opened" the symbol until it became diffused in its reference and meaning to the point that outer reality was only taken as a deceptive surface that had to be deformed in order to make the essence visible. The "expressionistic" element of style in Western art became increasingly obvious and important, even independent of the representation of the object, indeed reshaping or dissolving it. But in Inuit art, even when it becomes minimalistic and reductionist, as in Keewatin sculpture, the expressionist style underlines the "natural." Whatever the style, be it Impressionism, Symbolism, Fauvism, Cubism, or Abstraction, modernism searched, sometimes through the de-realization and abstraction of reality, for the "really" real, the essential below the accidental and shifting surface, and produced an irreversible separation of outer reality and deep structure. No such schism is visible in Inuit art, and no frantic intellectual endeavour or emotional anxiety, whatever the style.

Shamanism

With the concept of the shaman a further dimension opens up that gives the Inuit artist, the Native North American artist in general, and the Western artist a common base of self-understanding. The characteristics of the shaman and his spiritual power can be abstracted and universalized, metaphorized and aestheticized to describe the role of the modern artist. The shaman is in contact with, or rather together with, his spiritual helpers, in full control of the means of transformation because he has insight into the spirituality of the world and respects the laws of the cosmos. There are important similarities between shamanism and the roles the modern artist claims for himself, even though the artist, of course, acts under quite different conditions and has separated art from the cult activities of religious life and made it autonomous. The artist is in full control of his art and the means of transformation and connection, of transforming the concrete into the abstract, the accidental into the essential, surface decoration into meaning-giving structure, but stands in passive humility before the spirituality of the cosmos, which through his work he humbly and painfully, even to the point of being victimized (as is the shaman), attempts to represent in art. Van Gogh quite

consciously has been styled from early on as a modern artist healer, "a primitive against the fragmented world, primitive in all he demands from life, patient, infinitely modest, only not with regard to his artistic effort."[89] One of the path-breaking modern/postmodern artists, Joseph Beuys, saw the combination of social and spiritual functions which he effected, especially in his performance, as practically equivalent to the role of a shaman. With respect to shamanism in his works, Beuys remarked, "I take this form of ancient behavior as the idea of transformation through concrete processes of life, nature and history. My intention is obviously not to return to such earlier cultures but to stress the idea of transformation and substance. This is precisely what the shaman does in order to bring about change and development: his nature is therapeutic."[90]

Quite generally speaking, the notions of transformation and transition in mythical thought and shamanism suit - in different ways - the modern and postmodern intellectual climate; in postwar art, transformation is a dominant theme.

This meeting point between Native art and mainstream art in their shamanistic definition of the spiritual role of the artist is documented by the brothers Abraham Anghik and David Ruben, two Inuit artists with a Western education, and Anghik with professional training in various arts and crafts. They live in the South, have their own studios, and see themselves as professional artists among other artists. Nevertheless they do exclusively "memory art," going back to the primal sources of their roots in the western Arctic. The use of non-Inuit carving material and formal suggestions, for instance, from the Eskimo from Alaska, the Northwest Coast Indians, or the Natives of Africa, show the brothers' pan-primal interests and more cosmopolitan attitude. David Ruben has stated: "With the introduction of modern religion the shaman has slowly disappeared, but they live through the artist in this day and age. Myself and my brother [Abraham Anghik] - we are the extension of that. We are just a tool for somebody else. Some of the sculptures that I create are so powerful - it's as if they are emitting a life force."[91] This reidentification with the shaman as artist, as storyteller, and as healer, is corroborated by Indian artists' identification with the shaman. Norval Morrisseau is the most famous, though by no means the only or a rare example. He quite explicitly understood himself as a "shaman-artist."

Postmodern Culture and Art

Paradoxically, the reception of Inuit art is fostered both by its accord with modern aesthetic dogma, a fusion of content and form, *and* by the exhaustion of the modern dogma, its negative aesthetic. Modern aesthetic dogma offered an *ersatz* synthesis by preserving wholeness in form, negating mere surface realism and "easy" decoration in order to criticize the merely functional surface mechanics of a society that supposedly destroyed all

wholeness together with the identity of the individual. The maxim of postmodern culture and art is pluralism, whose danger is indifference.[92] The contemporary art market is characterized by an aesthetic tolerance that allows respect for the other. As has been mentioned, difference is the paradigm. The breakdown of predetermined structures, the elimination of barriers, the dramatization of (conflicting) relationships, and the influx of primary forms have initiated the rediscovery of the mythical and the archaic and made energy arising from dynamic contradiction the all-encompassing principle of aesthetics. Thus postmodern sensibility creates a favourable climate for the reception of Inuit art with its representation of the energetics of primal experience in primordial images. Inuit art fits into the postmodern scene, because it is not man-centered, because it locates all synthesis in nature. Inuit art sees the shaping *principles* of the world in the combination of duality and wholeness, or wholeness in duality, in struggle and conflict and thus in energy. This allows Inuit art a positive, even playful spirit, far removed from the modern identity-crisis and thus conforms at least in some respects with postmodern de-ideologizing, de-existentializing, and decentralizing tendencies.

This is allegedly a posthistorical age,[93] one for which history is no longer the foundation of being; neither are the dogmas of institutionalized religion. In order to fill the spiritual vacuum, our time is rediscovering its archaic roots. In the social sphere, plurality, not ideology, is the trend of the times, strengthened and accelerated by the Eastern European revolutions and the breakup of the Soviet bloc. Freedom and the free market have received a new justification and new glamour. The democratization of the market finds its focal point in difference, not sameness, in the free competition of all aesthetic ideologies, not in the polarization of trends and qualities. The synchrony of the non-synchronous[94] is cherished, because only the simultaneous presence of the nonsimultaneous can maintain the equality of chances in the market and the freedom of choice for the individual. Paradoxically, this triumph of democracy cannot be represented by modern art, because the eclecticism of the market undermines the modernists' claim to the exclusive ability and right of art – and an elitist kind of art at that – to represent the market's values, its essentials, which, however, now are no longer essentials, but compromises. These compromises are directed at granting freedom of choice without giving up certain standards of evaluation. Plurality of appearances, not the logic of hierarchy, is the catchword of the times, for which paradox is the meaningful figure. This paradoxical market structure includes the fact that the abandonment of the cultural hegemony of the West (and of the present) is demanded. However, the messages from the past and the ethnic other – like all messages and images in our artificial, media-oriented culture – can only be devised and accepted as fictions, without power over the present, but with the power of an energizing transgression of the used-to, the conventional and stereotyped. The transgression in Inuit art for

the White public is paradoxically an imaginative regression into a primordial world of primal experiences, which again provides an energizing point of comparison and departure.

Ultimately, Inuit art has a synthesizing quality that mediates between many tastes and tendencies, "naïve," modern and postmodern, by reasserting the balance of life, the (disturbed) equilibrium of forces, the singular vitality of nature, for which life is power and conflict, the enigma of the cosmos, the primordial manifestation of the human spirit, and the nomadism of the imagination. In its best pieces a singular vitalism is transferred into the equivalent of what might be called the aesthetic attitude in art. The aesthetic attitude, which has great attraction for the contemporary art scene, is an attitude of a post-ideological and post-individualistic age, an attitude of tolerance that focuses on plurality, not totality and essence. In Inuit art, it fuses with the "horizontal" mythical view, its abandonment of boundaries, its emphasis on the continuity of collective and individual experience, the solidarity of all living creatures, and the transformability and transitoriness of all life-forms, together with the energizing of nature and the preservation of the mystery of life and its unsolvable puzzles. It is an expression, on a purely aesthetic level, of respect for all life-forms and the dynamics of a continuum, harkening back to an earlier time of mythic-shamanistic forms of thought when animals, human beings, and spirits extended seamlessly into one another.

The important role of the non-human creatures of nature in Inuit art is based on the "hunter's mythical sacred relationship with the animal world," for "hunting was in itself a spiritual activity."[95] Though this relationship with the advent of Christianity and contemporary Western civilization has been secularized, it is still special, and increasingly finds an echo in Western developments - which is one of the reasons why Inuit animal sculptures are so popular. The acceptance of the animal on equal terms corresponds with the fact that contemporary Christianity has returned to thinking in terms of the unity of creation, including animal life, and together with ecological thinking has demanded respect for all living creatures. But the serious emphasis on the status of all beings as creatures of God (or the universe) and man's doubts about his own superiority, have also given the images of nature and the animal a new appeal, which also shows in the reception of Inuit art, especially the animal sculptures.

In postmodernism, wholeness means flexibility, the keeping open of all possibilities. Postmodernism has expanded the concept of aesthetics and suspended the clearcut borderlines between "high" and popular art, art and environment, structure and decoration. This makes for greater variety and tolerance in art. The context of Inuit art is established by three important aspects of this new flexibility: energy as the dynamic principle of aesthetics; a new appreciation of slowness in contrast to

acceleration; and, finally, a recourse to Kant's surprisingly simple definition of beauty in his <u>Critique of Judgement</u> (see below). The best of Inuit art, as a counterforce to functional rationalism, exemplifies what Jean-Francois Lyotard provocatively called "the energetic as autonomous force of an affirmative aesthetic of the present," which no longer criticizes and negates but serves the "transformation of energy."[96] Furthermore, the aesthetic attitude cultivates the "other" way of thinking, not only in choosing its own area of interest, but also its own pace. It might resist the acceleration of cultural consumption and rediscover the potential of *slow* (natural) experience, also the "slow" and pleasurable reception of works of art and the experience of their magic. The subjects and the methods of Inuit art suggest the unhurried natural pace of life which is a relief for the harried postmodern citizen.[97] Kant in his <u>Critique of Judgement</u> defined beauty in a lapidary way which, after the excesses of deconstruction in modernism and postmodernism, appears in a new, appealing light. For Kant, the beautiful is what by common consent pleases without conceptual idea. This is what Inuit art does by its naturalness, its vivacity, and its physical appeal. That it is able to do this, is however, partly the result of the cultural context of our time.

NOTES

1. This is a revision and updating of my analysis of Inuit art made in three contributions to the book-catalogue _Zeitgenoessische Kunst der Indianer und Eskimos in Kanada_, Gerhard Hoffmann, ed. (Stuttgart: Cantz/Canadian Museum of Civilization, 1988). The following argument, especially with regard to sculpture, concentrates on the "Inuitness" of Inuit art. The generalizations, of course, have to be complemented with studies of regional individual traits. Cf. the essay by Marie Routledge and Ingo Hessel and by Odette Leroux in this volume.

2. See the account by George Swinton in his _Sculpture of the Eskimo_ (Toronto: McClelland and Stewart, 1972), 13ff., 105ff., 129ff.

3. James Clifford, _The Predicament of Culture: Twentieth Century Ethnography, Literature and Art_ (Cambridge, Mass.: Harvard University Press, 1988).

4. George Swinton is right in substituting for the notion "primitive" that of "primal form" ("About My Collecting Inuit Art," in _The Swinton Collection of Inuit Art_, Darlene Wight, ed. [Winnipeg, Man.: Winnipeg Art Gallery, 1987], 6 - 9. See also Jamake Highwater, _The Primal Mind: Vision and Reality in Indian America_ (New York: Harper & Row, 1981).

5. The terms are Gombrich's; see his _The Sense of Order: A Study in the Psychology of Decorative Art_ (Ithaca, NY: Cornell University Press, 1979).

6. See Paul de Man, _Allegories of Reading: Figural Language in Rousseau, Nietzsche, Rilke, and Proust_ (New Haven, Conn.: Yale University Press, 1979).

7. Johann Joachim Winckelmann, _Gedanken Über die Nachahmung griechischer Werke_ (Thoughts Concerning the Imitation of Greek Works) (Dresden, 1755).

8. Gombrich, _Sense of Order_, vii. According to Gombrich, "theoretical concern with design... is a comparatively recent development and only the twentieth century has witnessed the final elevation of pattern-making into the autonomous activity of 'abstract' art" (_Sense of Order_, vii).

9. William Morris, "The Lesser Arts" (1877), in his _On Art and Socialism_, H. Jackson, ed. (London, 1947), 26.

10. Oscar Wilde, _The Artist as Critic: Critical Writings of Oscar Wilde_, Richard Ellman, ed. (Chicago: University of Chicago Press, 1982).

11. Maurice Denis, _Théories_ (Paris, 1913).

12. Cf. Werner Haftmann, <u>Painting in the 20th Century</u> (New York: Praeger, 1965), 24ff.

13. <u>Ibid</u>, 25.

14. See W. Metzger, <u>Gesetze des Sehens</u> (Frankfurt, 1975); Rudolf Arnheim, <u>Art and Visual Perception: A Psychology of the Creative Eye</u> (Berkeley, Cal.: University of California Press, 1971); and Oskar Pfister, <u>Expressionism in Art: Its Psychology and Biological Basis</u>.

15. Franz Marc, "Spiritual Treasures," in <u>Der Blaue Reiter Almanac</u> (1912), Wassily Kandinsky and Franz Marc, eds. (New York:Viking, 1974), 59.

16. Quoted in <u>Positionen heutiger Kunst</u> (Berlin: Nationalgalerie, 1988), 83.

17. Cf. Barnett Newman's statement of 1948: "We are asserting man's natural desire for the exalted, for a concern with our relationship to the absolute emotions. We do not need obsolete props of an outmoded and antiquated legend. We are creating images whose reality is self-evident and which are devoid of the props and crutches that evoke associations with outmoded images.... We are freeing ourselves of the impediments of memories, association, notalgia, legend, myth...." (Barnett Newman, "The Sublime is Now," <u>Tiger's Eye</u> 6 [1948], 53).

18. Donald Kuspit, "Concerning the Spiritual in Contemporary Art," in <u>The Spiritual in Art: Abstract Painting 1890 - 1985</u> (Los Angeles, Cal.: Los Angeles County Museum of Art; New York: Abbeville Press, 1986), 319.

19. The following examples are taken from the material collected for the exhibition catalogue <u>Zeitgenoessische Kunst der Indianer und Eskimos in Kanada</u>, 533. See also the introduction to Inuit graphics in the paper by Odette Leroux, reprinted in this volume.

20. George Swinton with regard to Josie Papialook, quoted by Marybelle Myers, "Josie P. Papialook," <u>Beaver</u> (1982), reprinted in <u>Inuit Art: An Anthology</u> (Winnipeg, Man.: Watson and Dwyer, 1988), 76.

21. As to various aspects of myth, see notes 45, 46, 54, 78.

22. Mircea Eliade, <u>Shamanism: Archaic Techniques of Ecstasy</u> (New York: Pantheon Books, 1964), 4. On shamanism and shaman in Inuit art see <u>Stones, Bones and Skin: Ritual and Shamanic Art</u> (Toronto, Ont.: Society for Art Publication, 1977); Jean Blodgett, <u>The Coming and Going of the Shaman: Eskimo Shamanism and Art</u> (Winnipeg, Man.: Winnipeg Art Gallery, 1978).

23. Snowshoes were decorated as a sign of respect for the quasi-"animate" objects that are of vital importance to the Inuit (and

the Indians) of the Far North: "A stimulus comes to the hunter in one of his dreams to try his luck for beaver. Should he succeed in his excursion, then he 'pays for' the admonition by decorating one of the tools used in preparing the flesh or hide of the animals so obtained." See Frank G. Speck, "Labrador Eskimo Mask and Clown," The General Magazine and Historical Chronicle 37:2, 159 – 72: here 172. Decorating the animal skins is a sign of reverence for the animal, which according to the world view of the Inuit and Indians "offers" itself freely to the hunter and therefore must be treated with respect. Cf. Ted J. Brasser, "Pleasing the Spirits: Indian Art Around the Great Lakes," in Pleasing the Spirits: A Catalogue of a Collection of American Indian Art (New York: Ghylen Press, 1982), 18.

24. K. Rasmussen, The Netsilik Eskimos: Social Life and Spiritual Culture, Report of the Fifth Thule Expedition 1921 – 24, 8(1-2) (Copenhagen, 1931).

25. Kenojuak Ashevak in Jean Blodgett, Kenojuak (Toronto: Firefly Books, 1985), 38.

26. Cf., for instance, Clement Greenberg, "The New Sculpture" and "Modernist Sculpture: Its Pictorial Past," in his Art and Culture: Critical Essays (Boston: Beacon Press, 1961), 139 – 45 and 158 – 63; Albert E. Elsen, Origins of Modern Sculpture: Pioneers and Premises (New York: George Braziller, 1974).

28. For Hegel the representation of the human figure in classical art was the depiction of free man and thus "the centre and content of true beauty and art, because only in it the spirit attains the appropriate existence in the sensual and natural sphere" (Hegel's Aesthetics: Lectures on Fine Art, T.M. Knox, trans., 2 vols. [Oxford, 1975] I, 413).

29. George Swinton, Sculpture of the Eskimo, 142.

30. Quoted by Swinton, Sculpture of the Eskimo, 143. In practice most Inuit artists, of course, start their work both with the idea and with "listening" to the stone to find out its possibilities. See the statement of Osuitok Ipeelee quoted by Jean Blodgett in "Osuitok Ipeelee," Inuit Art: An Anthology, 50: "How I work is that I have to think first, and then I have to look at the stone next to see if it's going to suit my imagination." Nutaraaluk Iyaituk said: "I stick to my idea regardless of the stone – but I also try to find the appropriate stone" (quoted by Marybelle Myers, "The Iyaituk Brothers: Nutaraaluk and Mattiusi," in Inuit Art: An Anthology, 67); and his brother noted: "Sometimes I get an idea first of what I want to make.... But sometimes I start chipping and the idea comes." (Inuit Art: An Anthology, 69).

31. Darlene Wight, "Introduction," The Swinton Collection of Inuit Art, 16.

32. Ernst Cassirer, The Philosophy of Symbolic Forms, 3 vols. (New Haven, Conn.: Yale University Press, 1955 - 57), III, 165 - 88.

33. David Ruben, comment on his sculpture Wind Goes Over the Tundra, in Out of Tradition: Abraham Anghik/David Ruben Piqtoukun, Darlene Wight, ed. (ex. cat; Winnipeg, Man.: Winnipeg Art Gallery, 1989), 53.

34. Cynthia Waye Cook, Inuit Sculpture in the Collection of the Art Gallery of York University (North York, Ont.: Art Gallery of York University, 1988), 9.

35. Ruben's comment on his sculpture Sila the Wind Spirit, in The Storyteller: Sculptures by David Ruben Piqtoukun, (ex. cat.; North York: Koffler Gallery, 1988), unpaged.

36. Ruben's Sila the Wind Spirit has a human face and a bird's body. The face of The Snow Goddess has "two sides - male and female"; they "combine in a mystical way to invoke the good spirits" (Ruben's comment on his The Snow Goddess, in The Storyteller, unpaged).

37. See for examples Sculpture/Inuit: Masterworks of the Canadian Arctic (Toronto: University of Toronto Press/Canadian Eskimo Arts Council, 1971), pls. 102, 103, 195, 202, 236, 248, 249, 253-302; or Swinton, Sculpture of the Eskimo, pls. 9, 54, 55, 58, 61, 62, 72, 91, 113, 118, 119, 120, 123, 124, 190, 201, 219, 220, 222, 223, 242, 243, 244, 247, 288, 289, 297, 300, 642, 644, 675, 681, 682, 683, 685, 686.

38. See Sculpture/Inuit, pls. 112, 113, 114, 115, 118, 120, 129, 130, 131, 132, 133, 134, 138, 139, 142, 143, 146, 153, 158,; or Swinton, Sculpture of the Eskimo, pls. 44, 74, 77, 88, 102, 105, 124, 199, 200, 210, 242, 243, 247, 249, 250, 253, 256, 257, 258, 259, 260, 261, 262, 263, 264, 265, 368, 385, 400, 401, 426, 427, 437 - 44, 458, 459, 466, 467, 469 - 473.

39. See Sculpture/Inuit, pls. 304, 306, 307, 311, 312, 314, 316, 317, 320, 322, 326, 327, 328, 329, 330, 331, 332, 334, 338, 348, 355, 357; or Swinton, The Sculpture of the Eskimo, pls. 5, 8, 29, 40, 53, 57, 58, 82, 109, 115, 116, 129, 132, 134, 135, 184, 204, 207, 209, 484, 488, 493, 504, 526, 531, 536, 539, 564, 591, 625, 626, 630, 651, 711, 712, 714, 716, 721, 722, 726, 727, 762, 767, 771, 808, 811.

40. For mask-like faces see the plates in the Masters of the Arctic, catalogue of the exhibition put on by the United Nations in 1989, 68f.

41. Idem.

42. Cf. Marybelle Myers, "The Iyaituk Brothers," in Inuit Art: An Anthology, 70, 72f, 74f.

43. See Uumajut: Animal Imagery in Inuit Art, Bernadette Driscoll, ed. (ex. cat.; Winnipeg: Winnipeg Art Gallery, 1985), pl. 85; Jean Blodgett, Selections from the John and Mary Robertson Collection of Inuit Sculpture (Kingston, Ont.: Agnes Etherington Centre, Queen's University, 1986), pls. 59, 60; Arctic Vision: Art of the Canadian Inuit, Barbara Lipton, ed. (Ottawa: Canadian Arctic Producers, 1984), 32.

44. See Out of Tradition: Abraham Anghik/David Ruben Piqtoukun, pls. 5, 7, 9, 15, 17, 18, 27, 30, 34, 35, 37, 39, 41, 55, 58, 59.

45. See Sculpture/Inuit, pls. 360, 361, 390; Swinton, The Sculpture of the Eskimo, pls. 141, 601, 602, 608, 611, 612, 649, 655, 656; or Pure Vision: The Keewatin Spirit, Norman Zepp, ed. (ex. cat.; Regina, Sask.: Norman Mackenzie Art Gallery, 1986), pls. 32 – 41, 42.

46. A. von Gennep, L'État actuel du problème totémique (Paris, 1920), 346. See also Lévi-Strauss, The Savage Mind (Chicago, Ill.: Chicago University Press, 1966), 142. In the subject of mythical geography see Ernst Cassirer, The Philosophy of Symbolic Forms, II, 106, 108, 114.

47. Ernst Cassirer, Was ist der Mensch? Versuch einer Philosophie der menschlichen Kultur (Stuttgart, 1960), 106.

48. See Sculpture/Inuit, pl. 190.

49. Uumajut: Animal Imagery in Inuit Art, pl. 85.

50. Bernadette Driscoll, "Interview with Pauta Saila," in Uumajut: Animal Imagery in Inuit Art, 46.

51. Swinton, "Animals: Images, Forms, Ideas," in Uumajut: Animal Imagery in Inuit Art, 41.

52. Lévi-Strauss, The Savage Mind, 136, 142.

53. Narrative - according to anthropologists like Claude Lévi-Strauss, semioticians like Umberto Eco, and theoreticians of narrativity like Greimas or Todorov - is the fundamental and irreplaceable means by which humankind orders the world. It is a universalizing method of depicting life. It simultaneously unveils and veils the mystery of life, showing both its definiteness and indefiniteness, continuity and discontinuity, coherence and incoherence. In the Enlightenment, Lessing rigorously divided the arts into time art, i.e., literature, and space art, i.e., the visual arts. Literature encompassed what can be presented successively in time, i.e. "action" (and the spiritual dimension of man), and to painting and sculpture, attaching less value to them, the body and its visible attributes. According to this division, narrative would "belong" to time art. But narrative is not restricted to a medium, and literature and the fine arts not only stand in opposition to one

another, they also connect. Indeed, through contrast and
tension, the static form of the image can ask narrative
questions, like those in Keat's <u>Ode to a Grecian Urn</u>: "What mad
pursuit? What struggle to escape?" See, for an overview of
concepts of narrativity and their problems, Wallace Martin,
<u>Recent Theories of Narrative</u> (Ithaca, NY: Cornell University
Press, 1986); <u>On Narrative: Recent Theories of Narrative</u>, W.J.T.
Mitchell, ed. (Chicago, Ill.: Chicago University Press, 1980).

54. <u>Sculpture/Inuit</u>, pls. 215, 344, 361.

55. Cassirer in his <u>Essay on Man</u> (New Haven, Conn., 1944) sees
the mythical world as a dramatic one, as a world of forces in
conflict with one another, which in the subject therefore call up
contradictory emotions. In Lévi-Strauss's definition, the
"savage mind" is characterized by a "consuming symbolic ambition
such as humanity has never again seen rivalled." As totemism,
mythical thought constitutes a "homology between two parallel
series - that of natural species and that of social groups."
There is no exclusive preference for one system of
classification. The world is seen as a natural unity *and* as
duality, it is "represented as a continuum made up of successive
oppositions." This mythical modality of thought contains and
mutually associates in an unbroken continuum *categorial*
oppositions (up-down, high-low), *elemental* oppositions (heaven-
earth), or *specific* oppostions (eagle-bear). (<u>The Savage Mind</u>,
220, 224, 139, 142). Furthermore, the mythical mode of
experience can be abstracted from the prehistorical situation and
universalized as one of the ways the human mind has available to
experience and relate to the elemental forces of the universe.
In Freud's and Jung's view the dreamlike experience of the
unconscious has forms similar to myth. In a further step of
interpretation, myth is recognized as a Western cultural concept,
as part of its taxonomic conventions; it is a model of thought
defined by the contrast between a primordial origin and present
time, between nature and culture and even culture and culture.
Though being part of the inventory of Western thought, the myth
concept is useful, even if it is fictional, it is part of a
system of differentiation that has its historical and universal
aspects. One can indeed proceed on the assumption that "it is
not finally some mysterious 'primitive philosophy' that we are
exploring," when we seek to understand myth, "but the further
potentialities of our thought and language" (Talal Asad, "The
Concept of Cultural Translation in British Social Anthropology,"
in <u>Writing Culture: The Poetics and Politics of Ethnography</u>,
James Clifford and George E. Marcus, eds. (Berkeley, Cal.:
University of California Press, 1986), 159; see also Clifford's
introduction and the other essays in this collection.

56. See note 37.

57. See Swinton, <u>Sculpture of the Eskimo</u>, pls. 138, 139, 140,
190, 191, 326; <u>Masters of the Arctic</u>, pp. 1, 10, 16, 17, 19, 25,
31, 36, 42, 45, 50, 56, 58, 59, 64.

58. George Swinton, "Contemporary Canadian Eskimo Sculpture," Sculpture/Inuit, 41.

59. Cook, Inuit Sculpture in the Collection of the Art Gallery of York University, 10.

60. See plates in Inuit Sculpture in the Collection of the Art Gallery of York University, 10ff.

61. Sculpture/Inuit, pl. 108. The following plate numbers are from this volume.

62. See Inuit Sculpture, 21.

63. Marybelle Myers, "People Who Know How to Dream," North/Nord (March/April 1974), 33.

64. Cassirer, Philosophy of Symbolic Forms, II, 103, 116, 129.

65. Brian Shein, "Introduction," The Storyteller, unpaged.

66. Out of Tradition, 41.

67. Out of Tradition, 60f.

68. Out of Tradition, 31.

69. Johann Wolfgang von Goethe, "Einfache Nachahmung der Natur, Manier, Stil," in Goethes Werke: Hamburger Ausgabe, 14 vols. (Hamburg: Christian Wegner Verlag, 1953), 12, 30 - 34.

70. See Swinton, Sculpture of the Eskimo, pls. 375, 377, 378, 525.

71. Norman Zepp, "Contemporary Inuit Art," in Pure Vision: The Keewatin Spirit.

72. See Edmund Carpenter's statement: "Can the word 'Eskimo' legitimately be applied to this modern stone art? I think not. Its roots are Western; so is its audience" (Eskimo Realities, New York: Holt, Rinehart and Winston, 1973, 194); and George Swinton's correct counter-assessment: "Contemporary Eskimo art has indeed become a new art form. It is the art of the new Eskimo Still, although they have changed, the Eskimo and his art are intrinsically and uniquely Eskimoan." (Sculpture of the Eskimo, 135). Nor is the following observation cited approvingly by Carpenter, accurate: "'It is the power of belief,' writes the arctic archeologist Froelich Rainey, 'which makes all the difference between original native art and contemporary native crafts'" (Eskimo Realities, 193). Art used to be part of the social and cult context, but it is now a category of its own. The difference is aesthetic and necessarily so; otherwise it would not be art in the Western sense of the word. Christianity and modern civilization, by removing taboos and the element of

fear, made this aestheticization of the stock of primal images possible. See also Zepp, <u>Pure Vision: The Keewatin Spirit,</u> 9 - 32.

73. See J. C. H. King, "Tradition in Native American Art," in <u>The Arts of the North American Indian: Native Traditions in Evolution</u>, Edwin L. Wade, ed. (New York: Hudson Hills Press, 1986), 65 - 92.

74. Lucy R. Lippard, <u>Mixed Blessings: New Art in a Multicultural America</u> (New York: Pantheon Books, 1990).

75. James Houston, <u>Canadian Eskimo Art</u> (Ottawa: Department of Northern Affairs and National Resources, 1954), 27.

76. See note 71.

77. Swinton, "About My Collecting Inuit Art," in <u>The Swinton Collection of Inuit Art</u>, 7.

78. Houston, "To Find Life in the Stone," <u>Sculpture/Inuit</u>, 55.

79. Swinton, "Contemporary Canadian Eskimo Sculpture," in <u>Sculpture/Inuit</u>, 42.

80. Notions like the primitive, the exotic, and the "other" lose their contrastive or nostalgic value for a given society at the moment in which this (postmodern) society recognizes the "primitive," exotic, and other in itself, in the "exotic" and more or less compulsive, construct-like nature of its own "reality" and its own cultural conventions. It then becomes impossible to write about the primitive, exotic, and other as if they were actually existing, clearly definable, and self-contained cultural forms; as if they were "objects" that occur only outside one's own civilization or even outside of one's own self. Furthermore, the description of the "mythical" and "primitive" as temporally and spatially isolated preserves of an other is scarcely tenable any longer because in an age of global communication media, such isolation is virtually a thing of the past. "Primitivity" and "mythical" world view are concepts of the imagination for the definition of Western cultural identity. See <u>Writing Culture</u>, Clifford and Marcus, eds.; cf also note 55.

81. Swinton, "In Appreciation," in <u>Pure Vision: The Keewatin Spirit</u>, Norman Zepp, ed., 6.

82. See Otto Bihalji-Merin, Nebojša-Bato Tomašević, <u>World Encyclopedia of Naïve Art: A Hundred Years of Naïve Art</u> (Secaucus, NJ: Chartwell Books, 1984).

83. See Edward Said, <u>Orientalism</u> (1978).

84. <u>Inuit Art Quarterly</u>, 3(1) winter 1989: 9 - 11.

85. Victor Shklovsky, "Art as Technique" (1916).

86. George Swinton, "Memories of Eskimo Point," in Eskimo Point/Arviat, Bernadette Driscoll, ed. (ex. cat.; Winnipeg: Winnipeg Art Gallery, 1982), 14.

87. Swinton, "Artists from the Keewatin," Canadian Art, 101 (April), 34.

88. Rankin Inlet: Kangirlliniq, Bernadette Driscoll, ed. (ex. cat.; Winnipeg: Winnipeg Art Gallery, 1981), 38.

89. Swinton, Sculpture of the Eskimo, 19.

90. Julius Meier-Graefe, in his article "Vincent" (1910).

91. Beuys goes on to say: "Of course the shaman can operate genuinely only in a society that is still intact because it lies in an earlier stage of development.... Since the intactness has gone, a kind of metamorphosis begins. So while shamanism marks a point in the past, it also indicates a possibility for historical development. It could be described as the deepest root of the idea of spiritual life, deeper even than the mythological level of the later stages of Greek and Egyptian cultures for example.... When people say that shamanistic practice is atavistic and irrational, one might answer that the attitude of contemporary scientists is equally old-fashioned and atavistic because we should by now be at another stage of development in our relationship to material" (Caroline Tisdal, Joseph Beuys [New York: Solomon R. Guggenheim Museum, 1979], 23).

92. Statement by David Ruben Piqtoukun, in Out of Tradition: Abraham Anghik/David Ruben Piqtoukun, Darlene Wight, ed., 41.

93. For a more extensive analysis of, and bibliographic information on, postmodernism and its various evaluations, see my essay on "Postmodern Culture and Indian Art" in this volume.

94. See Arnold Gehlen, "Ende der Geschichte?" in Einblicke (Frankfurt, 1975), 115 - 23.

95. Cf. Ernst Bloch, "Nonsynchronism and Dialectics," New German Critique, 11 (1977), 22 - 38; Reinhard Koselleck, Vergangene Zukunft (Frankfurt/Main: Suhrkamp, 1979); Siegfried Kracauer, History: The Last Things Before the Last (New York: Oxford University Press, 1969).

96. George Swinton, Sculpture of the Eskimo, 129.

97. It is interesting in this context that an exhibition at the Stedelijk Museum, Amsterdam, in 1990 that had to compete with the tourist-attracting suggestivity of van Gogh, used the supposedly suggestive and thought-provoking title Energies for a survey of

contemporary art.

98. Peter Sloterdijk (<u>Critique of Cynical Reason</u> [London: Verso, 1983]; <u>Eurotaoismus</u> [Frankfurt: Suhrkamp, 1989]) criticizes the acceleration of history and social life and looks for the chances of a non-nihilistic attitude of human consciousness towards itself. He finds it in the overcoming of *angst* and panic and narcissism, the abandonment of the frantic attempt to change reality according to one's own image, and in the discovery of slowness, in what he calls "Eurotaoism," which would be the tranquil realization that we cannot be other than as we are. Sloterdijk turns against the scientifistic concept of reason and quotes Wittgenstein's statement toward the end of his <u>Tractatus Logico-philosophicus</u>: "We feel that even when all scientific questions are answered, our life problems have not yet been touched."

TALKING WITH THE ARTISTS

by

Dorothy Harley Eber

In parts of the North the Inuit have a word for the person who comes into the community in search of information. The word is *apirsurti*, "one who asks questions." The calling has some tradition:

> "Can you remember the first time that you saw *Qablunnaat*-white men?" asked Jim Shirley, an *apirsurti* based in Rankin Inlet, of the great artist Jessie Oonark in 1981, a few years before her death. "Yes," she replied, "I remember seeing Kunuk (Knud Rasmussen) when I was a young girl.... My uncle, Mamnguqshualuk, spoke with him and while my uncle was speaking, Knud would be writing. My uncle spoke of our culture and traditions. I learned at the time that *Qablunnaat* ask a lot of questions. Kunuk asked all about Inuit, how they did things. He would ask questions for a long time. My uncle and I were the only ones who would be asked to come into his big tent. There was no end to his questions."[1]

Today *apirsurtiit* come to the North in some numbers, frequently to try and learn more about the remarkable artists of the North. We return of course usually with the big questions unanswered. Creativity remains a mystery. Nevertheless, *apirsurtiit* are unlikely to abate their efforts.

Few bring to their tasks the qualities of Kunuk. However, we who seek information in Arctic communities today have one great advantage: the light-weight portable tape-recorder. It is this technological tool that permits us to more easily approach the artists of the North in hopes of recording and preserving life stories, explanations of their work, and their own views and attitudes towards their art. Of course, terminology that interviewers and artists who live close to the art markets of the south might automatically employ in conversations together is rarely useful here where most artists represent the last generation to have been part of what was, until recently, one of the world's great hunting cultures. The great names of Western twentieth century art have only slowly entered into the consciousness of Inuit artists. When Pitaloosie Saila of Cape Dorset first surprised us with her bisected faces, people wondered if she were influenced by Pablo Picasso. "Do you know of Picasso?" an *apirsurti* inquired. "I know of him now," she replied. What had inspired her to draw faces that particular

way? "The two sides of the face are different and sometimes I like one side of my face better than the other." For the most part the art of Inuit artists still remains tied to the Inuit life they know and remember and their technical mastery (in which the great artists take enormous pride) is self-acquired. Few will articulate a "philosophy of art." However Arctic artists are eloquent and can be quite clear as to their intentions. "If you're making a carving of a loon, should it really look exactly like a loon?" Marybelle Myers asked Povungnituk artist Josie Papialuk on the tape-recorder in 1985. Josie replied, "I try to get the soul out." When Myers asked about the extraneous lines that appear in so many of his prints, Josie says, "Those are the winds," and explains he puts them there to show that "the winds are around."[2]

Not all interviews are done with a tape-recorder at hand, but its advantages are manifold, particularly as most interviews must be done across a language barrier. Many of us have been fortunate in that we have frequently been helped by a highly skilled interpreter, or *tusaaji*, as Inuit say. Often playing double roles, *tusaajiit* have acted as interpreters and guides to every category of Southerner who has come to the Arctic since the early explorers. Without their skills much of the accumulated knowledge of the North would not exist.[3]

Not surprisingly, *aspirsurtiit* encounter difficulties. Sometimes, though not often, our approaches are rebuffed; sometimes they are non-productive. Some artists are more articulate than others, or appear so when we approach them. And for a researcher working through an interpreter, doing justice to an informant's words and information is a demanding responsibility. A researcher must often return several times for additional interviews, and interviews must frequently be interpreted a second and third time, and a written translation obtained. Indeed, one can legitimately ask how such approaches can yield worthwhile results. The answer is simply that many artists are amazingly patient with their questioners and generous with their information. Even a stupid question has often provoked a brilliant answer.

For my part, I first took a tape-recorder north in 1970, inspired as so many were at the time by the Columbia University Oral History Program and the work of the great reporters who published some of the early oral biographies and oral histories created under its auspices.

My work that year was to interview the graphic artist Pitseolak Ashoona of Cape Dorset; but an early encounter while in the community was with Eleeshushe Parr whose husband, the great old graphic artist, had died just a few months earlier. In Parr's prints the shape of his hunters, their *kayaks* and their

Fig. 1. Parr and Eleeshushe in the 1940s. Photographed by Peter Pitseolak. Peter Pitseolak Collection. Notman Photographic Archives. McCord Museum of Canadian History, Montreal.

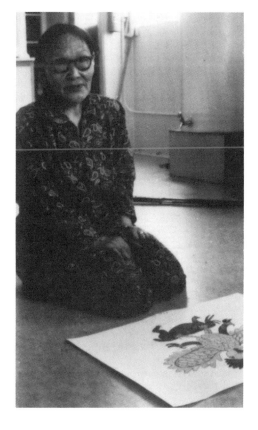

Fig. 2. Pitseolak Ashoona in 1968. Photograph: Dorothy Harley Eber

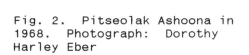

quarry are abstracted, but the images are strong and instinct always guided this old artist to use great restraint in putting down his pictures on paper. At the time of his death Parr's work was in demand. This was a matter of astonishment in Cape Dorset. Kenojuak Ashevak whose Enchanted Owl had become the best known of Eskimo prints, and her husband, Johnniebo, a relative of Parr, considered his walrus "just like boxes." He drew, people said, "just like a child." Indeed, his family encouraged him to put away his drawings before the grandchildren came home from school. Eleeshushe told me the story of Parr's artistic career, which began when he was the oldest resident of Dorset, with wry humour: "I tried to stop him because I thought people would laugh." When first approached to make drawings by the West Baffin Eskimo Co-operative Parr had not shown much interest. "He said he couldn't do anything, that he didn't know how. But they told him to do some drawings. He had to do some so he did five large papers. He got money for doing them and he got to like the work. He got to like doing the prints and he kept on doing them until he died."

1 learned from Eleeshushe that Parr liked doing the work-and liked the money.

Only in old age did Parr begin, as Inuit say, "to live with money." Prior to the Second World War, commercial transactions with the Hudson's Bay Company, for whom Inuit campers all across the Arctic trapped fox, were carried on by barter; but by the time Parr became an artist the cash economy was well entrenched. In settlement life money was important, and like jobs, scarce. (But like grandfathers everywhere, Parr enjoyed giving pocket money to his grandchildren. "Why not take the nickel; its bigger," he used to say to Tierak Ottochie, offering her a nickel or a dime. "I always took the dime, even though it was smaller," wise Tierak remembers.)

Although the extraordinary results were not foreseen, it was as make-work projects that art programmes were introduced in the North in the 1950s and 1960s and supported with government backing. The rationale behind one such programme (virtually the same as that for all other art projects across the North) was well explained by Father Henri Tardy, OMI, who became business manager for the Holman Eskimo Co-operative, in a letter he wrote April 12, 1972: "In 1961, when the fox and sealskin prices had gone down, it became evident that other sources of income would have to be found for the Eskimo people. It is from the necessity to improve living conditions that Graphic Art started in Holman." Father Tardy went on to remark, "For some time already, Kalvak had been drawing. Her first sketch of an old-time parka had convinced me that this woman had an artistic potential and I had been encouraging her to draw. She expressed herself with assurance, and her drawings became a way for her to explain

Fig. 3. "This is how we played tennis," Pitseolak Ashoona
explained when describing this Eskimo ball game which she
depicted in the scrapbook she filled with illustrations for her
oral biography, <u>Pitseolak: Pictures Out of My Life</u>, published in
1971. Felt pen, 1970. Private Collection.

legends and customs. 'White people tell stories in books, I tell them by my drawings,' she said."[4]

The opportunities the art programmes offered were eagerly seized upon. The money their talent brings is an important consideration to virtually all Inuit artists, and there are few who do not mention the fact in any discussion of their art. But they tell us just as emphatically that it is far from the only consideration.

Like Kalvak, many older artists believe that the old ways should be documented while those who lived the old way of life are still able to do so. Some set out purposefully to provide information; *aspirsurtiit* are sometimes helpful here. For instance, we find added richness in the work of the Holman artist, Mark Emerak, because of his explanations for some sixty drawings, which Bernadette Driscoll recorded on a tape in 1982, thus preserving important information for young Inuit and Southern students of Inuit life alike.[5] And as with creative artists everywhere, many find personal satisfaction and fulfilment in their work. "Drawing has provided a release from everything in the world," Jessie Oonark told a nurse as she lay dying at the Health Centre in Churchill, Manitoba, in February 1984.[6] The Cape Dorset artist Pitaloosie Saila once told me that as a young mother she started drawing because "I didn't want to be 'just a person,' not doing anything. I wanted to make something out of myself, to make some money to buy some food for the kids." And Cape Dorset's Pitseolak Ashoona declared, "I became an artist to earn money but I think I am a real artist." She informed us, "To make prints is not easy. You must think first and this is hard to do. But I am happy doing the prints.... I am going to keep on doing them until they tell me to stop. If no one tells me to stop I shall make them as long as I am well. If I can, I'll make them even after I'm dead."[7]

The finest artists of the North have brought great passion to their work.

SOME INTERVIEWS

In the spring of 1987 I had the opportunity to talk to three artists whose work was to form part of the exhibition In the Shadow of the Sun: the Cape Dorset artists Osuitok Ipeelee and Pauta Saila, both of whom I had met before, and a new acquaintance, Elisapee Ishulutaq of Iqaluit. The interviews with Elisapee and Osuitok were recorded at that time as were some of Pauta Saila's comments; his commentary on polar bears was recorded at an earlier date. The major motivating forces touched on earlier, economic need and personal fulfilment, are clearly in evidence, but the interview excerpts are personal statements,

highly individualized. They suggest the artists' preferences in regard to subject matter, give information on work habits, hint sometimes at rivalries (North and South, artists are subject to the same competitive drives.). They provide us too with sometimes surprising glimpses of the now lost hunting culture. Interpreters were Lisa Ell Ipeelie, Pitaloosie Saila, Pia Pootoogook, and Pisukti Oshaweetok. Susan Gardener Black supplied written translations for sections of certain tapes.

Elisapee Ishulutaq

Elisapee, whose work appears in the editions of prints issued by the Pangnirtung Eskimo Co-operative and editions of partially hand-coloured prints issued by Iqaluit Fine Arts, is an exceptionally productive artist who draws, carves and does designs for the Pangnirtung weave shop. Though she lives today in Iqaluit most of her life was spent in the Cumberland Sound. Her ancestors whaled for the American and Scots who arrived in the 1840s and eventually set up the Blacklead Island and Kekerten whaling stations. She herself was born after whaling ended but she is not surprised that older artists, now mostly dead, have made bowhead whaling a feature of Pangnirtung printmaking. In the 1940s, as she tells us here, she saw the last bowhead whale caught in the Cumberland Sound beached on the shore.

"I was born at Kanirterjuak when no one was at Pangnirtung, when we lived in the outpost camps. I am not sure if there were Hudson's Bay Company buildings at that time, if they went up before or shortly after I was born. But there were people living at Blacklead and there were people camped and living at Kerkerten so likely I was born in the 1920s, perhaps before 1925.

I can remember my grandfather, Netsiapik. He was an old, old man, all white haired but very Inuk looking, who played the violin really well. In the days when we still had the *qammait*, the tent huts, I would lie beside my grandfather in the hut. He told stories of going with the whalers and taking my father along when he was young. Mostly they would go to the floe edge in the season when the seals were pups. I, myself, do not remember when the whalers were around but I remember Inuit hunting the whale and how one time Angmalik [the Kekerten station Native leader in the last days of whaling] caught a whale with one of those powered harpoons and everyone rushed over. We were in our camp when we heard they had caught the whale and we went to where they had caught it, right in the inlet north of Pangnirtung.

It is a moment I recall very clearly, a really exciting
time. I was not a child; I was a young woman and I
stood beside the whale and looked way up.

I am not sure why some people choose to draw whales but
it may be that those older artists who remember the
whales and whalers of the past are influenced by that
era. I started both carving and drawing in 1970 when
we moved from our camp to the Pangnirtung settlement
and a man there asked me to draw. I started carving
because I liked what other people were doing and I
thought I'd give it a try. I thought I wouldn't have
the ability to create something on paper but I
surprised myself and I find I really enjoy it.

Why are Inuit such good artists? I think it is because
of strong will and determination, the determination to
make something, carvings or drawings, because of need.
Because with fewer sealskins being sold people must
make other things to compensate for the sealskins. But
I feel that if a person is determined and enthusiastic
about their work, they will be a lot more creative. If
I work at what I am producing, if I put more effort
into it, if I plan ahead what I am going to do, think
it out in my head, this is how I will achieve better
work. Natural ability? I think it is like the natural
ability to sew garments. If you want to sew something,
you go ahead and do it. If you want to try something,
you just go ahead and try.

I like to draw Inuit from the old days, pictures of
people doing things, not just people but people in
action; adults, children. I'm not sure if there were
shamans when I was a small girl but I have drawn a
picture of a shaman ceremony, persons sitting in a
circle with a person in the middle. I'm influenced in
my drawings by things that have happened in the past;
stories I've heard from my grandfather, mother and
father. I put on paper how it could have been.

I also draw the things I have seen and lived, what I
have experienced in my life. I recall camp life; the
sealskin tents, the *kayaks*, just how the sealskins were
set up. I can draw you such a picture any time. I
even recall how we used to have very little soap and
how when the soap [from the trader] was all used up we
would use duck eggs to wash the clothing. It really
helped. The clothing would be laid out and the duck
eggs kind of soaped in and then rinsed out and the
clothing hung out to dry.

Eating traditional food is something I very much enjoy.
When we're feasting we put the catch down on a board
and gather in a circle and the men cut it up. This
makes me remember feasting in the *qammait*. It was
pretty crowded on the bed part of the hut with everyone
feasting, huddled around, touching one another. I like
to remember these kinds of things.

Definitely if I could I would return to my past. I
feel it was a happier life. What I miss most today is
wearing the skin clothing. I really feel that nowadays
because people are not wearing the skin clothing that
they get sick a lot more easily, especially during the
winter when its so cold. Just a while ago people
seemed to have forgotten the skin clothing completely
but now you do see it when people go hunting; it seems
to be gradually coming back. If it were stressed that
caribou clothing is warm and can be life-saving if a
skidoo breaks down, I think people would want to wear
the skin clothing. Now they have the option of army
boots or *kamiks*, wind pants or caribou pants and they
seem to opt for the material clothing.

In the past we lived in the *qammait* year around,
improving them for winter with peat moss, the material
for insulation, when we had it. Sometimes on short
trips we'd sleep in an igloo. They served their
purpose when we built them and were quite warm; we'd
prepare a *kudluk* for the night.

Sometimes I draw igloos and I have myself a few igloo
drawings that I've made. But I never regret when my
drawings are gone. Quite the opposite. I'm happy that
people like and enjoy my drawings. When I see my work
in books I have mixed emotions, mixed reactions. I
don't know why. Partly, I'm shy, partly I'm very happy
and also thankful that my work is being shown in books.
Yes, the drawings have much improved since the first
ones. It's like sewing garments, when you first start
sewing duffel socks. Each time you make another pair
of duffel socks, you do much better than the time
before. It's the same idea: each time you sew, each
time you draw, it's much, much better than before.

Pauta Saila

Pauta is well known for his "dancing bears" which balance
lightheartedly on one hind paw, thrusting the others in the air.
His father, Saila, who was the Hudson's Bay Company Eskimo
"boss" for the Cape Dorset trading post was also a carver whose
work Pauta admired. "My father was a very good carver; he was

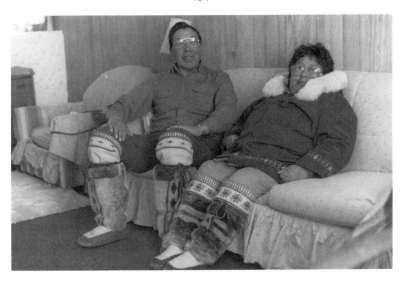

Fig. 4. Pauta and Pitaloosie Saila, 1987. Photograph: Dorothy Harley Eber.

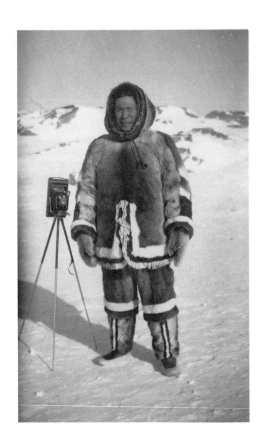

Fig. 5. Peter Pitseolak of Cape Dorset who sought to record the last days of Eskimo camp life, caught with his camera by his wife, Aggeok, about 1946. Peter Pitseolak Collection, Notman Photographic Archives. McCord Museum of Canadian History, Montreal.

better than me. If he carved an *ookpik* [owl] or a man or a
woman, it was done perfectly. It was completely real," he says.
In past years Pauta carved birds, seals, bears in many variations
of posture, as well as other subjects; but in the spring of 1987,
with his wife Pitaloosie interpreting, he said, "I make one
particular carving now though with different motions, the dancing
bear. I carve them the way the stone suggests. They're standing
on the left foot or the right foot depending on the stone."

Perhaps demand for these carvings has caused Pauta to narrow
down his subject matter, but Pauta's knowledge of the polar bear
is encyclopedic and comes from close observation. He has studied
them since boyhood, when he lived in his father's camp high up on
the western coast of the Foxe Peninsula, where polar bears are
many.

"When I was a young man I used to be always hunting
polar bears. Every year I used to get polar bears at
my camp, Nuwata. Sometimes one, sometimes two. When
they're fat they're really good to eat, like the white
man's roast beef! Are they the most dangerous of
animals? I don't know, they've never been mean to me.
Probably the polar bear is scared of humans, because if
they're not hungry, they just run away.

Has the polar bear magic powers? I've heard it but I
don't know. I don't know much about the shamans having
polar bears as their spirits. Around here most shamans
seemed to have wolf spirits. But I've heard there were
shamans who seemed to have the polar bear right in
their body. The way I heard it these persons who had a
polar bear for a spirit moved like the polar bear moves
and had the polar bear's voice in their bodies.

Polar bears are just like people. They can do many
things that humans do. They can stand or sit, like us.
They look around, just as we do. The polar bear acts
just as the hunter does. They hunt for their food as
the Inuit do, or used to do. They crawl very carefully
towards a seal exactly the same as a man.

When they're catching a seal on the ice, they won't
miss. They kill with the paw. I know when the polar
bear is at a seal hole waiting for a seal he will kill
with his bite. I've seen this three times. At the
seal hole they don't kill with the paw. Sometimes
they'll cover the *aiglu* [breathing hole] with snow;
that's so the seal won't see them. I think the polar
bear will wait for the seal lying right over the hole
so that when the seal comes up he can grab it with his
teeth. I know that the polar bear can kill young

walrus with a piece of ice. He throws the ice on the
head of the walrus to kill it. This is what I've heard
from my father, Saila. It was known that he was a good
hunter and I trust him that I am saying the truth.
Also, polar bears will only try to kill walrus with
very short tusks; walrus with long tusks they might not
be able to kill.

Some polar bears are more clever than Inuit, more
clever than humans. Hunters will not find them because
they're so clever. A polar bear can hide under the
ice, under the overhang with just his nose sticking
out. He will go under the ice ledge when he hears a
boat, before people see him. Its very hard to see them
when they're hiding like that. A hunter thinks there's
nothing around and even if he sees the polar bear's
nose, he thinks its a piece of ice.

Young polar bears when they grow up and are just about
the same size as their mothers, play with their mothers
and are very happy polar bears. Playing in different
ways, they probably learn many things before they
leave. Young polar bears are never hungry because
their mothers care for them better than their fathers.
Lots of times I've seen mothers with their cubs.
They're just like humans. They're fond of one another;
they seem to be always happy with each other. I don't
know if they mate for life but as soon as the polar
bear is pregnant, the polar bear starts to walk to the
mainland before the snow comes. The polar bears move
to the mainland, to the hills and mountains, so they'll
find places to stay in the caves.

Yes, I really like to do polar bears. Even a long time
ago people carved them. I like to do them better than
men or women. And *qalluunnaat*, the white men, like
them, too.

Osuitok Ipeelee

Osuitok grew up in the bountiful hunting territories around Cape
Dorset and still today is one of the community's best hunters.
According to the Inuit historian and photographer, Peter
Pitseolak, it was Osuitok's ancestor, the great shaman Ohotok,
who predicted years before their arrival that white people would
make Cape Dorset a point of settlement.[8] The influences of
shamanism are often apparent in Osuitok's sculpture, and Osuitok
told me when I first met him in 1970 that as a young man he knew
many men and women who were, or had been, shamans. Since youth
he has heard stories of the shamans and the spirit-helpers they
used to accomplish their work. "They could use animals, anything

Fig. 6. Osuitok Ipeelee. Photograph: Odette Leroux. Courtesy
of the Canadian Ethnology Service, Canadian Museum of
Civilization, Hull.

that grows, or winds, clouds, rains, even the fire. In the past
Cape Dorset people used to be shamans and believe in the shamans
but all that's long ago. Since the Anglican clergymen began
telling them not be shamans, they've thrown away their powers."

It is clear when talking to Osuitok that he is an artist who
delights in his vocation, appreciating (as many Southern artists
do) the freedom the creative life allows. He talks easily,
discussing difficulties and satisfactions, touching sometimes on
the shamans and the sources that inspire his work.

Before the government came up here there was only one
way of making money. People could make money from fox
furs and the other things we used to bring in, but only
a little money. Then it was learned that carvings here
in the Arctic have a price and when there were no jobs
available people quickly learned their value. That is
why they have tried so hard at it. If people hadn't
started carving we'd all be supported by the
government.

I, myself, learned to carve from my father, Ohotok, who
carved not in rock but in ivory. I tried to learn from
him but I also learned from Peter Pitseolak [a powerful
camp leader who took photographs and published his own
account of the last days of traditional camp life]. My
father was carving way back; each year before ship time
[the arrival of the HBC's annual supply vessel] he
would start carving and then take his ivory cribbage
boards and *kayaks* to trade with the people on the ship.
When my father died Peter Pitseolak was the only one in
Cape Dorset who knew how to carve ivory figures. I
really liked his carvings so I got started off by
learning from him. I learned from his dog teams how to
work and finish the dog team, the sled, the person, all
in ivory. Carving ivory is different from carving
soapstone, its delicate work. The texture is harder
and it breaks easily but you can make ivory carvings
that seem more real than those in soapstone.

There was no variety of tools in earlier days. I was
able to buy only files and a chipper, a chisel, but you
could work with the ivory very well. With this kind of
tool you'd keep sharpening it. When you polished the
ivory it came out very nicely. Yes, it was a big
change to start working with stone. In the early days
the quality of the stone was not very good and up to
today it is very hard stuff to work with. There's a
difference, too, in forming the stone. With ivory you
can do almost anything you want but with the stone its
a lot different.

From the start, even when doing ivory carving, I've always tried to make different kinds of carvings, not to do the same things over and over again like some carvers do. Some carvers make one carving which is very popular and then tend to make the same carving over and over even though they are fairly famous carvers. I try to make a lot of varieties of carving.

When I'm planning a stone I try to size it up, imagine what it might look like. I try to make the carving interesting to look at, not boring. I try to put life in that carving. Then I try to imagine the carving when its finished, and how much people will pay!

Whenever its possible, which is a lot of the time, I try to carve outdoors, because carving stone is not healthy; you can get ill from carving year after year. Its not good for your life when you inhale the soapstone. I'm always aware that it can make you sick if you inhale; it can also give you a headache and sometimes it makes my skin break out in hives. Sometimes when I'm carving outside people watch and the carvings I make get copied.

Yes, I used to carve a lot of half-human creatures, creatures that were turning into human beings, but I've stopped this now for a bit. It was well known that the animals the shamans controlled had the ability to turn into humans. Yes, that's the meaning [of these types of carvings]. I think of the shamans and these sorts of things. The shamans were a fact of life in the old days. People experienced their powers.

When a shaman was using his magic he had a real change of personality. When the animals entered into him he'd be chanting loudly: if a shaman was turning into a certain animal, he'd make that animal sound. Once he was filled inside, he'd begin to change, his face, and his skin followed, too.

I was born too late for real shaman work but I did catch up with one woman who did magic, Atsutoongwa. She was a sister of Pootoogook [a camp leader] and Peter Pitseolak. I did not see her change form but she had the seaweed as a spirit and I heard her voice making the sound the seaweed makes when it moves in the salt water. It is said the seaweeds have voices like the sound of certain winds. When there's a light wind and the wind noise mixes with a stream noise, it seems to make sense. They say its the same with the seaweed under water. When there are many seaweeds they make a

beautiful sound but only the shamans know the sound.
Only once when that shaman was filled with the spirit
of the seaweed did I hear that sound.

I try and make things that relate to what I've heard.
Only this way can a carving make sense. I don't carve
any old way. It takes planning to be a carver. I know
what I'm going to be working at tomorrow. We have to
go by our watches; we have to work enough hours just as
you do in a job. What's different in carving is that
we make up our minds and choose what to make.
Sometimes, although I've thought something out, it
doesn't work so I change my mind and make something
else. But each day I think to myself about what I'm
going to carve that day. I think of how the carving
will be put together; no one directs me. People in the
south aim to be good at their jobs. Well, this is the
job I try to do; you have to be good at it, too. But
still its the same thing; we try really hard, even
though we have no boss to watch over us!

Yes, some carvings are more successful than others.
Usually a carving goes ahead well if the rock is solid.
If the rock's not solid, it doesn't make for a good
carving. Yes, I get ideas from the shape of the stone.
Often you make a carving following the shape and often
it doesn't seem entirely up to you. You follow the
shape of the stone and you have a lot of fun with your
imagination and what it brings out in that stone.
Sometimes I'm not very happy with a carving when its
finished but *ayurnamat*! What can I do? I can't do any
more with it.

I don't know whether its the same with you but some
days are happy days, some not so happy. Sometimes I
carry on with a carving but for some reason I don't
really want to finish it. Nowadays, I generally begin
work at something I'm going to carve in the early
morning when its nice, just beginning to get light. I
carve at it all day, the next day and even into a third
day. I won't get tired of it. I won't get bored. So
long as nothing unhappy happens it makes for a good
carving. If something unhappy happens, even if it
doesn't directly concern me, it seems to get in the way
and the carving. Sometimes it doesn't go so well.
When a carving is finished, when it is completely
finished, you get a really happy feeling and your mind
is at rest, though not for long!

Fig. 7, Elisapee Ishulutaq signing an edition of her prints.
Photograph: Tom Webster. Courtesy of Baffin Kamutauyait,
Iqaluit, NWT.

Fig. 8. Interpreter Lisa Ipeelie with her baby Nina up on her
back, 1987. Photograph: Dorothy Harley Eber.

I've always got so many carvings in mind that I want to
make, so many ideas and plans that in some ways it's
hopeless.

When our interview was over Osuitok became an *apirsurti* himself
and said, "I have a question for you. Does your work bring you
joy?" My reply, of course, was affirmative. North or South, it
is a moving experience for a reporter to hear a great artist talk
about his work and what it means to him. Listening to the
artists of the North one realizes again and again how truly the
Inuit have interpreted their world for us, and with what skill
and enthusiasm. It seems likely that, whatever the difficulties,
aspirsurtiit will continue to take their tape-recorders to the
Arctic in hopes of interviewing the artists of the North.
Posterity will certainly want to know more about these remarkable
people.

CONTEMPORARY INUIT SCULPTURE:
AN APPROACH TO THE MEDIUM, THE ARTISTS, AND THEIR WORK

by

Marie Routledge and Ingo Hessel

INTRODUCTION

The term "contemporary Inuit sculpture" applies to a broad range
of works produced by the Inuit of Canada since the late 1940s.
This fascinating art form draws much of its dynamic from the
meeting of two cultures-traditional Inuit culture and twentieth
century Western culture as it is manifested in Canadian society
today. The conditions in which this art has flourished and
developed are discussed elsewhere in this publication.[1] Other
writers also provide an insight into the prehistoric and historic
antecedents of contemporary Inuit art and culture.[2]

The goal of this essay is to offer a framework for
understanding the essential forms and diversity of Inuit
sculpture. Approaches to the subject have focused on collections
of masterworks, specific communities or regions, individual
artists, themes, or materials. We will attempt to present a
synthesis of these considerations by examining the work of some
outstanding artists. They are grouped according to certain
important stylistic or attitudinal affinities, which are most
evident in the work from a particular community or region.
Through this juxtaposition of artists, styles, and attitudes, and
regional views, we intend to highlight some fundamental qualities
of the art and to illustrate the contribution of each sculptor.

This essay is primarily for newcomers to the subject of
Inuit art. However, those with greater experience may also find
the structure and analysis useful in sorting out their ideas on
the nature of Inuit sculpture.

SETTING THE STAGE: Early Contemporary Sculpture

Montreal, November 1949: an exhibition of some three hundred
objects made by the Inuit of Inukjuak and Povungnituk, Quebec,
opened at the Canadian Handicrafts Guild. From all accounts,
these carvings aroused such excitement and interest that they
were all sold in three days. This landmark event is generally
considered to mark the beginning of the contemporary period of
Inuit sculpture and, indeed, of all Inuit art.[3] From a
historical perspective, it set the stage for a remarkable era of
cross-cultural interaction and artistic stimulation involving a
tripartite cast of players: the Inuit with their talent for

carving, the Canadian and international public who greeted the
new art with enthusiasm and delight, and a wide range of
individuals and organizations who acted as facilitators and
prompters in the development of the contemporary art.[4] But what
of the sculptures themselves? What did the visitors to the Guild
see and buy that created such a stir?

Despite the importance accorded to the Guild exhibition, it
is surprisingly difficult to determine what works were actually
shown.[5] This is because the exhibition was really an
experimental venture; objects were not individually documented
prior to the sale and, as they were sold almost immediately, they
were hardly on view long enough to be reviewed or photographed as
they might have been in another art exhibition. This event has
become important in retrospect, for no one at the time could have
foreseen what was to follow. The general character of these
works and similar ones produced in the next three or four years
may be gleaned from published articles of the day,[6] later
accounts by participants in the exhibition[7] and, of course, the
sculptures now in public and private collections, which can be
dated fairly accurately to the late 1940s and early 1950s.

Included in the exhibition this publication accompanied were
three pieces from about 1950 and 1952 (cat. nos. 136 - 138).
They are all from Inukjuak and Povungnituk, the Inuit settlements
first visited by James Houston.[8] Two more sculptures from the
Guild's own collection, Birds on a Base (1949; fig. 1), by Lévi
Qumaluk of Povungnituk, and Dancing Bears (1953; fig. 2), by
Peesee Osuitok of Cape Dorset, are presented as text
illustrations. These five carvings exemplify the works of the
time, many of which were small and unassuming, and some of them
rather experimental. Woman Thinking of Man (ca. 1951; cat. no.
136), for instance, seems rough-hewn and naïve, as if made by a
person still lacking a sure hand. The work is not quite
finished-the semicircle incised next to the woman's face was
never carved with the features of a baby's face. The figures
appear to be based on illustrations in the instructional booklet
Eskimo Handicrafts (fig. 3) prepared by Houston for the Canadian
Handicrafts Guild and distributed in the North to encourage new
carvers and craftspeople.[9] In joining the figures, one on top of
the other, the artist followed the advice in the booklet and
created a new composition.[10]

The finely and carefully executed Box with Animal Heads and
Human Face (1950; cat. no. 137) has much in common with the kinds
of souvenir items made during the Historic period. Like the
cribbage boards fashioned out of walrus tusks for trade, this
object was obviously intended for a Southern function, perhaps as
a matchbox. An interesting feature is the human face, which
bears a rather striking resemblance to faces on certain
contemporary Alaskan objects.[11] Similarly, the incising and

Fig. 1. Levi Qumaluk, <u>Birds on a Base</u> (1949), stone with soap inlay, 7.5 x 13 x 8.5 cm. Collection: Canadian Guild of Crafts Quebec, Montreal. Photo: Charles King, courtesy of the Canadian Guild of Crafts Quebec, Montreal.

Fig. 2. Peesee Osuitok, <u>Dancing Bears</u> (1953), stone and ivory, 11 x 6 x 3.5 cm. Collection: Canadian Guild of Crafts Quebec, Montreal. Photo: Charles King, courtesy of the Canadian Guild of Crafts Quebec, Montreal.

Fig. 3. Illustration from the instructional booklet <u>Eskimo</u>
<u>Handicrafts</u>, published by the Canadian Handicrafts Guild,
Montreal, 1951. Photo: Canadian Guild of Crafts Quebec,
Montreal.

inlay on Peesee Osuitok's and Lévi Qumaluk's small pieces are reminiscent of the incised decorative work of the Historic period. However, in Qumaluk's <u>Birds on a Base</u>, a new material is being used: soap replaces the more traditional ivory inlay.[12]

The kinds of carvings being produced around 1950 were figurines, models, and decorated objects, which were widely sought and requested by art advisers like Houston when the demand for Inuit-made articles spread to communities across the Arctic. Indeed, as indicated by a 1950 photo of a display shelf in Inukjuak (fig. 4), the range of work being sought was varied, if not eclectic. While the makers of these early carvings are sometimes identified, they are not often so; Inuit art was still essentially anonymous. In a sense the 1949 public was reacting to the "Eskimo-ness" of the pieces, their exotic and "primitive" appeal. In general, they are not unlike the trade objects of historic times except, of course, that the recent works were done mostly in stone, not in ivory.

These first small tentative carvings, or "whittles" as many seem to be, had a charm and a simple directness and freshness that transcended the mere souvenir or model; there was, however, a feeling of hesitancy in many of the early pieces. Still to come was the sense of confidence, strength, humour, and flair that have become associated with contemporary Inuit sculpture. At this stage, Inuit carvers did not yet know what directions their work would take or what they were capable of creating.

The initial response to these first small carvings from the Arctic grew into a concerted effort to encourage talented individuals in as many communities as possible. Gradually, the art of each locality began to assume a particular identity, influenced by such factors as the availability of different materials, the tastes and encouragement of local buyers and art advisers, and the success of the more talented artists. The relative isolation of each community also fostered differences and unique characteristics, for although contemporary Inuit sculpture is often perceived as homogeneous, with respect to its cultural roots, its scale, and its emphasis on direct carving, it is remarkably varied and diverse within these boundaries.

One of the first communities to develop a reputation for its particular aesthetic was Inukjuak (formerly Port Harrison). Its artists were fortunate to have access to a rich, dark-green, veined stone, which they used to advantage in their carefully polished and beautifully modelled sculpture. Their sculpture from the mid-1950s shows the emergence of some classic images of contemporary Inuit art. Several developments are noticeable in a short span of only two to three years. For example, as the size of many pieces increased, they began to be seen less as personal souvenirs or native artifacts and more as artworks.[13] Partly

Fig. 4. Display shelf in Inukjuak, Quebec, 1950. Photo: Wilf Doucette, courtesy of the National Film Board of Canada.

because of this increased scale, but also because of the growing confidence of the artists, the character of the works was transformed. More and more, they reflected the ideas and personalities of their makers. We begin to see humorous, almost anthropomorphic depictions of animals like the fat creatures in Two Walruses, of about 1953 - 1956 (cat. no. 141) by Lévi Amidlak (b. 1931). The impressive display of plumage of the beautifully incised Owl (ca. 1955; cat. no. 139) imparts the sense of pride of not only the bird but also the artist. He is, unfortunately, unidentified but he is not without marked individuality. A very different subject that manifests a similar sculptural strength and bold composition is Mother and Child (ca. 1957; cat. no. 142), attributed to Syollie Weetaluktuk (1906 - 1962). The archetypal composition, with its elegant volumes and imposing shape, has a sculptural presence and sureness of form lacking in an earlier anonymous Mother and Child of 1952 (cat. no. 138). While typical of the Inukjuak interest in domestic life, Weetaluktuk's sculpture succeeds in making a statement that transcends mere literal representation. Works like his Mother and Child have become icons of contemporary Inuit art.

Another community that quickly developed a distinctive sculptural style in the mid-1950s was Salluit (Sugluk). As in Inukjuak, the most common subjects were scenes of traditional domestic life. Salluit was not blessed with excellent carving material; nevertheless, the local sculptors, many of them women, wrought some stunning works of art from the dull, coarse grey stone. Woman Combing Her Hair (ca. 1955; cat. no. 140) by Sammy Kaitak (b. 1926), is typical of the best Salluit pieces of this period. The huge, rather flat surfaces of the bodies of mother and child are interrupted occasionally by the superficially delineated folds of clothing. This broad handling of body structure contrasts with the small, delicate facial features and careful treatment of the hair, and reflects the artist's efforts to come to terms with realistic representation of the human figures.

In many ways early contemporary sculptures do harken back to the traditions of the prehistoric figurine and amulet, and the later trade souvenir. More importantly, they also represent a starting point, a new response to the task of making three-dimensional objects. In the early 1950s Inuit carvers were beginning to develop, perhaps unconsciously, a whole range of subjects, styles, and personal artistic concerns. While the influence of advisers and prompters is undeniable, it is remarkable that so many sculptors refrained from slavishly imitating models or responding to Southern tastes, and instead quickly broke new artistic ground. Contemporary Inuit sculpture was becoming a distinctive and expressive art form. The new work grew out of the current situation of the Inuit, reconciling abrupt social and cultural change with the continuity of

traditional values and aesthetics. The following sections
discuss some of the major styles and themes that have evolved in
contemporary Inuit sculpture since the 1950s, and the artists who
have brought them to life.

JOHNNY INUKPUK, DAVIDIALUK ALASUA AMITTU, JOE TALIRUNILI, AND THOMASSIE KUDLUK: "Showing the Truth" - Illustrative and Narrative Sculpture from Nunavik (Arctic Quebec)

> We carve Inuit figures because in that way we can
> show ourselves to the world as we were in the past
> and as we are now.... No matter what activity
> the carved figure is engaged in, something about it
> will be true. That is because we carve to show what
> we have done as people. There is nothing marvellous
> about it. It is there for everyone to see. It is
> just the truth.[14]

The idea of using sculptures, prints, or drawings to present
information on traditional activities, legends, or great personal
events is central to contemporary Inuit art. The art is, after
all, based on one group of people giving a glimpse of itself to
another.[15] Much of the sculpture produced since the 1950s is
thus consciously narrative or illustrative; it aims to convey
some truth or reality about Inuit culture.[16] Contemporary Inuit
art has become an adjunct to traditional oral communication (for
example, singing and storytelling) and the more recently
introduced written forms of the language. For some contemporary
artists, sculpture is a means of combining all three modes of
expression.

The desire to make images that are true, that deliver a
message or portray an event, has been a dominant force in the
Inuit communities of Nunavik, probably more so than anywhere else
in the Arctic.[17] In this quest for truth, the artists, working
primarily in Povungnituk and Inukjuak, have employed a great
variety of approaches, from detailed, almost super-realistic
images to more expressionistic interpretations.[18] The four
Quebec sculptors included in the exhibition, Johnny Inukpuk,
Davidialuk Alasua Amittu, Joe Talirunili, and Thomassie Kudluk,
reflect some of these stylistic variations. But more
importantly, they each express a unique vision in using sculpture
to convey cultural or personal truths. To these sculptors,
realism is largely conceptual, fashioned more by the mind than by
the eye's observation of nature. While Inukpuk concentrates on
depicting traditional activities, Davidialuk looks at the roots
of Inuit history, its myths and legends. The art of Talirunili
and Kudluk, on the other hand, is more personally oriented; the
former is caught up in the major events of his life, and the
latter in his eccentric brand of contemporary social commentary.

Johnny Inukpuk (b. 1911) is best known for his sculpture of
the 1950s and 1960s, when he was singled out as an important
artist with "an adventurous plastic sense."[19] Inukpuk's
sculptures almost always illustrate traditional domestic or
hunting activities; as the three sculptures in the exhibition
demonstrate, they invariably show a figure in the act of doing
something-feeding a child or cooking, blowing up an *avataq*
(sealskin float), or wringing out a sealskin line. This concern
with the details of daily life has been a trademark of Inukjuak
sculpture since the early contemporary period. In his earlier
works, such as <u>Woman and Child</u> (cat. no. 143) and <u>Man Inflating
an Avataq</u> (cat. no. 144), both from 1954, Inukpuk's "plastic
sense" is exhibited in the full, rounded, almost voluptuous forms
of the figures; like the *avataq*, they appear almost inflated, as
if wrapped in the stone's taut surface. The accents provided by
the inlaid ivory and careful incising relieve some of this
surface tension. In later works, such as <u>Man Wringing Sealskin
Line</u> (ca. 1964; cat. no. 145), this sense of surface and
plasticity takes a new direction. The artist has paid equal
attention to such details as the hair and clothing, but in a more
sculptural manner. An exaggerated enlargement of the head and
especially the hands (the main instruments of human action)
reinforces the motions of the illustrated activity.

Like many Povungnituk sculptors, Davidialuk Alasua Amittu
(1910 - 1976) used a great deal of incised line work to
articulate the anatomical details and textures of his subjects.
This practice of "drawing" on the sculpture seems quite in
keeping with the literal, narrative content of much of this work.
However, unlike many of his colleagues in Povungnituk, Davidialuk
eschewed a highly finished or precise approach to his sculpture,
choosing instead to emphasize the roughness of the forms and the
scratchiness of the lines. The immediacy and sense of vigour
that this method imparts to his art are already apparent in one
of his finest early works, <u>Mythological Bird</u> (1958; cat. no.
150), which appears to focus on the story of a woman who is
changed into a seagull.[20] Here, Davidialuk was able to maintain
the sculptural integrity of his strong forms while using this
expressive graphic element. As a narrative artist, Davidialuk
often used his work, including sculptures, drawings, and prints,
to capture the world of myths and legends.[21] In his sculptures,
he singled out a particular figure or event to represent an
entire story. <u>Tunnituarruk</u>, created before 1971 (cat. no. 146),
brings to life this bodiless creature with wings, and tattooed
breasts and vulva on her cheeks and chin. She is said to have
inhabited abandoned snowhouses and there are numerous stories
about the horror of meeting her. For Davidialuk, she became a
favourite subject. Another important subject was the legend of
how the Inuit acquired the sewing machine, record player, and
rifle. Two sculptures are related to this "modern myth":
<u>Igalunappaa: Pushing the Stranded Half-Fish Off the Rocks</u> (1964;

cat. no. 148) shows the hunter rescuing the stranded sea creature; in Igalunappaa with Sewing Machine, Rifle and Record Player (before 1976; cat. no. 149) the sea woman returns with the promised gifts.

Like his cousin Davidialuk, Joe Talirunili (1899 - 1976) ignored the general trend of Povungnituk sculpture by leaving his pieces rough and unpolished; he was, in fact, considered somewhat eccentric in the community. He also had no qualms about using whatever materials were available to him; plastic, wood, shoe polish, and thread, as well as stone and ivory, are commonly found in his work. Talirunili's personal vision and rugged, informal style link his work to folk art. An event from his childhood days is the subject of much of his work, in both his sculpture and his prints and drawings. Migration (ca. 1975; cat. no. 151) depicts an *umiak* constructed by a group of travellers who were stranded on an island after the ice broke up. Joe was so attached to the subject that he repeated it in numerous works, often identifying the figures in the boat in attached notes. Talirunili's other favourite subjects were rustic standing figures: men, women, and owls. Standing Woman with *Ulu* and Bag (1960 - 1976; cat. no. 152) holds her utensils as though they were female emblems (Talirunili's men are all hunters with bows, spears or rifles.) Although unidentified, figures such as this have a portrait-like quality; unlike Inukpuk's people, who are always occupied in some activity, they seem to be posing. Even Owl (ca. 1976; cat. no. 153) has the same silent and static pose and the same wide-eyed, expressionless gaze.

The work of Thomassie Kudluk (1910 - 1989) focuses on the Inuit world of today. Another sculptor who could be called a folk artist, Kudluk lived in the community of Kangirsuk (Payne Bay) and is the least known of this group of Nunavik artists. In formal terms, his sculptures are crudely cut out of the stone and barely modelled. The frequent use of shoe polish to paint the surface of the plain grey stone makes his works stark and decidedly unglamourous. They are far removed from Johnny Inukpuk's sensuous sculptures shaped in the beautiful green stone of Inukjuak. Yet, both artists have the same goal: to show us something of what it means to be Inuit. The social commentary and humorous, often ribald, observations on life expressed in Kudluk's work add a new dimension to Inuit sculpture as a descriptive vehicle. For example, a message is inscribed on the surface of Squatting Man and Dog (ca. 1976; cat. no. 154): "When you are short of something to wipe your ass with, you can wipe it in your pants. We in Quebec prefer not to do this." The subtle insinuation that the viewer may have questionable habits is typical of Kudluk. In Man with Telescope (cat. no. 155) and Man Mounting Woman (cat. no. 156), both about 1976, we see the search for a mate and the rather uncertain results of such an endeavour. Although inscriptions are fairly common in graphic art, few

Fig. 5. Thomassie
Kudluk, <u>Caribou Hunt</u>
(1978), grey stone, 4 ×
17.5 × 17.5 cm.
Collection: La
Fédération des
Coopératives du Nouveau-
Québec. Photo: La
Fédération des
Coopératives du Nouveau-
Québec.

Fig. 6. Underside of
<u>Caribou Hunt</u> shown in
figure 5. Collection:
La Fédération des
Coopératives du Nouveau-
Québec. Photo: La
Fédération des
Coopératives du Nouveau-
Québec.

sculptors carve messages onto their work; Kudluk, however, regularly incorporates written communication into his art. In a work not included in this exhibition, <u>The Caribou Hunt</u> (1978; fig. 5, 6), Kudluk seems to present us with a straightforward hunting scene. Yet, in keeping with his earthy, wry view of the world, the image is far from idealized. As the inscription indicates, these hunters have missed an excellent chance to catch the resting caribou because they were not paying attention, even after their dogs had picked up the scent. On the base of the carving, Kudluk has inscribed a totally unrelated and deliciously subversive commentary: "The man addresses the country of Canada with outstretched arms, saying to the White people: 'I am higher than all governments, therefore I deserve to be heard!'"[22]

OSUITOK IPEELEE, KAKA ASHOONA, KIAWAK ASHOONA, AQJANGAJUK SHAA, PAUTA SAILA, LATCHOLASSIE AKESUK: Mastering the Stone - An Explosion of Creativity in Cape Dorset

When James and Alma Houston first arrived in Cape Dorset as art advisers in the early 1950s, they were immediately impressed by the talent and independence of the people they met.[23] Since then, Cape Dorset has become synonymous with a group of artists who have dominated the history of both contemporary Inuit sculpture and graphics. In no other Inuit community has the making of art been such an integral part of the lives of its inhabitants.

Central to the vision of the Cape Dorset artists is their ability to use their drawings, prints, and sculptures to make dramatic formal statements, which may take the form of elegant, heroic, or playful images. Among other familiar themes, birds, bears and a variety of fantastic imaginary creatures lend themselves to interpretations that amalgamate dramatic composition with dramatic subject. In some respects, the Cape Dorset sculptures are the most decorative works in the exhibition. Their silhouettes and the sensuous appeal of their surfaces, particularly when polished, often constitute an important part of their aesthetic. The striving for beautiful design is a strong element in much of this sculpture, just as it is in the prints. At the same time, formal concerns are carried further by the many Cape Dorset sculptors who have also approached their work as a technical and compositional challenge, pushing their medium to its limits. Their virtuosity is evident in the carved shapes and balanced figures that defy the nature of stone-its hardness, brittleness, and weight. This mastery of the stone and a sensitivity to the dramatic possibilities of both subject and composition have made the works of these Cape Dorset sculptors some of the most visually compelling of the contemporary period.

The six Cape Dorset artists included in the exhibition-
Osuitok Ipeelee, Kaka Ashoona, Kiawak Ashoona, Aqjangajuk Shaa,
Pauta Saila, and Latcholassie Akesuk-are all master carvers.
They are mature sculptors who have developed a strong sense of
professionalism: most were hunters and trappers who began
carving occasionally in the 1950s and have become full-time,
career artists.[24] Many Inuit across the Arctic are now
developing a conscious identity as artists; but this process is
most evident in Cape Dorset, where artists benefit from the
constant strong support of managers and advisers, and a healthy
cooperative.

Osuitok Ipeelee (b. 1922) was well known for his work in
ivory even before the Houstons arrived.[25] Throughout Osuitok's
career, his inventive and compositionally exciting work has
exhibited a variety of qualities-from fine and delicate to
massive, action-filled, and almost brutal. In three sculptures
of birds, Osuitok treats the same subject in different ways to
emphasize its beauty. Owl with Fish in Beak (1964; cat. no.
169), a small, precious work, with its delicately incised
feathers and scales, recalls the skills and aesthetic employed in
his earlier ivory carvings. Yet, the visual twists, such as the
crossed legs of the bird, which draw our gaze around the body,
the precarious balancing of the top-heavy figure on its tiny
feet, and the comical, pie-eyed stare make it a wholly
contemporary creation. Bird Spirit (ca. 1968; cat. no. 171)
exemplifies Osuitok's interest in transformational figures.
Detail is minimized to concentrate on the sensuous, light-green
stone surface, and once again the curved limbs of this bird-human
invite our eyes to move around the figure. In Bird (1970 - 1979;
cat. no. 170), Osuitok takes another direction, this time
refining the subject and presenting it as an elegant, almost two-
dimensional silhouette. In much of his recent sculpture, Osuitok
leaves aside notions of beauty and preciousness to concentrate on
works that are powerful and heroic. Bear and Seal (ca. 1983;
cat. no. 172) shows these creatures locked in a battle for
survival. Osuitok effectively contrasts the dominant form of the
bear's smooth, arched body, with the broken, defeated curve of
the seal's neck.

Like Osuitok, who reworks certain subjects or themes to
explore their formal possibilities, Kaka Ashoona (b. 1928) has
developed a favoured compositional style-the framing of the
subject. In the early Medicine Woman (1953; cat. no. 161), the
powerful shaman has just pierced her body with a harpoon without
any physical injury. The helping spirits perched on her
shoulders, as well as the sinew line of the harpoon, frame the
woman's head and focus our view of her in this very special act.
The notion of focusing attention on a face to emphasize its
expressive force reappears in many later works. In much the same
manner Young Woman (1967; cat. no. 162) uses the twisted knots of

the figure's hair on either side of her face to create a
sensitive, elegant portrait with Matisse-like femininity. In
Woman with Racquet (1977 - 1978; cat. no. 163), the power and
determination of the subject playing a lacrosse-like game is
expressed in the strongly modelled face, this time framed by the
upraised arm and racquet.

In the early 1960s, when spirit and fantastic creatures were
popular subjects for many Cape Dorset sculptors, Kiawak Ashoona
(b. 1933), Kaka's brother, created some of the finest
interpretations. The extraordinary nature of his strange beasts
is emphasized through the precise and elegant rendering of
physical details and the visually dramatic poses. Spirit Bird
(1962; cat. no. 164) illustrates the more traditional type of
transformation image, in this case a bird-dog-human figure.
Presented almost as a two-dimensional silhouette, its backward-
gazing stance and twisted limbs make it comparable to the bird
images by Osuitok, discussed above. In Kneeling Spirit (cat. no.
165), also 1962, Kiawak has created a surreal image of a raging,
gargoyle-like horned beast with a human body. While its effect
may be fearsome, the sculpture is a sensitively carved and
carefully detailed nude figure. The rendering of the wrinkled
flesh on the sole of the rear foot is especially lifelike.
Kiawak's interest in the human form and particularly in studies
of expressive portrait-like faces is evident in his seminude
Woman Holding Fish (1978; cat. no. 166). Larger in scale, recent
works such as this continue his focus on dramatic poses. This
piece is also remarkable for the way in which the change in
colour of the stone at the woman's waist differentiates between
her skin and clothing.

Contortion and exaggeration dominate the sculpture of
Aqjangajuk Shaa (b. 1937). His large-scale animal and human
subjects are frequently in mannered postures that contradict
reality and suggest a love of the improbable. The sense of
struggle in many of Aqjangajuk's works perhaps parallels the
artist's struggle to wrest the shapes from the stone and
transcend the usual limits of carving in this material. Walrus
(ca. 1963; cat. no. 168) depicts this ungainly animal in an
unlikely pose. Caribou and Man (1977; cat. no. 167) is a
surprising image in that it shows the hunter grappling with the
caribou as a live adversary. Usually he is shown straining under
the weight of the animal carcass. Since the 1970s this type of
heroic representation has become popular in Cape Dorset and other
southern Baffin communities such as Lake Harbour, Iqaluit
(formerly Frobisher Bay), and Pangnirtung.

As we have seen, many Cape Dorset artists have consciously
attempted to challenge the stone and have created a wide variety
of elaborate, and even theatrical, images. Certain others, who
have chosen to accept and accentuate its characteristics, seem to

treat a narrower range of subjects. While remaining within the Cape Dorset tradition, these artists often exhibit an aesthetic similar to that of the Keewatin artists who are discussed in a later section.

In his sculpture, Pauta Saila (b. 1916) has concentrated much of his energy on one theme: the polar bear. Once asked why he repeated the same subject again and again, Pauta replied that he had a special affinity for the animal, that he just really liked making bears.[26] An early example, Bear with Two Cubs, of 1956 - 1957 (fig. 7), is delicate, even lyrical in its treatment. However, Pauta eventually began to focus on two aspects of this animal: its power and strength, and its potential for anthropomorphosis. Bear (cat. no. 158), a massive, blockish interpretation from 1964, derives its immense power and energy from the compression of the body into a boldly foreshortened form. It is interesting to note that in this respect Pauta's sculpture often resembles work from Baker Lake. But it is for his "dancing" bears that Pauta has become best known. Bear (1984; cat. no. 157), poised on one leg, stands in marked contrast to our usual impression of this animal. Its swaggering pose seems rather impausible; however, we should remember the Inuit belief expressed by Pauta himself, that "polar bears are like human beings."[27]

Like his father Tudlik, Latcholassie Akesuk (b. 1919) has concentrated on the owl as his favourite subject; however, he has increased the scale to more monumental proportions and has often integrated human elements. Latcholassie's owls, like Pauta's bears, are often wonderfully incongruous images. Owl (1970 - 72; cat. no. 159) is composed of a diminutive head and claws, and legs spaced to create rhythmic accents around the massive and otherwise unarticulated body. Bird-Man (1962; cat. no. 160) is a much more serious-looking piece. Its fused animal and human features make it not so much transformational as combinational. Its composition includes volumes, planes, and curves, not anatomical details; its statement is silent, formal, and static. In these respects it is not unlike the work of John Tiktak of Rankin Inlet and thus reflects a stylistic affinity with the Keewatin abstract figure sculptures.

JOHN TIKTAK, JOHN KAVIK, JOHN PANGNARK, LUCY TASSEOR TUTSWEETUK: Figurative Simplification and Abstraction in the Keewatin

A 1970 presentation of John Tiktak's sculpture was the first exhibition devoted to the work of one Inuit artist.[28] Since then, Tiktak has been acknowledged as a major figure of Inuit art. He is also considered a key member of a group of sculptors from the Keewatin area west of Hudson Bay whose work has been described as having a special "strength and purity of vision

Fig. 7. Pauta Saila,
Bear with Two Cubs
(1956/57), green stone,
19 x 13.3 x 11.8 cm.
Collection: John and
Mary Robertson. Photo:
National Film Board of
Canada.

Fig. 8. John Tiktak,
Mother and Child (c. 1962),
grey stone, 36.5 x 12.5 x
18 cm. Collection:
National Gallery of Canada,
Ottawa, gift of the
Department of Indian
Affairs and Northern
Development, 1989 (NGC
36322). Photo: Michael
Neill, courtesy of the
Department of Indian
Affairs and Northern
Development.

which reveals them to be artists of the highest order".[29] For
the most part, their sculpture is not immediately identifiable as
culturally rooted; depictions of spirits, legends, animals and
traditional activities are rare. The artists Tiktak, John Kavik,
John Pangnark, and Lucy Tasseor Tutsweetuk have concentrated on
reduced or abstract representations of human figures or heads.
Each has worked the stone so that its carved surface becomes as
much the artist's subject as are the figures that emerge from it.

It is interesting to speculate why such a radically
different approach to sculpture developed in this region. The
hardness of Keewatin stone is undoubtedly an important factor, as
it limits the artist's ability to render fine detail or to polish
surfaces to a high gloss. There are also perhaps links with the
experiences of the artists; the various Inuit groups of the
Keewatin endured more harsh periods of famine and deprivation
than did other people in the Arctic. Their pared-down sculpture
may be a reflection of a personal struggle for survival in which
life was often reduced to the most basic level of existence.[30]

John Tiktak (1916 - 1981) produced the most recognizably
figurative and least abstract sculpture of these four Keewatin
artists. His vision is classic-formal and elegant, yet not
overly refined. Although somewhat exceptional because of its
large size, Man (1965; cat. no. 174) is typical of Tiktak's
approach to the human figure. The static frontal stance and the
smoothly modelled volumes and surfaces give the figure a distant,
timeless quality. This work, like his equally notable studies of
mothers and children (fig. 8), presents the human being as a
universal figure. In Heads Emerging from Stone (ca. 1967; cat.
no. 173), Tiktak's style of carving is less finished. Clusters
of disembodied heads. or faces as he presents here, recur in the
work of several Keewatin artists. Similar motifs also appear in
prehistoric work (fig. 9), and direct relationships have been
suggested. However, as no connection can be proven, we can only
guess whether they represent families or gatherings, ancestors or
spirits, or simply heads used in a composition.[31]

The carving of John Kavik (b. 1897) is much more direct and
less calculated than Tiktak's. In general, his figures are
crudely fashioned, with less careful shaping and little attempt
to hide tool marks. In contrast to the timeless works of Tiktak,
his sculptures have a great sense of immediacy; they are
impressions rather than icons. The large work, Man Wearing
Goggles (ca. 1960;cat. no. 175), characterizes the roughness and
tactility of his sculpture. The truncated figure emerges from
the mass of the stone with features that have been cut and gouged
rather than modelled. This rough style is taken to its extreme
in works such as Demonic Figure (1963; fig. 10), in which the
stone has been hewn with violent, expressionistic strokes. A
ceramics project established in Rankin Inlet enabled Kavik to

Fig. 9. Dorset culture, Igloolik area, Faces, caribou antler, 10 x 5.5 x 2.2 cm. Collection: Eskimo Museum, Churchill, Manitoba. Photo: National Film Board of Canada.

Fig. 10. John Kavik, Demonic Figure (1963), grey stone, 13.6 x 9 x 7.8 cm. Collection: Art Gallery of Ontario, gift of Dr. Robert G. Williamson, C.M., 1989. Photo: Don Hall, AV Services, University of Regina for the Mackenzie Art Gallery.

experiment in a very different medium.[32] Not surprisingly, his
works in clay, as shown by Pot with Muskoxen (1967; cat. no.
176), are more modelled and include more naturalistic detail than
do his stone sculptures.

John Pangnark (1920 - 80) from Arviat (formerly Eskimo
Point) is considered the great "minimalist" of this group. He
went further than the others in reducing the human form to smooth
shapes and volumes. Carving single human figures almost
exclusively, he made his works progressively more abstract and
geometric until only a hint of their humanness remained.
Although stylized and angular, Man (1968; cat. no. 180) is still
instantly recognizable as the figure of a person. Woman (1970;
cat. no. 179) is a more abstract image of a woman's head framed
by the billowing shape of her parka hood. The composition has
been reduced to two basic shapes: a triangular wedge
representing the human figure intersected by a semi-circular form
(not unlike the blade of an ulu, the traditional woman's knife)
representing the garment. These planes and curves are
masterfully combined to create a composition that is at once calm
and dynamic. In Abstract Figure (1973; cat. no. 181), we see
the artist's most extreme geometricization of the human form and
most ambiguous interpretation of detail. Here, Pangnark has
invested the stone with the barest of human features.

Another Arviat artist, Lucy Tasseor Tutsweetuk (b. 1934), is
the only living member of this group who is still working. She
has devoted herself almost exclusively to the multiple head or
face motif. While the meaning of a specific piece is not always
obvious, a sense of family and motherhood pervades much of
Tasseor's work. The stone is often left rough and unfinished;
the small faces are arranged in clusters or separately, sometimes
lined up along natural ridges in the rock. Although often
producing small pieces, Tasseor prefers to work on a more
monumental scale. Faces with Igloo (ca. 1970; cat. no. 177) is
one such large work, which may certainly be interpreted as a
family or maternal scene: the mother's arms gather the children
protectively and the igloo is incised below. Reminiscent of
Tiktak's Heads Emerging from Stone (cat. no. 173), Faces Emerging
from Stone (ca. 1975; cat. no. 178) represents the more abstract
side of Tasseor's style: the faces are not only disembodied, but
also relatively disconnected from each other, and the mass of the
rock has remained intact.

TUNA IQULIQ, PETER SEVOGA, PAUL TOOLOOKTOOK, LUKE IKSIKTAARYUK:
Keewatin Variations - Mass and Figurative Sculpture in Baker Lake

In many ways, the sculpture of Baker Lake constitutes part of the
Keewatin history and aesthetic. As in Rankin Inlet and Arviat,
the encouragement of artists and the development of specific arts

projects did not begin in earnest until the mid-1960s. The life
experiences of the inland Inuit groups who settled in Baker Lake
have also paralleled those of the other communities; they too
experienced the devastating famines of the 1940s and 1950s, when
drastic changes in the caribou migration patterns left much of
the Keewatin without its staple food.

From their earliest work, Baker Lake artists began to be
known for their emphasis on the mass and bulk of the hard black
stone characteristic of the area.[33] Stripped of excess detail,
their sculptures feature broad, bulging volumes, which exaggerate
and emphasize the size, weight, and essential shape of the animal
or human figures depicted.

In this respect, Baker Lake artists maintain their link with
other Keewatin artists. Yet, as shown in the art of the four
artists chosen to represent this community, the essence of their
sculptural style lies not in its tendency toward abstraction, but
rather in its affirmation of the figurative content. The family
groups and studies of muskoxen, favourite subjects of many Baker
Lake artists, are two of the best known manifestations of this
interest. While echoing the dominant Keewatin sensibility, the
sculpture of Baker Lake also radiates an exuberance and a sense
of rugged vitality almost unmatched elsewhere in contemporary
Inuit sculpture.

Having lived and worked in Rankin Inlet for several years
before finally settling in Baker Lake, Tuna Iquliq (b. 1935)
bridges the differences between the Keewatin style of figurative
abstraction and the Baker Lake sensibility, by stressing the
elemental quality of the stone. Iquliq's powerful Grappling
Figures (ca. 1974; cat. no. 186) reflects an interest in dynamic
subjects, which is prevalent in Baker Lake sculpture. The nature
of this heroic struggle is vague; we do not know if it is a game
or a battle. Iquliq's approach is similar to Kavik's; his rough
gouging of the stone has charged its enormous bulk with
tremendous tension and energy. The meaning of Kneeling Woman
with Caribou Sleeves (1973 - 1975; cat. no. 187) is also
ambiguous; the human figure bears human and animal faces. Yet,
animal forms substituted for human body parts are not uncommon in
Baker Lake sculpture and underscore the very special mystical
animal-human relationships evident in the art of this community.

In contrast to Iquliq's firmly planted figures, those of
Peter Sevoga (b. 1940) rise up buoyantly from the ground. While
still emphasizing volume and weight, Sevoga gives his family
groups a certain quality of grace. Family with Goose (1971; cat.
no. 184) represents the unity of the family as well as the pride
of the hunter and the happiness of having sufficient food.
Compositional elements are woven together with a fluid sense of
line. The gently undulating forms, rounded and smoothly

polished, reinforce the impression of substance and permanence
conveyed by the subject and material. In <u>Mother and Children</u>
(1973; cat. no. 185), the flowing parka hood seems caught in the
wind and acts as a foil for the three faces. Here as in most of
his pieces, Sevoga's sensitive handling of the curving lines
enables him to either accentuate or counteract the stone mass.

Frequently portrayed by Baker Lake sculptors, the muskox
makes the ideal massive subject. An unusual animal in its own
right, with impressive horns, a humped neck, comparatively small
feet, and a flowing coat of hair, the muskox lends itself to
sculptural interpretation. Like many Baker Lake artists, Paul
Toolooktook (b. 1947) has created numerous versions of the
subject. In <u>Muskox</u> (early 1970s; cat. no. 188) he presents the
animal as a docile, grazing creature. As in other
representations, the proportions have been exaggerated to
emphasize the broad expanse of the huge, remarkable body. Yet
similar to Sevoga's figures, Toolooktook's muskox is given an
unexpected lightness by open space left under the body, a feeling
that is emphasized by the gently lifted front hoof.

More than any other sculptor from Baker Lake, Luke
Iksiktaaryuk (1909 - 1977) can be said to have embraced the
"minimalist" Keewatin aesthetic. By choosing to work in antler,
Iksiktaaryuk imposed upon himself severe restrictions on form
and, to a certain extent, subject matter. The thin or flat
shapes and the extreme hardness of the material may have dictated
his attenuated, rather crude style; however, it is more likely
that they simply suited it. The natural texture and shape of the
antler is preserved wherever possible, and little concern is
shown for careful finishing of carved or cut surfaces. <u>Family
Procession</u> (1965 - 1970; cat. no. 183) depicts a journey or trek
across the land. The figures move in single file up and over the
gentle arc of the branched antler base, but are isolated from one
another, without the sense of interconnectedness found in the
works by Sevoga. Iksiktaaryuk's <u>Shaman</u> (ca. 1975; cat. no. 182)
is poised for flight, a silent self-contained figure in a
mystical experience that we can glimpse but cannot share.

**MARK TUNGILIK AND AUGUSTIN ANAITTUQ: Intimate Delights -
Miniature Sculpture in Repulse Bay and Pelly Bay**

Although most Inuit artists work in a "table-top" scale or even
larger, some have chosen to create sculptures small enough to fit
in the palm of the hand. Fashioning single figures or
compositions of several small elements joined together, these
artists have added a truly intimate dimension to Inuit sculpture.
Because of its size, their work draws the viewer in, demanding to
be seen at close range. Much of it has a precious or jewel-like
quality, owing equally to the scale, the finesse of the carving,

and the natural beauty of the dominant ivory material. This sculpture almost always delights because of the apparent contradiction of its littleness and its ability to suggest an image at least as large as life.

More than any other type of contemporary Inuit sculpture, the small-scale or miniature genre is reminiscent of its antecedents-the carvings of the Historic and possibly even the Prehistoric periods. For, unlike modern Western sculpture, which originated as an adjunct to architecture, stepping down from the pedestal as it were, contemporary Inuit sculpture has evolved from the small hand-held objects of the past.

The clearest links are between the contemporary small-scale genre and carvings produced during the Historic period. During this era of early European contact, which is usually considered to have begun in the 1700s, the making of secular objects for an outside market became widespread. The products of this new artistic activity were usually executed in a very small or miniature scale. Intended as objects for trade with missionaries, whalers, and other northern travellers,[34] the works of this period were amazing in their technical precision and often took the form of models (*kayaks*, sleds, etc.; see cat. nos. 130 - 135) or tiny replicas of non-Inuit items like primus stoves (fig. 11), fox traps, rifles, or tools.[35] Ivory was the principle medium for these small creations, and many of the finest examples of this work from the Historic period were collected in the Repulse Bay region and elsewhere along the west coast of Hudson Bay.

It is more difficult to ascertain a relationship to prehistoric forms. The history of art-making in the North is, after all, episodic in nature rather than evolutionary.[36] The beautiful, small ivory carvings of both the Dorset and Thule cultures (see cat. nos. 122 - 129) certainly set a precedent for miniature carving in Canada's Arctic.[37] In both function and format, contemporary miniature sculpture is very different from its prehistoric antecedents. The new sculptures are made for sale rather than for magical and religious purposes. They are also designed to stand on a flat surface and to be viewed from one dominant perspective rather than to be carried in a pouch or worn as an amulet. Yet, the miniature sculptures of the contemporary period continue to reflect, both in their sculptural forms and in their portability, a sensibility to small-scale carving that harkens back to prehistoric times.[38]

Mark Tungilik (1913 - 1986) began carving in Pelly Bay while still in his teens,[39] and was already specializing in ivory when, in 1945, at the request of the resident missionary, Father Franz Van de Velde, he produced a small bust of Christ wearing a crown of thorns.[40] He later moved to Repulse Bay, and when James

Fig. 11. Artist unknown, Eastern Arctic (Lake Harbour area ?),
Primus Stove (1930). Collection: Canadian Museum of
Civilization. Photo: Canadian Museum of Civilization.

Fig. 12. Karoo Ashevak, Shaman (1972), whalebone, wood, antler,
ivory, and stone, 42 x 45 x 35 cm. Collection: John and Mary
Robertson. Photo: B. Patterson, courtesy of the Department of
Indian Affairs and Northern Development.

Houston arrived there in 1950 to identify and encourage artists, Tungilik brought him the first sculpture, an "exquisitely formed" small ivory carving of a bird.[41] Until his death, Tungilik continued to produce pieces that usually measured only a few centimetres high, even though his failing eyesight often required him to wear two pairs of eyeglasses at once while he worked.[42] His works most commonly consist of tiny ivory figures mounted on stone bases; animals, spirits, and especially people with oversized heads and staring eyes, are carved in a vigorous, expressionistic style. The model-like Hunter in a Kayak (1957; cat. no. 203) is reminiscent of replicas from the Historic period. The earlier Magic Caribou, of 1951 (cat. no. 201), however, with its eerie humanlike stance, springs largely from Tungilik's personal vision and illustrates the mystical content of much of the artist's work. Shaman and Spirit, from 1981 (cat. no. 200), is remarkably powerful despite its tiny size. It too delves into the supernatural and is marvellously ambiguous – we wonder which figure is which. In Men and Foxes (1982; cat. no. 204), Tungilik carried miniaturization to its extreme-the almost microscopic figures are arranged in a small landscape. Yet, Tungilik's work does not derive its character solely from its size; in particular his human figures and spirits are notable for their energy and presence.

Augustin Anaittuq (b. 1935) lives in Pelly Bay and began to carve around 1966.[43] Like many Inuit artists, Anaittuq carves only sporadically, and yet, as Father Van de Velde noted in 1970, "When he does, it is sure to be a small masterpiece."[44] The four pieces included in the exhibition are part of a group of forty sculptures produced around 1975 in a period of intense activity. Anaittuq's compositions of that time are seldom more than four or five centimetres high. Made of ivory or a combination of other materials and ivory, they usually present a scene or vignette of Inuit life, or depict legends. Works like Drying Fish (1975; cat. no. 206), follow the tradition of much of the art from the Repulse Bay and Pelly Bay area, which concentrates on fairly straightforward representations of domestic and hunting activities. However, like Thomassie Kudluk, Anaittuq often goes beyond generalized illustration and infuses the small-scale genre with a personal note of wit or a social comment. Tall and Thin, Short and Fat (cat. no. 205) depicts the quirks of individual physiognomy. Suicide (cat. no. 207) and Drinking (cat. no. 208), on the other hand, are serious in their depiction of two problems threatening the traditional values of Inuit society.

KAROO ASHEVAK, JUDAS ULLULAQ, MAUDIE OKITTUQ, AND ABRAHAM ANGHIK: Of Spirits and Shamans – Surreal and Expressionistic Approaches to Sculpture and the Impact of Spence Bay

Beliefs in spirits and the supernatural date back to prehistoric

times. The animistic world view of the Inuit acknowledged the existence of spirits in all aspects of nature-in animals, the weather, the land, and the sea. Independent spirit beings, powerful and often malevolent, also inhabited the landscape and were respected and feared. The Inuit felt they had to live in harmony with all types of spirits in order to survive in their environment.[45] This situation required the assistance of shamans as intermediaries and propitiators. Although abandoned by some, these beliefs survive today in modified form despite the influence of Christianity, with which, in fact, they seem to coexist; they have certainly inspired many artworks.

By their very nature, spirit and shamanic images tend to be exceptional and even bizarre in their content. They portray beings who often exist on a different plane of reality, and events, such as transformations, that are not witnessed by everyone. In their depictions of these images, artists generally conform to established sculptural styles, as we have already seen in works from Arctic Quebec and Cape Dorset. In the late 1960s, a group of artists in the central Arctic community of Spence Bay began to focus on spirits and other beings as subjects. They also developed a special exaggerated, expressive, and even surreal style to represent them.

The Netsilik peoples of this region seem to have particularly strong spiritual beliefs.[46] This might account for the strong emphasis on spirit and shamanic themes, but does not account for the style. It is likely that the predominant carving material of the late 1960s, whalebone, influenced the style adopted by the artists of Spence Bay. The unique qualities of whalebone-its large size, complex natural shapes, and varying textures-lend themselves to the creation of sculptures whose forms can be easily exploited and exaggerated. After the carving potential in Spence Bay was confirmed, quantities of whalebone (and even stone) had to be flown in because of a shortage of good local supplies.[47] Probably the most important factor in the establishment of a new sculptural style, however, was the work of one remarkable talent, Karoo Ashevak. Nowhere else has the style of an entire community been so dominated by the work of a single artist.

Like most of his fellow artists, Karoo Ashevak (1940 - 1974) chose to work in whalebone, rather than stone. Its unusual characteristics perfectly suited his style and subject matter, which consisted mainly of figures of humans, including shamans, and a multitude of spirits. Reinforced by his dreams and imagination, his belief in the awe-inspiring power of the supernatural and the role of the shaman often led him to create a repertoire of eerie and grotesque images. These are tempered and enhanced, however, by his sense of humour and inventiveness. As a result, his sculptures are surreal in both subject and

form-fantastic and frequently large assemblages of whalebone with inlays or additions of ivory, stone, antler, sinew, and string. A complex construction illustrating Karoo's mastery of the whalebone medium and his talent for composition, Spirit (1972; cat. no. 192) probably represents a shaman and his helping spirit. Fantasy Figure with Birds, also 1972 (fig. 12), may represent a similar shamanic scene. The main figure's second mouth, apparently gaping in a scream or roar, is juxtaposed with three whimsical birds; this work epitomizes Karoo's careful balancing of playful representation with serious subject matter. In The Coming and Going of the Shaman (ca. 1973; cat. no. 191), Karoo paraphrased the familiar mother-and-child motif of Inuit sculpture to portray the passing on of shamanic powers. The large and porous head and hand represent the older (and deteriorating) shaman, the smaller and denser ones, the younger shaman.[48] Whalebone Face and Figure (cat. nos. 189, 190), both 1974, illustrate the more extreme facial distortions characteristic of his later works. While Karoo exaggerated and mismatched the size and shape of eyes, noses and mouths in his earlier sculptures, these features were still fairly symmetrically situated along vertical and horizontal axes. Beginning in 1973, we see a Picasso-like displacement of these features. Interestingly enough, this complication of two-dimensional facial design was accompanied by a streamlining of overall sculptural form, which now consisted of fewer elements and less varied materials. By concentrating attention on the distorted masklike faces, Karoo intensified their surreal quality. Karoo's career was cut short by his untimely death, yet he continues to hold a special place in Inuit art. His works strike a chord in many viewers because of their originality and exuberance, and their overt supernatural and psychological nature.

Although Karoo Ashevak's uncle, Judas Ullulaq (also known as Ooloolah; b. 1937), now lives in the neighbouring community of Gjoa Haven, his work reflects the Spence Bay style. His subject matter is very different from his nephew's; Ullulaq prefers to portray more typically Inuit themes like hunting, fishing, and daily chores, in an illustrative manner similar to Johnny Inukpuk's. He also works in stone more often than in whalebone. However, Ullulaq greatly admires Karoo's work and has incorporated certain of its stylistic characteristics into his own sculpture. The most obvious similarity is in the faces-large and expressionistically carved with twisted, asymmetrical, and even grotesque features. Mouths gape, and large drilled nostrils flare. Eyes are made prominent with ivory and stone inlay-they seem to have an astonished or frightened look-and other details like teeth and tattoo marks are frequently inlaid with contrasting materials. Ullulaq seems to enjoy construction, assembling his works from several component pieces, as did Karoo. Fisherman (cat. no. 193) and Hunter with Harpoon (cat. no. 194),

both from 1982, are typical of his work in their mixture of
materials and their detailing. Faces dominate the sculptures and
tend to rivet our attention, while other body parts and clothing
are somewhat schematized but equally well finished. For the most
part, Ullulaq's figures are unmistakably human in scale,
proportion, and anatomical detail: his main subjects are hunters
rather than spirits. He seems to have adapted Karoo's style,
using its expressive and inventive possibilities to give
traditional Inuit images a greater psychological impact.

The sculptures by Maudie Okittuq (b. 1944), like those of
Karoo Ashevak, reflect a fascination with spirits and myths. In
particular, she concentrates on representations of the Inuit sea-
goddess, who is considered to be the mother of all sea animals.[49]
A sense of otherworldliness is conveyed by her sculpture, largely
through her rendering of a figure's face. Although Karoo's
distortions or Ullulaq's exaggerations are not evident, the
strongly modelled facial features of Okittuq's women—almond-
shaped eyes, flat triangular noses, and thin lips-very clearly
echo the heightened expressionist sensibility that these other
Spence Bay artists have brought to the interpretation of humans
and spirits. Okittuq also differs from Karoo and Ullulaq in her
preference for working with a single piece of stone. Usually
conceived without inlay or added elements, her broad, rounded
forms can be characterized as more traditional carvings. Without
the playful "tinkering" and punning that Karoo adds to his work,
Okittuq's approach to the spirit world is serious and
straightforward. Sedna (1978; cat. no. 196) shows the mother-
goddess as half woman, half sea-creature (perhaps a seal or
fish), reflecting her origins in the human world and her present
status; she appears to be looking up at us from her underwater
home. The neatly plaited braid, often mentioned in the sea-
goddess mythology, suggests that she is calm and in good humour.
The change of colour in the stone at the figure's waist
reinforces the dual nature of her physical being. The subject of
Spirit Woman with Braid (ca. 1980; cat. no. 197) is more
ambiguous. The woman's four pawlike limbs suggest that the
sculpture may be inspired by the stories of the woman who married
a dog; the Central Eskimos have combined these stories with the
sea-goddess mythology.[50] Whether the face below represents the
woman's offspring is also unclear. In any event, the work
conveys the presence of a strong, protective female being. In
Seated Woman (1980; cat. no. 195) these notions of maternity and
life-giving become less mythological and spiritual, and more
concretely human. With her large belly and folded legs, the
figure is both fetal and female. The contorted facial features
suggest that she is in labour.

Artists like Karoo and Okittuq have used their work to
explore and confirm traditional Inuit spiritual beliefs. This is
more problematic for younger Inuit artists who have not had a

traditional upbringing on the land; they have attended school, learned English, and have been exposed to a myriad of southern influences. Like many young Indian artists, they have been faced with the choice of portraying a way of life that they have not actually experienced, or coming to terms with their own particular situation and searching for an understanding of their past through their art.

One such artist is Abraham Anghik (b. 1951) from Paulatuk in the western Arctic, who now makes his home on Saltspring Island in British Columbia. In general, Inuit sculptors are sheltered from outside artistic influences because of their relative isolation. Anghik, however, has made an effort to learn from other art traditions. He has sought formal artistic training, studying silversmithing, carving, and printmaking techniques at the University of Alaska. Consequently, he is familiar with the art of Alaskan Eskimos, Northwest Coast Indians, and other native groups, and has incorporated some of their stylistic elements into his personal style. He frequently works in wood, bronze, and silver, as well as more traditional Inuit materials like whalebone, ivory, and stone (although he prefers exotic stones from Africa and South America). His training in design and jewellery-making is clearly evident in his precise use of line, and his careful working of detail and polishing. In Spirits Along a Seashore (1985; cat. no. 198), Anghik, like Karoo Ashevak, has chosen a piece of whalebone whose natural form is already expressive and strongly sculptural to realize this work, which he describes as "images of howling spirits, Raven and its young, and demons."[51] The grotesque face at the top is very much in Ashevak's style, while the more graphic relief carving below shows a Northwest Coast Indian influence. A similar use of tightly controlled linear design can be seen in Angatkro with Owl Spirit Helpers (1985; cat. no. 199); one side of the sculpture shows a shaman drumming, and the other side depicts his singing spirit, flanked by owl spirit helpers.[52] Again, some exaggeration and distortion of the facial features is used to denote the supernatural character of this person. Anghik's experimentation and eclecticism, and his fusion of different cultural elements, are probably indicative of future directions in Inuit sculpture.

CONCLUSION

This essay has highlighted some of the attitudes and stylistic developments that have shaped contemporary Inuit sculpture over the last forty years. These factors are often associated with community or regional developments and tend, therefore, to make the overall picture of Inuit sculpture more of a mosaic than an integrated whole. The term "contemporary Inuit sculpture" aptly defines this period of artistic production, during which certain

cultural, social, commercial, and aesthetic forces have come to bear. However, in view of the multiplicity of styles and individual talents, its usefulness or even appropriateness as a generic stylistic label is limited. Viewers will invariably be influenced by the Inuit cultural content and attracted by the sensual appeal of the materials in specific works. It is our conviction that the unique approach used by each artist in expressing his or her ideas must also be recognized and appreciated. Tasseor creating her minimalist groups of faces in Arviat, Kaka carving his dramatic head studies in Cape Dorset, or Kudluk fashioning his caustic social-message carvings in Kangirsuk: all these artists have responded to their particular circumstances, but more importantly, they have all summoned individual aesthetic sensibilities and creative talents to produce their sculptures.

As well, we have approached this essay with the view that Inuit carving can and should be placed in a broader sculptural aesthetic framework:

> The specific character of sculpture, above and
> beyond its tridimensionality, lies in the
> inseparability of the image it creates from
> the tangible solidity of the sculptured object
> in natural space, from the quality of the material
> and its volume....[53]

This excerpt, from the Encyclopedia of World Art, is a reminder of how sculpture as a means of artistic expression enables the artist to create a new, tangible object. With a presence and life of its own, the character of this object depends as much on its physical and material qualities as it does on the subject depicted. From traditional examples to modern extensions of the medium, whether in classical Greek temple statuary, African figures and masks, the work of Henry Moore, or the more modern metal sculptures of artists like David Smith and Donald Judd, the intimate fusion of the idea and the three-dimensional "stuff" of a work, when interpreted through the artist's sensibility, results in its communicative power as a sculpture.

The direct-carving method used by sculptors like Davidialuk, Osuitok, Tiktak, and Karoo is a central feature of their work. By axing, sawing, and filing to remove excess material, they have engaged in a reductive process to extract forms from more or less resistant media. This craftsmanlike approach allows the artists to display both their skills and imagination, and gives their work the strong tactile quality that is central to the aesthetic of Inuit sculpture.

The methods of these artists is direct in another sense as well, for they do not use preparatory drawings or maquettes to

assist in the realization of their subjects. In a sense, Inuit artists sketch in the stone, shaping images as they are conceived in their memory and imagination. Moreover, their sculptures are created on a human scale that is determined by the relationship between the block of stone and the hands of the maker; we can thus relate to them on an intimate, personal level. These qualities of immediacy and vitality speak to our hearts as well as our minds.

The Inuit sculptors represented in this exhibition have undoubtedly made an important contribution to their cultural heritage. Moreover, the artistic significance of their works will give them an honoured place, not only in Canadian art, but also in the history of twentieth-century sculpture.

NOTES

1. See the essays, "Inuit Art: A History of Government Involvement" by Helga Goetz and "The Fourth World and Fourth World Art" by Nelson Graburn in the present volume.

2. See the essay, "The History of Inuit Culture" by Patricia Sutherland in the present volume.

3. For a more in-depth discussion of the history of contemporary Inuit art, see Helga Goetz's essay, cited above. See also Virginia Watt's essay, "The Beginning" in Canadian Guild of Crafts Quebec: The Permanent Collection: Inuit Arts and Crafts c. 1900 - 1980 (Canadian Guild of Crafts Quebec, Montreal, 1980), 11-15, and James Houston's essay, "Port Harrison, 1948" in Port Harrison/Inoucdjouac (Winnipeg: Winnipeg Art Gallery, 1977), 7 - 11. The Guild's name was changed to its present "Canadian Guild of Crafts Quebec" in 1967. (Author's note: Since the writing of this essay, research on the 1949 exhibition has been greatly advanced by Darlene Coward Wight in her essay, "The Handicrafts Experiment, 1949 - 1953" in the exhibition catalogue The First Passionate Collector: The Ian Lindsay Collection of Inuit Art [Winnipeg: Winnipeg Art Gallery, 1991], 45 - 92).

4. See again the Goetz and Graburn in this publication. One of the best general essays on the historical situation of Inuit sculpture is still Charles Martijn's "Canadian Eskimo Carving in Historical Perspective," Anthropos 59 (1964), 549 - 596.

5. Two works in the present exhibition, Woman Thinking of Man (cat. no. 136) and Box with Animal Heads and Human Face, (cat. no. 137) were some of the earliest sales at the Canadian Handicrafts Guild. The authors are interested in contacting any collectors who can trace other pieces from the period 1949 - 1953. [Again the authors refer readers to Darlene Wight's more recent findings as mentioned above in note 4].

6. James Houston wrote many illustrated articles to promote the new art. These include: "Eskimo Sculptors," Beaver (June 1951), 34 - 39; "In Search of Contemporary Eskimo Art," Canadian Art IX, 5 (spring 1952), 99 - 104; and "Contemporary Art of the Eskimo," Studio, 147, 731 (February 1954), 40 - 45. Montreal art critic Robert Ayre also provided some interesting insights. For a selection of his reviews from the 1950s, see "Historical Notes," Inuit Art Quarterly (winter 1987), 15 and Virginia Watt, "In Retrospect," Inuit Art Quarterly (spring 1987), 17 - 18.

7. One collector who has spoken publicly about his purchases at the first guild sales is Ian Lindsay. Brief reference is made to this in his article "Iconoclastic Reflections on Collecting Inuit Art," Inuit Quarterly (spring 1986), 4. Mr. Lindsay's important

collection of sculpture of the 1940s and 1950s is now part of the collection of the Winnipeg Art Gallery.

8. For an account of Houston's activities at this time, see again Helga Goetz's essay.

9. James Houston, Eskimo Handicrafts (Montreal: Canadian Handicrafts Guild and the Department of Resources and Development, 1951), 3. The translation of the Inuktitut caption below the drawing reads: "The small Eskimo man and woman shown above are carved from ivory that is one year old or more. They could have been made in any position, either sitting or walking. They are carefully smoothed and polished. Can you make one?"

10. Ibid., 1. "These suggestions should in no way limit the Eskimo. He should be encouraged to make variations and introduce new ideas into his handicrafts."

11. Nelson Graburn notes a general similarity between the images in Eskimo Handicrafts and those found in Alaskan government publications of the same period in his article "The Discovery of Inuit Art: James A. Houston-Animateur," Inuit Art Quarterly 2, 2 (spring, 1987), 3 - 4.

12. Soap was not the only material experimented with as a substitute inlay. Other artists used, for example, the plastic melted down from old coloured phonograph records.

13. It has generally been assumed that the increased scale of artworks was the result of market demand. However, James Houston has stated that Inukjuak artists like Akeeakashuk began to carve larger works on their own, and that in fact buyers were concerned about the possible "unEskimoness" of such pieces (conversation with James Houston, March 1988).

14. Paulosie Kasadluak, "Nothing Marvellous" in Port Harrison/Inoucdjouac (Winnipeg: Winnipeg Art Gallery, 1977), 21.

15. Jean Blodgett has examined the narrative quality of Inuit art in the exhibition catalogue Eskimo Narrative (Winnipeg: Winnipeg Art Gallery, 1979).

16. Although the Inuit of the 1950s may have considered that the purpose of their art was to describe their world to people in the South only, many of today's artists have also expressed the notion that their sculptures, prints, and drawings are a legacy and record of the old ways for their grandchildren and future generations of Inuit. See, for example, the artist's comments included in Dorothy Eber's essay "Talking with the Artists" in the present volume.

17. See George Swinton's discussion of realism in "The Povungnituk Paradox: Typically Untypical Art," in <u>Povungnituk</u> (Winnipeg: Winnipeg Art Gallery, 1977), 22 - 23. Another interpretation in offered by Nelson Graburn in "The Eskimos and Airport Art," <u>Trans-Action</u> IV, 10 (October 1967), 28 - 33, and "Eskimo Soapstone Carving: Innovation and Acculturation," paper read at the 65th Annual Meeting of the American Anthropological Association, Pittsburgh, 1966.

18. Swinton, <u>op. cit.</u>

19. Robert Ayre, "Choice Work by Eskimos on View Here," Montreal <u>Star</u> (November 14, 1953), as reprinted in the <u>Inuit Art Quarterly</u> (winter 1987), 15.

20. Bernard Saladin D'Anglure, <u>La parole changée en pierre. Vie et oeuvre de Davidialuk Alasuaq, artiste inuit du Québec arctique</u> (Quebec City: Ministère des Affaires culturelles, 1978), 74.

21. Like a number of his fellow Povungnituk sculptors, he participated in a project initiated in the community in 1959 to encourage the depiction of Inuit oral history in stone. Taped and written versions of the stories were collected and later published with illustrations of carvings, thus further reinforcing the role of sculpture as an adjunct to the written word in capturing oral history. See Zebedee Nungak and Eugene Arima, <u>Eskimo Stories-Unikkaatuat</u>, Bulletin No. 235, Anthropological Series No. 90 (Ottawa: National Museums of Canada, 1969). A later book also included both stories and reproductions of Davidialuk's sculptural and graphic interpretations. See Bernard Saladin D'Anglure, <u>op. cit</u>.

22. Marybelle Myers, ed., <u>Things Made By Inuit</u> (Montreal: La Fédération des Coopératives du Nouveau-Québec, 1980), 47.

23. James Houston, "Cape Dorset 1951," in <u>Cape Dorset</u> (Winnipeg: Winnipeg Art Gallery, 1980), 9 - 11; and Alma Houston, "Cape Dorset" in the same publication, 13 - 16.

24. For discussion of this evolution of the artist's identity see Marie Routledge, <u>Inuit Art in the 1970s</u> (Kingston: Agnes Etherington Art Centre, 1979), and Marion Jackson, <u>Baker Lake Inuit Drawings: A Study in the Evolution of Artistic Self-Consciousness</u>, Doctoral Thesis, University of Michigan, University Microfilms International, Ann Arbor, 1985.

25. James Houston; Alma Houston, <u>loc. cit.</u>

26. Dorothy Eber, "Glimpses of Seekooseelak History," in <u>Cape Dorset</u>, Winnipeg Art Gallery, Winnipeg, 1980, 25.

27. See Dorothy Eber's interview with Pauta in her essay "Talking with the Artists."

28. Gallery One-One-One, <u>Tiktak: Sculptor from Rankin Inlet</u> (Winnipeg: University of Manitoba, Gallery One-One-One, 1970). The curator of the exhibition was George Swinton.

29. Norman Zepp, <u>Pure Vision: The Keewatin Spirit</u> (Regina: Norman Mackenzie Art Gallery, 1986), 35.

30. For a moving account of these hardships, see Farley Mowat, <u>People of the Deer</u> (Toronto: McClelland and Stewart Ltd., 1952).

31. Jean Blodgett, <u>Multiple Human Images in Eskimo Sculpture</u>, Master's Thesis, University of British Columbia, Vancouver, 1974, 99 - 100.

32. For descriptions of the project, see Claude Grenier, "Some wonderful, creative years in Rankin Inlet," <u>About Arts and Crafts</u> V, 1 (1982), 28 - 34; and Nancy A. Newman, "The Rankin Experiment: Exploration in Clay," <u>Rankin Inlet/Kangirlliniq</u> (Winnipeg: Winnipeg Art Gallery, 1981), 41 - 47.

33. For examples of the earliest work, see <u>Eskimo Carvers of Keewatin N.W.T.</u> (Winnipeg: Winnipeg Art Gallery, 1964).

34. See Jean Blodgett, "The Historic Period in Canadian Eskimo Art," <u>Beaver</u> (summer 1979), 17 - 27.

35. Jean Blodgett, "Repulse Bay Sculpture," <u>Repulse Bay</u> (Winnipeg: Winnipeg Art Gallery, 1979), 36.

36. Robert McGhee gives a concise account of the stages of prehistoric culture and art in Canada's Arctic; he describes them as "neither simple nor direct" in "Prehistoric Arctic Peoples and Their Art," <u>The American Review of Canadian Studies</u> XVII, 1 (spring 1987), 5 - 14.

37. For an examination of these objects, see Patricia Sutherland's essay, "The History of Inuit Culture" in the present volume.

38. Prehistoric objects were small because of their makers' nomadic way of life. In the community of Pelly Bay, contemporary artists were encouraged to produce small carvings in order to minimize transportation costs. Father Franz Van de Velde, OMI., <u>Canadian Eskimo Artists: A Biographical Dictionary-Pelly Bay</u> (Yellowknife: Government of the Northwest Territories, 1970), 2.

39. Canadian Arctic Producers Co-operative Limited, <u>Marc Tungulik-Recent Sculpture</u> (Ottawa: Canadian Arctic Producers Co-operative Ltd., 1982), 1.

40. Father Franz Van de Velde, OMI., <u>op. cit.</u>, 23.

41. James Houston, "Repulse Bay 1950," <u>Repulse Bay</u> (Winnipeg: Winnipeg Art Gallery, 1979), 21.

42. Department of Indian Affairs and Northern Development, Inuit Art Section files, information recorded August 1968.

43. Jean Blodgett, <u>Augustin Anaittuq</u> (Toronto: Art Gallery of Ontario, 1985), 1.

44. Van de Velde, <u>op. cit.</u>, 9.

45. For more extensive discussion of shamanism and related beliefs, see Jean Blodgett, <u>The Coming and Going of the Shaman: Eskimo Shamanism and Art</u> (Winnipeg: Winnipeg Art Gallery, 1979).

46. Jean Blodgett cites various sources stating that Netsilik peoples had particularly strong spiritual beliefs, in her catalogue, <u>Karoo Ashevak</u> (Winnipeg: Winnipeg Art Gallery, 1977), 3 - 4.

47. Abjon Bromfield, "Operation Whalestone," <u>North</u> 16, 6, (November-December 1969), 1 - 7.

48. For a more complete explanation, as given by the artist to John McGrath, see Jean Blodgett, <u>Karoo Ashevak</u>, 5 - 6.

49. For more information on the sea-goddess, known variously as Sedna, Taleelayo, or Nuliayuk, see Nelda Swinton, <u>The Inuit Sea Goddess</u> (Montreal: Montreal Museums of Fine Arts, 1980).

50. Eugene Arima, "A Review of Central Eskimo Mythology" in Nungak and Arima, <u>op. cit.</u>, 115 - 117.

51. Personal communications, November 1987.

52. <u>Ibid</u>.

53. Giulio Carlo Argan, s.v. "Sculpture," <u>Encyclopedia of World Art</u> (London: McGraw Hill Publishing Company Ltd., 1966), XII, 816.

INUIT TEXTILE ARTS

by

Maria Muehlen

The skill of sewing was highly developed in the traditional
culture of the Inuit, as the physical survival of the entire
family depended on the skin clothing masterly crafted by the
women of the household. This skill was handed down from mother
to daughter, and being a good seamstress was the most highly
prized quality in a woman of marriageable age. Her sewing skills
gave the traditional Eskimo woman an important status, as her
hunter husband depended on her sewing for his survival just as
much as she depended on the food from the animals that he hunted.

THE WALL HANGINGS OF BAKER LAKE

The textile objects of the Inuit, such as parkas, were not only
useful; as they were richly ornamented, they also had
considerable aesthetic value. As a consequence, the first Arts
and Crafts Officers working in Northern communities in the early
1950s tried to channel these sewing skills into activities that
would produce goods for sale in southern Canada. In Baker Lake,
Elizabeth Whitton, wife of the local Anglican missionary, was
hired in 1966 to establish a sewing programme. She set up a
sewing shop, where people could buy supplies to work with at home
and later return the finished products, such as mittens, duffel
socks, and *kamiks* for sale. Occasionally, a small hanging was
made from scraps left over from the cuttings of more utilitarian
objects. Eventually, this sewing programme was discontinued and
replaced by a factory-oriented operation, where women worked as
employees in the craft shop. They were trained to use sewing
machines and to manufacture mass-production items. This project
was doomed to failure, mainly because of the women's dislike for
a factory system, which did not allow them to work at home.

The sewing programme was revived in 1970 after Jack and
Sheila Butler, an artist couple, arrived in Baker Lake to work
with the arts and crafts programme. With the shutdown of the
"factory" for parkas and other mass-production items in the
spring of 1970, many of the local women had found themselves
without employment. Soon after the arrival of the Butlers, the
local seamstresses started bringing in small hand-sewn items in
the hope of selling them to the Craft Shop. The Butlers did
purchase some items and sold most of them locally. Encouraged by
this, the women brought more. These items again included
occasional wall hangings-"some small, charming, stitched and

appliqued pictures, made from scraps left over from the cutting of garments."[1]

Soon recognizing the potential interest of these hangings to consumers in southern Canada, Sheila Butler took the bold step of ordering large quantities of felt and duffel to be shipped on the annual sea-lift. This led to the flourishing of the unique art form of wall hangings in Baker Lake. The technique consisted basically of sewing small pieces of felt onto a background of duffel using the same small, even stitches as for skin clothing. The design was often enhanced by decorative embroidery.

The several outstanding artists who emerged carried the new art form far beyond the merely decorative. As the women became more familiar with the new medium, they grew bolder and created larger and more adventurous designs. Galleries began to hold solo exhibitions of individual artists; public galleries like the Winnipeg Art Gallery and the Art Gallery of Ontario featured wall hangings in their exhibitions of Inuit art. In the mid-1970s, Baker Lake wall hangings had achieved such national fame that the better-known artists were commissioned to execute immense hangings for display in public buildings like the National Arts Centre in Ottawa and the Legislative Assembly in Yellowknife.

Without direct links to the traditional culture, the women artists were guided in the composition of their images by the intuitive sense of design that they had used in cutting and sewing the complex skin clothing for their families. In one of her reports, Elizabeth Whitton referred to "the incredible ability Inuit women have of making garments after seeing a drawing or picture and of being able to make a person a parka after just looking at him... or of being able to adjust a standard garment to a perfect individual fit after only a look at a would-be purchaser in it."[2]

Marybelle Myers, another Arts and Crafts Officer who worked for many years with women in Arctic Quebec (now Nanuvik), made the same observation: "The Eskimo women seem to have an uncanny eye for design components and measurements. Even today, they do not use paper patterns but cut the cloth by eye, as it were. Some women use a long string for measurement, tying knots to indicate the length of arm or back. One wonders how they remember which measurements the knots signify but they operate, it seems, with an infallible sequence or else an innate sense of proportion. Others simply scrutinize the area to be covered and proceed to the cloth."[3]

This may explain why the women artists are able to visualize mentally the entire composition of a large wall hanging without ever seeing it until after it is finished. Sheila Butler remembers,

one of the high points being the production
of an immense hanging, approximately 12 feet by 20
feet, by the young woman Rita Ahveeleeayok. This
large scale is even more remarkable when you consider
that the entire work of cutting and sewing was done
in a very tiny three-room house in the midst of
Ahveeleeayok's family of three children and a
continuous stream of visitors, relatives and friends.
In fact, the artist was never able to see the entire
hanging because her house was too small to hold the
work unfolded. She saw it section by section, with
finished portions being folded up as work progressed.
The only wall in Baker Lake large enough to hold this
hanging was in the newly constructed school gymnasium.
So when it was completed we took it to the gymnasium
for the first viewing. The hanging seemed so right
in the setting that teachers and students worked to
raise money and subsequently purchased Ahveeleeayok's
large hanging for the Kamanituak Public School in
Baker Lake. It has remained permanently on the wall
where it was first hung.[4]

Also related to the sewing of parkas is the wonderful sense
of colour and sophisticated design so striking in many Baker Lake
wall hangings. After Inuit contact with European explorers,
brightly coloured glass beads became popular trade items because
Inuit seamstresses loved to decorate the front panels of parkas,
particularly those of women, with elaborate bead designs. A
large quantity of beads covering certain areas of the parka
(which traditionally had been visually separated by a different
colour of skin) became a sign of prestige and affluence. Thus,
image-making of a kind, albeit fairly abstract, was certainly not
new to Inuit seamstresses. The creative instinct that had led
them to decorate their parkas lavishly during the long winter
months was transferred to the new medium of wall hangings, which
they called *neevingatah* (literally translated as "something to
hang").

Any discussion of wall hangings in Baker Lake should begin
with Jessie Oonark, one of the most important contemporary Inuit
artists. Fortunately, her talent was recognized early, and she
enjoyed a special status from the start of the arts programme in
Baker Lake. Recognition and acclaim from museums and collectors
in the South soon followed. Until her death in 1985, she was
showered with special honours and awards, all of them richly
deserved. From the very beginning, Oonark's wall hangings showed
an astonishing assuredness, an unerring flair for design and
colour, and a bountiful imagination.

While her early compositions show her motifs in a kind of
free-floating space, she later developed compositions that are

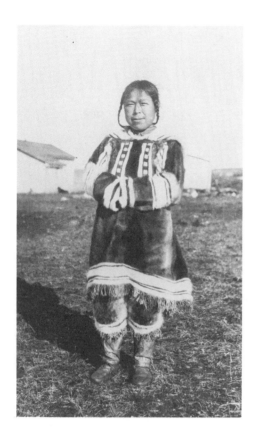

Fig. 1. Young Eskimo girl from Baffin Island in traditional skin clothing, c. 1926. National Museums of Canada, Ottawa, Ontario.

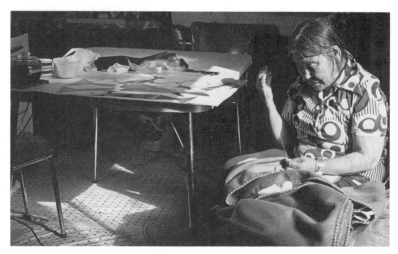

Fig. 2 Jessie Oonark at home, working on a wall-hanging. Photo: Jack Butler.

carefully balanced, often symmetrical, and of almost regal dignity and poise. Although she may depict unceremonious subjects like travellers or hunters in action, her friezes of processions of figures are reminiscent of Egyptian paintings because of their elegance, their ceremonial stances, and the combination of frontal and profile views of faces, which are her trademark. Another characteristic feature is the abstract quality of her designs. She reduces all subject matter to its most essential elements, leaving out any distracting details.

This tendency toward abstraction is progressive in her work; in her later work, we find images of seemingly pure abstraction. But even her most abstract designs from the later period are always somehow rooted in realism.[5] The rhythm of line, form, and colour, however, creates ever-new decorative and expressive patterns. The artistic quality of these wall hangings rests upon the startling richness and variation of this pictorial rhythm.

While Oonark is interested in shape and colour, and the interaction between the coloured background and the appliqué patterns, Marion Tuu'luuq is fascinated by surface patterns and the formal effects of embroidery combined with felt appliqué. Tuu'luuq was highly accomplished at applying heavy embroidery on parkas-usually in somewhat geometric designs-her wall hangings echo this tradition. On most of them, the entire background is covered with a combination of embroidery and felt appliqué, onto which more embroidery is stitched. The resulting surface texture has a three-dimensional quality, reminding us that wall hangings combine the two-dimensional nature of graphics with the three-dimensional aspect of sculpture. The exquisite effect of Tuu'luuq's wall hangings is due to this sculptural quality, together with a marvellous colour sense.

Irene Avaalaaqiaq represents another direction in Baker Lake hangings, a more narrative approach in which storytelling is the artist's main concern. In an interview, she stated that her favourite theme is stories about half-human, half-animal creatures, which are inspired by her grandmother's stories. This motif of transformation-an animal-spirit turning into a human or a human transforming into an animal-dominates Avaalaaqiaq's work. The lively interaction of these composite creatures, facing each other with open mouths, creates a tension between them and unites the composition. Using a set vocabulary of motifs, she replays her transformation theme in infinite variations.

According to Avaalaaqiaq, she cuts out her appliqué shapes first and then rearranges them on the prepared duffel background until she is pleased with the visual result.[6] Her designs are often framed so as to achieve an interesting interplay between positive and negative space.

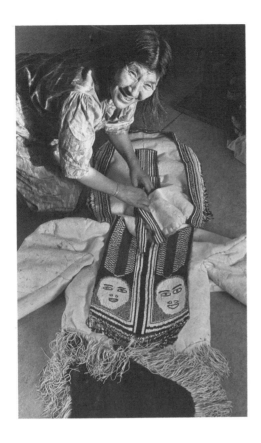

Fig. 3 Marion Tuu'luuq holding a parka which she had sewn for the Butlers. Photo: Jack Butler.

Fig. 4 Elizabeth Angranaqquaq (b. 1916) from Baker Lake. Photo: Canadian Government Photo Centre.

A more "painterly" approach is evident in Elizabeth Angrnaqquaq's hangings. She tends to fill every inch of her wall hanging with embroidery, even filling in the space around the animals and human figures, which are often also exclusively embroidered. The resulting blurred line between subject and background fuses both into one almost painterly surface pattern suggestive of an oil painting. This effect is enhanced by the use of embroidery floss to model the bodies of animals and feathers of birds: highlights, indicated with lighter thread, create the illusion of volume. Her hangings evoke a sense of richness and abundance-rivers teeming with fish or a tundra in bloom, alive with wild animals and birds. Stylistically, Angrnaqquaq represents the opposite end of the spectrum from Oonark. Oonark's linear designs with their sharply defined contour lines and shapes of flat colour contrast with the fluid style of Angrnaqquaq's tapestries, which blur contours and weave all elements into one lively surface texture.

If Angrnaqquaq's style is painterly, Winnie Tatya's creations could be called graphic. Her well-balanced, symmetrical compositions show clean, stylized shapes against a neutral background, like the white background in a drawing or print. She makes no effort whatsoever to integrate background and image. Her creations derive their impact from the strength of the stylized animal and human figures, sparsely decorated with even V-stitching. The composite figures, bird with human head, fish body with wings and a human head, and other mysterious creatures, are vaguely reminiscent of Avaalaaqiaq's spirit creatures. However, while Avaalaaqiaq's creatures are distributed loosely across the picture space, Tatya's images are carefully arranged, often with a central, larger figure, surrounded by smaller ones in a symmetrical composition. Tatya also uses a favourite motif of Baker Lake imagery: the multiple image, in which one subject-for example, a bird or a human figure-is repeated many times, often in rows: only slight individual variations allow for variety and tension in the composition.

Approximately fifty seamstresses have worked on wall hangings in Baker Lake at one time or another. The five in this article have been singled out because their work is of outstanding quality and represents the main stylistic approaches adapted in this medium.

Many artists of wall hangings in Baker Lake also consistently contributed drawings to the Baker Lake printshop. Avaalaaqiaq has even worked as a printmaker at times. Their graphics show clearly that some are used to thinking in terms of organizing cutout shapes on a certain area and linking them with embroidery. In a drawing, this is rendered as a combination of areas of flat colour linked with contour lines. There are other

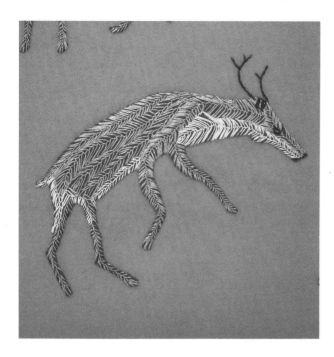

Fig. 5 Detail of embroidery by Elizabeth Angranaqquaq. Photo: Inuit Art Section, Indian and Northern Affairs Canada, Ottawa.

Fig. 6 Untitled. Wall-hanging made out of duffel, felt, and embroidery floss by Winnie Tatya, Baker Lake, 1979. Collection: Inuit Cultural Institute, Arviat, NWT.

close links between the two media in Baker Lake. Wall hangings
and drawings both tend to present complex, restless compositions,
often covering the entire picture space. A delight in bold,
clashing colours is also evident in both the graphics and the
textile arts. In fact, the combination of bold colours and
eccentric compositions, which disregard any of our Western
pictorial traditions (such as single perspective and relative
size), give Baker Lake imagery in textiles and graphics an
expressive, dynamic quality that is at once upsetting and
appealing.

Baker Lake wall hangings reached their peak of popularity in
1976, when the Art Gallery of Ontario held an exhibition of Baker
Lake art called The People Within. After the Butlers left, life
slowly drained out of the whole project. Although most artists
continued to produce until 1987, when the project was closed down
officially, there has never been another outburst of creative
energy like that in the early 1970s. Only time will tell whether
it was a temporary phenomenon or whether the new generation will
pick up the challenge, develop the art form further, and make it
grow and change to suit their needs for expression.

PANGNIRTUNG TAPESTRIES

The astonishingly intuitive approach that allowed traditional
women to fit their families' garments "by eye" finds expression
in the even more complex technique of tapestry-weaving practised
in Pangnirtung, on Baffin Island. The most logical explanation
for the ease with which Pangnirtung women have adopted this
foreign craft and perfected it is their natural understanding of
proportions, colours, and designs.

The Weave Shop was established by the territorial government
in 1970 and initially produced sashes, scarves, rugs, and
blankets. After Pangnirtung women had fully mastered the
technique that, according to Don Stuart, they learned in one
month instead of the six months he had expected, tapestries woven
in the Aubusson technique with narrative motifs designed by local
artists were introduced.[1] Initially, they were done as
"originals"-editions of one, later in editions of ten-most of
which were sold locally. They were scarcely known outside
Pangnirtung for many years and, after an initial exhibition in
Montreal in 1972, there were no more until 1978. Since then,
each tapestry has been produced in a limited edition, usually
between ten and twenty, and then the cartoon is destroyed. Also
since that time, the tapestries have been exhibited in annual
collections in a network of galleries, in much the same way the
Inuit prints are marketed. The weavings bear another similarity
to Inuit printmaking in that they are the result of a
collaborative effort between the designer and the weaver.

Fig. 7 Jeannie Dalla working in the Pangnirtung Weaveshop.
Photo: Rebecca Dall, Inuit Art Section, Indian and Northern
Affairs Canada, Ottawa.

Fig. 8 <u>Untitled</u>. Wool tapestry by Malaya Akulukjuk, woven by
Olassie Akulukjuk, Pangnirtung, c. 1974. Photo: Inuit Art
Section, Indian and Northern Affairs Canada, Ottawa.

When an image is to be chosen for a new tapestry, the whole group selects a suitable drawing from the existing inventory of drawings. Unlike cartoons in French Gobelin workshops, the drawings used are normal-sized and are blown up so that a cartoon may be created for the weaving. The weavers then proceed to choose the colours, in order to transform the drawing into a tapestry.

As the weavers often work from line pencil drawings, they deserve the same credit for the final product as the "artist." In fact, the distinction between the "artist" and the "craftsperson" of a tapestry is somewhat artificial, as the colours are usually chosen by the weaver. This is often done in discussion with the whole group, but everybody tends to defer to Kawtysee Kakee's colour sense. This is remarkable as Kawtysee, who has worked with the Weave Shop since 1974, is deaf and mute, and can communicate with her colleagues only through a sign language developed among themselves.

The early designs were somewhat awkward, showing large single-figure images against a neutral background. However, they have a raw, unselfconscious quality that is lost in the later, more refined images. Like other Northern art programmes, the Pangnirtung Weave Shop has depended upon outside advisers for stable management and cautious guidance in artistic matters. This explains the somewhat uneven production from 1972, when Donald Stuart, the initiator of the project, left, until 1978, when Megan Williams was hired as manager. Around 1977 - 1978, single-figure images gave way to more complex compositions in which landscapes and figures in them assumed prominence.

Malaya Akulukjuk's work clearly reflects this shift. The production of 1977 contains mainly images by her that generally represent a single decorative motif of a bird or group of birds. The following year already shows a slight shift from the decorative toward the pictorial; her Children at Summer Camp (1980) is a complex scene of a group of children playing in front of two skin tents. The different patches of skin presented in a range of greys form a delightful pattern and act as a backdrop for the four children playing in what seems to be the soft light of the midnight sun.

As has often happened in the history of Northern arts, Malaya's talent was discovered by accident.[8] Don Stuart, a professional weaver who launched the Weave Shop project, realized early in its operation that the weavers had extraordinary dexterity but lacked imagination for pictorial designs for tapestries. It was suggested to him that he should approach one of the local shamans to ask for some drawings and he subsequently met Malaya Akulukjuk. Since then, she has become one of the major contributors to both the printshop and the Weave Shop.

Fig. 9 <u>Children at Summer Camp</u>, wool tapestry by Malaya Akulukjuk, woven by Olassie Akulukjuk, Pangnirtung, 1980. Photo: Inuit Art Section, Indian and Northern Affairs Canada, Ottawa.

Fig. 10 <u>Malaya's Story</u>, wool tapestry by Malaya Akulukjuk, Pangnirtung, 1981. Photo: Inuit Art Section, Indian and Northern Affairs Canada, Ottawa.

Malaya's drawing style was celebrated in the tapestry
Malaya's Story (1980). According to Deborah Hickmann, who was
manager of the Weave Shop at the time, each weaver chose one of
six drawings that were then used to develop the imagery in this
tapestry.[9] They wanted to show the two different subjects in her
work: scenes of daily life in Inuit society and the spirit
creatures that still live in people's imagination. The tapestry
shows a blend of these two worlds, the physical and the spiritual
realities. The tapestry also illustrates how far the Weave Shop
has moved away from the single image of the early years. The
complex composition consists of various groups of figures against
a background that suggests the vast expanse of the snow-covered
tundra, interrupted by the line of the seashore and the receding
horizon. Subtle variations in the shades of colour, achieved by
twisting several single-ply yarns, relieve the monotony of large
areas of unstructured space. This technique, not unlike mixing
several colours when stencilling rather than using colour
straight from the tube, creates a tweedy effect that makes it
possible to "paint" with wool.

Malaya's Story is also a celebration of her style in that it
shows the strength of her drawings. Her figures, whether human
or animal, are always vibrant with life and movement. The simple
turn of a head or twist of an arm can make her figures come alive
despite the limiting technique of weaving that allows only fairly
simplified forms and can easily make a figure leaden and
lifeless.

Elizabeth Ishulutaq is another artist who has consistently
contributed drawings to both the printshop and the Weave Shop.
Her images immediately arrest attention because of their
interesting compositions, which often combine several viewing
perspectives. Woman and Child in Tent House, for example, shows
the woman foreshortened as if seen from a bird's-eye view while
the child is presented in profile. The whole scene is presumably
encircled by the outer walls of the tent. The narrative details-
woman, child, household utensils, outstretched bearskins-all
combine to create a highly sophisticated design.

In contrast to Malaya Akulukjyk, Ishulutaq has little
interest in spiritual subject matter. Her drawings deal with
everyday life: scenes inside the igloo, the hunt, and overland
travel. The skilful use of foreshortening and of different
viewpoints, often including aerial perspective, have led to
memorable images.

Wall hangings from Baker Lake and tapestries from
Pangnirtung are produced exclusively by women. Both media
require infinite patience, manual dexterity, and careful
planning. The artists have to work within limitations unknown by
Southern artists. In Baker Lake, usually only a certain range of

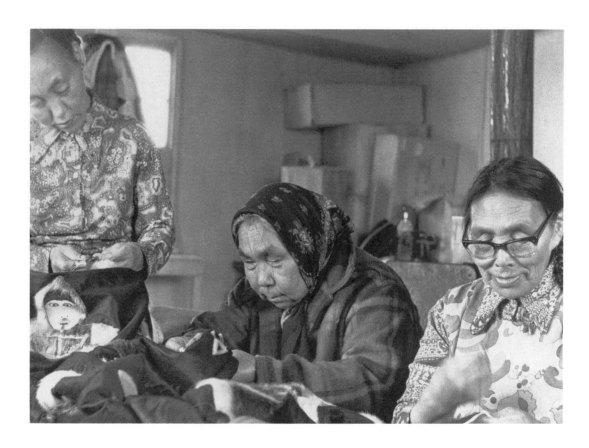

Fig. 11 Annie Niviaxie, Malaya Crow, and Mina Napartuk working
on an appliqué wall-hanging in Great Whale River. Photo: Inuit
Art Section, Indian and Northern Affairs Canada, Ottawa.

colours in shroud and duffel is available, while in Pangnirtung, the weavers must work with whatever colour of wool is in stock.

As most of the female textile artists in Baker Lake and Pangnirtung do not speak English, any other meaningful paid employment would not be open to them. Jessie Oonark was a janitor before her artistic talents were discovered. Sewing and weaving make it possible for these women to continue their status as equal partners in their households. While their traditional contribution to the survival of their families was the fabrication of windproof and waterproof skin clothing, they now provide for their families through their skill in creating wall hangings and tapestries. But the beauty of their creations suggests that producing them fulfils a deeper need than monetary reward. In her article "Sewing Fine Seams: The Needlecraft of Baker Lake Women," Allison Gillmore states that Inuit women in historic times "responded to a hostile universe seemingly beyond their control by creating art by transforming skin and sinew into pattern and form."[10] She concludes:

> Inuit women artists bring to their modern art the physical skills and the spiritual perceptions developed in pre-contact times. Perhaps more importantly, their motive for art-making is now more urgent than ever before. The threats to the survival of the Inuit people are no longer the shadows of bad hunting and bad weather; in the modern North they are the less direct but no less menacing shadows of overwhelming acculturation and rapid change. In the face of these pressures, the work of women's hands takes on increasing value as an affirmation of cultural identity: the art made by Inuit women expresses, as traditional clothing once expressed, the strength and beauty that can exist in spite of spiritual and physical hardship."

NOTES

1. Sheila Butler, "Wall-hangings from Baker Lake," <u>Beaver</u> (autumn 1972), 26 - 31.

2. PAC File 255-5/159, vol. 5.

3. Marybelle Myers, "A Time for Catching Caribou and a Time for Making Clothes," in <u>Arts from Arctic Canada</u> (Ottawa: Canadian Eskimo Arts Council, 1974), 26 - 30.

4. Sheila Butler, <u>op. cit.</u> 29.

5. Jean Blodgett, "Oonark," Winnipeg: Winnipeg Art Gallery, 1986, 53.

6. Inuit Art Section, Department of Indian and Northern Affairs, Ottawa; artists biographical files.

7. Don Stuart, "Weaving in the Arctic," <u>Beaver</u> (summer 1972), 60 - 62.

8. Renata Hulley, "Two-Dimensional Art in Pangnirtung," honours research essay, Carleton University, Ottawa, 1984.

9. Deborah Hickmann, personal communication, November 1987.

10. Allison Gillmore, "Sewing Fine Seams: The Needlecraft of Baker Lake Women," <u>Arts Manitoba</u> 3, 4, 29 - 32.

THREE DECADES OF INUIT PRINTMAKING:

Evolution and Artistic Trends, 1958 - 1988

by

Odette Leroux

It is generally true that the artistic expression of a people is something that is not static, but changing. Inuit art is no exception: it bears the stamp of the period when the artist lived and of his social milieu. The work of Inuit art, be it sculpture, drawing, print, or hanging, has a particular style depending on the artist, place and region, and time of execution (whether the fifties, sixties, seventies or eighties). Consequently, artistic creation reflects the changes that have occurred in Inuit society since the start of the modern era. Art is a means that the Inuit use to express, affirm, and fulfil themselves, and to provoke reflection.

Contemporary Inuit graphic art already has a history of thirty years. This movement began in Cape Dorset, and progressively developed in other localities in the Northwest Territories and the Territoire-du-Nouveau-Québec. The Cape Dorset artists stand at the forefront of this new Canadian artistic expression, in which they have had a fundamental and decisive role. Each area of the Canadian Arctic has developed one or more printmaking centres with its own very individual creative language. Since 1959, annual collections of catalogued prints have been regularly exhibited and offered for sale by art dealers in North America and Europe. Today, these works appear in public and private collections in Canada and abroad.

Contemporary Inuit art derives primarily from narration.[1] The artists express the true-to-life, that is, the present reality of their immediate environment.[2] They also record cultural life, past and present, in the light of their personal emotions. The extent to which the historical context and the traditional way of life have influenced artistic creation is surprising; works produced by Inuit artists bear the clear imprint of their society and their culture. It is through art that they transmit to us their values, which relate mainly to their lives and their immediate concerns.

The Inuit artists have no academic artistic training; theirs is an innate or natural talent. They do not use models, but rely on their memory and their imagination.

Baffin Island, and more specifically Cape Dorset, is the cradle of this new trend in contemporary Canadian art. Dr.

George F. MacDonald, Director of the Canadian Museum of
Civilization, provides us with an eloquent portrayal of its
beginnings:

> Contemporary Inuit art was encouraged by the foresight
> and involvement of the Canadian Handicrafts Guild (now
> called the Canadian Guild of Crafts Québec) and James
> A. Houston, the Guild Arctic representative. Not only
> did Houston help the Inuit expand their sculpturing
> activities, but he was also instrumental in the devel-
> opment of the graphic arts at Cape Dorset.[3]

The interest in trying out the printmaking technique was the
joint result of the curiosity of artist Oshuitok Ipeelee, who
wished to learn the process of commercial printmaking, and James
A. Houston's desire to explain that process. Using an engraved
walrus tusk of carved ivory, the master demonstrated the
procedure to the student, prompting the latter to respond, "'We
could do that,' he said, with the instant decision of a hunter.
And so we did."[4] This first experience aroused the enthusiasm of
a group of Cape Dorset artists, and led to their initiation into
printmaking.

The first two years, 1957 and 1958, must be considered their
period of apprenticeship in printmaking technique. This
experimental period resulted in an exhibition of a series of
thirteen prints that were offered for sale on December 11, 1958,
at the Hudson's Bay store in Winnipeg, Manitoba. This historic
event was well covered by the Winnipeg _Free Press_ in its edition
of Saturday, December 13, 1958 (fig. 1). It seems that this
collection was then quickly forgotten; one rarely sees any
reference to these first pictures. James A. Houston himself does
not refer to them specifically in his work _Eskimo Prints_. He
does, however, discuss their sale:

> By spring of 1958, we had laboriously assembled a small
> series of prints from a dozen artists.... [These were
> exhibited] for the first time at the Straford Theatre
> in Ontario during the Shakespeare Festival. This
> exhibition was in every way successful and all the
> prints offered were sold.[5]

A few other authors also made reference to the existence of
these first prints. Mary M. Crag mentions this uncatalogued
collection, lists the artists, and reports that twenty prints
were made, thirteen of which were offered for sale.[6] Dorothy
Eber emphasizes the experimental nature of the work done prior to
the first catalogued collection of 1959.[7] The 1957 – 1958
collection of graphic art from Cape Dorset was indeed composed of
experimental works, which consequently were not listed in a
catalogue as the later collections would be.

497

This primitive drawing of a weasel is a stone cut by Oshaweetuk.

Canada's Eskimos have taken up a new art, lithographing, and the first prints to come down from the north are having their premier showing at an exhibition of Eskimo handicrafts which opened Friday on the fourth floor of the Hudson's Bay Co. store. The series of 13 prints feature mainly animal and bird life, and a few figures, and are close in design to the now world-famous Eskimo sculpture. The Eskimo first draws his subject on a flat stone. All the areas he does not wish in his picture are scraped away. The raised surface that remains is then inked and the print is obtained by placing a piece of paper on it. After 20 or 30 prints have been made the stone printing blocks are destroyed so the prints will never again be identically produced.

Baffin Island Woman is the title of this powerful two-tone lithograph by an Eskimo named Pootagook.

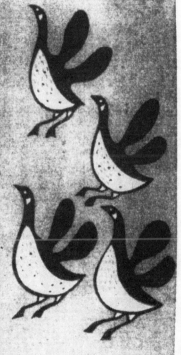

This lithograph, Geese Rising, comes from a stone cut by a Baffin Island Eskimo, Kadlakuk.

Ike Cannot Pardon O. Henry

WASHINGTON (AP) — President Eisenhower can not write a new ending for the life story of author O. Henry, famed for trick endings to his short stories.

The White House reported Friday the president would like to grant a pardon for O. Henry, who served a prison term for embezzlement 60 years ago.

But it can't be done, the president's special legal counsel said, because the president is without power to grant a posthumous pardon.

William Sydney Porter, who wrote as O. Henry, was convicted of embezzling $854.08 from an Austin, Tex., bank. Porter died in 1910 at the age of 48. His widow, Mrs. Sara Coleman Porter, lives in Weaverville, N.C.

Paul Wakefield, president of the Texas Heritage Foundation, asked the president to grant the pardon, saying "there exists today abundant proof of his innocence and of his conviction purely on circumstantial evidence."

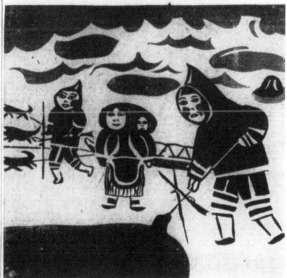

Mungetok, a Baffin Island Eskimo, did this unusual lithograph called Hunters On Ice.

GRAND OPENING

Fig. 1. Article published in the Winnipeg <u>Free Press</u>, Saturday, December 13, 1958.

Over the years, the master printmakers of Cape Dorset have
used a great many techniques to reproduce drawings, including
stencil, stonecut, transfer by frottage, linocut, copper
engraving or burin engraving, soft-ground etching, and
serigraphy. They have sometimes used them in combination:
stonecut and stencil, stonecut and serigraph, hand-coloured
lithograph. We will not elaborate here on the various
techniques. However, since the stonecuts of Inuit artists are
especially appreciated and have contributed greatly, thanks in
part to James A. Houston, to the development of the Cape Dorset
print, we shall explain how they are produced.

Since stone is a material that is naturally available in the
tundra, the Inuit artists wanted to take advantage of it. The
technique of relief is basic to the stonecut (fig. 2). First,
the reversed design is transferred to the stone;[8] with his tools,
the printer then cuts away the stone around the outline of the
drawing; the remaining relief will form the black or coloured
parts, while the portions that have been chiselled away will
yield white. The medium demands great patience and dexterity of
the printer. The Cape Dorset artists have adopted a work method
that was once used in Europe and the Far East,[9] and which is
based on a division of labour between the designer (in this case
the artist) and the master printer; the first executes the
drawing[10] and the second carves the stone and strikes the print.
The two tasks are at once distinct and complementary. Since
1959, the Cape Dorset printers have mastered and skilfully
exploited two basic techniques, stonecut and stencil.

Inuit printmaking owes nothing to "classical" visual
representation, with its perspective and chiaroscuro. It
expresses a special aesthetic that invites us to appreciate its
"formal code." We will attempt a summary of its general
characteristics. The title of the work is closely linked to the
content of the image, which the spectator takes in quickly,
entering immediately into the heart of the subject. The design
occupies a large part of the pictorial space; line and style are
unique for each artist; curved and straight lines are used more
often than crooked lines, and hatchings render the natural
texture of the stonecut and the copper or burin engraving.
Perspective, which is not a significant element, is created, for
example, by superimposing and juxtaposing shapes; multiple points
of view are a well-known feature, for very often the artist turns
the paper, creating numerous angles. Volume is constantly
suggested by use of the curved line; form is presented frontally
or in profile, sometimes both at once, and very often occupies
the entire pictorial space. The flat areas are conspicuous;
black predominates, and where there is colour, cool tints are
more frequent than warm ones, except for the Baker Lake school,
which is set apart by its use of primary colours. Different
shades of colour are obtained by means of the stencil technique.

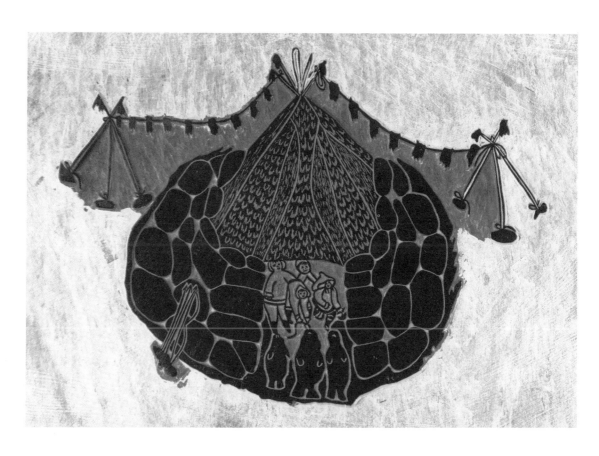

Fig. 2. Pitseolak Ashoona (1904 - 1983)/*Eegyvudluk Pootoogook* (b. 1931), <u>Summer Tent of Old</u> (1969), carved stone block, 44 × 77 cm. CMC no. IV-C-4006/CD 1969-8. Photographer: Dennis Fletcher.

The works were selected primarily on the basis of their style and aesthetic character. Each participant is represented by a group of two to four works chosen for their themes, styles, developmental traits, periods, distinctive artistic tendencies, and marked aesthetic character. Lastly, the selection committee has chosen those artists whose creative genius has contributed to the flowering of this Canadian artistic movement. Members of the first generation of artist,[11] they are the pillars of these schools. And as we shall try to show in this survey, each school, while respecting the freedom of expression and individual character of its member artists, has its own style and line of thought.

THE CAPE DORSET SCHOOL (AFTER 1959)

As the initiator, the Cape Dorset school has a special place in contemporary Inuit art. In drawing and printmaking, the Cape Dorset artists depict their activities, knowledge, and feelings-in short, their personal vision of the world. Some of them, such as Pitseolak Ashoona, Parr, and Pudlo Pudlat, have concentrated on portraying the social milieu in which they live; sometimes, like Pudlo, they describe the major changes that take place there. Others, such as Kenojuak Ashevak and Pitaloosie Saila, devote themselves to traditional motifs, developing the play of shapes and colours. The art of Cape Dorset is individualized, rich, innovative, and diversified.

Kenojuak Ashevak is a very prolific and widely known artist whose works are extremely versatile. The bird is her preferred motif, though she also features various animal forms like the rabbit, dog, bear, and fish. In 1960 she incorporated the human form into her compositions. She has been attracted to the human face since 1963, and since 1974 it has become her hallmark. Kenojuak employs the bird as her principal motif or as part of compositions in which human and animal figures are juxtaposed. She has on occasion drawn camp scenes, strange mythological creatures, and shamans.

It is possible to retrace Kenojuak's artistic evolution through certain prints. Rabbit Eating Seaweed (1959) has become part of the legend of her celebrity. This, her first work, was based on an original appliqué design that appeared on a sealskin bag in the fifties.[12] The subject of the composition is fascinating: the seaweed, done with a very effective abstract realism, occupies almost the entire composition, which the rabbit serves to balance and unify. The whole is coloured with various shades of turquoise. The artist was to employ this style until the period 1962 - 1963. Kenojuak's classic work is the celebrated Enchanted Owl (1960; figs. 3 and 3A).[13] The print is a decisive statement of the artist's preference for birds, and

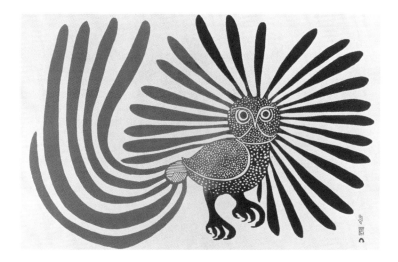

Fig. 3. Kenojuak Ashevak (b. 1927)/*Eegyvudluk Pootoogook* (b. 1931), <u>The Enchanted Owl</u> (1960), stonecut, proof/50, 61 x 66 cm. CMC no. CD 1960-24. Photograph: Inuit Art Section, Department of Indian and Northern Affairs, Ottawa.

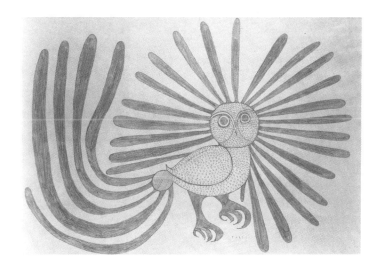

Fig. 3A. Kenojuak Ashevak (b. 1927), <u>The Enchanted Owl</u> (1960), drawing for the print, graphite, 45.5 x 61.4 cm. Gift of Mr. M. F. Feheley, Toronto, 1984. National Gallery of Canada, Ottawa #28743

especially the owl. The simultaneous frontal and profile treatment, the elaboration of extended, curvilinear shapes, the juxtaposition of various textures and flat areas, the interplay between positive and negative space, and the use of negative space in the background of the print-these comprise the graphic vocabulary that the artist was to exploit during her career.

The Arrival of the Sun (1962) provides a good summary of the forms in Kenojuak's graphic repertoire of the early sixties: the animal shapes, at once realistic, fantastic, and in movement, are integrated with each other. In 1980 Kenojuak explained how she works during a personal interview with Jean Blodgett:

> It's more an interplay of form and colour which I enjoy performing and I do it until it satisfies my eye and then I am on to something else.[14]

The Arrival of the Sun is an excellent illustration of this remark. The yellow and black used in this composition give it the desired visual impact. Jean Blodgett, an expert on Kenojuak's work, also points out that

> birds... lend themselves to her style of drawing with its emphasis on graphic elaboration rather than straightforward representation.[15]

This is indeed an accurate comment on the artist's production. A girl's face, a key motif in Kenojuak's work, appears in her prints starting in 1974. In Watching My Animals (1981; fig. 4) she achieves a symmetrical, balanced composition in a very realistic style. The subtle colour is connected with the introduction of pastel tints in Cape Dorset in the early eighties. The mixed technique adopted here (stonecut and stencil) is held in high regard by the artists. The stonecut renders line and texture, and the stencil the subtlety of tone; combining the two techniques yields unique results.

Summer Owl (1979) is a work of great beauty that encapsulates the artist's approach to her creations. This subtle and basically realistic composition, featuring an owl set off against coloured abstract forms in various patterns, creates a very sophisticated visual effect. The lithograph readers the drawing and the subtlety of line particularly well. Kenojuak's art is the product of her interest in elaborating shapes. Her subjects are realistic, but some tend toward abstraction, like Birds and Foliage (fig. 5), done about 1970.

Although Pitseolak Ashoona is not as well known as Kenojuak Ashevak, she is very talented; and her work, in addition to being very distinctive, is at least as important as Kenojuak's.

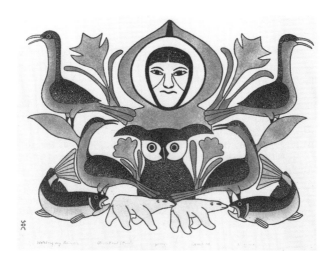

Fig. 4. Kenojuak Ashevak (b. 1927)/*Sagiatuk Sagiatuk* (b. 1932),
<u>Watching my Animals</u> (1981), stonecut and stencil, 49/50, 63.2 x
86.5 cm. CMC no. CD 1981-26. Photograph: Inuit Art Section,
Department of Indian and Northern Affairs, Ottawa.

Fig. 5. Kenojuak Ashevak (b. 1927)/*Lukta Qiatsuk* (b. 1928),
<u>Birds and Foliage</u> (1970), stonecut, proof III/50, 61 x 86.4 cm.
CMC no. CD 1970-2. Photograph: Inuit Art Section, Department of
Indian and Northern Affairs, Ottawa.

Pitseolak depicts the traditional way of life in striking
fashion, adding a touch of personal humour. Here she tells how
she began her artistic career:

> When James Houston, whom we call Sowmik-the left-handed
> one-came to Cape Dorset and told me to draw the old
> ways, I began to put the old costumes into the drawings
> and prints. Some days I am really tired of the old
> ways-so much drawing. But many liked my parkas-many
> people used to like my clothes.[16]

The Critic (fig. 6), done about 1963, is a graphite pencil
drawing that reveals the artist's fertile imagination. The
subjects of Pitseolak's work are many and varied; they include
the human figure and family life, birds, sports like games and
fishing, and camp scenes. The artist is often inspired by events
in her own life, which she incorporates into her pictures.[17] The
two copper engravings Happy Family (1963) and Woman with Geese
(1967) are very interesting both thematically and graphically.
In non-chemical engraving (such as these copper engravings), the
design can be incised directly onto the plate by the artist
himself, without using any preparatory sketch. Every line cut on
the metal plate has its counterpart in the drawing. The design
is rendered intact; no changes are made. Woman with Geese and
Happy Family are superb illustrations of Pitseolak's style,
showing her imaginative, even unique, interpretation of everyday
subjects and her complete facility in expressing them. (The
detail in the clothing reveals the interests of this expert
seamstress.) Her figures, whether frontal or in profile, are
very often juxtaposed in the same work, thereby acquiring even
more flexibility. Despite her singular approach, her subjects
are imbued with movement, even if the frontal view suggests
stability. Humour and joviality, the *leitmotif* of her art
generally, are also the keynote of these compositions.

In Summer Tent of Old (1969; see also fig. 2) a very
representative work from the late sixties, Pitseolak depicts
another aspect of the traditional life. The artist draws the
spectator into her work by using a bird's-eye view of the
principal form, the tent, which incorporates her figures and
their catches. The superimposed forms create an effect of depth;
the clothes line in the background complements the central motif
and once again brings out the distinctive character of
Pitseolak's works. The execution and the selection and use of
colour are very representative. The Inuit are followers of
shamanism, which is characterized by nature worship and belief in
spirits. On this subject, dealt with in The Shaman's Wife (1969)
the artist commented:

> My father used to tell stories about how he was once
> almost killed by a powerful shaman.... They were

Fig. 6. Pitseolak Ashoona (1904 - 1983), <u>The Critic</u> (c. 1963),
graphite, 47.6 x 61.1 cm. National Gallery of Canada, Ottawa.
Gift of the Department of Indian Affairs and Northeren
Development, Hull, 1989. INAC no. 3.80.60. Photograph: Inuit
Art Section, Department of Indian and Northern Affairs, Ottawa.

Fig. 7. Pudlo Pudlat (b.
1916)/*Lukta Qiatsuk* (b.
1928), <u>Running Rabbit</u>
(1963), stencil, proof
1/50, 63 x 49.9 cm. CMC
no. CD 1963-35.
Photograph: Inuit Art
Section, Department of
Indian and Northern
Affairs, Ottawa.

Eskimos just like other people but they had these
strange powers. They had power over the hunt-they
could bring the animals-and they had power to kill....
But they were very good-looking people-you would really
never believe they were shamans.
There were good shamans and bad shamans but most
people feared them....[18]

Pitseolak Ashoona is certainly a superb artistic chronicler of
the traditional Inuit way of life.

Parr was an excellent hunter who has depicted for us his
universe of man and animals. He has a remarkable artistic
vocabulary and a peculiar style that features heavy, densely
hatched lines, flat areas, and a predominance of black. The
three prints presented here provide a very good summary of his
art. In My People (1961) and Walrus Hunters on Sea Ice (1967)
Parr presents the human figure frontally, as he sees it, huge or
tiny, in all sizes; he depicts animals in profile, in similar
fashion. Six years later, Parr executed a composition featuring
animals and hunters in profile. These two pictures show people
who have the upper hand over animals and who seem in control of
the situation. The line, whether vertical, horizontal, or
diagonal, and the strong black forms play a role of primary
importance. The stonecut provides a marvellous rendering of the
play of lines and textures, Parr did not use colour in his work
until 1970. Like Pitseolak Ashoona, he is a chronicler of a very
particular aspect of the traditional life. His style has
somethying of abstract realism.

Pudlo Pudlat is a lucid and penetrating observer. Familiar
with the traditional Inuit way of life in the Arctic, he has also
been a perceptive witness of the changes it has undergone, Pudlo
decided to describe these changes on the basis of his own
experience. He often juxtaposes forms from the old days and the
forms of today, and sometimes adds imaginary forms to his
compositions, using all of these as components of his vision of
the Inuit world. Furthermore, this innovative artist has a
remarkable instinct for synthesis, as can be seen in Running
Rabbit (1963; fig. 7). The shape is outlined, and the face is
shown inside that shape. In this quasi-abstract treatment of a
realistic subject we have a revelation of Pudlo's interest in the
possibilities of formal abstraction.[19]

The work Long Journey (1974) marks the beginning of Pudlo's
use of the human figure, dwelling-place, and landscape; these
motifs were to reappear constantly and assume great importance in
Pudlo's work. (The religious motifs first appeared in 1969.)
The mass on the right and the form of the church on the left
serve to stabilize the composition. Long Journey is a striking
example of the social character of Pudlo's art. Pungnialuk

Fig. 8. Pudlo Pudlat (b. 1916), <u>Northern Landscape</u> (1976),
acrylic paint and coloured pencil, 56.8 x 66.3 cm. National
Gallery of Canada, Ottawa. Gift of the Department of Indian
Affairs and Northern Development, Hull, 1989. INAC no. 3.83.15.
Photograph: Inuit Art Section, Department of Indian and Northern
Affairs, Ottawa.

(1978) is another unconventional creation in the abstract-
realistic style. The caribou depicted is not quite complete, is
left unfinished or flattened; but it has hind feet none the less.
About 1975 - 1976, Pudlo took up acrylic painting; <u>Northern
Landscape</u> (1976; fig. 8) is typical of his iconography. In 1976
Pudlo's works began to show evidence of his interest in modern
technology, and in particular the airplane. <u>Arrival of the
Prophet</u> (1983) and <u>Flight to the Sea</u> (1986) are splendid
variations on this theme that demonstrate the artist's humorous
attitude to contemporary society. Since a prophet can be
transported by helicopter, why not a fish? There is an ambiguity
between movement and stability expressed in these two pictures.
The inspired use of warm and cool colours lends force and power
to these works, and particularly to the prophet. In addition to
being outstanding examples of the artist's creative talents,
Pudlo's prints illustrate for us his very contemporary concerns.

 Pitaloosie Sails's artistic career began in 1960 when she
took up drawing,[20] but her first prints date from 1968. She has
treated various subjects, including the human figure, mother and
child, and birds; she has also developed several stylistic
approaches that are characteristically lacking in embellishment
and which in themselves articulate a new trend. <u>Bird in Morning
Mist</u> (1984) is a masterful work, imposing and grandiose. The
subject occupies almost all of the pictorial space. A single
line defines a form that is stripped of all artifice. Even
though no line exists inside this figure, one is discreetly
introduced by the contour of the head turned to the right, which
compels the eye diagonally down to the bottom of the composition.
This expert structure, presented both frontally and in profile,
like the omnipresence of volume, creates an ambiguity between
stability and movement. The blending of grey-green, grey, and
black tints, as well as the textural effect, completes this
majestic work. <u>Bird Spirit at Sea</u> (1984) reveals to us a
different dimension of Pitaloosie's creativity. She offers us a
bird in profile, its beak open and its body surrounded by
semicircular or attenuated shapes that lend extraordinary
movement to the composition. Here we can see the artist's deep
interest in design, form, texture, and colour. These two works,
though based on realistic motifs, are presented in a formally
abstract style. The variety of expression to be found among
artists such as Kenojuak Ashoona, Parr, Pudlo Pudlat, and
Pitaloosie Saila has been instrumental in the burgeoning of the
Cape Dorset school, whose works are today in great demand.

THE POVUNGNITUK SCHOOL (AFTER 1962)

The Povungnituk school has carved itself an enviable place in
contemporary Inuit art. Its work conveys an austere and static
realism (except for Josie P. Papialuk, whose art partakes more of

dynamic realism) no doubt because of its historical approach and its distinctive mode of expression. The artist chips and carves his design directly onto the stone in its original state, crude and unsmoothed, using no preliminary sketch. The result is a refined art similar to Cape Dorset copper engraving. The palette is rather sombre, with black and dark colours predominating, especially in the sixties. Certain graphic elements, such as the integration into the work of the stone's outer edges and of syllabic writing, are closely associated with the Povungnituk style. Here is how George Swinton perceives this art:

> Experience, events and dreams
> Thoughts of the past and present,
> Of lore and history,
> Are narrated by imagery on paper....
>
> They [the prints] are less concerned with aesthetics than with expression, less with grace than with reality Their essence derives from straight-forward narration, an invitation to listen and to participate in the presentation of their creatures, events, experiences, fantasies or lore, uncluttered by symbolism.
>
> ... [They involve] the act of narrating on stone or paper... describing, illustrating or narrating that which the eye sees and the mind means.[21]

Davidialuk Alasua Amittu has used his art to recount historical events, simple stories, legends, and myths. The main theme of his work is the struggle for survival. As Harold Seidelman explains, it is most important to understand the role of the storytellers in the traditional Inuit way of life in order to appreciate fully the origins and meaning of Inuit art:

> With the possible exception of shamanism, story-telling was the most important creative activity of individuals and for communities. The ability to tell stories well was a source of prestige and personal pride.... A high level of skill was demanded in narration....
>
> In addition to their role of entertainment, stories were used to pass on the inherited wisdom of the culture.... But the stories do not dwell only on the sombre aspects of life. They often added a much-needed element of humor to Inuit life.
>
> In the oral tradition that Davidialuk inherited, there is no easy separation between simple tales, historical accounts, legends and myths.[22]

In <u>Lumak</u> (1962) and <u>Face</u> (1964) we recognize, both in the title of the former and the content, an art of a legendary and mythical character. The treatment is most fascinating. Davidialuk frames his two images so as to centre attention on the story he is telling. He chisels the stone block so as to create a negative space, which we associate with non-presence, thus bringing out the significant elements of his compositions. The positive space produces the desired visual effect and centres attention on the story. The play of positive and negative surfaces and contrasting light and dark forms highlights the dramatic content of the work. In <u>Lumak</u> the motifs are counter-balanced: the outlined shape of the seal is being rejected-it is depicted both positively and negatively-and consequently its importance is emphasized. Both of these compositions are well balanced. The colour and textural effect created within them complement their aesthetic and pictorial aspect. Survival is this artist's major theme because he had a difficult childhood, growing up in great poverty; this is plainly evident in his work.

Davidialuk Alsua Amittu and Joe Talirunili are very well known, as are-to a lesser degree-Juanisialu Irqumia and Josie P. Papialuk. All four have practised drawing, carving, and printmaking, and have a distinctive style, whatever medium they use. As in Davidialuk's case, the art of the other three has been greatly influenced by their life experience. The traditional life is a reality for Joe Talirunili, as for Juanisialu Irqumia and Josie P. Papialuk, even though their interpretations of it are different.

Joe Talirunili deals with a limited number of themes to which he constantly returns: camp scenes, the human figure, the owl, and the "Migration," a story that has great influence on his art. Ian G. Lindsay has well defined Talirunili's preoccupations:

> Although Talirunili infrequently depicted legends and elements of the supernatural, his prints nonetheless hold hidden reference to beliefs and taboos formerly associated with the ritual of the hunt.[23]

Like Davidialuk, Joe likes to create frames for his compositions, as we can see in <u>Spring Camp</u> (1962), <u>Owl</u> (1964), and <u>Shipwreck</u> (1969). The first two of these seem frozen in time; <u>Spring Camp</u> presents active subjects, but without implying movement-they are as stationary as the two owls-whereas <u>Shipwreck</u> suggests action. <u>Spring Camp</u>, with its profile view, is a reassuring, even conven-tional composition; the scene is oriented toward the left of the picture and space is created by placing forms on top of each other. This work contains the basic elements of the artist's traditional graphic vocabulary. In the two owls, presented in frontal close-up, we can see his unpolished style of execution,

another distinctive trait. The shipwreck scene, with its
unconventional semicircular structure, unfolds logically from
left to right; the figures portray a story that was probably true
and possibly experienced by Joe himself. The boat depicted
vertically on the left, the four abstract shapes, and the great
empty space underscore the nonconventional character of this very
finely executed work. The blue ensures the unity of this great
composition. The syllabic writing is the text of a story
integrated into the work, emphasizing its historical nature.

 While his treatment of subjects is clearly defined, on
occasion Joe incorporates two or even three motifs in one
picture, as in the splendid drawing The Boat Was Caught in the
Ice (fig. 9), done about 1970. The translation of the
inscription on the drawing reads as follows:

> This boat was caught in the ice but they had made it to
> land. They were trying to go to a place where they
> could meet some white people but they had to fix their
> boat when they got on land. It took them three months,
> April to July.
>
> Even these dog team sleds were caught in the moving
> ice.
>
> These people living in igloos were always ready for a
> polar bear at night or day. Because they had no guns,
> they only used spears. They never slept at night when
> there was no moon and it was snowing outside. Their
> dogs could help them kill a polar bear.[24]

Joe Talinurili reveals his world to us through stories.

 Like Joe, Juanisialu Irqumia has a personal vocabulary to
convey his perception of the traditional life. He is inspired
primarily by the endless repertoire of Arctic animals and by
hunting, fishing, and trapping activities. He depicts women
engaged in fishing and doing traditional female chores, and gives
us an insight into the traditional family. Juanisialu's work is
based on the constant, active confrontation between man or woman
and animals, as in Hunting Bear with Bow (1964) and A Hunter
Drags His Catch (1976). And as in the work done by Davidialuk
and Joe, the framing of the subjects is fairly important here as
well. His subjects are presented from the side, with their faces
conspicuous and often in closeup against the Arctic space, an
arena of emptiness, immensity, confrontation, and movement. The
design emerges from the positive space, delineating the key forms
and suggesting their volume. Black is the artist's preferred
colour, and syllabic writing is an integral part of his work.
The realistic/historical art of Juanisialu focuses on the
intimate relationship between man and animals. In a very

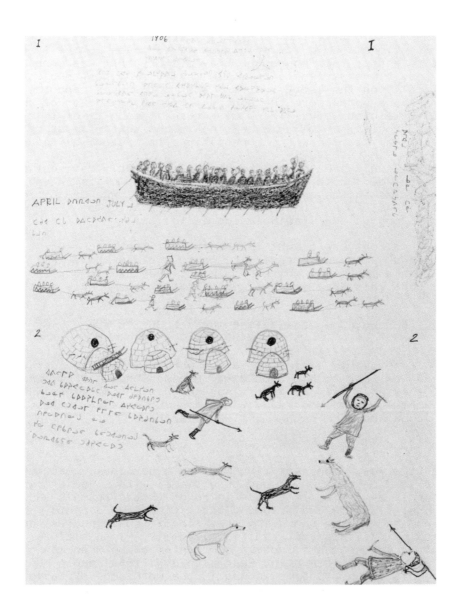

Fig. 9. Joe Talurunili (c. 1899 - 1976), <u>The Boat was Caught in the Ice</u> (c. 1970), graphite, crayon, and felt pen, 45 x 58.7 cm. CMC no. IV-B-1648. Photographer: Richard Gardner. Photograph: Inuit Art Section, Department of Indian and Northern Affairs, Ottawa.

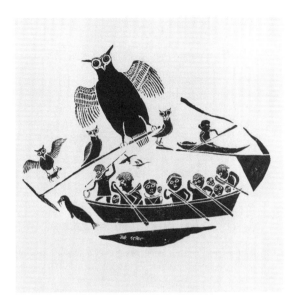

Fig. 9A. Joe Talirunili (c. 1899 – 1976)/*Lucy Sakiassia Amaruali*
(b. 1958), <u>Story about Hunters Lost in Icebergs While Hunting
Seals</u> (1975), stonecut, B/50, 60.5 x 70.5 cm. CMC no. POV 1975-
32. Photograph: Inuit Art Section, Department of Indian and
Northern Affairs, Ottawa.

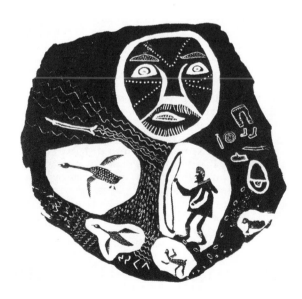

Fig. 10. Josie P. Papialuk (b. 1918), <u>Hunting Spirit</u> (1962),
stonecut, 10/25, 44.5 x 44.5 cm. CMC no. POV 1962-138.
Photograph: Inuit Art Section, Department of Indian and Northern
Affairs, Ottawa.

personal way, he celebrates the animals of the Arctic.

Josie P. Papialuk is a most fascinating artist. While closely tied to his colleagues of the Povungnituk school in that he too produces realistic/historical art, he is also set apart from them by virtue of his humour and whimsy. Although Josie has recounted-albeit somewhat cursorily-themes from the traditional life, such as fishing, hunting, and animals, there is no question that he prefers to portray all species of birds, in all their shapes, and to a lesser extent, habitation (especially igloo construction), tattooed faces, masks, and human figures. His first prints, such as <u>Hunting Spirit</u> (1962; fig. 10), have a very rich graphic vocabulary. Here we find his humans, birds, and animals in profile, frontal views of his tattooed faces, and his graffiti-in zigzags, inverted Vs, circles, semicircles, pointillism, and broken lines of every description. His compositions of this period are framed by the outer edges of the stone printing block, and presented, embellished with graffiti, inside a positive space:

> It makes sense to him to include both tangible and
> intangible elements in his pictures since both are
> features of what he knows to be reality. Speech and
> motion patterns are as real to him as the beings
> generating them and it doesn't occur to him not to draw
> the chatter and the footprints of his creatures.
> Similarly, he gives shape to the surrounding air and
> the movement people and animals make as they walk, fly
> or swim through it.... The presence of moving "wind" is
> one of the profound realities of Papialook's
> existence.... The wind is, he says, always different
> colours and shapes.[25]

Josie's designs consist of positive forms delimited by negative spaces. Like his colleagues, he uses a rather dark palette. The serigraphs selected-<u>Fixing an Igloo During a Wind Storm</u> (1980), <u>It is Very Windy and He Is Cold</u> (1982), and <u>Kayak Looking for Food</u> (1983)-express a new artistic tendency and, compared to Josie's earlier works, owe more to drawing than to printmaking. The design, which is of primary importance, is presented in a negative space: the line of the shapes and graffiti is explored very intensely, animating the compositions. The bold, vivid colour enhances the black lines of the design. These pictures are both fanciful and comical, particularly when Josie interprets them for us, as he did for his first work:

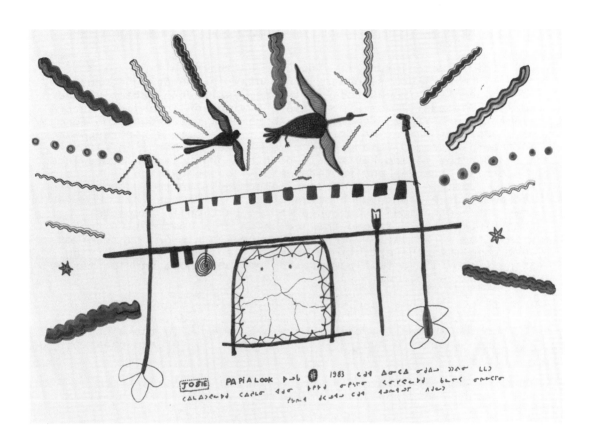

Fig. 11. Josie P. Papialuk (b. 1918), <u>Scene with Drying Skin</u>
(1983), felt pen, 50.2 x 65.8 cm. National Gallery of Canada,
Ottawa. Gift of the Department of Indian Affairs and Northern
Development, Hull, 1991. INAC no. 3.84.21. Photograph: Inuit
Art Section, Department of Indian and Northern Affairs, Ottawa.

> Is this a rainbow?
> No, it's not. I was not making a rainbow. It's a strong
> wind. I like it because it will show for a long time. All
> winds are different. During the fall, for instance, they
> are red.[26]

The second picture is without question a self-portrait of
Josie: this figure reappears constantly in the designs, and the
rendering of the human face is the same as in the artist's other
works. One again, Josie portrays the wind, an intangible natural
element; here it is depicted in vibrating lines around the form
of the person suffering from the cold. The same lines reappear
in the third composition, this time around the birds in flight
and under the moving kayak. In both his prints and his drawings,
the artist observes and renders natural elements with acuity and
skill. Josie's drawings, accomplished works in their genre, are
the equal of his prints in terms of expressive quality. However,
they are aesthetically enhanced in two particular respects:
their intense colour, and the inclusion of a descriptive text
within the work itself. The text becomes a historical testimony
that completes the artistic statement, as in Scene with Drying
Skins (fig. 11), a felt-pen drawing of 1983 whose caption may be
translated as follows:

> Skin stretcher, caribou meat drying-very tasty. This
> is the way it was a long time ago. They dried the meat
> in the summer, so that they would have it in the winter
> when they were hungry in the winter. Plover and other
> birds can fly in the wind.[27]

Josie P. Papialuk conveys a very colourful and distinctive
version of a world he loves; there is a wonderful freshness to
his style.

In conclusion, we can only reiterate Mary M. Craig's
observations on the remarkable art from Povungnituk:

> Povungnituk artists may one day be considered the most
> important documentarians of all the Arctic.... Its
> history is embedded in the rock and the sea and
> consciousness of its people.[28]

THE HOLMAN SCHOOL (AFTER 1965)

While the artists of the Holman school have an endless repertoire
of themes to their credit, they give special attention to games,
dancing, and stories, as well as to subjects from traditional
culture.

Holman art is actively and playfully realistic. Mark

Emerak, for example, depicts traditional scenes involving camping, animals, fishing, and hunting, and more specifically, human figures, games, and feasts held after catching fish and game (a theme peculiar to Mark), as in Feasting on Caribou (fig. 12), a posthumous lithograph of 1987 based on a 1971 drawing. Mark's very personal style makes use of both outline and line drawing. His scenes are drawn in a single line, sometimes two, and he occasionally frames part of his composition. The human figure is a constant in his work: it is depicted frontally and immobile, in profile and moving, standing, sitting, vertically, horizontally and diagonally. Women's Clothes (1968) is a stonecut of great sensitivity. It is becomingly framed by the natural surround of the stone printing block and by the quite inspired use of colour. However, this type of composition was used only twice in 1970. The engraved lines render the forms of the silhouettes and the clothes, and also bring out their detail. The artist breaks the formal monotony by representing the two end figures from the back and the three central figures from the front. The play of textures reveals the unfinished state of the stone, and the colour creates the visual effect.

Marks's palette is usually relatively dark. Bull Caribou (1980 – 1981) is a work that is stylistically unique among the artist's prints. While it deals with one of Mark's favourite themes, the hunt, the emphasis is placed on the catch itself, the caribou. The animal shape of blue and purple, presented from the side, occupies a large part of the pictorial space and therefore seems in control of the situation. The human forms are depicted in a nonconventional fashion-tiny and animated, attacking their prey with arrows that fly at it from all sides. This picture demonstrates Mark's fertile imagination, as well as his skill in portraying a traditional subject from a different point of view. In 1982 he did a lithograph entitled First White Man's Ship (fig. 13). This work of a topical social nature, the only one of its kind created in Holman, makes reference to the influence of the first contacts. Great Whirlpool (fig. 14), a stonecut pulled from a 1971 drawing, appeared in 1987 in an album of posthumous works. In this exceptional kinetic work, Mark gives us personal interpretation of a whirlpool. While very different from his realistic works, this print reproduces their formal elements in its cool colour and tonalities, texture, frame, and engraved line. Thanks to his singular creations with their realistic/historical tendencies, Mark Emerak has made a significant contribution to the Holman school.

Helen Kalvak, with her fertile imagination, remains Holman's most prolific artist, followed closely by Agnes Nanogak and Mark Emerak. Her themes have been more or less those of her predecessor, though she has also dealt with dance, legendary and mythical stories, and the spirit world, including shamanism and dreams. Since the publications of the first catalogued

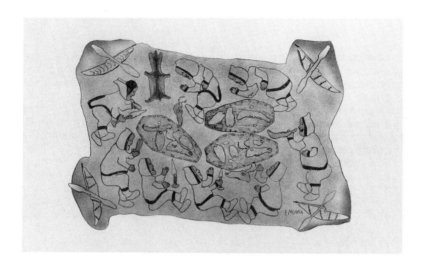

Fig. 12. Mark Emerak (1901 - 1984)/*Mary Okheena* (b. 1961),
<u>Feasting on Caribou</u> (1987), lithograph, 44/55, from a pencil
drawing of 1971, 50 x 65 m. CMC no. UN HI 1987-11 (KEMP).
Photograph: Inuit Art Section, Department of Indian and Northern
Affairs, Ottawa.

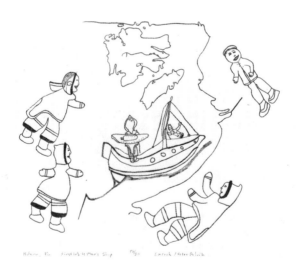

Fig. 13. Mark Emerak (1901 - 1984)/*Peter Palvik* (b. 1960), <u>First
White Man's Ship</u> (1982), lithograph, 35/50, 38 x 46 cm. CMC no.
HI 1982-4. Photograph: Inuit Art Section, Department of Indian
and Northern Affairs, Ottawa.

Fig. 14. Mark Emerak (1901 - 1984)/*Harry Egutak* (b. 1925); *Louis Nigiyok* (b. 1960), <u>Great Whirpook</u> (1987), stonecut, 44/55, from a pencil drawing of 1971, 50 x 65 cm. CMC no. UN HI 1987-7 (KEMP). Photograph: Inuit Art Section, Department of Indian and Northern Affairs, Ottawa.

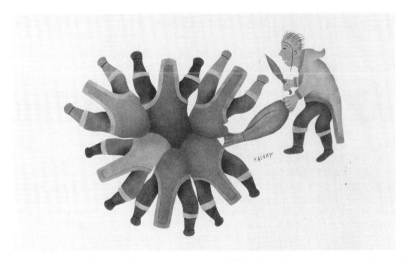

Fig. 15. Helen Kalvak (1901 -1984)/*Elsie Klengenberg Anaginak* (b. 1946), <u>Sharing the Hunt</u> (1987), stencil, 44/55, from a pencil drawing of 1970, 50 x 65 cm. CMC no. UN HI 1987-2 (KEMP). Photograph: Inuit Art Section, Department of Indian and Northern Affairs, Ottawa.

collection of Holman prints of 1965, Helen Kalvak has had a
clearly defined style and set of themes. The formal elements of
her art can be seen in the 1968 stonecut Nightmare. Her subjects
are always presented in a negative space, the composition's forms
are full and individualized as required, and the design or line
defines the subjects, which are often depicted in different ways
in the same picture. Here, the figures are shown full-face, in
profile and slantwise. The design is usually centred in the
middle of the page, and occasionally the picture is completed by
incorporating a structural element into the composition-a semi-
circle or a vertical strip on the left, as in Nightmare. The
human figure is very important in Helen Kalvak's art; it has been
constantly present in her work since it first appeared in 1965.
She portrays it simply as such, or in one of its many aspects-
travelling, hunting, wearing amulets, playing games, dancing.
The stencil Couple with Two Dogs (1982) is a remarkable
composition that features the formal elements described above.
The artist took up the stencil technique again in 1977, when it
had come back into fashion after being abandoned for almost ten
years. The stencil adds the extra dimension of colour to her
art. The design becomes more expressive with the juxtaposition
of different tints, and more clearly renders the details of the
clothing of the Western Arctic region. One of the artist's last
prints, done in stencil from a 1970 drawing, was published in
1987 in an album of posthumous works; it is called Sharing the
Hunt (fig. 15). This abstract/realistic work, anecdotal in
character, deals with a very important aspect of Inuit culture,
that of sharing. This testimony to that concept invites
reflection and admiration.

Agnes Nanogak has been associated with the Holman school
since 1967, when her drawings were first converted into prints.
During this same period she executed many drawings, some of which
were used to illustrate two publications. The style of her
prints and drawings is closely linked to that of the Holman
school, and bears particular resemblance to that of Mark Emerak
and Helen Kalvak. However, she parts from them in the
expressionistic qualities of her art, as we can see in High Kick
(fig. 16), a 1984 stonecut and stencil celebrated for its
rendering of colour (black, white, and red), the exuberance of
the subjects, and the bulk of their forms. The design is
constructed of a positive space and negative lines, in the
typical Holman style. The treatment of texture, volume, and
movement, however, is original. This balanced, expertly
presented composition deals with one of the artist's familiar
themes; the others include animals, the spirit world (shamanism,
dreams), and legendary and mythical tales. A new style appeared
in 1980 - 1981, when Agnes Nanogak's drawings were made into
stencils and lithographs. It can be seen in two expressions of
her narrative flair, Kangyak Flying (1968) and Four Winds (1986),
in which colour lightens and transforms her art. The ample,

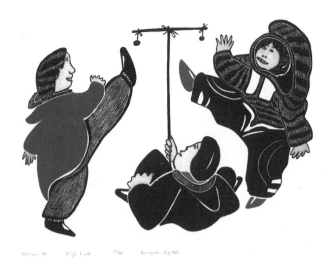

Fig. 16. Agnes Nanogak (b. 1925)/*Harry Egutak* (b. 1925), <u>High Kick</u> (1984), stonecut and stencil, 27/40, 53.5 x 77.5 cm. CMC no. HI 1984-25. Photograph: Inuit Art Section, Department of Indian and Northern Affairs, Ottawa.

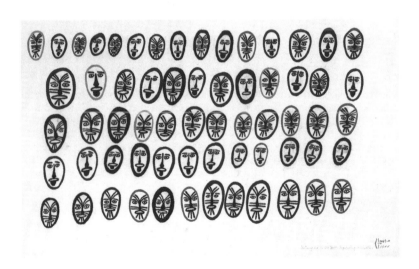

Fig. 17. Luke Anguhadluq (1895 - 1982)/*Magdalene Ukpatiku* (b. 1931), <u>The Young and the Old</u> (1977), stonecut and stencil, 29/29, 62.2 x 98.4 cm. CMC no. BL 1977-3. Photograph: Inuit Art Section, Department of Indian and Northern Affairs, Ottawa.

well-defined forms, enhanced by colour, complete the original
composition and testify to the artist's sense of humour and her
ease in handling her subjects; while the dramatic intensity of
the supple, airy forms makes the movement of the second subject
seem tangible. Agnes Nanogak is certainly one of the great
creators of the Holman school.

THE BAKER LAKE SCHOOL (AFTER 1970)

The Baker Lake school has produced a number of great artists,
including Luke Anguhadluq, Jessie Oonark, Myra Kukiiyaut, and
Simon Tookoome. The human figure, one of their favourite
subjects, is given remarkable treatment, according to the
vocabulary and vision of each artist. The exploitation of
effects, realistic and abstract forms, and primary colours is one
of the particular features of the Baker Lake school. Its artists
are experienced colourists, and their work may be classified as
formal abstract realism.

 The art of Luke Anguhadluq is as significant as that of Parr
(Cape Dorset) and Juanisialu Irqumia (Povungituk). But while
Juanisialu's subjects show man and animals in close relation,
Luke Anguhadluq remains distanced from his subjects (for example,
there is no direct relation between fish and fisherman or between
hunter and catch). Luke Anguhadluq's range of themes is more
varied: he dwells chiefly on human beings, animals, the
traditional activities of hunting, fishing, games and dancing,
and sometimes myths, legends, and the spirit world, especially
shamanism. His prints are noteworthy for their forms, which are
realistic, quasi-abstract at times, and presented as flat
surfaces, with volume practically non-existent. Space is mostly
negative, and occasionally the composition covers almost all of
the paper. Fishing Camp (1970) is a disconcerting,
unconventional work, simultaneously realistic and abstract, but
including all the elements needed to identify the subject as a
fishing camp. Depth is created by arranging the forms on top of
each other, and the traditional motifs of the *ulu* (a woman's
knife) and harpoon distinguish the women from the men. The two
blue tents and the red tent on the right and the yellow fish at
the top left serve to balance this superb composition, which
could almost be called minimalist. Family (1971) takes the human
figure as its subject, one that is very popular with the artists
in the Keewatin region, both in printmaking and carving. Luke
Anguhadluq has devoted much attention to it: as part of a couple
(standing), alone (standing), or in a swarm of faces monopolizing
the pictorial surface, as in The Young and the Old (1977; fig.
17). The artist's characteristic treatment of facial features is
readily identifiable, with its well-defined style, especially in
the eyes, mouth, and tattooing on the women's faces. The
interest of this stonecut lies in its expert juxtaposition of

forms, its colour, interplay of lines, rendering of flat areas, and volume. With its two forms and two colours, <u>Drum Dancing</u> (1975) is a work that is simultaneously realistic and abstract, and one whose great power is evident from the first glance. Dancing to the drumbeat is one of Like Anguhadluq's favourite themes; he has used it many times, but never has he matched the austere treatment of this stencil. <u>Hunting Caribou from Kayaks</u> (1976) is also abstract realism. Here the skilfully arranged forms are represented from three different points of view; the design covers practically the entire printing block. The work's structure lies in the repetition of motifs and colour from left to right: Luke has shown four turquoise forms for the tents, and the same for the kayaks, which are set off against the mauve texture of the background; the river as well as three caribou are in two other shades of turquoise; the multitude of black caribou emphasize that motif, which seems to repeat to infinity; and this splendid composition is completed by two vertical lines between the tents and the river. The skilful use of colour and tonalities as well as the rendering of texture are evidence of a very talented colourist.[29] Once again, a distance is established between the hunters and the animals. Notwithstanding the many elements at play in this work, the scene is static, as in the previous compositions. Luke Anguhadluq was a distinguished creator; his formal, realistic, and abstract art made its contribution to the fame of the Baker Lake school.

Jessie Oonark's is a characteristic, essentially feminine art. This very prolific artist has also gained notice for the great versatility and ease with which she expresses herself in drawings, hangings, and prints. Her themes are approximately the same as those of Luke Anguhadluq, and like him, she favours the human figure, She is particulary attracted to the human face, which she presents frontally or in profile, or both together. The formal, realistic, and abstract[30] art of Jessie Oonark is anchored in the Baker Lake tradition not only in its subjects but also in its approach to and treatment of lines, form, and colour. Her first prints, such as <u>Inland Eskimo Woman</u> (1960; fig.18), were produced at Cape Dorset. This is a work which is not easily accessible. We must look two or three times before realizing that what we have before us is a female silhouette in profile. <u>Inland Eskimo Woman</u> already has certain of Jessie Oonark's characteristic stylistic traits-the subject, the profiled form, the negative space, the rendering of line and texture, the outline of the forms, the two-dimensional image (although the curved line here lends a little volume), and the size of the hood. This very informative work is similar to <u>Woman</u> (1970), one of Jessie Oonark's first creations at Baker Lake. Her talent as a colourist is evident here, as she introduces us to the traditional female garment, the *amautik* (a woman's anorak), whereas the subject of <u>Favourite Daughter</u> (1985) is wearing contemporary garb. Note the similarity of the faces and limbs

(each subject has a head-dress), the interest in colour, the symmetry, and the play of lines, forms and texture in the contemporary costume. Here we have signs of the interests of an expert seamstress. The development that has taken place between these two designs is revealing: the first is presented as a flat surface, while the second conveys a certain volume; both subjects, however, are frozen in time. Clearly, what Jessie Oonark is doing here is displaying clothing to us, and pointing out its historical importance. The subject herself seems to be secondary, as in Big Woman (1974). Jean Blodgett comments:

> Big Woman... [conveys] to us a feminine concern for personal appearance among the Inuit women who traditionally did not use jewellery or make-up. Another form of adornment, in addition to elaborate hair-dos, was tattooing-faces, hands, even arms and thighs were decorated with black soot tattoo marks. The woman in Big Woman..., whose face is quite heavily tattooed, also has beautifully dressed hair. Two large stylized ulus (the woman's knife) to the sides of her head provide additional visual and compositional embellishments.[31]

The treatment of the head-dresses and traditional feminine articles is refined and elegant. While Jessie Oonark was very attached to her way of life, she, like Pudlo Pudlat from Cape Dorset and Mark Emerak from Holman, was influenced by the modern vehicles in the Arctic. We should not be surprised to see the skidoo implanted in some of her compositions, such as Sunface and Birdcatchers (1971), a wall hanging. One of Jessie Oonark's last prints, The People (1985) is a fascinating arrangement of the motif she no doubt used most often, the human face. With no background, this composition covers most of the pictorial surface. From a face presented frontally in blue, a circle develops, creating a double spiral in red and blue that incorporates and juxtaposes a multitude of profiled faces in black, including four birds at the bottom and one at the top of the spiral. The rounded face at the very centre of the composition is encircled by all those other faces that seem to be moving in and out, creating an utterly captivating ensemble. While static, there is a slight vibration to the work that is somewhat reminiscent of Mark Emerak's Great Whirlpool. But its interest lies primarily in the visual effect of the whole.[32] Jessie Oonark has left behind a body of work whose aesthetic value is equally only by its reputation.

The art of Myra Kukiiyaut is very contemporary. It, too falls within the province of abstract realism, and is closely tied to traditional Inuit culture, from which the artist draws her inspriation. Her work deals chiefly with dreams, birds, animals and the juxtaposition of man and animals; but she is

especially interested in stories, myths, legends, shamanism, and
the spirit world. Her very distinctive graphic approach derives
from the lyrical expressionism of forms that are coloured, fluid,
vaporous, sinuous, and moving in a picture without a background.
Dark Caribou (1973), The Shaman Flies with His Helpers (1980),
and Flying Over the Land (1985) provide an excellent visual
summary of her art. The coloured shapes serve to structure the
pictorial plane: in the first work, they are juxtaposed in a way
that is orderly yet energetic; in the second, they intermingle
and overlap in a disorderly and very agitated fashion, creating
an effect of depth and different levels; and in the third they
come together in a kind of stability. She prefers above all to
establish an intimate reationship between her subjects. Myra
Kukiiyaut does not delimit her forms; only rarely does she
provide them with outlines. While cool tints predominate in her
compositons, she likes to contrast them with one or two warm
colours. Myra Kukiiyaut has a rich vocabulary, she celebrates
form, and her talent as a colourist links her clearly to the
Baker Lake school.

Simon Tookoome interprets his universe in a very distinctive
manner. Like the other Baker Lake artists, he favours the human
face, which he has explored in all its aspects. It is always
present, whether in scenes from the traditional life, the spirit
world (particularly shamanism), legendary and mythical stories,
or the interaction between men and animals. The face in profile,
which appears in his first compositions, was to be developed over
the years; in his recent work it proliferates, and becomes his
favourite subject. On the other hand, the full face that can be
seen in his early works soon disappeared. Simon Tookoome draws
his faces with hair, and almost always with headgear, alluding to
the severity of the Inuit climate, A Vision of Animals (1972),
Qadruhuaq, the Mysterious Helper (1973), and An Embarrassing
Tumble (1976) are representative works. Tookoome 's rigid
shapes, delimited by his black, repetitive line, generated
ambiguity; when he presents two faces in profile face to face or
back to back, for example, his design creates confusion,
especially in his powerful interpretation of An Embarrassing
Tumble. Jean Blodgett speaks of "Tookoome's penchant for the
visual double entendre."[33] The formal diversity obtained by the
play of positive and negative space is magnified by the textural
effects, the subtlety of the tonalities and the preponderance of
cool colours, which are usually set off by a warm colour. Some
works are treated in two dimensions, while others have little
depth; in all of them, however, everything is static, and the
forms are well circumscribed. Over the years, compositions that
cover almost all of the stone surface have become a favourite of
his. Simon Tookoome 's art is formal, realistic, and abstract;
he has created several works in black and white, including the
very powerful Argument (1976).

Fig. 18. Jessie Oonark (1906 - 1985)/*Eegyvudluk Pootoogook* (b. 1931), <u>Inland Eskimo Woman</u> (1960), stonecut, proof/50, 61 x 32 cm. CMC no. CD 1960-62. Photograph: Inuit Art Section, Department of Indian and Northern Affairs, Ottawa.

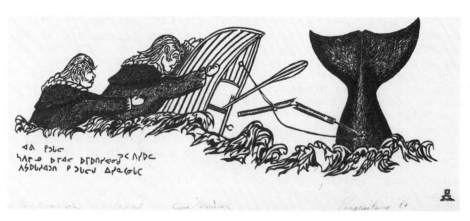

Fig. 19. Lipa Pitsiulak (b. 1945)/*Jeetaloo Akulukjuk* (b. 1939), <u>Danger in the Whale Hunt</u> (1984), stonecut, 36/50, 34 x 61 cm. CMC no. PA 1984-28. Photograph: Inuit Art Section, Department of Indian and Northern Affairs, Ottawa.

THE PANGNIRTUNG SCHOOL (AFTER 1973)

The Pangnirtung school includes such great artists as
Elisapee Ishulutaq, Tommy Nuvaqirq, Lipa Pitsiulak, and several
others, who have given Pangnirtung a distinctive aesthetic: an
intimist art deriving from historical realism, a landscape with
colours that modulate from cool and soft to dark and textured,
and which emerge according to the artist's individuality. The
subjects treated by the three artists include the traditional
Inuit life, animals, birds, hunting and fishing, transportation,
games, and dancing. Elisapee Ishulutaq and Tommy Nuvaqirq
especially like to depict the *umiak* (a sealskin boat) and other
boats, while Lipa Pitsuilak favours legendary and mythical tales
and the spirit world, including shamanism and dreams.

The essentially feminine art of Elisapee Ishulutaq portrays
her vision of the way of life at Pangnirtung, on Baffin Island.
She has concentrated on the human figure, but her approach from
that of Pitseolak Ashoona, Helen Kalvak, Luke Anguhadluq and
Jessie Oonark. In the powerful Woman Thinking (1983) the render-
ing and execution of the woman's form, which is done in the
intimist style, allows us an insight into her character. She is
presented frontally, and attention is centred on the profundity
of the carefully drawn face. The curved volume of the hood and
the continuing curves of the arms accentuate the face, and the
representation of the two feet pointing inward reinforces the
structure of the composition. The arrangement of verticals,
horizontals, and curves effectively situates the lines and
volumes of this composition in a negative space. While the grey,
green, brown, and rust are rather sombre colours, the yellow
brightens the whole, as the play of tonalities emphasizes the
outline and creates textural effects. The artist has humanized
her character. The human being, as a subject by itself or in a
composition, is as important in Inuit art as it has been in
European and Canadian art for centuries. Like Pitseolak Ashoona,
Elisapee Ishulutaq generally presents it to us engaged in
traditional activities, as in the wall hanging Woman and Child in
Tent House, done about 1980, and Preparation for Food (1984),
where she has depicted her characters inside their traditional
dwelling. The print offers us a profile view and a bird's-eye
view, and the hanging a bird's-eye view. The two contain similar
motifs, such as the skins, the *qulliq* (traditional oil lamp) and
other forms that characterize the artist's graphic vocabulary.
The inside wall of the igloo in the background provides the print
with its structure. The igloo is depicted by means of juxtaposed
shapes consisting of vertical, horizontal, and curved lines that
capture its volume and monumental nature. The man and woman are
represented so as to show the close cooperation that exists
between the Inuit couple; both are portrayed in their individual
roles and with the tools proper to them: man the provider, woman
the housekeeper. The design is made very expressive by the green

pastel, brown, and grey colours and their various shades.
Ataktoo: Moving from Fresh Water to Salt Water (1984) deals with
an important facet of the traditional life-travel. The elements
of the composition are realistic, but the motif of the *umiaq*
(sealskin boat) on water is slightly confusing. (The *umiaq* has
appeared in her work since 1975). Here again we find the
artist's characteristic style of colouring. Elisapee Ishulutaq
is a great artist of the Pangnirtung school; in her intimist
realism, she has a very personal mode of self-expression, and she
is a great colourist.

Tommy Nuvaqirq has been a member of the Pangnirtung school
since its beginnings in 1973. His artistic production is
diverse, like that of his two colleagues; it might be termed
historical landscape realism. He has focused on whaling boats,
and his works include some of the most accomplished on this
subject, in addition to being of historical importance. This
motif gives him aesthetic scope for his famous seascapes. Since
Pangnirtung overlooks Pangnirtung Fiord near Cumberland Sound,
his interest in this theme is hardly surprising. Two major works
in this vein are Whaling in the Cumberland Sound: 1930s (1977)
and Happy Return (1986). In the first, the mass of water is
shown in the foreground, in the middle distance are the main ship
and its succession of seven boats linked by cable, as well as one
final shape no doubt representing the land, and in the background
the sky. What stands out in this picture are the string of boats
and the silhouettes of the passengers suggested in the distance,
and also the magnificent rendering of the blues, with all the
various shades that stencil can give. In the second picture, we
have in the middle distance a profile view of a sailing ship
equipped for the hunt, with a few passengers on board; behind it
is a mass that can be identified as the land and several birds in
flight. Once again, three pictorial planes have been defined:
first, water and boat, second, the sky, and third, the five seals
in profile (these probably related to the hunters' dreams of
prey). The stencil is remarkable for its colour gradations of
turquoise, blue, beige, grey, and red, and its finely executed
etching of such motifs as the seals, the upper sky, the sails and
the birds.

In View of the Future (1985), with its contemporary houses,
is without doubt a view of Pangnirtung looking out on the sea
(where a ship is outlined) and on magnificent fiords, the one on
the right surmounted by an *inuksuk* (stone cairn). This landscape
scene is excellently structured; its colours are warm, its shapes
and planes well defined, and the stencil leaves a strong
impression of freshness that allows us to appreciate once again
the artist's great talent as a colourist. Tommy Nuvaqirq and
Pudlo Pudlat (Cape Dorset) are both interested in depicting their
respective localities as they exist today, and both provide us
with very interesting social commentary. Influenced by the

history of the whaling boats of Cumberland Sound and by his splendid homeland, Tommy Nuvaqirq has used his talent to pay them tribute.

The art of Lipa Pitsiuak is one of high dramatic power, grounded in historical realism: he transfers to stonecuts traditional motifs from tales and from the past. His relatively dark palette became lighter in the early eighties. <u>Disguised Archer</u> (1976) and <u>Mad Dance of the Qailertetang</u> (1977) are two works from his classic period. Lipa Pitsiulak presents his scenes in open Arctic space; his figures are active and exert a great deal of energy, thereby creating great pictorial tension that is further magnified by the various textural effects. The first work is a close-up and profile of a disguised hunter, bow in hand, ready to shoot. The motif is supported by the horizon created by the juxtaposed stones, which are actually part of a cache. This two-plane composition is well-balanced, and enhanced by the skilful use of brown and black, as well as by the juxtaposition of smooth and textured surfaces. The second picture presents a group of three dancers seen in profile, supported by a horizontal line for the ground and framed by two stone cairns, The figures are in movement and each holds a traditional object: respectively a drum, a harpoon, and an *avataq* (an inflated sealskin float). The textured surfaces emphasize movement, while the flat surfaces create balance; brown and black are used for dramatic effect, while the flesh colour of the faces and the golden yellow and olive green brighten the composition.

<u>Danger in the Whale Hunt</u> (1984; fig. 19) expresses another aspect of his style, on which the artist has these comments:

> I usually try to relate my drawings to the history, the life of our ancestors. This one is whaling. The print is showing my father's experience as a whaler. The idea comes from my father's stories, it is not a legend. These are my visions of how our ancestors' everyday life might have been.... I want to portray this so it will not be forgotten.[34]

A number of artists from this school have produced works of a dramatic nature in stonecuts (or lithographs). Lipa Pitsiulak remains very active, in carving as well as in drawing. In 1985 he took up a new process, etching, which allows him to create works of great finesse. He continues to use his art to record the tales and experience of the past. His historical approach is characteristic of the Povungnituk artists.

CONCLUSION

In the period 1957 - 1958, a dozen artists produced twenty small
series of prints, which were the first Inuit prints to enter the
art market. Jean Sutherland Boggs, former director of the
National Gallery of Canada, wrote the following when the
printmaking centre at Cape Dorset had been in existence for ten
years:

> It is now just ten years since the first Eskimo prints
> from Cape Dorset appeared to surprise and excite us by
> the boldness and liveliness of their design and the
> originality of their subject matter. During these
> years prints have retained their distinctive
> characteristics and that simplicity of vision which are
> among their great attractions.[35]

Today close to one hundred artists are exercising their
talents as designers and prinmakers in more than five different
areas of the Canadian Far North,[36] environments that have
influenced their creativity and their particular aesthetic. The
works of these artists are intimately linked to their
surroundings and their history, and they allow us to appreciate
the symbols and images of another culture. They awaken the
imagination, arouse admiration and invite reflection. Over the
years, the Inuit artists have established a bond with their
admirers; they have used their art as a means of communication
and reconciliation. Consequently we cannot remain indifferent to
it. We can only praise the tenacity and skill with which two
generations of artists continue to develop their cultural
heritage.

During the thirty years of its history, Inuit printmaking
has earned itself a reputation of national and international
dimensions. It stands apart from traditional art and modern art
in general, while remaining very contemporary and typically
Inuit.

ACKNOWLEDGEMENT

The drawings and prints are reproduced by permission of the
artists, through the following institutions:

West Baffin Eskimo Co-operative Ltd.
La Fédération des Coopératives du Nouveau-Québec
Holman Eskimo Co-operative Ltd.
Sanavik Co-operative Association Ltd.
Pangnirtung Eskimo Co-operative Ltd.
Office of the Public Trustee for the Government of the Northwest
Territories

NOTES

1. Jean Blodgett, _Eskimo Narrative_ (Winnipeg: Winnipeg Art Gallery, 1979), 3.

2. George Swinton, _Sculpure of the Eskimo_ (Toronto: McClelland and Stewart, 1972), 130.

3. George F. MacDonald, _The Cape Dorset Print: Commemorating Twenty-Five Years of Printmaking at Cape Dorset_ (Ottawa: National Museum of Man, National Museums of Canada, 1983), unpaged.

4. James A. Houston, _Eskimo Prints_ (Barre, Mass.: Barre Publishers, 1967; Don Mills, Ont.: Longman, 1971), 11.

5. _Ibid._, 16 - 18.

6. Mary M. Craig, "The Cape Dorset Prints," _Beaver_ (spring 1975), 23 - 24.

7. Dorothy Eber, "The History of Graphics in Dorset: Long and Viable," _Canadian Forum_ 54 (March 1975), 31.

8. Each school has its own way of transferring the design to the print, and the results are further modified by the printer's style. These are aspects that we will not cover in this survey.

9. James A. Houston, _Eskimo Prints_, 22.

10. Drawing is a mode of artistic expression that is independent of printmaking; it should be considered separately and on its own. This survey will therefore deal primarily with the artistic development of printmaking, which holds a special place in contemporary Inuit art and has become a recognized genre. For reference purposes, however, drawings will be used in this text to illustrate the stylistic continuity between drawings and prints.

11. Marion E. Jackson, _Contemporary Inuit Drawings_ (Guelph, Ont.: Macdonald Steward Art Centre, 1987), 11 - 12. We are using the author's terminology.

12. Jean Blodgett, _Kenojuak_ (Toronto: Mintmark Press, 1983), 34.

13. Fifty copies are normally pulled of an Inuit print, and so it was for this stonecut: twenty-five in red and black, and twenty-five in green and black.

14. Jean Blodgett, _Grasp Tight the Old Ways: Selections from the Klamer Family Collection of Inuit Art_ (Toronto: Art Gallery of Ontario, 1983), 92.

15. <u>Ibid</u>.

16. Dorothy Eber, ed., <u>Pitseolak: Pictures Out of My Life</u>
(tape-recorded interviews), (Montreal: Design Collaborative
Books; Toronto: Oxford University Press, 1971; Seattle:
University of Washington Press, 1972), unpaged.

17. Jean Blodgett, <u>Grasp Tight the Old Ways</u>, 128; Dorothy
LaBarge, <u>From Drawing to Print: Perception and Process in Cape
Dorset Art</u> (Calgary: Glenbow Museum, 1986), 18.

18. Dorothy Eber, ed., <u>Pitseolak</u>.

19. Dorothy LaBarge, <u>From Drawing to Print</u>, 19.

20. Jean Blodgett, <u>Grasp Tight the Old Ways</u>, 126

21. George Swinton, "The Povungnituk Eye," <u>Povungnituk 1985:
Print Catalogue</u> (Montreal: Fédération des Coopératives du Nou-
veau-Québec, 1985), unpaged.

22. Harold Seidelmaln, "Davidialuk's Work: A Living History,"
<u>Arts and Culture of the North</u>, 4 (autumn 1980), 279.

23. Ian G. Lindsay, "Foreword," <u>Povungnituk 1976: Print
Catalogue</u> (Montreal: Fédération des Coopératives du Nouveau-
Québec, 1976), unpaged.

24. Marybelle Myers, ed., <u>Joe Talirunili: "A Grace Beyond the
Reach of Art"</u> (Montreal: Féderation des Coopératives du Nouveau-
Québec, 1977), unpaged.

25. Marybelle Myers, "Josie P. Papialook," <u>Beaver</u> (spring 1982),
22, 24, 25.

26. <u>Povungnituk 1980: Print Catalogue</u> (Montreal: Fédération des
Coopérativies du Nouveau-Québec, 1980), 12.

27. Indian and Northern Affairs Canada, Inuit Art Section:
print and drawing catalogue card no. 3.84.21.

28. Mary M. Craig, "Povungnituk: Its History Reflected by Its
Printmakers," <u>Arts and Culture of the North</u>, 2 (November 1977),
59.

29. Jean Blodgett, <u>Tuu'luq/Anguhadluq</u> (Winnipeg: Winnipeg Art
Gallery, 1976), unpaged.

30. Ian G. Lumsden, <u>The Murray and Marguerite Vaughan Inuit
Print Collection/Collection d'estampes inuit</u> (Fredericton, NB:
Beaverbrook Art Gallery, 1981), 11.

31. Jean Blodgett, Grasp Tight the Old Ways, 54.

32. Jean Blodgett and Marie Bouchard, Jessie Oonark, a Retrospective (Winnipeg: Winnipeg Art Gallery, 1986), 64 - 65.

33. Jean Blodgett, Grasp Tight the Old Ways, 65.

34. Pangnirtung 1984: Print Catalogue (Pangnirtung, NWT: Pangnirtung Eskimo Cooperative, 1984), unpaged.

35. Jean Sutherland Boggs, Cape Dorset: A Decade of Eskimo Prints and Recent Sculptures (Ottawa: National Gallery of Canada, 1967), unpaged.

36. From a conversation with Terrence P. Ryan, general manager of the West Baffin Co-operative Limited, and Sandra B. Barz, editor of Arts and Culture of the North.

BIBLIOGRAPHY

Art Gallery of Ontario
1976 The People Within/Les gens de l'intérieur. Toronto, Ont.:
Art Gallery of Ontario

Baker Lake Print Catalogues, 1970 - 1987.

Barz, Sandra, ed.
1981 "Inuit Artists Print Workbook." Arts and Culture of the
North, New York.

Blodgett, Jean
1976 Tuu'luq/Anguhadluq. Winnipeg, Man.: Winnipeg Art Gallery.

1978 Looking South. Winnipeg, Man.: Winnipeg Art Gallery.

1979 "Christianity and Inuit Art." Beaver autumn:16 - 25.
 "The Historic Period In Canadian Eskimo Art." Beaver
summer:17 - 27. Eskimo Narrative. Winnipeg, Man.: Winnipeg Art
Gallery.

1981 Kenojuak. Toronto, Ont.: Mintmark Press.

1983 Grasp Tight The Old Ways: Selections from the Klamer
Family Collection of Inuit Art. Toronto, Ont.: Art Gallery of
Ontario.

1986 North Baffin Drawings. Toronto, Ont.: Art Gallery of
Ontario.

Blodgett, Jean and Marie Bouchard
1986 Jessie Oonark: A Retrospective. Winnipeg, Man.: Winnipeg
Art Gallery.

Butler, Sheila
1976 "The First Printmaking Years at Baker Lake: Personal
Recollections." Beaver spring:17 - 26.

Cape Dorset Print Catalogues, 1959 - 1987.

Craig, Mary M.
1975 "The Cape Dorset Print." Beaver spring:22 - 29.

1977 "Povungnituk: Its History Reflected by Its Printmakers."
Arts and Culture of the North 11(1), November:59, New York.

Driscoll, Bernadette
1982 Inuit Myths, Legends and Songs. Winnipeg, Man.: Winnipeg
Art Gallery.

1983 Baker Lake Prints and Print-Drawings 1970 - 76. Winnipeg, Man.: Winnipeg Art Gallery.

1984 "Tatoos, Hirstick and Ulus: The Graphic Art of Jessie Oonark." Arts Manitoba 3(4) autumn:12 - 9.

Eber, Dorothy, ed.
1971 Pitseolak: Pictures of My Life (tape-recorded interviews). Montreal, Que.: Design Collaborative Books; Toronto, Ont.: Oxford University Press, 1971; Seattle, Wash.: University of Washington Press, 1972.

1972 "Looking for the Artists of Cape Dorset." Canadian Forum 52 (618/619) July/August:12 - 16.

1973 "Jonniebo: Time to Set the Record Straight." Canadian Forum 52 (624) January:6 - 9.

1978 "The History of Graphics in Dorset: Long and Viable." Canadian Forum 54 (649) March:29 - 31.

Fry (Delange), Jacqueline
1971 "Contemprary Arts in Non-Western Societies." Artscanada 28 (162,163) December/January 1972:96 - 101.

1987 "Contemporary Inuit Art and Art from other 'Tribal' Cultures." American Review of Canadian Studies 17(1) spring:41 - 46.

Goetz, Helga
1977 The Inuit Print/L'estampe inuit. Ottawa, Ont.: National Museum of Man (now Canadian Museum of Civilization).

Graburn, Nelson H.H.
1987 "Inuit Art and Expression of Eskimo Identity." American Review of Canadian Studies 17(1) spring:47 - 63.

Greenhalgh, Michael and Vincent Megaw, eds.
1978 "Touch and the Real: Contemporary Inuit Aesthetics-Theory, Usage, and Relevance." Art in Society. New York: St. Martin's Press; London: Gerald Duckworth.

Holman Print Catalogues, 1965 - 1970, 1972 - 1977, 1979 - 1987.

Houston, James A.
1971 Eskimo Prints. Barre, Mass.: Barre Publishers, 1967; Don Mills, Ont.: Longman, 1971. Bilingual.

1981 "The Inuit Intuit." Art/Craft Connection summer:17 - 18.

Jackson, Marion E.
1985 "Inuit Prints: Impressions of Culture in Transition." LSA 9 autumn:6 - 12.

1987 "Inuit Drawings: More than Meets the Eye." American Review of Canadian Studies 17(1) spring:31 - 40.

Jackson, Marion E. and Judith M. Nasby
1987 Contemporary Inuit Drawings. Guelph, Ont.: Macdonald-Steward Art Centre.

Jenness, Diamond
1922 "Eskimo Art." Geographical Review 12(2) April:161 - 174.

LaBarge, Dorothy
1986 From Drawing to Print: Perception and Process in Cape Dorset Art. Calgary, Alta.: Glenbow Museum.

La Vallée, Thérèse
1970 Povungnituk: Gravures et sculptures du Nouveau-Québec. Collection Panorama. Montreal, Que.: Lidec Inc..

Lochhead (Bryers), Joanne Elizabeth
1974 "The Graphic Art of the Baker Lake Eskimos from July 1964 to July 1973." Master's thesis, University of Toronto.

Lumsden, Ian G.
1981 The Murray and Marguerite Vaughan Inuit Print Collection/ Collection d'estampes inuit. Fredericton, NB: Beaverbrook Art Gallery.

Metayer, Maurice, ed. and Agnes Nanogak, ill.
1972 Tales from the Igloo, Edmonton, Alta.: Hurtig Publishers.

Myers, Marybelle, ed.
1977 Davidialuk. Montreal, Que.: Fédération des Coopératives du Nouveau-Québec.

 Joe Talirunili: "A Grace Beyond The Reach of Art." Montreal, Que.: Fédération des Coopératives du Nouveau-Québec.

1980 Things Made by Inuit. Montreal, Que.: Fédération des Coopératives du Nouveau-Québec.

Myers, Marybelle
1982 "Josie P. Papialook." Beaver spring:22 - 29.

Nanogak Goose, Agnes
1986 More Tales from the Igloo. Edmonton, Alta.: Hurtig Publishers.

National Gallery of Canada/National Museums of Canada
1967 Cape Dorset: A Decade of Eskimo Prints and Recent Sculp-
tures. Ottawa, Ont.: National Gallery of Canada, National
Museums of Canada.

National Museum of Man (now Canadian Museum of Civilization)/
National Museum of Canada
1970 Oonark/Pangnark. Ottawa, Ont.: Canadian Arctic Producers
Ltd. with the cooperation of the National Museum of Man/National
Museums of Canada.

1983 The Cape Dorset Print: Commemorating Twenty-five Years of
Printmaking at Cape Dorset. An exhibition at Rideau Hall by the
National Museum of Man/National Museums of Canada.

Pangnirtung Print Catalogues, 1973, 1975 - 1980, 1982 - 1987.

Povungnituk Print Catalogues, 1962, 1964 - 1966, 1968 - 1970,
1972, 1973, 1975 - 1978, 1980, 1982 - 1987.

Roch, Ernest, ed.
1974 Arts of the Eskimo: Prints. Texts by Patrick Furneaux and
Leo Rosshandler. Montreal, Que.: Signum Press; Toronto, Ont.:
Oxford University Press.

Routledge, Marie
1979 Inuit Art of the 1970's. Kingston, Ont.: Agnes Etherington
Art Gallery.

Ryan, Terrence P.
1964 "Drawings from the People." North 11(5) September/
October:25 - 31.

1965 "Eskimo Pencil Drawings: A Neglected Art." Canadian Art
22(1):30 - 35.

Saladin d'Anglure, Bernard
1978 La parole changée en pierre. Vie et oeuvre de Davidialuk
Alasuaq, artiste inuit du Québec arctique. Les cahiers de
patrimoine. Quebec City, Que.: Ministère des affaires
culturelles, 11.

Seidelman, Harold
1980 "Davidialuk's World: A Living History." Arts and Culture
of the North 4(4) autumn:279 - 281.

Swinton, George
1971 Eskimo Art Reconsidered." Artscanada 28(162/163)
December/January 1972:85 - 94.

1972 Sculpure of the Eskimo. Toronto: McClelland and Stewart,
255.

Swinton, Nelda
1980 The Inuit Sea Goddess. Montreal, Que.: Musée des beaux-
arts de Montréal.

1981 The Jacqui and Morris Shumiatcher Collection of Inuit Art.
Regina, Alta.: Norman Mackenzie Art Gallery.

Taylor, William E., Jr., and George Swinton
1967 "Prehistoric Dorset Art." Beaver autumn:32 - 47.

Vastokas, Joan M.
1971 "Continuities in Eskimo Graphic Style." Artscanada
28(162/163) December/January 1972:69 - 83.

1986 "Native Art as Art History: Meaning and Time from
Unwritten Sources." Journal of Canadian Studies 21(4) winter:7 -
36.

Watt, Virginia J., ed.
1980 Canadian Guild of Crafts, Quebec: The Permanent Collection
Inuit Arts and Crafts-circa 1900 - 1980. Montreal, Que.: Cana-
dian Guild of Crafts, Quebec.

West Baffin Eskimo Co-operative
1975 Pitseolak. Cape Dorset, NWT: West Baffin Eskimo
Co-operative in cooperation with the Department of Indian and
Northern Affairs.

1979 Parr: A Print Retrospective. Cape Dorset, NWT: Kingait
Press.

Winnipeg Art Gallery
1977 Povungnituk. Winnipeg, Man.: Winnipeg Art Gallery.

1979 Baker Lake Drawings. Winnipeg, Man.: Winnipeg Art Gallery.

 Cape Dorset. Winnipeg, Man.: Winnipeg Art Gallery.